A HISTORY OF PAINTING IN NORTH ITALY

VOLUME 2

AMS PRESS

NEW YORK

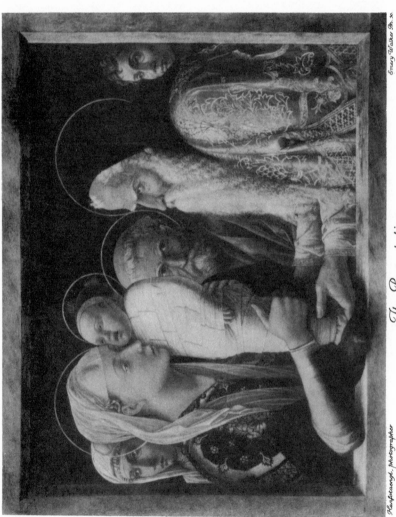

The Presentation
Andrea Mantegna
Kaiser Friedrich Museum, Berlin

A
HISTORY OF PAINTING
IN NORTH ITALY

VENICE, PADUA, VICENZA, VERONA
FERRARA, MILAN, FRIULI, BRESCIA

FROM THE FOURTEENTH TO THE
SIXTEENTH CENTURY :: BY J. A.
CROWE AND G. B. CAVALCASELLE

EDITED BY TANCRED BORENIUS, Ph.D.

IN THREE VOLUMES ILLUSTRATED

VOL. II

LONDON
JOHN MURRAY, ALBEMARLE STREET, W.
1912

Library of Congress Cataloging in Publication Data

Crowe, Joseph Archer, Sir, 1825-1896.
 A history of painting in north Italy.

 Reprint of the 1912 ed. published by J. Murray,
London.
 Bibliography: p.
 Includes index.
 1. Painting — Italy, Northern. 2. Painting, Gothic —
Italy, Northern. 3. Painting, Renaissance — Italy,
Northern. I. Cavalcaselle, Giovanni Battista, 1820 —
1897, joint author. II. Title.
ND619.N67C76 1976 759.5 76-22574
ISBN 0-404-09290-X

Reprinted from the edition of 1912, London
First AMS edition published in 1976
Manufactured in the United States of America

International Standard Book Number:
Complete Set: 0-404-09290-X
Volume II: 0-404-09292-6

AMS PRESS INC.
NEW YORK, N.Y.

CONTENTS

VOL. II

CHAPTER I

CHAPTER II

CHAPTER III

CHAPTER IV

CHAPTER V

CHAPTER VI

CHAPTER VII

LIST OF ILLUSTRATIONS

VOL. II

vii

NOTE

The editor's notes are marked with an asterisk.

PAINTING IN NORTH ITALY

VOL. II

CHAPTER I

SQUARCIONE, MANTEGNA, AND THE CHAPEL OF THE EREMITANI

THE birth and growth of the Venetian school have been treated in these pages as an independent part of the history of Italian painting ; but constant reference was made to the principles and teaching of the Paduans as affecting the progress of their more insular neighbours. We shall find it necessary to devote considerable attention to these Paduans ; first of all for the sake of reconstructing their lives in a manner agreeable to historic truth, and next to strip their earliest masters of a fictitious importance.

During the fourteenth century Paduan art was a mere exotic. The men who throve were Altichiero, Avanzi of Verona, and Giusto of Florence ; Guariento being in practice a Venetian. Wherever remains of local craftsmen are found they exhibit an humble and unpresuming mediocrity ;[1] and as the fourteenth century closes, Giottesque is supplanted by Umbrian feeling.

[1] Amongst the older works about Padua, there are some which, having previously escaped notice in these pages, may now be mentioned. (1) Roncaiete, near Padua (church of). Small altarpiece, wood, gold ground, in two courses. Below, the Virgin and Child between SS. James and Lawrence presenting a kneeling patron, Fidenzio and Bartholomew; above, the crucified Saviour bewailed by the Virgin and evangelist between an archangel and St. John the Baptist, St. Lucy and another female saint. This is a coarse work of the middle of the fifteenth century. (2) Piove, church of San Niccolò. Virgin and Child, on gold ground between SS. Martin, John the Baptist, Nicholas, and Francis, an altarpiece of five pointed gables, inscribed: "Gisielmus de Veneci pinxit hoc opus." The figures are lean, of poor shape, and defective in nude form; the colour is of greenish olive, and the author a man of the stamp of Lorenzo of Venice. (3) Same place, church dei Penitenti. Fresco of the Assumption with the kneeling

Here, as at Venice and Verona, the influence of Gentile da
Fabriano and Pisano for a time prevailed ; but that influence was
faint and dubiously extended to the works of Jacopo di Nerito.[1]
It was fortunate under these circumstances that a study was at
last founded by Squarcione, in which the rudiments of education
might be attained. At the time when we may suppose this novel
institution to have been started, the fervent religious spirit of an
earlier age had begun to fade, and classics were about to revive
under the patronage of the Universities. A man like Squarcione,
whom we may credit with intelligence and a spirit of enterprise,
might and probably did gather a number of youths together for
the purpose of teaching them an art in which he was himself but

apostles below, by a feeble Giottesque of the rank of those whose works we see
about Ravenna. A lunette with the Eternal and angels is of the eighteenth
century. (4) In the sacristy of the same church, an altarpiece of the Virgin and
Child adored by two donors, with six saints, two of which are St. Francis
and Santa Chiara, in trefoil niches at the sides, and five pinnacles, with the
Ecce Homo between the Virgin and St. John, and the angel and Virgin annunciate.
This is a greatly injured piece with figures one-third of life-size, of sombre flesh-
colours, and remarkable for the sharp contrasts and staring eye of the period of
Semitecolo and Lorenzo. It is a work of the close of the fourteenth or rise
of the fifteenth century. [* This polyptych is now in the sacristy of the Chiesa
Matrice at Piove. Signor Pinton thought he had deciphered on it the signature
of Paolo da Venezia and the date 1332 (*Nuovo archivio veneto*, ser. i. vol. i.
pp. 108 *sqq.*); but he seems to have been mistaken (cf. Testi, *La storia della
pittura veneziana*, i. 204).]

Amongst local Paduans we may also notice one of whom nothing else in known
but the following. (5) Venice, belonging to a dealer, Giacomo Cassetti, living at the
Campo Santa Marina. Two lunettes with busts of bishops, one of them reading
a book, in the thickness of which we read the words : " Opš Campagnola
pa. 1474." These two pieces are stated to have been in the church of the
convent de' Miracoli at Venice. They are painted in the coarse manner of a
contemporary of Guariento, and have no relation to the Paduan style of the
Squarcionesque school, though the name, which appears genuine, seems to be that
of a Paduan artistic family. [* The present owner of these paintings is unknown.]

[1] Of Jacopo di Nerito it is said in Moschini (*Vicende della Pittura in Padua*,
8vo, Pad. 1826, pp. 19–20) that he painted a picture once in San Michele of
St. Michael in gigantic proportions, trampling Lucifer under his feet. On this
picture was the inscription : "Jacobus de Neritus discipulus Gentili de
Fabriano." There are pictures in Padua which have the stamp of Gentile, and
may for want of a better name be called by that of Nerito : *e.g.* (1) Padua,
Marchese Galeazzo Dondi-Orologio. St. Michael enthroned with the dragon under
his feet, natural in pose, round-headed, with crisp locks and a jewelled diadem.
His dress is that of an ecclesiastic with much embossment. The manner of the
artist is a mixture of Guariento and Michele Giambono, perhaps a little better
than that of the pictures by the latter. Were not our attention called to Nerito,

a slight adept. That there was a large demand for pictorial creations is proved by the employment of strangers as well as by the constant increase in number of the members of the Paduan guild. But the steady obscurity in which the masters of this guild remained is as remarkable as the disappearance of their labours. The regulations under which members were affiliated were exceptionally liberal, enabling Italians of southern and northern birth and even Germans to compete, yet the result as regards Paduan painting was not the less infinitesimal;[1] and if we take Squarcione as the representative of the Paduan standard of his time, he was neither better nor worse than local men of poor talents in Italy or Germany.

we should say this was a work by Giambono. It may, however, be the missing piece mentioned by Moschini. [* The picture seen by the authors in the Dondi-Orologio collection appears to be identical with one which now belongs to Mr. B. Berenson of Settignano, and which may be confidently ascribed to Giambono. As shown by Mr. Rushforth (in *The Burlington Magazine*, xx. 106 *sq.*) it probably does not represent St. Michael, but a representative of the angelic order of Thrones.] But, in addition to this, we have (2) a standing figure of St. Michael trampling on the dragon and piercing it with his lance in the parish-house of the church del Torresino, near Padua. [* It is now in the Communal Gallery at Padua, No. 1893.] Of this piece we are told that it was once in San Michele of Padua. Its style is that of a man of later date than we can assign to Nerito, a pupil of Gentile da Fabriano, and would more properly be ascribed to Lazzaro Bastiani had he lived long enough. This, however, may be an old copy extensively repainted of Nerito's original. Of the same stamp as the immediately foregoing is (3) an angel Gabriel, part of an Annunciation, a canvas (No. 613) in the Communal Gallery of Padua under Nerito's name. It is injured, and almost entirely repainted in oil, yet in better condition than the St. Michael of the church del Torresino. The figure is heavy in frame and head, with a high forehead and large hands and feet—little, in fact, to remind us of Gentile da Fabriano. [* For additional information concerning the two last-mentioned pictures, see *antea*, i. 221, n. 4.] (4) Further, St. John the Baptist, St. Peter, and a bishop, oblong panels, in possession of Marchese Galeazzo Dondi-Orologio, St. Gregory, and a Franciscan bishop, once in the Capo di Lista collection, now in the Communal Gallery at Padua, all forming part of one picture; small slender figures with coarse feet, clad in tortuous drapery with heavy embossments. These panels reveal something of the style of Giambono, the tempera being treated in the fashion of Gentile da Fabriano. Here the name of Nerito would be more just than in the foregoing, the work being like Gentile's, and only a little below his powers. [* Of the last-mentioned pictures those which once belonged to the Marchese Dondi-Orologio can no longer be traced.]

[1] Moschini, *Vicende, ub. sup.*, pp. 20 *sqq.*, publishes the names of most of the artists registered in the guild of Padua, and of others who practised as painters. The list is too uninteresting for repetition.

In dealing with Francesco Squarcione, however, it will be
necessary to remember that the produce of his atelier was
probably seldom absolutely his, but rather that of his numerous
disciples. There is nothing more curious, indeed, than that
a man himself unskilled should have acquired a name as the
founder of a school. It appears that he was born in 1394,[1] and
in 1422 inherited from his father Giovanni, a notary of Padua,
so much as enabled him to pursue the trade of a tailor and
embroiderer.[2] At a period when guilds were large and com-
prised many branches, the business of the embroiderer was
naturally allied, especially in the north, to that of the designer;
and we may yet have occasion to describe the rise of Giovanni
da Udine, one of Raphael's journeymen, from a family in which
embroidery was hereditary. "Before he came to manhood" (we
quote Scardeone's *Antiquities of Padua*) "Squarcione had been
attracted to the study of painting; and he had scarcely left the
school forms, as he himself has written, than he determined to
see the world and visit distant countries. In this wise he
became acquainted with the provinces of Greece, from whence
he brought back useful reminiscences and memoranda.[3] He also

[1] Scardeone (*De Antiq. Urbis Pat.*, 4to, Basileæ) says he died, aged 80, in
1474. [* Prof. Vittorio Lazzarini has lately unearthed a considerable number of
documents which throw much light on the history of Paduan painting and
correct several of the accepted ideas concerning this school. The greater part of
the records found by Prof. Lazzarini have been published by Prof. Andrea
Moschetti in the *Nuovo archivio veneto*, ser. ii. vols. xv. and xvi. In one of
these documents, dated August 23, 1419, Francesco Squarcione is stated to be
twenty-two years old; he must therefore have been born in 1397 or 1396
(Lazzarini and Moschetti, *loc. cit.*, xv. 251). He died between 1468 and 1472;
see *postea*, p. 7, n. 5.]

[2] Selvatico, *Scritti d'arte*, 8vo, Flor. 1859, p. 34, speaks of records in which
it is proved that Squarcione on the death of his father in 1422 bought a house
and five fields in the contrada di Ponte Corvo. In the later document of Dec.
29, 1422 (*more patavino* 1423), a paragraph is said by Moschini (*Vic.*, p. 27)
to run thus: "M. Franciscus Squarzonus sartor et recamator filius q. s. Joannis
Squarzoni, Notarii civis et abitator Padue in contracta Pontis Corvi." [* Squar-
cione's father was dead as far back as 1414; see Lazzarini and Moschetti, *loc.
cit.*, xv. 86, 249. The house and the landed property Squarcione acquired in
1422 were situated at Castelnuovo, near Padua. *Ibid.*, pp. 87 *sq.*, 252.]

[3] Verbatim as follows: "Quo—circa annavigavit in Greciā, et totam illam
provinciam pervagatus est: unde multa notatu digna tum mente, tum chartis, quæ
ad ejus artis peritiam facere visa sunt, inde domum secum detulit" (Scardeone,
ub. sup.. p. 370). Out of this passage, and none other, Selvatico and many others
extract more than can reasonably be conceded. The former says, for instance:

went the circuit of Italy, making friends of noble persons chiefly by affability and honesty. Once settled at home, and widower of a first wife, who died childless, he married a second, who bore him two sons, and he gained the reputation of being the best teacher of his time. Not content with the acquirement of knowledge for himself, he delighted to communicate what he knew to others, and in the course of his career he taught no less (as he tells us) than 137 pupils, and won the name of father of painters. The practical result to him, however, was not so much wealth as fame ; he lived with fair means in his own house at Padua, in the neighbourhood of the Santo, hiring lodgings when he visited Venice ; he was a man of great judgment in art but of small practice,[1] instructing youths not so much by his own example as by placing before them models and panels." [2] From whence these models came we learn distinctly from Vasari, who says they were casts from the antique or pictures imported from various places, but chiefly from Tuscany and Rome.[3] Squarcione, in fact, was an *impresario*, who formed a collection for the benefit of persons desirous to follow the artistic profession,[4] and then chose the most promising to carry out his commissions. He was clever enough to discern the precocious talents of Mantegna, and, having adopted him, to register him at a tender age in the Paduan guild. He numbered amongst the attendants of his study Niccolò Pizzolo, Matteo Pozzo, Marco Zoppo, Dario of Treviso, Bono of Ferrara, and Ansuino, and gave them work to do on his account ; but, says Scardeone, what he painted is quite

"C'e ragione, di credere che in questo amore (the love of the classic) lo rasodassero i viaggi che in virile età egli intraprese per l'Italia e per la Grecia, e le molte pitture marmi e disegni che da quelle regioni egli trasportò in patria " (*Scritti, ub. sup.*, p. 8).

Ridolfi (*Marav.*, i. 110) follows Scardeone more closely, saying : " Passò in Grecia disegnando in carte le più curiose cose vedute."

[1] Vasari is still stronger. He says : " Si conosceva lo Squarcione non esser il più valente dipintor del mondo " (iii. 385).

[2] Here too not a word is said of statues or marbles. The words are : " Signa aut pictasq̃ tabellas plurimas habuit, quarũ magisterio et Andreã et reliquos condiscipulos instruxerat, magis quam editis a se archetypis, aut ditatis seu novis exemplis ad imitandum præbitis " (Scardeone, *ub. sup.*, p. 371).

[3] Vasari, iii. 385 *sq.*

[4] It appears, moreover, that Squarcione had a special method of teaching his pupils the theory and practice of perspective. See the document published by Lazzarini and Moschetti, *loc. cit.* xv. 292 *sq.*

uncertain, unless we should say (though we dare not affirm) that his are the monochromes inside the western portal of the Santo.[1] What Scardeone did not know in 1559, has been revealed to us by the archives of Padua. It may be true, though we doubt it, that Squarcione went to Greece.[2] He was certainly settled in 1423 at Padua, keeping shop as a tailor and embroiderer after the death of his father. In the spring of 1439 he finished a Crucifix for Fantino Bragadini, a Venetian noble, in the detached chapel on his estate of Terrassa, near Padua.[3] In 1441 he was employed at the organ of the Santo, and his name first appears in the lists of the Paduan guild.[4] He contracted, as Vasari informs us, to decorate the chapel of San Cristoforo at the Eremitani, and entrusted the execution to Pizzolo, Mantegna, and others.[5] In 1444 he laid in with plain colours several ceilings at the Santo.[6] There is a payment to him in the cathedral registers of 1445 at Padua, for a figure " by the Corpus Christi in the sacristy."[7]

[1] Scardeone, *ub. sup.*, p. 371.

* [2] Recent research having confirmed most of the statements of Scardeone, it seems likely that his account of Squarcione's travels may also be relied upon, the more so as in giving it he refers to a (now lost) autobiography of the painter. Prof. Moschetti suggests that these travels took place between the years 1423 and 1428, as there are no records of him dating from that period (*loc. cit.*, xv. 110). The first available document concerning Squarcione dates from 1414 and relates to the purchase of a piece of land near Padua (*ibid.*, pp. 86, 249). He married for the first time in 1418 (*ibid.*, pp. 87, 265), and was in 1419 staying at Bassano (*ibid.*, pp. 87, 251), from where he, however, soon returned to Padua (cf. *antea*, p. 4, n. 2). He is mentioned as a painter for the first time in 1429 (Lazzarini and Moschetti, *loc. cit.*, xv. 87, 256). In 1433 he received payment for having adorned a tabernacle in Santa Sofia at Padua (*ibid.*, pp. 102, 258 *sq.*).

[3] The record at length is in Campori, *Lettere art. ined. pub. di G. Campori*, Mod. 8vo, 1866, p. 348. It is dated May 19. [* See also Lazzarini and Moschetti, *loc. cit.*, xv. 102 *sq.*, 261 *sq.*]

[4] Moschini, *Vicende, ub. sup.*, p. 27. Gonzati, *La Basilica di S. Antonio di Padova, ub. sup.*, i. doc. xxxiv. [* Moschini states that Squarcione is repeatedly mentioned in the statute of the painters' guild during the period 1441–63. In the statute itself, as published by Odorici in the *Archivio veneto*, vols. vii. and viii., there are, however, only two records of him, one without a date and the other dated 1459. The document concerning the painting of the organ of the Santo is published in full by Lazzarini and Moschetti, *loc. cit.*, xv. 267.]

* [5] This statement of Vasari is now proved to be incorrect. See *postea*, p. 13, n. 2.

[6] *Ib*, [* The date should be 1445. See Lazzarini and Moschetti, *loc. cit.*, xv. 271.]

[7] Moschini, *Vicende, ub. sup.*, p. 27. [* See also Lazzarini and Moschetti, *loc. cit.*, xv. 103 *sq.*, 270.]

In 1446–49 he was constantly engaged in the commonest house work at the Santo, and delivered a subject piece for an altar in the choir.[1] An agreement exists in which Squarcione, on the 2nd of January, 1449, promises to Leone de Lazzara an altar-piece for his oratory at the Carmine of Padua; and an entry in the accounts of the house of Lazzara, dated March 28, 1452, determines the date of its completion.[2] In 1449 the fore cloth of the high altar of the Santo was furnished by him for five lire and a fraction; and in 1462 he delivered a series of designs for tarsias carried out twelve or fifteen years later by Lorenzo of Lendinara.[3] In 1465 he received a formal exemption from taxation from the Great Council of Padua, in consideration of his casting a model of the city and territory of Padua ; [4] and in 1474 he died, a respected citizen of his native place.[5] At uncertain dates he accepted orders to paint the cloisters of San

[1] *La Basilica, ub. sup.,* doc. xxxiv. [* Cf. Lazzarini and Moschetti, *loc. cit.,* xv. 102, 271 *sq.*]

[2] *Scritti. d'arte,* by Selvatico, *ub. sup.,* p. 34; and see the facsimile in Gaye, *Cart.,* i. [* See also Lazzarini and Moschetti, *loc. cit.,* xv. 104, 273 *sq.*]

[3] *La Basilica, ub. sup.,* doc. xxxiv., cxxxiv, and cxxxiii. The tarsie done by Lorenzo of Lendinara on Squarcione's design in the sacristy of the Santo were taken down shortly before 1871, after cartoons had been made of them; they were all but destroyed and manufactured anew. Hence these works have now lost all historical and artistic value. Yet we may still discern in a St. Jerome a Squarcionesque character, and the outlines taken from the tarsie have also the general character of Squarcione's work in 1452. [* Cf. Lazzarini and Moschetti, *loc. cit.,* xv. 102, 272; 106 *sq.,* 285 *sq.*—In 1454 Squarcione lost his first wife (*ibid.,* pp. 94 *sq.*). He married again the following year (*ibid.,* pp. 95, 281 *sq.*). By his second wife he had a son Bernardino, who in 1466 went to live in the monastery of Sant'Antonio at Padua, whereupon Squarcione adopted one Giovanni, the son of the beadle Vendramino, as his own child (*ibid.,* pp. 98 *sq.,* 290 *sqq.*) It is proved by records that Squarcione in 1456 and 1463 was at Venice (*ibid.,* pp. 107, 283 *sqq.,* and Lazzarini in *Bollettino del Museo Civico di Padova,* i. 116). An inventory of the objects contained in the Scuola Grande di San Marco at Venice, dated 1466, mentions two paintings by Squarcione (cf. C. Ricci, *Jacopo Bellini,* i. 48, and L. Venturi, in *L'Arte,* xi. 154).

[4] The record in full is in Campori, *Lett. ined., ub. sup.,* pp. 348–9. [* See also Lazzarini in *Bollettino del Museo Civico di Padova,* i. 116.] In 1466 Squarcione witnessed Calzetta's contract to paint the chapel of Corpus Domini at the Santo. Moschini, *Vic.,* p. 66, n. 1. [* Cf. De Kunert, in *L'Arte,* ix. 55.]

[5] He was buried at San Francesco (Scardeone, *ub. sup.,* p. 371). [* On May 21, 1468, Francesco Squarcione made his second and last will, in which he is stated to be ill; he stipulated that he should be buried in the monastery of Santa Giustina at Padua (Lazzarini and Moschetti, *loc. cit.,* xv. 99, 293 *sq.*). For the first time, in 1472 he is mentioned as dead (*ibid.,* pp. 100, 294 *sq.*).]

Francesco of Padua, in green earth or monochrome,[1] and a
Madonna for the Lazzara family. Of all these creations the
majority have perished, the altarpiece and Madonna of the
Lazzara being alone preserved. From these and from the chapel
of the Eremitani, we judge of Squarcione's style, rejecting as a
falsification of the sixteenth century the Virgin, Child, and
Patron with his signature in the Manfrini Palace at Venice.[2]

The first thing to be noticed in these two works is their utter
dissimilarity; that of 1452, now in the Communal Gallery of
Padua, exhibiting defects unpardonable in a second-rate Muranese,
the second revealing talents such as Mantegna would respect.
Assuming both these pieces to issue from the same hands, they
baffle our comprehension; nor can we conceive how Squarcione
could pass them both for his own, unless we suppose the public
to have known that he was in no case the author, the real name
concealed under his being that of some disciple in his atelier.
The subject in the first instance is a Glory of St. Jerome between
SS. Lucy and John the Baptist, Anthony the Abbot and Giustina,
each of the saints standing on a pedestal in a niche with a frilled
border. A heavy frame with twisted pillars resting on a panelled
skirting encases the whole. For a long time this important
work lay forgotten in a corner of a dormitory at the Carmine,
a melancholy instance of carelessness and neglect;[3] and now
that it hangs in the Paduan Gallery we observe with regret
the injuries which it has received. The nimbs have all been
repainted in red and yellow; the face of St. Lucy and portions
of her figure are scaled away, and large pieces in each niche

[1] Ridolfi, *Marav.*, i. 110. There were some remnants of these frescoes in
Brandolese's time. See *Pitture di Padova*, note to p. 247.)

[2] Venice, Manfrini Palace. Canvas, with figures half the life-size, of the Virgin
seated, and the Child on her knee blessing a friar in prayer to the right (half-
lengths). This canvas, inscribed "F. Squarcione 1442" (? 7), exhibits a style of
coquetry and affectation in the Virgin's pose and character that betrays a painter
of the sixteenth century, and of Raphael's following. It is a work of the time
when artists of many climes, and amongst them the Flemings, imitated Sanzio;
when, in fact, there was a general blending of Italian and foreign schools. The
medium is oil, and the colour reminds us by its texture of the Veronese workshop
of Giolfino. The signature is a forgery. [* The editor has no knowledge of the
present owner of this picture.]

[3] It was re-discovered by Brandolese in 1789. (See *Pitture di Padova*, note
to p. 187.)

FRANCESCO SQUARCIONE

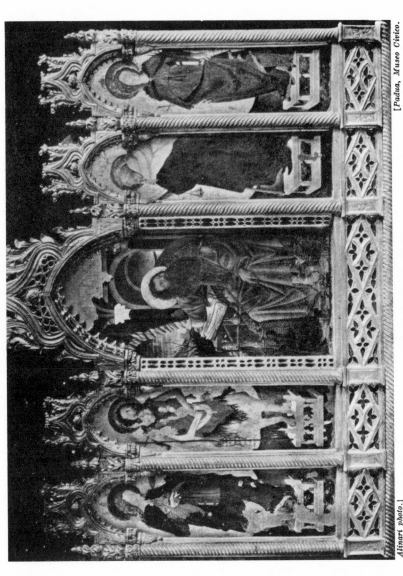

[Padua, Museo Civico.

GLORY OF ST. JEROME.

Alinari photo.]

[Il. 8]

have suffered in a similar manner, showing the bare canvas
glued to the wood beneath the gesso. It is no light task to
reproduce in fancy the original condition of these panels.
St. Lucy, a slender female apparition holding with curious
daintiness a couple of eyes in a plate, is minutely drawn with the
tenuous outline which distinguishes Marco Zoppo ; the wrists
and fingers being affectedly bent in the fashion of Crivelli or
Quiricio ; a thick crop of uncurled hair covers her high rounded
skull, her dress is cast in soft and simple folds, and the flesh is
of a dull yellow, coldly modelled with fine hatching. St. John
in his camel's hair stands quaintly with the left hand in his
waistcloth. A strange jumble of lines assuming various resolute
forms, as horse-shoes, discs, and the like, serve to designate the
depressions and projections of flesh in a face grimacing with
coarse passion, as if the artist had tried to generalize the features
like a Chinese, with a traditional abhorrence of nature. The
frame displays an equal contempt of the reality, and the drapery
is tortuous and confused. Here again, the person whose name
is most suggested is Zoppo. Much apparent seeking is shown in
the pose of St. Jerome resting his head on his wrist; but the
drawing and the flatness of the coffee-coloured flesh are alike
repulsive. St. Anthony in profile holds a book and looks a
meditative hunchback. St. Giustina, with Byzantine almond-
shaped eye and pouting lips, has the brow of a person diseased
in brain, and a projecting head copiously covered with thorny
locks ; and her movements have the coquetry of those peculiar to
Quiricio's females.[1] The painter of such a picture as this would
never have struck us as a traveller familiar with Greek examples.
The architecture which he depicts is as childish as that of
fifteenth-century miniatures. Unselect types, false shapes,
deformed heads, exaggerated details of muscle and veins may
abound in the work of one bred in the confined circle of the
antiquated schools, but would hardly be found in that of a man
who studied the classic. Squarcione, if he be the author, is a

[1] Padua, Communal Gallery, No. 399, originally at the Carmine. The pillars
and their bases are renewed, as well as the frieze above the capitals. The pieces
scaled are, in the St. Lucy, nose and forehead, right hand and arm, skirt of blue
tunic and part of the pedestal ; in the Baptist, two large pieces of the torso, the
right leg below the knee, and the left leg ; St. Jerome, the face ; St. Anthony, the
black mantle and its white cape. Many parts of drapery are newly repainted.

poorer draughtsman than any of the contemporary Venetians; he is far below Jacopo Bellini, inferior even to Quiricio. His colour has the dullness which marks the Paduans, the melancholy hardness of Zoppo, Schiavone, Bono, Ansuino, and Dario. Painters such as these might issue from an atelier capable of producing the Lazzara altarpiece ; a purer source must be discovered for the art of Pizzolo, Mantegna, and the Canozzi. At the very time when the disciples of Squarcione were producing this paltry example, Mantegna was giving to the world the St. Luke and attendant saints at the Brera, and the St. Euphemia of the Naples Gallery, both remarkable emanations of a spirit nurtured in the love of the genuine classic. It was not under Squarcione that Mantegna could acquire this superiority, but rather in contemplating the masterpieces of Fra Filippo, who had left great frescoes in Paduan churches; [1] of Uccelli, whose scientific creations decorated Paduan edifices ; of Donatello, long a resident at Padua. We shall have to inquire, not whether Squarcione taught Mantegna, but whether Mantegna did not teach at last in the atelier of Squarcione. Nor must we omit to observe that a constant intimacy united Mantegna with Jacopo Bellini and his sons, who were then living at Padua,[2] and that they too would be inclined to promote the reform of old and worn-out styles by means of the Florentines of the revival.

That Squarcione, in his polyglot workshop, watched the growing change in Paduan art, and took advantage of it, is proved by the Virgin and Child still preserved in the house of the Lazzara family at Padua. Without stopping to examine dubious examples related to the earlier productions of 1452,[3]

[1] Fra Filippo, it is now proved beyond a doubt, worked at Padua in 1434. See the records in Gonzati, *La Basilica, ub. sup.*, i. note to doc. xxxv.

* [2] It is not known when the Bellini stayed at Padua ; cf. *antea*, i., 115, n. 3.

[3] In the class of Squarcionesque art peculiar to the altarpiece of 1452, we may register the following : (1) Villa di Villa, near Padua (curacy). St. Jerome kneeling before the Crucifix, on gold ground, tempera. (2) Padua, Via del Vescovado, No. 1648. House front with distempers, the name of Christ between two female saints in niches. The drawing and painting of these much-injured remains are quite those of Squarcione's altarpiece. (3) Of a ruder style on a house in the Via Rialto, corner of Via San Luca, a Trinity, SS. Margaret, Catherine, Barnabas (legs only pre- served), Andrew, John the Baptist, Bartholomew, Jerome. and Nicholas.

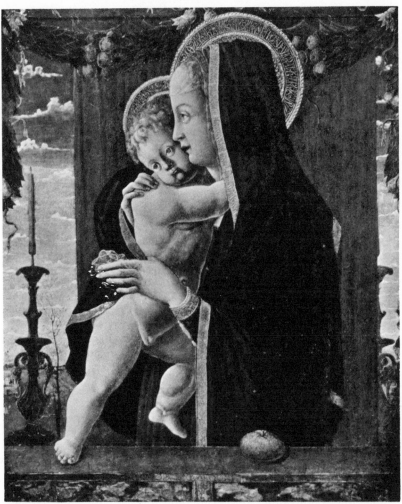

THE VIRGIN AND CHILD.

we shall find in this new creation of the Squarcionesque work-
shop ample reason for believing that the Florentines had not
come to Padua in vain. Behind a screen of stone, but in front of
a red curtain with a rich festoon of leaves, of figs, and of pears,
the Virgin in profile presses to her bosom the Infant Christ.
Some outer object has struck the Child, for he looks back and
springs with a running action into his mother's arms. The
thought is happy and well carried out, the distribution good, and
the drapery of simple cast. The Virgin's eye is clear and open.
Form is rendered with softness and regularity, with a plump
and pleasing fleshiness. The hands are delicate, and indicate
a gentle birth and blood; the colour was once no doubt solid,
and of a fair transparence. On the screen are the words : "Opus
Squarcioni pictoris."[1] But for this we should say the artist
is Mantegna, and even in the face of this we might incline to
the opinion that Mantegna had a share in the work as journey-
man to Squarcione. We thus explain the contradiction so
eloquently suggested by two pictures proved to have been
executed in Squarcione's atelier. We do so by supposing that
the first was due to the feebler class of Squarcionesques to which
Marco Zoppo belongs; the second to Mantegna, Pizzolo, or one
of similar fibre, to whom the lessons of great masters imparted

[1] Padua, Casa Lazzara. Panel, tempera, a little warped ; to the left of the red
curtain a repainted sky, with a landscape and a leafless tree. The Virgin's blue
mantle is repainted in oil, also the border hanging over the left arm. There are
repainted spots beneath the Virgin's eye and on the Child's left cheek, mouth, and
breast; in fact, the whole work has suffered from restoring and varnishing,
and most of the outlines have been done over afresh. [* This picture is now in
the Kaiser Friedrich Museum at Berlin, No. 27A.]

There is an interesting panel tempera of the Virgin and Child in possession
of Signor Malaman, a photographer of Padua, which has been assigned to
Squarcione. It is a kneepiece representing the standing Virgin with the Infant
Christ in her arms, on gold ground. The Virgin's frame is full, the head firmly
outlined, and of very marked aquiline features. The drapery seeks the form, and
is looped up so as to gain a double fall. The Child is a good nude. This seems
the work of a man who has studied bas-reliefs, and chiefly those of Donatello.
The olive flesh tone is broadly hatched with red in the old Venetian manner,
producing a brownish shadow. The lights are hatched up also, the modelling
being suggested by the hatchings. The work is different from that in Conte
Lazzara's Madonna, but of the same date, and might be by one of the Bellini
under the superintendence of their father. [* The present whereabouts of this
picture is not known to the editor.]

a novel power.[1] The public exhibition of the Madonna of the Conte Lazzara would alone account for Squarcione's celebrity; and it is easy to conceive that a man who claimed by virtue of his signature to possess talents borrowed from Mantegna, should have been angered when Mantegna determined to exhibit under his own name. That he did this at some period of his career is very obvious, but from that hour he incurred the enmity of the impresario; and this we believe is the secret of the sworn hostility which divided Squarcione and Mantegna, and which Vasari has attributed to another cause. Before they parted, more than one creation worthy of comparison with that we have described may have been furnished by the industry of Mantegna and swelled the triumph of Squarcione;[2] but the youthful Paduan soon became an independent master, and whilst Squarcione on the strength of his acquired fame received the visits of emperors and patriarchs, Mantegna laid the corner-stone of a wide renown.

Before addressing ourselves to the task of examining the great Paduan's career, we shall find it convenient to cast a

[1] That Squarcione commonly used the work of his pupils is perfectly evident from a contract of the year 1466, in which Piero Calzetta agrees to paint an altar-piece for Bernardo de' Lazzara of Padua, promising to work on a design not his own, and to imitate a sketch annexed to the contract, taken from a "drawing of Squarcione's done by Pizzolo." See the contract in Moschini, *Vic.*, p. 66: "In la dicta tavola de depenzer el dicto maistro Piero una historia simile al Squizo, ch'è suso questo foglio el quale e ritratto da un disegno de Maestro Francesco Squarcion el quale fo de man de Niccolo Pizzolo."

[2] We know, unhappily, of none at present, unless the Madonna in possession of Signor Malaman at Padua should be counted among the number.

We may, however, here mention without impropriety a few productions bearing Squarcione's name: (1) Bologna, Galleria Ercolani, formerly in Mr. Malvezzi's collection. St. Dominic and his Brethren fed by Angels. This small panel is part of a predella in the manner of Zoppo, very careful in outline and filled with small slender figures. The colour is raw, reddish, and like that in Zoppo's authentic pieces. [* See *postea*, p. 52, n. 5.] (2) Rovigo Gallery, No. 83. Small panel, with six figures representing the dead Christ on the Virgin's lap, attended by four figures, three of which are Faith, Hope, and Charity. The treatment is tempera of a rude kind, by a German hand, and the initials "I. M." on the back of the panel suggest Israel Meckenen. (3) Padua, Casa Papafava. St. Peter in benediction, adored by a kneeling monk, with a dog kneeling near him, holding in its mouth a scroll inscribed "Esto fidelis." This is clearly in the style of Jacopo Montagnana. (4) Casa Maldura, No. 22. Small panel of the Crucifixion, a picture of the time under notice, but of little value and not entitled to the name of Squarcione. [* The Maldura collection is now dispersed.] (5) Dresden Gallery,

glance at the chapel of San Cristoforo in the church of Sant' Agostino degli Eremitani at Padua, in order to test the exact meaning of Vasari's statement that Squarcione, having the order to decorate that chapel, deputed Pizzolo and Mantegna to carry it out.

The oratory of San Cristoforo is not less important as illustrating North Italian art than the Brancacci as the cradle of the Florentine *cinquecentisti*. The character of its pictorial adornments is essentially Paduan, but it is clear that here, as in Assisi, more than one or two hands contribute to create the general impression. The foundation of the building may be traced to the middle of the fourteenth century, at which time it belonged to the family of the Ovetarii of Cittadella.[1] Antonio Ovetari made provision in his will, dated Jan. 5, 1443, that a sum of 700 ducats of gold should be spent in painting the walls of the chapel with scenes from the lives of St. James and St. Christopher. In obedience to this bequest the services of Squarcione were engaged ; and though we are ignorant of the exact time in which the scaffoldings were first erected, there is reason to believe that the last touches were given in 1459–60.[2]

No. 149A. Wood, the Marys and Magdalen mourning over the dead body of Christ. See *postea*, in the Bolognese and Ferrarese school, a notice of the painter Coltellini. (6) Verona, Communal Gallery, No. 358. The Tiburtine Sibyl: see *postea* in Falconetto. Missing or unknown to us are the following : (7) Padua, chapter-house of San Giuseppe (a small church no longer in existence). The genuineness of the painting here was doubted (see Selvatico, *Scritti, ub. sup.* p. 27). (8) Marchese O. Buzzaccherini. Virgin inscribed : "M^gr Squarzoni Fransisci opus" (Moschini, *Vic.*, p. 29). (9) Scuola di San Giovanni Evangelista, later in possession of Bishop Dondi-Orologio. Virgin, Child, and Angels (Brandolese, *Guida*, p. 62; Moschini, *Vic.*, p. 29).

[1] See in Moschini (*Vicende*, p. 37) a record of 1372, which proves the existence of the chapel at that date. On a stone inserted into the apse behind the altar we read : " Sepulcrum Liberti Boni q̃. Dnĩ Johãis de Ovetaris de Citadella et suorum heredium, hic eciam jacet nobilis vir Blaxisis. q^da Dñ Nicolai de Ovetariis de citadelã q. obiit anno dnĩ MCCC.LXXXXI die lune XVI Oct." Beneath is a shield with three helms divided horizontally by a pale with three stars.

* [2] The documents discovered by Prof. Lazzarini compel us to revise entirely the hitherto accepted theories as to the paintings in the Ovetari chapel. The orders for the frescoes were given on May 16, 1448; one half of the work (consisting chiefly of the paintings on the ceiling and the right wall) was entrusted to Giovanni d'Alamagna and Antonio Vivarini; the other to Niccolò Pizzolo and Andrea Mantegna (Lazzarini and Moschetti, *loc. cit.*, xv. pp. 152–6, 317 *sqq.*). It appears that the painters set to work in July of the same year (*ibid.*, p. 154). Giovanni d'Alamagna and Antonio Vivarini were very slow in fulfilling their task,

The chapel opens into the right transept of the Eremitani—
a high rectangle, with lunettes and a vaulted roof in four sections,
lighted by windows and a rosette in the faces of a pentagonal
tribune ;[1] through the whitewashed entrance, one sees the apsidal
arch covered, in front, soffit, and sides, with remnants of painting;
a skirting of six feet separates the lowest course of subjects from
the floor; and each of these is enclosed in a monochrome ornament
chiefly representing festoons pinned down by scutcheons and
carried by boy angels ; these and the moulded ribs of the ceilings
are variegated with colour ; and though some parts are feebler
than others, and great injury has been done by age and restoring
even to Mantegna's greatest masterpieces, the whole has a grand
and imposing effect. It seems probable that the decorations
were completed in the following order :

1. Vaulted ceiling of the chapel in four sections. In each
section a framed medallion in a garland of leaves and fruit
containing an Evangelist, and an angel on a cloud at each of the
lower angles (*a, b, c, d* in plan).
2. Soffit of apsidal arch. Fourteen seraphim in red and
yellow monochrome with gilt nimbs on blue ground (*e* in plan).[2]
3. Frescoes on the right side of the rectangle in three courses,
the upper ones divided into two. Of these first St. Christopher
erect in a landscape (*j*), next St. Christopher before the king
who was afraid of the devil (*g*), St. Christopher before the
devil on horseback (*h*), and St. Christopher addressing a crowd
of kneeling soldiers (*i*).
4. Front face of the apsidal arch. Representing a human
head looking out above the capital of each pilaster, and an

so that when Giovanni died in 1450 they had only executed a portion of the
paintings of the ceiling. It seems very likely that Antonio Vivarini took no part
in the decoration of the chapel after Giovanni's death (*ibid.*, pp. 160 *sq.*) ; the
remainder of the work with which these two had been entrusted was carried out
by Pizzolo, Mantegna, Ansuino, Bono, and others. All the frescoes seem to have
been completed in 1452, as the final payment for these was made on May 15 of
that year (*ibid.*, xv. 160 ; xvi. 73). Contrary to what Vasari affirms, Pizzolo
did not die while engaged in his work at the Eremitani ; he was still living
in 1453 (see *postea*, p. 21, n. 1).

[1] The rosette is filled with a glass window representing St. Christopher. The
windows of the pentagon are plain, the walls themselves being, with the exception
of that immediately behind the altar, bare of painting.

[2] The sides of the pilasters of the apsidal arch have little left of the paintings
which once adorned them. On the inner face of the arch there is but a scutcheon
of the Leoni family recording the date of one of the restorations of the chapel.

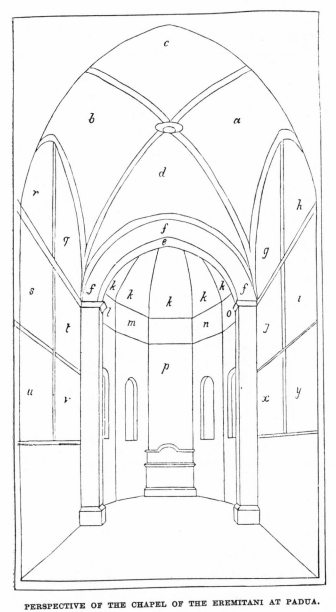

PERSPECTIVE OF THE CHAPEL OF THE EREMITANI AT PADUA.

antique monochrome border of fruit and leaves binding a string
of bulls' skulls (*f* , *f*).

5. Semidome of the tribune. Triangular sections representing
the Eternal between St. James, St. Peter, St. Paul, and
St. Christopher (*k, k, k, k*).

6. Four rounds in the upper frieze of the pentagon of the
apsis. Representing four Doctors of the Church (*l, m, n, o*).

7. The Assumption in the centre face of the pentagonal
apsis (*p*).

8. Left side of the rectangle of the chapel. St. James com-
muning with devils (*q*), St. James and St. John called to the
apostleship (*r*), St. James baptizing Hermogenes (*s*), St. James
before Herod Agrippa (*t*), St. James going to martyrdom (*u*),
St. James martyred (*v*).

9. Lowest course on the right side of the rectangle of
the chapel. Martyrdom of St. Christopher (*x*) and removal of his
body (*y*).[1]

The Squarcionesque element in this series is modified in degree
according as the person employed is more or less imbued with
the lessons of Donatello. A coarse and characteristic ugliness
pervades the principal figures in the ceilings; and with all
respect for the opinion of Vasari, who assigns them to Mantegna,
they are clearly by another hand. We are accustomed to see in
the trial-pieces of a young beginner the traits that subsequently
cling to his style. The Evangelists, far from revealing the period
of a youth's striving, are, on the contrary, mature efforts akin to
those ascribed to Squarcione's early time. The artist is a man
of doubtful taste in decoration, surrounding the circular frames
of his subjects with the heaviest class of vegetable and fruit
ornament. He is acquainted with perspective, and correctly
suggests the thickness of the openings through which his figures
appear; but his adaptation of nature to the figures themselves is
surprisingly imperfect. It would be difficult to find in any school
a more grotesque representation than that of St. Luke, with his
ox at his side, painting a panel of the Virgin and Child. An art
like that of Jacobello and Giambono, altered by the serious
childishness of Zoppo, is apparent in the saint's hooked eye-

[1] The chapel has suffered in all its parts from damp; the plaster is scaled in
many places; more than once repairs have taken place, the latest in 1865, when
the frescoes were isolated by the care of the civil engineer, Gradenigo. [* They
have subsequently been restored by Signor A. Bertolli.]

brows, staring eyes, and bony hands, in the tortuous drapery and earthy tones. Squarcione probably employed the painter on the rudest labours of his workshop.[1]

If St. Luke and his companions embody the results of Squarcione's local teaching, the angels at the angles of the same ceiling offer new and interesting peculiarities. They are all plain, and derive their plainness chiefly from the blackness of their eyes ; but their attitudes and motion, their proportion and shape, are derived from Donatello, whose models young Mantegna followed and reproduced.[2] We revert to the normal character of the Evangelists in the vaulting of the apsidal arch, where un-natural types and defective heads purposely tinted in red and yellow remind us of Schiavone.[3] Wherever colour is applied it is of the dark and disagreeable tone conspicuous in the pictures of the artists we have named.

We may thus observe that amongst the journeymen of Squarcione's atelier there were men of low powers, unacquainted

[1] The four Evangelists are represented with their symbols. The St. Luke has been described. St. Mark reads in a book with the lion at his side (gold ground). St. John, an old Byzantine type with deformed head and quaint prominences, keeps in its place a scroll in which he is writing, by means of a style. The nimbus is embossed the hands are long, thin, and out of drawing. St. Matthew turns the leaves of a book—a diminutive and not ill-done angel near him. Half his head is gone. The ornament of the rounds in which the Evangelists are por-trayed is better than that of the moulded ribs of the vaulting, which is complicated in detail, and raw in the contrasts of its colours. [* There are two different kinds of design noticeable in the ornaments along the ribs. One is very rich and strongly gothic, the other simpler and more classic. The former design is very nearly paralleled in the work of Giovanni d'Alamagna and Antonio Vivarini ; we may therefore safely ascribe the ornaments in question to these painters, who are recorded to have executed some paintings on the ceiling of the chapel (see antea, p. 13, n. 2). Cf. Lazzarini and Moschetti, loc. cit., xv. 161.]

* [2] These figures are strongly reminiscent of the style of Giovanni d'Alamagna and Antonio Vivarini. They and part of the ornaments of the ribs are probably all that the two painters did in the Ovetari chapel. See Lazzarini and Moschetti, loc. cit.

[3] These seraphs are very defective in drawing and shape, and have the heavy jaw of Schiavone (e.g.) in his picture No. 1162 in the Berlin Museum. Six with double wings and red flesh carry torches ; eight with yellow wings, an orb and lily, and yellow flesh are dressed in white shirts ; but several of these figures are almost invisible, being injured by damp. [* As Schiavone, who was born in 1435 or 1436, did not become a pupil of Squarcione until 1456, it seems impossible that he had any share in the decoration of the Ovetari chapel, the paintings in which were finished by 1452.]

GIOVANNI D'ALAMAGNA AND ANTONIO VIVARINI (IN PART)

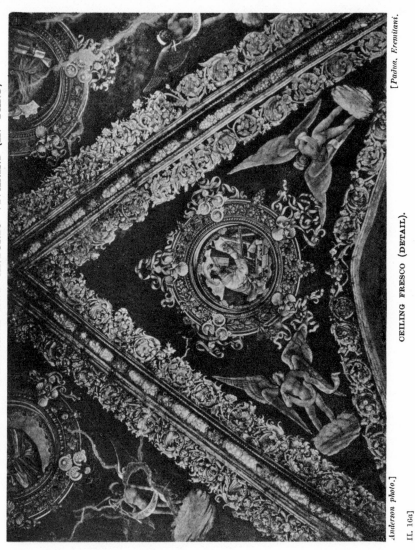

Anderson photo.]

[Padua, Eremitani.

CEILING FRESCO (DETAIL).

IL. 16a]

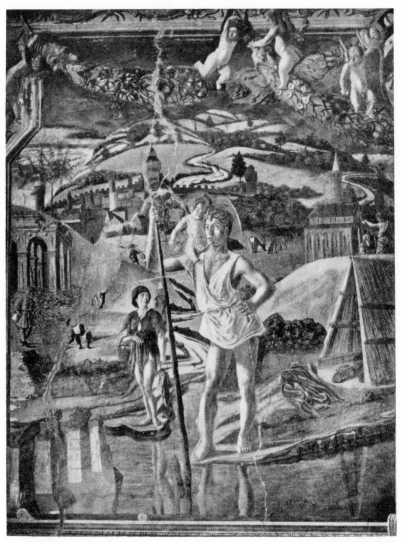

ST. CHRISTOPHER CARRYING THE INFANT CHRIST.

II. 16*b*7

with the antique, educated under old traditions, yet willing to improve when chance brought talented strangers to their vicinity. No doubt, when Uccelli and Donatello visited Padua between the years 1443 and 1453, Squarcione, whose study was open, hoped to derive some advantage from their superior talents, and advised his pupils to seize a favourable opportunity for acquiring knowledge otherwise difficult to attain ; he perhaps frequented the workshops of the Florentines in person. Certain it is that the poorest of the Squarcionesques visited Donatello or studied his masterpieces, and this is proved as clearly by the Evangelists at the Eremitani chapel as by the subjects on its walls, whether these be by Bono, Ansuino, Pizzolo, or Mantegna.

Bono is, without exception, the feeblest of all the Squarcionesques. He stands on the level of the painter of the ceilings ; but is, if possible, more strangely and seriously grotesque. His St. Christopher halts in the attitude of a porter on the brink of a stream, in a broken landscape, a scanty jerkin covering his frame, leaving the arms, breast, and legs completely bare. His head is monstrous ; and he carries on his shoulders a hideous dwarf intended for the infant Saviour. A ruder display of false anatomy, rawer contrasts of bricky lights and inky shadows, a more repulsive exhibition of muscular rigidity, are not to be found in the Paduan school ; yet Bono here is not independent, he works to order ; and the framing of snakes and cornucopias parting his fresco from that immediately above it, as well as the festoon on which angels play, are executed on the design of an abler man. Had Squarcione's study been furnished with a company of such painters, they would have done the master little credit ; yet mediocrity has its vanities, and Bono signs his fresco in letters of uncommon size.[1]

Above him, in the left-hand section of the lunette, an artist

[1] On the right foreground one reads "Opus Bonii," in large letters, and though we are not sure that the signature has not been retouched, it may be genuine, as the Anonimo (ed. Morelli, p. 33) tells us that the fresco is by Bono "Ferrarese over Bolognese." There is a long split in the wall to the left of the figure of St. Christopher ; the landscape is of dull and dirty tone. Some study of nature is shown in the reflection of the saint's legs in the water which he is about to wade into. The best part by Bono is the ornament from the pendentive to the left, where an angel dances with one foot on the capital, to the scutcheon at the upper corner (right).

of the same genus but of higher powers represents St. Christopher taking leave of the king who was afraid of the devil. Fairly arranged and appropriate in action, the figures are outlined with unusual sharpness and curious inaccuracy. Exaggerated tension is given to straining muscle, extraordinary development to extremities and articulations ; the faces are chalky and wooden, mapped out in blocks without sufficient contrast or blending of lights into shadows.[1] Yet this journeyman's work is less disagreeable than that of Bono. It particularly reminds us indeed of frescoes in the Schifanoia at Ferrara; and as Zoppo, who painted there, calls himself occasionally Zoppo di Squarcione, he may well be the author of this fresco. The next subject in the lunette is still more in Zoppo's style, representing the devil as a crowned prince on horseback in converse with St. Christopher, and attended by two falconers. It is surprising what slight feeling for colour is displayed in this piece, and we shall rarely find tones so dull or so sharply contrasted allied to shapes so wooden and outline so coarse. Yet with all this poverty of talent we trace the influence of Donatello in the sit of the draperies ; and notice the medley of unattractive features so repellent in Zoppo's Virgin and Saints of 1471 in the Museum of Berlin.[2]

The Adoration of St. Christopher introduces us to Ansuino of Forlì, a painter but little known in history, who represents the holy giant erect in a palace, with the palm-tree in his hand, adored by a band of armed captains. It is characteristic of this example that it has the same general aspect as those of Bono or Zoppo, but that the scene is more animated. A purer taste rules the selection of architectural details ; perspective is applied with some approach to correctness, even in the foreshortening of parts ; form assumes a more satisfactory proportion and a

[1] The colour here is not so inky as in the St. Christopher by Bono, but the effect is a little flat. The face of the king is ugly, but not so repulsive as that of the page in profile to the right. The outline of the saint before the king seems cut out of paper, and the bulging calves are as unnatural as the thin ankles and large feet.

* [2] There is no proof that Zoppo painted in the Schifanoia Palace (see *postea*, p. 250, n. 2). Moreover, it was not until 1454 that he became an apprentice to Squarcione, so that it seems highly improbable that any of the paintings in the Eremitani chapel are by him. The two frescoes dealt with above have in fact a very close likeness to that signed by Ansuino da Forlì.

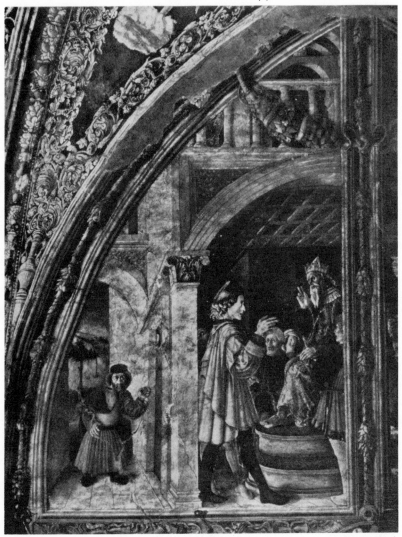

ST. CHRISTOPHER BEFORE THE KING.

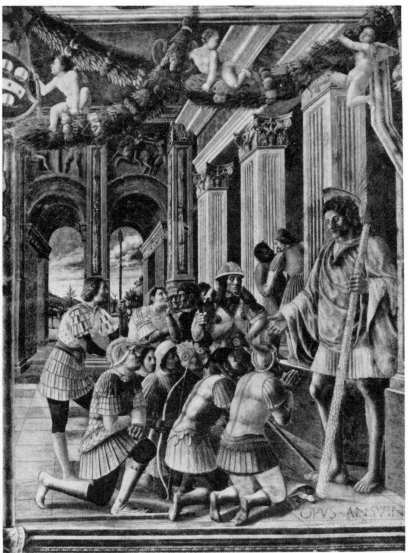

ADORATION OF ST. CHRISTOPHER.

more finished surface, though still cast in a rough and ill-favoured mould, and the figures gain some of the dignity of statuary without absolute starkness or rigidity. Colour too is treated with less harshness than before, and is of a lighter tinge. It is clear that a struggle is going on between old and inveterate conventionalisms and the novel claims of sculpture; Paduan art, in fact, begins to present the character afterwards known as Mantegnesque, without showing much progress in the blending of light and shade, or feeling in the production of tone.[1]

It has been customary to accept the teaching of Squarcione as a sufficient cause for a change due, some said, to the effect produced by the Greek antiques which he had gathered in his studio, yet it is difficult to see how the mere act of setting a draughtsman to copy from the antique could have produced that change. The laws of sculpture attracted indeed the attention of painters, but the sculpture which formed the basis of study was that which adorns the Santo at Padua; it was the bronze work of Donatello. Such was the prestige and the power of that great master that he simultaneously reformed carving and painting in the north. What he gradually achieved as regards the latter we find in Zoppo, Bono, and Ansuino, and shall observe in Pizzolo and Mantegna; what he did for the former is curiously enough illustrated in the chapel of San Cristoforo by the terra-cottas of his scholar Giovanni of Pisa. In the altar fronting Pizzolo's Assumption of the Virgin, we see a high relief of the Madonna between Six Saints, the Eternal above in an ornament of cornucopias, the Adoration of the Kings in a predella. In a frieze are gambols of children. It is surprising how nearly allied this monument is in ornament and in style to that of some frescoes on the walls. The Virgin is a long bony figure of a lean shape, with strongly marked lineaments, grimacing and unpleasant as Donatello's Penitent Magdalen. The borders of cornucopias and festoons are also Donatello's, and when transferred to panel or fresco form a

[1] This fresco is signed "Opus Ansoini," an inscription which, like that of Bono, is not free from suspicion; but the Anonimo (p. 23) says one of the frescoes of this side of the chapel is by "Ansuino da Forlì." The contrasts of light and shade, though still sharp, are less so than in the parts previously examined.

strong feature in the Mantegnesques. The draperies are looped up with girdles, and surcharged by Giovanni's inferior taste with hanging folds. It was a natural consequence of the great Florentine's teaching that, being himself unselect and coarse in the choice of his models and in the rendering of form, his less gifted pupils should exaggerate his defects.[1] To no other source can we trace the marked unattractiveness of Giovanni of Pisa, Zoppo, Bono, and Ansuino. But whilst in respect of the latter proofs are wanting to establish a direct connection with Donatello, no such difficulty meets us in dealing with Pizzolo, the next painter at the Eremitani to whom our attention is directed.[2]

Pizzolo, who, according to the oldest authorities, finished the Eternal amidst Saints in the semidome of the Eremitani chapel, and the Assumption beneath it, is the only disciple of Squarcione to whom Vasari makes a particular allusion in treating of the Eremitani.[3] He says of this artist that his works were few in number but good in quality, and that his example was of great value to Mantegna. He states further that he knew of nothing else that he had done except an Eternal in the house of the prefetto Urbano at Padua, and concludes

[1] Giovanni of Pisa is noted as the modeller of these terra-cottas by the Anonimo (p. 23), who calls him the companion and pupil of Donatello. The latter statement is confirmed by the account-books of the Santo, in which we find several entries containing his name. He is called "Zuan compagno" in the accounts relative to the Crucifix, executed by Donatello in 1444–9, and Zuan da Pixa in the memoranda of payments for statues and reliefs of the high altar of the Santo done in 1447 by Donatello. (See Gonzati, La Basilica, ub. sup., i. doc. lxxxi.) He was therefore the assistant of the great Florentine sculptor.

[2] It was stipulated in the agreement of May 16, 1448 (see antea, p. 13, n. 2), that Pizzolo and Mantegna should themselves execute an altarpiece "de medio relievo" for the Ovetari chapel, in conformity to a sketch which had been approved on that day. The ancona was, however, modelled in 1448 by Giovanni da Pisa (Lazzarini and Moschetti, loc. cit., xv. 156 ; xvi. 70, 73).

[2] But before proceeding to examine his share in the decoration of the chapel we have still to follow the traces of Ansuino, whose hand is apparent in the garlands and borders above and at the left side of the Adoration of St. Christopher, and in the heads and bulls' skulls on the front face of the apsidal arch. In the former the children supporting the garlands have the general character of Bono's without his squareness and angularity ; in the latter the heads looking over, and the dolphins on the capitals, are an imitation of the antique in Ansuino's manner.

[3] Anonimo, p. 23 ; Vasari, iii. 387.

with an expression of regret that so good a painter should have perished in his prime.[1] Confirmatory of Vasari we have first the Anonimo, who says that Pizzolo laboured with Fra Filippo and Ansuino in the chapel of the Podestà,[2] and next the account-books of the Santo, from which it appears that "Niccolò depentor" was one of Donatello's journeymen there in 1446–7 and 1448.[3] The figures assigned to him are five in number. The Eternal sits enthroned on clouds in an almond-shaped glory, his head surrounded by a cruciform nimbus, and his feet resting on a cluster of cherubs' heads. His aged face, with its marked features and small eyes, has the wild stamp peculiar to the creations of the middle-age Christian period, and recalls the types familiar to Jacopo Bellini. The hands are large and incorrect ; but there is an undoubted compactness in the arrangement of the parts. St. Paul, to the right, stands on a cloud with the traditional sword and book in his grasp, and distantly resembles a statue by Donatello. St. Christopher in a similar attitude is coarser, with a vulgar face not un-scientifically drawn. St. Peter and St. James to the left are also solemn and grave apparitions.[4] Of the nude we may say that it is dry and coarse, but it is better proportioned and reveals a more conscientious study of nature than that of Bono, Zoppo, or Ansuino. The masks too are more cleverly imitated from the reality or from stone than we have hitherto seen them.

[1] In some street-riot, *ibid.*

[*] Niccolò was the son of Pietro di Giovanni di Villa Ganzerla, a herald of the city of Padua. He was born in 1420 or 1421. " Pizzolo " (pronounced pìazolo, *i.e.* piccolo) was a sobriquet of the artist, not his family name. He was still living in 1453, but died probably shortly afterwards. See Lazzarini and Moschetti, *loc. cit.*, xv. 138–46, 306–12.

[2] Anonimo, p. 28. It is probable the Podestà and prefetto Urbano were one person.

[3] He contracts to paint the Angels and Evangelists of the altar of the Santo by Donatello, April 27, 1446. [* This is not what the document in question states ; Niccolò is merely mentioned in it among Donatello's assistants, and, further, the document dates from 1447 : see Lazzarini, in *Nuovo archivio veneto*, ser. ii. vol. xii. p. 161.] There are also entries of payments to him in 1447, as " garzon " of Donatello at the Santo ; and he paints a carved Crucifix by the same in 1448. (Gonzati, *La Basilica, ub. sup.*, i. doc. lxxxi.)

[4] The half of St. James remains, the whole length of the left side of the figure from the shoulder downwards being bare even of surface lines. The blue drapery of the Eternal is bleached by time, and vast spots disfigure the ground about St. Paul and St. Christopher.

The attitudes are more satisfactory, and the action truer than before. The drapery is ample and copiously folded, and evidently imitated from clammy cloths wetted and dried to a certain stiffness, whence the papery tortuousness and sculptural character which it displays. In the flesh tone we may note a general warmth, produced by yellow light, and a brownish half-tint, the technical treatment of distemper being different from that of other workmen in the chapel, creating a lighter general surface, more blended modelling, and less inky shadows. Rich colours are used in preference to dull ones in drapery ; and the general harmony is better on that account. We can scarcely attribute this diversity to any other cause than that Pizzolo, who worked in the same chapel as Fra Filippo, learnt from that master of tempera some tricks unknown to his local brethren,[1] but he uses line hatchings to indicate the forms beneath the dresses, and betrays the use of carved models.

Below the Eternal and Saints of the semidome are the four Doctors of the Church seen through circular openings in perspective. St. Jerome, behind his desk, bends to his task and writes. St. Augustine, in the same position but looking to the right, turns the pages of a book with a coarse hand, and has a round reading-stand at his elbow. St. Gregory's desk is open and shows its shelves full of books ; he supports his head with his right hand while lost in the perusal of some sacred author. St. Ambrose, with a string of tallow candles hanging to the wall behind him, raises his pen, but pauses for a moment before beginning to write. Here again we see illustrations of a novel kind in this chapel. The artist cannot be Pizzolo, nor Bono, nor Ansuino. His passion is perspective, to which he almost entirely sacrifices the figures. Desks, reading-stands of divers forms, doors ajar and half-open, book-shelves are introduced in such positions as to require the solution of difficult problems in each case. Projections of shadows are also scientifically outlined and correctly represented ; not even the frames and openings in which the saints appear are excepted from this general rule. It is unfortunate, on the other hand, that these busts of doctors should be as unattractive in features as they are incorrectly drawn. In ugliness and

[1] See *antea*, note to p. 10.

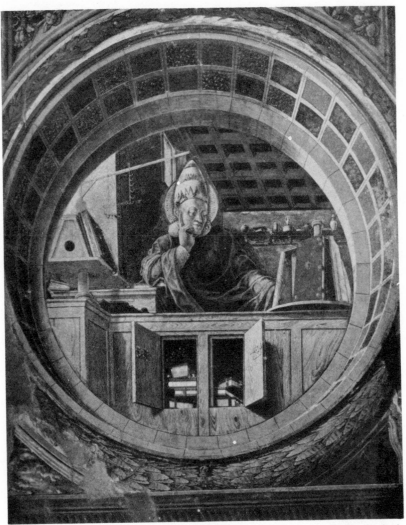

ST. GREGORY.

II. 22].

coarseness as well as rigidity, in dullness of colour and sharp
contrasts of light and shade, they rival the poorest creations
in the chapel, yet the bold roughness of the contours and
hatching, combined with true divisions of chiaroscuro and irre-
proachable perspective, might lead us to believe that this is
the work of Lorenzo of Lendinara, one of Mantegna's com-
petitors at Padua, whose praise may be found in Vasari and
Pacioli,[1] and whose tarsias exhibit character scarcely distin-
guishable from that in the rounds before us.[2]

From the contemplation of the semidome and its pictorial
adornment, we naturally turn to the Assumption in the apsis,
where the art seems to differ in no perceptible manner from that
of Mantegna. The Virgin, in an almond-shaped glory, supported
by cherubs, ascends to heaven to the sound of trumpets, cymbals,
and tabors played by angels. Her form is detached from the
sky, seen through the opening of an arch of red porphyry. In
the production of this accessory we note a tasteful application
of carved ornament and a perfect application of perspective laws.[3]
The Paduan school seldom produces a better or more judicious
distribution of space than this, not only in the glory, but in the
angels who fly with playful action through the sky. A novel
gaiety and a pretty variety of elastic movements animate the
scene, and the old Paduans seem for a moment to relax their
gloomy frown and condescend to mirth. The Virgin's light and
easy movement is appropriate to her slender shape. Drapery
is no longer cumbered with repeated folds, though still in
straight and broken lines reminiscent of sculpture. The angels
seem taken from a bas-relief, and the spirit of the whole is that
derived from Donatello's bronzes at the Santo. On the fore-
ground are the apostles witnessing the miracle, one with his arm
thrown round a pillar, two in each other's embrace, a fourth
shading his eyes with his hand, a fifth grasping his neighbour's
shoulder, all looking up. No previous example of this school
gives an illustration of momentary grouping better conceived

[1] Vasari, iii. 404, and Pacioli, *De Proportione*.

[2] It may be that the perspective was prepared by Lorenzo, and that the
painting was executed by one of the Squarcionesques. In that case Zoppo's
would be the hand. [* Cf. *antea*, p. 18, n. 2.]

[3] The same laws are well applied to form, and one sees the feet of the apostles
on the edge of the picture as if from below.

or carried out. Each figure is of natural and not unnoble propor-
tion, free in motion, well foreshortened where foreshortening is
required; the draperies winding, and clinging, and falling after
the fashion of the Florentine sculptors. The masks are coarse
but manly, the hands and feet of strong working size. We are
reminded by all this of Donatello and Mantegna, and we see the
indelible impress of the teaching of a Tuscan carver. But that
an early authority tells us the artist is Pizzolo, we should say
here stands Mantegna.[1] Vasari indeed affirms that Pizzolo at
the Eremitani was not inferior to his younger rival; but he corrects
his judgment by adding that Pizzolo's is the Eternal of the
semidome. No doubt a new phase is inaugurated in this portion
of wall-painting; but Vasari's praise would be less applicable
there than in the Assumption. It is in the latter especially that
the progress of the Paduans is apparent. In the Virgin and
angels an approach to Mantegna, in the apostles below a still
closer relation to him. Between the Assumption as a whole and
the frescoes in the lunette at the left side of the rectangle
of the chapel, a marked connection also; between these again
and the more perfect specimens of Mantegna's art, no greater
difference than might arise from the master's correction or
improvement of his own style. Did Pizzolo assist Mantegna
in the lunette frescoes on the left side of the Eremitani chapel,
or did the very reverse occur? Certain it is that the composition
of these frescoes is of one stamp with that of those in the lower
course, the treatment alone being that of a man of less experience.
But the same difference is apparent in the upper and lower parts
of the Assumption. Shall we again inquire here whether
Mantegna was under the orders of Pizzolo? It is to be con-
sidered, under all circumstances, that were the Assumption by
Pizzolo, we should be forced to deprive Mantegna of many of
his works.

[1] The fresco is injured; there are spots and discolorations; some parts are
scaled away, but the outlines remain, and enough is preserved to justify a distinct
opinion. The blue ground or sky has been changed by time to a green hue, which
spoils the harmony of the picture.

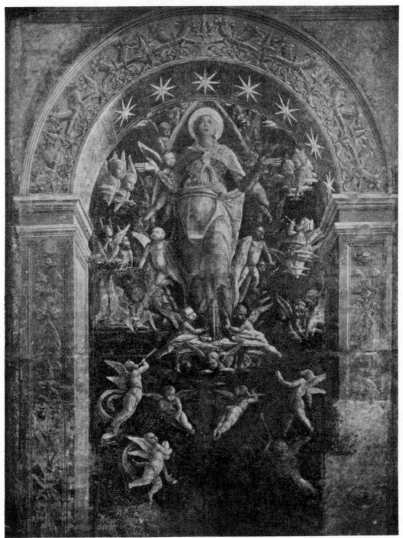

THE ASSUMPTION (DETAIL).

CHAPTER II

ANDREA MANTEGNA AT PADUA

ACCORDING to the evidence of almost contemporary writers, Andrea Mantegna was born at Padua in 1431,[1] and painted a Virgin and Child for the high altar of Santa Sofia in his native place at the age of seventeen. Appropriate lines on the picture itself attested the precocious ripeness of the artist, and proclaimed his talent, age, and country.[2] Of his parentage but a vague tradition is preserved. We may believe it to have been humble and unpretending, for the boy was adopted by Squarcione, registered as his foster-child in the Paduan guild on the 6th of November, 1441, and brought up under the care of

[1] It has been a moot question whether he was of Padua or of Mantua, but the arguments pro and con prove conclusively in favour of Padua ; and this opinion is now so generally accepted that it would be waste of space to discuss it anew. We need only bear in mind the sources : Annot. Vasari (iii. 383, n. 1—Selvatico) ; Scardeone, *ub. sup.* ; Ridolfi, *Marav.*, i. 111 ; Brandolese, *Testimonianza sulla Patavinità*, etc., Pad. 8vo, 1805 ; Gennari, *Notiz. intorno alla patria di A. M.*, 8vo, Pad. 1829 ; Coddé, *Pitt. Mantov.*, 8vo, 1837 ; D'Arco, *Delle arti di Mantova*, fol. Mant. 1857.

* It is now proved by contemporary records that Andrea Mantegna was not a native of Padua. A document of 1456 describes him as "Andream Blasij Mantegna de Vincentia pictorem" (Stefani in *Archivio veneto*, xxix. 192). His brother Tommaso is, on the other hand, stated to be of Isola di Carturo, a village situated between Padua and Vicenza and forming part of the Vicentine territory during the fifteenth century. This fact, coupled with Vasari's statement (iii. 384) that Andrea was born in the country, makes it seem very likely that Isola di Carturo is the birthplace of Andrea Mantegna. See Lazzarini and Moschetti, in *Nuovo archivio veneto*, ser. ii. vol. xv. pp. 131 *sqq.*

[2] " Andreas Mantegna Pat. an. Septem. et decem natus, sua manu pinxit MCCCCXLVIII." Scardeone (*Antiq. Pat., ub. sup.*, p. 372) so transcribes the inscription, which Vasari obviously read also (iii. 386 *sq.*). [* Compare, moreover, G. B. Maganza, *Rime*, vol. iv. (1583), fol. 66 *r.*]

strangers.[1] Mantegna's vanity or the adulation of contemporaries afterwards gave a fictitious rank to his father, whom we learn to call by the title of Ser Biagio.[2] That Squarcione gave Mantegna the first lessons is told by historians; but he could not prevent his foster-child from visiting rival workshops; and nothing is clearer than that, with or without connivance, he studied the masterpieces of Donatello, Lippi, and Jacopo Bellini. One or two panels at Padua, purporting to be juvenile efforts, might indeed be considered to discountenance this belief; but one of them, an Ecce Homo bearing a signature, is a spurious reminiscence of Giambono or Nerito,[3] and the other, a bust portrait of a friar, would only prove that, in his tenderest years, Andrea was a realist of the stamp of Zoppo or Schiavone.[4] The earliest

[1] "Andrea fiuilo de M. Francesco Squarzon depentore" (Moschini, *Vicende*, *ub. sup.*, p. 34; Giovanni de' Lazzara to Saverio Bettinelli, Jan. 31, 1795, in D'Arco, *ub. sup.*, ii. 224–5; Brandolese, *Testim.*, *ub. sup.*, note to p. 8). [* The above entry is really undated; it was probably made between 1441 and 1445. Cf. Odorici, in *Archivio veneto*, viii. 121.] From this same source we learn that a record of Nov. 21, 1461, contains the conditions of sale of a house contiguous to that of "Andree Squarçoni pictoris," in the contrada di Santa Lucia at Padua; on June 22, 1492, Mantegna sells his house in the contrada, calling himself "Spectabilis miles et comes magnificus dominus Andreas Mantegna quondam honorandi viri Ser Blasii habitator Mantue in contracta sancti S. Dominici." [* Cf. Lazzarini and Moschetti, in *Nuovo archivio veneto*, ser. ii. vol. xv. pp. 135, 304 *sq.*] A contemporary sonnet also exists (Quadrio F. S., *Indice universale della storia e ragione di ogni poesia*, Milan, 8vo, 1752, p. 102) in which Mantegna is called "Andrea Mantegna, pictore dicto Squarzono." [* This sonnet has been published by Prof. A. Venturi in *Der Kunstfreund*, i. 292.]

[2] See the foregoing note. Vasari states that Mantegna herded cattle in his youth, from which we may infer that Biagio was an agricultural labourer or a small farmer. [* We now know that he was a carpenter. See Lazzarini and Moschetti, *loc. cit.*, xv. 131, 299 *sqq.*]

[3] Padua, Communal Gallery, No. 6; bequeathed by one of the family of Capo di Lista. Small panel, tempera. The Saviour is in the tomb, seen to the middle, showing the stigmata. Behind him the cross. Cruciform nimbus, blue ground. The panel is split down the middle. On the edge of the tomb: "Opus Andreæ Mantegna pat." The head is large, with bushy hair heightened in gold; the features bony and aged; the mouth grimacing and open; the tempera is dull, grey, and altered by varnish. But for the signature, which however seems an old addition, we should say this picture is by Giambono or Nerito. [* It is now generally held to be a work of Giambono.]

[4] Padua, Dr. Fusaro; once in the Eremitani, afterwards in the hands of the Signori Caldani and Barbieri. Bust, tempera, on panel, of an Augustine monk in a black frock and cowl, holding with his large and very ugly hands a book on which are the words: "Preditus ingenio tenui que magistrum effigiat Paulum MANTINEA

wall-painting to which his name is affixed is that of St. Bernardino and St. Anthony, bearing the initials of Christ, a lunette with life-size figures above the high portal of the Santo at Padua; but this fresco has been ruined by time and restoring, and affords no clue to his manner.[1] The Madonna of 1448 having perished in the seventeenth century,[2] the first work in which a genuine character is displayed is the altarpiece of St. Luke and saints completed for Santa Giustina of Padua in 1454, and now at the Brera.[3] The monumental style of distribution preserved in this piece, and the necessary repose of the saints in niches, give no scope for various artistic display. St. Luke, in a marble throne, sits writing at a round table ; at his sides St. Benedict with a scourge, St. Prosdocimus, and St. Justina, a Benedictine nun. In

cernite quæso." The background, a wooden interior with a beam ceiling, book-shelves, an hour-glass, an inkstand, and a bell, is much too small for the figure ; the bony shape and dull colour, the mask and drawing recall Cranach. It is a wooden and inanimate portrait, solidly and minutely treated, with a very fine broken outline, in a flat dull flesh tone without relief. This may be an early Mantegna, as it may be an early Schiavone or Zoppo. It has the stamp of Squarcione's shop, but in the present state of our information can scarcely be traced back to the author of the altarpieces of 1454—the St. Luke of the Brera and the St. Euphemia of Naples. [* The present whereabouts of this picture is not known. Cf. Kristeller, *Andrea Mantegna*, p. 175, n. 1.]

[1] Padua, Santo, inscribed: "Andreas Mantegna optumo favente numine perfecit MCCCCLII. XI. Kal. sextil." Gonzati, *La Bas., ub. sup.*, i. 124 *sq.*

[2] Ridolfi, *Le Marav.*, i. 111.

* It is proved by a contemporary record that Mantegna in 1449 went to Ferrara to execute portraits of the Marquis Lionello d'Este and his favourite Folco da Villafuora. See *postea*, p. 101, and A. Venturi, in *Rivista storica italiana*, i. 606 *sq.* These portraits are also lost.

[3] Milan, Brera, No. 200, in its complete state m. 1·71 high by 2·30, the figures about a third of the life-size. The condition of the picture is pretty good. The hand of St. Benedict, the shadows in the head of St. Euphemia are altered by restoring, and bits here and there have been stopped with colour. The surface is heavily varnished, which seems likely to produce scaling. Scardeone relates that this piece was on the altar of St. Luke in Santa Giustina at Padua, and that the painter's name was *artificiose* attached to it. The gildings, says Brandolese, were injured in the eighteenth century by lightning, and restored ; hence, perhaps, the disappearance of the signature (Brand., *Pitt. di Padova*, note to pp. 102–3). The contract signed 1453, and payments up to 1454, are in Moschini (*Vicende, ub. sup.*, p. 34, n.). The price was 50 ducats of gold.

We shall speak of an Annunciation in the Dresden Museum, No. 43, amongst the works of the Ferrarese school, premising that the signature of Mantegna and the date of 1450 on that picture being a forgery have been removed. (See *postea*, Baldassare Estense.)

a second course, half-lengths of the Man of Sorrows, between the
wailing Virgin and Evangelist; St. Jerome penitent; a bishop,
and two others : all on gold ground, with carefully stamped and
gilt nimbuses. In spite of the formality of this arrangement,
we have a fine proof of Mantegna's talent. St. Luke bending
over his desk—a natural creation, not easily matched in the
Paduan school—is grave and meaning, without too much statuary
coldness, the face a thoughtful and attractive one. The hands
and feet are correct and drawn with perspective truth ; the pro-
portions good, the transitions natural ; the harmonies well
balanced and chosen ; the drapery minute, but not overladen.
In no production of the Florentines or Paduans at this period is
more science exhibited. To the lower class of Squarcionesques
is left the unenviable quality of coarse and repulsive masks.
Mantegna has seen and avoided the defects of his countrymen.
The finely moulded head and pleasing figure of St. Benedict
remind us of a Tuscan type such as Lippi might have produced ;
the St. Justina, in her pose and classic shape, is a reminiscence of
the antique ; the Saviour passive in his tomb, would be a counter-
part of the Vivarini's at Bologna, but that it is bolder in
conception and more powerfully executed. Grimace in some
measure disfigures the Evangelist and the Virgin, who wrings
her long and slender hands. St. Jerome penitent, though
resolute in air, is affected in the vehemence of his movement, but
the half-length bishop is a stern and solemn personage of grand
mien. A peculiar feature in the drawing of the parts is the pure-
ness and scrupulous polish of the outlines ; searching to a fault
are the shadows and reflections. In this we observe a tendency
which distinguishes the Paduan from the Florentine ; and
Mantegna, whilst studying carved or painted models, preserves
a northern realism. He is occasionally harsh and vulgar, but
strong and muscular at the same time; so that he appears to
unite the qualities of Michelangelo with those of Dürer. His
tempera has none of the dullness of the common Paduan—has
brightness, transparence, and melody, but is not free from
dryness ; its modelling is clean, and it is well relieved by ample
light and shade ; of a pleasant yellowish tinge in the one, of a
cool grey in the other, and perfectly finished. To whom this
peculiarity is due, whether to the first Vivarini, whose pictures

ANDREA MANTEGNA

Alinari photo.]
[*Milan, Brera.*

THE ALTARPIECE OF ST. LUKE.

II. 28]

were known at Padua, or to Jacopo Bellini, or to Lippi, it is
difficult to say. Mantegna's treatment differs from that of the
Vivarini, as well as from that of Lippi, by greater solidity of
substance, a finer system of hatching, and sharp touches produced
by liquid siccatives. He is superior as a colourist in tempera to
contemporary Venetians.

A less important but not less characteristic specimen of his
skill at this time is the St. Euphemia of the Naples Museum,
almost an imitation of a marble statue, of a broader and more
classical mould than the saint of the same name in the Milan
altarpiece, fleshy, admirably drawn and foreshortened, but
dimmed in colour by age and neglect.[1] It is the only production
of the Paduan period, in addition to the St. Luke of the Brera,
which has been preserved ; the Virgin and Child in the Casa
Scotti at Milan, with its forged inscription, being by Liberale of
Verona, and the St. Bernardino at the Brera, by Domenico
Morone, or some old master of that stamp.[2]

Vasari's opinion seems to be that Mantegna only began to
paint in the Eremitani of Padua after 1448.[3] He is probably
right. We may conjecture that after Schiavone, Zoppo, Bono,
and Ansuino had done their best, and Pizzolo had been removed
by a violent death, it was thought expedient to try Mantegna.[4] We
are unable, however, to discover exactly where Pizzolo ends and

[1] Naples Museum, Room XV., No. 30, previously in the museum of Velletri.
Canvas, tempera, inscribed on a cartello: " Opus Andreæ Mantegnæ MCCCCLIIII."
The saint stands in a niche with the knife in her bosom, a lily in her left hand, the
right hand with a palm in the jaws of the lion; above the niche a rich festoon.
The forms are not imitated from nature but from marble ; the draperies classic,
the feet very cleverly foreshortened. (See the engraving in D'Agincourt,
Pl. cxxxix., where the original picture is reversed.)

[2] Milan, Casa Scotti. (See *postea*, p. 173, n. 3.) This Virgin and Child was previously
in Casa Melzi at Milan. It is supposed by Dr. Waagen (" Andrea Mantegna," in
Raumer's *Taschenbuch*, dritte Folge, erster Jahrgang, imp. 8vo, Leipzig, 1850, pp. 482,
526, and 585) to be that done for the Abbot of Fiesole; though Vasari, who
mentions the Fiesole Virgin, says it is a half-length. The signature on the step
of the throne, "Andreas Mantinea, p. s. p. 1461," is a forgery. See also Selvatico's
very proper doubts in notes to Vasari, iii. 417, and Vasari himself, iii. 394.

Milan, Brera, No. 163, canvas, life-size, assigned by Hartzen to Piero della
Francesca. See *History of Italian Painting* (1st ed.), vol. ii. note to p. 562, and
postea in Domenico Morone.

[3] Vasari, iii. 387.

[4] See *antea*, p. 13, n. 2.

where Mantegna begins. There is obviously some dovetailing of their work in the apse and semidome, and their joint labour perhaps continues in the lunette frescoes at the left side of the chapel, where St. James communes with the spirits and is called to the apostleship. In the first we see the saint in a stone pulpit exorcising three flying monsters, whilst the audience below expresses fear and wonder in various attitudes of stupor. The nude parts are coarse and unselect, but the action is good, the drawing correct, and the drapery, in spite of superabundant gathering, well adapted to the forms. The scene, too, is animated and well arranged, according to the best Tuscan laws of composition, with a high centre of vision. The colour, in feeling and tone akin to that of Pizzolo, is gayer in tint and less strongly relieved by shadow than that of Andrea. We find, in fact, a perfect medley of the art of Pizzolo and Mantegna.

In the call of James and John to the apostleship, the fishermen kneel in front of Christ, who welcomes them in presence of Peter and Andrew ; Zebedee in his boat still hauling at the nets. A fine landscape of the wild character peculiar to the Lombard-Venetian country appropriately enlivens the scene.[1] Peter with his back to the spectator is as grand a creation as any that Piero della Francesca ever produced—noble in mask and in attitude. Form, movement, drapery, and colour are similar to previous ones, and only inferior in scientific rendering or in boldness and accuracy of outline to those of Mantegna's ascertained frescoes. The angels in the upper festoons are spirited and mirthful, like those of the Assumption. It is again a question whether the leading artist be Pizzolo or Mantegna. Here, however, doubt may be allowed to cease. We shall assume as a probable conjecture that St. James exorcising the devils, and St. James called from his nets, were designed by Mantegna, and partly executed by Pizzolo. The compositions which immediately follow these, St. James baptizing Hermogenes, St. James before Herod Agrippa, and the rest of the chapel are all Mantegna's and his alone.[2]

[1] A pretty garland of apples and leaves hangs over both frescoes, and children gracefully rest in them. The ornament round the frame is of beans and acorns in monochrome.

[2] It will be seen from the foregoing that we may consider the following passage from the Anonimo with regard to the artists employed in the chapel as

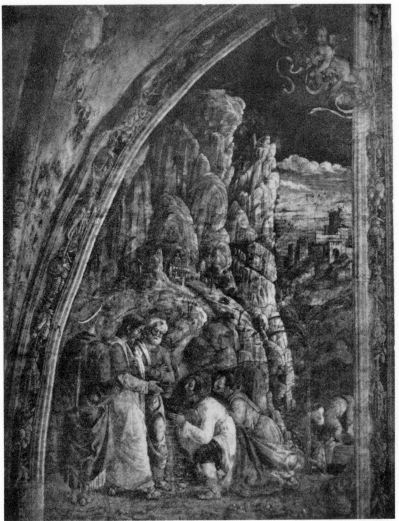

Anderson photo.] [Padua, Eremitani.

THE CALL OF JAMES AND JOHN.

There are three distinct qualities conspicuous in the subject of St. James performing the rite of baptism, which are not always found united in Mantegna. In a very earnest spirit and with studied thought he seeks to combine the stately composure of statuary, the momentary action of nature, and an excessive simplicity of realism. St. James in a quadrangular court, and in front of a portico, bends to his task, and pours a streamlet of water from a copper vessel on the head of the kneeling Hermogenes. The books of the old and forbidden lore lie most of them scattered on the ground, but one of them is still intently read by a man who stands with his back to the spectator on the right foreground ; three or four persons are calm witnesses of the ceremony, a fifth communicates the circumstance to an eager stranger, whose garment is seen through the square pillars of the colonnade ; and two children, with curious awe, look on to the left. Buildings of classic architecture, though not quite pure in taste, are drawn with a perfect command of the simpler rules of perspective ; the vanishing and measuring points being correct for a picture to be seen at the level of the beholder, but incorrect for one so near to the vaulting of the chapel. By a judicious and subtle use of garlands in the hands of angels, a pleasant filling is given to the upper corners of the fresco. More in the spirit of statuary is the reading man, a tall and well-built figure, whose long and ample cloak of yellow hue alternately falls in puffs or clings in broken puckers to his frame ; cleverly suggestive is the glance and gesture of the youth in the colonnade speaking and turning towards one whose form and face are concealed by the square pillar ; a true piece of realistic nature is that of the children—a boy with a water-melon in his hand, restraining the infantine curiosity of his younger companion. Yet, in the midst of this variety, an undoubted unity is attained. There is no figure inappropriate or trivial in pose, in action or expression. Piety is as strongly marked in the face of the proselyte as confident power in that of St. James. Almost all the heads are portraits. What we may reprove is the

in the main correct: "The left-hand face is *all* by Mantegna ; of the right hand, the lower part is by Mantegna also, the upper by Ansuino da Forlì and Bono of Ferrara, or Bologna. The Assumption behind, and the figures in the cupola, are by Niccolò Pizzolò, by whom also (?) are the Evangelists (Doctors) with the cupboards in perspective " (Anon., *ub. sup.*, p. 23).

artificial arrangement of the draperies, the multiplicity of their folds in under-garments of muslin texture, the clinging and pro- truding of the mantles of woollen stuff, peculiarities which give a very distinct impress to Mantegna's style, and were very closely imitated by Ferrarese artists of the stamp of Tura. We may admire, as worthy of the sixteeenth century, the flying angel at the upper corner of the colonnade, which recalls one of Donatello's children in the Santo of Padua.

Mantegna from the first betrays a total absence of that feeling for tone which is so charming in Giovanni Bellini. He contrasts his tints on scientific principles, one colour being accurately balanced by another, in accordance with the laws of harmony ; but he has not the fibre of a colourist, nor does he know how to produce depth by imperceptible gradations ; and in his merciless severity he is the forerunner of Carpaccio, the Signorelli of the North, and Montagna, the Dürer of Vicenza.[1]

Turning from the scene of the baptism to that of St. James before Herod Agrippa, we are struck by an increase of sculptural attitude, antique costume, and classical architecture. The prefect in his chair, the soldiers in their armour and plaited skirts, the triumphal arch in the background, all illustrate a close and untiring study of a bygone period. In distribution, perspective, and treatment, the character of the artist remains the same. He is extremely and severely careful, but he hardly avoids affecta- tion in the pose of the officer near the saint, in that of a guard leaning against the stone balustrade fronting the throne, and the sentinel at the other side, who looks like a portrait of Mantegna, so closely does he resemble the bronze of the painter's tomb.

Lower down the wall we come upon the procession to execu- tion ; St. James, between the two officers of his escort, stopping in his progress to bless a kneeling paralytic. Through the opening of a richly decorated arch we see the common habita-

[1] The monochome framing of these two frescoes is admirably carried out, and so well relieved by the throw of its shadows that it recalls the bronzes of the baptistery of Florence ; parting the subject is a fine combination of leaves, blossoms, vases, and medals. The effect of this monochrome on a dark ground, contrasting with the dark green festoons and playing angels, is one peculiarly characteristic of Mantegna. Purely imitative of the antique is the medallion of a horse, two nudes, and a breastplate in the wall of the right-hand fresco. The blues in the dress of St. James and others are bleached.

ANDREA MANTEGNA

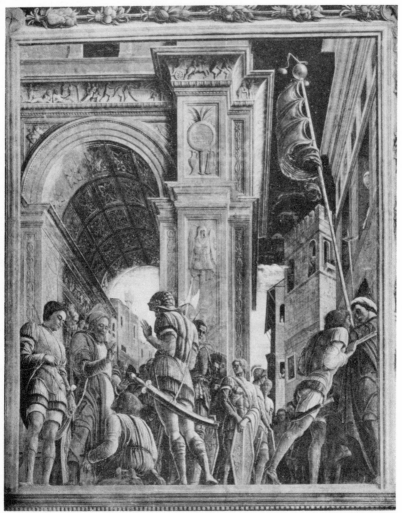

ST. JAMES GOING TO MARTYRDOM.

tions of an Italian city. To the right a man thrusts back the crowd; and in the distance between the principal groups are the legionaries halting at the mouth of a long and narrow lane.[1] If in previous frescoes Mantegna dwells with complacency on the studies of the archæologist and perspective draughtsman, he does so now with an obtrusive zeal. He considers the human form as a mere geometrical unit, subjecting it to the same maxims as the architecture; the lines of the frames vanish to a central point, and the attitudes are chosen as if to illustrate the difficulties of this novel practice. He carries to the same extreme the habit of statuesque action, and thus doubly violates the ordinary laws of nature. Nothing seems more probable than that before he laid in this fresco he set models of each figure at given distances, and worked out the drawing of each by a separate operation. The demonstration is no doubt clever, but has its obvious disadvantages. The cleverness is too apparent and is accompanied by an unnatural strain; the flexibility of flesh is sacrificed unconditionally, and the scene is an exhibition of skill without being a representation of the truth. We may in part conceive under what circumstances this strange effort was made. In the previous subjects some critics no doubt observed that the centre of vision was ill chosen for the place in which the

[1] The sky of this fresco is altered by the dropping of the blues. Amongst peculiarities we note the cleverness with which the hard stone of the arch is grained to imitate nature. Examining one figure like that of St. James, we shall remark that the contours of the face and features and the hatchings are coal-black, and that the deep shadow in the drapery is also coal-black; a red bricky flesh tone covers the surface, and the lights are produced by chalky streaks. Not content with the ordinary folds of garments, Mantegna turns up the sleeves of St. James's overcoat to get more drapery, a clear imitation of Donatello's artfulness.

There is an old copy of this fresco of a small size on canvas in the house of the Marchese Galeazzo Dondi-Orologio at Padua. [* Selvatico mentions a series of copies of all Mantegna's frescoes in the Eremitani as belonging to the Marchese Dondi-Orologio; these copies had formerly been in the Casa Scotti at Padua and are probably identical with those which the Anonimo (*ub. sup.*, p. 26) saw in the Casa Strà in that town (see Selvatico, in Vasari, iii. 427). We may believe that three paintings of this series (viz. St. James going to Execution, the Martyrdom of St. Christopher, and the Removal of the Body of St. Christopher) are now in the collection of Mme. Édouard André of Paris. See Gräff, in *Monatshefte für Kunstwissenschaft*, iii. 108 *sq.* An original drawing by Mantegna for the fresco of St. James led to Execution belongs to the Hon. A. E. Gathorne-Hardy of Donnington Priory, Newbury.]

picture is seen. Persons who might have had experience of
Donatello's talent in adapting sculpture to its place, perhaps
suggested the means of correcting this error. Some artist deep
in the knowledge of perspective, such as Uccelli, for whose
works Mantegna confessed the greatest respect,[1] might even
have offered his assistance. Determined under these circum-
stances to show his power, Mantegna possibly sets himself to his
task with exaggerated ardour. He chooses at once a most
difficult centre of vision, at a considerable distance beneath the
plane of delineation. He precipitates the lines to such an
extent that he conceals the lower parts of all the dramatis
personæ, except those which stand on the very edge of the fore-
ground. More than this, having the necessary points for the
retreat and measurement of the parts at right angles to the plane,
he tries a view of a square tower presenting one of its angles
to the spectator. In this we think he was unsuccessful ; for
repeated tests made upon correct copies of the picture only lead
to the conclusion that, if Mantegna intended his tower to be
rectangular, he failed to make it so,[2] and was thus practically
unacquainted with the secret of that intricate operation, the
measurement of lines vanishing to accidental points on the
horizon. Yet the mere attempt to solve this problem attracted
considerable attention, not only in Mantegna's own time—per-
spective being taught by regular professors at Padua [3]—but at a
later period ; and Daniel Barbaro, in the preface to his work on
this subject, singles out the fresco of St. James going to Martyr-
dom as one which entitles its author to the highest praise. Yet
Mantegna might have learnt from the example of Piero della
Francesca, his contemporary, that true art consists in the
judicious use of all the acquirements which serve to make it per-
fect, and not by obtruding one of them to the sacrifice of the
rest.[4] He had something to learn from that great artist, not

[1] Vasari, ii. 214.

* [2] M. C. V. Nielsen holds a different opinion : see *Filippo Brunellesco og
Grundlaeggelsen av Theorien for Perspektiven*, pp. 46 *sqq.*

[3] Michele Savonarola, *De Laud. Patav., ub. sup.* Muratori, vol. xxiv. p. 1180
of *Script. Rer. Ital.*

[4] Daniel Barbaro, in Anon., pp. 142 *sq.* Lomazzo also (*Idea del Tempio*, 8vo,
Milano, 1590, pp. 17, 52–3, and 150) says : " Il Mantegna è stato il primo
che in tal arte ci habbi aperti gli occhi, perche hà compreso che l'arte della
pittura senza questo è nulla. Onde ci hà fatto veder il modo di far corrispondere

only in this respect, but in the choice of the purest standard of architectural beauty. But this was not the only fault which he committed in the blindness of his ardour. He was not content with exhibiting himself as the most skilful master of a science as yet uncertain in its rules. It was open to him to hold —as Vasari says that he held—that statues were more perfect and were better in their parts than the human figure, because they were created by sculptors who sought to combine from numerous examples the ideal of uncommon perfection; [1] but it was not the office of a painter to take statues bodily into his pictures and present them to the spectator as models of the highest art. That he did this, especially in the frescoes before us, is very plain ; he not only introduced sculptural attitudes, but imitations of the modern classic of Donatello. In the figure of a soldier standing with his hands on an ancient shield, a steel cuirass seems cast in the mould of its wearer, and offers to the eye all the accidents of fleshy muscularity. Clinging dress is preferred to ample folds because it shows the character of the slender figures and the vanishing of the pectoral and other lines. Drapery, if necèssary, is cast so as to strengthen the effect of curves directed concentrically to a given point ; the smallest details being searched out and rendered with prying minuteness. Palling and disappointing at last is the strictness with which every particle of work is found to have been calculated and carried out. Hands, wrists, knees, and feet are correctly rendered according as their perspective places change ; not a projection or a furrow in the human head is omitted, not an outline of projected shadow neglected ; realism of detail, as in the worn shoes of the kneeling convert, is unnecessarily displayed ; but in the midst of this over-application, one element of life seems altogether lost or forgotten—there is no pulsation of blood in any of the flesh. As for charms of colour, they too are necessarily incompatible with the system of delineation ; the

ogni cosa al modo del vedere." But, he adds : " Se ben egli le (all the qualities) possedette tutte pur nella prospettiva, che fù sua principale non potè levar con la sua maniera gl' intrichi di quella si che non paresse fatta con arte." The same author says Andrea Gallerato possessed drawings of Mantegna with the perspective rules illustrated and described on them. See also the just remarks of Selvatico on Mantegna's perspective in Comm. Vasari, iii. 448 and following.

[1] Vasari, iii. 389 *sq.*

tempera is coarse and dry, yet high in surface, hatched with dark
strokes as if the painter had become familiar with the technica
of wood-engraving; with correct harmony of neutral tone, but
without the brilliancy of the colourists ; and we guess the im-
portance attached by Mantegna to the attainment of a necessary
quality, when, looking at certain heads which have been finished
with anxious care, we find them covered with a lattice-work of
black scratches invisible at a distance, and correcting an other-
wise obvious dissonance.

Were we but half as well informed by historians of the
various turns and vicissitudes in Mantegna's life up to this time,
as we are of his artistic progress by the pictures he produced,
we should know much that would fetter our interest. We guess,
however, that certain events must have accompanied certain
changes in his art. It cannot be doubted that the constantly
increasing tendency to see from the *locus standi* of a sculptor
was due to the presence of Donatello at Padua, that the passion
for testing perspective problems by their application to the human
form was contagiously derived from Uccelli ; and that the
simultaneous study of antique remains and familiar nature might
be derived from Jacopo Bellini. About this period Mantegna's
acquaintance with the latter became closer ; he married Niccolosia
Bellini, and thus became a member of what may be called the
Florentine faction at Padua ;[1] he may have been completely
estranged by this act from Squarcione, his father by adoption,
but we may well believe that the seeds of discord had been sown
between them long before.[2] Is it not curious, indeed, that for

[1] See *antea* in Jacopo Bellini, i. 114. It is as well to correct at once an error
made by Coddé (*Mem. Biogr.*, *ub. sup.*, p. 97), who asserts that Mantegna declares
himself in his will to have been married to a lady of the family of the " Nuvolosi."
The will states that Mantegna's wife was called " Niccolosia," and we believe it to
be correct that Niccolosia is the Christian name of Jacopo Bellini's daughter.
The reading of Coddé would oblige us either to disbelieve Vasari, or to suppose
that Mantegna was twice married. But it is natural that a superficial examination
should lead Coddé to take a Christian for a family name. See the will of
Mantegna in Gaye (ii. 80), and in D'Arco (ii. 50, 52), and Moschini (*Vicende*, p. 50).

* [2] We have seen *antea*, i. 115, n. 2, that Mantegna married Niccolosia Bellini
in 1453, that is to say about a year after the frescoes in the Eremitani chapel
had been finished. As far back as 1448 there had arisen differences between
Squarcione and Mantegna, which were, however, settled on January 26 of that
year. The conciliation of 1448 was declared to be null in 1456. See Stefani, in
Archivio veneto, xxix. 192.

centuries opinion should have held that Squarcione was the
master who directed the genius of Mantegna to the study of
classic sculpture and the antique, but that when he quarrelled
with Mantegna he found nothing to reprove in the frescoes of the
Eremitani except their sculptural character and lack of nature?
A truer and, we may think, a more logical cause for the es-
trangement of Mantegna was his partiality for the rival work-
shops of the Florentines and of Bellini. No doubt there were
gibes and jeers exchanged between the students ; parties declared
themselves for one side or the other, and private rancour was
added to artistic rivalry. A welcome lever of attack was
furnished to Squarcione by Mantegna's exaggerated zeal in
straining art for a conventional purpose, but the attack would
have lost its point if the very peculiarities which Squarcione
censured had been due to Squarcione's teaching. The same
perseverance with which Mantegna appropriated all that savoured
of antiquity in sculpture, he applied to copying ancient architec-
ture. He might in this respect have been animated by the
example of Squarcione, who is said to have brought back draw-
ings from various parts of Italy, but he would surely have derived
a natural partiality for it from daily association with the artists
who visited Padua, the professors of the Paduan University, and
a select band of learned inquirers who devoted time and means
to the discovery of local antiquities. The province of Padua
and Verona was at that time perhaps one of the best fields for
such researches that Italy possessed. Verona had her circus and
remnants of other ancient buildings ; the neighbouring country
had its classic remains ; all these Mantegna visited chiefly in
company of Felice Feliciano, a famous collector of inscriptions ;
and we see the fruits of his discoveries or observation in the
chapel of the Eremitani, where classical edifices are revived with
consummate skill.[1] On the arch of the fresco representing St.
James before Herod Agrippa, a fragment of a Latin epigraph is
introduced which may have been found in some old ruin.[2] On

[1] Felice Feliciano dedicated his Epigrammata MS. in the library of Verona to
Mantegna, and there relates (1463) how he, Mantegna, and Samuele da Tradate
visited the country about the lake of Garda, measuring monuments and copying
inscriptions (Selvatico in Vasari C., iii. 452, 457). [* Cf. *postea*, p. 87, n. 3.]

* [2] "T · PVLLIO | T · L · LINO," etc. This is a copy of an inscription on a tomb-
stone once on the Monte Buso, near Este ; see *Corpus Inscriptionun Latinarum*,

the far more florid and richly decorated one in the St. James
going to Martyrdom is a medallion enclosing the name of
L. Vitruvius Cerdo, an architect connected with some of the
fallen buildings at Verona.[1]

That a constant intercourse took place with antiquaries and
professors is proved by the fulsome eulogies of Mantegna in
dedications of books, in elegies and sonnets, where the artist's
talents are necessarily compared with those of the masters of
Greece.[2] Adulation was fashionable and almost as shameless at
that time as when it was sold subsequently to princes at the
price of diamonds by such venal scribes as Aretino. It was
effective in proportion to the popularity of the writer, and might
repose on a genuine basis in Mantegna's case, but if so it
represented, as has been truly said, the opinions of a select few
and not the admiration of the million, for which indeed the art
of Mantegna could have no charm.

Squarcione's charge against Mantegna was that he lent him-
self to the pernicious practice of imitating the hardness of
marbles as contradistinguished from the softness and flexibility
of flesh ; he added that Mantegna had done better to paint his
figures in monochrome, than to tint them in so many colours,
since they made no pretence to resemble living things.[3] What-
ever may have been the motive, there was no denying the truth,
of this opinion, and Mantegna very properly tried to correct the
exaggerations into which he had fallen. The fruits of this
endeavour are very clear in the Martyrdom of St. James, where
feats of scientific draughtsmanship are avoided, a reasonable

vol. v. pt. i. No. 2528. Jacopo Bellini copied the same inscription in the Louvre
sketch-book (fol. 48). Below this inscription there is in the fresco another, of
which, however, only a few syllables are visible (AVG . . . | ROM . . . 10 | VMA
. . . L . . .).

[1] Cerdo was the architect of the arch of the Gavii at Verona, which no longer
exists. (See Selvatico, Comm. in Vasari, iii. 452.)

[2] We may name Ciriaco of Ancona, Giovanni Marcanova of Padua, Matteo
Bossi, abbot of Fiesole, Janus Pannonius, Pamfilo Sasso, Benevoli, Leonardi,
Battista of Mantua. Extracts from the writings of these may be seen in Anon.,
pp. 145 and foll., and especially the eulogy by Janus Pannonius, pseudonym of
John of Czezmicze, of whom Mantegna painted a (missing) portrait in company
of Galeotto Marzio, a student at Padua in 1458, and the eulogy of Camillo
Leonardi of Pesaro in *Speculum Lapidûm*, printed at Venice in 1502.

[3] Vasari, iii. 389.

vanishing point is chosen, human models are preferred to statues, and nature is consulted for a broad and effective landscape. On the brink of a ditch with a light fronting of rails, lies the prostrate form of St. James, closely guarded by men of all arms on foot and horseback ; astride of him a grim and muscular executioner with a huge mallet ready to come down. To the right is part of a ruined arch overgrown with ivy ; in the middle ground an almost leafless sapling, and a road ; and in the distance a rocky terraced hill, a castle, and ill-repaired defences. What particularly strikes the eye is an obvious struggle between past habit and a novel resolution. The spirit of Donatello still lingers in three figures of soldiers on a road behind the Martyrdom, foreshadowing as it were those of Michelangelo in the round of the Uffizi. The positive realism, which forms a prominent feature in Andrea's character, is displayed in the coarse and muscular shape of the executioner clothed in a patched jerkin. In powerful contrast again are the mounted guards, one of them on a foreshortened horse not unfamiliar to us in Uccelli or Jacopo Bellini's sketches, another curbing his charger after the fashion of the riders in the triumphs of Hampton Court. In the technical treatment of distemper an obvious change. In every part, and particularly in the figures at the right-hand corner of the picture, the surface loses its previous rigidity and metallic tone ; shadows are less sharp and black, and hatched lines give the modelling with greater softness ; but the iron nature of the painter's art is still reflected in the cutting contrasts of yellow hills, red walls and paths, and dull green bushes.[1]

Not without encouragement in this self-imposed reform, we think, Mantegna relaxes more and more from the grimness of

[1] In this fresco the substance of Mantegna's colour is less solid than before and more liquid ; the hatching is softer, and the red-brick tone is milder than before, and shaded with less blackness. The head of St. James is not in Mantegna's spirit, and seems done by a younger man in his school. The head of a man looking at him and stooping over the railing is injured; and just there a dangerous split is to be seen in the wall. The blues of the sky and dresses are either blackened or bleached. A bit on the upper part of the ruin to the right is restored in oil. Of this piece also there is a small canvas copy in the house of the Marquis Galeazzo Dondi-Orologio at Padua (see Anonimo, p. 26). [* This copy is now untraceable. See also *antea*, p. 33, n. 1.]

his style in the Martyrdom and Removal of St. Christopher in the
lowest course of the right-hand chapel wall. He divides his
space into two parts by a pillar. The giant saint stands bound
on the left hand, awaiting his doom. Near him the archers,
under a bower overgrown with vine, leaning against a massive
building covered with antique reliefs and inscriptions; on one
side three profiles of spectators, at a window the judge wounded
by an arrow.[1] To the right the second and final scene, where the
body of St. Christopher covers the foreground of a street, and is
removed by soldiers.[2] But for the copies of these frescoes which
are preserved in the gallery of Parma, we should lose many
of the details of the composition, but guided by these we note
the perfect nature of the architecture and its perspective.[3]

Both subjects have a common vanishing point marked by
the nail-hole struck by Mantegna's own hand in the pillar
between them. Retreating lines of the bower and toning of the
walls in harmonic colours produce a masterly effect of distance;
flesh and dress are rendered with more liquid hatching than
before; rotundity is sought with less trenchant means, and
portions of faces are broken in light with a cold grey. The
drawing has not so much of hard searching, but the action of

[1] Almost all of the figure of St. Christopher is obliterated, as well as part of the
legs of the archers and spectators to the right. The dresses of the three specta-
tors are also deprived of colour. Beneath two busts in bas-relief in the wall
below the window occupied by the wounded judge, an inscription of which one
can read the words: " T · PONENVS · | M · F · MARCEL · | . . . PATRI · S · | . . . DIAE |
. . . ET OVIVI | VIII." The figure of an archer partly concealing the un-
intelligible words is greatly injured. [* The beginning of this inscription is given
in the *Corpus Inscriptionum Latinarum*, vol. v. pt. i. No. 2989.] In the scaled
parts about the legs of St. Christopher the original drawing in red is visible on
the wall.

[2] Here also we have but the outline of St. Christopher's head and frame, and
of the figures in rear of him. The right-hand corner of the composition is in a
similar bad condition. Here it is that according to Vasari (iii. 391) Mantegna painted
a portrait of Squarcione as an obese archer—the second figure to the right from
St. Christopher—and other portraits, for which see Vasari (iii. 391).

[3] Parma, Galleria Reale, No. 437, on paper, in oil, the same mentioned in
Anonimo (p. 84) in the gallery of M. Michiel Contarini. [* There are old copies
of these frescoes also in the André collection at Paris. See *antea*, p. 33, n. 1.]

A large copy of the Martyrdom of St. Christopher was ordered some forty
years ago by the city of Padua from the painter Signor Gazotto.

The Arundel Society has partly issued a chromolithographic series of the
frescoes.

ANDREA MANTEGNA

Alinari photo.] [[*Padua, Eremitani.*

THE MARTYRDOM OF ST. CHRISTOPHER.

the slender figures still wants relaxing. From the foot of the standing St. Christopher which remains, we see how perfectly the artist was acquainted with the structure of bone, of muscle, and of flesh, how anxiously he tried to avoid the stony look so bitterly reproved by Squarcione. A bolder foreshortening than that of St. Christopher dragged away by ropes in the last fresco is not to be found in the Paduan school ; a finer arrangement of groups and accessories, more ready movements, cannot be imagined. Here it is that we become fully acquainted with Mantegna's lofty position amongst artists. Here we mark how much more gifted he was in some senses than the celebrated men of the following century. We compare his giant figure with Titian's David and Goliath, or Death of Abel in the ceiling of the sacristy at the Salute in Venice, and we perceive that the great Venetian lives on the achievements of the Paduan, content to enjoy the fruit garnered by Mantegna, who for his part fixes rules indispensable to the future expansion of art. What indeed would have become of that art had not some one sacrificed the end to the means, and dwelt with severe patience and solemn pleasure on the dryest problems ? [1] It was necessary that some one should be found to level the road leading to perfection ; and such an one we justly recognize in Mantegna, who without sense of spontaneous or ideal grace, and without feeling for colour, had the power and indomitable will of Donatello and Buonarrotti.

We spoke of three profiles of spectators in the Martyrdom of St. Christopher ; they differ so essentially in form and treatment from others in the fresco that they might be due to a different painter. In appearance the central one is the oldest of the three, a man with strongly marked features, a bald head and padded cheeks, with his hands crossed over his waistband ; to his left a younger person about forty years old ; to his right, one, in a red cap, still younger. A bright flesh-tone, a soft style of modelling, an outline free from ruggedness, and delicate hands, extreme individuality, and constant consultation of nature remind us of late creations by Gentile Bellini. Mantegna, who had never exhibited any of the portrait character peculiar to the Venetians, suddenly seems to favour simple nature in drawing

[1] See Selvatico (Comm. in Vasari, iii. 455).

and in tone. Had a single fresco of the Bellini been preserved, we might perhaps be able to hold some strong opinion as to the author of these figures ; but without this certainty we can only say that the Bellini might have painted so. More curious perhaps than the variety between this and other parts of the Martyrdom is the coincidence, that in the two youngest heads we trace a likeness to the medal portraits of Gentile and Giovanni. We may acknowledge the difficulty of distinguishing accurately between heads in their natural state and those which Venetian fashion encumbered with wigs; but so far as it is possible to judge, there is a resemblance between the nearest personage of the group to the medal of Camelio, and it might be that the next one is Jacopo Bellini, and the third Giovanni. If this should be admitted, we may presume that, at the time of producing this piece, Mantegna was already wedded to Jacopo's daughter, and the four painters were bound together by ties of relationship.[1] We might then suppose that the change, wrought in Mantegna after the completion of the St. James going to Martyrdom, occurred under the auspices and encouragement of the Bellini, who, as rivals of Squarcione,[2] would be interested in bringing their brother-in-law to a proper admission of the exaggerations of which he had been guilty. We are ignorant, as has been said before, of the exact period when this marriage took place ; we may believe without any violation of historical data that it was celebrated when Mantegna was at work in the chapel of the Eremitani; and nothing can prevent us from thinking that Jacopo Bellini had a share in directing the career of Mantegna. We may assume that the full force of the Bellinesque influence was exerted when Andrea began the Martyrdom of St. James. Amongst the riders there we see something akin to the action and foreshortening of those in Jacopo's sketch-book ; and the general softening of his style as a colourist and draughtsman is perhaps due to the same cause ; nor is it unlikely that the portrait character and soft impression conspicuous in the three figures we have noticed may have been the fruit of some transient but powerful expression of Bellinesque opinion in Mantegna, when stung by the criticism of Squarcione. Meanwhile it is but fair to say, that what Mantegna might have

* [1] See *antea*, p. 36, n. 2. [2] Vasari, iii. 388 *sq*.

gained from the Bellini, he repaid to them in kind ; and for many a year, as we are now aware, Giovanni Bellini held truly to the standard which his brother-in-law had set up, and did honour at once to the lessons of his father, his relation, and Donatello.

The time was now approaching when events of great influence on the future expansion of North-Italian art were to take place. Having become celebrated in the Lombardo-Venetian territory by the works which he had finished, and by others which had not as yet been brought to perfection, Mantegna attracted the attention of the Marquis of Mantua, who used uncommon persuasion to induce him to leave Padua. Jacopo Bellini was removed by death from the scene, and his sons were induced to withdraw to Venice.[1] From that moment the Paduan school lost its importance, and was overshadowed alike by the Venetian and the Veronese. Premising that there are no genuine pictures by Mantegna at Padua except those which we have described,[2] and reserving to ourselves the pleasant task of following

* [1] As before stated, Jacopo Bellini continued to live until 1470-71, and we do not know when the Bellini stayed at Padua.

[2] We may cite the following as pictures assigned or assignable to Mantegna : (1) Padua, Dr. Fusaro ; formerly belonging to the Barbieri family. Half-length of the Virgin with the Child on a parapet ; a festoon of apples hangs from the upper corners ; a head of an emperor in a medallion is in the parapet, and two scutcheons ; distance, sky ; wood, tempera, half life-size. This panel might be called Mantegna with more propriety than any of the so-called originals at Padua. It is so rubbed that the wood is bared in many places. The movement and drawing are exact counterparts of those in a panel at Berlin (No. 27), but without the frame and ornament of angels' heads. The outlines are broken and sharp, and if this be a genuine Mantegna, it is a mere relic. [* This painting was subsequently in the collection of the late Mr. Charles Butler of London and was sold at the Butler sale, May 25, 1911, No. 49.] (2) Padua, Conte Miari. Christ at the Column ; see *postea*, Antonello. (3) Padua, Casa Antonio Gradenigo. Lunette panel with three angels carrying the emblems of the passion ; see *postea*, Liberale of Verona (4) Padua ; originally in Casa Capo di Lista, now in the Communal Gallery. Small panel tempera of the Resurrection. Christ rising with the banner and the guards, one of them extended on the centre of the foreground and looking at the Saviour from under his arm. This is a Mantegnesque composition copied from a print, and similar to the panel of the same subject in the Lochis Gallery at Bergamo. (5) Padua, Casa Maldura. Virgin adoring the Child. A small, injured panel, with figures half the life-size, by Luigi Vivarini. (6) Same gallery. Holy Family and Magdalen. Wood. For a time this piece bore the forged name of A. Mantegna. The old inscription on a cartello has been recovered as follows : " Marchus Palmiza Foroliviensis." (7) Padua, Casa

Mantegna later to Verona and to Mantua, we shall devote a short space to the examination of the lives of the painters who imitated and carried abroad the pure ugliness of the school of Squarcione.

Antonio Nordio. Adoration, between the Annunciation and Circumcision, a triptych by a German of the sixteenth century. (8) Piove, in possession of the apothecary Signor Mangini. Nativity; see *postea*, Antonio da Pavia.

Amongst the lost works of Mantegna at Padua are the following : (1) San Benedetto. St. Benedict on canvas in the choir (Anonimo, p. 24). (2) Spirito Santo. Christ sends the Apostles to preach the Gospel (Ridolfi, *Marav.*, i. 113).

CHAPTER III

THE SQUARCIONESQUES

IT has been the habit of some very great historians to crave the pardon of their readers for introducing them to dull but necessary fragments of history. There is no page in artistic annals more calculated to test the patience of the writer or the constancy of the reader than that which treats of the genuine pupils of Squarcione. Yet in every species of inquiry there is something to create interest, and the melancholy works of the Squarcionesques will not be described in vain, if they serve to prove the real mediocrity of a master hitherto honoured beyond his deserts, and of a school encircled by an artificial halo.

That Squarcione is not to be judged by such works as bear his signature, has become evident in the course of this narrative ; that the true character of his teaching has been misconceived, may be illustrated by the career of his disciples. Of these the earliest is perhaps the Dalmatian Schiavone, whose Christian name, according to Scardeone, was Gregorio.[1] The rude freedom

[1] Scardeone, *Antiq. Pat., ub. sup.*, p. 371. But Sansovino (*Ven. Descr.*, p. 286) describes a tempera of Christ on the Mount in the Scuola di San Marco at Venice, and calls the painter Giorgio Schiavone allievo di Squarcione, and Ridolfi (*Marav.*, i. 110) calls him Girolamo.

* The name of this artist is really Giorgio Chiulinovich; he was born at Sebenico in 1435 or 1436. In 1456 he entered the service of Squarcione for three years and a half, the contract being made at Venice. In 1462 Giorgio had returned to Dalmatia, carrying with him some drawings belonging to Squarcione, and also owing his master some money. A painter named Marinello, whom Squarcione in 1464 empowered to demand the return of his property, succeeded in obtaining both money and drawings from Giorgio, but instead of handing them over to the rightful owner he kept them all for himself ; and in 1474 we find that Squarcione's son Bernardino appealed to—Giorgio Chiulinovich, then

and boldness to which he attained are shown in two figures of
St. Jerome and St. Alexius in the Lochis Gallery at Bergamo,
where we recognize the style of Squarcione's altarpiece of 1452.[1]
So quaint is the ugliness of these saints, that one hardly con-
ceives how they could have been seriously accepted as sacred
pictures. It is not that patrons were ever wanting for artists
of a low class, who might rival the wooden rigidity and coarse-
ness of forms, the lame action of extremities, or the paltry style
of drapery conspicuous in these pieces ; but there is something
so childish in the exaggerated character of the heads, in the
awkward pattens of St. Jerome, in the black boots of St. Alexius,
in the grotesque architecture and the dry landscape, that an
involuntary smile must needs overspread the features of the
spectator. Yet these hard and solid temperas are honoured
with the name of Mantegna, and are the necessary precursors
of others inscribed by Schiavone. The oldest of these temperas
in point of time is a Virgin and Child enthroned between two
angels in the Museum of Berlin,[2] in which a marked absence of
nature in the shape of the faces and frames, and a stark stiffness
of limb, are but slightly compensated by affected grimness and
solemnity. In this poor work Schiavone calls himself the pupil
of Squarcione, and there can be little doubt that he finished it,
as he finished the previous one at Padua, after his introduction
in 1441 to the guild of that city.[3] That Schiavone was utterly

staying at Padua, to get back from Marinello both what he himself had passed
on to him and also a drawing by one of the Pollaiuoli which Squarcione had lent
to Marinello. After this we hear nothing more of Giorgio Chiulinovich. See
Lazzarini and Moschetti, in *Nuovo archivio veneto*, ser. ii. vol. xv. pp. 116 *sqq.*,
283–7, 295 *sq.*

[1] Bergamo, Lochis Gallery, Nos. 161 and 159, under the name of Mantegna.
Wood, tempera, the sky of the latter darkened.

[2] Berlin Museum, No. 1162. Wood, tempera, 2 ft. 7 in. high by 1 ft. 10 in.,
from the Solly collection, inscribed: "Opus Sclavoni Dalmatici Squarcioni."
This no doubt is the centre of an altarpiece which the Anonimo describes in San
Francesco at Padua. It had St. Jerome and three other saints at the sides. In
the time of Brandolese (*Pit. di Pad.*, p. 252) the central Madonna alone remained.
When Moschini wrote his *Guida di Padova* (p. 85) in 1817, the panel was in the
archiepiscopal palace, and when he wrote the *Vicende della Pittura* in 1826 (p. 64)
it had been sold. The blues of sky and dress are in part renewed.

[3] We assume that Schiavone is the painter inscribed under the name of
Gregorio (see Moschini, *Vicende, ub. sup.*, p. 23). [* Cf., however, *antea*, p. 45,
n. 1.]

unaware of his weakness is proved alike by the earnestness with
which he labours and the patient minuteness of his outlines.
He is not free from the error of preferring the motionless
character of stone to the flexibility of flesh ; his shading is
made with straight hatching, and his surface is raw and dull.
No pupil of Squarcione can more justly claim to have painted
the seraphs and angels in the soffits of the chapel of San
Cristoforo at the Eremitani ; and if under all circumstances it
may be still doubtful whether he really carried out that work,
the only person capable of contesting the authorship is Zoppo,[1]
who comes very near him in the technical treatment of tempera,
and who might dispute with him the four saints in the sacristy
of the canons of Padua, but that they are the side panels of the
Madonna at Berlin.[2]

There is no more important altarpiece by Schiavone than that
now preserved in the National Gallery, a Virgin and Child with
four saints, a little better handled than the Virgin of Berlin,
and not without resemblance of manner to the creations of
Girolamo da Camerino and even of Crivelli.[3] The most
affectedly quaint of his pictures, however, is the Virgin and
Child belonging to a gentleman at Sinigaglia, in which taste-
less architecture and garlands of fruit and flowers are duly
commingled after the Paduan fashion, and an attempt is made

* [1] See *antea*, p. 16, n. 3.

[2] Padua, sacristy of the canons. Small panels answering the description of
those seen by the Anonimo as side pictures to the Madonna in San Francesco
(Anonimo, p. 12). On one of them St. Louis and St. Anthony of Padua, on the other
St. Jerome and St. Francis, both in landscapes, the skies repainted, the colour
hard, semi-transparent, the outlines very careful.

[3] National Gallery, No. 630, in ten compartments, the central one of the
Virgin and Child inscribed on an unfolded scrip : "Opus Sclavoni disipuli
Squarcioni S." When in the Dennistoun collection this piece was set up in
a different form from the present one, the upper course being Christ in the
tomb between St. Anthony of Padua and St. Peter Martyr, the second the
Virgin and Child between St. Bernardino and St. John the Baptist, the predella
containing half-lengths of SS. Anthony the Abbot, Catherine, Cecilia, and
Sebastian. Wood, tempera ; centre 3 ft. 6 in. high by 1 ft. 1¾ in. ; sides 2 ft. 2 in.
high by 9 in. broad. The altarpiece belonged to M. E. Beaucousin before coming
into the National Gallery. All the figures are on gold ground, the Virgin and
Child in the same attitudes as at Berlin. We note an imitation of a fly near the
inscription, and mark common features in this and in the imitation of fruit-
garlands between Schiavone and Crivelli.

to copy the strained action of Crivelli and the drapery of Donatello.[1]

Marco Zoppo holds a higher place than his comrade in the ranks of the Squarcionesques.[2] He also is vain of having visited the famous atelier of Padua, and informs his patrons

[1] Sinigaglia, Signor Benucci Buonaventura. Wood, tempera, one-third of life-size, well preserved, and probably the same picture as that noticed at Fossombrone by Lanzi (ii. 116). It represents the Virgin and Child behind a window, imitating grotesquely enough a classic style of architecture, the arch above being hung with a garland of fruit and flowers, about which are two angels with trumps. Behind the Virgin a marble screen and a landscape. Outside the window and nearer the spectator than the Infant Christ, who sits on the sill, two little angels, each of them with a dish in his hand; on the one to the left a fly. Between the two a bronze platter with fruits and two vases. On a cartello the words : " Opus Sclavonici dalmatici Squarzonis." Nothing is more curious than the carefulness of the overcharged details or the variegated tinting of the marbles, reminding us of the peculiarities of the Ferrarese school. The movements of the head and hands are daintily awkward as in Crivelli, the dress tucked with girdles as in Giovanni of Pisa's imitations of Donatello. Very little relief is produced by the patient hatching of the parts, and the colour has a Ferrarese redness of enamel. [* This picture is now in the Gallery at Turin (No. 162).]

We may note in continuation : (1) Louvre, No. 1523; school of Mantegna. [* Now ascribed to Schiavone.] Virgin and Child between two playing angels. This is a panel combining the styles of Schiavone and Zoppo, and more Ferrarese in tempera than those of Schiavone generally. (2) Venice Academy, No. 616. Virgin and Child, from the ex-monastery of Santa Croce. This picture recalls Crivelli in the landscape and figures; it is a very careful Venetian piece. (See the engraving in Zanotto, *Pinac. dell' Accad. Ven.*, fasc. 34.) (3) England, Mr. Fuller Maitland, of Stanstead House. Virgin and Child in front of a bridge, and two angels. The painter affects to have drawn this group on a worn parchment, the sides of which are nailed to a panel; on the left a fly, which suggests to some one who writes on the back of the picture the name of the painter Mosca. The style is that of Schiavone, and between his and Zoppo's. There is much of the Ferrarese in the affected movement and the introduction of accessorial detail. (4) In the style of the immediately foregoing, an enthroned saint, part of an altarpiece, and a Virgin and Child, surrounded by a halo of cherubs' heads, a St. Catherine, full-length, small panels, more or less preserved, in the collection of the Conte Riva at Padua. [* These pictures are not among those which the Conte Riva in 1872 bequeathed to the city of Bassano and which are now exhibited in the Museo Civico of that town.] (5) Finally, a Virgin and Child in a highly ornamented arch between two angels, with the initials A. P. in the pilasters, in the collection of Mr. Barker in London. [* Now in the National Gallery, No. 904.] The style is very like Schiavone's, but the initials point to Antonio da Pavia, of whom *postea*.—Moschini mentions a picture at the Brera, originally in San Prosdocimo of Padua (*Vicende*, p. 63). No such picture is to be traced.

[2] Malvasia, *Felsina pittrice*, p. 30, tells us, we know not on what authority, that Zoppo is the pupil of Lippo Dalmasio.

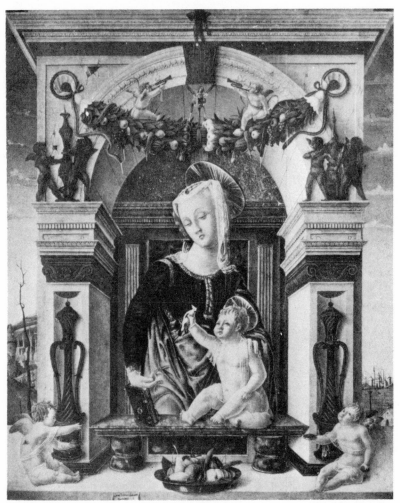

THE VIRGIN AND CHILD.

on every occasion that he is Zoppo di Squarcione. Having taken part, as we conjecture, in frescoes at the Eremitani,[1] he resided for a time in Venice, where he painted altarpieces in considerable number. That of Santa Giustina, which has perished, was done in 1468 ;[2] another, ordered for the Minorites of Pesaro, is preserved and bears the date of 1471. A little later Bologna was the place of his habitation, and there he is said to have lived at least till 1498.[3] Peculiarly characteristic of Zoppo's style is the tendency to imitate the stiffness and reflected modelling of brass, and simultaneously to realize something like veneering or tarsia. Had he been employed alternately by Giovanni of Pisa and by Lorenzo of Lendinara, he might have obtained exactly the manner we have described. Nor is it improbable that sculptures should have been objects of his attention on the one hand, and the cutting out of tarsia a part of his professional acquirements on the other. Both Giovanni and Lorenzo were contemporaries at Padua, and the latter Zoppo's fellow-pupil under Squarcione. The brass epoch in Zoppo is his first, the tarsia his second ; towards the close, and particularly during the Bolognese stay, a better art develops itself, with a local stamp distantly reminiscent of Cossa's or Costa's. We shall be able to observe that Zoppo was employed with Costa and many others in the decoration of the Schifanoia at Ferrara.[4] The greatest honour which he now

[1] See *passim*. It is obviously an error of Vasari (iii. 405) to say that Zoppo painted the Loggia, used as a chapter-house in the Santo of Padua, the frescoes there having been relieved from whitewash, and proved to be by Giotto.

[2] Sansovino, *Ven. Descr.*, *ub. sup.*, p. 42.

[3] Malvasia speaks of frescoes by Zoppo on the front of the Casa Colonna at Bologna, dated 1498, but these paintings no longer exist (*Felsina*, p. 35).

[*] Marco Ruggieri, called "lo Zoppo " (the lame), was born at Bologna in 1431 or 1432. In April 1454 he became an apprentice to Squarcione, who on May 9 of the following year adopted him as his son. A few months afterwards Marco, however, left the house of Squarcione and went to live in Venice. The adoption therefore became null, and Squarcione, moreover, now claimed that Marco should pay him for his board and training. The judgment in this case, delivered on Oct. 9, 1455, was almost wholly against Squarcione. See Lazzarini and Moschetti, *loc. cit.*, xv. 120-124, 275 *sqq.* In September 1462 Marco was at Bologna, from where he wrote a letter to the Marchioness Barbara of Mantua, declaring that it was impossible to finish in time a pair of *cassoni* she wished to have by Christmas in that year. See *L'Arte*, ii. 253.

[* 4] Cf., however, *postea*, p. 250, n. 2.

enjoys is undeserved. He never, we think, directed the studies of Francesco Francia.[1]

There is no picture more truly characteristic of his first period than the Virgin giving the breast to the infant Saviour in the Manfrini Palace at Venice.[2] One can scarcely conceive, without looking at such pieces as these, the serious childishness of this peculiar class of painters. From the niche in which the Virgin is confined a double garland of apples and other fruit depends, having just been placed there by angels. Below these, half a dozen naked or half-clad boys play the quaintest instruments. As if this were the most natural and appropriate conception that fancy can suggest, Zoppo carries it out with a most loving carefulness and finish of outline, hatching up the parts with consummate care, forgetting neither shadow nor reflection, but producing a dull twilight of tone with a crystalline surface ; nothing more curious than the unvarying nature of the texture, be it flesh or drapery, except perhaps the tortuous turn of the contour, the ugliness, affected classicism, and perfect rigidity of the forms. Equally remarkable is the gaudy yet melancholy tint of the dresses. A second specimen of this kind is the Virgin of Mercy, attended by two donors and saints, in the palace of Prince Napoleon at Paris.[3] The tarsia phase is more completely illustrated by the Virgin amidst saints in the gallery of Berlin, a panel ordered, as we have seen, for the Minorites

[1] This is stated by Malvasia (*Felsina, ub. sup.*), but is not proved by Francia's works.

[2] Venice, Manfrini. Canvas, tempera, m. 0·73 broad by 0·89 high. Injured by repeated varnishing. Inscribed on a cartello : " Opera del Zoppo di Squarcione." A second cartello to the right is bare. Behind the throne a landscape with leafless trees. The Virgin wears a crown over a white veil, the Saviour is dressed in a light yellow cloth. [* This picture is now in the collection of Lord Wimborne at Canford Manor. Many critics ascribe it to Schiavone, whose style it closely recalls.]

[3] Paris, Prince Napoleon ; once belonging to Mr. Weber at Venice, and to Mr. Mündler in Paris. Small panel, inscribed : " Madonna del Zopo di Sqarcione," on the pilasters of the Virgin's throne. The Virgin, with the Infant on her knee in benediction, opens out her cloak, in front of which are the male and female donors kneeling. At the sides SS. Louis, Francis, and Jerome, Bernardino, Anthony of Padua, and a bishop ; a garland above is supported by two angels carrying censers. The tone of this piece is less dull than that of the Manfrini Palace. [* It now belongs to the King of Roumania. See Bachelin, *Tableaux anciens de la Galerie Charles I^er, Roi de Roumanie*, pp. 12 *sq.*]

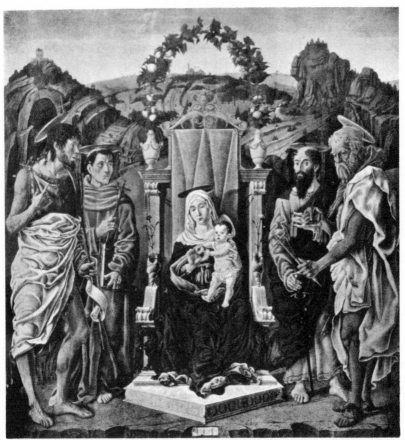

THE VIRGIN AND CHILD WITH SAINTS.

of Pesaro in 1471.[1] There is something distressingly grotesque in the colossal coarseness of the figures and the disharmony of crumpled and serpentine drapery. Lean parched flesh in aged figures is made to contrast with a brassy pinguidity in the Child; and as much care is bestowed on the veins and muscles of the one as on the laps of flesh in the other. One can easily fancy such a piece to have been done by an artist affected in a puerile way by the models of Donatello at Padua or those of Giacomo della Quercia at Bologna. The whole surface at the same time presents the appearance of a map set up in various parti-coloured sections, semitone being altogether wanting, shadow green, and light of a rosy pallor. This is the style of a Madonna surrounded by saints in courses in the sacristy of the Collegio de' Spagnuoli at Bologna, where a Virgin annunciate in a round distinctly recalls the Doctors of the Church in the cupola of the Eremitani chapel;[2]

[1] Berlin Museum, No. 1170. Wood, 8 ft. 5 in. high by 8 ft. 1 in. From the Solly collection; previously in San Giovanni Evangelista and the Osservanti at Pesaro. Inscribed on an unfolded paper: "Marco Zoppo da Bolognia pinsit MCCCCLXXI I Vinexia." The Virgin is in a stone chair with festoons and in a hilly landscape; at her sides, standing, SS. John the Baptist and Francis, Paul and Jerome. The Virgin is in the act of giving an apple to the Infant. Mark the affected daintiness of the hands and their conventional anatomy, the false classicism of the throne with a griffin supporting the arms, and a conch on the arm itself doing duty as a flower-pot. [* A half-length of the Madonna and Child in the collection of Sir Frederick Cook at Richmond shows a great similarity to this work. It is signed "Marco Zoppo da Bologna opus." See also *postea*, p. 53, n. 1.]

[2] Bologna, Collegio de' Spagnuoli, sacristy. Composite altarpiece in twenty-one parts. In the centre the Virgin on gold ground between saints in niches— Andrew, Gregory, James, and Jerome; in pinnacles, the Eternal between the Virgin and the Angel annunciate; in pilasters, SS. Anthony of Padua, Catherine, John the Baptist, Peter, Paul, Anthony the Abbot, a female, and another saint; in the predella, rounds of the Virgin adoring the Infant and St. Joseph, St. Jerome penitent, and Christ in the boat with the fishermen. Four small pilasters parting the predella subjects contain SS. Roch, Dominic, Francis, and Sebastian. On a cartello at the foot of the Virgin's throne: "Opera di Zoppo da Bolognia." The largest figures are about 2 ft. high, some of them, *e.g.* the Infant Christ and the pilaster saints, the St. Sebastian especially, rubbed down to the wood; the predella piece in a great measure injured by scaling and stains. The upper rounds are fairly preserved, with the exception of the latter, which are better done than usual, and recall the style of the Canozzi of Lendinara; the figures are paltry, with thin spider legs, and the tempera of a dull and hard enamel. [* Allied in style to the predella pictures are two very similar little representations of St. Jerome in the Desert, one (signed "Marco Zoppo op.") in the Gallery at Bologna (No. 778), the other (signed "Marco Zoppo d. a Bononia") in the collection of Baron von Brenken at Wewer.]

of a Crucifix in the choir of San Giuseppe de' Cappuccini outside Bologna,[1] and of a Man of Sorrows at San Giovanni Evangelista of Pesaro.[2] The improvement of Zoppo is shown in a foreshortened head of the Baptist in the same place,[3] and his approach to Cossa and Costa in a St. Apollonia at San Giuseppe.[4] There are examples of his manner in considerable numbers at Bologna and elsewhere,[5] but the principal occupation

[1] Bologna, San Giuseppe fuori Porta Saragossa. This Crucifix is in the old Sienese form, with the tearful Virgin and Evangelist on the arms of the horizontal beam and a skull beneath the Saviour's feet. The principal figure is of the size of life, with a vulgar grimacing face. The finish of this hideous work is quite remarkable, the art displayed in it being not above that of the Sienese Giovanni di Paolo or Simone de' Crocefissi. [* It is now in the Museo Civico of Bologna, which also contains a Nativity of Christ by Zoppo (No. 198).]

[2] Pesaro, San Giovanni Evangelista, sacristy. Christ in the Tomb supported by two angels; an ill-preserved and split panel, m. 0·75 square; very carefully outlined. The angels with white head-cloths, Mantegnesque, and mouthing; the face of Christ a little less repulsive than in the foregoing Crucifix; the tempera of a thin dry yellow in lights. [* This picture is now in the Museo Oliveriano at Pesaro, No. 35.] The same subject in the National Gallery, under the name Tura (No. 590), is very like the above in every sense, and is undoubtedly by Zoppo. [* It is now officially restored to him. Yet another Pietà by Zoppo is in the Vieweg collection at Brunswick.]

[3] Pesaro, San Giovanni Evangelista, sacristy. [* Now Museo Oliveriano, No. 32.] Round, wood, foreshortened head of the Baptist looking up and cut off at the neck (10 in. in diameter). This is a Mantegnesque and not inelegant face, with long frizzled air about it, minutely detailed in the features, the form better rendered than of old and better modelled; on the back of the panel a modern sentence as follows: "Il pittore che ha fatto questa testa fu Marco Zoppo da Bologna, 1415 (?)."

[4] Bologna, San Giuseppe fuori Porta Saragossa, altar of sacristy. The saint is erect in front of a hanging which conceals a landscape and sky, holding the palm and pincers. In the frame of the period, gilt in broad flat surfaces, small panels are let in representing scenes from the saint's life, half-lengths of the Virgin and Angel annunciate and two saints; beneath the chief figure a coat-of-arms. Canvas. St. Apollonia is under life-size. There is more true realism in the drawing of extremities than before; the flesh tint is a little flat and reddish, but the movement is still rigid and statuesque. This is an example of Zoppo's broadest and best manner, the small panels at the side, especially that of the saint before the judge having her teeth drawn, being animated compositions of reddish flesh-tone. [* This altarpiece has now its place in the Bologna Gallery, No. 352; it is catalogued under "Unknown painter of the Ferrarese school."]

[5] (1) Oxford University, under the name of Signorelli. Half-length of St. Paul, a present of the Hon. Fox Strangways; a panel with gold ground. This is a rude tempera by Zoppo. (See *History of Italian Painting*, 1st ed., iii. 35.) (2) Bologna, Gall. Ercolani, No. 155. Small panel of the crucified Saviour between the Virgin and Evangelist, the Magdalen at the foot of the cross. The vehemence of the

of his brush at Bologna seems to have been the painting of house-fronts; and we regret that none of these decorations have been preserved, that we might compare them with those executed by Dario, the comrade of Zoppo at the study of Padua.[1]

movement and expression recall the Mantegnesque and Crivelli; but Ercole Roberti might have a claim to the authorship as well as Zoppo. In the same category (No. 44), St. Dominic and his Brethren fed by Angels, assigned to Squarcione. (See *antea*, p. 12, n. 2.) [* The Ercolani collection is now in great part dispersed, and the editor is not sure as to where these pictures are to be found at present. He would like, however, to point out that the above descriptions correspond in every particular to Nos. 11 and 17 in the Museo Oliveriano at Pesaro. As has been pointed out by Prof. C. Ricci (in *Rassegna d'arte*, vii. 103), No. 17 is certainly by Giovanni Francesco da Rimini, as may be seen from the types with the characteristic staring eyes, the hands, the folds, etc.] (3) Ferrara, Costabili Gallery. No. 40, Christ crucified, between the Virgin and evangelist, on gold ground; Nos. 93–94, Virgin and Angel Annunciate; rounds. These pieces are in style like the work of Zoppo at the Collegio de' Spagnuoli and the Crucifixion at the Ercolani College at Bologna. The figures have the vehemence already noted in these pieces. (Note that the Costabili collection is diminishing every year, as pictures are constantly sold by its owner, and these may already have passed into other hands.) [* This collection no longer exists.] (4) Bologna Gallery, No. 209. Virgin and Child between St. John the Baptist and St. Augustine. This common piece is now called Zoppo's. [* In the current catalogue it is ascribed to the Tuscan school.] (5) Rome, Palazzo Barberini. Two panels, with subjects we cannot explain, are here assigned to Botticelli. In one an interior with persons of both sexes; above, the Virgin and Angel annunciate; in the other a baptism of a new-born child, the mother in bed to the right. The figures are long and slender, the architecture imitates the classic, the drapery is crumpled and false; all this more in the character of Zoppo than of Botticelli. [* These pictures represent the Presentation of the Virgin in the Temple and the Nativity of the Virgin; they are now labelled Fra Carnevale.] (6) Verona, Museum, No. 350. Virgin, Child, and youthful Baptist, and two angels. The name of Zoppo here is misplaced, the work being by Francesco Benaglio. [* In the current catalogue it is attributed to Francesco Benaglio, though with a query.]

In the Academy of Venice (No. 601) there is a panel representing St. James, assigned to Paolo Zoppo. Such a person has been named in the Life of Bellini, and may be the miniaturist of Brescia, who lived some time at Venice. (See D'Arco, *Delle arti di Mant., ub. sup.*, ii. 60.) The painting in question, greatly injured as it is, recalls a third-class work of the followers of Girolamo da Santa Croce. [* It is now officially attributed to "An unknown painter who recalls the style of Girolamo da Santa Croce."]

In the Berlin Museum, too, we have a Nativity (No. 131) assigned to Rocco Zoppo, of whom Vasari speaks as a pupil of Perugino (iii. 591). The picture is that of an Umbrian of the following of Palmezzano and Signorelli. [* It is at present labelled Marco Palmezzano.]

[1] There are none of these decorations standing, though they are mentioned by Malvasia (*Felsina*, p. 35), nor are any traces preserved of the following pictures mentioned by the same author: (1) Bologna, Osteria della Sega da Acqua,

Dario is perhaps one of the oldest of the disciples of Squarcione, being mentioned in the accounts of the church of the Santo in 1446 as "discipulo de Squarzon."[1] None of his pictures exist except a Virgin of Mercy in the gallery of Bassano, one of the poorest productions imaginable. The Virgin stands erect in the middle of the canvas, holding back her mantle, which covers a number of devotees. She is adored by a small kneeling donor, and attended by the Baptist and St. Bernardino.[2] Margaritone in the thirteenth century was not inferior to Dario,

portico, half-length, Virgin and Child, small. (2) Signori Bianchi, Virgin and Child. (3) Signor Bartolomeo Musotti (afterwards Signor Fosci), Virgin and Child, signed : "Marco Zoppo da Bolognia opus." This is perhaps the same as that noted by Annot. Vasari, iii. 406, in the possession of a picture-dealer whose shop was in the Palazzo Zampieri at Bologna. [* It might also be identical with the painting now belonging to Sir Frederick Cook; cf. *antea*, p. 51, n. 1.] (4) Casa Camillo Scappi, Virgin and Child. (5) Casa Balli, ditto. (6) Casa Bolognetti, Christ on the Mount ; also signed (Annot. Vasari, iii. 406).—Of the portrait which Zoppo did, according to Vasari, of Guidobaldo of Montefeltro (iii. 406 *sq.*), we know nothing.

[1] Gonzati, *La Basilica, ub. sup.*, i. 55, and doc. xxxv.

* As a matter of fact, the painter is referred to in these records simply as "Dario depentori," Gonzati having added in his transcript the words "da Treviso, discipulo de Squarzon." Dario appears to have been a native of Pordenone. In 1440, at the age of about nineteen, he became a journeyman of Squarcione; the agreement styles him "pictor vagabundus"—an appellation which the story of his life quite justifies—and he promises not to steal any of Squarcione's things. It appears that in 1446 he was still living with Squarcione, but he soon afterwards entered into partnership with the painter Piero da Milano, who was settled in Padua. Dario seems, however, not to have been the most desirable of companions, for in January 1448 he had to make a public acknowledgment of the debts which he had contracted with Piero. In 1455 we find him settled and married at Treviso ; and the following year the Venetian Government wanted him to do some work in the Ducal Palace. From 1459 to 1466 he was living at Asolo. A rude fresco of the Madonna, now in the Municipio of Asolo, was executed by him in 1459 for the church of San Biagio in that town; it is signed "1458 adi 21 del mese de aprile Dariu p." In 1467 he decorated the town-hall of Conegliano with frescoes; in 1469 we find him at Serravalle painting the front of the Palazzo Troyer; and in 1473 he was again at Conegliano. See Lazzarini and Moschetti, *loc. cit.*, xv. 171 *sqq.*, 263 *sqq.*, 289, xvi. 75 *sq.*, 80 *sq.* Gerola, in *Miscellanea di studi in onore di Attilio Hortis*, p. 871 *sqq.*

[2] Bassano Gallery, formerly in San Bernardino. Canvas, all but life-size, much injured and restored, but still bearing the remains of a signature which Verci (*Notizie della città di Bassano, ub. sup.*, p. 23) testifies to have been "Darius p." We note especially the large disproportioned extremities, the false forms, and the ignoble masks, also the dull and dirty tempera. The Virgin's face alone has some regularity.

DARIO

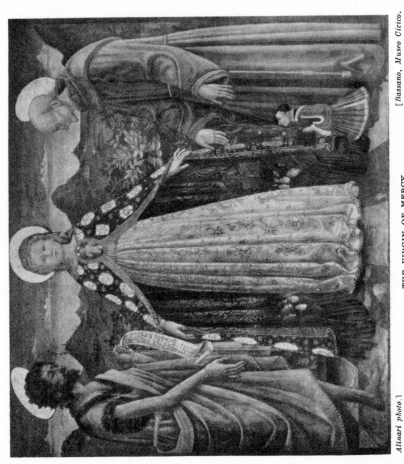

Il. 54]

THE VIRGIN OF MERCY.

who seems to have been a mere house-painter. His faces are
monstrous, his forms put together in defiance of nature. Simon
da Cusighe, one of the most elementary artists of the Trevisan
March, was his equal, Bellunello of San Vito his superior. Yet
we are told that the Venetian Signoria employed him in 1469 to
take the portrait of Catherine Cornaro.[1] To what labour could
Squarcione put such a man, except whitewashing or rude patterns
for embroidery? At the Eremitani he might have carried a
hod ; there is no fresco there but is too good for him. After
the breaking up of Squarcione's atelier he wandered home, and
there are copious examples of his industry in house-fronts at
Serravalle, Conegliano, and Treviso. It is not the art which these
decorations display, but the necessity which dictated the use
of it, and the spirit which it displays, that may interest us.
We see that throughout the North there was as great an
abhorrence of white walls in the fifteenth century as in Egypt
and in Greece at the remotest periods. Every one who could
afford it concealed the simplicity of architecture under imitations
of carved objects and tracery of more or less taste. Fable,
folklore, ancient history furnished subjects, and where ornament
even of this kind became too costly, proverbs or mottoes were
used in its stead. One of the best dwellings in the high street
of Serravalle, with balconied windows and bays, is covered with
graffiti and with friezes of foliage and vases, of which the
authorship is boldly claimed by Dario. From his inscription
beneath a projecting balustrade, we learn that he carried out this
work in 1469.[2] Similar friezes of pomegranates and other fruits
are to be found on the town-hall front, where a grotesque profile
of a man, with a stick held to his lips, is shown sitting at
an opening. On the balcony above the figure are the ciphers
1476, and a long Latin inscription attributes the building of the
hall to a member of the Venetian family of Venier.[3] Beneath

[1] MS. Istoria di Catt. Cornaro, in Verci, *ub. sup.*, p. 23. [* Cf. Gerola, *loc.
cit.*, p. 880 *sq.*]

[2] The inscription runs thus: "1469 Desideriŭ Impiorŭ p̄ibit (peribit),
Darius p." The house is No. 829-849, Contrada Grande. [* It is now the
Palazzo Troyer, 20-21 Via Regina Margherita.]

[3] " Aula fuit turpi genio confecta ruinas sepe prius testata graves; Max
Gabriel omni virtutum splendore nitens, quem clara propago Veneris genuit,
sterni fundamine ab imo jussit et inde novam quam spectas summere formam."

the first-floor windows of a house in the high street bearing the date of 1499, a dog is the only pictorial adornment, but one reads in panelled apartments : "The son's good works are a father's joy," "Laus Deo, honor et gloria," "La suberbia regna neli poveri chativi."[1] A florid classic style, reminding us of Mantegna, is displayed in another house opposite that of Dario, where Roman medallions are surrounded with ornament of cornucopias and dolphins, and the larger spaces are filled with allegories of justice and of love. This is too modern for Dario, but is the continuation of his art[2] and the fruit of his example.

In Borgo della Madonna at Conegliano, a large edifice of three storeys is covered with Mantegnesque vases and tracery of divers colours. In the spandrils of the lower colonnade two knights before a judge, whose grim face peers out from a parapet ; a female playing a viol, and another partially effaced standing looking on in a characteristic attitude. Higher up beneath a window an ox holds a scroll on which is written : "Son lostaria del bo ; chi vol del pollo e vedello" ; elsewhere, an angel supporting a coat-of-arms, and in large letters "Darius." The art is that of Dario at Serravalle.[3] Other specimens are to be found close by in the Contrada Santa Caterina ;[4] in the Casa Biadene, where subjects and mottoes are commingled ;[5] in Borgo

[1] Serravalle, No. 833, Contrada Grande, dated : "MCCCCLXXXXVIIII. die IIII. mensis julii."

[2] Serravalle, opposite No. 749, Contrada Grande. The ornaments are mostly on a red ground.

[3] Conegliano, No. 323, Borgo della Madonna. Under the arches of the colonnade are remains of paintings, and chiefly of an Annunciation. Inside the house, too, cornices and festoons are painted in some of the rooms in the same style as the front.

[4] Conegliano, Casa Matiuzzi, No. 17. Here the wall is made to imitate a front with pillared recesses, the recesses being filled with helmets and shields or foliage, the pilasters with leaves and flowers, the friezes with medallion heads and vases, all in a rude sort of monochrome.

[5] Conegliano, Via del Teatro. Here are friezes with sports of children with wild beasts, vases, and cornucopia ; a female in a foreshortened attitude is represented as if supporting one of the balconies, and children are shown bearing the weight of long chimneys clinging to the walls. There are also figures on horseback, and a harbour with a galley. Beneath the latter one reads : "Io me sforzaro di navecar tanto achorto che al dispeto di nimis spero entrar in bon porto" ; and under another subject: "Lo homo solecito che il bon se prochaza sempre la fortuna con lui se abraza." In one of the rooms of this house are distempers, representing a female on an elephant, a

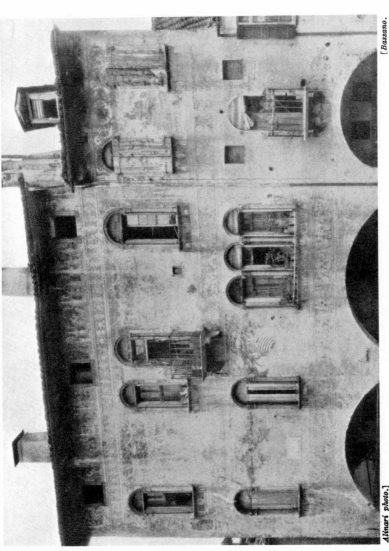

Alinari photo.]

[*Bassano.*

PAINTED HOUSE-FRONT.

II. 56]

Sant' Antonio,[1] and Strada Grande;[2] but here and in the Contrada del Duomo[3] a later hand and better taste are apparent, though all displaying the Paduan style brought by the Squarcionesques to Treviso.

From Conegliano we wander to Pordenone. We there find house-decoration as frequent as elsewhere, Mantegnesque in spirit, and above the level of Dario;[4] we revert to his rude and unattractive style in colossal figures on the main square and some private buildings of Bassano.[5] At Spilimberg the old palace of the Counts Manaco is covered with scenes derived from ancient fable and history; amongst the rest a Judgment of Paris, a Rape of Ganymede, and the Constancy of Scævola;[6] and on the face of the old castle, allegories of virtues which are not to be confounded with the fragments left by Pordenone.[7] Treviso itself furnishes the most modern specimens of house-decoration, giving proof of a deep study of the greater Mantegnesque

car drawn by sea-monsters, women on dolphins, etc., all in the character of Dario's art. There are also more modern decorations in other rooms.

[1] Conegliano, Borgo Sant'Antonio, No. 407. Here are rude monochromes on parti-coloured grounds of sacrifices, birds, and single figures, with friezes of leaves, fruit, and monsters.

[2] Conegliano, Strada Grande, No. 237. Dario's style is here improved, and the ornament better, but the figures are still rude and ill rendered. The whole consists of children riding on dragons, shields, lances, centaurs, all in monochrome in yellow and blue.

[3] Conegliano, Contrada del Duomo, No. 86. The ornament here is still better than in the foregoing example. The friezes represent weapons offensive and defensive, arabesques and cupids, and full-length figures.

[4] Pordenone, No. 419, Contrada San Marco, office of the old Imperial Government, is covered with eagles, and foliage, and shields. No. 28 in the same street is conspicuous for a chain ornament, festoons, masques, prepared in monochrome on a blue ground, the art Mantegnesque of 1500 and about equal to that of the latest at Conegliano. In the same manner and reminiscent of Girolamo da Treviso and Pennacchi, a fight of horsemen and figures, No. 95 in the Contrada di San Marco.

[5] Bassano, Piazza, close to the clock tower. Chain-ornament and figures, and two large warriors with swords, at the side of a window, like Dario's work in the Virgin of Mercy. House contiguous to the Porta Prato: Sacrifice of Abraham, Judgment of Paris, etc., in the style of followers of Dario.

[6] Spilimberg, Casa de' Conti Manaco. These wall-paintings are coloured and not monochrome, similar in art to those of Bassano.

[7] Spilimberg Castle. Winged lion, Fortitude, Temperance, and other subjects. Pordenone's is a warriors head, with a winged helmet in a round held by two children.

examples ; and in one house, at least, a clever attempt is made
to represent in correct perspective imitations of brackets and
cornices, openings, pedestals, statues of men and horses, and
arabesques interspersed with gambols of children, as they might
look if they were real and seen from the street.[1]

When the Trevisans at the close of the fifteenth century
attempted more serious painting, such as that of a St. Nicholas,
on the front of a house near San Niccolò,[2] they were very much
below the mark ; so much so, indeed, as to show that Tommaso
of Modena, who filled several churches with frescoes, was superior
to his successors, amongst whom Dario, Girolamo the elder of
Treviso, Pennacchi, and a sixth-rate named Antonello are to be
numbered. Of Pennacchi we shall not speak at present, as he
surrendered local art for that of the Bellinesques ; but Girolamo
the elder may arrest a moment's attention. Federici, in his
notices of Treviso, is at pains to adduce proofs that Girolamo was
the son of respectable parents, and the brother of Lodovico
Aviani, a poet ; but pedigree makes no painter, and Girolamo
was a very humble member of the profession. The earliest
reference that has been made to his works is one to the effect
that he finished an altarpiece and frescoes for a chapel in San
Niccolò of Treviso in 1470 ;[3] but his oldest known production is
that possessed by Signor Fabrizio Pieriboni at Lonigo, which
bears traces of the date 1478. It is a small arched panel
representing the Death of the Virgin, with a multitude of dry
figures of an ugly livid tint. Outlines of angular break, recti-
linear drapery with cross lines to indicate folds, and loud
contrasts of tertiary colours are its conspicuous defects.[4] More

[1] Treviso, No. 520, Contrada sotto portico Forabosco in Scorzeria.

[2] Treviso, front of No. 1050, Contrada Isola di Mezzo. Beneath the figure,
which is placed between two pillars, to which four angels cling, one reads :
" . . . dela scuola de Sancto Nicolaus a fate depenzere questa figura 1471,
adì 16 Marzo." There are pieces of the face and dress of the saint (who
holds a lily and book) scaled away. Federici, *Mem. Trevig.*, i. 216, assigns
this to Girolamo the elder of Treviso.

[3] Treviso, San Niccolò. The altarpiece represented the Virgin, Child,
SS. John the Baptist, Gregory, Anthony the Abbot, and James, and bore the
following inscription : " Hieronymus Tarvisio, p." (Federici, *Mem. Trevig.*, i.
215 *sq.*). Both altarpiece and frescoes are lost.

[4] Lonigo, Signor Fabrizio Pieriboni. Small arched panel in tempera with
figures about a foot high. The Virgin lies in her tomb surrounded by the
apostles; in the sky the Redeemer. Inscribed: " H Tarvisio pinsit

distinct evidence of Squarcionesque influence on Girolamo is afforded by a picture ordered in 1487 for one of the chapels in the Treviso cathedral by the Canon Pietro dalle Laste. His subject is the Virgin and Child enthroned in a portico, with St. Sebastian at the pillar on one side, St. Roch on the other, and two angels playing instruments.[1] The only praise to which Girolamo is entitled in reference to this creation is that of clever and appropriate arrangement. His architecture is in the shape and taste of Zoppo's, and of good proportion ; but the figures, though correct in size and in place, are wooden and rigid, and frequently out of drawing. They are of a coarse peasant grain, cutting in outline, hard and uniform in colour, and, worse still, unrelieved by transitions of any kind, reminding us occasionally of Ercole Roberti Grandi in the withered character of the limbs. The lights and shadows are both flat, and pitted sharply against each other. Quantitative balance of tones is preserved in dresses and accessories, but the contrasts are not the less violent.[2] At San Salvatore of Colalto in 1494 Girolamo again illustrates his skill in the distribution of space, and sets a Madonna with four saints in fit attitudes within a court, but he fails to over-

1" Federici, who saw the picture when it belonged to the Canon Carlo Adami of Treviso, gives the date as 1478 (*Mem.*, *ub. sup.*, i. 217). The colour is gone in many places, and what remains is discoloured. [* The editor has no clue to the present owner of this work. Perhaps of even earlier date is a little tempera painting on silk which many years ago was in the collection of Signor Giuseppe Piccinelli at Seriate, near Bergamo. It represents St. Jerome kneeling with open arms in front of a grotto; near by him are a crucifix and a lion. A *cartellino* in the lap of the saint bears the mutilated inscription : " Tarvissi . . . Mño 14 . . ."; on the back of the painting is written in characters of the fifteenth century : " Hieron. Tarvis 1475 (?) faciebat in (?) monasteri eremitani Padue." See the German edition of this work, v. 350.]

[1] Treviso, Duomo. Wood, figures life-size, inscribed on a cartello : " Hierony- mus Tarvisio pinsit, MCCCCLXXXVII." The St. Sebastian somewhat recalls Grandi ; the St. Roch is a common personage, nearly related to those with which we are regaled by Marco Marziale. The architecture is similar to that of Zoppo in the picture of Berlin, the tempera rough and uneven.

* [2] Probably slightly later than this work is a lunette representing the Transfiguration of Christ, now in the Venice Academy (No. 96); it originally adorned an altar in Santa Margherita at Treviso, erected in 1488. See Biscaro in *Atti dell' Ateneo di Treviso*, 1897, p. 263.—Federici (*ub. sup.*, i. 218) describes a Descent from the Cross, signed "Hieronymus Tarvisio pinxit MCCCCLXXXII," which was seen by him in the Royal Gallery at Turin. This painting is now untraceable.

come the principal defects of his style.[1] Here, however, his composition recalls that of the Vivarini; the outline being minute and careful, the flesh rosy and slightly shaded with olive-brown, and hardness or immobility less conspicuous than before. Striking is the oval head of the Madonna, with its regular division of features, small eyes, mouth, and rounded chin; striking the angular character of the drapery. It is here if anywhere that we trace the source of Catena's art.[2] Similar to this of Colalto, and perhaps more delicately handled, is the Virgin with Saints at San Vigilio of Montebelluna; fair in the same style is the St. Martin sharing his Cloak in the church of Paese near Treviso.[3] Better and suggestive of greater power, the Christ at the Column in Casa Rinaldi at Treviso.[4] In this quaint panel, to which the painter's name is not affixed, there is an echo of Antonello da Messina. The Saviour stands grim and threatening in his pain, with long hair rolled into curls, falling down the sides of his cheeks. His frame is lean and bony, and drawn with decisive angularity; his face is coarse and vulgar, but there is a wild expressiveness in the look and glance that testify to a rugged sort of strength.[5]

[1] Colalto, San Salvatore, near Conegliano. Wood, tempera, figures three-quarters the size of life. Virgin and Child between SS. Francis, Basil, Nicholas, and Anthony of Padua. On a cartello at the step of the throne: "Hieronimus Tarvisio, p. MCCCCLXXXXIIII." The panel is much damaged and scaled, and in part discoloured, and strong varnishes are gradually cracking up the whole surface.

* [2] We have seen previously (i. 254, n. 1) that Catena is not identical with Vincenzo da Treviso. It is to the latter artist that this remark of the authors' refers.

[3] Montebelluna, church of San Vigilio. Panel, tempera with figures as above. Virgin, Child, SS. Vigilius, Anthony the Abbot, Chiara, and Lucy; inscribed: "Hieronymus Tarvisio, p." This also is a greatly injured piece. [* It is now in the cathedral of Treviso.] Paese, parish church. Arched panel, with a view of San Niccolò of Treviso in the distance; inscribed: ". . . onymus . arvisio p." The figures are large as life, the whole scaled and retouched.

[4] Treviso, Casa Rinaldi. Wood, bust, behind a parapet, on which a cartello without a signature is fastened; blue ground. The colour is no longer pure tempera, but mixed in the new method and enamelled; the lights yellow, and the shadow, such as it is, grey. [* The present whereabouts of this picture is unknown.]

[5] The catalogue in the text may be extended as follows: (1) Lovere, on the lake of Iseo, gallery of Conte Tadini. Virgin with the dead Christ on her lap; an ugly and injured panel of small size, inscribed: "Hieronymus Tarvisio pinsit." (2) Turin, Signor Orlandi. Here formerly was a Christ supported in the sepulchre by two angels; small, with the painter's signature, and well preserved. [* This

Squarcionesque art thus extends, as we perceive, to a considerable distance in the direction of the Alps, differing essentially from that of the Friulans, and producing works less able than those of contemporaries of the same school at Verona, Vicenza, and Ferrara.

Whilst Dario carried the influence of Squarcione to the North, a man of no greater merit than himself contributed to prolong it in Padua. This man was Parentino, whose earliest creation is a religious allegory in the Museum of Modena, and whose latest wall-paintings were left unfinished in 1494, in the second cloister of Santa Giustina at Padua. The allegory bears Parentino's signature and the Christian name of Bernardino,[1] and represents the Saviour carrying his cross, St. Jerome penitent before the crucifix, and a kneeling bishop in a landscape. Dario, feeble picture now belongs to the Brera Gallery at Milan (No. 154); it is signed "Hieronimus Tarvisio p."] (3) Treviso, fragment of a fresco, transferred from Santa Caterina to the church of Sant' Agostino; subject, a saint (? Sebastian) and two angels in flight. This is all that remains of an altarpiece which, according to Federici, represented St. Sebastian, a patron, the podestà, Pietro Tron, and a Servite friar (*Mem., ub. sup.*, i. 216). The inscription on the piece described by Federici was as follows: "Hæc Palla facta fuit per scolam S. Sebastiani de Eleemosinis plurium Personarum Anno MCCCCXCII. Hieronymus Tarvisio P." [* To these pictures may be added: (4) Dessau, Old Ducal Palace. The Virgin and Child, signed "Hieronimus Tarvisio p." (5) Hamburg, Weber Collection, No. 27. The Virgin adoring the Child, signed "Hieronymus Tarvisio p." In this painting Girolamo shows himself influenced by the Vivarini.]—Girolamo probably painted house-fronts in Dario's fashion. As such we may notice: (1) Treviso, Pescaria Vecchia. House-front with gambols of children and two horses on brackets, one of the latter not unlike that in Girolamo's St. Martin dividing his Cloak at Paese. (2) Piazza del Duomo, No. 1548. Trophies in fresco; but here the ornament is Mantegnesque, and in better taste than that of Girolamo. [* The frescoes on this house-front are the work of Giovanni Matteo of Treviso; they were finished in 1504. See Biscaro, "Note e documenti per servire alla storia delle arti trivigiane," from *Coltura e Lavoro*, 1897, pp. 31 *sq.*]

[1] He is called Lorenzo Parentino in Anonimo, but the elegiac in his praise by Don Rafaello of Piacenza (Armeniados, 8vo, 1518, Cremona in Anonimo, p. 255) calls him Bernardo; and as this elegy was written by a Benedictine, and probably at the close of Parentino's life, we may assume that "Lorenzo" in the Anonimo is a lapsus calami (see Anonimo, p. 11). But as the Anonimo also says that Parentino entered the Benedictine order, it has been supposed that he assumed the name of Lorenzo on taking the frock (see Morelli's notes to Anonimo, p. 110). [* The former supposition seems to be the correct one. The Anonimo really states that Parentino entered the order of St. Augustine; and this makes us feel fairly safe in identifying Bernardino Parentino the painter with the Augustinian friar of the same name who died on October 28, 1531, at the age of ninety-four, and who was buried in the oratory of San Niccolò di Tolentino at Vicenza. See the epitaph in Faccioli, *Museum Lapidarium Vicentinum*, i. 147, No. 148.]

draughtsman as he was, might have jested at the drawing of this piece, which combines the faults of the Byzantines with an imitation of the classic. We may look in vain for specimens of a similar kind by one taught to feel the beauties and appropriate character of movement in classic statues. One should think that a painter conscious of these beauties would transfer them to his canvas; but Bernardino has the wish and none of the skill to attain this object. His figures are an exhibition of skin and bone, false in anatomy, unnatural in action, raw and flat in tempera ; his draperies are tortuous and crushed into the most minute and meaningless folds ; and the only details he succeeds in giving are those of rock and hill in distance and of reptiles on a foreground.[1] A slight improvement on this unpleasant style may be seen in three scenes from the life of St. Anthony the Abbot at the Doria Palace in Rome, a series which reveals the influence of Mantegna, and is for that cause assigned to him,[2] but greatly beneath the powers of that master. In similar pieces belonging to the collection of the Marchese Pianciatichi at Florence,[3] a new feature introduced into subjects of a sportive

[1] Modena Gallery, No. 467. Canvas, tempera, m. 1·12 high by m. 1·52, originally in the country-seat of Cataio. On the cartello are the words : " Bernardin Parençan pisit."

[2] Rome, Doria Palace, private apartments. Small panel: St. Anthony receives Offers of Wealth. He stands in a hilly landscape enlivened with incidents, between three quaintly dressed personages, one of whom offers a plateful of gold, the others tempting him with wands of office. Picture Gallery, No. 140: St. Anthony's Dream. He is tempted by devils, and lies extended on the foreground of a cavern ; small panel. Private apartments : the Youthful St. Anthony distributing Alms ; wood. These are three panels forming part of one predella, the last-named comprising a figure (to the left behind St. Anthony) extremely like the portrait of Mantegna, and bearing the letter A on its cap. Hence no doubt the name of Mantegna given to the picture. The style, however, is that of Parentino at Modena slightly improved. The figures are vulgar, ill-proportioned, and very ill-drawn, but in a more Mantegnesque spirit than at Modena; the action is some-times well intended, and foreshortenings are attempted. Very rich details are given in the landscape, and classic models are followed in depicting vases and ornament ; there is even a copy of an antique relief of a fight in the Almsgiving of St. Anthony. The tempera is dull and of a brownish grey. The figures are all about one-fourth of life-size.

[3] Florence, Galleria Pianciatichi, No. 333. Canvas, tempera, on a red priming. To the right a man blows a horn ; children play instruments and dance in the middle distance, and in front of them a man reclines and sports with a monkey. No. 334, a male and female seated on rude plinths play instruments ; a square fountain to the left is decorated with a bas-relief. We note the same skinny

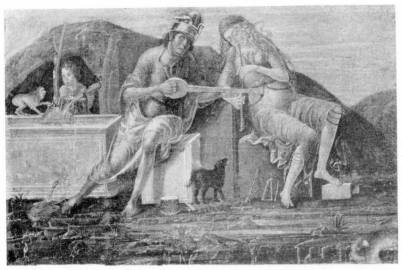

CONCERT.

[Berlin, Kaiser Friedrich Museum.

CONCERT.

[Berlin, Kaiser Friedrich Museum.

and every-day character is that of an arabesque frieze with
figures of females and skulls of oxen in good classical taste,
showing that Parentino, as he advanced in years, might have
been the competitor of Dario in a rude sort of art chiefly applied
to the decoration of houses. That this was his peculiarity we
might infer from the glowing description given by Father Della
Valle of the scenes from the life of St. Benedict in the cloister
of Santa Giustina at Padua, a series partly executed by Parentino
and partly by Girolamo del Santo, of which a few fragments are
still preserved in a passage leading from the monastery to the
church of that name. Della Valle, following the example of a
Benedictine, who calls Parentino, in the usual poetic strain,
Parrhasius, Zeuxis, and Apelles, launches out into fulsome
eulogies of this work, in which we may admit some slight
improvement upon the earlier pieces we have described;[1] but

and bony figures here as at Modena, and the same dull tempera. The forms are
also incorrect and coarse as before. These canvases are under Squarcione's name ;
they illustrate the effort of a feeble hand to imitate the antique, to set forth
animated and not ill-conceived groups ; the artist, however, tries for more than
he can carry out. [* These pictures are now in the Kaiser Friedrich Museum at
Berlin (Nos. 1628 and 1628A).]

The spirit which we discern in the pictures of the Doria and Pianciatichi
collections might lead us to assign to Parentino an engraving now in Casa Lazzara
at Padua, in which some have seen the hand of Squarcione. It represents a man
to the right blowing a horn, another to the left doing the same, dancers, and a
female with a leg of pork and sausages in each hand. This genre subject takes
a classic air from the ornaments of an antique tomb, on which the player to the
right is seated. (See Zani, *Materiali per servire alla storia dell' origine e de'
progressi dell' Incisione*, 8vo, Parma, 1802, pp. 59 *sqq.*) [* Passavant describes
this engraving in *Le peintre-graveur*, v. 117, No. 86; it is signed " $\frac{\cdot B}{SE}$." The
editor does not see in it any particular resemblance to the style of Parentino, who
moreover is not known to have practised engraving. There are impressions of the
engraving under notice in the Uffizi at Florence, in the Bibliothèque Nationale at
Paris, and in the Museo Civico of Padua (the last-mentioned impression being
probably identical with the one mentioned by the authors). Yet another im-
pression appeared at a sale at Gutekunst's in 1907, and is reproduced in the sale
catalogue (No. 683); the subject is here interpreted as a satire on the Jews.]

[1] Padua, Santa Giustina. These frescoes were minutely described in 1609 by
Girolamo da Potenza, a monk of Santa Giustina, and subsequently by Brandolese
(*Pitt. di Pad.*, p. 99) and Della Valle (*Delle Pitture del Chiostro Mag. di Santa
Giustina*, without imprint), both writers using the MS. of Girolamo da Potenza.
The southern wall of the cloister and one compartment adjacent were painted by
Parentino with scenes from the life of St. Benedict, one of them bearing the
date of 1489, another that of 1494, and the pilaster at the side of the last space
(Death of St. Benedict) the name "Opus Parentini." The ornaments of the

what he says of the ornament surrounding the subjects, and what
we see of that ornament as engraved by Mengardi, justifies the
belief that Parentino was little more than a decorator,[1] and one
whom we may believe incapable of painting the panels assigned
to him in the sacristy of the canons of Padua,[2] in the Academy
of Venice,[3] and in the Museum of Berlin.[4]

pilasters and framings interspersed with heads of Benedictine popes have been
engraved, and exhibit taste in selection, but Morelli (Anonimo, p. 111) warns us not
to trust to these as exactly corresponding to the originals. In 1542, 4, 6, the
cloister was finished by Girolamo del Santo, and the fragments which remain are
no doubt remnants of his and Parentino's work. These fragments represent
chiefly heads of men and women, but also small parts of figures of men, birds,
and animals, some of them like Parentino's work at Modena, outlined in his
tortuous manner and incorrectly drawn; others more Mantegnesque, and such as
Girolamo del Santo might have done ; others again, though still of the vulgar
type common to the Paduan, attributable to a cleverer painter, not below Jacopo
Montagnana in power. Amongst these ruins we also see parts of a Crucifixion
which may have been that painted by Agnolo Zoto in 1489 (Moschini, *Guida di
Padova, ub. sup.*, p. 134), though we still see a Crucifixion in the old refectory
which fully justifies (in grimace, coarse vulgarity, and defective art) the opinion of
the Anonimo (p. 48) that Zoto, if he be the painter of it, was an "ignobile
pittore." [* Parentino's frescoes in the second cloister of Santa Giustina were
in 1895 rescued from the whitewash with which they were covered in great part
in the beginning of the nineteenth century. A specimen of them in their present
state is reproduced in Caprin, *L'Istria nobilissima*, ii. 99.]

 * [1] In addition to those mentioned above, we may note the following paintings
by Parentino : (1) Budapest, Picture Gallery, No. 105, Pietà. (2) Fiesole, Villa
Doccia, collection of Mr. H. W. Cannon, No. 23, Battle of Amazons. (3)
London, Collection of H.M. the King, St. Sebastian. (4) Milan, Galleria
Borromeo, No. 13, The Betrayal of Christ ; No. 56, Battle of Amazons. (5) Padua,
Museo Civico, No. 424, The Expedition of the Argonauts (cf. *postea*, p. 246, n. 3).
(6) Paris, Louvre, No. 1678, The Adoration of the Magi. (7) Venice, Academy,
No. 606, St. Gabriel ; No. 608, The Virgin Annunciate. Formerly in the convent
of Santa Maria at Monte Ortone, near Padua. (8) Verona, Museo Civico, No. 331,
The Conversion of St. Paul (cf. *postea*, p. 120, n. 1). (9) Vicenza, Museo Civico,
No. 248, The Announcement to the Shepherds ; No. 249, The Procession of the
Magi. On the whole, Parentino appears as a not uninteresting eclectic, imitating
alternately Mantegna, Ercole Roberti, and Giovanni Bellini.

 [2] Padua, sacristy of the canons. Pietà. Tempera, on panel, 7 ft. 4 in. long by
2 ft. 8 in. high. The Saviour lies at full length in his winding-sheet, which is raised
at the head by the Evangelist. The Virgin wails over the body, and the Magdalen
wrings her hands at the foot. The scene is laid in front of the sepulchre of
white marble. This is a dull distemper, with grey high surface shadows,
Mantegnesque in character, and in the style of Andrea da Murano and Lazzaro
Bastiani, *e.g.* in the upper part of the altarpiece at Trebaseleghe and the Pietà
at Cittadella.

 [3] Venice Academy, No. 100, Nativity, for which see *passim*, Lazzaro Bastiani.
 [4] Berlin Museum, No. 48. See *antea* in Mansueti.

A Paduan whom Vasari classed amongst the disciples of
Giovanni Bellini is Jacopo da Montagnana, a Mantegnesque
painter, altered to some extent during the expansion of his style
by the study of Bellini and Carpaccio. He was born before
1450, and enrolled amongst the members of the Paduan guild in
1469.[1] His frescoes in the town-hall of Cividale[2] are mentioned
by historians with the same respect as those which he finished
during 1476, in competition with his brother-in-law Calzetta,
Matteo del Pozzo, and Agnolo Zoto, in the Gattamellata chapel
at the Santo of Padua.[3] The mutilated remains of ornament
in the niches of the monument sacred to the memory of that
chief and his son, if proved to be his, would entitle him to a
certain rank amongst the better class of Mantegnesques. His
constant employment at the Santo in later years, the designs
which he furnished for certain candelabra,[4] the wall-paintings
entrusted to him in the whitewashed cloisters of the novitiate
in 1487,[5] are evidence of the esteem in which he was held.
Engravings of classic subjects with which he covered the town-
hall of Belluno in 1490, and fragments which were saved from

[1] Vasari, iii. 170, and Moschini, *Vicende*, p. 65. We describe him as born before
1450, on the supposition that he was twenty when he entered the guild.

[*] Jacopo dei Parisati da Montagnana seems to have been born in 1440–43. In
1458 he became a pupil of the painter Francesco dei Bazalieri at Padua. See
Lazzarini and Moschetti, *loc. cit.* xv. 186 *sq.*, xvi. 95 *sq.*

[2] These frescoes no longer exist; with reference to them is the following :
"1475. Era podestà in Cividale, Lorenzo Veniero . . . al qual tempo fu dato
principio alla fabrica del palazzo del commune sopra la piazza maggiore . . . che
fu poi con bellissime pitture ornato, tra le quali viene con molta admiratione
risguardato un Cadavero del gigante Golia senza il capo. Fu opera del Mon-
tagnana, pittore famosissimo che depinse ancora la stantia dove se riduce il
maggior Consiglio di Cividale." (*Historia di Belluno di Giorgio Piloni*, Venice,
1607, lib. vi. p. 245.) We thus correct an error of Miari, *Dizionario Bellunese*,
4to, Belluno, 1843, p. 54, who confounds the hall at Belluno with that of Cividale.
[* The authors presume that the town mentioned by Piloni is Cividale del
Friuli. Cividale is, however, also another name for Belluno ; and there can be
no doubt that Piloni's words do refer to the town-hall at Belluno.]

[3] Anonimo, p. 5 ; Gonzati, *La Basilica, ub. sup.*, i. 59, and doc. xxxvii. [* Cf.
Lazzarini and Moschetti, *loc. cit.*, xv. 175 *sqq.*, xvi. 82 *sqq.*] The monochromes
here and the arms of Gattamellata are classical, in the Mantegnesque style, and
recall the detail of Andrea's triumphs at Hampton Court ; the rest of the chapel
is whitewashed. See also Scardeone, *Antiq. Patav.*, p. 373.

[4] Gonzati, *ub. sup.*, i. 66.

[5] *Ibid.*, i. 295–6, and doc. cxlii. A Marriage of St. Catherine still in this
cloister may possibly have been by Lorenzo Canozzi or Filippo da Verona.

the ruins of it some seventy years ago, create the impression that he was one of the second-rates, who most faithfully preserved the traditions of Mantegna in his early haunt of Padua. We find it difficult to understand why the town-council of Belluno consented to the destruction of frescoes valuable as works of art, and interesting in the highest degree as authentic productions of a rare though well-known master. As examples of a peculiar taste they were almost unique ; they might lack many qualities of selection, of form, of drawing, and of colour, for they were due to men who had many superiors in other schools, but they were very fairly composed and powerfully conceived, and they gave copious illustrations of the manner in which the influence of Mantegna and that of the Venetians became commingled at the close of the fifteenth century. All that we can guess from the fragments preserved at Belluno and Padua is that the outlines were rough, wiry, and coarse, as compared with those of the great Paduan, that the flesh was metallic in tone, and that it was painted with liquid tints in a resolute and hasty method.[1] We might easily be led by

[1] Belluno town-hall. Of this hall, rebuilt seventy or eighty years ago on a modern scale, we are told by Piloni (*ub. sup.*, lib. v. p. 200) that it was first erected in 1409. In a calendar of records preserved in the Municipio of Belluno (*Dizionario di Francesco Alpago*, 30 8bre 1773, p. 210) we read : "No. 10, 1490, 12 Nov. nel libro delle Provigioni Let. L. (The book itself is missing.) Pitture sopra la facciata del Palazzo Vecchio e nella Comunità (Hall of Council) di Giacomo da Montagnana. Costorono Duc. 280 d'oro . . ." [* Cf. Lazzarini and Moschetti, *loc. cit.*, xvi. 98.]

Miari [Florio], *Dizionario*, etc., *Bellunese, ub. sup.*, pp. 53–4, gives an exact account of the town-house, the ground-floor of which was divided into two principal spaces : the fore-hall decorated with paintings, which still exist, by Pomponio Amalteo (1529) ; the council-hall with pictures by Jacopo da Montagnana. The wooden ceiling was framed with a cornice containing the cognizance of several Bellunese families, and chiefly those of Girolamo da Mula, podestà in 1490. On the wall opposite the chimney was a fresco of the Saviour erect in benediction between the Virgin and Evangelist, assigned to Mantegna (and engraved as such), but by Montagnana, if we judge of it by the engraving. (Is it necessary to say that Mantegna was not at Belluno in 1490 ?) [* This painting is now in the Museo Civico of Belluno. Kristeller, *Andrea Mantegna*, p. 455.] On the chimney was an inscription : "Non hic Parrasio non hic tribuendus Apelli, hos licet auctores dignus habere labor. Euganeus vix dum impleto ter mense Jacobus ex Montagnana nobile pinxit opus." In half-lengths between the windows were figures of Zeno, Hesiod, Atlas, Pythagoras, Cicero, and the prophetess Nicostrata. On the walls were five scenes from Roman history, illustrating the story of the Horatii and Curiatii. 1°, the fight ;

JACOPO DA MONTAGNANA

MUTIUS SCÆVOLA BEFORE PORSENNA.

From an engraving by M. Toller, reproducing a fresco formerly in the Hall of Council at Belluno.

[Il. 66]

comparison to assign to the same hand the Madonna Crowned
by Angels in the Communal Gallery at Bassano, a fresco once
in the Pretorio of that town. That such a work should have
been attributed to Mantegna is natural when we look at the
form and architectural decoration of the composition; but spirit-
less outline, stolid types, and rough treatment too surely mark
the handiwork of a later Paduan, and we may consider them
due to Montagnana with the more propriety as we possess
numerous authentic paintings in a similar manner at Padua.[1]
In the hall leading to the Curia-Vescovile, in the episcopal
palace, a dull and much repainted fresco of the Resurrection
of Christ, above a door, is doubtless by Montagnana, as well
as the heads of emperors and captains on the beams of the
hall ceiling,[2] and the old chapel in the same building is covered
throughout with legendary and scriptural subjects, certified by

2°, the triumphal return; the deeds of Mutius Scævola : 1°, he kills the secretary
of Porsenna ; 2°, he burns his hand in the fire ; 3°, subject obscure,—each incident
copiously illustrated with classical detail of architecture and costume. Nineteen
small fragments of this important work are preserved, viz. four containing heads
from the triumph of Horatius, and the profile of Cicero, in the hands of Signor
Bucchi at Belluno; ten in possession of Conte Agostino Agosti of Belluno, in
part from the triumph, e.g. the bust of two children on the extreme right of that
composition, in part from the frescoes of Scævola ; five belonging to Professor
Catullo at Padua. [* Some of the fragments seen by the authors in the Agosti
collection are now in the Museo Civico of Belluno. See Fogolari, in *Bollettino
d'arte*, iv. 287 *sq.*] Lanzi (ii. 113) speaks with due commendation of these frescoes ;
and the commentators of Vasari (iii. 170) err, as we see, in blaming him for
confounding works of Amalteo with those of Montagnana, being unaware that
the latter are lost and the former preserved.

[1] Bassano, Communal Gallery. Fresco transferred to canvas, with life-
size figures of the Virgin and Child on a throne of porphyry in a painted
recess of florid classic architecture. An angel at her feet plays a violin ; two
others hold the crown above her head ; in a lunette the Eternal, half-length, in
benediction. A chain ornament and festoons behind the principal group remind
us of similar accessories in the palace of Mantua. The left side of the picture
is wanting. Especially Mantegnesque are the angels, so much so as to suggest
not only Montagnana but Bonsignori. It may be that the fresco was executed
by Montagnana from a cartoon of Mantegna. Note the mechanical outline of a
coarse black sharpness, the bricky flesh, and dark shadows.

[2] Padua, Palazzo Vescovile. At the corners are two soldiers guarding the
sepulchre and looking up. This fresco is repainted and of a dull red tinge.
That Montagnana is the painter is proved by the style, but also by Scardeone,
who says (*Antiq. Patav.*, p. 373): "Pinxit Christi resurrectionem super portam
in prima aula episcopatus." The heads on the vertical faces of the beams of
the ceiling are monochromes on blue ground.

Montagnana's own signature to have been executed in 1495. Looking at the more conspicuous parts of this complicated decoration, such as a St. John the Baptist, a Christ in benediction, a Crucifixion, and half-lengths above the door, we shall be struck by the square forms, the coarse aspect, and bold spirit of the figures, and we see the germs of a vehement art like that of Bartolommeo Montagna.[1] We may be less certain as to the authorship of the Annunciation in the new episcopal chapel, an altarpiece of pleasant Paduan shape, reminiscent of Lippi's earlier style rather than of that peculiar to Montagnana.[2] It may be difficult also to trace his hand in the Bellinesque Crucifixion on one of the pilasters at the Santo, which indeed is said to have been finished in 1518 by Girolamo del Santo,[3] but we may find character akin to his in the portraits of bishops forming the upper frieze of the great hall in the epis-

[1] Padua, ex-episcopal chapel in the Episcopal Palace. This is a rectangle, with scenes from the lives of the martyrs in the lower courses, figures of apostles in second courses, and monochromes in five lunettes indistinct from age and other causes. In the ceilings are the symbols of the four Evangelists and the four Doctors. On a painted pilaster is a retouched inscription as follows: "Jacobus Montna pinxit MIIIIXCV." All these wall-paintings are more or less altered by time and repainting. The best subject is that of the flaying of a martyr, a spirited composition with the vehemence of Signorelli in its chief figures. The principal personages are about life-size.

[2] Padua, Episcopal Palace, chapel. The Annunciation between the Angel and Tobias, and the archangel Michael holding a balance. The scene of the annunciation is laid in a street, the Eternal in benediction (repainted) appearing in the sky in an embossed halo. The figures are a third of life, the Virgin's mantle and that of the archangel, in part renewed. This seems the careful production of a young man, the composition pretty, and the tempera very careful. The only Paduan feature is the colour; the style is not that of Montagnana, as we see it in the old chapel.

[3] This Crucifixion is on canvas, and assigned by all guides to Montagnana, but it is stated, on what authority is not said, that it was finished by Girolamo del Santo in 1518 (Isnenghi [Padre Antonio], *Basilica di Sant' Antonio*, 12mo, 1863, p. 61). We see no trace of two hands here, and if Girolamo finished, he also began the work. [* Contemporary records prove that Girolamo del Santo in 1518 was commissioned to finish this picture, which seems to have been begun about 1511 by another artist, and which had not been completed owing to the death of the former owner of the altar. See Baldoria, in *Archivio storico dell' arte*, ser. i. vol. iv. pp. 57 *sqq.*] The Saviour is crucified on a tree from the branches of which sprout the heads of the twelve minor prophets. Below are SS. Sebastian, Gregory, Ursula, and Buonaventura. The Christ is well proportioned and Bellinesque, the St. Sebastian likewise so, and the figures generally slender; the art displayed is not that of Montagnana.

copal palace at Padua.[1] These bishops are all accompanied by
canons, and stand or sit in couples conversing or in thought.
They seem to have been drawn with great care from nature ;
what they want in historical value as likenesses is compensated
by their importance as illustrations of Paduan painting at the
close of the fifteenth century. The perspective is judiciously
calculated in each piece to suit its altitude ; the movements
are natural and various, and the drapery well and simply cast.
A marked superiority in treatment distinguishes this work from
that of Belluno ; for though, in faces and in form, the coarse-
ness and realism of Montagnana are occasionally apparent, the
cloths have a novel lie of fold and strong harmony of tones ;
and the outlines exhibit power akin to that of Bartolommeo
Montagna ; and it is but fair to presume that this and other
productions of the same kind were carried out chiefly by the
Vicentine, whom we shall learn to know as a master combining
the vehemence of Signorelli and Carpaccio with the sterner
character of the Veronese.[2] We shall be the more disposed
to maintain this opinion as the frescoes, representing the Eternal
and Apostles, scenes from the creation, the nativity, and the
finding of the Madonna of Mont' Ortone, in the church of that
name near Padua, are traditionally of a later date than those
of the episcopal hall, and executed by Montagnana in 1497,
in the ruder and more common manner already noticed in
earlier and equally genuine pieces.[3] We might now describe

[1] Padua, Episcopal Palace, great hall. These portraits fill the four sides of
the hall, the last of them having been done in 1494 (Moschini, *Vic.*, *ub. sup.*,
p. 65). The whole of those on the wall facing the chief entrance are completely
repainted, and those above the door itself partly so. Many bits in the rest are
also new. Each bishop is accompanied by a canon. The lower walls and ceiling
are modern, having been renewed under Clement XIII. in 1759.

[2] We shall see (in Montagna) that there is a fresco at Praglia, very like the
portraits at the Episcopal Palace in its style and treatment.

There is also a house-front, No. 385-6, Via San Francesco, at Padua, with
allegorical figures of the seasons in monochrome, and friezes containing children
and monsters much in this manner likewise, yet ruder, and perhaps by Jacopo.

[3] Santa Maria di Mont' Ortone near Padua. Choir: in the semidome
eighteen monochrome rounds representing nine saints, greatly injured, and nine
scenes from the creation. In the semidome front the Eternal in a glory of
cherubs, and the twelve apostles beneath him. In the ceiling of the choir the
four Doctors of the Church ; and in the two side-lunettes, 1°, the Discovery of the

a considerable number of productions on wall or on panel, exhibiting some of the features of Montagnana's style, or that of his school; but their enumeration may be left to the compass of a note, and we shall be content to know that Montagnana made his will in 1499, and is not supposed to have long survived.[1]

Miraculous Picture of St. Mary of Mont' Ortone, and 2°, the Nativity of the Virgin. These frescoes, duly noted in the Anonimo (pp. 31-2), who leaves the painter's name in blank, are mentioned by Scardeone (*Antiq. Patav.*, p. 373), who assigns them without any reticence to Montagnana. They are defective in form and disagreeable in colour, and seem to have been hastily done; but we must remember that their present appearance may be due to their having been recovered from whitewash. In the choir the miraculous image, which is the subject of one of the frescoes, was preserved, covered by two side-panels, signed, according to Moschini (*Vicende*, p. 66), with the date of 1497. We may inquire whether Vasari intended to allude to this piece when he wrote that Bartolommeo Montagna painted an altarpiece in the church of Santa Maria d' Artone at Padua (Vasari, iii. 649 *sq.*). [* In the first edition of the *Lives* (vol. i. part ii. p. 453) he ascribes the same work to Jacopo da Montagnana.]

[1] (1) Padua, Communal Gallery, No. 9, rude tempera of SS. Agata, Francis, and Jerome, of the same art as a Nativity in the same collection; and a Virgin and Child amidst four saints from the convent of Salbono, now in possession of Signor Giacomo Moschini at Padua. In these three pieces we see the decline of Montagnana's art, vulgar faces and forms, short and thick-set frames, and in each case damaged surfaces of tempera, due in part to time, in part to restoring. (2) Padua, Casa Lazzara. Four small panels representing scenes from the story of St. James, much damaged, but recalling at a distance Mantegna and Carpaccio. [* These paintings, as well as that which formerly belonged to Signor Moschini, can no longer be traced.] (3) Casa Papafava. St. Peter in Benediction, attributed to Squarcione, see *passim* ; a figure commingling the style of Montagnana and Bart. Montagna, of good chiaroscuro and firmly touched (wood, tempera, 1½ ft. by 2 ft.). Through the opening behind the saint a neat landscape reminiscent of Antonello and the Bellini. At the saint's feet a kneeling patron and his dog. (4) In the same style as the foregoing, two small saints, Paul and Peter in niches, attributed to Mantegna, in possession of the Earl of Wemyss, Gosford House, Longniddry. (5) Prato della Valle, Padua, house, No. 2692. Annunciation, a mere relic in fresco, suggesting the name of Montagnana, less than that of Canozzi ; if to the latter we could give the Granting of the Rules to St. Francis in the great cloister at the Santo. (6) Padua, side-portal of the Servi. Lunette of the Virgin and Child between SS. Jerome and Anthony of Padua and angels. This is a better fresco than those of Mont' Ortone, and perhaps one of the earlier ones of Montagnana. A large piece of it is wanting. (7) Padua, house-front, No. 3195, Via del Santo. Monochrome of a winged statue and a monster on a bracket, a wallpainting of the period under notice more artistic than Dario, and Mantegnesque in aspect. (8) Padua, Casa Dondi-Orologio [* now London, collection of Mr. J. P. Heseltine]. Copy of a fresco of the Martyrdom of St. Sebastian, once in the Scuola dei SS. Marco e Sebastiano, attributed to Mantegna, but seemingly an exaggera-

If it were desirable further to extend the notice of the Squarcionesques and Mantegnesques at Padua, we might also dwell upon the lives of Matteo del Pozzo,[1] Agnolo Zoto,[2] and Pietro Calzetta,[3] but it is better to deal lightly with these

tion of the style of Montagna. Remnants of the frescoes themselves are in the Communal Gallery of Padua, Nos. 403 and 404, a single figure tying his shoe, St. Mark, St. Peter Martyr and three kneeling personages, transferred to canvas; part of a half-length, too, of rude workmanship, belonging to Signor Gradenigo at Padua, and a bust head, now belonging to Dr. Tescari at Castelfranco: all these pieces are by one hand, and show the decline of Mantegna's art in the hands of Montagnana and his followers. [* The two last-mentioned fragments are now untraceable; yet another representing a soldier is in the Museo Archeologico of Padua. These frescoes are said to have been executed in 1481, and were destroyed in 1819. Before they perished they were copied by Signor Luigi Pizzi; his copies are now in the Museo Civico of Padua. See De Toni in *Bollettino del Museo Civico di Padova*, i. 56–60, 70–72.] (9) Padua, Servi sacristy. Virgin of Mercy between SS. James, Christopher, a monk, and Jerome; half-ruined and effaced. This is a flat tempera of mixed Venetian and Paduan style, recalling chiefly the Vivarini's school. (10) A still ruder specimen is the Virgin and Child between SS. Sebastian and Prosdocimo in the sacristy of Ognissanti at Padua, a very ill-preserved bit and without character. (11) Venice Academy. No. 617. Virgin and Child between SS. Prosdocimo, Lawrence, Stephen, and Liberale, from the suppressed convent of Santo Stefano of Padua. Here again is a Mantegnesque picture, recalling Liberale of Verona and the Canozzi, but too injured to allow of a decided opinion. (12) Padua, Santo, tenth pilaster in the left aisle. Virgin adoring the Infant, between a female saint, recommending a kneeling friar, and St. Joseph; life-size, injured and greatly repainted, dated 1494. The style seems a mixture of the Venetian of B. Vivarini and Mantegna.

[1] Pupil of Squarcione, according to Scardeone (*Antiq. Pat.*, p. 371). He was in the Paduan guild in 1470 (Moschini, *Vicende*, p. 25), worked in the cappella Gattamellata at the Santo in 1469, 1470, and 1471, died in 1471, author of a St. Francis in one of the pilasters of the Santo (Anon., p. 7). Not one of his works is known. See Gonzati, *La Basilica*, doc. xxxv.–xxxvii. [* Matteo del Pozzo of Venice began to study under Squarcione in 1447, when seventeen years old. The paintings in the Gattamellata chapel were not commenced until 1470. Lazzarini and Moschetti, *loc. cit.*, xv. 108, 175 *sqq.*, 272 *sq.*, 294 *sq.*, xvi. 82 *sqq.*]

[2] Agnolo Zoto is registered in the guild of Padua in 1469 (Moschini, *Vicende*, p. 25), and is recorded as one of those who painted in the Gattamellata chapel at the Santo in 1472 (Gonzati, *La Basilica*, i. 58 and doc. xxxvii.); he painted a St. Paul on a pilaster of the same chapel (Anon., p. 8), and some of the seasons and zodiacal signs in the Salone (Scardeone, *ub. sup.*, pp. 201 *sq.*; Gonzati, *ub. sup.*, i. 58). [* Cf. Lazzarini and Moschetti, *loc. cit.*, xv. 178 *sq.*; xvi. 85, 88.]

[3] Calzetta (Pietro) was brother-in-law to Montagnana (Anon., p. 7), and contracted as early as 1466, in presence of Squarcione, to paint the chapel of Corpus Christi at the Santo, and an altarpiece from a drawing made by Pizzolo from a sketch by Squarcione. (Contract in Moschini, *Vicende*, p. 66, n. 1.) [* A copy of this drawing is appended to the document in question and is reproduced by De Kunert in *L'Arte*, ix. 53.] In 1470 he restores certain works by Stefano of

distant and feeble offshoots of the Paduan school, and to close
the notice of it with a few words on the merits of the Canozzi.

The Canozzi[1] were not Paduans. Lorenzo, the elder, was
born in 1425; Cristoforo, the younger, a little later, at
Lendinara.[2] Their father was a carpenter, and they naturally
followed the paternal trade ; but being men of considerable
enterprise they established themselves at Modena and Padua,
Lorenzo being chief partner in the former, Cristoforo chief
partner in the latter place. Vasari states that Lorenzo was
Mantegna's rival at Padua ; we may consider him to have been
Mantegna's companion in the school of Squarcione ; and we
have seen how likely it may be that he had a share in the
frescoes of the Eremitani.[3] He was a painter, a maker of
tarsia, a modeller in terra-cotta, and a printer of books, and
Paciolo declares him to have been completely master of perspec-
tive. Between 1460 and 1470[4] the firm of Lorenzo and

Ferrara at the Santo, having contracted in that year to join Matteo del Pozzo and
Montagnana in painting the chapel of Gattamellata (Gonzati, *La Basilica*, i. doc.
xxxvi., xxxvii., and i. 58). There are still payments for the latter work in 1476
(*ibid.*, doc. xxxvii.). In 1481 he gilds the chapel of Sant' Antonio (*ibid.*, p. 58), and
in 1500 he was still employed at the Santo (*ibid.*, p. 57). An Ecce Homo under
glass on the left side of the chapel of the Santo, near the fourteenth altar, and near
the door of the chapel of the Reliquie, is by Calzetta, but so injured as almost to
defy criticism. Apparently in this style is a Pietà in a niche in a pilaster of the
right aisle, of the vulgar Mantegnesque manner peculiar to the Paduans of this
period. [* Calzetta was in 1455 an apprentice to Pietro da Milano. See Lazzarini
and Moschetti, *loc. cit.*, xv. 173 *sq.* and xvi. 81. Cf. also *ibid.*, xv. 174 *sqq.*
and xvi. 81 *sqq.*]

[1] It may suffice to say that copious notices of these artists are to be found in
Campori (*Gli artisti*, etc., *ub. sup.*, pp. 229 and following), in Gonzati (*Basilica*),
the Anonimo ed. Morelli (Vasari, iii. 404 *sq.*), Brandolese (*Del Genio dei Lendi-
naresi*, Pad. 1795), Luca Pacioli (in *De Proportione*), and Scardeone (*Antiq.
Patav.*, p. 373).

* [2] It appears that they were really born at Ferrara, whence their father
Andrea di Nascimbene in 1436 moved to Lendinara. See A. Venturi, in *Rivista
storica italiana*, i. 623.

* [3] In 1449-53 Lorenzo and Cristoforo executed tarsias for the studio of
Lionello and Borso d'Este in the castle of Belfiore, near Ferrara (A. Venturi, *ub.
sup.*, i. 622).

[4] The tarsie at San Marco in Venice, assigned to "the Canozzi" by Sansovino,
are really by Antonio and Paolo da Mantova, and executed (see Zanotto, *Guida
di Ven.*, p. 49) in 1520-30. In a similar manner the choir-stalls at the Frari
assigned to the Canozzi are (Zanotto, *Guida*, p. 473) by Marco di Giampietro of
Vicenza, July 1468.

Cristoforo at Padua finished the carving and inlaying of ninety stalls in the choir of the Santo at Padua,[1] and in 1465 of stalls in the choir of the cathedral at Modena.[2] Matteo Colacio minutely describes the first in a volume printed during the year 1486 at Venice,[3] enumerating the various subjects introduced and praising the beauty of the design, the woods employed being mulberry, mountain ash, cypress, willow, maple, lentisk, liquorice, box, cherry, ebony, tamarisk, and white varieties occasionally dyed.[4] The stalls perished by fire in 1749, and of all their decorations a single figure of St. Buonaventura and a view of the Santo have been preserved as dossals to the confessionals of the Luca Belludi chapel; they might alone prove the master's proficiency in perspective, and his natural clinging to Paduan or Mantegnesque form. At Modena, where the choir has undergone change, there remain four panels representing the Doctors of the Church, in which natural shape and good proportions are combined with a certain individuality highly to be commended in works so difficult of execution as these.[5] So clever indeed is the arrangement of parti-coloured woods in the flesh-parts, that the transition from light to shade is by no means so abrupt as one might suppose. Angularity is to be found in the outlines, and a broken character in the drapery, but nothing more in this respect than might be due to the peculiar schooling of the artists. At the time when these pieces were being completed, Gutenberg's Bible was reprinted (1462) by the same enterprising firm, and was followed by the books of Aristotle with the comments of Averrhoes. Between 1474 and 1477 Lorenzo undertook the tarsie of the presses in the sacristy at the Santo of Padua, on designs furnished ten years earlier by Squarcione.[6] Till quite recently they were originals, comprising six standing saints and four views of streets, more or less in Squarcione's

[1] Gonzati, *Basilica*, i. 70–71 and doc. xliv.　　　[2] Campori, *Gli artisti*, p. 230.

[3] "Matthæus Siculus Christophoro et Laurentio fratribas," in *De verbo, civilitate* (Venice, 1486), fol. d. 1 *v. sqq.*

[4] Records in Gonzati, *Basilica*, i. 70–71.

[5] The St. Ambrose is signed as follows : " Hoc opus fatũ fuit p̃ Christophõ P. et LA Vrentius fratres de Lendinaria, 1465." Besides these figures there are panellings with tarsie, containing imitations of doors, shelves and utensils, birds, cups, mitres, and the like.

[6] See *antea*, p. 7, n. 3, and Gonzati, *Basilica*, doc. cxxxiii., cxxxiv.

style of 1452, the details of shelves, cupboards, and niches being much akin to those in the rounds of the semidome at the Eremitani chapel.[1]

That Lorenzo Canozzi undertook painting is certain, though no specimen of his skill exists ;[2] but if we bear in mind his character as a tarsia-maker, we could assign to him some second-rate wall-distempers, such as the " glories " of St. Francis and St. Chiara in the first cloister of the Santo,[3] a Virgin and Child, like veneering, in the Comune,[4] and some eight fresco portraits of churchmen in the ex-library of the canons of the Lateran at Padua. Though very incorrectly drawn, and poor productions by different hands, the last-mentioned are remarkable for the application of vanishing points to details of lodges, houses, ceilings, and shelves; and the angular character of the drawing as well as the mapping of the lights and shadows betray the hand of men accustomed to inlaying.[5]

At Lendinara, the birthplace of Lorenzo,[6] we look in

[1] Being damaged by worm-holes, these tarsias were taken down shortly before 1871 and inlaid afresh from outlines taken with transparent paper on the old work. The new tarsia is more polished but has not the character of the old, and Padua has thus lost a set of very interesting relics by the officious zeal of persons insufficiently experienced to deal with matters of art. The saints are Bernardino, Jerome, Anthony, Louis, Buonaventura ; the head of St. Jerome being one of the few that has retained the old style. Four perspectives of streets in tarsia are also in a room at the Santo between the sacristy and chapter-house. But even these are in a great part remounted.

[2] " El San Zuan Battista sopra il Pilastro secondo a man manca (in the Santo) fu de man di Lorenzo di Lendinara." Anonimo, p. 6.

[3] Padua, Santo. Lower course, St. Chiara erect in prayer between twelve females kneeling in prayer. In a lunette above, St. Francis (effaced) between ten kneeling Franciscans. Parts of the fresco are scaled, others discoloured, others again renewed. The outlines are sharp and rude, the flesh bricky. the figures generally paltry and rigid ; the whole mapped in the style of inlaying.

[4] Padua, Comune. Half-lengths, panel, gift of Dr. Antonio Tolomei. The Child sits on a stone, upon the face of which an unicorn is painted. This is a rough tempera, tarsia in treatment.

[5] Padua, ex-library now annexed to the chapel of San Giovanni di Verdara. The drawing is very minute, the drapery broken, the flesh bricky and hatched over in dull grey—the forms incorrect, the perspectives good and true. The style is lower but akin to that of a portrait of an Augustine monk in possession of Dr. Fusaro, assigned to Mantegna (see *antea*, p. 26); there is something German too in the draperies.

[6] Brandolese assigns to Lorenzo a St. Anthony between SS. Christopher and Onofrius in San Biagio of Lendinara, but this altarpiece is missing (*Del Genio,*

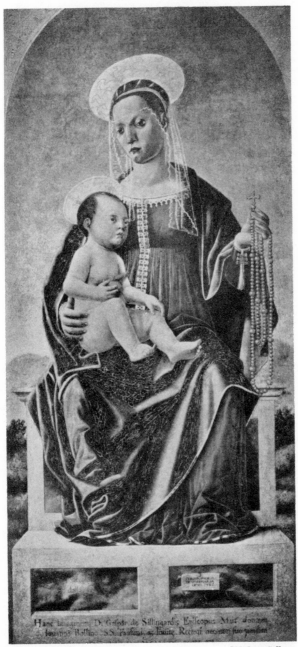

THE VIRGIN AND CHILD.

vain for pictures, but find a terra-cotta not unworthy of atten-
tion.[1]

After Lorenzo's death in 1477,[2] his brother Cristoforo carried
on the business partly at Parma, partly at Modena. He had
already exercised a rude sort of talent in tarsias executed for the
Duomo of Parma in 1473,[3] or for private patrons at Modena in
1477 ;[4] but these are of less interest than the Virgin and Child
with his signature and the date of 1482 in the royal gallery of
Modena, a panel in which broken or continuous outline betrays
the *tarsiatore*, and wooden form or incorrect drawing the feeble
powers of a third-rate Paduan.[5] Not that these or other pieces,

etc., p. vi). He also ascribes to the same a Virgin and Child between SS.
Lawrence and Anthony of Padua, in the Duomo of Lendinara. It is, however, by
Bissolo. At Santa Maria Nuova, near Lendinara, there is a panelled loft for the
singing-choir painted with ornaments that might be by the Canozzi, but it is in
bad condition.

There is a canvas of Christ and the Marys in the House of Martha, No. 152 at
the Venice Academy, inscribed: " Opus Laurenzi Chanozio patav. . . ." But
this is a work of the sixteenth century with a false signature.

[1] Vasari says, iii. 404, that Lorenzo modelled terra-cottas. That which may
be seen at Lendinara is a Virgin and Child mutilated and whitewashed above
the door of a shop, No. 150 in the Contrada del Duomo. The Virgin's nose is
gone, likewise the Infant's toes.

[2] See his epitaph in Scardeone, *Antiq. Patav.*, p. 373, or in original on the
wall of the first cloister near the door leading to the second cloister at the Santo.
He died on the 13th of April.

[3] Parma, Duomo, stalls of choir with perspectives as usual. A bearded St.
Mark (bust), a St. Jerome (bust), reading, St. Luke, and a bishop, inscribed :
" Opus Christofori Lendinarii miri artificis MCCCCLXXIII," the first of these figures
recalling Marco Zoppo and the local painter Caselli, whose education was partly
Venetian. There is also a tarsia (round) of a youth reading in the sacristy of the
Duomo, where, the wood having fallen, we see the original design cut into the
ground. On a bench in the sacristy one also reads the following : " Luch.
Blanch. Parm. gratus Crist. Lenden. cultor forulum hunc prot. hoperis perfecit."
Date illegible.

[4] Cristoforo was made citizen of Modena in 1463 (Campori, *Gli artisti*, p. 231),
and there are records in the Modena archives proving his presence at Modena
in 1475, 1477, 1478, and 1483. The tarsie are four Evangelists, on one of which
one reads : " Christoforus de Lendenaria hoc opus f. 1477." Similar in character
to the foregoing.

[5] Modena Gallery, No. 485. Wood, life-size, originally in the chapel of San
Giovita, near Modena. The Virgin is seated in a landscape, and holds in her left
hand a cross and chaplet; a transparent veil is bound to her head with a
cincture. Below her feet are two inscriptions, one as follows : " hāc imaginem de
Gaspar de Sillingardis Episcopus mut. donavit Jovanni Bollino S.S. Faustini ac
Jovitæ Rectori nec non suo familiari anno Dñi MDCV Die XIII Februarii," another

whether of painting or tarsia, which might be attributed to the
same hand, are of themselves attractive,[1] but because they lay
bare the track followed by Paduan art, and show how the manner
and example of the Canozzi, having already affected Zoppo,
extended to most of the cities in the valley of the Po, mingling
with the Umbro-Florentine at Ferrara, and with the Venetian at
Parma. In some cases we discover the pupils of the Canozzi,
for instance in a Pietà of 1485 in the Gallery of Modena by
Bartolommeo Bonascia,[2] and we see the continuation of their
teaching crossed with that of Francia or Costa in the works of

so: "Christophorus de Lendenaria opus 1482." The high surface shadows of strong
enamel are scaling, though the picture has been restored, and is thus dulled in
tone. The parts are mapped and drawn as tarsia, the drapery angular in lines.

[1] Lucca, San Martino. Five pieces of tarsia are preserved here, four repre-
senting perspectives, one a bishop less than life-size. On one of the per-
spectives one reads : " Christophorus de Cannoccis de Lendinara fecit opus.
MCCCCLXXXVIII."

Modena Gallery, No. 442. Panel of the Crucifixion with the thieves and usual
scenes. In the foreground St. Francis receiving the Stigmata, and St. Jerome.
This piece with figures a third of life-size was first called Mantegna, and after it
was brought from La Mirandola by the Duke Francesco IV. it was called Gerard
of Harlem. The real author may well be Cristoforo Canozzi, the style being that
of a tarsiatore partly Mantegnesque, partly Ferrarese. The figures are dry and
bony and motionless, the features being mapped out, and the draperies cut
straight by lines. The vehicle is high in enamel like that of the Ferrarese and of
Canozzi in his picture of 1482 ; the finish is very great, the colours gaudy and
intense, the marks ugly and repulsive. [* This picture is probably an early work
of Francesco Bianchi Ferrari. Its *cimasa* representing Christ appearing to the
Magdalen is now also in the Modena Gallery (No. 412). See A. Venturi, in
L'Arte, i. 282 *sqq.*]

[2] Modena Gallery, No. 480. Canvas, Christ in the Tomb between the Virgin
and Evangelist, inscribed : " 1485. Hoc opus pinxit Bartholomeus de Bonasciis."
The face of the tomb imitates that of an antique sarcophagus with hippogriffs
and vases. The contours generally are rectilinear, which shows that the painter
was used to inlaid work. The Christ is not undignified, and is Bellinesque in a
certain measure. This painter indeed is cleverer than Cristoforo Canozzi, com-
mingling the character of the followers of Piero della Francesca with those of
Bellini and Mantegna. The flesh in this picture is injured. [* Bartolommeo
Bonascia, who painted " a head " for the oratory of the Ospedale della Morte at
Modena in 1468–70, died of the plague as late as 1527. He was also a wood-
carver and an engineer. See A. Venturi, in *Archivio storico dell' arte*, ser. i.
vol. iii. pp. 383, 391.]

[3] F. Bianchi Ferrari is mentioned by Lanzi (ii. 346) as the author of an altar-
piece once in San Francesco of Modena, and as the alleged master of Correggio
(Spaccini in Annot. Vasari, iv. note 2 to p. 110). There is one picture by him
under Francia's name in the Gallery of Modena (No. 476), the Annunciation,

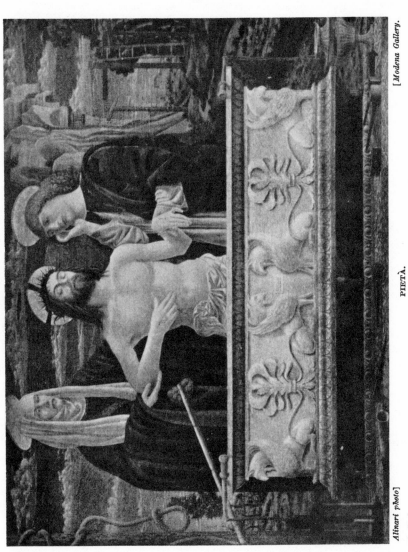

PIETÀ.

[Modena Gallery.

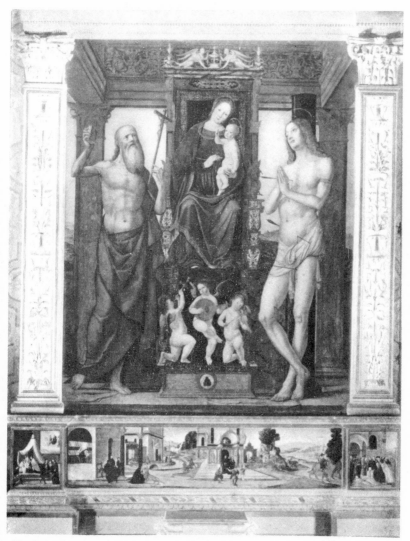

THE VIRGIN AND CHILD WITH SAINTS.

II. 76b]

Francesco Bianchi Ferrari, Giovanni Antonio Scaccieri,[3] Marco
Meloni of Carpi,[4] and Bernardino Loschi.[5]

Of Ansuino da Forlì we can say no more than that his name
is undiscoverable anywhere but on the walls of the Eremitani
chapel. There is indeed a profile assigned to him in the Correr
Gallery at Venice, but the fine character of its drawing and
expression, and the blended modelling of its flesh, reveal the
hand of an Umbro-Ferrarese ; and the St. Christopher at Padua
does not prepare us for the comparative perfection of the portrait
at Venice.[6]

a panel executed for the church of the Santissima Annunziata at Modena. From
records recently discovered in the archives of the brotherhood of that name
under the dates of 1506, 1507, 1508, and 1511, 1512, it appears that this piece was
left unfinished at his death in 1510 by Francesco B. Ferrari, and finished by Gio.
Antonio Scaccieri in 1512. (See *Intorno al vero autore di un dipinto attribuito
al Francia; Nozze Venturoli-Bianconi*, by Andrea Cavazzoni Pederzini, 8vo,
16 pages, Modena, 1864.) The style here is a mixture of Francia, Costa, and
Panetti, with a patience of execution exceeding that of Mazzolino. The figures
are slender, the colour bricky and mapped, shadows bituminous, and flesh horny
and light. The painter is obviously a follower of the Canozzi, influenced by the
school of Francia. The Duke Francis IV. paid 500 secchins for this alleged
Francia in 1821. [* It is now officially restored to the real authors.—Other
works of Francesco Bianchi Ferrari are : (1) Berlin, Kaiser Friedrich Museum,
No. 1182. The Virgin and Child with Saints. (2) London, Wallace collection,
No. 2. A Youth watching a Sleeping Girl. (3) Modena Cathedral. Frescoes
on the ceiling of the sacristy (executed in 1507). (4) Modena, San Pietro. The
Virgin and Child with Saints. (5) Rome, Galleria Nazionale, No. 2370. The
Agony in the Garden.—For notices of this painter see A. Venturi in Thieme and
Becker, *Allgemeines Lexikon der bildenden Künstler*, iii. 586 *sq.*; and Cook, in
Gazette des Beaux-Arts, ser. iii. vol. xxv. pp. 376 *sqq.*

 [4] Marco Meloni is the painter of a picture in the Modena Gallery (No. 483)
representing the Virgin between SS. John the Baptist, Bernardino, Francis, and
Jerome; two angels support the crown above her head. On the throne one reads :
"Habes mi Divi Bernardini confraternitas Marci Melonis opus, anno D.CCCCC IIII,
Kalendis Juni peractum." This picture was in San Bernardino of Carpi. Its
figures (all but life-size) are wooden in form, but there is also here a distinct imi-
tation of Perugino and Cima. [* The Modena Gallery also contains the predella
which originally accompanied this painting as well as a St. Jerome by Meloni.]

 [5] Of whom there is a Virgin and Child with Saints in the Modena Gallery
(No. 477); he is also a painter indulging in defective drawing, lame movements,
rectilinear outlines, and absence of feeling for colour; but see *postea* in the
painters of Parma.

 [6] Venice, Correr, Sala XVI., No. 9. Wood, tempera, m. 0·49 high by 0·35. Profile
of a man at a curtained window, through which one sees a castle, water, and
ships, and a servant before two men on horseback. [* Signed on the wall beneath
the window " A. F. P." Cf. *postea*, p. 236 *sq.*]

Bono, the author of one of the frescoes at the Eremitani, is rarely noticed in the annals of art ; but we may fairly believe that he was taught by Pisano, and we know that he painted St. Jerome in the Desert, a small panel once in the Costabili Gallery at Ferrara, and now in the National Gallery. In this curious old tempera the saint reposes on a stone in a rocky landscape, the signature on a cartello indicating that Bono was of Ferrara and a disciple of Pisano. We shall accept its genuineness the more readily as the cold and solid treatment of the subject, and the hummocky outline of the distance heightened with gold, indicate a Ferrarese affected by the lessons of Umbrian teachers.[1] There is copious evidence in contemporary records that Bono was paid by the dukes of Ferrara to decorate their castles at Migliaro and Belfiore during the years 1450 to 1452.[2] We are led to think that he was in the service of the superintendents of the cathedral at Siena in 1442 and 1461 ;[3] but there is no vestige of his works in any of these places. It is not

[1] London, National Gallery, No. 771 ; previously in the Costabili collection at Ferrara, afterwards belonging to Sir Charles Eastlake. Panel, tempera, 1 ft. 8 in. high by 1 ft. 3 in., inscribed : "Bonus Ferariensis Pisani disipulus." The saint wears a yellow cap, and holds a scapular. His face is wild, like that of St. Anthony in a Pisano of the National Gallery.

[2] We are indebted to the Marquis Campori for notices of the fact that Bono in 1450 painted the lodge of the palace del Migliaro and chimneys in the house of the Castaldo of Casaglia near Ferrara. In 1451 he painted in the palace of Migliaro ; in 1452 a studio, probably at Belfiore.

[3] Annot. Vasari, iii. 27, n. 2 ; Cittadella, Documenti . . . risguardanti la storia artistica ferrarese, p. 364.

[4] Dresden Museum, No. 44. Nativity with the forged inscription : "Antonius Florentinus MCCCXXXIII." Note the inky shadows and raw contrasts of line in this picture.

[5] Venice, Lady Layard ; previously in the Costabili collection. Ecce Homo. The Saviour sits under an arch, through which a landscape is seen. Though not free from scaling and abrasion, this piece can still be judged of. The forms are dry and bony, and not unlike those of Galasso Galassi, the colour dim and raw, and the landscape Mantegnesque in its minuteness.

[6] Ferrara. An Ecce Homo like the last belongs to the Conte Massa at Ferrara, and may be taken for a work of the same hand. The general tone here is dull brown, but enamelled and high in surface. A third specimen of the same kind in Casa Canonici at Ferrara represents the Saviour in white with the cord round his neck and the Magdalen at his feet. [* A replica of Lady Layard's Ecce Homo belongs to Prince Liechtenstein of Vienna ; it may be that one which was seen by the authors in the Massa collection. The picture which formerly was in the Casa Canonici is obviously identical with one which now belongs to Baron Tucher of

doubtful that a pupil of Pisano capable of painting the St. Jerome of the National Gallery might, at a later period, and especially under the control of another master, produce the St. Christopher of Padua. The stamp of that manner is impressed on a Nativity with a false inscription in the gallery of Dresden,[4] and two or three pieces commingling Ferrarese with Mantegnesque peculiarities in Venice,[5] Ferrara,[6] and Munich[7] ; and it might be that his fourth- or fifth-rate powers were employed in the decoration of the Schifanoia Palace at Ferrara.

The pictorial creations of Pizzolo have altogether disappeared. Assuming that he is one person with Niccolò " depentor," journeyman to Donatello, we learn from records that he did various bits of tinting and gilding for the Florentine in 1446, 1447, 1448.[8] We know further that he painted in the chapel of the Podestà an Eternal,[9] and that a house-front supposed to be by him existed at a recent date in Padua.[10]

Vienna (reproduced in *Münchner Jahrbuch der bildenden Kunst*, 1908, I. Halbband, p. 27).]

[7] Munich, Pinakotek, No. 1023. Virgin and Child between two bishops and two Franciscans, one of them St. Anthony of Padua with the lily. This picture is called Mantegna, chiefly because the abbreviation of the word Maria on a pilaster has been read as a monogram of Andrea Mantegna. The forms are angular and dry, the flesh of a dull brown, the general tint of the picture dark and glowing, perhaps on account of varnishes ; the dresses are in strong primary contrasts. The style is a mixture of that of Galasso and Tura, and recalls that of the foregoing examples. We may therefore class this piece under the name of Bono. [* It is now labelled " School of Ferrara, about 1480."]

[8] Gonzati, *Basilica*, i. doc. lxxxi. [* Niccolò " depentor " is undoubtedly identical with Niccolò Pizzolo ; but see *antea*, p. 21, n. 3.]

[9] Vasari, iii. 388, and Anonimo, p. 28.

[10] Moschini, *Vicende*, p. 60. This front was inscribed : " Opus Nicoletti." [* In 1441 Niccolò Pizzolo had executed some paintings in the church of Monte Ortone, near Padua (Lazzarini and Moschetti, *loc. cit.*, xv. 125 *sq.*, 268 *sq.*). See also *antea*, p. 21, n. 1.]

CHAPTER IV

MANTEGNA AT MANTUA

TOWARDS the close of the year 1456, Mantegna was visited on several occasions by an agent of the Marquis Lodovico Gonzaga, who sounded him as to his willingness to leave Padua and take service at Mantua. The terms offered to him were most tempting—fifteen ducats a month, lodging, corn and fuel, and the expenses of the journey. For a time he hesitated. His friends wished to keep him at Padua,[1] but the brilliant prospect of a residence at court, the flattering tone in which the Mantuan agents spoke, made a deep impression on his mind; and in January of 1457 he had gone so far as to declare that he would entertain the idea of coming, though bound before doing so to complete an order from the protonotary of Verona.[2] During the whole of 1457 the painter was in no condition to move; he had no doubt much work on hand and a list of unfulfilled promises to settle; but Lodovico did not lose sight of his object, and at last succeeded in inducing Mantegna to fix a date for the transfer of his family and workshop to Mantua. It was arranged that the commissions of the protonotary of Verona and others should be attended to during the summer and autumn of 1458,[3] that three

[1] "Non obstante le molte persuazione daltri in contrario diliberai totaliter venire a servire la prefata vostra Ex." Mantegna to Lodovico Gonzaga, Marquis of Mantua, May 13, 1478. (Baschet, A., "Documents sur Mantegna," *Gazette des Beaux-Arts*, 8vo, Paris, 1866, vol. xx. p. 338, n.1. The same in Italian with variations under the title of *Ricerche*, 8vo, Mantova, 47 pages, 1866, p. 38.)

[2] Lodovico Gonzaga to Andrea Mantegna, Mantua, Jan. 5, 1457. (*Gazette des Beaux-Arts, ub. sup.*, vol. xx. p. 322; *Ricerche*, p. 18.)

[3] To this time we may assign the missing portraits of Galeotto Marzio of Narni and Janus Pannonius. See Jan. Pan., *Poemata*, 1784, cit. Selv. Comm. Vasari, iii. 438 and 457, and Anonimo, pp. 144 *sq*. and 255 *sq*.

months should be given for the despatch of private affairs, and that the Mantuan service should begin at the opening of 1459.[1] A letter in the Marquis's own hand expressed his extreme pleasure at this prospect of a settlement. The summer and autumn had gone, and winter was partly spent, yet no signs of Mantegna's coming were observed[2]; the Duke wrote in December to remind him of his promise.[3] Mantegna asked for eight weeks more to finish the work of the protonotary. When this was granted, the podestà of Padua begged the Marquis for still more time, that Mantegna might finish a "little piece" for him. With great courtesy the Marquis acceded to the podestà's desire, but in April Mantegna was still at Padua, thinking less of moving than ever.[4] It was of no avail that the Marquis, in May, sent twenty ducats by a trusty messenger for a boat to take the painter to Mantua[5]; the old excuse was constantly repeated, the protonotary's altarpiece was incomplete. Lodovico now wrote to the latter to ask him whether he would not allow his picture to be finished at Mantua, and informed Mantegna that he had taken this step[6]; but the protonotary was far too wary to consent to this arrangement, and insisted on the despatch of the panels to Verona, subsequent to which, it was suggested, Andrea might be spared to visit Mantua for a day.[7]

That Mantegna soon after left Padua to visit Verona is probable. How long he remained there is uncertain. His employer, Gregorio Corraro, was a dependent of Eugenius IV. and nephew to Cardinal Anthony of the old family of Correr, appointed abbot in commendam of San Zeno at Verona, and apostolic protonotary in 1443. For the adornment of the abbey-church he caused a new altar to be erected in the choir, and

[1] Lodovico Gonzaga to Andrea Mantegna, Mantua, April 15, 1458. (*Gazette des Beaux-Arts*, p. 323.)

*[2] In October 1458 Mantegna took as his pupil a boy aged thirteen, named Giovanni Battista. Lazzarini and Moschetti, in *Nuovo archivio veneto*, ser. ii. vol. xv. pp. 138, 301.

[3] Lodovico Gonzaga to Andrea Mantegna, Mantua, Dec. 26, 1458. (*Gazette des Beaux-Arts*, p. 325.)

[4] Same to same, Mantua, Feb. 2, 1459, and March 14, 1459. (*Ibid.*, pp. 325-6.)

[5] Same to same, Mantua, May 4, 1459. (*Ibid.*, p. 327.)

[6] Same to same, Mantua, June 28, 1459. (*Ibid.*, p. 327.)

[7] Same to same, undated. (*Ibid.*)

ordered the altarpiece at Padua.[1] If we consult historians, they
tell us that Mantegna adorned the fronts of several houses at
Verona and finished a couple of pictures besides, and it has
generally been assumed that his stay there was a lengthened
one. Under these circumstances it is important to note that
the Madonna of San Zeno is the only Veronese masterpiece of
which we can prove the genuineness ; and it was not executed
at Verona. Had we not undoubted testimony of this, we should
have guessed it from the style of the compositions themselves : [2]
the side compartments recalling Andrea's beginnings at Padua ;
the predella, Donatello ; and the Martyrdom of St. James as
well as the Virgin, productions of a later and still bolder phase.
It is unfortunate that this noble collection should have been
removed from the principal altar of San Zeno and hung at a
great height in the choir ; a mischance that the predellas should
be scattered in the museums of Paris and of Tours, but we are
content to know that they all exist and are well preserved.
Of the subject there is nothing to say but that it is the Virgin
and Child, of life-size, amidst angels, attended by eight saints
in a classic portico, with festoons of fruit overhanging the square
pillars of the court and the marble throne in which the Virgin
sits. Six parts, forming one complex, seem to have been
finished at distinct intervals. To the left St. Peter stands with

[1] Verona, San Zeno. " La Pala nella cappella maggiore in Coro è in tre
partimenti . . . opere bellissime del Mantegna. Oltre l'altare la detta pala fu
fatta a spese di Gregorio Corraro abate comendatore eletto da Eugenio IV. l'anno
1443. Le sedi del Coro furono fatte da' suoi eredi in virtù del suo testamento "
(*Ricreazione pittorica ossia notiz. univ. delle Pitt., etc., di Verona*, 12mo, Verona, 1720,
pp. 179–180). That Gregorio Corraro was protonotary we learn from Giovanni
de' Agostini, *Notizie delle opere degli scrittori Veneti*, in which there are notices
of *Progné*, a tragedy, and other literary prolusions by this author, who died
patriarch at Venice in 1464.

[2] Vasari (iii. 392) states that Mantegna painted a picture " for the altar of San
Cristofano and Antonio," but in what church he omits to say. He also " painted
the altarpiece at Santa Maria in Organo " (iii. 393), but the only altarpiece there
in a style approaching that of Mantegna is that of the Buonalini chapel, described
by Vasari himself (v. 329) as by Girolamo dai Libri (cf. *postea*, p. 203, n. 2). We
must therefore suppose that Vasari assigns the same picture to two artists, or
assume that the Mantegna is missing.

* The altarpiece which Mantegna, according to Vasari, executed for Santa
Maria in Organo is undoubtedly identical with the picture by him which now is
in the collection of Prince Trivulzio at Milan. See *postea*, pp. 110 *sq*.

ANDREA MANTEGNA

[II. 82]

THE VIRGIN AND CHILD WITH SAINTS.

the book in his hand, St. Paul at his side, leaning on a two-handed sword ; beyond them the young St. John the Evangelist with a classic face and figure reading, and St. Augustine with mitre, psalter, and crook of office; to the right St. John the Baptist, also reading, heedless of the vicinity of St. Zeno, St. Lawrence, and St. Benedict ; on the throne the Virgin in front of a marble bower, through the pillars of which the sky appears ; on the steps, amidst garlands by the side of the Virgin's chair, and about a wheel halo modelled after the rose in San Zeno, angels gambolling, singing, and playing instruments ; below, in the form of a predella, Christ on the Mount, Christ Crucified, and the Ascension. If we confine our attention to the left side of the picture, we notice a group of men remarkable for grandeur of proportions and sternness of mien, clad in sculptural draperies, but reminiscent in mask of the old and solemn impersonations of the mediæval time. They alternately recall aged types, to which Bartolommeo Vivarini was partial,[1] or antique models with finely chiselled lineaments and articulations, familiar to the student of the Greek age.[2] There is less of flexibility and elasticity in movement, less rotundity in modelling, than we are accustomed to in Mantegna's expanded style. The period of execution may have been that in which the Call to the Apostle-ship was completed at the Eremitani. Turning to the right, we have a St. Benedict like that of the Brera, St. Lawrence with a head that might be taken for a youthful pagan hero carved by Donatello, a mitred saint that seems to have issued from a relief by Ghiberti, a St. John of grim wildness. In each personage a fine individuality ; in each figure studied action and correct shape of limb, of muscle and extremity ; drapery of searching finish in the fold, yet of statuesque grandeur in cast. In treatment and colouring we see the hand of the fresco-painter, a thin distemper of an iron tinge in flesh, shadowed with grey, lights and darks worked in over a ground surface of neutral red, a vehicle of subtle texture sufficiently resinous to hold, not too viscous to project; absence of half-tone, severe correctness of definition in balanced mass of chiaroscuro, occa-sional sharpness in the peach on a lip, and a warm metallic hue

[1] This especially in St. Peter and St. Paul.
[2] *E.g.* in the St. John the Evangelist.

in reflections. All this points to the time when Mantegna composed the St. James proceeding to Martyrdom at the Eremitani.[1] Some of the angels singing about the Virgin seem quite Florentine in air, others have the full-blown mask and rotund cheeks and eyes imitated by the indiscriminate dependence of Caroto and Liberale; the Virgin herself supports the Child erect on her lap, and has an undulating movement and free action, revealing a still later phase in the development of Andrea's manner. Highly characteristic in every part is the introduction of medallions in the pillars of the court and in those of the throne. Here is an emperor crowning some favourite, a group of legionaries on foot and horseback, a Minerva; there a female on a dolphin, a duel, or a colossus like that of Montecavallo. In the predella of the Crucifixion now at the Louvre nothing can exceed the polish of the figures; nowhere except in the fresco of the Eremitani has Mantegna further pushed the boldness of foreshortening. His art in balancing the groups is great. On one side grief and lamentation contrasted with the calm of the Redeemer and repentant thief; on the other carelessness and gambling, and the unrepentant thief in his agony; fine is the gang of dicers, grand the episode of the fainting Virgin, a wonderful mixture of the dramatic and sculptural, here and there grimace, from which Mantegna is never free when he indicates pain; in the Saviour one of the finest nudes produced in Central Italy since Jacopo Bellini's Crucifixion; Donatellesque the writhing thief, equally so the repentant one, who seems modelled on the Marsyas of the Uffizi.[2]

* [1] The Eremitani frescoes having, as we now know, been completed 1452 (see *antea*, p. 13, n. 2), it seems impossible that any of the parts of the San Zeno altarpiece could be contemporary even with the latest of the wall-paintings at Padua.

[2] Verona, San Zeno. As to the condition of this piece, we shall mark a bit scaled out in the dress of the St. John the Evangelist, and other little injuries of a similar kind; and, besides, a disagreeable lustre produced by varnishes, and a certain dullness of tone caused by age. The figures in the body of the principal pictures are life-size; the predellas, of which one is No. 1373 at the Louvre, the others (not seen) in the Museum of Tours, m. 0·67 high by 0·93. When the altarpiece was taken to Paris in 1797, the predellas were separated from it, and were not returned at the peace. There are copies of them in San Zeno. In the predella at the Louvre the nimbuses are abraded and the surfaces washed over with some

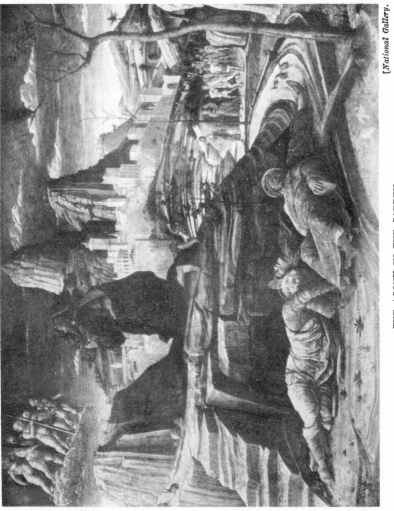

THE AGONY IN THE GARDEN.

[*National Gallery.*

ANDREA MANTEGNA

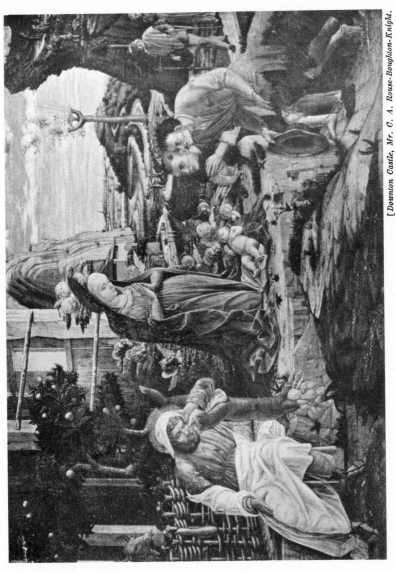

THE ADORATION OF THE SHEPHERDS.

II. 84b]

But whilst Mantegna was busy at this piece, he was also working in 1459 at a smaller one for Giacomo Marcello, podestà of Padua,[1] which in our opinion can be no other than the Christ on the Mount in the collection of Mr. Baring. Here the Saviour kneels on a rock before the angels that bring him the symbols of the Passion ; in the distance, Iscariot and his band hasten out of the town, which for this once is a view of Padua, with the city gate and the church of the Eremitani ; and the apostles sleep calmly in the foreground.[2]

At this source Giovanni Bellini first imbibed his fondness for the Mantegnesque ; here he studied the sculptural in attitude and in drapery, and the realistic in expression, without reaching to the scientific level of his brother-in-law. No creation of Mantegna shows more science in distribution and drawing, nowhere do we find a more startling contrast between imitation of the plastic in drapery and of nature in faces. An excessive, a coarse and vulgar realism, is combined with the hardiest foreshortening in the sleeping apostles ; a brown transparence covers the surface, and the picture makes on the whole the impression of a potent bitter.

That these and perhaps other masterpieces should all have been finished at Padua on the eve of Andrea's settlement at Mantua, might make us doubt that he ever stayed for any length of time at Verona, yet his influence in the Veronese school was great and lasting, and there are marks of his brush at least on one fresco, which might prove his stay there. We must remember, however, the proximity of Mantua to Verona ; we must bear in mind that Goito, where Mantegna frequently

brown preparation. The Marsyas alluded to in the text is an antique restored by Donatello (Uffizi, West Corridor, No. 155). [* The supposition that this is the statue which Donatello restored (see Vasari, iii. 407) is incorrect ; cf. Dütschke, *Antike Bildwerke in Oberitalien*, iii. 133 *sq.*]

[1] See *antea*, p. 81.

[2] London, Baring collection, previously in the Fesch and Coningham Galleries, inscribed : " Opus Andreæ Mantegna." Mark the round heads and protruding bellies of the angels.

* This picture is now in the National Gallery, No. 1417.

Closely allied to the predella of the San Zeno altarpiece and to the Agony in the Garden is a picture of the Adoration of the Shepherds in the collection of Mr. C. A. Rouse-Boughton-Knight of Downton Castle (Ludlow, Herefordshire). The design, but only part of the execution of this picture seem to be by Mantegna himself.

resided, was a castle stronghold of the marquises and dukes of
the Gonzaga family, from whence the painter might occasionally
visit Verona, and where he could receive Veronese artists. The
façade of a house near San Fermo, on which traces of frescoes
remain, is made to imitate stone panelling with round openings,
a sentinel with lance and shield, an equestrian statue, and
fragments of heads, of children, and monsters. These fragments
display the style of Mantegna at the moment of his retirement
from Padua,[1] but it is a solitary example, and other ornaments
of the same kind on the fronts of houses and in Sant' Anastasia,
as well as temperas in private collections at Verona, fail to
convince us that they should be classed amongst the productions
of his pencil.[2]

The paucity of Mantegna's works at Verona might be
favourable to an opinion, accepted by many, that he finally
entered the service of the Gonzagas in 1460,[3] an opinion
strongly confirmed by circumstantial evidence, though no positive
testimony proves it. But in 1463 the painter began residing at

[1] Verona, San Fermo in Pescheria; parts of the front whitewashed.

[2] (1) Verona, Casa Giolfino a Porta Borsari. Square spaces in the upper part of
this house contain figures of soldiers on foot and horseback, and a fight of horse-
men in monochrome. The colour is so abraded that the character of the work
can hardly be distinguished; but the painter may be Giolfino. Lower down on
the same front is a Virgin and Child, and part of an angel, clearly by Giolfino.
(2) Verona, Piazza San Marco, No. 854. The frescoes on this front are, as we shall
see, by Falconetto. (3) Verona, Casa Tedeschi, previously San Bonifacio, near
the chapel of Santa Maria della Scala. The paintings of this front are also by
Falconetto. (4) Verona, Sant' Anastasia. Frescoes above the altar of St. Vincent
Ferrerio, assigned to Mantegna. These frescoes may be by Francesco Benaglio,
Liberale, or Falconetto. See *postea*. (5) Verona, Casa Bernasconi [* now Verona,
Museo Civico, No. 153]. Canvas, tempera, with figures one-third of life, of Christ
carrying his Cross (busts). This, we shall see, is in the manner of Francesco
Mantegna. (6) Same place [* now Museo Civico, No. 152]. Panel, tempera, with
figures half life-size, of the Virgin and Child full-length, inscribed on the hem of
the Virgin's dress : " ◁ N Ω R ⊠ A ∞ M ◁ N(TIN) ⊠ A M . . ." This is a picture with
a suspicious signature, and probably by one of the Benaglii. (7) Same place [* now
Museo Civico, No. 134]. Arched piece with figures all but life-size, of the beato
Giustiniani and a mitred saint, kneeling. This dull-toned production with its grey
shadows seems a cross between Mantegna and B. Vivarini, and may be by
Antonio da Pavia.

[3] Certain notices gathered by Signor Giuseppe Arrivabene (MS.) state : " A
letter of Albertino Pavesi, dated Oct. 11, 1460, shows that Mantegna was then
lodging at the court of the Marquis " (D'Arco, *Delle Arti di Mantova, ub. sup..* i. 26),
but a more tangible proof is Mantegna's letter to Lodovico Gonzaga, dated Mantua,

Goito in the service of the Marquis Lodovico, and he complains, as artists always complained in these days, that he had had no pay for more than four months.[1] From shreds of a correspondence which now took place, we discover that Lodovico was making use of Mantegna's designs to decorate one of the rooms in the castle of Cavriana, and ordering panels for a chapel. The panels are mentioned in a letter addressed by Mantegna to the Duke on the 26th of April, 1464, from Goito, and we can only regret that the records which throw light on this interesting period should not be accompanied by corresponding notices of pictures.[2] Complete darkness indeed covers this and the next two years,[3] till we alight on a despatch in which Aldobrandini, the Marquis's agent, writing from Florence in July 1466, tells Lodovico Gonzaga that Mantegna has been there, conducting certain business with great credit to himself and honour to his master.[4]

Looking round amongst Mantegna's works at divers epochs, we are struck by a small triptych in the Uffizi at Florence, which might, we think, have been done at Goito in 1464.[5] This triptych

May 13, 1478, in which he reminds his patron that he " has been nearly nineteen years at his service " (*Gaz. des B.-Arts*, p. 338). [* The above-mentioned letter of Pavesi is published in Kristeller, *Andrea Mantegna*, p. 400. For another letter by the same person, mentioning Mantegna and dated May 15, 1463, see Braghirolli, in *Giornale di erudizione artistica*, i. 195.]

[1] Mantegna to Lodovico Gonzaga, Dec. 28, 1463, from Goito (*Gaz. des B.-Arts*, p. 329). The Marquis replied at once from Cavriana, sending him thirty ducats (*Ricerche, ub. sup.*, p. 27).

[2] Mantegna to Lodovico Gonzaga from Goito, March 7, 1464, speaks of designs for the four walls of a room in the castle of Cavriana ; and Lodovico to Mantegna, March 12, 1464, from Belgioioso in reply, and also Giovanni Cattaneo, overseer of Cavriana, to Lodovico, Cavriana, March 12 ; further, Mantegna to Lodovico from Goito, April 26, 1464, saying he will have done his work in a few days, and he talks of " postponing the varnishing " of certain pictures on panel for the " chapeleta." (*Gaz. des B.-Arts, ub. sup.*, pp. 329, 330).

* [3] A MS. of Felice Feliciano in the Biblioteca Capitulare in Treviso contains a delightful description of an excursion which Feliciano, Samuele da Tradate, Mantegna, and Giovanni Marcanova made in September 1464 for the purpose of studying the antique remains on the shores of the Lake of Garda. See Kristeller, *ub. sup.*, pp. 176, 472 *sq.*

[4] Giovanni Aldobrandini to Lodovico Gonzaga, Florence, July 5, 1466. (D'Arco, *Delle Arti di Mantova, ub. sup.*, ii. 12.)

[5] Florence, Uffizi, No. 1111. That a picture answering the description of this was in the chapel of the castle of Mantua in Vasari's time is known from his notice of the fact (iii. 394 *sqq.*). Small figures on panel, all in good preservation.

once adorned a chapel belonging to the Gonzaga, and was sold to
Antonio de' Medici, prince of Capistrano. The centre panel repre-
senting the Adoration of the Magi was a favourite of Mantegna,
and he began an engraving of it;[1] the sides are the Circumcision
and the Resurrection. In the first the Virgin sits to the right in
a choir of cherubs, attended by the aged Joseph. A kneeling
king bends before her, having deposited a rich casket on her lap.
In rear to the left are the two magi and their suite in a rocky
landscape, and a glory of pretty angels fills the upper air. The
masculine and sculptural character of the Virgin is attenuated by
the pleasing form of the Child ; great animation and cunning
perspective give life to the groups ; and a perfect harmony of
tone imparts a general charm to the piece. There is on the whole
a curious mixture in this work of northern realism and Florentine
plasticity. A grander composition and one more Italian in its
lines is that of the Circumcision, where the Virgin attended by
the prophetess and a female of noble air holds the Child in pre-
sence of Simeon beneath the arches of a temple ; a boy kneels to
the left with a plate in his hand, and St. Joseph, a tall apparition
looking on, reminds us by his naturalism of the searching creations
of Dürer. Bas-reliefs in the arched recesses re-echo the old
traditions of scripture, and present to us the sacrifice of Abraham,
and Moses showing to the people the tables of the law. The
rising Christ in the Resurrection is less perfect, and recalls the
strained attitude and crumpled draperies peculiar to Crivelli,
whilst the slender worshippers below are occasionally disfigured
by coarse and vulgar masks.[2] Nothing can exceed the exquisite-
ness of these three pieces, in which the lights are frequently
heightened with gold.

Of the same or very nearly the same period is the Virgin and
Child with a pretty framing of angels in the Berlin Museum, in
which we may detect the present which Mantegna once made to
his friend Matteo Bosso, Abbot of Fiesole ;[3] and the noble Pre-

* [1] Bartsch, 9. This engraving is by some imitator of Mantegna. Kristeller,
ub. sup., pp. 388 *sqq.*

[2] This slenderness suggested to Selvatico (Vasari, iii. 396, n. 1) that Pizzolo might
have had a part in the work, and there is no doubt the style of drawing is very
like that of the Assumption in the semidome of the Eremitani chapel at Padua.

[3] Berlin Museum, No. 27. Wood, tempera, 2 ft. 6 in. high by 2 ft. 1¾ in., from
the Solly collection. This is an ill-preserved panel, the Virgin and Child being both

sentation in the same collection, a picture of antique simplicity
in its types, grandly contrasting with the Socratic ugliness of
those peculiar to Giovanni Bellini.[1] Perhaps, too, we see at
Berlin the likeness of Matteo Bosso, whose familiarity with
Mantegna is proved in a letter preserved by Scardeone.[2] A

injured. The Virgin is graceful, holding the Child on the parapet, on which a
book lies. On the perpendicular face of the parapet is a coat-of-arms ; a festoon
falls over from the upper angles ; the composition is the same as that of Dr.
Fusaro's Madonna at Padua (see *passim*), ground blue. The picture answers
Vasari's description of a Madonna at Fiesole (iii. 394). That Matteo Bosso was
Abbot of Fiesole is stated in Poliziano (*De veris ac salutaribus animi gaudiis*,
Flor. 1491, *ap.* Comm. Vasari, iii. 394, n. 2). [* In the opinion of the editor,
Mr. Berenson is right in doubting that this picture is a work of Mantegna, and in
ascribing it rather to a pupil of Bartolommeo Vivarini who is trying to imitate
Mantegna (*The Study and Criticism of Italian Art*, i. 99 *sq.*). The same com-
position occurs not only in the painting which formerly was in the Fusaro collection,
but also in one bearing the signature of Bartolommeo Vivarini, in the Museo
Civico of Venice (Sale XV., No. 28). Cf. *antea*, i. 49, n. 2.]
 [1] Berlin Museum, No. 29. Canvas, tempera, 2 ft. 2¼ in. high by 2 ft. 8¾ in., from
the Solly collection. The Virgin presents the Child in swaddling clothes to Simeon
in presence of Joseph, the prophetess, and another. This piece was once in the
Bembo collection (Anon., p. 17), afterwards in that of the Gradenigo at Padua
(Giovanni de' Lazzara to Giovanni Maria Sasso, Padua, March 3, 1803, in Campori,
Lettere, p. 351, and Vasari, iii. 419, n. 4). The Simeon is a noble type, grave and
dignified as one of Leonardo's ; the other figures are very select; great is the finish
of every part, but the colour is very thin and has been darkened by repeated
varnishes. [* It seems unquestionable that this noble and powerful work is from
Mantegna's own hand ; and yet Morelli considered it as a free copy of a picture
in the Querini-Stampalia collection in Venice (Sala II, No. 2), which according
to him is the original by Mantegna (*Die Galerie zu Berlin*, p. 98). The latter
painting is very much retouched, and therefore difficult to judge ; it gives, how-
ever, more than anything the impression of being a later imitation of the Berlin
picture.]
 [2] Berlin Museum, No. 9. Wood, 1 ft. 5 in. high by 1 ft. ¾ in., tempera, bust, on
green ground. This is also grey from time, but well rendered, not free from
rigidity, sharp in contrasts of light and shade. That Mantegna painted Bosso's
portrait is stated by Selvatico (Comm. Vasari, iii. 419), who cites authorities. There
is a replica of this portrait, less finished perhaps, and embrowned by varnish. It
was till lately in London, having formed part of the Bromley collection. On the
back of the canvas are the words : " Ludov. patav. S. R. E. Tit. Slaurindam
presb. card. Madiarot, archiep. Flor. et patr. Aquilei," which may be modern.
[* There can be no doubt that the person whose features are reproduced in these
two paintings is Cardinal Lodovico Mezzarota Scarampo (died in 1465). See
Kristeller, *ub. sub.*, pp. 170 *sqq.*]
 We shall return to this gallery to state that No. 28, the Dead Christ and two
angels, cannot be by Mantegna. (See *postea* in Bonsignori.) [* The authors do
not mention this picture when dealing with Bonsignori in the first English edition

masterpiece of this time is surely also the small and highly
finished St. George in armour at the Academy of Venice, whose
spare and well-proportioned body is capped by a classic head
like that of St. Lawrence in the altarpiece of San Zeno.[1] Nor
can we assign a later date to the Martyrdom of St. Sebastian in
the Imperial Gallery at Vienna, where contortion and pain are
rendered with the same fidelity as repose in the Venice example.[2]
We might be tempted to assume that this beautiful little figure
with its cold silver-grey tones was undertaken by Andrea on his
return from one of those expeditions in which inscriptions and
antiques were sought for and discovered, the name being written
perpendicularly in Greek letters on the pillar of a round arch,
while fragments of sculpture, two colossal heads, a foot, and two
boys in marble lie on the parti-coloured floor.

In December 1466 Mantegna had settled down with his
family in Mantua; with such resolution to reside there per-
manently that he borrowed a hundred ducats from the Marquis
to enlarge and improve his lodging.[3] There during the winter
months, and in summer at Buscoldo, whither he retired during
the heats to a purer and higher air, he attended to the orders of
his patron, furnishing, as the fancy of Lodovico might dictate,
pictures of a secular nature, portraits, or designs for arras.[4]

of the present work. In the German edition (v. 509, n. 119) they state with regard
to the above-mentioned painting : " After having seen it again we declare that we
no longer believe that it is by Bonsignori. It is far too Venetian for Mantegna and
the Mantegnesques, and has most in common with the Vivarini. We are, however,
not yet prepared to suggest any definite attribution." The picture is now labelled
"Giovanni Bellini," and is undoubtedly a work by this master. See *antea*,
i. 147, n. 4.]

 [1] Venice Academy, No. 588. Wood, tempera, m. 0·61 high by m. 0·32, formerly
in the Manfrini Palace. The saint holds the stump of his lance, and the dragon
is at his feet ; distance a hilly landscape, seen through an opening from which
a festoon depends. The shadows here are thin enough to show the underground,
yet the colour has the lustre of enamel.

 [2] Vienna, Imperial Gallery, No. 81. Wood, 2 ft. 1 in. high by 11 in., inscribed :
" TO EPΓON TOT ANΔPEOT Γ." The colour is dry and spare, but harmonious ;
the contortion of the frame powerful, as in Michelangelo's slaves at the Louvre;
distance a landscape ; the lights of the architecture touched in gold.

 [3] Mantegna to Lodovico, Mantua, Dec. 2, 1466, in Baschet (*Gaz. des B.-Arts*,
p. 331), but note that in the text the date of this letter is given as the second, and
in the copy of the letter itself as the eleventh of December.

 [4] In the Archives of the Camposanto at Pisa there is the somewhat surprising
record that on July 3, 1467, thirty soldi were spent on a luncheon in honour of the

In June 1468 he was busy with some subject of an unknown character, derived from a book to which mysterious allusions are made.[1] In July 1469 he is asked for a turkey and turkey-cock for the Marquis's arras-makers, the originals to be found strutting in the gardens of Mantua.[2] In 1471 he finished two portraits which have been identified with more haste than judgment with those in the Hamilton collection near Glasgow.[3] From that time till 1474 we may suppose him absorbed in the execution of the wall-distempers of the Camera de' Sposi, in the castle of Mantua. As a painter, we observe, his life is obscure; as a man he is revealed to us with great clearness in the correspondence of these and subsequent years. With some regret we perceive that he never succeeds in living quietly with his neighbours; and after quarrelling with them he involves the Marquis in the dispute, and loudly calls for justice. Of this there are two curious instances in 1468 and in 1475. On the first occasion he makes enemies of a gardener and his wife living near his town-lodging in the via Pradella, and he never walks out with or without his wife but he is pursued by this enraged couple, who exhaust the vocabulary of abuse against him. In communicating this to the Marquis, Mantegna goes so far as to say that but for his respect to his Excellency he would be led to commit some folly.[4] On the second occasion Mantegna charged Francesco Aliprandi with

painter Andrea Squarcione who at that time was about to finish his paintings in the Camposanto (Supino, *Il Camposanto di Pisa*, p. 28). We have seen before that Mantegna is occasionally called Andrea Squarcione (cf. *antea*, p. 26, n. 1), so it is quite probable that the above-mentioned entry refers to him. There is no other record of works by him in the Camposanto at Pisa, and we look in vain for any of them there at present.

[1] Mantegna to Lodovico, June 28, 1468. (*Gaz. des B.-Arts*, p. 332.)

[2] Lodovico to Mantegna, July 11, 1468. (*Ibid.*, p. 333.)

[3] Same to same (*ibid.*). The two portraits at the Duke of Hamilton's are those which were sold in 1666 at the lottery of the Renier collection. They are, it is said, life-size busts of Lodovico Gonzaga and Barbara of Brandenburg. In their present condition they certainly have not the appearance of pictures by Andrea Mantegna. They are in oil, in the style of Francesco or Lodovico Mantegna. [* These portraits were acquired at the Hamilton sale by M. Henri Cernuschi of Paris, and appeared again at the Cernuschi sale in Paris, May 25–26, 1900 (No. 53).] See Sansovino, *Ven. Descr.*, p. 378, and Anonimo, Morelli's notes, p. 145.

[4] Mantegna to Lodovico, July 27, 1468, and Lodovico to Carlo Agnelli and to the Vice-Podestà of Mantua (exc. in *Gaz. des B.-Arts*, p. 333). The gardener and his wife were effectually stopped from further objurgations.

stealing five hundred quinces from his garden at Buscoldo, which
gave the accused an opportunity of writing to the Marquis
denying the theft and upbraiding Mantegna for bad language.
"Besides," adds this incensed individual, with whom Andrea
was engaged in an action for trespass, "there is not a single
person in the vicinity with whom he agrees ; he is at law with
Zohan Donato de' Preti, with Gaspar of Gonzaga, with Antonio
of Crema, with the arch-priest of San Jacomo, with Messer
Benevoglia." [1]

It is pleasant to turn from these bickerings, which exhibit
Mantegna in no amiable light, to an episode of another kind.
One of the Marquis's sons, the Cardinal Francesco Gonzaga, was
a collector of gems and antiques, and a passionate admirer of
music ; he writes from Foligno on July 18, 1472, telling his father
that he is going to the baths and intends to stop two days in the
beginning of August at Bologna.　There he begs Mantegna may
be sent to him with the player Malagiste, that he may show the
first his collection of cameos, bronzes, and antiques, whilst the
second dispels the tediousness of a watering-place by his singing
and playing.　Lodovico did not hesitate for a moment to accede
to this request, and Mantegna started at a short notice for
Bologna, returning a fortnight after with the cardinal to Mantua.[2]
It was not long after this that the Marquis displayed his benevo-
lence by exempting Mantegna's property from the land-tax.[3]

When we read the story of the sack of Mantua by the
imperialists in 1630, we find it natural enough that treasures of
art should have become rare in that miserable city.　It was
hardly possible that three days of plunder, preceded by a siege
of three months and a capture by storm, should leave a single

[1] Mantegna to Lodovico, June 30, 1474; Lodovico to Mantegna, July 2, 1474;
Mantegna to Lodovico, Sept. 22 and 29, 1475; and Francesco Aliprandi to Lodo-
vico, Sept. 27, 1475.　The end of this quarrel was that Mantegna could not prove
that Aliprandi had stolen his quinces. (*Gaz. des B.-Arts*, pp. 335–7.)　[* In 1475
Mantegna also had a quarrel with the two engravers Zoan Andrea and Simone da
Reggio.　See Hind, *Catalogue of Early Italian Engravings*, pp. 332 *sqq.*]

[2] Cardinal F. Gonzaga to Lodovico, Foligno, July 18, 1472; Lodovico to
Mantegna, July 1472, from the country-seat of Gonzaga. (*Gaz. des B.-Arts*,
pp. 334–5.)

[3] D'Arco, *Arti di Mantua*, ii. 13.　The property of Buscoldo was exempted
on Nov. 20, 1472.　In 1474 another property at Goito was exempted from "dazio
e Gabella" likewise. (*Ibid.*)

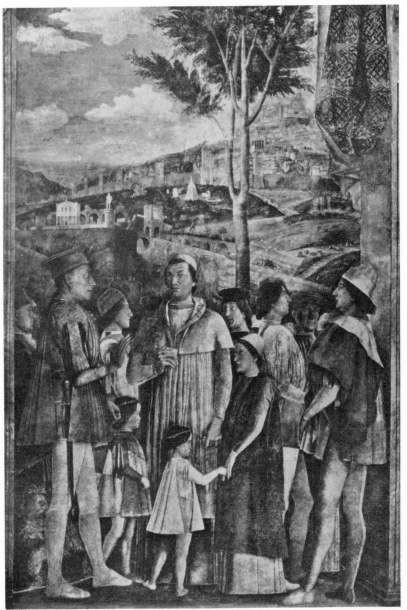

MEETING OF THE MARQUIS LODOVICO AND CARDINAL FRANCESCO GONZAGA.

monument in its original state. We are therefore almost agreeably surprised to find that an entire chamber facing the Lago di Mezzo in the old castello, and a second one looking out on the Piazza del Pallone, called the Schalcheria, should contain frescoes by Mantegna. By a lucky chance it happens that the first of these rooms is fairly preserved, and that the frescoes are authenticated by a signature. The name by which the place was known is, according to Ridolfi, " Camera degli Sposi," though in its configuration and arrangement resembling a dining-hall. The northern side is most completely filled with paintings ; above the door leading to the suite of ducal apartments now occupied by the Mantuan records, a flight of winged angels in a landscape supports a tablet with an inscription alluding to the Marquis Lodovico, his wife Barbara, and Mantegna, and dated 1474. To the left of the door a groom holds the Marquis's charger, and servants a brood of large white hounds in leashes. To the right the Marquis, accompanied by his children, meets his son the young cardinal, Francesco Gonzaga, at Sichia near Mantua ; the followers of both being arranged in a formal but not ill-conceived group. On the western face a shield is supported by four children.[1] The northern wall is bare. On the eastern, above

[1] Mantua, Castello. The inscription, though repainted over an old surface corroded by time, is attested in its present form by one of the family of Lazzara, who thus rescued the original from oblivion ; and it is the more necessary to bear this in mind because Brandolese (*Testimonianze intorno alla Patavinità di A. Mantegna*, Pad. 1805, p. 13) declares the date to have been 1484, in opposition to the testimony of Zani and many others. As it now stands the words are these : " Ill. Lodovico II. M. M. Principi optimo ac fide invictissimo, et ill. Barbarae ejus conjugi mulierum glor. incomparabili suus Andreas Mantinia patavus opus hoc tenue ad eorū decus absolvit anno MCCCCLXXIIII." This inscription does not exactly cover the previous one, the old ciphers being still visible beneath the new. There is room for more letters at the close ; and the restorer has obviously not been content with retouching the date, but has altered its position. As to the treatment of the paintings, they have all the same air ; the ceiling being, perhaps, looser and slovenlier than the rest, which may be owing to later additions. It had become necessary in 1506 to restore the so-called Camera de' Sposi with the aid of Francesco Mantegna. (Francesco M. to the Marquis Francesco, Mantua, Oct. 2, 1506 ; Isabella, Marchioness of Mantua, to the Marquis Francesco, Sept. 24 and Oct. 20, 1506, in Gaye, *Carteg.*, ii. 90 ; D'Arco, *Delle Arti, ub. sup.*, ii. 68, 69.) This restoration by F. Mantegna is visible in the angels holding the tablets, of which large pieces are now wanting, but which were retouched in 1506, and in our day by Sabatelli. The heads of the two servants holding dogs near the door are modern and on a new piece of

the chimney, Lodovico, in an arm-chair, receives a message from
his chamberlain in a garden decorated with a classic temple.
He is surrounded by Barbara of Hohenzollern, her daughter and
a female dwarf, and a suite of persons of both sexes. In a
neighbouring compartment is a reception of guests on a staircase
—all the figures over life-size. The ceiling of this apartment is
curved and broken into groinings; in the sections above the
lunettes are scenes from the fables of Hercules, of Orpheus,
and Apollo, on gold ground; in those above the corbels medal-
lions of emperors, eight in number. The centre imitates a
circular opening looking out to the sky and protected by a parapet
in perspective, at which laughing women stand and cupids sport;
all this, unfortunately, in a very bad state of preservation.
Nothing can exceed the finish and precision of the parts that
have remained untouched by time or restoring. We admire the
natural air and correct drawing of the servant holding the
charger; we count the hairs on the hounds in leash; we note
the fidelity of portraiture in faces neither comely nor attractive;
and wherever the hand of Mantegna is traceable, a bolder and
freer system of wall-painting than that of Padua; colours of
much body, dulled unhappily to a monotonous iron tone.[1]

With every allowance for the necessities of the occasion, we
cannot consider this decoration attractive. The Marquis, his

intonaco, but those of the groom and third keeper of the dogs are preserved,
and treated like the foreshortened Christ in the Brera of Milan. In the Reception
at Sichia, several parts, such as the Marquis's jacket, the cardinal's cap, and the
dress of the boy taking his hand are bleached white. It is in this fresco that
we observe heads of the character of those by Piero della Francesca; the hands,
too, are small and slender.

[1] A large flaw and scaling have damaged the right side of the fresco represent-
ing the Marquis with his wife and family. A figure stooping over the Marquis's
chair is all but obliterated, and both distance and foreground are much dis-
coloured. To these causes and a general bleaching of the surfaces we may
attribute the comparative hardness apparent here, for there is a raw iron tinge in
the whole; and yet we observe freedom of hand united to a rougher contrast of
light and shade and less perfect perspective than usual. The outlines, too, are
harder, and the modelling worse than they ought to be.

In the lunettes there never was any other ornament than shields of arms.
Some of the coves above them no longer contain more than traces of the subjects
that once adorned them. The subjects that are preserved are monochromes, of
which we can still distinguish Hercules killing Antæus, leading Cerberus, shooting
his arrows, and fighting the lion; Orpheus playing; Apollo charming the
monster; rape of Dejanira; and others. Amongst the medallions of emperors are

wife, their children, and the dwarfs—of which they kept a peculiar breed in lodgings built for the purpose—were the plainest people imaginable; some of them downright ugly and deformed. The short jackets and tights and the round caps of the period formed an awkward dress; the scenes depicted were homely and uninteresting to all but those immediately concerned. It was, therefore, out of Mantegna's power to exhibit variety, or do more than enrich each episode with copious detail of landscape and architecture. In the ceiling he was free to use his fancy, and there he revels in some sort of gaiety, solving problems of perspective with great cleverness, and creating models of arrangement subsequently carried out by Melozzo and Peruzzi. There is a strong contrast between the gambols of naked children on the cornice hung with garlands; the laughing air of the inferior mortals—amongst them a negress—looking down from their altitude, and the starched appearance of the Gonzaga on the walls. Mantegna indeed seems to feel some ease in doing this; he plays with the difficulties of perspective, and betrays none of the anxious searching noticeable at Padua; he takes the light from the windows in the north and east faces, giving each part the projection it would have in real relief. The corbels and the ornaments which spring from them are tasteful, and the angels which support the tablets and medallions are in good and lithe action; the blue sky in the central opening cleverly broken

those of Galba (hair new), Otho, Julius Cæsar, Octavius (retouched), and four others too injured to be distinguished. There are also monochromes on gold ground, in garland framings. Amongst the figures in the centre, we may note a boy-angel leaning against the parapet, and foreshortened so as to show the soles of his feet; near him another looking over from the inner side, like that of Raphael in the Sixtine Madonna (restored in 1506); near that again an angel foreshortened holding an apple, and the head of another peeping through the openwork; a boy playing with a peacock, others presenting their back or looking through; then a female with a comb, and two others looking down and laughing (restored), a basket projecting over the balcony (new), a female with a jewelled head-dress, and a negress. On the pilasters of the hall, monochrome arabesques on mosaic ground (repainted mostly in yellow). It has been assumed that the Camera de' Sposi was still unfinished in 1484; and this on the strength of a letter of February 1484, from Lodovico Gonzaga, Bishop of Mantua, to the Cardinal della Rovere, saying that Mantegna cannot work for him (the cardinal), being busy at a camera, for the finishing of which the Marquis is waiting. But this, no doubt, is some other camera than that of the Sposi. See the letter in D'Arco (*Delle Arti*, ii. 194).

with white clouds. The artist is in the full swing of his art,
though uncongenial in his hardness, and ill-favoured by the
nature of his subject. It was not till ten years later, we think,
that he painted in the Schalcheria, where the central portion of
the ceiling gives evidence of his presence ; [1] but, subsequent to
that period, the rounds of emperors above the corbels and the
hunts in the fourteen lunettes of this room were renewed by
some one of the stamp of Costa or Caroto. If we seek to ascer-
tain what other labours Mantegna undertook in his leisure hours,
or at his country-house during the period subsequent to 1474,
we should say he produced that wonderful figure of the Dead
Christ bewailed by the Marys which now adorns the Brera,
having long adorned the palace of the Gonzaga, and once formed
part of the collection of Cardinal Mazarin. It remained unsold
in Andrea's possession till his death, and was disposed of in
payment of his debts. It is a picture in which Mantegna's
grandest style is impressed, foreshortened with disagreeable
boldness but with surprising truth, studied from nature, and
imitating light, shade, and reflection with a carefulness and
perseverance only equalled by Leonardo and Dürer; displaying
at the same time an excess of tragic realism, and a painful un-
attractiveness in the faces of the Marys.[2] We might suppose
Mantegna to have finished also the two monochromes in the
gallery of the Duke of Hamilton near Glasgow, one of them
representing a female carrying a basin, the other a female looking

 [1] The centre figures of a man and child holding arrows seem Mantegnesque; and
we have the evidence of Raffael Toscano that Mantegna painted here (D'Arco, *Delle
Arti*, ii. 69). There is also notice of a frieze by our artist in a hall near the
Archivio Secreto (*ibid.* citing Coddé), and of portraits of the Emperor Frederick III.
and the King of Dacia in a camera of the castello (*ibid.* citing Marco Equicola).
 [2] Milan, Brera, No. 199. Wood, tempera, m. 0·68 high by m. 0·81. The flesh is
reddish and shadowed with a dull grey and looks almost like a monochrome.
The hands are contracted, the belly fallen in, the forms of the legs and knees
marked through the white cloth covering them ; almost repulsive is the detail of
the wounds in the feet and hands. The tempera is in part faded and abraded,
e.g. in the shadow of the white sheet. To this picture Lodovico alludes in a letter
to the Marquis Francesco, dated Oct. 1506 (D'Arco, *Delle Arti*, ii. 70), and in a
second from the same to Isabella in Nov. 1507 (Gaye, iii. 564). It was taken
possession of by the Bishop of Mantua, and was carried off from the Gonzaga
Palace in 1630. It was in Cardinal Mazarin's palace at Rome in 1696 (Félibien,
Entretiens, Paris, 1696, ii. 168), bought by Giuseppe Bossi at the beginning of the
nineteenth century and taken to Milan.

up and drinking,[1] and the Death of the Virgin at the Madrid
Museum, in which the apostles surround the bed of Mary, and
perform the funeral service in a colonnade looking out upon the
lake and city of Mantua.[2]

The Marquis's gift to Mantegna of a piece of land in 1476
enabled him to lay the foundations of a villa, and to launch into a
current of extraordinary expenditure. Being extremely vain and
possessed of the belief that no Italian prince enjoyed the services
of a painter like him,[3] Mantegna wished to make a display of
his importance by raising an edifice remarkable for its decorative
beauty; yet at the time when he most brooded over this design
he was in debt to a considerable amount, and persecuted by the
original owners of his property at Buscoldo, who had never been
paid. The Marquis, it is true, had frequently promised to satisfy
this demand; he had even consented to help Mantegna to the

[1] Duke of Hamilton, Glasgow. [* Now National Gallery, No. 1125.] These
are two very grand performances of classic air, highly finished and heightened
with gold, yet broadly carried out; they recall the allegories of the Castello.
[* Dr. Kristeller suggests (*ub. sup.*, p. 372) that these figures represent the Vestal
Virgin Tuccia carrying water in a sieve and Sofonisba drinking the cup of
poison. They are now commonly held to be works of Mantegna's school only.]

[2] Madrid Museum, No. 248, and formerly in the collection of Charles I. (see
Vertue's catalogue). Wood, 1 ft. 9 in. by 1 ft. 4½ in. Here some of the types recall
those of the Eremitani.

This is one of three small panels by Mantegna, once in the Mantuan collection,
and subsequently purchased by Daniel Nys for Charles I.; the two others,
representing the Virgin and Child between six saints, with incidents from the lives
of SS. Christopher, George, Francis, Jerome, and Dominic in the distance (wood,
1 ft. 9 in. by 1 ft. 5 in.), and the Adulteress taken before Christ (half-lengths,
1 ft. 9½ in. by 2 ft. 4 in.), are missing. [* The editor understands that the former
of these two paintings is now in the collection of Mrs. J. L. Gardner at Boston.—
Akin in style to the portraits in the fresco of the Meeting at Sichia is the profile
of a boy prelate presumably of the Gonzaga family (perhaps Lodovico Gonzaga the
younger) in the Gallery at Naples (cf. Frizzoni, in *Napoli Nobilissima*, iv. 24;
Kristeller, *ub. sup.*, p. 173).—Other works of Mantegna which may be mentioned in
this connection are the portrait of a man in the Palazzo Pitti as Florence and the
superb full-length figure of St. Sebastian until lately in the church of Aigueperse
(Puy-de-Dôme) and now in the Louvre. The landscape background of the latter
picture recalls that of one of the frescoes in the Camera degli Sposi. We may
suppose that the St. Sebastian was brought to France by Gilbert de Bourbon,
Comte de Montpensier, to whom Aigueperse belonged, and who in 1480 married
Chiara Gonzaga, the daughter of Mantegna's princely employer Federico. See
Mantz in *Gazette des Beaux-Arts*, sér. ii. vol. xxxiv. pp. 375 *sqq.*; Kristeller, *ub.
sup.*, pp. 138 *sqq.*]

[3] Mantegna to Lodovico, May 13, 1478. (*Gazette des Beaux-Arts*, p. 338.)

settlement of his affairs, and to the building of his house [1] ; but
the promises of a military chieftain in these days were usually
dependent on his successes, and Lodovico at the close of his
reign was habitually needy. Mantegna, who was not a man to
take a serene view of matters in general, in a querulous mood
one day in 1478 penned a long letter of complaint to Lodovico,
reminding him of the assurances made nineteen years before,
recalling his claim to eight hundred ducats for the property of
Buscoldo, his expectations of help to liquidate charges amounting
to six hundred ducats more, and his well-founded hopes of assist-
ance in the erection of his villa, winding up with the assertion
that though aged and burdened with boys and girls in a marriage-
able state he was now in worse circumstances than when he first
came to Mantua.[2] Lodovico was disposed to be angry with this
missive, but he did not hesitate to reply, admitting with soldier-
like frankness that he had not done all that he intended, but
urging that he had done as much as he could considering the
poor condition of his finances, and concluding with asseverating
that though his own income was diminished by the increase of
arrears and the pawning of his jewelry, he would pay all that he
had given his word for.[3]

Less than a month after this Lodovico Gonzaga expired at
Goito, leaving his marquisate and its encumbrances to his son
Federico.[4]

With the opening of the new reign Mantegna's hopes of
improving his fortune rose, and it is to the honour of the Marquis
that he fulfilled all the engagements of his father, confirming
the painter in the freehold of the land formerly given to him at
Goito and Mantua, and burdening his exchequer with the sums
due for the property of Buscoldo.[5]

[1] The house still exists, and bears the following inscription : "Super fundo
a Do. L. Prin. op. dono dato, An. C. 1476, And. Mantinea hæc fecit fundamenta,
XV Kal. Novembris." It was still unfinished in 1494 (D'Arco, *Delle Arti, ub. sup.*,
ii. 31). Ridolfi tells us the house was covered with paintings, which the
imperialists destroyed at the sack of Mantua (*Marav.*, i. 115).

[2] Mantegna to Lodovico, May 8, 1478, *ub. sup.*

[3] Lodovico to Mantegna, May 15, 1478. (*Gazette des Beaux-Arts*, p. 339.)

[4] See Barbara of Brandenburg to Federico Gonzaga, June 12, 1478. (Baschet,
Gazette des Beaux-Arts, ub. sup., p. 339.)

[5] Both records, dated June and August 1481, are in D'Arco (*Delle Arti, etc.,
ub. sup.*, ii. 15, 16).

Mantegna had thus reason to be convinced of the favour of Federico, the tone of whose letters, when condoling with him on his bad health, or treating of the pictorial works in the palaces of Gonzaga and Marmirolo, was always condescending [1]; and he was kept in good humour by acknowledgments of his talent from some of the most influential families of Italy. From the Duchess of Milan came a note in 1480, requiring that he should paint her portrait from a likeness, but our artist was by no means flattered with the commission, and Federico replied in June communicating his refusal, and observing that "these excellent masters were so capricious, we must be content to get from them what they were willing to give." [2]

In February 1483 Lorenzo de' Medici, passing through Mantua on his return from Venice, was induced to stop there and accompany the heir-apparent, Francesco Gonzaga, to the atelier of Mantegna; the Florentine prince was pleased to admire all that he saw there, the "heads in relief" and other antiquities which formed the artist's cabinet.[3] Little less than a year after, Giovanni della Rovere, Governor of Rome, wrote to Lodovico Gonzaga, Bishop of Mantua, and brother of the Marquis Federico, asking him to use his interest with Mantegna to furnish a picture for him; but Lodovico replied that Andrea had no time to spare for such an undertaking, being pressed to finish for the summer a *camera* in which the Marquis was anxious to reside.[4] Federico, it would seem, was in poor health, his correspondence being carried on chiefly by his brother. He died before midsummer 1484, leaving the government in the hands of his son Francesco II.

[1] Federico to Mantegna, from Gonzaga, Oct. 16, 1478, inviting him. This is followed by Andrea's excuse, being sick, and a kind rejoinder of the Marquis regretting his illness, which may, he hopes, not prevent the furnishing of certain designs. Federico to Giovanni da Padua (Mantua, April 24, 1481) mentions the coming of Mantegna to Marmirolo to superintend works there. It is needless to say there are no paintings left either at Gonzaga or Marmirolo. (See *Gazette des Beaux-Arts*, pp. 478-9.)

[2] Francesco Gonzaga to Bona, Duchess of Milan, Mantua, June 20, 1480 (*ibid.*, p. 480), and Selvatico, Annot. Vasari, iii. 428.

[3] Francesco Gonzaga to Federico, Feb. 23, 1483. (*Gazette des Beaux-Arts*, p. 480.)

[4] Lodovico Gonzaga to Giovanni della Rovere, Feb. 25, 1484. (D'Arco, *Delle Arti, ub. sup.*, ii. 194.)

A more serious blow than the death of this prince could not have befallen Mantegna. He could scarcely conceal from himself that it would be vain to expect from a youth, as Francesco then was, the services which he might have derived from Federico and Lodovico; yet his necessities were such that he required assistance. We therefore see him at this time in considerable trepidation as to the means of keeping up his old style of living, and supplicating distant patrons for that which he had thought to find at Mantua. He addressed, amongst others, Lorenzo de' Medici, who had probably given him commissions before, explaining the loss he had incurred by the successive deaths of the two marquises, the burden imposed on him by the furnishing of his new house, and the want of a subsidy.[1] In the meanwhile,

[1] 1484, Mantua, Aug. 26, A. Mantegna to Lorenzo de' Medici (unpublished) :—
" Magnifico signore et benefactore mio singulare. (Da poi le debite recommandazione.) La vostra magnificencia è optimamente informata de lo amore mi era portato da li doi miei Ill. Sign[i] la gratia de li quali mi pareva havere in tal forma vendicato che mi persuadevo de loro ogni bene in ogni mia opportunità. Per la qual cosa presi animo in volere fabricare una casa, la quale speravo mediante le loro servigie, non havendo facoltà da me, conseguire lo optato mio desiderio de fornirla. Mancommi la prima speranza non senza grande jactura ; mi è mancata la seconda, la quale mi augumentava l'animo a major cosa ; tante erano le dimostrazione de la sua felice memoria verso di me. Il perchè non dico ch el mi parà essere destituto per la perdita facta ho demesso alquanto di animo. Non obstante che la indole di questo novello signore mi fa pilgiare qualche restauratione, vedendolo tutto inclinato a le virtu; per mi bizogna far qualche pratica, la quale fin tanto non se perviene al fine, fa stare sempre l'homo, dubioso ; et è causa ch'io pilgi reffugio dove son' certo non mi sia essere denegato sussidio, al quale reputo per el piu vero quello de la vostra magnificentia, ben'che io habia fatto perdita di molti signori con li quali tenevo servitu et da loro non vulgaramente amato mediante le sue humanità et lo adminiculo di qualche mia operetta. Onde havendo indubitate speranza in la magnificencia vostra ricorro à quella, si volgia dignare per sua liberalita darmi qualche adiuto et accontentarsi volere participare in essa cosa, prometendoli farne tal memoria, che in me non sara mai imposto macule de ingratitudine : et questo mio fiduciale scrivere non lo imputo a me ma a la vostra magnificentia la quale per la sua benignità è sempre solita far bene non tanto a quelli sonno suoi dediti, ma chi ella non vide mai : et se ella cognosce che sia in me he che io habbia cosa li sia grata, prego vostra magnificentia non cum mancha prontezza volgia fare prove di me, che n'a la sicurtà che ho presa in lei perquesta mia lettere : il che reputerò ad cosa gratissima. Recommandomi infinite volte a la vostra magnificentia la quale Iddio felicemente conservi " ANDREAS MANTINIA, V."

" ad. magnifico et generoso viro domino Laurentio de medicis majori honorando Florentie."

Favoured by G. Milanesi.

however, his relations with the young Marquis took a pleasanter turn ; distant protectors continued to crave his services, and pecuniary distresses were for a time forgotten.

Amongst his first patrons at Padua, Mantegna, once numbered the Marquis Lionello d'Este, Lord of Ferrara, whose portrait was ordered of him in 1449.[1] His connection with the Ferrarese court ceased when he accepted the Mantuan appointment, yet the memory of his talent outlived this temporary estrangement ; and when the Marquis Francesco became intimate with the house of Este, and meditated marriage with Isabella,[2] the Duchess's desire to have a Madonna from the painter's hand was eagerly favoured. About 1485 this piece was finished and delivered,[3] and we may identify it with the beautiful half-length of that subject which adorned the collection of the late Sir Charles Eastlake, or with the less pleasing example of the same kind belonging to M. Reiset in Paris.[4] Our preference for the former may be due to its better preservation,[5] but, apart

[1] In the account-books of the Ferrarese court there is an entry, dated 1449, of payment for a panel bought by Marquis Lionello to be painted by "Andrea of Padua," with Lionello's likeness on one side and that of the favourite Folco da Villafuora on the other. This record was discovered by the Marquis Campori. [* Cf. *antea*, p. 27, n. 2.]

[2] Francesco was twelve years old and Isabella nine when they were betrothed in 1480. (Schivenoglia in D'Arco, *Delle Arti*, ii. 23.)

The name of Mantegna was well known later at Ferrara. When Costa contracted in 1499 to paint the choir of the cathedral of Ferrara, it was part of the contract that his work should be valued by Andrea Mantegna. See L. N. Cittadella, *Documenti ed illustrazioni risguardanti la storia artistica ferrarese*, p. 70.

[3] Francesco Gonzaga to Mantegna, Nov. 6 and 14, and Dec. 12 and 15, 1485, from Goito. (*Gazette des Beaux-Arts*, pp. 481 *sq.*) [* See also Kristeller, *ub. sup.*, pp. 482 *sq.*]

[4] Paris, M. Reiset. Virgin, Child, and three figures, a female and two males, inscribed "Andreas Manten" ; very carefully executed on canvas, but injured. [* Dr. Kristeller (*ub. sup.*, p. 325, n. 1) refers to a report that this picture is now in the André collection in Paris. This is, however, not confirmed by M. Yriarte (*Mantegna*).]

[*5] The picture which Mantegna in 1485 was executing for Eleonora of Aragon, Duchess of Ferrara, is no doubt identical with the Virgin and Child with Seraphs by Mantegna which in 1493 is mentioned in an inventory of the works of art belonging to the Duke of Ferrara (see Campori, *Raccolta di cataloghi*, p. 1). This painting is now commonly identified with a panel in the Brera Gallery (No. 198) which for a long time was ascribed to Giovanni Bellini (see *antea*, i. 187, n. 9); after having in 1885 been freed from the repainting which covered it to a great extent, it was, however, at once recognized as a most beautiful work of Mantegna. It came to the Brera from Santa Maria Maggiore in Venice, whither it probably had

from this, its character is more nearly assignable to Mantegna's best period; and it is rare to find in his works so much comeliness and feeling allied to grand form, broad modelling, and brilliant tone. The Infant erect on the Virgin's lap is completely naked, and throws his arm with charming flexibility round his mother's neck. The form is antique in its simplicity; there is great affection in the pressure of the Virgin's hands on hip and breast. The boy Baptist to the right points upward, and accompanies the gesture by an expressive glance; St. Anna above is grave and severe; St. Joseph to the left of Leonardesque regularity.[1] We can easily suppose this noble canvas to have been thrown off at the period when the Triumphs were first begun. Between 1485 and 1488 we may assume that Mantegna devoted all his energies to this, the greatest—and for him evidently the most enticing—of his works.[2] He was only induced to interrupt its completion in consequence of Francesco Gonzaga's wish that he should visit Rome. Innocent VIII. had about this time completed the erection of a chapel for his private use in the Vatican, and asked Francesco Gonzaga to let Mantegna adorn it. This request Francesco did not think it politic to refuse, and he accordingly sent the painter with a knighthood and a flattering letter of introduction to the Pope in midsummer of 1488.[3] During the two years which followed, Mantegna

passed during the political troubles which overtook Ferrara towards the close of the sixteenth century. See Frizzoni, in *Zeitschrift für bildende Kunst*, ser. i. vol. xxi. pp. 101 *sqq.* The inventory of 1493 registers yet another work of Mantegna, "uno quadro de legno depincto cum le Marie" (the three Marys at the Grave); it can no longer be traced.

 [1] London, collection of the late Sir Charles Eastlake [* now Dresden Gallery, No. 51]. Canvas, 1 ft. 8 in. high by 2 ft. 4¼ in. This may also be the picture noticed by Ridolfi as belonging in his days to Bernardo Giunti (*Marav.*, i. 116). It is slightly changed in tint by varnishes, and there is a slight retouching in the St. John. [* A Holy Family in the collection of the late Dr. L. Mond comes very close to this picture.]

 [2] See *postea* in a letter from Rome, where he speaks of the Triumphs being incomplete.

 [*] Cf. also a letter from the Chancellor Silvestro Calandra to the Marquis Francesco, dated Aug. 25, 1486, in which it is related how "the duke" (probably Ercole of Ferrara), while visiting Mantua, on that day went to see the Triumphs of Cæsar on which Mantegna was then working. (Braghirolli, *ub. sup.*, i. 200 *sq.*; Kristeller, *ub. sup.*, p. 483.)

 [3] Francesco Gonzaga to Innocent VIII., June 10, 1488. (Gaye, *Cart.*, iii. 561; D'Arco, *Delle Arti*, ii. 19.)

laboured with little intermission at the frescoes entrusted to him, composing a Baptism of Christ and other subjects, and leading the while a life of privation rather than of pleasure.[1] Being frequently visited by the Pope at his labours, but little used to feel the effects of his generosity, he is said to have imagined an artifice for the purpose of insinuating that he wanted money. Having introduced into his monochromes a figure without any of the known attributes of the virtues, he forced Innocent to inquire what the meaning of it might be, and said it meant "Discretion." The Pope rejoined, "Put her in good company, and add Patience," a recommendation which Mantegna found it useful to follow.[2] But what he dared not tell the Pope directly he confided to the Marquis ; and it is very amusing to catch from the tone and context of his letters a reflection of the intercourse between both. Mantegna writes with the full confidence of one accustomed to gracious treatment. On the 31st of January, 1489, he declares that his Holiness only gives boarding-expenses ; were he not assured indeed that by his diligence he is duly serving the interests of his lord, he would prefer being at home, for there is a great difference between the habits and customs of the Vatican and those of Mantua. He begs the Marquis to send, if but a line, to one who calls himself a child of the house of Gonzaga ; asks him to see that his Triumphs are not spoiled by rain coming in at the windows, for he is proud of having painted them and hopes to paint others ; he recommends the *brigata*—his family at Mantua—concluding with a wish for a benefice for Lodovico.[3] To this Francesco vouchsafes a friendly though not over-warm answer at the close of February, urging him to more speed in the chapel, in order that the beautiful Triumphs may be completed, concluding with a vague wish that a place may be found for Lodovico and with a curt assurance of service.[4] In June again Mantegna despatches an epistle, saying

[1] Berlin Museum, No. 21. To this period is assigned a Judith with the Head of Holofernes in the Berlin Museum. This panel, a tempera, dated 1489, is by a scholar of Ghirlandaio. [* It is now officially ascribed to D. Ghirlandaio.]

[2] Vasari, iii. 400 *sq.*, v. 396 ; Ridolfi, *Marav.*, i. 114.

[3] Mantegna to Francesco Gonzaga, Rome, Jan. 31, 1489. (Bottari, *Raccolta, ub. sup.*, viii. 27 ; D'Arco, *Delle Arti*, ii. 20.)

[4] Francesco Gonzaga to Mantegna, Mantua, Feb. 23, 1489. (Bottari, viii. 27 ; D'Arco, ii. 20.)

that he has tried to do honour to his lord by exerting himself to the utmost in his professional duties ; he is in favour with his Holiness and the whole court ; he alludes again to the matter of the benefice, and to the frescoes at the Belvedere, which he describes as no small matter for a man without help, anxious to do his best and win the prize ; enters into a description of the Sultan's brother, a prisoner at that time in the Vatican, of whom he promises to send a drawing, and ends with a hope that his Excellency will not consider him too facetious.[1]

On this occasion Francesco made no instant reply, but in December he wrote to Mantegna and the Pope simultaneously, requesting that the painter might return in time for the festival of his marriage with Isabella d'Este.[2] Mantegna, however, was ill in bed when the courier came, and declined to move—a resolution in which he was encouraged by the Pope, who meanwhile reported to the Marquis confirming the statement of Andrea's sickness.[3] In the following month, while Francesco was going through the solemnities of his wedding, the Belvedere chapel, so shamefully sacrificed at a subsequent time by Pius VI., was finished, and a Madonna produced for Francesco de' Medici.[4]

If we had any doubt that Mantegna at this period was in the fullest expanse of his talent, we should be convinced of it by this beautiful little canvas, which we still admire in the gallery of the Uffizi[5] ; it is surprising that Andrea should have compelled his usually hard and rugged pencil to so much softness. The Virgin sits on a stone supporting the sleeping Infant upon her knee, her glance downcast, tender, and mournful; she seems to hush the half-dying and flexible Child into slumber ; about her a fine cast of sculptural drapery ; behind, a ragged shred of rock tunnelled by quarrymen ; a road with shepherds and their flocks, a distant hill and a castle—for Mantegna's stern habits a wonderfully tender performance. Of the same phase, if not done at Rome and

[1] Andrea Mantegna to Francesco Gonzaga, Rome, June 15, 1489. (D'Arco, ii. 21-2.)

[2] Francesco Gonzaga to Andrea Mantegna, Mantua, Dec. 16, 1489, and same to Pope Innocent VIII., same date. (D'Arco, ii. 22-3.)

[3] Andrea Mantegna to Francesco Gonzaga, Jan. 1, 1490, and Innocent VIII. to Francesco Gonzaga of same date. (D'Arco, ii. 23-4.)

[4] Vasari, iii. 400 *sqq.*, and Annot. *ibid.*

[5] Uffizi, No. 1025. Small figures on canvas, fairly preserved.

at this time, is the Man of Sorrows, enthroned with angels, in the gallery of Copenhagen; a splendid exhibition of skill in the reproduction of nude and accessorial detail, but too realistic to produce absolute pleasure.[1] We are accustomed to grimace in Mantegna's rendering of grief, and grimace is not wanting in this instance ; yet the expression is striking for its power, and we know of no picture of the master in which form is given with more purity, drapery with more studied art, and chiaroscuro with more Leonardesque perfection.

With the summer of 1490 Mantegna's stay at Rome came to an end, and the Pope dismissed him with " valet " and a handsome note of acknowledgment to the Marquis of Mantua.[2] From the close of September to the opening of the next year, and during the whole of 1491, the painting of the Triumphs was resumed at Mantua,[3] and when the Marquis rewarded his artist, in February of 1492, with a fresh gift of land, he declared the present to be justified by the works of the castello and the Triumphs of Cæsar, then in course of completion.[4]

[1] Copenhagen Museum, No. 200. Wood, tempera, 1 ft. 6¾ in. broad by 2 ft. 6½ in. This picture was formerly in the collection of Cardinal Valenti, Secretary of State under Benedict XIV. at Rome. The Saviour is on a sarcophagus, showing the stigmata, two angels behind him holding the corners of his winding sheet. To the left Jerusalem at sunset, to the right Golgotha, and at different planes in a highly finished distance a variety of incidents. On the pedestal of the sarcophagus to the right the words in gold letters: "Andreas Mantinia." The colour here was no doubt once very clear and transparent, but the picture has been abraded, and is injured especially in the right arm of the Saviour, the wings of the angels, and the sky. The flesh is warmly tinged and relieved with cool shadows, the Saviour's head large for the frame.

[2] Innocent VIII. to Francesco Gonzaga, Rome, Sept. 6, 1490, in which Mantegna is entitled knight. (Moschini, *Vicende*, p. 43, and D'Arco, ii. 24.)

[3] There is a splendid drawing by Mantegna at the Uffizi, dated 1491, from which it has been said that a picture of Judith with the head of Holofernes and a slave holding the sack, in the collection of the Earl of Pembroke, is done. This is a mistake. The panel in question, 7 in. broad by 11 in. high, is not taken from the drawing at the Uffizi, and is different from it. The treatment is oil, probably by a Fleming copying an engraving, and a Fleming, we should add, of the sixteenth century.

* There exist several other versions of this composition, viz. a picture imitating a bas-relief in the National Gallery of Ireland (perhaps an original by Mantegna), another painting in the same manner by some pupil of Mantegna belonging to Mrs. J. E. Taylor of London, engravings by Mocetto (Bartsch, 1), Zoan Andrea (Bartsch, 1), etc.

[4] Moschini, *Vicende*, p. 43. [* See also Kristeller, *ub. sup.*, p. 486.]

It has frequently been asked for what purpose these canvases were intended, and various suggestions have been made at sight of them, as they hang irreparably injured on the walls of Hampton Court Palace. The mystery is partly explained in a letter dated 1501 from Sigismund Cantelmo to the Duke of Ferrara. Cantelmo was a gentleman of the Ferrarese court who afterwards perished in the service of his lord. He was on a mission at Mantua at the opening of the sixteenth century, and kept the Duke informed of the gossip as well as of the politics of the Gonzagas. He writes, on the 24th of February, 1501, describing the performance of the *Adelphi* of Terence and comedies of Plautus in the castle of Mantua.[1] The theatre, he says, was a long rectangle figuring the interior of a classic dwelling-house with colonnades along the sides, the pillars faced with arabesque reliefs, simulated capitals and bases. The space was divided diagonally into two equal parts ; one half being occupied by the stage, the other half filled with seats for the audience and for the orchestra. The stage was hung with golden tapestry and greenery ; it was decorated on one face with six pictures of the Triumphs of Cæsar by Mantegna; there was a grotto in the angle formed by the two sides of the building, with a sky illuminated with stars, and a circle enclosing the signs of the Zodiac, about which the sun and moon revolved in their several orbits. Inside, too, was the wheel of fortune, the goddess herself on a dolphin ; on the parapet of the stage, the Triumphs of Petrarch, also by Mantegna ; a pair of candelabra ; and at the sides, the arms of the empire, of the Pope, the Emperor, the Duke Albert of Germany, and the Duke of Ferrara; above the whole a blue heaven, with the emblems peculiar to the season. We have every reason to believe that the Triumphs of Petrarch alluded to in this letter were done by Francesco Mantegna, in imitation of those of his father, and that they were finished at Marmirolo in 1491-2 ;[2] both together would form an appropriate decoration for a theatre, being on

[1] Sigismund Cantelmo to the Duke of Ferrara, Mantua, Feb. 23, 1501. (Campori, *Lettere ined., ub. sup.*, p. 3.)

[2] Bernardino Ghisulfo to Francesco Gonzaga, Marmirolo, July 16, 1491. Francesco (? Mantegna or Bonsignori) and Tondo together are about to begin painting the Triumphs on canvas, as Messer Mantegna has done, as they will thus be better and more durable (D'Arco, ii. 24, and Gaye, *Carteg.*, ii. 29). The Triumphs of Petrarch have perished.

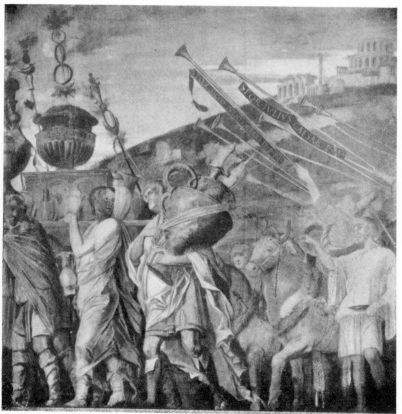

THE TRIUMPH OF JULIUS CÆSAR (FOURTH PICTURE).

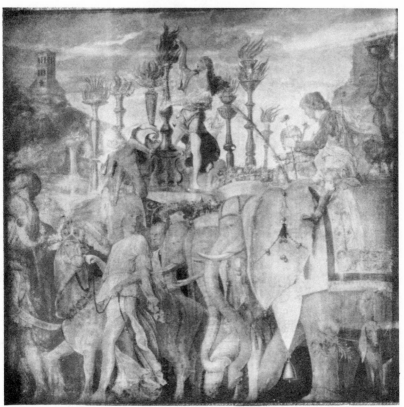

THE TRIUMPH OF JULIUS CÆSAR (FIFTH PICTURE).

canvas and easily moved; but they can scarcely have been intended for this express purpose, their paleness and finish of tone being calculated for the daylight of a palatial chamber rather than for the glare of lamps and candles. Under all circumstances, however, they were such as to attract attention, and Mantegna might well be proud of his share in them. They were an embodiment of all that he had learnt and acquired from youth upwards; they illustrated his love of scientific perspective, his fondness for plastic examples, his deep and untiring study of the antique.

In a series of nine canvases of the finest texture, once divided by pilasters inlaid with martial ornament, we have a varied representation of the different parts of a Roman triumphal procession. First come the heralds with a flourish of brazen horns, then the standard-bearers and attendants holding aloft the pictures of Cæsar's victories; the cars, with their horses, drivers, and leaders laden with the spoils of art and of war, statues, busts, catapults, helms, shields; these are followed by stretchers on men's shoulders heavy with the weight of vases, cups, and bullion; on the heels of these again a band of trumpeters heralding the advance of tribute in kind, oxen, sheep, and elephants bedecked with flowers; more soldiers staggering under loads of trophies; captives, males, females, and children, moving past the grated windows of the prison where their fellow-sufferers have perhaps been butchered; then Cæsar himself in chariot of state surrounded by officers raising high the busts of captured cities. In countless articles of common use in ancient times; in the statues, shields, helms, and breastplates forming the peculiar feature of these pictures, we think we see Mantegna copying the treasures of that rich collection which Lorenzo de' Medici and Francesco Gonzaga admired and envied, and exhausting the catalogue of antiquities discovered throughout Italy. His horses, kine, and elephants are natural, his costumes accurate, to a surprising degree. He was the only artist of this period, not excepting the Florentines, who was pure and accurate in the attempt to reproduce the semblances of a bygone time; surpassing alike Botticelli and Piero della Francesca, and reducing the Sienese to pigmies. With a stern realism which was his virtue, he multiplied illustrations of the classic age in a severe

and chastened style, balancing his composition with the known
economy of the Greek relief, preserving the dignity of sculptural
movement and gait, and the grave masks of the classic statuaries;
modifying them, though but slightly, with the newer accent of
Donatello.[1] His treatment was the reverse of that which marked
the frescoes of Padua, more akin to that of the portraits in the
castle of Mantua; he no longer drew with a black and incisive
line, nor modelled with inky shadow; his contour is tenuous and
fine, and remarkable for a graceful and easy flow; his clear
lights shaded with grey, are blended with extraordinary delicacy;
his colours are bright and variegated, yet thin and spare, and of

[1] Hampton Court. No. 873 to 881. The Triumphs are in such a con-
dition that we do not inquire what parts are injured, but rather are there any
bits uninjured. No. 873. Here we note, as in part preserved, the banner
beneath the Roma Victrix, part of the yellow drapery of the trumpeter nearest the
spectator, the buskin of the next figure to the right, the gold body-piece of the
Ethiopian, and part of the skirt and sleeve of the standing figure on the extreme
right. No. 874. Part preserved: wheel and ornament of car to the left, blue
jacket and red scabbard of standing figure in centre of foreground, bust of Cybele
(retouched); on the tablet of the car to the right: " Imp. Julio Cæsari ob Galliam
devict. militari potencia triumphus decretus invidia spreta superata." No. 875.
Part preserved : the shield in the left-hand trophy, with a fight of centaurs,
satyrs, and others about a female, and the ornament of a shield in the centre of
the picture. No. 876. Face of the youth on the extreme right, in which the
outlines are kept, lights being retouched on the cheek, and the hair and neck new.
This is a splendid and broadly handled head, like that of the Evangelist at San
Zeno of Verona. Head of the youth behind the face of the bullock, the nose and
mouth being retouched; the neighbouring amphora. No. 877. In part preserved
the head of the female leading near the bullock, the colour superposed by the
restorer having fallen out and left the original bare. This beautiful figure was
copied by Rubens in his picture at the National Gallery (No. 278). Part of the
elephant is thus likewise visible, as well as a piece of the head of the Indian
sheep to the right. No. 878. Preserved: the hair of the first figure to the left and
his yellow hose, and bits of the head next to the right, a breastplate and helmet
in the middle of the canvas, and a head-piece on the right. No. 879, No. 880,
all repainted. No. 881. In a slight degree preserved, the shield above the
wheel of the car and the lower semicircle of the wheel. The monogram M. on
the hindquarters of the horse is new, but no doubt repainted on the old lines.
On the arch behind the figures is the colossus of Montecavallo. Amongst the
many copies of these Triumphs are those of the Imperial Gallery at Vienna,
Nos. 72 to 80, some of them much injured (No. 72). They were reduced from the
prints, as we see from the interlacing on which the drawing was taken. There is
another copy on copper at Schleissheim, Nos. 505–8. It is hardly necessary to say
that these Triumphs were purchased for Charles I. of England, valued after his
death at £1000, and kept back by Cromwell for the adornment of Hampton Court
Palace.

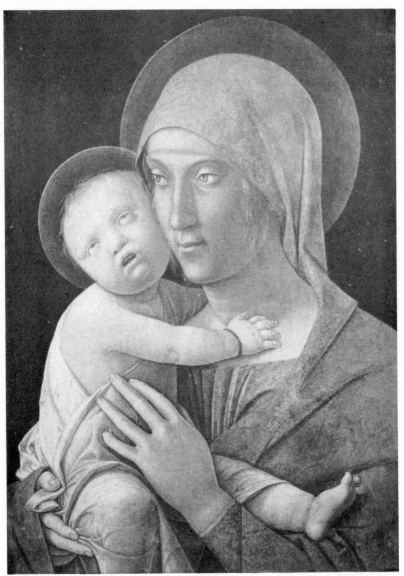

THE VIRGIN AND CHILD.

such gauzy substance that they show the twill throughout. After much use, no doubt, and frequent rolling for the sake of transport, the surfaces became injured; the canvases lost their brightness and required repair, and what now remains is with slight exceptions the daub of a most ruthless and incompetent restorer.

It is characteristic of the works which Mantegna now undertook that they more or less betray the aid of his assistants, of whom he had several in the persons of his sons Francesco and Lodovico Mantegna, Francesco Bonsignori, and Caroto.[1] We detect their presence by observing that the bitterness of the master is frequently attenuated by the mildness of his disciples, yet in the years which immediately followed 1492 we have several fine productions : a bust-portrait of a person of station treated in a soft and greatly blended manner with some feebleness in the silhouette and shading, and a Virgin and Child of smiling aspect and careful execution, in the Gallery at Bergamo,[2] and an allegory of Parnassus and Wisdom Victorious over the Vices in the

[1] Vasari states (v. 280) that Caroto was Mantegna's pupil and assistant, adding that Mantegna sold Caroto's works for his own. The same author tells us (v. 299 *sq.*) that Bonsignori was also Mantegna's pupil, and we know Bonsignori was in Mantua in the pay of the Marquis of Mantua. See *postea*.

[2] Bergamo, Lochis Gallery, No. 154. Life-size bust of a man in a red dress and red conical cap, with a gold chain and locket, on which the monogram is written. The brows are bushy, the hair plentiful, the mouth, nose, and cheek slightly injured. The ground is repainted in oil and of a green tone. [* Morelli (*Die Galerien Borghese und Doria Panfili in Rom*, p. 360, n. 1) rightly claimed that this is a work of Francesco Bonsignori. It comes especially close to the portrait of a Venetian senator by Bonsignori in the National Gallery.]

Carrara Gallery, No. 153. Virgin and Child. Half-length, half the size of life. The Virgin holds the face of the Infant to her own, and smiles; her mantle is blue embroidered with gold. This is a very careful light-toned tempera on canvas, a present to the gallery from the Count Carlo Marenzi. [* Intimately related to the Madonna in the Carrara Gallery are two pictures in the Museo Poldi-Pozzoli (No. 625) and the Kaiser Friedrich Museum at Berlin (Simon collection, No. 5), respectively, and the Adoration of the Magi in the collection of Mr. J. G. Johnson of Philadelphia. With the last-mentioned painting we may again associate the Ecce Homo belonging to Mme. Édouard André of Paris. All these works are pervaded by a strange sentiment of mystery. See Fry, in *The Burlington Magazine*, viii. 87 *sqq.*]

In the Lochis Gallery the Resurrection, No. 169. Much injured panel, which may have been original once, if it be not a copy from a print. We have already noticed a feeble replica in the Capo di Lista collection at Padua, *passim* in Squarcione. The piece at Bergamo may be that mentioned as by Mantegna in a Mantuan inventory of 1627 (D'Arco, ii. 165).

Louvre. We are ignorant of the history of the former; the latter
were ordered for the private rooms of the Marchioness Isabella,
and were part of a series completed by Perugino and Costa. In
the first, Mars and Venus on a rocky arch of natural formation
stand in gentle dalliance, whilst Cupid sends his darts into the
cave of Vulcan ; the Muses dance to the sound of Apollo's lyre,
and Mercury leans on Pegasus and listens ; in the second,
Minerva and other goddesses expel the Vices from a garden, and
welcome the approach of Justice, Force, and Temperance from
heaven. With all the finish of the Triumphs, these subjects are
drawn with classic taste and correctness, they are delicately
modelled and heightened with gold; and we see the ground
painted up to a firm but somewhat dark incised contour. There
is some very beautiful detail of trees, a warm hue and pleasant
harmony, in the Expulsion of the Vices. Gayer tints than
Mantegna's usual ones enliven the Parnassus, and this we may
attribute to the co-operation of Bonsignori ; but the fanciful
composition, the faultless outline, and flying drapery are due
to Mantegna alone.[1]

In a sadder mood, but still with great power, the lean
St. Sebastian of La Motta was added to the treasures of Andrea's
own gallery[2]; and the Assumption, belonging to the Marquis

[1] Louvre, No. 1375. With a piece added on all round, and so m. 1·60 high
by 1·92, canvas, the Parnassus ; the sky is retouched and the colour dulled by
varnishes. No. 1376. Expulsion of the Vices, enlarged likewise, of similar size
and in similar condition. These pictures formed part of a series in the boudoir
of Isabella, Marchioness of Mantua, an apartment called in contemporary re-
cords the studio, near the grotto on the ground floor of the castello. The studio
contained, besides the foregoing, several Mantegnas now missing: e.g. a panel
imitating a bronze relief with four figures, another panel of the same kind repre-
senting Jonah cast into the sea ; two pictures by Costa, one by Perugino, Michael
Angelo's Cupid, and several antiques. The two Mantegnas of the Louvre were
removed at the sack in 1630, and were for a time in the palace of the Duke of
Richelieu at Richelieu. See D'Arco's inventory of the "Studio" in Delle Arti
ii. 134–5. [* As for the paintings in the studio of Isabella, see Förster in the
Berlin Jahrbuch, xxii. 154 sqq.]

[2] La Motta in Friuli, Galleria Scarpa [* now Venice, collection of Baron
Franchetti]. Tempera, 2 ft. 10¼ in. broad by 7 ft. 1 in. high. St. Sebastian, in a hip
cloth with his arms bound behind his back, pierced by several arrows ; on the
foreground a lighted taper; above, a double string of corals; on a cartello :
"Nil nisi divinum stabile est, cætera fumus." This lean and spindle-shanked
figure was in the painter's atelier at his death, and was originally intended for the

Trivulzi at Milan, was finished in 1497.[1] During these days also
Mantegna began the Madonna della Vittoria, perpetuating with
his brush a pious fraud not uncommon in that age. It was in
1495 that Francesco Gonzaga commanded the forces of the
Venetians and fought the battle of Fornovo. He was beaten
by Charles VIII. of France, with a loss of three thousand men,
and to celebrate the event he caused the church of Santa Maria
della Vittoria to be erected at Mantua, and ordered Mantegna to
design the altarpiece. It may be seen at the Louvre, representing
the Marquis armed in proof at the Virgin's feet in a bower of
green leaves, attended by the archangels, St. Longinus, and
St. Andrew, and comforted by the intercession of the young
Baptist and St. Elizabeth.[2] There is no doubt a fine realism in
the kneeling Marquis ; great research and minuteness in the
details of the bower, and in the reliefs which adorn the throne ;
but the composition is crushed by the heavily wigged archangels,
and the drapery is no longer cast in the flowing style so admir-
able in creations of an earlier period. It is probable, indeed,
that the disproportion of the figures and the poverty of form in
the children, as well as the broken character of the dresses, are
due to the helping hand of Francesco Mantegna, whilst the taste
for minutiæ and the searching method in which the parts are
made out are the result of Mantegna's frequent use of the graver.
It was, we think, after his return from Rome that Andrea gave

Bishop of Mantua (Lodovico Mantegna to Francesco Gonzaga, Oct. 2, 1506, in
D'Arco, ii. 70). It became the property of Pietro Bembo (Anonimo, p. 19), and
was sold by his heirs in 1807 to one of the Scarpas. The flesh of the breast of
the figure is abraded, and the whole dimmed by varnishes.

[1] Milan, Marquis Trivulzi. Canvas, with life-size figures, representing the
Virgin and Child in an elliptical glory in the sky, above a landscape and groups of
lemon-trees; at the sides, SS. John the Baptist, a canonized Pope, Romualdo, and
Jerome, and three boy-angels in the centre of the foreground. On a square page
the words: "A. Mantinia pi. an. gracie 1497, 15 Augusti." The Virgin is fine, and
the saints are sculptural in shape and attitude; but we revert here to a less
pleasing art than that of the Triumphs. This piece indeed is one which in-
fluenced the later Veronese. It is now dimmed by varnishes. [* This picture
was originally in Santa Maria dell'Organo at Verona. Kristeller, ub. sup.,
p. 316.]

[2] Louvre, No. 1374. Canvas, m. 2·80 high by m. 1·60. The art here, especi-
ally as displayed in the St. Elizabeth, reminds us of that in the chapel of
Sant'Andrea at Mantua, by Francesco Mantegna. [* For the history of this
picture, see Kristeller, ub. sup., pp. 311 sqq.]

himself up to the task of engraving his own works [1]; and it is very likely that the time he spent over copperplates forced him to employ assistants on paintings which of old he would have carried out in person. To this cause, and to this alone, we may assign the comparative feebleness of such late productions as the Triumph of Scipio, belonging to Mr. Vivian, and the Virgin and Child between the Baptist and Magdalen in the National Gallery. The latter is a rosy pallid piece in which strange contrasts are created by the juxtaposition of bright clear tints in flesh and drapery with strongly marked foliage and vegetation, the disharmony being increased by the strong shadow in the trees, and the absence of it in the dramatis personæ.[2]

The Triumph of Scipio is a monochrome fanciful after the fashion of Botticelli, and far less chastened in style than the great series of Hampton Court. It was begun in Mantegna's old age for Francesco Cornaro, a friend of Pietro Bembo at Venice, and we know from a note of the latter to Isabella in 1505 that Cornaro was very indignant at not receiving it, though advances had been made for its completion.[3] But whilst the

[1] The reader is referred for Mantegna's engravings to the pages of Vasari, Bartsch, and Passavant. [* See now also Kristeller, *ub. sup.*, pp. 376 *sqq.*, and Hind, *ub. sup.*, pp. 329 *sqq.* It is no longer held that Mantegna himself reproduced any of his paintings in engraving.]

[2] National Gallery, No. 274, having formed part of the collections of Cardinal Monti (1632) and Mellerio at Milan. Canvas, 4 ft. 6½ in. high by 3 ft. 9½ in., inscribed: "Andreas Mantinea C. P. F." Note the disproportions here; the feeble frame of the Virgin, the large torso and spindle legs of the Baptist.

[3] London, collection of G. Vivian, Esq. [* now National Gallery, No. 902]. This is a monochrome on a canvas, 8 ft. 10 in. long by 2 ft. 4½ in. high, roughly executed, wanting in the usual delicacy of Mantegna and blackened by retouching. It was taken at Mantegna's death by Sigismund Gonzaga, Bishop of Mantua, out of the atelier (Lodovico Mantegna to Isabella d'Este: Gaye, iii. 564), yet passed ultimately into the house of the Cornari, for whom it was intended, *i.e.* Casa Cornaro Mocenigo a S. Polo in Venice. See Bembo to Isabella d'Este, Jan. 1, 1505, in Gaye, ii. 71; Lodovico Mantegna to Francesco Gonzaga, in D'Arco, *Delle Arti*, ii. 70. The art in the piece is quite reminiscent of that of Botticelli, just as at times that of Botticelli has recalled Mantegna, *e.g.* in a picture of one of the Seasons, once belonging to Mr. Baldeschi at Rome, and since purchased by M. Reiset in Paris (Annot. Vasari, iii. 422, and *History of Italian Painting*, ed. Douglas, vol. iv. p. 269). [* Other monochrome paintings by Mantegna or his school are Samson and Delilah, in the National Gallery (No. 1145); Sibyl and Prophet, in the collection of the Duke of Buccleugh in London; The Judgment of Solomon, in the Louvre (Gallery of Drawings, No. 241); Mutius Scævola, in the Print-room at Munich (No. 3069); and the Sacrifice of Abraham and the Triumph of David in the Imperial Gallery at Vienna.]

ANDREA MANTEGNA

THE TRIUMPH OF SCIPIO.

hoary artist alternately devoted his attention to the composition of pictures, the superintendence of his atelier, and the finish of his copperplates, he was also consulted on many points involving judgment in professional matters, and it was very nearly his good fortune to see a statue of Virgil erected after his design on some square in Mantua. At a court occasionally visited by men skilled in literature and in art, the subject of Virgil might naturally be expected to be mooted. That a sovereign who prided himself on his patronage of letters, and lived habitually at Mantua, should do something to honour the author of the *Æneid*, had no doubt often been suggested. One prince, it was said—an Italian, and a man of experience and education—had put his country to shame by casting a bronze of Virgil into the lake.[1] What more beautiful halo could be thrown around the family of Gonzaga than that created by a monument to the memory of the greatest of Latin poets. This idea germinated in Mantua, and in 1499 a friend of the Marchioness Isabella consulted Pontanus and Vergerius at Naples as to the best form to be given to a statue of Virgil, the appropriate turn of an inscription, and the person most competent to furnish the sketch.[2] As we might expect, the name of Mantegna was at once mentioned, and he furnished a drawing so fully in the spirit of the classic time that it seems a copy from the antique.[3]

The later years of the century, especially those subsequent to the Roman stay, had been good ones for Mantegna. He sold his property at Padua in 1492,[4] furnished his house at San Sebastian

[1] Carlo Malatesta occupied Mantua in 1397, and committed the act here alluded to.

[2] J. Dhatri to Isabella d'Este, Marchioness of Mantua, Naples, March 17, 1499, in the archives of Mantua, but printed in *Gazette des Beaux-Arts*, vol. xx., *ub. sup.*

[3] Paris, collection of M. His de La Salle [* now Louvre, His de La Salle collection, No. 58]. Virgil is drawn on a pedestal, holding a book in both hands, in splendid draperies, his head crowned with laurel; on the plinth a tablet, held by two angels, with the words: "P. Vergilii Maronis æternæ sui memoriæ imago." We have only seen a copy of this drawing and a reduced facsimile in the *Gazette des Beaux-Arts*, *ub. sup.* [* Morelli ascribes this drawing to Bonsignori (*Die Galerien zu München und Dresden*, pp. 233 *sq.*).]

[4] D'Arco, *Delle Arti*, ii. 225. [* See also Lazzarini and Moschetti, *loc. cit.*, xv. 135 *sq.*, 304 *sqq.*]

about 1494,[1] settled all the disputes with his neighbours at
Buscoldo, and married his daughter, Taddea, with a large dowry
in 1499.[2] Lodovico, his son, had a good place as overseer
and agent to the Marquis Gonzaga at Cavriana in 1502.[3]
Mantegna thus enjoyed the prospect of an easy and undisturbed
old age. But misfortune overtook him again. Having become
a widower he fell into illicit amours, and had an illegitimate
child, whom he christened Gian Andrea.[4] He sold his house at
San Sebastian and lived in lodgings [5] ; his son Francesco in-
curred the displeasure of the Marquis and was banished in 1505
to Buscoldo, neither the tears of Andrea nor the intercession of
Isabella availing to remit the sentence [6] ; but even under these
trials Mantegna's courage did not forsake him. He made a will
in 1504, assigning a considerable sum to his favourite son
Lodovico, with the charge of bringing up Gian Andrea, securing
a competence to Francesco, and leaving a legacy of 200 ducats
for the endowment and decoration of a chapel in the church
of Sant' Andrea.[7] He then entered into a contract with
Sigismund Gonzaga, Bishop of Mantua, and the canons of the
church, to furnish and adorn the chapel, to erect a monument for
his family in it, and to lay out a garden in its proximity ; and he
spent upon these baubles a considerable amount of money.[8]
Not content with this, he bought a new house for which he
promised to pay 340 ducats in three instalments.[9]

[1] Andrea Mantegna to Francesco Gonzaga, Mantua, Sept. 2, 1494, in which
the painter notifies that his son Lodovico has caught and wounded an officer of
the Marquis's household, whilst stealing the stones in the yard of the house.
(Gaye, i. 325 ; D'Arco, ii. 31—gives date Sept. 3.)

[2] Moschini, *Vicende*, p. 49 ; D'Arco, ii. 43-44.

[3] Lodovico Mantegna to Francesco Gonzaga, Jan. 16, 1502, from Cavriana.
(Gaye, iii. 563.)

[4] See will in Moschini, *Vicende*, p. 50, n. 1.

[5] This is evident from the fact that he lived in the Contrata Bovi at Mantua in
1504, and states in a letter to Isabella d'Este in 1506 that he has bought a new
house in order to be spared continual change of hired lodgings. See records in
D'Arco, *Delle Arti*, ii. 52 and 61-2.

[6] Isabella to Francesco Gonzaga, April 1, 1505, and Francesco Mantegna to
Francesco Gonzaga, June 3, 1506. (D'Arco, ii. 58, 65.)

[7] Moschini, *Vicende*, p. 50, n. 1 ; D'Arco, ii. 50 *sqq*.

[8] Gaye, iv. 565 ; D'Arco, ii. 54, 70, 71 ; Coddé, *Pit. Mantov.*, pp. 108-9.
The will was modified in favour of Gian Andrea by a codicil, dated Jan. 24, 1506
(D'Arco, ii. 62, 63.)

[9] See note 5 above.

These were unfortunate and imprudent ventures. When the day came to pay the instalments Mantegna's means were exhausted, and his health was seriously impaired.[1] A plague visited the lowlands and drove all persons of good and middling fortune from Mantua—a merciless quarantine being kept up between the infected locality and the neighbouring country.[2] Sick as he was, Mantegna still struggled on. He had a commission for a painting of Comus from the Marchioness Isabella,[3] and he tried hard to finish it ; but his strength was not equal to the task,[4] and he was obliged in January 1506 to apply to his protectress for aid, and offer for sale his precious bust of Faustina.[5] She did not answer as she had been used to do, and thus offended the pride of the old master. She even bargained with him for the Faustina, and got it from him through her agents.[6] No incident is more affecting than this. Mantegna could sell land and houses, and live in lodgings, but to part with his antiques was exquisite torture. When he gave the Faustina to Jacopo Calandra to be sent to the Marchioness, he did so with such reluctance, that Jacopo said he was sure Mantegna would die of the loss.[7] From that time, indeed, his heart seems to have been broken. He lingered on through the summer, and expired on the 13th of September.[8] His last wish had been

[1] See note 5 previous page.

[2] See D'Arco, ii. 64, 65. The Marchioness withdrew to the villa of Sacchetta near Cavriana.

[3] See the subject described by Calandra, D'Arco, ii. 65, 66. [* Kristeller *ub. sup.*, p. 497.]

* [4] As a matter of fact, there was a picture representing the Grove of Comus in the studio of Isabella; it is now in the Louvre (No. 1262), and displays all the characteristics of Lorenzo Costa's style. The composition answers, however, remarkably well to the description which Calandra gives of the " tabule de lo dio Como" for which Mantegna in July 1506 had not yet completed the design (cf. *antea*, n. 3). It is therefore not impossible, as Dr. Kristeller suggests, that the picture in the Louvre was begun by Mantegna and for the most part executed by Costa. See Kristeller, *ub. sup.*, pp. 358 *sq.*; Förster, in the Berlin *Jahrbuch*, xxii. 173 *sqq.*

[5] Andrea Mantegna to Isabella, Jan. 13, 1506. (D'Arco, ii. 61, 62.)

[6] Jacopo Calandra to Isabella, July 14, 15, Aug. 1 and 2. (Bottari, *Raccolta*, viii. 30, 31, 33, 34.) [* Cf. Kristeller, *ub. sup.*, pp. 496 *sqq.*]

[7] *Ibid.* The bust is now in the Museum of Mantua, No. 25.

[8] Francesco Mantegna to Francesco Gonzaga at Perugia, Mantua, Sept. 15, 1506. (Coddé, *Pit. Mantov.*, p. 164.) [* Kristeller, *ub. sup.*, pp. 498 *sq.*]

that the Marquis should see him, but Francesco was bent on
matters of more interest to his ambition ; and whilst Mantegna
was drawing his last breath, met Julius II. at Perugia, and
became generalissimo of Holy Church. The Marchioness, too,
wrote coldly to her husband on the 21st : " You know Andrea
died suddenly after you left."[1] The news had already been
communicated in letters of melancholy import from Mantegna's
children. Francesco Mantegna, from the place of his exile,
begged for help especially to satisfy the Bishop of Mantua in the
matter of the chapel.[2] Lodovico in October with more explicit-

[1] Isabella to Francesco Gonzaga, Sept. 21, 1506. (D'Arco, ii. 67.)

[2] Francesco Mantegna to Francesco Gonzaga, Sept. 15, 1506. (Coddé, *Pit.
Mantov.*, p. 164.)

[3] Lodovico Mantegna to Francesco Gonzaga, Mantua, Oct. 2. (D'Arco, *Delle
Arti*, ii. 70.) [* Kristeller, *ub. sup.*, p. 499.]

[4] There are of course numerous pieces assigned to Mantegna which are
by other hands. A list of these may be made as follows: (1) Bassano, Com-
munal Gallery. Virgin and Child, fresco. (See *passim* in Montagnana.) (2)
Belluno, town-hall. (See *passim* in Montagnana.) (3) Belluno, Casa Persicini.
Virgin and Child between two angels, an injured piece with embossed ornament,
of the school of Gentile da Fabriano. [* No longer traceable.] (4) Bologna,
Galleria Zambeccari, No. 49 [* now Bologna Gallery]. Christ liberating Adam
from the Limbus, perhaps the same panel registered in the Mantuan inventory
of 1700 (D'Arco, *Delle Arti*, ii. 189). Six long lean figures of repulsive shape
and face, coloured in a brownish tempera, unfinished and probably copied
from a print. (5) Galleria Ercolani, No. 155. Crucifixion, small panel. (See
passim, Zoppo.) (6) Cheltenham, Thirlestaine House, ex-Northwick collection
(now dispersed), No. 98 of the catalogue. Small triumphal processions, on panel,
4 ft. 9 in. by 2 ft. 4 in., similar in style to another panel of the same size at
Cobham Hall (see *postea* in the Friulan school) ; other so-called Mantegnas in
this collection were not genuine. (7) Cremona, Museo Civico Ala-Ponzone.
Bacchanal, tempera, copy from Mantegna's print, as Selvatico (Vasari, iii. 418,
n. 1) has justly observed. (8) Ferrara, Conte Canonici. Christ in the Tomb, signed
" Andreas Mantinea," a forgery (see *antea* in Carpaccio). (9) Florence, Galleria
Pianciatichi, No. 298. Two small panels representing severally St. John the
Baptist and St. Peter, by Cosimo Tura (see *postea*). (10) Uffizi, No. 1121. Portrait of
Isabella d'Este, Marchioness of Mantua (see *postea* in Bonsignori). (11) Hampton
Court. The Annot. of Vasari quote Dr. Waagen's *Works of Art and Artists in
England* for four pictures by Mantegna in this collection in addition to the Triumphs,
but the subjects given are those of pictures in the catalogue of the gallery of
Charles I., one of which is at Madrid. (12) Liverpool, Walker Art Gallery, Roscoe
collection, No. 28. Virgin with the dead Christ on her lap. This may be a part of
a predella by Ercole Roberti, of which two pieces are in the Museum of Dresden.
(See *postea* in the Ferrarese school.) (13) London, Earl Dudley. The Pietà.
(See *antea*, Crivelli.) (14) Gosford House, Longniddry, Earl of Wemyss. Two small
panels of St. Peter and St. Paul. (See *antea* in Montagnana.) (15) Mantua, Santa

ness declared that the debts of his father were 200 ducats, that he owed 100 ducats for the chapel, which must be paid, and as the Cardinal Gonzaga had put an embargo on the contents of the atelier, he asked permission to sell the Christ " *in scurto* " and the Triumph of Scipio, which together with the St. Sebastian and the two pictures for the chapel might produce enough for an honest liquidation.[3] So perished in the midst of pecuniary troubles the greatest artist of his age, the favourite of princes temporal and spiritual, the titular painter of a court, and the presiding genius of the North Italian schools.[4]

Maria degli Angeli. The Assumption, tempera, on panel high up in the choir, a solitary figure of the Virgin in a glory of cherubs. This seems to be the centre of an altarpiece by some feeble contemporary of Mantegna ; the types are poor, the colour rosy. (16) Of the same period and style in Santa Maria delle Grazie, frescoes of the Nativity and of a Virgin of Mercy between St. Christopher and St. Onofrio. (17) San Sebastiano. On the front of this church we see traces of a fresco of the Virgin and Child, St. Sebastian, a bishop, and two kneeling personages. [* This painting has now been transferred to the Museo Patrio at Mantua.] Susani (*Nuovo Prospetto di Mantova*, 8vo, 1818, p. 75) assigns this to Mantegna, but of this opinion nothing can be said in confirmation. There are also here two half-lengths of apostles in rounds, but they are totally repainted. (18) Mayence. We look in vain for pictures assigned to Mantegna in the museum of this town. (See Annot. Vasari, iii. 430.) (19) Milan, Ambrosiana. Daniel and the Lions, monochrome by one of Mantegna's disciples. Nativity, assigned at different periods to Squarcione, Pizzolo, and Mantegna ; this piece has a Lombard character and might recall the works of Bramantino. (20) Modena Gallery, No. 50. Lucretia with the dagger, two soldiers in rear. (See *postea*, Ercole Roberti.) No. 498 (Cat. of 1854). Bust of Mantegna, not genuine. No. 258. Crucified Saviour, Virgin, and Evangelist ; school of Van der Weyden [* now officially ascribed to the German school of the fifteenth century]. No. 54 (Cat. of 1854). Christ guarded by angels and two sleeping soldiers, not genuine. (21) Munich, Pinak., No. 1023. Virgin, Child, and Saints. (See *passim* in Bono of Ferrara.) (22) Oxford, Christ Church. Christ carrying his Cross. (See *postea*, Francesco Mantegna.) Canvas, with two heads on gold ground of R. van der Weyden. (23) Pavia, Galleria Malaspina. Virgin, Child, St. Anthony Abbot, and St. Anthony of Padua, with the signature " Andreas Mantinea pata-vinus pin. 1491," judged a forgery by Selvatico, and not to be seen when the authors visited this gallery. (See Vasari, Annot., iii. 428.) [* See *postea*, p. 403, n. 1.] (24) Rovigo, Galleria Comunale, No. 73. Small panel of Christ going to Golgotha, a caricature of the manner of Alunno. (25) Rome, Gallery of the Capitol, No. 161. Canvas, with figures under life-size of the Virgin and Child, SS. Peter, Lucy, and another female saint ; feeble picture by some follower of the manner of Catena [* now officially ascribed to Catena]. (26) Doria Palace, No. 164. Christ carrying his Cross ; bust of hard thin colour, probably by Bonsignori, of which there is one replica at the Hermitage called Palmezzano, and a second with the true name of Bonsignori in the collection of Marquis Campori at Modena. (27) Same palace, private

It has been supposed that the altarpieces in the chapel at
Sant' Andrea were finished by Mantegna before his death, but
the handling does not confirm this belief. They were probably
by his pupils. One of them is a canvas in oil representing the
Virgin and Child and St. Elizabeth with the young Baptist,
St. Joseph to the left, St. Zacharias to the right, a repainted
example of the decrepitude of the Mantegnesque school ; the
other, likewise in oil, is a Baptism of Christ, overdaubed in most
parts and perhaps by the sons of Mantegna.[1] They foreshadow
the decline of Mantuan art to the level which it held before
Mantegna's arrival.[2] A better specimen of the manner taught

apartments and picture gallery, No. 140. (See *antea* in Parentino.) (28) Rome,
Vatican Gallery. Pietà. (See *antea* in Gio. Bellini.) (29) Treviso, Galleria
Comunale. Virgin and Child, half-length, by Gio. Bellini. (30) Turin Museum,
No. 164. Virgin, Child, and young Baptist with five saints ; a fine picture and
greatly repainted, may have been by Mantegna. (31) Library. Circumcision,
miniature by Francesco Mantegna or Caroto. (32) Venice, Correr Museum,
Sala XVI., No. 8. Christ crucified between the Virgin and Evangelist, panel.
(See *postea*, Ercole Roberti.) (33) San Giobbe, half-length of the dead Christ.
This is by one of the Vivarini. (34) Vienna, Liechtenstein collection. Bust-
portrait of a man in a red coat and cap, not by Mantegna, though of the fifteenth
century.

 Amongst pieces recorded by historians as works of Mantegna we miss the
following: (1) Venice, Spedale degli Incurabili, sacristy. Virgin and Child.
St. Joseph, and the Magdalen. (Boschini, *Le R. Min.*, Sest. di D. Duro, p. 21.)
(2) Study of Ottavio de Tassis. Pictures by Mantegna. (Sansovino, *Ven. Descr.*,
p. 377.) (3) Casa Francesco Zio. Mutius Scævola burning his hand (Anonimo,
p. 84), perhaps the same piece that afterwards came into Charles I.'s collection
at Whitehall. (See Bathoe's catalogue, London, 1757, p. 167.) [* The picture in
the Casa Zio was a small monochrome, and may therefore well be identical with
the canvas which is now in the Print-room at Munich (see *antea*, p. 112, n. 3),
The Whitehall painting, on the other hand, was on panel.] (4) Padre Anselmo
Oliva. Christ at the Limbus. (Ridolfi, *Le Marav.*, i. 116.) (5) Jacopo Piglietta.
Virgin and Child in monochrome. (*Ibid.*) (6) Mantua, Ducal collection in 1627.
Half-length of Christ carrying his Cross (yet this may be the picture at Christ
Church, Oxford, which is mentioned *postea*). Head of St. Jerome, David
and Goliath. Four pieces with Tobias, Esther, Abraham, and Moses. Ditto,
inventory of 1665. Flight into Egypt, a portrait, a Virgin and Child, and
Christ at the Limbus. (D'Arco, ii. 160, 164, 165, 183, 188, 189.) (7) Mantua,
San Francesco. Portrait of Louis XII. (? by Francesco Mantegna.) (8)
A Flagellation, executed for Barbara of Brandenburg. (D'Arco, ii. 271.) (9)
Bologna, Casa Zacconi. A Christ by Mantegna. (Lamo, *Graticola di Bologna*,
p. 30.)

 [1] In the same church is a canvas of the Entombment, a lifeless creation of the
sixteenth century, and a Salutation, without a trace of the art of Mantegna.

 [2] The reader may look into D'Arco, *Delle Arti*, etc., for notices of **Mantuan**

by Mantegna is that displayed in the four Evangelists at the angles of the ceiling in the chapel of Sant' Andrea,[1] in which Mantegnesque character is mingled with something that reminds us of Costa. Were this the peculiar feature of the style acquired by Francesco Mantegna, we could assign to him with some propriety the Christ carrying his Cross under Mantegna's name in the museum of Christ Church at Oxford,[2] a modification of the same subject also under Mantegna's name in possession of Dr. Bernasconi at Verona,[3] and Christ appearing in the Garden to the Magdalen in the National Gallery.[4]

artists previous to the coming of Mantegna. In the Torre della Gabbia, now a private dwelling, there are remnants of pictures of Giottesque character, dating from the fourteenth century—subjects: the Marriage of St. Catherine, the Crucifixion, Christ amongst the Doctors, and an Adoration of the Magi, all by different hands. Vasari says, Stefano da Verona, disciple of Agnolo Gaddi, painted at Mantua. Are these frescoes by him? They are more Giottesque than those assigned to Stefano at Verona. There is further a rude fresco, half-length of the Virgin and Child and St. Leonard, in the chapel of the Incoronata in the Duomo of Mantua, a rude work inscribed: "Don Btolomeus de artusis de Cremona fecit fieri die 26 8 . . . 1432."

[1] They are greatly injured, and reveal the influence, if not the hand, of Lorenzo Costa.

[2] Oxford, Christ Church. Christ carries the cross, followed by a soldier in a helmet, and preceded by three men. Canvas, 2 ft. 6¼ in. broad by 2 ft. ½ in.; the Saviour open-mouthed, with a dry bony face and thorny hair, the helmeted soldier heavy and reminding us of the masks of Costa; the drapery crumpled in zigzags, the tints of dresses sharply contrasted; the flesh tints dull. This may be a piece mentioned in the Mantuan inventory of 1627 (D'Arco, ii. 156).

[3] Verona, Dr. Bernasconi. [* Now Verona, Museo Civico, No. 153.] Canvas, tempera, with figures one-third the life-size. Christ carries his cross; behind him a man in a yellow cloth head-dress. The art here is that of the foregoing, but perhaps a little better; the colour is dim and brownish.

[4] London, National Gallery, No. 639, from the Duroveray and Beaucousin collections. Christ is in profile; the treatment is fair, the colouring lively and rich. Francesco Mantegna may find a competitor for the authorship of this piece in Caroto. [* Two companion pieces of this work, representing the Resurrection of Christ and the Holy Women at the Sepulchre, have subsequently been added to the National Gallery (Nos. 1106 and 1381). Closely allied in style to these works is a little Nativity belonging to Mr. Roger E. Fry of Guildford.]

Of a Mantegnesque character, but not exactly like the foregoing: (1) Casa Susani at Mantua. Two angels on green ground, carrying the symbols of the passion. They recall the portraits in the Duke of Hamilton's collection. [* The present owner of these pictures is not known.] (2)·Santa Maria della Carità at Mantua. A saint erect in a niche. Canvas, tempera as above. In these three pieces the form is angular and the colour of thick surface.

Of the lives of the Mantegnas, it may be sufficient to say that Francesco, the

Another craftsman who signs a limited number of Mantuan
pictures at this time is Antonio of Pavia, whose productions,
however, are not worthy of any particular attention.[1]

date of whose birth is unknown, painted much for the Marquises of Mantua, and
especially in their summer-residences of Marmirolo and Gonzaga. He survived
Andrea Mantegna more than ten years. Lodovico does not seem to have resumed
the brush after the death of his father. The bust of Andrea Mantegna, by
Sperandio of Mantua, was put up in the chapel at Sant' Andrea by his grandson
in 1560 (see D'Arco and Coddé). [* This bust is now ascribed to Gianmarco
Cavalli.]

[1] D'Arco justly says of this painter that he reduced Mantegna's art to a mere
form. He is registered amongst the workmen at the Palace del Tè in 1528
(D'Arco, *Delle Arti*, i. 50). There is a canvas tempera by him in the Museo
Virgiliano at Mantua representing the Virgin and Child between SS. Jerome,
Anthony, Peter Martyr, and another saint. The forms of these figures are
heavy; the tempera is raw and mapped off in loud contrasts of light and shade,
the style a mixture of Bartolommeo Vivarini and the Mantegnesque. The piece
is signed "Ant. Papiešis p." In this manner we have the Conversion of St. Paul,
an ugly piece in the Museum of Verona, No. 331, and a rude Nativity under the
name of Mantegna, seen by the authors in the house of Mr. Mangini, an apothecary
at Piove. [* In the opinion of the editor, Prof. A. Venturi is right in ascribing
the former painting to Parentino; see *Madonna Verona*, i. 48 *sq.*] Finally we
notice an Annunciation between four saints, an altarpiece in double courses with
scenes from the life of the Virgin and of Christ in a predella, assigned to Antonio
of Murano, in the church of Santa Maria di Castello at Genoa. In this, as in the
Mantua piece, we see something akin to the manner of Andrea of Murano, such
as we find it in the altarpiece of Mussolone. [* We now know, from a contemporary
record, that the altarpiece at Genoa is by Giovanni Mazone d'Alessandria. See
Alizeri, *Notizie dei professori del disegno in Liguria*, iii. 535 *sqq.*

The Brera Gallery at Milan contains since 1899 an altarpiece (No. 194)
representing St. John the Baptist between SS. Augustine and Ivo, signed "Ant.
da Pavia p. Mantua MCCCCXIIII." This picture was formerly in the church of
Santo Stefano at Novellara.]

CHAPTER V

THE VICENTINES

IT is difficult to realize the extent of Mantegna's influence on the painters of North Italy without a special study of the various schools which derived their importance from his teaching. The Venetians reformed their style in part on the models which he created ; the Paduans clung to his system with melancholy pertinacity ; and the Vicentines, the Veronese, and the Ferrarese adopted his manner with avidity. Of the Vicentines, we think, history has said less than they deserved ; they were not artists of the highest class, nor were they men to achieve an European fame, but they had a genuine native power, which it is our duty to acknowledge and explain. Verlas, whose pictures, as we have had occasion to observe elsewhere, betray an approximation to Pietro Perugino, was not entirely devoid of Mantegnesque peculiarities ; and his countrymen Giovanni Speranza, Bartolommeo Montagna, and Giovanni Buonconsiglio were deeply imbued with them.

No dates of Speranza's life have been preserved ; we only know that several churches at Vicenza boasted of his works in the seventeenth and even in the eighteenth century ; and Vasari states that he and Montagna were disciples of Mantegna.[1] Both, it is clear, were admirers of Mantegna, but it is doubtful whether he was personally acquainted with them. Verlas produced his Madonnas in the first twenty years of the sixteenth century ; Speranza was probably his contemporary ; it is, however, a moot question whether Verlas affected Speranza and

[1] Vasari, vii. 526.

* Giovanni Speranza was born in 1480, a natural son of the noble Battista Vajenti and Catarina de Iadra. He married Elisabetta Castelnuovo, and died at Vicenza in 1536. (Bortolan, *S. Corona*, p. 168.)

121

Montagna, or whether Montagna and Speranza took some Umbrian character from independent sources. Two altarpieces by Speranza are in existence, one in the church of San Giorgio at Velo in the province of Vicenza, the other in the gallery of Vicenza, each of them inscribed with his name. At Velo the Virgin sits enthroned in a court, listening to the music of angels and attended by four saints: in a lunette, the Man of Sorrows and two angels; the figures distinguished by length and slenderness, and a strained grace not unknown to Verlas; the flesh pale yellow without modulations, and ill relieved by spare dark shadow; the angels of the upper course rivalling in dryness those of Bartolommeo Montagna and Buonconsiglio.[1] The second, larger still, is a quaint reproduction of the Assumption assigned to Pizzolo in the chapel of the Eremitani at Padua, with a couple of adoring saints in the foreground, one of whom seems obviously by Buonconsiglio. We infer from this that Speranza studied Paduan art about the time of Jacopo Montagnana, and employed Buonconsiglio as his assistant. He vainly tries to acquire the vigour of the Mantegnesque school, imitating it coldly and carefully but with childish exactness, avoiding the squareness and vehemence of its figures, but repeating withered and angular shapes and straight or broken drapery. His tempera has not the solid substance nor the metallic tinge of the Ferrarese, but a clear pallor and filmy surface of a dull rosy hue.[2] In other examples a closer relationship between Speranza and Montagna is manifested, especially in a half-length Virgin

[1] Velo. Panel, tempera, figures half the life-size, inscribed: "Js. Sperātie de Vagentibus me pinxit."
The saints are SS. George and Martin to the left, Anthony the Abbot and Sebastian to the right. There are large pieces injured in the breast and leg of the Saviour, the blue dress of the Virgin, and the dais behind the throne. The blue sky and part of the Virgin's mantle are repainted. There are marks of scaling and repainting in other parts also, and the colour is daily disimproving.

[2] Vicenza Gallery, No. 280, originally in San Bartolommeo of Vicenza (Vendramini Mosca's *Guida di Vicenza*, i. 7; Boschini, *I gioieli pittoreschi ... di Vicenza*, pp. 86-7). This panel, with figures about a third of life-size, is inscribed: "Joannes S . . . pinxit." It is greatly injured and discoloured. There is something very childish in the way angels support the arms or feet or sides of the Virgin. To the left St. Thomas kneels with the girdle, a figure treated with the power and in the style of Buonconsiglio; to the right St. Jerome. The whole piece is in a pilaster frame with arabesques and grotesques. Above, the Eternal looks down. The

and Child with a praying patron, seen by the authors in the
Casa Nievo at Vicenza, where Umbrian composure and staid
movement are combined with undeveloped form akin to that
which marks the youthful creations of Montagna. In this piece
Speranza is an oil-painter, nearly allied to the greatest of the
Vicentines.[1] It puzzles us at last to distinguish his hand from
that of Montagna; and there is a Madonna, belonging to the
Conte Agosti at Belluno, in which we hesitate to decide whether
it be one of Speranza's last or an early one by his countryman.[2]
With this admission it is not meant to be affirmed that Montagna
was the pupil of Speranza. They may have been companions,
and at some period have commingled their styles. It would be
rash to assert anything where dates are absolutely wanting. At
Santa Corona and Santa Chiara of Vicenza two or three more
specimens of Speranza are preserved[3]; there is also a Madonna

blue mantle of the Virgin is injured. In the lower framing are figures of the
apostles.

 * Admitting that the type of St. Thomas shows a certain resemblance to those
of Buonconsiglio, still the figure seems to the editor to be by the same hand as
the rest of the picture. Besides, we now know that Speranza was the younger
of the two artists, and that Buonconsiglio was settled in Venice when this
painting was executed.

 [1] Vicenza, Casa Nievo. Wood, oil, half-length of the Virgin behind a parapet
on which the Child stands with cherries in his tunic. A green hanging intercepts
the sky and landscape; to the left a patron in prayer (bust). Done in oil at one
painting, with spare colour of a reddish yellow but clear tint, inscribed " Joanne
Sperancie pinxit " on the parapet.

 [2] Belluno. Canvas, tempera, representing the Virgin (half-length) with the
Infant on a parapet, sitting on a white cushion and holding his hand out to be
kissed by a votary; a hanging of gold damask intercepts the landscape and sky
(retouched). The execution is too good for Speranza, not good enough for
Bartolommeo Montagna. The Virgin has a soft regular head in Montagna's
character, the votary seems by Speranza, and the Child is poor in form. [* The
editor does not know where this picture is to be found at present.]

 [3] (1) Vicenza, Santa Corona. Two panels at the sides of the first altar, left of
the portal. Each contains a saint (the B. Giovanni da Schio and the B. Isnardo
da Chiampo), one-third of life-size, the latter signed " Joañes Sperancia pinsit."
In both the ground is repainted. The style here again is an approach to that of
Bartolommeo Montagna. [* The B. Isnardo is also dated : 1512.] (2) Vicenza,
Santa Chiara (see Vendramin Mosca's *Guida*, i. 23, and *Gioieli*, p. 51). Virgin
and Child enthroned between SS. Francis and Bernardino, or Anthony of Padua.
Much injured and restored, with a doubtful inscription on a cartello : " Opus
Joannes Sperāza 1441 " (?). [* This picture was in 1866 exposed for sale in the
Scuola di San Rocco at Venice, and is now untraceable. See Borenius, *The
Painters of Vicenza*, p. 92, n. 1.]

with his name in the Casa Piovene at Padua,[1] and a Virgin with
the Child and St. Joseph in the collection of Mr. Vernon in
England [2] ; but they afford no further clue to his career.

Bartolommeo Montagna had a larger grasp of principles than
his Vicentine contemporaries. A born Brescian, or of Brescian
parents, he began life independently between 1470 and 1480,[3]
having finished altarpieces as early as 1483,[4] and dwelling in a
house of his own purchasing at Vicenza in 1484.[5] At a moment
when, as we now discern, his style had not ripened to the
fullness which it afterwards acquired, he was known to patrons
beyond the limits of Vicenza,[6] and is noticed as taking employ-

[1] Padua, Casa Piovene. Half-length, with a patron in prayer, signed " Jo.
Sperancia pin." but greatly repainted. [* The editor has not been able to trace
this and the following painting.]

[2] No. 295 at Manchester Exhibition of 1857, inscribed " Giovanni Speranza,"
belongs to G. E. A. Vernon, Esq. [* Other extant works by Speranza are :
(1) Budapest, Picture Gallery, No. 95. The Virgin and Child, signed " Joann . . .
Sper . . . pinxit." (2) Milan, Brera, No. 224. The Virgin and Child between
SS. Mary Magdalen and Joseph, signed " Joañes Sperãtia pisīt." (3) Vicenza, ex-
monastery of San Domenico, refectory. The Crucifixion ; the Agony in the Garden.
Frescoes, much injured ; executed in 1526. Cf. Borenius, ub. sup., p. 218.]

In the style of Verlas and Speranza we have : (1) Padua Comune, No. 448.
Virgin adoring the Child between St. Catherine and another saint. (2) No. 456.
Small panel of the Virgin and Child. These are feeble clear pieces of careful
execution.

Missing: (1) Vicenza, San Tommaso. Incredulity of St. Thomas, with a
kneeling nun (Boschini, Gioielli, p. 54). (2) San Francesco. Virgin and Child
between St. Joseph and St. Anthony of Padua, with a small Nativity in the
Virgin's throne (ibid., p. 86, and Vendramin Mosca, i. 46). (3) San Giacomo
(Carmelitani). Crucifixion of the Child St. Simonetto at Trent (Gioieli, p. 106 ;
Mosca, i. 52). (4) San Bovo. Virgin and Child between St. Paul and St. Bovo
(Gioieli, pp. 126-7). (5) San Bartolommeo (?). Virgin between SS. John the
Baptist, Augustine, Jerome, and Bernardino, with a predella containing the
Baptism of Christ, the Marriage of the Virgin, and an Ecce Homo ; also the
ceiling of the chapel containing the altarpiece " in the style of Speranza" (Gioieli,
p. 88); but Mosca says the ceiling is by Montagna (Mosca, i. 7).

[3] He is called " Barth. Montagna qᵐ Ant. ab Urcis novis pictore, et habit. in
civ. Vincentiæ," in a will, dated 1480, to which he was a witness. See Magrini,
Elogio di B. M., ub. sup., p. 43. Orzinuovi is near Brescia.

[4] In the will of Gaspar Trissino, dated Vicenza, June 30, 1483, the testator
orders a residue of five ducats to be paid to Montagna for a picture done by him
for the church del Lazaretto. (Magrini, pp. 34, 43.)

[5] Deed of purchase March 5, 1484, and will, postea. (Magrini, pp. 34, 43-4.)

* [6] On August 15, 1482, Montagna was commissioned by the Scuola Grande di
San Marco at Venice to execute two paintings for the house of that brotherhood,
one representing the Deluge, the other the Creation of the World or some other

ment at Bassano in 1487.[1] What he did at that time must
necessarily have been of little account as compared with creations
due to a more recent period. Amongst the earliest productions
of his brush we count the Madonnas of the Lochis collection at
Bergamo; of San Bartolommeo, now in the gallery of Vicenza ;
of San Giovanni Ilarione, once in San Lorenzo at Vicenza : the
first of which seems to have been executed in 1487, and the last
not much later. In these and some other examples Montagna
does not issue from the formal path familiar to the painters of
his vicinity. He places the Madonna on a throne or in adoration
between two standing saints, in cold or composed attitudes ;
he is very careful, and shows diligence in minutiæ of foreground
or distance ; he has but little of the boldness of after-years. At
Bergamo his figures are firm in movement ; they are outlined
and touched without timidity or hesitation ; but the frames are
slender and stiff, dressed in broken drapery unrelieved by broad
shadow. The masks are in the quiet mould of Speranza's, and
coloured in hard even tints of viscous tempera impasto.[2] The

subject from Genesis. Sansovino states that Montagna began " the Ark of Noah "
(*Venetia*, p, 286), but is silent as to the other picture. Whatever Montagna
painted in the Scuola was destroyed by the fire which ravaged it in 1485. See
also Borenius, *ub. sup.*, p. 7.

[1] March 9, 1487, payment of l. 6, soldi 4, arch. com. of Bassano in Magrini,
p. 44. We find no works of Montagna's at Bassano, but are reminded of his style
in a Virgin and Child between two Saints, by old Bassano, in the Communal
Gallery, a picture inscribed and with the date of 1519 (No. 2, Bassano Gallery).

[2] Bergamo, Lochis Gallery, No. 128. Small panel, very much flayed. Virgin
and Child between SS. Sebastian and Roch, inscribed: " B. Mōtagna f. "; but on
the back of the panel we read: " Mr Biolameus Mōtagna brixianus habitator
Vincētia hanc depinxit, &c., 1487. . . ." A cold-toned curtain behind the Virgin,
a parapet behind the throne, and through the openings behind, sky and landscape.
This picture belonged to Count Brognoli at Brescia in 1816 (Campori, *Lettere*,
p. 418).

* A fresco of the Virgin and Child now in the National Gallery (No. 1696)
shows in composition, drapery, colouring, and the type of the Madonna a close
affinity to the above panel. According to an inscription on the modern frame of
the National Gallery painting, this was executed in 1481 for the choir of the
church of Magrè, near Schio. See Borenius, *ub. sup.*, p. 10. In this connection
we may also mention a number of other early Madonnas by Montagna in the
Museo Civico of Verona (No. 396), the collection of Signora Fanny Vaeni of
Venice, the Kunsthalle at Bremen (No. 16), the collection of M. P. Delaroff
of St. Petersburg, the Museo Civico of Vicenza (No. 270), the Brera Gallery
(No. 161; cf. *postea*, p. 132, n. 1), and the National Gallery (No. 1098). See
ibid., pp. 15 *sqq.*

Virgin adoring Christ between St. Monica and St. Mary
Magdalen in the Gallery of Vicenza,[1] and the Madonna between
St. Anthony of Padua and St. John the Evangelist at San
Giovanni Ilarione,[2] are not less careful than that of Bergamo.
An Umbrian repose dwells in the lazy calm of the dramatis
personæ, reminding us of Speranza and Cotignola ; but the faces
have peculiarities by which Montagna is always distinguished, a
long oval, though not a simple shape, a thin barrelled nose,
arched brows, a small mouth with a round projecting chin, and
eyes of great convexity guarded by broad and drooping upper
lids. Such works as these testify to Montagna's undeveloped
power, as he first entered on his profession, and prove him to
have been bred in the local school of Vicenza.[3] In 1491 he was
accounted the best amongst the masters of the town, and his
name in public records is coupled with the flattering qualification
of *celeberrimus pictor*.[4] In close proximity to Venice, where the

[1] Vicenza Gallery, No. 257, from San Bartolommeo of Vicenza. Canvas. The
Child lies on an elevation in a trellis through which a landscape appears. The
foreground is abraded. This picture is mentioned in all the local guides.

* We find the same blond and cool quality of colour as in the above painting
in a number of other early works by Montagna, namely, a Madonna in the collection
of the late Sir W. Farrer at Sandhurst Lodge, a Virgin and Child with St. John
in the collection of the late Dr. L. Mond of London, a Madonna in the Metropo-
litan Museum of Art at New York, Christ appearing to the Magdalen between
SS. John the Baptist and Jerome, once in San Lorenzo of Vicenza and now in the
Kaiser Friedrich Museum of Berlin (No. 44B), and a Madonna between four saints
originally above the high altar of San Bartolommeo at Vicenza and at present in the
Museo Civico of that town (No. 283) ; cf. *postea*, p. 134, n. 4. See Borenius,
ub. sup., pp. 19 *sqq.*

[2] San Giovanni Ilarione, near Vicenza ; done for the Balzi-Salvioni family, and
originally in San Lorenzo of Vicenza (*Gioielli*, p. 104 ; Ridolfi, *Marav.*, i. 141).
Wood, figures less than life-size. The throne is in front of a gilt pattern screen,
behind which sky and trees. The Virgin's head reminds us by its affectionate air
of Filippino Lippi. St. John is soft, after the fashion of Pinturicchio. The
colours are worn away and altered by damp ; treatment, mixed oil and tempera ;
inscribed : " B . rtholomeus Montagna pinxit." Three or four pieces in the dress
of the Evangelist are scaled off.

* [3] There is reason to think that even the earliest extant works by Montagna
show the influence of various Venetian artists. They especially recall the
Vivarini and Antonello. See Berenson, *Lorenzo Lotto*, pp. 47 *sqq.* ; Borenius,
ub. sub., pp. 31 *sqq.*

[4] A record of Dec. 16, 1488, relates to the purchase of lands near Vicenza by
B. M. (Magrini, p. 34).—His son Benedetto is noted as " magister pictor " in another
record of May 22, 1490 (*ibid.*, p. 34), and a third dated June 10, 1491, which is that

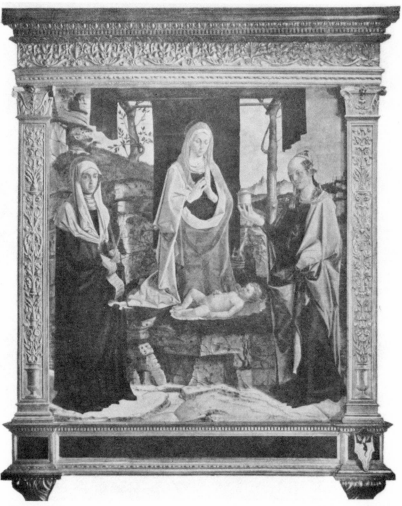

THE VIRGIN AND CHILD WITH SAINTS.

Bellini held pictorial sway, he soon learnt to appreciate the talents of its chief celebrities; he became attracted by the charm of Bellinesque arrangement, and sympathized with the rugged nature of Carpaccio's art. A new force became apparent in him; he acquired skill in delineation, a tendency to realism in nude, and resolute action. Under these altered conditions he produced, we may suppose, the Virgin and Child between St. John the Baptist and St. Onofrio, a dusky brown picture, once at San Michele and now in the Gallery at Vicenza, in which the lean-ness of his figures gains a strong significance.[1] But his style did not reach its true development till after he had visited Padua. In that city, to which he probably transferred his atelier for a time in 1491, he left broad traces.[2] He painted a fresco of the Crucifixion at Praglia, in which masculine development and over-weight of head reveal his contact with Montagnana; and he had

cited in the text, refers to the sale of lands previously purchased—1488 (*ibid.*, p. 34).

* Magrini states that the above-mentioned record of May 22, 1490, is to be found in the *Atti* of Pietro Revese in the Archivio Notarile at Vicenza. Yet the only document of 1490 which the said *Atti* contain is one dating from Dec. 16, in which *Bartolommeo* Montagna, not Benedetto, appears as taking part in the negotiations about a sale which was concluded between the sons of Pietro of Brescia and Baldissera, the brother of Bartolommeo Montagna. It should be noticed that the terms "Bartholameo dicto Montagna" used in this record may through the contractions well have been read by a careless eye as "Benedicto Montagna."

[1] Vicenza Gallery, No. 273, originally in San Michele of Vicenza (Ridolfi, *ub. sup.*, i. 141; Boschini, *ub. sup.*, p. 45; and Mosca, *ub. sup.*, i. 88). Wood, oil, greatly injured by scaling, inscribed: "Opus Bartholomei m" The scene is in a bower, as in No. 257 of the Gallery of Vicenza. There are pieces wanting in the Virgin's mantle, the frame and limbs of the Baptist.

* Allied in style to this work is a half-length of the Virgin and Child in the Museo Civico of Belluno. See Borenius, *ub. sub.*, p. 42.

* [2] The account of Montagna's life and work between 1491 and 1496 given by the authors is not borne out by the facts. Firstly, as to the visit which he is supposed to have paid to Padua, there is absolutely no evidence that he was there in 1491; and it is only an assertion of some writers (the earliest being, I think, Rossetti, *Descrizione delle pitture . . . di Padova*, 1765, p. 143) that the series of portraits in the Vescovado was painted in 1494. We have nothing to prove that the fresco at Praglia was executed between 1491 and 1496; and the only fresco in the Scuola del Santo that can be ascribed to Montagna certainly belongs to a much later period of his life, as does also the *pala* in Santa Maria in Vanzo. Furthermore, we now know from contemporary records that the frescoes in the Cappella di San Biagio in SS. Nazaro e Celso at Verona were painted in 1504-6, not in 1491-3.

a large share, we may believe, in the long series of portraits which decorates the hall of the episcopal palace.[1] With more versatility than Montagnana and greater facility for finish, he surpassed him also in truth and variety of movement, in a just application of perspective laws, and in appropriate cast of drapery. At the Vescovado, especially, he excels in the management of dress, to which he gives the Umbrian branching fold; he contrasts tints with a bolder harmony; and though his forms retain something of the bony rigidity and coarseness by which he and Montagnana are both distinguished, they are animated with a peculiar spirit, derived after a lengthened study from Carpaccio. It was not unnatural that his residence at Padua should have brought him into companionship with the ablest follower of the Mantegnesque style; but the models of Mantegna himself necessarily occupied his attention; and his admiration for them is reflected in all the frescoes and altarpieces which he subsequently completed. Of these the most important at Padua is the Virgin and Child between four saints at Santa Maria in Vanzo, where the sternness and force of Mantegna are united to the dryness, sharpness, and bold balancing of primary tints familiar to Carpaccio. Melancholy composure in the regular head of the Virgin is ably contrasted with calm severity of mien in the saints, and the vestments are cleanly moulded to the frames as if they were of bronze.[2]

[1] Padua. See *antea* in Montagnana as to the period and authorship of these portraits.

Praglia. Fresco in the refectory, representing the Crucified Saviour between the Virgin and Evangelist; the Magdalen at the foot of the cross, and to the right a kneeling figure. The fresco had been whitewashed and has been since recovered; but the five lower figures are repainted, and the Eternal with angels in a lunette is but just visible. The outline of the Saviour is masculine and powerfully rendered in Montagna's fashion. The authorship of our Vicentine is affirmed by the Anonimo (p. 3). [* The Crucifixion has now been removed from the refectory to another room.]

Vasari assigns to Montagna the Madonna of Mont'Ortone, but see *antea* in Montagnana.

[2] Padua, Santa Maria in Vanzo, high altar. The Virgin is enthroned in a portico, between SS. Peter, John the Baptist, Catherine, and Paul. Two angels play instruments at the foot of the throne, and there are three medallions in a lower framing, in two of which are poor figures of St. Lorenzo and St. Francis. On the stem of a pear on the foreground a cartello with the words: "Opus Bartolomei Mõtagna." Canvas, oil, the flesh of a ruddy tinge laid in at one

From Padua, where he produced much that has since perished, Montagna proceeded to Verona, whither he was called by the superintendents of an oratory founded in honour of San Biagio in the church of SS. Nazaro e Celso. In the summer of 1491 the first mass had been read in the new building, to which the relics of St. Biagio were to be translated, and it was proposed that the cupola should be decorated by Falconetto, whilst Montagna furnished the picture for the altar of the apsis and the subjects on the walls and semidome. In 1493, at which time Falconetto was at his labour's end, Montagna also completed his

painting after Carpaccio's manner. [* This is surely a comparatively late work by Montagna, as is proved by the soft colouring, and also by the landscape and the sentiment of the whole scene, which clearly reveal the influence of Giorgione and Titian. Akin to it in the type of the Virgin and the action of the Child as well as in the general characteristics of style is a Madonna in the collection of Signor Achille Cologna of Milan (signed "Opus Bartolomei Montagna"). See Borenius, *ub. sup.*, pp. 72 *sq.*]

The Coronation of the Virgin, St. Lorenzo Giustiniani and other saints, a fresco in the apsis of Santa Maria in Vanzo, has been attributed to Montagna, but looks of a later date and done in the style of Girolamo del Santo (Brandolese, *Pitt. di Pad.*, p. 73).

As missing we note : (1) Padua, Casa Marco da Mantoa. Head of the Virgin. (Anonimo, p. 25.) (2) Padua, Santo. Fresco of St. Giustina on a pilaster. (Anonimo, p. 8.)

The Anonimo (p. 10) also assigns to Montagna frescoes in the Scuola del Santo. These frescoes suggest some remarks.

The subjects were given out to different painters at different times—some of them are by Titian ; they are taken from the legend of St. Anthony of Padua and the beato Luca Belludi. There are but three in the series likely to suggest any doubts as to their authorship. 1°, St. Anthony admonishes Ezzelino ; 2°, St. Anthony miraculously averts a Storm. These two frescoes are a mixture of the Squarcionesque and German ; the figures being coarse and vulgar, yet still distantly like those of Montagna. If he did this at his first coming to Padua, he improved greatly afterwards : the composition is poor ; there is a lack of life in the personages, though resolute action and bold execution are not quite wanting ; and the colours are reddish and rough. In the Admonition some groups suggest the artist's acquaintance with engravings by Lucas of Leyden. 3°, St. Anthony appears to Luca Belludi. This is a wall-painting of the beginning of the sixteenth century, by a painter whose art recalls that of Filippo of Verona or Michele of Verona. The vulgarity of the figures exceeds anything of the kind in Montagna. [* The authors' hesitation in connecting any of these paintings with Montagna is indeed fully justified ; but there is a fresco in the Scuola del Santo which shows all the characteristics of Montagna's style, namely, that representing the opening of St. Anthony's tomb in 1350 (cf. Frizzoni, *Notizia d'opere di disegno*, p. 21). It is obviously a late production of the artist's, coming close to the *pala* of Santa Maria in Vanzo.]

part; and though damp has all but obliterated his compositions, and local jealousy induced the Veronese to substitute a work of Bonsignori's for his, the fragments of both are still in existence, and of considerable value as mementoes of his manner.[1] In the sections of the semidome are St. Biagio and six companions, whilst the four walls of the apsis contain remains of incidents taken from the saint's legend, his solitude on the Argean mount, where beasts and birds flocked round him for a blessing, his cure of a cripple when led to prison, his torture with the card, and his execution. In the dim figure which centuries have darkened or abraded, and in the graven outlines which survive the scaling of the colours, we note Montagna's study of nature, his realism in portraiture, his firmness and precision in drawing. He reveals force without selection, and prefers wiry to fleshy models, though

[1] Verona, San Biagio. The chapel was founded on May 7, 1489, the first mass was read on the 23rd of June, 1491, and the walls were ready for painting at the end of the following July. (*Di Santo Biagio, &c., venerato in SS. Nazaro e Celso di Verona*, by Luigi Brusco, 12mo, Verona, 1834, pp. 59 *sqq.*) We have the authority of Moscardo (*Historia di Verona*, 1668, p. 95) and of Dal Pozzo (*ub. sup.*, *Pitt. Veronesi*, p. 255) to the effect that the frescoes in San Biagio are by Montagna. The style alone proves it. That Falconetto's part was finished is proved by the account-books of San Biagio (Brusco, *ub. sup.*, p. 65). [* The records of the payment of Montagna for the frescoes in San Biagio embrace the time between June 17, 1504, and Feb. 6, 1506; see Biadego, in *Nuovo archivio veneto*, ser. ii. vol. xi. pp. 116 *sqq.* Falconetto painted in San Biagio between 1497 and 1499; see *ibid.*, pp. 110 *sq.*]

The altarpiece, of which the centre is missing, has been attributed without authority (Vasari, Annot., v. 330) to Girolamo dai Libri.

In the first fresco San Biagio, seated in a white tunic and red mantle, gives the blessing to a bird; he is surrounded by animals in a landscape. The figure is partly obliterated. In the second he cures a cripple, but much of the composition is lost. In the Torture some heads are preserved and have a fine portrait character. The Decapitation is quite ruined. Where colour remains it is in a reddish monotone.

The parts of the altarpiece here preserved are panels in oil, with figures about half the size of life, the standing saints in a portico, the other panels half-lengths, one with St. Giuliana slightly injured, that in possession of Dr. Bernasconi [* now in the Museo Civico of Verona] slightly abraded in the hand of the saint to the right (a friar). The head of Christ in the Pietà is spotted.

* This polyptych adorned originally the high altar of the church of SS. Nazaro e Celso, and has never been in the chapel of San Biagio. It is no doubt contemporary with Montagna's frescoes in that chapel. For its history, see Borenius, *ub. sup.*, pp. 58 *sqq.*—In 1507 Montagna finished an altarpiece for the church of San Sebastiano at Verona; this painting is now in the Venice Academy (see *postea*, p. 132, n. 4).

his contrasts of light and shade are still strong and well made
out. To these we add the altarpiece, of which the wings and
upper course are separately exposed in the transept and sacristy
of San Nazaro, and in the collection of Dr. Bernasconi. In the
right transept, St. John the Baptist, accompanied by St. Benedict
and the SS. Nazaro and Celso ; in the sacristy, the Saviour in his
tomb supported by angels, St. Giuliana and a Franciscan martyr; at
Dr. Bernasconi's St. Biagio and another saint.[1] In the Redeemer's
lean and macerated frame and face, great power and a vulgar but
dramatic expression ; in the saints strong relief and accurate
proportion of shadow, finished form and serious energy of mien ;
the colours, as in Carpaccio, sharp but harmonic in juxtaposition,
the flesh tint low but fused and of enamel brightness. Bellini,
Carpaccio, Mantegna, had all been studied by Montagna before
producing this masterpiece ; and Antonello too, whose system of
opaque treatment, with its metallic and glowing brilliancy, is
followed here, as it is by Montagna's friend Buonconsiglio, with
great cleverness and effect.

At the close of 1496 Montagna returned from his wanderings
and settled down to constant duty in his favourite residence of
Vicenza.[2] He devoted two years to a Madonna with Saints for
the chapel of the Squarzi family at San Michele of Vicenza;[3] he
delivered an altarpiece of considerable dimensions to the neigh-
bouring church of Sandrigo,[4] and accepted a contract for a picture
in the Duomo from Cardinal Zeno ;[5] of these three pieces the

* [1] The last-mentioned picture is now in the Museo Civico of Verona (No. 76).

[2] In September 1497 he is witness to a will at Vicenza. (Magrini, *ub. sup.*, p. 34.)

[3] There are records of payment for the Squarzi altarpiece monthly in the
accounts of the Squarzi reprinted in Magrini (*ub. sup.*, pp. 45-7), and a final state-
ment of debt on Sept. 26, 1499, in which Bartolommeo Squarzi cedes to Montagna
a piece of land in liquidation of all claims. The monthly payments above men-
tioned are made to Philip and Paul, sons of Montagna, who, however, are not
mentioned in his wills.

[4] Sandrigo. The altarpiece here represented the Virgin and Child between
SS. Philip and James, and is noticed by Moschini (*Guida di Venezia*, ii. 607), with
the false date of 1449. It is now missing. [* The editor has been able to identify
this picture with one which some years ago was presented to the Glasgow Gallery.
It is, however, only the work of a weak follower of Montagna. Borenius, *ub. sup.*,
p. 45.]

[5] Vicenza. The altarpiece of the Duomo represented the Virgin, Child, John
the Baptist, and other saints ; it was finished in 1502, and is praised by Boschini
(*Gioielli*, p. 4), and by Mosca (i. 30). It is now missing.

Madonna alone is preserved in the gallery of the Brera at Milan. If at first Montagna appears of timid local habits, he now bursts out into the full swing of exuberant strength. His figures have the size of nature ; the Madonna with the Child in her arms sits on a rich throne in a vaulted portico, lighted by openings cut into lozenges or rounds ; in couples at the sides, St. Andrew and St. Monica, St. Ursula and St. Sigismund; on the pediment three angels with instruments. Without delicacy in the rendering of form, Montagna strikes us here by energetic movement and bold expression. His outlines are very decisive, occasionally sharp and angular ; his drapery, broken by cross folds in the northern fashion, is artfully cast so as to leave flat planes at appropriate distances to suggest the under shape. His proportions are good ; light and shade are well balanced ; and the scale of tints in contrast, whether in dresses or in the marbles of the portico, is calculated with the raw sharpness and success habitual to Carpaccio. With this and with flesh of a reddish brown strongly relieved by dark warm grey, the altarpiece of the Brera seems to combine the vigour of Carpaccio and Signorelli with the muscular dryness of the Mantegnesques and of Dürer.[1]

In this stern way Montagna now proceeds almost uninterruptedly to the end.[2] Within the province to which his practice was now chiefly confined,[3] he found a constantly increasing number of patrons. He painted for San Rocco of Vicenza two altarpieces, now at Venice, in one of which the rude vigour of his style is almost as potently marked as at the Brera;[4] for San Marco of

[1] Brera, No. 165 ; originally in the Squarzi chapel at San Michele of Vicenza (see *antea*, *Gioieli*, pp. 44–5 ; Lanzi, ii. 118 ; Ridolfi, *Marav.*, i. 141). On the step of the throne : "Opus Bartholome Montagna ICCCCLXXXXVIIII." Canvas.

In the same gallery, No. 161, a Virgin and Child between SS. Francis and Bernardino, classed as " an old Florentine," is by one of the Montagna, perhaps Benedetto. The picture was in San Biagio of Vicenza (see *Gioieli*, p. 95) ; it is now greatly damaged. [* In the current catalogue of the Brera Gallery this painting is ascribed to Giovanni Speranza. The editor, however, believes it to be an early work by Montagna. See Borenius, *ub. sup.*, pp. 17 *sq.*]

[2] In Nov. (5) 1499 Montagna buys land at Cittadella, and lets it to the former owner (Magrini, p. 35). In Feb. 1503 he settles some outstanding accounts at Vicenza in the matter of the property ceded to him by the Squarzi (*ibid.*, p. 35).

* [3] Montagna worked in Verona between 1504 and 1506 (see *antea*, p. 130, n. 1), and still later in Padua (see *antea*, p. 128, n. 2).

[4] Venice Acad., No. 80. Wood, m. 2·15 high by 1·62, inscribed with a retouched signature : "Opus bartholom . . Montagna." Virgin and Child enthroned between

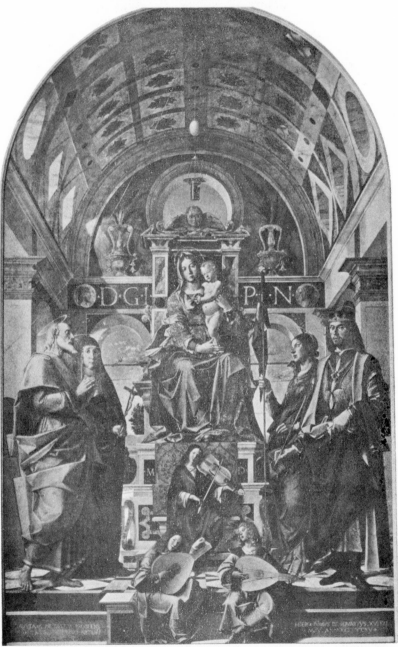

THE VIRGIN AND CHILD WITH SAINTS.

II. 132]

Lonigo, a characteristic votive picture since transferred to the Berlin Museum[1]; for the church of Monte Berico, the Pietà dated 1500, one of those pieces in which models of rustic force are faithfully reproduced, and grimace accompanies the rendering of pain, and yet a strong feeling is created by impassioned action and clever drawing.[2] In a more quiet mood in the same year he finished the Nativity of Orgiano,[3] and the Madonna with Saints at Sarmego[4]; in 1502 the Madonna of the Duomo at Vicenza ordered by Cardinal Zeno, and since lost[5]; in 1503 the Virgin and Child of the Marchese Campori at Modena. There is something half Bellinesque, half Mantegnesque in the air of the Virgin here; a pleasing expression gives charm to her face, and it is a kindly thought to let the Infant free the bird in its grasp instead

SS. Sebastian and Jerome; the Child in a dancing motion, the Virgin heavy in shape, St. Sebastian a disagreeable type of a strong realistic nature. Tone olive, colour viscous, the arrangements of dais and accessories Carpacciesque. The Virgin's dress is injured. Magrini states that this piece was in San Rocco of Vicenza. [* Magrini is mistaken; it was painted in 1507 for the church of San Sebastiano at Verona. Cf. *postea*, p. 135, n. 11, and Borenius, *ub. sup.*, pp. 61 *sq.*]

No. 78. Wood, m. 1·83 high by 1·61, originally in San Rocco of Vicenza. Christ between St. Roch and St. Sebastian, dry lean figures of a less rugged class than the foregoing. [* In the opinion of the editor this picture is too feeble for Montagna and can only be ascribed to his school. See Borenius, *ub. sup.*, p. 91.]

In the same class: Venice, Correr Museum, Sala XV., No. 39, half-length of a female martyr, injured and spotted.

[1] Berlin Museum, No. 44. Canvas, 6 ft. 6 in. high by 5 in., inscribed " Opus . . . Montagna," originally in San Marco of Lonigo, afterwards in the Solly collection. Virgin and Child between St. Omobuono giving alms to a man, and St. Francis, with a small St. Catherine and patron in front ; a dark-tinted picture with a certain monotone in the colours.

[2] Monte Berico. Canvas, oil, figures less than life-size. The Virgin with the dead body of Christ on her lap; to the left Joseph, to the right the Magdalen and Evangelist; distance landscape; sky and foreground new, and the figures all more or less injured; inscribed : " Opus Bartholom. Montagna. MCCCCC v Aprile."

A fresco of the Saviour in the Virgin's lap in the sacristy of this church, much restored, seems by Montagna.

[3] Church of Orgiano, near Vicenza. Canvas, figures all but life-size of the Virgin and St. Joseph praying at the sides of the Infant Christ, who is seated on the ground; landscape distance; inscribed on a cartello : " Opus Bartolomei Montagna MCCCCC." This is a repainted and injured work.

[4] Sarmego. Virgin, Child, the Baptist, and Evangelist; greatly injured. Magrini speaks of a small picture at Vicenza, dated 1502 (not seen). See Magrini, *ub. sup.*, p. 35.

[5] See *antea* and *Gioieli*, p. 4.

of flying it with a string [1] ; one hardly expects such a trait from a man so usually stern as Montagna. Another picture in the grand manner is the Virgin and Child attended by St. Onofrio and the Baptist, and three angels with instruments, in the Certosa of Pavia [2] ; yet another, of great mastery in the intertress of contrasted tints and the balance of light and shade, is the Presentation of the Child in the gallery of Vicenza.[3] A number of

[1] Modena, Marchese Campori. Half-lengths, panel. The Virgin holds the Infant sitting on a parapet; a green hanging intercepts the sky. With her left hand the Virgin holds a book on the parapet. This is a well-preserved picture in which the technical system of Antonello is applied, as it was by Buonconsiglio, in olive and semi-opaque but lustrous tones. Inscribed : " Bartholomei Montagna ac opus MCCCCCIII. die XIII Aprili." [* This picture is now in the Modena Gallery. Allied to it in style are a number of Madonnas belonging to Mrs. Tate of London (cf. *postea*, p. 136), Lord Lucas, Signor Antonio Grandi of Milan, and the Museo Civico at Vicenza (No. 271), a Holy Family in the collection of Sir Hubert Parry at Highnam Court, Gloucester, and another in the Strassburg Gallery (No. 223).]

[2] Pavia, Certosa, above the sacristy door. Figures less than life, abraded.

[3] Vicenza Gallery, No. 263. Canvas. St. Simeon kneels as the Virgin, also kneeling, presents the Child to him; behind the Virgin (left) St. Joseph, behind Simeon a kneeling patron ; in a lunette St. Jerome. This picture was in San Bartolommeo (*Gioieli*, p. 90 ; Mosca, p. 5) ; it is signed " Opus Bartolameus (*sic*) Montagna." The treatment is that of the school of Antonello da Messina, producing a low brownish semi-opaque surface of glowing aspect.

[4] Vicenza, San Bartolommeo. Virgin, Child, and three angels on a pediment between SS. John the Baptist, Bartholomew, Augustine, and Sebastian ; inscribed " Bartholomeus Mōtanea pinxit "; on a predella, the fall of the idol, the casting out of a devil, baptism of a proselyte, St. Bartholomew beaten before the judge, decapitation. This piece is scaled, abraded, and repainted, but still recalls Bellini in its arrangement, and Cotignola in the thinness of the forms. [* This picture is now in the Museo Civico of Vicenza (No. 283). It belongs to an early phase of Montagna's career. Cf. *antea*, p. 126, n. 1.]

[5] Venice, Lady Layard. (1) Small fresco with half-lengths of Christ between a bishop and a female saint. Not without retouching, but strong in colour ; signed " Bartolomeus Motanea pinxit "; originally in the Cappella Tanara at San Gio. Ilarione, near Vicenza. (2) A bust of St. John the Baptist on panel in oil, brown in tone, warm in shadow, firmly touched, and well preserved.

[6] England, late Northwick collection. Procession to Calvary. Canvas, with figures half-size of life, reddish in flesh tone.

[7] Louvre, No. 1393, half-length. Ecce Homo in the glowing tones like Buonconsiglio, fair if not select in nude. Small panel, inscribed on a cartello : " Bartholomeus Mōtagna fecit." (Shadow of torso retouched, ground dark, the signature much rubbed.)

[8] Vicenza, Santa Corona, second altar to the right. The Magdalen on a pedestal in an arched chapel, between SS. Jerome, Mary of Egypt, Monica, and Augustine ; in a predella, the communion of the Magdalen, Noli me tangere, and the Magdalen

less important examples might be cited: at San Bartolommeo of Vicenza,[4] at Lady Layard's in Venice,[5] in the late Northwick Gallery,[6] in the Louvre,[7] at Santa Corona,[8] in the Communal Gallery,[9] in the cathedral,[10] and at San Lorenzo of Vicenza.[11] The latest productions of the master are the Madonna and Saints of 1517 in the Vicenza Gallery [12] and the Nativity of 1522 in the

meeting a priest in the wilderness. The figures are not without grandeur; the drawing is clear, and the tone warm and brown; inscribed : " Opus Bartholomei Montagna." Canvas, with life-size figures.

[9] Vicenza Gallery, No. 274, formerly in San Biagio. Predella with scenes from the life and martyrdom of St. Biagio, once part of a large altarpiece representing the Virgin, Child, SS. Biagio, Francis, a bishop, Anthony of Padua, Bernardino, and Buonaventura (*Gioieli*, p. 94). [* This picture is not by Montagna, but shows a most distinct affinity of style to the frescoes ascribed to Domenico Morone and his school in the library of the monastery of San Bernardino at Verona (see *postea*, p. 194). Cf. Borenius, *ub. sup.*, pp. 99 *sq.*]

[10] Vicenza Duomo, chapel of St. Catherine. Virgin and Child between St. Mary Magdalen and St. Lucy. Canvas, with life-sized figures, signed "Õũ . . . Bar . . . Montagna"; a lunette representing St. Sebastian, Christ, and the Baptist, of the close of the eighteenth century. This is a picture of Montagna's old age, perhaps in part completed by his son Benedetto.

In the Cappella Proto are remnants of a fresco of the Virgin adoring the Child with St. Peter, St. Paul, St. Joseph, and another saint. These remnants have been rescued from whitewash, and recall those of San Biagio at Verona; the forms are fair and very precisely reproduced, but the colours are greatly altered. In the same chapel a kneeling portrait on a pilaster, a ruined figure of St. Anthony the Abbot, and a repainted one of St. James.

[11] Vicenza, San Lorenzo, Proto chapel. On the wall facing a tomb, itself of old decorated with paintings, are remnants of a scene from the martyrdom of St. Peter, apparently the removal of his body after crucifixion. The corpse is removed to the left; there are spectators on foot, a guard on horseback, and others in front of some houses. Little more than the outlines remain, and we are reminded of the later frescoes of Mantegna at the Eremitani of Padua.

Fragments of other frescoes, once in San Marcello, are now in the Scuola Elementaria at Vicenza, and suggest the same remarks as the fragment in the Layard collection.

Verona. Dal Pozzo notices a Virgin between St. Sebastian and St. Jerome, dated 1507, in San Sebastian at Verona. It was removed in 1716 and is now missing (*Pitt. Veron.*, pp. 56–7, 262). [* Cf. *antea*, p. 132, n. 4.] Montagna was in Vicenza in that year, and received payments for work in the town-hall (Magrini, p. 35). In 1508 he sells certain lands (*ibid.*).

[12] Vicenza Gallery, depôt; originally in the church of Breganze, near Vicenza. Virgin and Child between SS. Peter, Anthony the Abbot, Paul, and a bishop; once signed and dated 1517 (Magrini, p. 36); much injured, and in part by assistants. [* There is no longer a picture answering to this description in the Museo Civico of Vicenza, which, on the other hand, contains a Virgin and Child with the Infant St. John, signed " Opus Bartholomei Montagna pinxit 1520 12 Mazo." Borenius,

church of Cologna,[1] both of them inferior to works of a previous time. At intervals he painted small half-lengths of the Madonna, of which several have been preserved, as if to prove that his vehemence could be tempered to a certain amount of delicacy and softness. Two of these are in Vicenza ; two more are in Venice.[2]

ub. sup., pp. 79 *sq.*] In the same collection a Christ at the Column, No. 228, reminiscent of that phase in Montagna in which he resembles Buonconsiglio and Antonello.

[1] Cologna. We have the acknowledgment of debt from the Scuola di San Giuseppe to Montagna for the piece, from which it appears that it was ordered on the 21st of April, 1520, for eighty ducats. The deed of acknowledgment is dated Vicenza, Nov. 4, 1521. The picture, a small canvas in the transept, is inscribed "Bartholameus Montagna MDXXII. dì XIII. Marti." It is much injured by restoring the colour of a reddish brown, the figures short and vulgar. In the middle of the picture, the Infant Christ adored by the Virgin ; at the sides, St. Joseph, St. Sebastian, Job, and the shepherds ; in a lunette, Christ in the tomb between two angels between St. Nicholas and another saint. In a predella, the Marriage of the Virgin, the Circumcision, and the Flight into Egypt.

[2] Vicenza, Signor Jacopo Cabianca. The Infant is seated on the parapet before the Virgin. Two openings in the background expose a view of sky and landscape. Wood, oil, figures half the size of life. [* The present owner of this painting is not known to the editor.]

Vicenza, Casa Tressino. Virgin and Child in a landscape ; inscribed " Opus Bartolomei Montagna." Panel, much injured. [* This might perhaps be the picture now in the collection of Signor A. Cologna of Milan ; see *antea*, p. 128, n. 2.]

Venice, Signor Felice Schiavoni. Virgin and Child in a landscape. Arched panel in a pillared frame of the period, in oil, and a little raw. This is feebly treated as if with the assistance of Benedetto, and reminds us, as all poor Montagnas do, of the Cotignola. [* Possibly identical with the Holy Family now in the Museo Civico of Venice ; see *postea*.]

Same hand : Virgin and Child in front of a green curtain. The Virgin prays with joined hands; the Child holds a book. Marks of restoring are in the forehead and cheek of the Virgin and in the forehead of the Infant. This, however, is a better picture than the foregoing. [* It was subsequently in the Samuelson collection, and belongs now to Mrs. Tate of London.]

Rovigo, Galleria Comunale, No. 136. Virgin and Child with the boy Baptist. Later than Montagna and in the manner of Polidoro.

Venice, Signor Rotamerendis. In the hands of a gentleman of this name, Magrini mentions a Christ in benediction, inscribed : " Opus Br̃meus Mõtagna, Vincentia die 24 m. Ot̃bres 1507 " (Magrini, *ub. sup.*, p. 38). This is no doubt the same mentioned in Cicogna, *Iscr. Venez.*, iv. 386–8, as having been in San Giorgio at Venice. [* The painting under notice is now in the collection of Dr. Fritz Harck of Seusslitz, Saxony. The signature has been cleaned, and at present reads : "Opus Bartholom. Montagna (trace of a word) die 24 septembris 150 " (last figure illegible). See Harck, in *Archivio storico dell' arte*, ser. i. vol. ii. pp. 213 *sq.* —The following extant paintings by Montagna still remain to be mentioned : (1) Bergamo, Galleria Morelli, No. 44, St. Jerome, Signed " Opus Bartholomei

In October 1523 Bartolommeo died, bequeathing the bulk
of his property to his son Benedetto [1]; he bequeathed to him
also his practice; but from 1528 to 1541, during which Bene-
detto is known to have produced numerous altarpieces in Vicenza

Montagna." (2) Cartigliano (near Bassano). Parish Church, chapel to the left.
The Virgin and Child between SS. John the Baptist and Peter ; in a lunette, God
the Father worshipped by two angels. (3) Englewood, New Jersey. Collection
of Mr. Dan Fellows Platt. The Virgin and Child (4) London, collection of
Mr. Edmund Davis. St. Jerome. (5) London, collection of the late Sir William
Farrer. The Vestal Claudia ; a Marriage Scene. *Tondi* from a *cassone.* (6) Milan
collection of Dr. G. Frizzoni. St. Jerome. (7) Milan, collection of Sig. A. Grandi.
St. Sebastian. Signed "Opus Bartholomei Montagna." (8) Museo Poldi-Pezzoli
No. 617, St. Jerome. No. 618, St. Paul. The Vestal Tuccia ; Bilia and Duilius
(*tondi* adorning a *cassone*). (9) Paris, Louvre, No. 1394. Three Angel Musicians,
Signed "Opus Bartholomie Montagna." (10) Venice, Caregiani collection. The
Virgin and Child between SS. John the Baptist and Francis. Signed " Bartho-
lameus Montag m pinxit." (11) Vicenza, Casa Franco. Christ bearing the Cross.
—The editor has not seen two single figures of SS. Bartholomew and Augustine
which belong to the Duke of Norfolk and are ascribed to Montagna. They formed
originally the insides of the shutters of the organ in San Bartolommeo at Vicenza.]
 There are several pictures of Montagna's missing ; others are incorrectly named ;
some have not been seen by the authors. (1) Bologna, Galleria Ercolani. Virgin
and Child and a distant landscape, inscribed : "Bartolamio Scholaro de Ze Be."
This has been assigned to Montagna, but it is probably by another painter (Magrini,
p. 36). It is now mislaid. (2) Venice, Scuola di San Marco. " Vi fu anco comin-
ciata l'arca di Noè da Bartolomeo Montagna " (Sansovino, *Ven. Descr.*, p. 286).
[* Cf. *antea*, p. 124, n. 6.] (3) Vicenza, Chiesa degli Angeli. St. Sebastian between
SS. Roch and Bellinus : above, the Virgin and Child, SS. Francis and Anthony of
Padua (Boschini, *Gioieli*, p. 75). Missing, as are likewise : (4) San Bartolommeo.
Four large figures once on panels closing the great organs (Magrini, p. 39).
[* Cf. *antea*.] (5) Vicenza, San Biagio. Virgin and Child between SS. Nicholas
and John the Baptist, with two children playing instruments (*Gioieli*, p. 92). (6)
Nativity (Ridolfi, i. 141). (7) Carmelitani, chapter-house. Virgin and Child,
crowned by two angels, between SS. John the Baptist and James ; two angels.
(8) San Girolamo. Fresco of St. Jerome in the desert above the outer portal
(*Gioieli*, p. 83). (9) Casa Gualdo. The whole house was decorated internally with
frescoes by Montagna (Magrini, pp. 40–41). (10) San Felice. Here were four
altarpieces of which the subjects are not given (*Gioieli*, p. 125, but see Benedetto
Montagna). (11) San Lorenzo. Christ appearing to the Magdalen, St. Jerome,
and St. John the Baptist (*Gioieli*, p. 105 *bis*). [* Cf. *antea*, p. 126, n. 1.] (12)
Crucifixion (Ridolfi, *Marav.*, i. 141). (13) San Rocco. St. Roch, St. Sebastian,
and an angel (Ridolfi, i. 141). (14) Scoletta di Santa Barbara. Virgin and Child
between a bishop, St. Gottardo, and St. Job (*Gioieli*, p. 121). (15) San Tom-
maso. Virgin and Child between St. Thomas, St. Augustine, and a male and
female patron (*Gioieli*, p. 53).
 [1] Montagna made two wills, one dated October 5, 1521, which is almost repeated
in a second, dated May 6, 1523. There is no artistic interest served by the pub-
lication of either. The first was drawn up by a lawyer, Francesco Zanechini, to

and its vicinity, he did not exhibit anything like the talent of
his father.[1]

In Giovanni Buonconsiglio, commonly called "il Marescalco,"
Vicentine art offers a new variety. This painter having, we

whom Montagna "pro solutione dedit unum quadrum Virginis Mariæ"—in
margin of will of 1521 (Magrini, p. 49). To the will of 1523 the same notary
makes this note in chalk: "Nota quod die Dominica XI:a mensis Octobris
suprascriptus prædictus testator ex hac vita migravit . . ."

[1] We have seen (*antea*) that Benedetto was the son (he has usually been called
the brother) of Bartolommeo Montagna. He seems to have acted as his father's
assistant so long as his father lived. His own works date after Bartolommeo's
death. [* This is not the case; for in 1522 he is recorded as having painted by
himself some frescoes in a chapel in Sant' Agostino at Padua. These paintings
are now destroyed. See Moschetti, *La prima revisione delle pitture in Padova e
nel territorio*, i. 25.] By him we have (1) a Virgin and Child between SS. Peter,
Paul, Francis, and Anthony of Padua, in Milan, Brera, No. 159, inscribed: "Bene-
detto Montagna pinxit, 1528," a dark-coloured panel, ruined by restoring, and dis-
playing little beyond the decrepitude of Bartolommeo's art. (2) There is a Trinity
between St. Monica and St. John the Baptist, in Vicenza, Duomo, canvas, oil,
with figures all but life-size, inscribed: "Benedictus Montagna f. 1535," dark in
tone, but better than the foregoing. [* This picture is now in the Museo Civico
of Vicenza, No. 268.] (3) A Virgin and Child between St. Christopher and
another (female) saint, assigned to Bartolommeo (Ridolfi, i. 141), is in Lonigo,
Duomo (choir), inscribed with a new signature: "Benedetto Montagna m' a pense
1541," ruined. Further, (4) Modena Gallery, No. 34 (Cat. of 1854). Virgin and
Child receiving a flower from St. John the Baptist, three angels, signed and dated
"1548. M. B." Ugly and mechanical work, and if by Benedetto, which may
be doubted, singularly like one by Bernardino Loschi. (5) Stuttgart Museum, No.
509. Marriage of St. Catherine, assigned to Bartolommeo, but of the school and
perhaps by the son. [* This picture is now labelled "North Italian school of
the fifteenth century." It shows exactly the same characteristics of style as the
Veronese paintings mentioned *antea*, p. 135, n. 9. (6) In Santa Maria del Carmine
at Vicenza there is a Virgin and Child between SS. Sebastian and Anthony the
Abbot, signed "Beneditus Montagna p." This is a poor work, imitated from
the Squarzi altarpiece by Bartolommeo now in the Brera, and from the same
artist's Madonna and Saints at present in the Venice Academy.]

Missing: (1) Vicenza, Servi. Trinity with SS. Giustina, Christopher, John the
Baptist, Anthony the Abbot, and another (female) (*Gioieli*, p. 38). (2) San Biagio.
Coronation of the Virgin, with St. Anthony the Abbot below, dated 1535 (*Gioieli*,
p. 92, and Ridolfi, i. 141). Nativity, dated 1534, with a Conversion of St. Paul in
a predella (*Gioieli*, p. 93). Virgin and Child between St. Peter and St. John
Evangelist (*Gioieli*, pp. 93, 94). (3) Virgin and Child, St. Francis, and St.
Bernard (? Milan, Brera, No. 161). See Boschini, *Gioieli*, p. 95. (4) Carmelitani.
Virgin and Child, angel on the throne-step with a lute, two angels hanging the
crown above the Virgin's head, St. Sebastian and St. Anthony the Abbot (*Gioieli*,
pp. 106 *sq.*). [* Cf. *antea*.] (5) San Rocco. Virgin and Child between St.
Sebastian and St. Roch (*Gioieli*, p. 118). (6) San Felice. Ridolfi assigns to
Benedetto here: 1°, Massacre of the Innocents; 2°, Virgin and Child between

think, been assistant to Speranza,[1] felt the influence of the
Paduan school, and subsequently took Antonello da Messina
for his model. He was the contemporary of Montagna, with
whom he had some general affinity of thought and of manner ;
and he practised alternately at his birthplace Vicenza, at
Venice, and in the neighbouring provinces.[2] Till very late in
the fifteenth century he clung to tempera ; and one of the most
striking of his works is that which he completed in that medium
for San Bartolommeo of Vicenza. It is the production of a man
well acquainted with the technical difficulties of his profession,
familiar with the anatomy of the human frame, and so far
advanced in study as to have acquired types and masks pecu-
liarly his own. His subject is the favourite one of the Virgin,
Evangelist, and Magdalen mourning over the dead body of the
Saviour. He represents it in a sad sepulchral way, with great
force of action and anguish of expression, and with strong
realism. Endowed with searching powers and a truer feeling
for colour than Montagna, he still wants attractiveness. The
Saviour, in his conception, is an emaciated corpse, of good
proportions and vulgar parts, rigid in death, and lean from
suffering ; the Virgin wailing with the head of Christ on her
lap, a woman of everyday aspect ; the Evangelist wringing his
fingers with violence, a man of coarse nature ; the more placid

SS. Felix and Fortunatus ; 3°, SS. Florian, Simplician, Prudentia, and Perpetua ;
4°, a picture with saints. These seem the four altarpieces assigned by Boschini
(*Gioieli*, p. 125) to Bartolommeo. (7) Monte Berico (church of). Adoration of
the Kings (*Gioieli*, p. 61). (8) Verona, private gallery at Sant' Elena al Duomo.
St. Jerome in the Desert (Dal Pozzo, p. 284). (9) Padua, Sant' Agostino. Chapel
by Benedetto, "fiol del Montagna" (Anonimo, p. 31). [* Benedetto Montagna
was also active as an engraver. For a notice of his work in this capacity, see
Borenius, *ub. sup.*, pp. 116 *sqq.*]

* [1] Cf., however, *antea*, p. 122, n. 2.

* [2] Whilst still a comparatively young man Buonconsiglio went to Venice.
Indeed, the earliest known document in which Buonconsiglio's name occurs,
dated Jan. 22, 1495, shows him as residing in that town ; and he made it his
home for the rest of his life. He always, however, kept in touch with his native
country : he executed pictures for its churches ; he paid the tax at Vicenza,
where he possessed a house in the Contrada di Santa Corona. For some time
during the second or third decade of the sixteenth century he was working at
Montagnana near Padua. He was still living in May 1535, but was dead
in 1537. See Ludwig, in the Berlin *Jahrbuch*, xxvi. Supplement, pp. 88 *sqq.* ;
Borenius, *ub. sup.*, pp. 155–8, 193 *sq.*

Magdalen, a portrait. The heads are all short and square, and
with horizontal lines out of proportion long ; the features con-
tracted into angles, and energetic as in Dürer ; the drapery
clean in cast, but broken like Mantegna's. Skill is shown in
chiaroscuro and reflections ; and broad effects are attempted by
an application of· evening light, especially to the landscape and
clouded sky. The picture thus produces an impression of power,
and yet it is unpleasant, from the earthy tinge of the flesh, the
greenish brown tone of the surface, and the common air of the
figures. If there be any other peculiarity in addition, it is that
the hands are thin and small, and awkwardly cramped.[1] The
difference between Buonconsiglio and Montagna at first may
thus appear to have been confined to technical treatment,
Montagna's colour being lucid, unbroken, sombre, and occasion-
ally harsh ; Buonconsiglio's sombre likewise, but opaque. Their
education in other respects seems to have been the same ;
but whilst Montagna improved by studying Carpaccio and the
Paduans, Buonconsiglio changed under the influence of Antonello
da Messina; and about 1497, when he delivered the Madonna
with Saints to SS. Cosmo e Damiano at Venice, of which a
fragment is still preserved in the Academy, he had turned his

[1] Vicenza Gallery, No. 279 ; formerly in San Bartolommeo (*Gioielli*, p. 90; Mosca,
p. 5). Panel, tempera, in a frame with monochrome arabesques, skulls, vases, tritons,
and cupids. In a pinnacle St. Catherine (No. 278), and in two medallions at the
upper corners the Virgin and Angel annunciate (Nos. 276, 275). It is character-
istic of the execution that there is no trace of stippling or hatching in the tempera.
The landscape of hills and rock is not without atmosphere, and has something
in common with those of Lotto. The touch is resolute and given with a full
brush. The Magdalen wears a fillet with pearls, and a tassel and veil over
her hair. Her yellow dress is slashed and the bodice laced in front, the
same dress as in a portrait at the Louvre, which we may assign to the master
(Louvre, No. 1673, *postea*). On a cartello to the left: "Joanes Bonichōsilii
P. Mareschalcho."
We may add to this early work at Vicenza the following: Vicenza, San
Lorenzo, right transept. Christ crucified between the Virgin and St. John.
Fresco. The Saviour is lean and bony, but drawn in the spirit of Buonconsiglio
and Montagna. Two prophets in rounds, and three angels with the symbols of
the passion below the Crucifixion, are monochromes by the same hand, showing
the influence of Paduan teaching on the Vicentines. Mosca, i. 56, has no name to
append to this fresco, which he calls "mediocre." [* Among the earliest extant
paintings by Buonconsiglio may be classed a half-length of the Virgin and Child
in the collection of Herr A. von Beckerath of Berlin, and a wing of a polyptych,
containing two figures of saints, belonging to Mr. J. Annan Bryce of London.

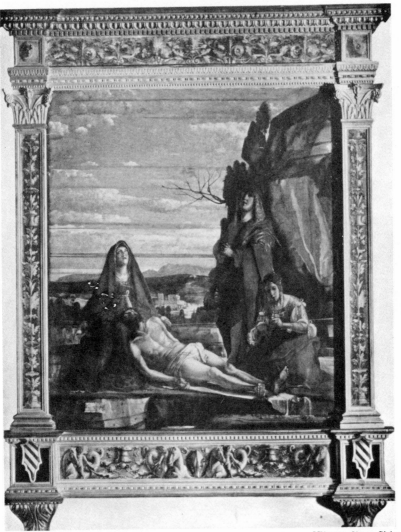

PIETA.

back on the old practice of tempera with steady resolution.[1] His attention was now very exclusively given to the alteration in mediums, and his types thus retain all their early characteristics; but they become brighter and more glossy from the use of brown high surface and semi-transparent shadows and full-bodied lights. Practically, indeed, Buonconsiglio may be considered to have made better and bolder use of the new system than Luigi Vivarini, and to have been at least the equal in this sense of Basaiti, when Basaiti issued from the Vivarini atelier.

There is every reason to believe that Buonconsiglio inhabited Venice constantly at this time,[2] for he adorned several of its churches and public buildings, and his name has been read in the registers of the guild of St. Luke. It is unfortunate only that so many of his pictures should have been lost or mutilated.[3] To correct the absence or insufficiency of these we have the great

[1] Venice Academy, No. 602. Fragment of a large piece in SS. Cosmo e Damiano alla Giudecca, with a cartello let into the right corner containing the signature as follows: "1497 a dìj 22 decēbrio Joanes Boni Chōsilij Mareschalchus da Vicenza p." We have here half of three figures of St. Benedict, St. Tecla, and St. Cosmo, all but life-size; the faces short, broadly shadowed, and well outlined, in the mould of the artist and of Montagna at San Nazaro at Verona. The outlines and shadows are high in surface and laid in over the ground flesh-tone; lights ditto with copious fluid and semi-opaque colour. (See Zanotto, *Pinac. Ven.*, fasc. 3, for the vicissitudes which this picture underwent.) The above-mentioned fragment was once in the Manfrini collection. [* A very important work by Buonconsiglio which also dates from 1497 is a Mystic Conception (the Virgin between SS. Peter and Joseph) in the parish church of Cornedo, near Vicenza (signed "Boniconsilii Joa. fecit 1497"). Borenius, *ub. sup.*, pp. 167 *sq.* Other pictures showing Buonconsiglio in this phase of his career are the portrait of a man (perhaps the artist himself) in the Gallery of the Capitol at Rome (No. 147, signed "Zuane Mareschalcho p.") and an Ecce Homo in the collection of Mr. T. Humphry Ward of London (signed "Joanes Vicentinus pinsit"). *Ibid.*, pp. 168 *sq.*]

* [2] Cf. *antea*, p. 139, n. 2.

[3] Venice Acad., Nos. 601 and 602 (catalogue of 1867). Canvases, representing St. Mark and St. Jerome. These are part of a larger work, of which the lion of St. Mark was the centre, described by Zanetti (*Pitt. Venez.*, p. 68) as in the Magistrato della Messetaria. The missing parts are a Magdalen and St. John the Baptist. Size, m. 0·78 high by 0·65. [The two first-mentioned pictures are obviously identical with those noted under Nos. 155 and 160—as SS. Matthew and Luke—in the current catalogue of the Venice Gallery. They come, however, not from the Magistrato della Messetaria but from the Cappella dei Lucchesi in the Chiesa dei Serviti, and are the work of Girolamo da Santa Croce. The

Madonna and Saints of 1502, originally ordered for the oratory
of the Turchini, but now in San Rocco of Vicenza,[1] where we
observe that he is not content to imitate Antonello's works
technically, but appropriates his types and forms and mode of
expression. The Virgin and Child are still broad in mask, with
the vertical distances shortened to excess, but they are also
fleshy and plump, and the form of the latter is very like that
of Antonello in the Madonna of San Gregorio at Messina.[2] The
nude St. Sebastian is more muscular than that of Antonello,
but quite in his mould and character. We may believe that
Buonconsiglio, for some years of his life, performed the duties
of Antonello's assistant, and had a share in such pictures as the
Pietà at Vienna,[3] the small Head of the Virgin in the Academy
of Venice,[4] and some of the numerous figures of St. Sebastian
preserved in Continental galleries. We might point out two
of the latter especially as deserving of attention in this respect,

painting executed by Buonconsiglio for the Magistrato della Messetaria is at
present in the depôt of the Imperial Gallery at Vienna. See Borenius, *ub. sup.*,
p. 185, n. 2.]

Missing are the following : (1) Venice, San Domenico. Annunciation and
Saints in two compartments (Boschini, *Le Ric. Min.*, Sest. di Castello, p. 14).
(2) SS. Gio. e Paolo. St. Thomas Aquinas and Saints (Boschini, *Le Ric. Min.*,
Sest. di Castello, p. 60). (3) Same convent, refectory. St. Dominic disputing
with Heretics (Boschini, *Le Ric. Min.*, Sest. di Castello, p. 67). (4) San
Giovanni Evangelista. Scene from the legend of the cross (Sansovino, *Ven. Desc.*,
p. 284). [* This is the picture by B. Diana now in the Venice Academy (No
565).] The St. Thomas is the only picture by Buonconsiglio mentioned by Vasari
(iii. 650).

[1] Vicenza, San Rocco (Mosca, i. 107). Virgin and Child in a chapel deco-
rated with mosaics, in front of a red hanging, between SS. Paul, Peter, Dominic,
and Sebastian. Wood, figures life-size, not free from restoring, inscribed on a
cartello : " Joanes Boni-Chonsili pinsit ICCCCCIJ." This picture is sombre in tone
and a little flat, and here and there neglected and puffy in outline. The shaded
side of St. Sebastian's face is repainted, ditto the breast. The outlines are all sharp,
the extremities those of poorer-class models. Treatment hard and horny from
excessive use of vehicle, but still not without modulations. [* This picture has
lately been transferred to canvas and is now in the Museo Civico of Vicenza.]

* [2] In the opinion of the editor, the Child recalls Antonello's *Bambino* only
as regards the poise of the head, while the forms seen quite different. These
and the pose seem, on the other hand, strongly reminiscent of the Infant Christ
in Giovanni Bellini's San Giobbe *pala*, which has served as model also for other
details of this composition. See Borenius, *ub. sup.*, p. 170.

[3] Vienna, Imperial Gallery, No. 5.

[4] Venice Academy, No. 590.

the full-lengths in the Lochis Gallery at Bergamo [1] and in the Casa Maldura at Padua.[2] Two votive altarpieces, St. Sebastian between St. Lawrence and St. Roch, in San Giacomo dell' Orio, and Christ between St. Jerome and St. Secondo in the Gesuati, at Venice, illustrate this period of Buonconsiglio's art, but they also prepare us for a further change in his manner.[3] From 1510 to 1513 he was busy with the completion of three large works for altars in the cathedral of Montagnana. One of them represents the Virgin and Child between St. Sebastian and St. Roch,

[1] Bergamo, Lochis Gallery, No. 222. Small panel, with St. Sebastian in a hip-cloth, bound to a tree, the left hand behind his back, the right above his head; in a landscape with castellated houses. The figure is thin, and of a low tone in the flesh, the shadows high in surface.

[2] Padua, Casa Maldura. [* Now Piazzola sul Brenta, collection of the Conte Camerini.] St. Sebastian bound to the pilaster of a portico, through the arches of which a landscape appears. Panel transferred to canvas, oil, a little flayed, scaled and retouched. The landscape has the melancholy tinge of that in Buonconsiglio's Pietà at Vicenza. The figure is square and fleshy like his later ones.

* Since we now know that Antonello was in Venice perhaps only in 1475-6, and that he died in 1479, it seems hardly likely for mere chronological reasons that Buonconsiglio could have been his assistant. Nor can I see any grounds for connecting Buonconsiglio's name with the wonderful little Antonello at Bergamo, the copy from him at Venice, or the feeble Pietà at Vienna. With the fine St. Sebastian in the Camerini collection the case is different. The type and the rocky ground recall indeed Buonconsiglio. The attribution to Francesco Morone, which I hear that Dr. Frizzoni has proposed for this work, may, however, be the correct one, judging particularly from the analogies which this interesting canvas shows with Morone's St. Francis receiving the Stigmata in the Museo Civico of Verona (No. 348).

[3] (1) Venice, San Giacomo dell' Orio, right of high portal. St. Sebastian bound to a pillar in a chapel; near him, erect, the two saints; on a cartello the words: "Joanes Boni-Chosili dito Marescalcho p." The outlines here are not clearly correct, and the draperies seem flattened down as they might be in a bas-relief, the folds branching in Montagna's manner. St. Sebastian, a common mortal of bony but muscular shape, the head round and short. St. Roch flat-headed, with a pleasing face. The whole is well relieved by equal light and shade, and of glowing colour treated after Antonello's manner. (2) Venice, Gesuati ; originally in San Secondo, where Boschini took it for a picture by the Vivarini (*Le Ric. Min.*, Sest. della Croce, p. 63), afterwards at the Spirito Santo, and removed from thence during the restoring of the chapel. The Redeemer in benediction stands on a pedestal, with the orb in his left hand, in a domed chapel ; San Secondo, in armour, holds a banner, St. Jerome a book. Wood, figures life-size ; inscribed in a cartello on the pedestal: "Joanes bonichōsilij dito Mareschalco p."; much restored and repainted, and scaling in several places. Here we see the tendency (in the head of the Saviour) to imitate Romanino in the shortening of the vertical proportions of the face. Especially repainted are the blue mantle of Christ and

and bears the date of 1511[1]; another, with St. Catherine on
a pedestal attended by Tobit and the angel and St. Thomas
Aquinas, is inscribed 1513[2]; a third of greater size is the
Madonna, in a chapel of rich architecture, with six saints and
two boys playing instruments. All three betray a revolution in
style[3]; Buonconsiglio loses sight in some measure of Antonello,
and acquires a tasteful brilliancy of colours by studying, if
not Titian, at least Romanino. In the canvas of 1511, the
St. Sebastian reminds us of young Titian, the handsome St. Roch
recalls Romanino; and the rosy flesh and bright show of tints
in dresses prove acquaintance with Lotto. The same features
are more or less apparent in the St. Catherine of 1513 and in
the larger Madonna with Saints, where great boldness and
confidence are exhibited in the execution, and yet we notice
occasional hardness not unnatural in a painter who imitates
others.[4] It is in considering this stage of Buonconsiglio's

St. Jerome's red cloak. This piece is engraved in Zanotto (*Pinac. Ven.*, fasc. 3),
who tells a long story of how it came to San Secondo. From this account it
would be a production of a later date than those of Montagnana (1511–13), but
the execution does not confirm this belief.

[1] Montagnana, Duomo, chapel to the left of the choir. Two angels hold a crown
over the Virgin's head. Canvas, oil, figures almost of life-size; inscribed on the
step of the throne on a cartello, "MDXI. Joañes Bonic'osilis Mareschalco p.," and
on a lower place, "Vincentius Montonus hoc. grat. obtent. ex voto obtulit";
and a shield with a coronet and griffin rampant on a field gules. The colour has
been abraded and retouched.

[2] Montagnana, Duomo, right of portal. St. Catherine on a pedestal looking up
in a portico. Canvas, figures of life-size; inscribed in a cartello on the pedestal:
"MDXIII. (? one cipher wanting) Joañes Boniconli p." This piece is greatly
injured by restoring (1732); the head of St. Catherine recalls those of Romanino;
the colours of copious impasto and rich tone.

[3] Montagnana, Comune. Virgin and Child with two boy-angels playing at
the foot of her throne; left, SS. John the Baptist, Jerome, and Peter; right, Paul,
Augustine, and Sebastian; inscribed: "Joanes Boni. cõsilij p." Canvas, figures
life-size. The SS. Paul and Sebastian as in San Rocco of Vicenza; the treatment,
however, broader and more modern. Note the ill-drawn feet of St. Paul, the eyes
of the Virgin out of place from restoring, and the mantle of St. Peter new. The
flesh is of Romanino's brown tinge, *e.g.* in the altarpiece of Santa Giustina of
Padua. But this picture is ruined by restoring.—Montagnana, Monte di Pietà.
Here is a Virgin holding the Child in a standing attitude on a parapet. It is
called by the name of Buonconsiglio, but too injured to justify an opinion (size,
half-life).

*[4] Buonconsiglio also painted some frescoes at Montagnana. One of them was
formerly to be seen in the Hospitale Hierusalem of that town; it represented the

practice that we come to assign to him two very interesting
portraits at the Louvre, which have puzzled criticism up to
this time : a female in red velvet with slashes and favours,
a glove in one hand, a chain falling from her neck in the other,
a fillet with letters binding her long hair; a man in a black
cap and dark green damask dress, holding a letter addressed
" Dn° Bñardo di Salla." The sombre glow and hardish flatness
of the flesh tint in the man, is produced by technical handling
like that of Buonconsiglio. The warm and livid tone of the
female's face, the modulation of the touch in the hands, seem
to indicate a somewhat later execution; something in the dress
and colour suggesting Beltraffio or Costa, whilst the hands recall
those of Francia; and yet the costume is that which Buonconsiglio
uses in the earliest of his pictures, and the treatment is that
of his middle period.[1]

In 1519 we find our artist composing a Madonna with five
saints and a patron, for the parish church of Montecchio
Maggiore, near Vicenza; but there are proofs of his existence
at Venice till much later. He is the author of the plates in
The Triumph of Fortune by Fanti, published in 1526 [2] ; he is
proved by a document of 1527 to have been living at Venice,
and as late as 1530 his name still appears on the register of the
Venetian guild of St. Luke.[3]

Virgin and Child between some saints. The central portion has been transferred
to canvas, and has lately come into the possession of the Venice Academy.
Another proof of Buonconsiglio's activity as a *frescante* at Montagnana is the
great and admirable painting in the semidome of the choir of the cathedral,
representing the Assumption of the Virgin. See Borenius, *ub. sup.*, pp. 180 *sqq.*

[1] Louvre, Nos. 1519, canvas, m. 0·69 high by 0·53; and 1673, same measure,
catalogued "unknown." No. 1519 has been assigned to Carpaccio, 1673 to
Catena and others. [* The official attributions are at present, for Bernardo :
Savoldo ; and for the Lady : Venetian school of the sixteenth century. The
editor feels inclined to think that Bernardo and also the Man feeding a Hawk
in Windsor Castle, which is doubtless by the same hand as the Louvre picture,-
show indeed the characteristic glowing colour of Savoldo ; while for the Lady
the attribution to Bartolommeo Veneto suggested by Morelli (*Die Gallerien zu
München und Dresden*, p. 223) seems perhaps nearest the mark, as is indicated
by the general resemblance to the female portrait by Bartolommeo in the Perego
collection at Milan, by the careful painting of the details of costume and the gold
chain, etc. Though the two pictures are companion pieces of old, their style does
not appear to point to a common artistic origin.]

[* 2] These plates are not by Buonconsiglio; see Borenius, *ub. sup.*, pp. 202 *sq.*

[3] Moschini (*Guida di Venezia*, ii. 569) says that Buonconsiglio's name was on

Isolated pieces in the much injured altarpiece of Montecchio reveal a growing relationship between Buonconsiglio's manner and that of a contemporary Vicentine, Marcello Fogolino.[1]

Fogolino is, we think, a native of the Friulan provinces, being perhaps descended from a family of craftsmen of which

the register of the Venetian guild in 1530. [* He was the head of the guild in 1531. See Ludwig, *loc. cit.*, pp. 89, 92 *sq.*; Borenius, *ub. sup.*, p. 193.] The record of 1527 is a power of attorney drawn by the jeweller Calisto Anichino of Ferrara, appointing Giovanni Buonconsiglio his agent at Venice (Cittadella, *Doc.*, *ub. sup.*, p. 128). Buonconsiglio's son Vitruvio inhabited Ferrara (*ibid.*, p. 112). [* For additional information concerning Vitruvio Buonconsiglio, see Borenius, *ub. sup.*, pp. 195 *sqq.*]

[1] (1) Montecchio Maggiore, seven miles from Vicenza, traditionally the birth-place of Buonconsiglio, parish church. Arched canvas, oil, figures life-size. Virgin, Child, and two Angels holding the crown in front of a hanging; the scene laid in a vaulted chapel. At the sides, left, the patron in profile in a black hat, SS. Gregory and Mary Magdalen; right, a female, SS. Catherine and John Baptist; on a cartello the words: "I (D) XVIIII. Joañes Bonij ch . . . silij." This picture is scaled, and almost entirely repainted, but some original character is kept in the Infant Christ and angels. These in a certain measure remind us of Fogolino. (2) Tresto, province of Padua, ch. of Santa Maria. Virgin and Child crowned by two angels between SS. Matthew and Jerome, with two kneeling friars; in a lunette, Christ in the tomb between three angels. Arched panel with figures under life-size. The character is that of a feeble Bellinesque, like Bissolo, but the drapery is curt, and the outline is given in the Vicentine manner, and this may be a very late creation by Buonconsiglio. [* The editor ventures, how-ever, to think that this is really a work by Bissolo; the sweet, fleshy types, the mild colour-scheme, the slender trees, the general style, pleasing but forceless, seem so unmistakably his.] (3) Bergamo, Signor Rizoni. Virgin and Child, St. Joseph and another saint; much injured and dimmed, and signed (? genuine): "Joanes Bonichonsilij Marescalco"; an unimportant piece. [* Present where-abouts unknown.] (4) Dresden Museum, No. 193. Virgin, Child, and Saints. Half-lengths, wood. This picture is either by Palma Vecchio or an assistant in his school. [* We still have to mention some works by Buonconsiglio, dating from the later stages of his career, viz.: (5) Bassano, Museo Civico, No. 124. St. Sebastian. (6) Bergamo, Galleria Carrara, No. 125. The Resurrection of Christ. (7) Breslau, Schlesisches Museum, No. 652. The Virgin and Child between SS. John the Baptist and Stephen. Signed "Joannes Bonij consilij dito Marescalcho a. p." (8) Florence, Palazzo Pitti, No. 338. The Virgin and Child with St. James the Greater and a Donor. (9) London, collection of Mr. T. Humphry Ward. The Virgin and Child with SS. Mary Magdalen, Peter, and Paul, and the boy St. John the Baptist. (10) London, sale at Christie's (March 23, 1910, No. 106). St. Michael slaying the Dragon. (11) Venice Academy, No. 715. The Virgin and Child between SS. John the Baptist and Catherine. Signed "Joanes Boni consili dito Mareschalco." (12) Vicenza, Museo Civico, No. 145, Christ carrying the Cross. No. 180, Concert.] We miss the following: Vicenza, San Michele. Virgin and Child (two angels holding the crown above her head), Angel and Tobit, SS. Gregory and Helen. (Mosca, p. 86.)

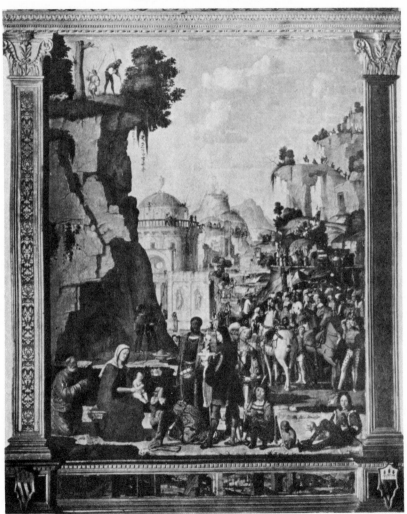

THE ADORATION OF THE MAGI.

there are traces at Udine at the rise of the fifteenth century.[1] One of the few records to which we can trust for elucidating his life describes him as of San Vito,[2] in the neighbourhood of which he spent some of his later years ; but his apprenticeship was made at Vicenza.[3] His pictorial career is not dissimilar from Buonconsiglio's in this, that whilst at first he displayed much of the Vicentine, he afterwards lost something of that manner. His juvenile efforts are no doubt those which remain at Vicenza : the Adoration of the Magi, a small tempera once commissioned for San Bartolommeo and now in the public gallery, and a predella with six saints in a private house. As a youth he was evidently brought up to admire the semi-Umbrian models of Verlas and Speranza. Careful execution and patient finish are marked features in the Adoration, into which he seems to have introduced his own portrait; but these praiseworthy characteristics are counterbalanced by incorrectness of drawing and absence of relief and atmosphere, as well as by feeble monotony of types.[4]

[1] In the Archivio Comunale at Udine, which, as well as the Archivio Notarile, has been thoroughly searched for us by the kindness of Signor Joppi, we find a record of 1410, April 17, in which Giovanni Fugulini, painter of Udine, is described as possessed of certain lands.

[2] See *postea*, p. 149, n. 2.

* [3] A considerable number of documents relating to Marcello Fogolino have now been brought to light. Yet so far we only know of very few records showing Fogolino as staying at Vicenza. These date from 1519 and 1520; the following year the artist was settled at Pordenone, and it was probably from there that in 1526 or 1527 he went to Trent (cf. *postea*, p. 150, n. 3). There can, however, be no doubt that Fogolino spent many years of his earlier life at Vicenza; contemporary documents generally describe him as a Vicentine.

[4] Vicenza Gallery, No. 281; formerly in San Bartolommeo (*Gioielli*, p. 87 ; Mosca, i. 3; Ridolfi, *Le Marav.*, i. 119-20). To the left, the Virgin and Child with one of the kings prostrate at her feet; the usual personages behind the scene, in a landscape not without Peruginesque character. A youth holds a horse, on whose collar we read "Marcelos pintore," and on a cartello fastened to the Virgin's seat are the words "Marcellus fogollinus p.p." In a predella are the Annunciation, Birth of Christ, and Flight into Egypt. Small panel, tempera, of washy tint, without atmosphere, treated much like Buonconsiglio's earliest Pietà. [* Other works by Fogolino which were once in San Bartolommeo at Vicenza and now belong to the Museo Civico of that town are a bust of St. Jerome (No. 260) and two frescoes representing the same saint and a Pope. A Madonna in the Weber collection at Hamburg (No. 129) stands very close to the Adoration of the Magi at Vicenza. More mature if still comparatively early works by Fogolino are a Madonna and Saints formerly in Sant' Antonio at Camposampiero and now in the Mauritshuis at the Hague (No. 347)—perhaps

In the predella, originally at San Francesco of Vicenza, an improvement is apparent; and Fogolino, though still cold in his mode of treatment, already gains a glow of tone not unlike that of Buonconsiglio.[1] A Virgin and Child with Saints in the Berlin Museum ushers in a more settled manner. It was executed for a Vicentine church, and is a broadly touched picture with a substantial unbroken tint of a sombre shade ; a certain fleshiness and curtness of proportions may be observed in the figures ; and something in the modelling and air of the faces recalls Moretto da Brescia and Bernardino Licinio.[2] Fogolino and his countryman Bernardino have indeed been occasionally confounded, as we see in the Academy of Venice, where a Madonna and six saints in the style of the altarpiece at Berlin is catalogued under Licinio's name.[3] But the chief variety in

the closest approach of Fogolino to Montagna; and a full-length Virgin and Child in the Museo Poldi-Pezzoli at Milan.]

[1] Vicenza, Signor Luigi Robustelli. In the middle of the picture St. Francis receiving the Stigmata, adored by the kneeling friar ; to the left, SS. Chiara and Peter; right, Paul and another. This long predella is executed in the style of Buonconsiglio, and but for a certain rotundity in the types and coldness of execution, we might call it his. [* This picture is now in the Museo Civico of Vicenza (No. 259).]

[2] Berlin Museum, No. 47. Canvas, 8 ft. 2¾ in. square. Virgin and Child between SS. Francis, John the Evangelist, Buonaventura, Anthony of Padua, Bernard of Siena, and Louis of Toulouse. Note the low unbroken mahogany tone, the short fat type of the Child, the curtness of the figures generally, and the coarseness of the articulations. Signed: "Marcellus Fogolinus p." Originally in San Francesco of Vicenza (*Gioieli*, p. 86 ; Mosca, i. 46 ; Ridolfi, i. 120). [* It is proved by records in the Biblioteca Comunale at Vicenza that Fogolino in 1519 and 1520 was working (for part of the time with Speranza) in the church of San Domenico in that town. There still remain frescoes by him (representing apostles, saints, etc.) in the room behind the present church ; they are closely allied in style to the *pala* now at Berlin. A fresco of the Virgin of Mercy to the left of the main entrance of Santa Corona at Vicenza was, according to M. Bortolan (*S. Corona*, p. 287), executed in 1519; it is no doubt a work by Fogolino, as may be seen from the types and forms of the figures, the landscape, etc. The frieze of angels and view of Vicenza around a Madonna of the fourteenth century above the fourth altar to the left in the same church are no doubt rightly ascribed by the authors to Fogolino (see *postea*, p. 150) ; we may add that the two female saints painted *al fresco* on each side of this altar also display the characteristics of Fogolino's style. These paintings were probably executed in 1519-20, when the altar in question is known to have been restored (Bortolan, *ub. sup.*, pp. 270 *sq.*).]

[3] Venice Academy, No. 164; said to have been in the Scuola de' Calzolai at Udine. Canvas, m. 2·37 high by 1·80. Virgin and Child between SS. Anthony,

Fogolino is observable in votive Madonnas commissioned at Pordenone, and preserved to this day in the cathedral of that town.[1] One of these was contracted for by the Scuola di San Biagio at Pordenone, on the 15th of March, 1523, and represents the Virgin and Child between St. Biagio and St. Apollonia ; the other was delivered a little earlier to the superintendents of the cathedral, and is a Glory of St. Francis between St. John the Baptist and St. Daniel. It is very clear that Fogolino here commingles Friulan and Vicentine features with others derived from disciples of Raphael. The heads in the Glory of St. Francis are still reminiscent of Licinio, the handling is pastose and broad with swimming outlines and modelling, the drawing loose in flesh and in drapery.[2] In the altarpiece of San Biagio the Raphaelesque element is more marked, in the free motion of two angels crowning the Virgin, and in the action and shape of the Virgin and Christ, whilst the handling is bold as before.[3] It is

Bernardino, Louis, Francis, Clare, and Buonaventura. The figures here also are square, short, and puffy; the types and treatment like those at Berlin. [* This picture is now officially ascribed to Fogolino.]

[1] On April 8, 1521, Fogolino was settled in Pordenone and had executed an altarpiece for the church of Pasiano, a village near that town. On April 21 of the same year he was commissioned to complete the frescoes in the church of San Lorenzo at Rorai Grande which had been begun by Pordenone. Fogolino's work was valued by Pellegrino da San Daniele and the guardian of the monastery of St. Francis at Pordenone on August 3, 1521. See Joppi, in *Monumenti storici pubblicati della R. Deputazione veneta di storia patria*, ser. iv. *Miscellanea*, vol. xii. Appendix, pp. 28, 80 *sq.*

[2] Pordenone, Duomo (San Marco), third altar to the right. St. Francis holds a cross ; the Baptist has the same symbol ; and St. Daniel, in an orange dress, with a lion at his feet, points to a scroll on which is written : "cum veniet S. Sanctorum cessabit . . ." The figures all want shoulders. Here Fogolino may have been assisted by his usual journeyman, his brother Matteo. We trace this picture to him by the style and also indirectly by record. There is a contract dated June 29, 1523, in the Archivio Notarile of Udine, in which Marcello Fogolino of San Vito accepts a commission to paint, for Santa Maria at Visinale near Prata, the Virgin and Child between SS. John the Baptist and Paul, with the Eternal in a pinnacle ; and this picture (now missing) is to be equal in every respect to that of St. Francis in the church of San Marco at Pordenone. The surface of the altarpiece is dimmed by varnishes, the landscape dusky and retouched ; the colour has the fat impasto of Bonifacio, and the drapery is a styleless imitation of Palma's.

[3] Pordenone, Duomo, of old in San Biagio. The contract for this canvas is in the Archivio Notarile of Udine, and dated March 15, 1523 ; the price was fourteen ducats. The execution is not so good as in the foregoing, and betrays the hand of an assistant, probably of Matteo Fogolino. It is of a rosy unbroken flesh tone

not unlikely that Giovanni da Udine, who had been at Rome and was on the eve of returning thither (1523), had brought home a number of Raphaelesque designs, and thus altered the current of artistic fashion in Friuli. From Pordenone, Fogolino now revisited Vicenza, where he introduced his new manner into a frieze of angels in Santa Corona [1] and a Nativity in San Faustino,[2] combining in both examples, with the shallow boldness of an imitator, the plump forms and natural movements of the Raphaelesques with the broad treatment of the followers of Giorgione and Pordenone.[3] In later days chance brought him back into the north,[4] and we learn from a letter in his own hand that he was living in 1536 at Trent, and had been appointed in

with little shadow, scaled in parts and restored. There is something in the treatment recalling Pordenone's picture of 1515 in the Duomo of Pordenone.

[1] Vicenza, Santa Corona, fourth altar to the left as you enter. In the centre is an old Virgin of the fourteenth century, around which are a number of Fogolino's puffy angels, imitating in movement those of the Raphaelesques ; the colour is brown, even throughout, and of substantial impasto.

[2] Verona, Signor D^re Bernasconi ; formerly in San Faustino of Vicenza (*Gioieli*, p. 43, and Ridolfi, *Marav.*, i. 120) ; signed "Marcellus Fogolinus p." The Child in the foreground is very puffy ; the head like one of Mazzolino's, but the picture generally (it represents only the kneeling Virgin and St. Joseph in front of a house and landscape) recalls Giorgione, Pordenone, and Raphael alternately. We are reminded by the forms also of Gaudenzio Ferrari. Canvas, with figures under half life-size, not uninjured. [* This picture is now in the Museo Civico of Verona, No. 136).]

In the same style, Louvre, No. 1159, half-length of the Virgin and Child with St. Sebastian ; but like an earlier work in which Matteo Fogolino might also have a share.

* [3] As we have seen (*antea*, p. 148, n. 2), the painting at Santa Corona was probably executed in 1519–20. There is no proof that Fogolino went back to Vicenza after having painted the two altarpieces at Pordenone. He was in that town in May 1524 (Joppi, *loc. cit.*, pp. 28, 83), and probably continued to live there for the next two years. Then, on Jan. 25, 1527, Marcello and Matteo Fogolino were sentenced by the court of Udine to exile from the Venetian territory on the charge of having killed Liberale, a barber of Belgrado (a village on the banks of the Tagliamento). The two brothers settled subsequently at Trent ; but by acting as spies over the plans and doings of the Imperialists, they succeeded in obtaining safe-conducts which enabled them to visit the dominions of Venice. The latest available record concerning Marcello Fogolino shows him as living at Trent in 1548. See Di Sardagna, in *Monumenti storici pubblicati della R. Deputazione veneta di storia patria*, ser. iv. *Miscellanea*, vol. vi. pp. 265 *sqq.*

[4] We find him and his brother buying land at Pordenone in the last days of January 1533. In the contract they are called : "M° Marcello Pittore e M° Matteo de Fogolinis Vicentini, abitanti in Pordenone." Acta Pier Ant. Frescolino, **Arch. Notar. Udine.**

March of that year to make preparations of an architectural and decorative kind in certain edifices of the town and its neighbourhood for the coming of King Ferdinand.[1] This letter leads us to search the churches of Trent and its vicinity; and there, in truth, are copious traces of his presence. In the Santissima Trinità we see the Madonna between St. Michael and five other saints adored by the kneeling figures of Andrea Borgo (*d.* in 1532), and his wife, Dorothea Tonno (Thun). This picture was for many years an ornament of the chapel of the Thun family in the church of San Marco, and has been assigned to Moretto of Brescia and Romanino, both of whom are known to have practised in this part of Italy. We have already observed some common features in Moretto and Fogolino. There is no mistaking here the puffy forms of the latter, his affection for Raphael's models, and his peculiarities of hand which differ from those of Moretto.[2] Equally characteristic and exactly

[1] "Car^mo m̃. infiniti saluti. Avisovi como fui arzonti (? aggiunto) a trēto (Trento) Li Signori del R. SS. gardinale subito me manda accŏrti (a certi?) casteli del R. SS. gardenale a far provisiò de adornar e frabicar p la venuta đ la maistà de Re Fredinando el qual se dice che a questo mayo venira a Trento. Et al presente son ritornato a Trento. Et nŏ no posuto interogare la cossa me cometesi p miš alisandro. Ma p lo primo meso le mandero al tuto cenza (senza) falo. Non altro—Dio sia convui.

"Adi 3 Mazo 1536 in Trento.

"Statj di bona volgia c̃h de curto speroc̃h mio fratelo matteo et tuti li soi compagni venira ha habitare a Pordenŏ come da primo & & & Credo c̃h me intendati p ch mi veno movesto qualque parola quãdo iro a Pordenŏ. Al presente he in ordene vinti milia fanti todechi (Tedeschi) et fa vinti milia ratione nŏ altro.

"Matteo si aricomãda molta . . .

"MARCELO FOGOLINO, P.
"VOSTRO."

(Address) "Al molto mag^co ns
Bastiano Mantega car^mo
honorando
in Pordenŏ"

(and in another but contemporary hand)

"Lt̃a de m̃° Marcello
figolino."

(We owe communication of this letter to the kindness of the Conte Pietro di Montereale, a great collector of Friulan records.)

[2] Trent, Chiesa della Santissima Trinità. Arched canvas. Virgin crowned by two angels, between SS. Michael, Chiara, Catherine, Rosa, and Buonaventura. In front, kneeling, the Podestà to the right, his wife to the left; distance, sky and

similar in method is the Virgin and Child between St. Andrew
and St. Peter in the church of Povo, near Trent.[1] Nor is it
improbable that frescoes in the rooms of the castle of Trent, and
particularly a couple of ceilings, should have been painted by
Fogolino, though assigned to Giulio Romano.[2] There is also an
altarpiece in the Duomo of Trent, very like a work of our artist,
and a house-front near the cathedral likewise in his style.[3]

landscape. Same style as in the later examples of Fogolino. [* Some years ago
this picture was removed from SS. Trinità and passed into the possession of
Prince Galeazzo von Thun und Hohenstein (of Rome and Povo). See Menestrina,
in *Strenna dell' " Alto Adige,"* 1904, p. 13, n. 1.]

[1] Povo, near Trent. In a lunette, the Eternal; in a predella, the Call of Andrew
and James to the Apostleship, the Adoration of the Magi, and the Martyrdom of
St Peter. Wood, arched; style as before. Here again the brown unbroken line
recalls Gaudenzio Ferrari.

[2] Trent, Castello, round hall. Four medallions, with frescoes of incidents from
ancient history, lunettes with figures and tritons and allegories in the spandrils
of each lunette, assigned to Giulio Romano, and no doubt Raphaelesque, but by
Fogolino. In a room on the first floor within the court, and near the loggia,
painted by Romanino, a ceiling divided like that of the Farnesina, with heathen
divinities in the lunettes, and children in the central rectangle; all boldly and
effectively foreshortened. The character generally is like that of the immediately
foregoing, but there is something more Ferrarese on the whole.

It may be that these frescoes were done upon designs furnished by Giulio
Romano, or some other Raphaelesque. [* We know from a contemporary docu-
ment that the latter ceiling is by Dosso Dossi (Schmölzer, *Die Fresken des
Castello del Buon Consiglio,* pp. 24 *sqq.*). As to the former, there exists no record
proving that it is the work of Fogolino, while there is documentary evidence to
show that he executed many other paintings in this building and also that
he painted in the adjoining so-called old castle. According to Herr Schmölzer,
the following are the paintings by Fogolino which are still to be seen in the first-
mentioned edifice: the arabesques on the ceiling of the great hall on the second
floor, the friezes (of which only traces survive) on the principal front and the
front facing the Court of the Lions, and finally the frescoes in the ex-tavern on
the ground floor. In the old castle, the court is adorned with frescoes by
Fogolino and his journeymen. *Ibid.,* pp. 50 *sqq.* Herr Schmölzer ascribes the
paintings in the round hall to Brusasorzi (pp. 53 *sqq.*).]

[3] Trent, Duomo, Cappella Manci, altar to the right. St. Anne, the Virgin and
Child, between SS. Nicholas and Vigilio, the latter presenting a wooden shoe
to the Infant Christ. Canvas, very high up, assigned to Romanino, not uninjured,
and as far as one can see really by Fogolino. [* This picture has now its place
on the left-hand side of the choir.] House-front, opposite portal of Duomo, with
figures of horsemen. Missing: Vicenza, San Tommaso, altarpiece of high altar
(Ridolfi, i. 120). [* Boschini, *ub. sup.,* p. 53, ascribes it to Bart. Montagna.] In
the Lochis Gallery at Bergamo (No. 126) is a miniature representing the celebra-
tion of a mass (engraved in Rosini, t. xcvii.), a careful and tasty little piece, of

good execution, which may well be by Fogolino, to whom it is assigned. [* Fogolino also executed some engravings, for notices of which see Passavant, *Le peintre-graveur*, v. 145 *sqq.*, and Hind, *Cat. Early Italian Engr.*, pp. 512 *sqq.*).]

We may notice here, amongst other Vicentines of small interest, Petrus Vicentinus, of whom we have the following : Venice, Correr Museum, Sala XV., No. 29, bust of Christ at the column, a very ugly Mantegnesque piece, of opaque and earthy colours, a poor tempera on panel, signed in a cartello on a parapet : " Petrus Vicentinus pinxit."

Another artist of Vicenza is Girolamo Vicentino, respecting whom we have but the following : Bergamo, Lochis Gallery, No. 25, bust panel, Christ carrying his Cross, in oil, a little better than the work of Petrus. This Girolamo may be the one who witnessed B. Montagna's will in 1523. His panel is inscribed : " Jeronimus Vicentinus p." [* Another work by this artist is a bust of St. Sebastian in the Castello Colleoni at Thiene, near Vicenza (signed " Hieronimus Vincentinus.")]

CHAPTER VI

THE VERONESE

THERE are few cities of Northern Italy in which art was more effectually changed by Mantegna's example than Verona. After a brilliant period of activity, during which the noble principles of Tuscan composition were illustrated in the works of Altichiero and Avanzi, the traditions of the Florentines were neglected or forgotten, and the fifteenth century opened without a single painter of genius. Whilst Turone and his comrades preserved in their ateliers the lowliest precepts of their craft, it was vain to hope for pictorial progress. And yet there was now, as there ever had been, a demand for pictures of a better kind. The question was how such a demand could be satisfied, and by whom. The Venetians, in a similar position, had employed Gentile da Fabriano, a stranger; the Veronese were more fortunate in finding one amongst their fellow-countrymen whose style bore the impress of Umbrian teaching. It has been held, indeed, that previous to the rise of Vittore Pisano,[1] the Veronese rose to a fair level of eminence under Stefano da Verona, whom Vasari describes as a pupil of Agnolo Gaddi[2]; but there is every reason to suppose that this opinion is baseless, and that Stefano da Zevio, the contemporary or disciple of Pisano, is the only person of that name whose existence is beyond dispute.[3]

* [1] Cf. *postea*, p. 155, n. 2.
[2] Vasari, i. 641 *sq.* and iii. 628 *sqq.*
[3] All paintings under the name of Stefano at Verona and in its neighbourhood are of the fifteenth century, and are not of a style at all related to that of A. Gaddi. Had Vasari suggested Lorenzo Monaco or any other miniaturist as the master, he might find converts to the opinion that Stefano, or even Pisano, were taught in his school. Amongst the works which Vasari assigns to Stefano, there is not one in which we can trace as much Giottesque character as we find

Pisano's birth and education are involved in obscurity. On the one hand, dal Pozzo mentions a Madonna in his own possession inscribed with the date of 1406, from which it would appear that the painter called himself Vettor Pisanello de San Vi Veronese ;[1] on the other hand, Vasari asserts that Pisano was journeyman to Andrea del Castagno at Florence.[2] Both statements are open to grave suspicion, the form of inscriptions in the fifteenth century being unlike that which dal Pozzo has preserved, the life of Castagno being in itself a contradiction of Vasari's theory. There is no insuperable objection to believing that Pisano spent some of his earlier years in Tuscany, however little his works may reveal of Florentine schooling.[3] Had it chanced that he followed the footsteps of Gentile da Fabriano, and after serving his apprenticeship in Umbria settled in the Tuscan capital, he would be the second of his class on whom the

in those of Altichiero. We shall see that the theory of Veronese critics is untenable, according to which there are two painters of the name of Stefano, one the author of frescoes of the fourteenth, a second of frescoes of the fifteenth centuries. We shall enumerate amongst the works of Stefano da Zevio the wall-paintings at Illasi which have been assigned to his older homonym. (See C. Bernasconi, *Studi sopra la Storia della Pittura Ital.*, Dispensa viii. 1865, Verona, p. 219). [* See also *postea*, p. 165, n. 1.]

[1] Verona, Casa de' Conti dal Pozzo. Virgin and Child between SS. John the Baptist and Catherine, and on a cartello the words : "Opera di Vettor Pisanello de San Vi Veronese MCCCCVI." (Dal Pozzo, *ub. sup.*, pp. 9 and 305.) [* This picture is now in the depôt of the Kaiser Friedrich Museum at Berlin. It is not by Pisano, but by some follower of Squarcione. See Von Tschudi, in the Berlin *Jahrbuch*, vi. 18 *sqq.*]

[2] Vasari, ii. 682, iii. 5. In another place Vasari says it was a tradition in Florence that Pisano's early works were in the old Chiesa del Tempio at Florence (iii. 13).

* [3] Much documentary information concerning Pisano has come to light since the authors wrote their account of his life and works. Of greatest importance are the records which lately have been discovered by Dr. Giuseppe Biadego (see *Atti del Reale Istituto Veneto di scienze, lettere ed arti*, vol. lxvii. pt. ii. pp. 837–59 ; vol. lxviii. pt. ii. pp. 229–48 ; vol. lxix. pt. ii. pp. 183–8, 797–813, 1047–54). To begin with, it is proved by them that the Christian name of the artist was Antonio, not Vittore, as Vasari states. He was the son of Puccino di Giovanni di Cereto di Pisa and Elisabetta di Niccolò of Verona. The first mention of him occurs in the will of his father, made in Pisa in 1395 (Biadego, *ub. sup.*, vol. lxix. pt. ii. pp. 1047 *sqq.*). He must then have been a mere infant if a statement in the Veronese *Anagrafi* (census returns) that he was thirty-six years old in 1433 is to be considered as approximately correct (*ibid.*, vol. lxvii. pt. ii. p. 839). There exists a record proving that in 1422 Pisano was settled at Verona, though temporarily staying at Mantua (see *postea*, p. 159, n. 5).

principles of the great Florentines made no impression. Pisano
was celebrated amongst his contemporaries for richness of poetic
fancy in general delineation and superior skill in the drawing of
animals.[1] Guarino, his countryman and panegyrist, affirms that
he could represent the waves in motion or at rest, the sweat on
the labourer's brow, and the neighing of horses ; but he dwells
chiefly on the power with which he reproduced portraits, scenery,
birds, and quadrupeds.[2] Porcellio, the scribe of Alfonso of
Arragon, Basinio of Parma, and Tito Strozzi, are unanimous
in the same strain.[3]

The high-flown character of this eulogy contrasts most
curiously with the bare reality of Pisano's early style. In his
youth, we think, he painted, for the convent of San Domenico,
the Madonna at present in the Gallery of Verona. The Virgin
sits in the middle of a court with the Child on her lap, surrounded
by a flight of diminutive seraphs ; the halo about her head
is adorned with peacocks' feathers ; roses cling to a bower at the
sides of the court ; a quail hops upon the Virgin's dress, and
peacocks strut along. In the foreground St. Catherine, with

[1] " In pingendis rerum formis sensibusque exprimendis ingenio prope poetico
putatus est." Facius (B.), *De Viris Illust.*, 4to, Flor. 1745, p. 47.

[2] Guarino Veronese, after having been in Constantinople, Florence, and Venice,
settled at Verona in 1422, where he was professor of Greek. In 1429 he was
appointed by Nicholas III., Duke of Ferrara, private tutor to his son Lionel. He
may have known Pisano at Verona and at Ferrara. His poem in praise of
the latter is published in Bernasconi, *Il Pisano*, etc., 8vo, Verona, 1862, p. 14).
[* See now also Vasari, *Gentile da Fabriano e il Pisanello*, ed. by A. Venturi,
pp. 39 *sqq.*; and Biadego, *ub. sup.*, vol. lxviii. pt. ii. pp. 230 *sqq.*]

[3] Porcellio (Pietro), banished from Rome after 1434, by Pope Eugenius IV., for
taking part in a popular outbreak, was secretary to Alfonso of Arragon, one of
Pisano's sitters, in 1452. Basinio, born in 1425 at Parma, was professor of
eloquence at Ferrara in 1448, and afterwards in the service of Sigismund
Malatesta of Rimini. He might know Pisano at Ferrara and Rimini. He
died in 1457. Tito Strozzi was born at Ferrara in 1422, and died in 1505. All
these eulogists are therefore more or less connected with the Ferrarese court,
where Pisano was a favourite. Facius, too, who wrote respecting him, was
at Ferrara at the wedding of Alfonso's (of Arragon) daughter with Lionel
in 1444. At that ceremony are known to have been present Porcellio and
Guarino. The rhymes of Porcellio, Basinio, and Strozzi in praise of Pisano,
are in the " Carmi Latini," ed. Cesare Cavattoni, 8vo, Verona, 1861, in Bernasconi's
" Il Pisano." [* See also Vasari, *Gentile da Fabriano*, etc., ed. Venturi, pp. 61 *sq.*,
55 *sqq.*, and 52 *sq.*] Another poet, Gio. Santi, alludes to Pisano in his *Rhyme
Chronicle*, lib. xxii. cap. 91, " Et in medaglie et in pictura el Pisano."

a crown of roses on her wrist, receives the palm of martyrdom, and listens to the chaunt of angels reading a psalter. The crowns, borders, flowers, and a fountain in the distance are embossed and gilt. Long and streaming draperies embarrass the frames, soft and tender harmonies of tint enliven the dresses ; shadow is carefully avoided, and the drawing is minute to a fault. Affected elegance and slenderness are combined in impersonations of the sex ; distorted action and short proportioned stature mark the angels ; in every face and shape a puerile forgetfulness of nature. That Pisano had just issued from a school of illuminators, like Lorenzo Monaco, or Pietro of Montepulciano, we might readily believe.[1]

Of a more truly graceful character and somewhat less infantile in treatment is a Virgin and Child, by Pisano, belonging to Dr. Bernasconi at Verona ;[2] of little additional power the Annunciation, St. George and St. Michael, on the sides of the Brenzoni chapel at San Fermo Maggiore. Having transferred the peculiar features of a miniaturist from parchment to panel, Pisano now extends a similar practice to wall-distemper, following with melancholy exactness the path pursued a century before by the comrades of Lippo Memmi. We still observe the fashion of embossment, the fine tenuous outline, the slender air, and the shadeless flatness of previous examples ; we notice a continued partiality for birds and animals ; at the same time the germ of a new and important study. The regular propor-

[1] Verona Museum, No. 359. Wood, m. 1·29 high by 0·95, from the convent of San Domenico. The treatment is that of a miniature, the light of a rosy tinge, gently and minutely shaded to green by minute hatching. The Child is defective in shape; the foreheads generally are high and convex, the hands spidery and coarse at the finger-ends; the whole surface is now embrowned by time. [* This picture is surely too feeble for Pisano, though without doubt it betrays his influence. Cf. Zoege von Manteuffel, *Die Gemälde und Zeichnungen des Antonio Pisano aus Verona*, p. 51.]

[2] Verona, Dr. Bernasconi. Small panel, gold ground. Two angels fly at the Virgin's shoulders ; a quail is at her feet. The Child is less lame than previously, and there is more genuine grace in the attitudes. This is perhaps the picture noticed by Persico (*Descrizione di Verona, ub. sup.*, ii. 34) in the Galleria Sanbonifazio. [* The painting seen by the authors in the Bernasconi collection now belongs to the Verona Gallery (No. 90). It certainly resembles Pisano's work in many respects, though at the same time it differs considerably from it. It has, moreover, been largely repainted.]

tions of the saints reveal Pisano's growing acquaintance with antique carved work and his wish to infuse into the tight dress of the period the simplicity of an older age.[1] In the Cappella Pellegrini at Sant' Anastasia, where he displays the prominent marks of his style, he seems to have acquired more ease in representing instant action, more correctness of outline, and a better knowledge of foreshortening. It is apparent that his attention was concentrated on heads ; and their portrait character, as well as the neatness with which they are finished, prepare us for the course which he afterwards took. We admire the spontaneity of movement in St. George with his foot in the stirrup, or the pleasing profile of the female saint near him, in a flowing dress and basket-cap ; we may praise good perspective in the horses, and contrast it with the childish absence of the same science in the landscape.[2] The care and trouble which Pisano bestowed on his subject are illustrated by the designs for some parts of it in the collection of the Archduke Albrecht

[1] Verona, San Fermo Maggiore, Cappella Brenzoni. The Annunciation is a fresco in the sections at the sides of a pointed tomb, on which we read the inscription : " Hic data Brenzonio requies post fata Jacobo Francisci que eadem marmora corpus habet ipse etiam patrijs cultor sanctissime legum junxisti cineres Bartolomee tuos. Quem genuit Russi Florentia Tusca Johañis istud sculpsit opus ingeniosa manus." The date of this tomb is variously stated : traditionally as 1430 ; in Vasari, Annot., iii. 10, note 2, as 1420. At the side to the right, in a cartello, are the words " Pisanus pinsit." The Eternal sends the Infant in a ray to the Virgin. In the side pinnacle are St. George in profile and St. Michael. The colour has faded away and is partly scaled off, the wax embossments dropping, and dust clinging where it can. This is the art which influenced Giambono. [* The Brenzoni monument seems to have been erected about 1430–35, and the frescoes of Pisano belong probably to the same period. Cf. Zoege von Manteuffel, *ub. sup.*, pp. 9 *sqq.*, and Biadego, *ub. sup.*, vol. lxviii. pl. ii. pp. 242 *sqq.*]

In this church are two fragments of fresco assigned to Pisano : above the entrance to the Cappella degli Agonizzanti, an Adoration of the Magi, of a period immediately subsequent to that of the painter ; above the portal, an Annunciation, possibly by Falconetto.

[2] Verona, Sant' Anastasia, Cappella Pellegrini. Vasari is all wrong in his description of the subjects. St. George is here represented mounting to fight the dragon, who awaits him in the left-hand corner of the composition ; in the distance the sea and a ship, and incidents from St. George's legend. Beneath the principal scene is still a solitary figure of a pilgrim, the St. Eustachio mentioned by Vasari having disappeared. The fresco is high, and can be seen with difficulty. It is also covered with dust. A large piece above the dragon is wanting. Vasari mentions other frescoes in the chapel which have perished (iii. 8 *sqq.*).

at Vienna,[1] and his conscientious study of nature in three figures drawn from life in the British Museum.[2]

Subsequent to the employment of Gentile da Fabriano at Venice (*circa* 1422), Pisano was entrusted with the execution of a fresco in the hall of the Great Council, which at the close of the century was replaced by a canvas by Luigi Vivarini[3] ; he was also invited by Filippo Maria Visconti to decorate some of the rooms in the castello of Pavia,[4] but he does not seem to have left Verona for any length of time till after 1435. His fame as a portrait-painter was then considerable, and an order is still preserved in the accounts of the house of Este which proves that he took a likeness for Nicholas III., Duke of Ferrara, in 1435.[5] He afterwards visited Rome,[6] and during the pontifi-

[1] Vienna, under the names of Niccola Pisano and (!) Berna. Vellums with female heads, females with dogs, falcons, and quails. [* These drawings can only be ascribed to the school of Pisano (Wickhoff, in the Vienna *Jahrbuch*, vol. xiii. pt. ii. pp. clxxx *sqq*.). There exist, however, several drawings by Pisano which were utilized by him for the Sant' Anastasia fresco. They are to be found in the *Recueil Vallardi* (a large collection of drawings chiefly by or after Pisano) in the Louvre, in the British Museum, and elsewhere. See Hill, *Pisanello*, pp. 92 *sqq*.]

[2] British Museum. Three full-lengths in the quaint costume of the time, signed " Pisanus f." Vellum, pen and ink.

[3] See Facius, *ub. sup.*, and *antea* in Vivarini (Luigi). See also Sansovino, *Ven. Descr.*, p. 325, and *History of Italian Painting* (1st ed.), vol. iii. p. 99, for proof that Gentile had done work at the Hall of Council previous to 1423. [* He seems to have painted there about 1409 ; see Colasanti, *Gentile da Fabriano*, pp. 10 *sq*. Nothing is known as regards the date of Pisano's fresco. For a discussion of several questions in this connection, see Hill, *ub. sup.*, pp. 27 *sqq*.]

[4] Filippo Maria Visconti became Lord of Pavia in 1412, and died in 1447. The frescoes at Pavia are described by the Anonimo (ed. Morelli), p. 46, and mentioned by Ces. Cesariani, *Vitruv.*, p. cxv. Breventano, in Anonimo, notes, p. 180, says this represented hunts and animals.

[5] *Précis* of record furnished by the kindness of the Marchese Campori.

[*] This document really records that Lionel, on Feb. 1, 1435, ordered two ducats of gold to be paid to a servant of Pisano because this servant had brought and presented to Lionel, in the name of his master, a likeness of Julius Cæsar. This was probably a wedding-present, as Lionel was married to Margherita Gonzaga in the same month. See Vasari, *Gentile da Fabriano*, etc., ed. Venturi, p. 38 ; Hill, *ub. sup.*, pp. 59 *sq*. On July 4, 1422, Pisano bought a piece of land at Verona ; we learn from the document in question that he was then staying at Mantua, but that his home was in the Contrada di San Paolo at Verona. On Aug. 10, 1423, the whole of the price of the house had been paid by Pisano (Biadego, *ub. sup.*, vol. lxix. pt. ii. pp. 801 *sqq*.). At Verona, on July 8, 1424, Pisano's mother acknowledged a debt of 600 ducats to her son ; this sum had been bequeathed to him by his father (*ibid.*, vol. lxix. pt. ii. pp. 1047 *sqq*.). In

cate of Eugenius IV. completed the series of subjects left
unfinished at San Giovanni Laterano by Gentile da Fabriano.[7]
It is not improbable that he followed Eugenius to Ferrara,
where the memorable Synod sat in which the differences of
the Eastern and Western Churches were destined not to be
appeased.[8] During his stay there in 1438 he was honoured
with sittings for a medal by John Palæologus,[9] and he enjoyed
the favour of the Duke and his son Lionel, to whom he pro-
mised a picture when he should have settled at Verona.[10] It
has been supposed, and is by no means unlikely, that this piece,
to which Lionel alludes in a letter to his brother, is that which

1425 and 1426 Pisano was working at the court of Mantua (*ibid.*, vol. lxviii. pt. ii.
p. 185). We know of no record of him from the next few years; but in April and
Nov. 1431, and in Feb. 1432, we find him at Rome, receiving payment for work in
the Lateran (Vasari, *Gentile da Fabriano*, etc., ed. Venturi, p. 33; Hill, *ub. sup.*,
p. 49). In 1431 he seems, however, to have gone from Rome to Verona for a
hurried visit, touching Ferrara on his way north (Vasari, *ub. sup.*, pp. 36 *sqq.*;
cf. *postea*, n. 10). In July 1432 he received a passport from the Pope, Eugenius
IV. (Vasari, *ub. sup.*, pp. 36 *sq.*; Hill, *ub. sup.*, p. 56); and in 1433 he is mentioned
in the Anagrafi of the Contrada di San Paolo at Verona (Biadego, *ub. sup.*,
vol. lxvii. pt. ii. p. 839). * [6] Cf. the preceding note.

[7] Platina, *Lives of the Popes*, ad Martin V., Vasari, iii. 5 *sq.*; Facius, *ub. sup.*,
pp. 47, 48. Vasari may be right in affirming (ii. 294) that Gentile da Fabriano
and Pisanello were at Rome together with Masaccio, but this can hardly have
been when Masaccio painted at San Clemente.

[8] Jan. 10, 1438, to Jan. 10, 1439.

[9] Giovio (Paul) to the Duke Cosimo, Florence, Nov. 12, 1551 (Bottari, *Raccolta.
ub. sup.*, v. 83), thinks this medal was done at Florence, but it is more likely that
the statement in the text is correct, for Pisano's connection was altogether with
the Ferrarese and not with the Florentine court.

[10] Lionel d'Este to Meliaduse, his brother (Maffei, *Verona Illustrata*, iv. chap. vi
p. 278), says: " Pisanus omnium pictorum huiusce ætatis egregius, cum ex Roma
Ferrariam se contulisset, tabulam quamdam sua manu pictam ultro mihi pollicitus
est, quamprimum Veronam applicuisset."

* Maffei's transcription of the passage in Lionel's letter in which he speaks of
Pisano is incomplete. It runs thus in Mr. Hill's translation: " Pisano, distinguished
among all painters of this age, when he came to Ferrara from Rome, promised to
me a certain picture painted by his hand in which was the image of the Blessed
Virgin. And since the picture was at Rome in the hands of a certain friend of his,
he offered, as soon as he should have come to Verona, to write to him in order
that he might entrust it to you, to the end that you might send it to me instantly;
and at your going hence I for some reason forgot to tell you, as I wished." The
date of this letter is Jan. 20, 1432; Meliaduse appears to have gone to Rome
after Sept. 22, 1431, and we have seen (*antea*, n. 5) that Pisano was back in Rome
by Nov. 27, 1431. Vasari, *Gentile da Fabriano*, ed. Venturi, pp. 36 *sqq.*; Hill,
ub. sup., pp. 51 *sqq.*

ANTONIO PISANO

THE VISION OF ST. EUSTACE.

II 160]

once belonged to the Costabili collection in Ferrara and is now
in the National Gallery.[1] Almost the only specimen of Pisano
in England, it represents a vision of the Virgin and Child in a
round glory, with St. Anthony the Abbot and St. George in
the foreground. There is no denying the vulgar character of
the Infant, nor the tortuous cast of the drapery; but a grim
wildness distinguishes St. Anthony, and St. George is an exact
reproduction of a knight in the broad hat, short cloak, and
armour of the time. Even in this late phase of his practice
Pisano's fashion of embossing continues.[2] In his special walk
as a portraitist, we admire at Mr. Barker's in London the like-
ness of Lionel d'Este, also a relic of the Costabili collection,
a grave, even stern, profile of a youth with curly chestnut
hair, coloured in pastose and highly fused tints [3]; and we trace
the influence of this art by the imitation of Giovanni Orioli,
which hangs in the National Gallery.[4] Having returned to

* [1] Since we now know that Lionel's letter was written as early as 1432, it
is difficult to identify the picture mentioned in it with the Madonna with
SS. Anthony and George, which shows a very mature style.

[2] National Gallery, No. 776. Presented by Lady Eastlake. Wood, tempera,
19 in. high by 11½ in. Inscribed "Pisanus p." Before its restoration under the
care of the late Sir Charles Eastlake, the preparation was laid bare in the cowl
of St. Anthony and the armour of St. George. [* As to Pisano's studies for this
picture, see Hill, *ub. sup.*, pp. 157 *sqq.*]

[3] London, Mr. Barker. Wood, tempera, bust, half the size of life, and fairly
preserved. The profile to the right. [* This picture is now in the Galleria Morelli
at Bergamo (No. 17). It dates very likely from the forties (see Hill, *ub. sup.*,
pp. 151 *sqq.*). To an earlier phase of Pisano's career (*circa* 1435) belongs a portrait
of a young lady in the Louvre (No. 1422 *bis*); it represents probably Ginevra, the
daughter of Niccolò III. of Este (cf. *ibid.*, pp. 70 *sqq.*). Another work by Pisano
which we may ascribe to about the same period as the last-mentioned painting is
the Vision of St. Eustace, in the National Gallery (No. 1436; see *ibid.*, pp. 62 *sqq.*).]

[4] London, National Gallery, No. 770. Wood, tempera, 1 ft. 9½ in. high by
1 ft. 3 in.; also from the Costabili collection. Profile to the left, outlined with less
finish and more mechanically than that by Pisano. Above the head we read:
"Leonellus Marchio Estēsis"; on a parapet: "Opus Johañes Orioli." Purchased
from Sir Charles Eastlake's collection. Orioli is obviously a pupil of Pisano,
and keeps his style better than Bono Ferrarese. His flesh is warm and neatly
finished with hatchings; his surface is harder than Pisano's, and has a glassy
transparence like that of Matteo da Siena.

* This painter was a member of the Savoretti family of Faenza. The earliest
record of him dates from 1443; his death occurred between Jan. 23, 1473, and
Sept. 24, 1474. He received payment for the above portrait on June 21, 1447.
See Ballardini, *Giovanni da Oriolo*.

Verona, Pisano paid occasional visits to Ferrara during the reign of Lionel. He received offers from the court of Mantua, as appears from a letter addressed by Paola Malatesta to Giovanni Francesco Gonzaga in May 1439,[1] and perhaps in consequence of these offers he came to Mantua,[2] carved the medal of the Marquis and his daughter, and painted the chapel and pictures noticed by Facius [3] ; but even at the time of his connection with the Gonzagas he kept his interest at Ferrara, and there is an extant decree in which Lionel of Este orders a vessel to be got ready to take Pisano, "*pittore eccellentissimo,*" to Mantua.[4] The paucity of works during these later years is

[1] D'Arco, *Delle Arti, ub. sup.*, note to i. 38. The Marchioness causes a promise of 80 ducats to be made to Pisano. [* See, however, Vasari, *Gentile da Fabriano,* etc., ed. Venturi, pp. 44 *sq.*]

* [2] He was probably at Mantua by this time. See *postea,* n. 4.

[3] *De V. Illust., ub. sup.*, pp. 47–8. The medal of Cecilia Gonzaga, daughter of Giovanni Francesco, is dated 1447.

[4] Record favoured by the kindness of the Marchese Campori.

* This document is dated Aug. 15, 1441. Pisano seems to have left for Mantua on the following day (Vasari, *Gentile da Fubriano,* ed. Venturi, pp. 47 *sq.*).—In 1438 Verona was stricken by the plague, and many Veronese citizens fled to Mantua to escape it. The Marquis of Mantua, Gianfrancesco Gonzaga, was the commander-in-chief of the army of the Venetian Republic, which from the year 1437 had been at war with the Duke of Milan. In July 1438 Gianfrancesco, however, went over to the side of the Duke of Milan, and forced all able-bodied Veronese within his domains to join his army, and forbade the others to leave the Mantuan territory without his permission. A *Ducale* of Sept. 30, 1439, granted amnesty to all the Veronese who had fled to Mantua, provided they returned to Venetian territory, but for the present they were to stay *a Padua citra* (Vasari, *Gentile da Fabriano,* etc., ed. Venturi, pp. 42 *sqq.* ; Hill, *ub. sup.*, p. 61). Pisano appears to have been at Mantua by this time, but did not avail himself of the amnesty; on the contrary, we learn from a document of 1441 that he was among those Veronese who followed the Marquis of Mantua when he entered Verona, after this town had, on Nov. 17, 1439, been captured by the troops of the Duke of Milan. A few days later Verona was recaptured by the Venetians, and Pisano returned to Mantua (Biadego, *ub. sup.*, vol. lxvii. pt. ii. pp. 841 *sq.*). On May 11, 1440, we find him at Milan (Biscaro, *Archivio storico lombardo,* ser. iv. vol. xv. pp. 171 *sqq.*). From the beginning of 1441, at any rate, Pisano seems to have been at Ferrara. He executed there a portrait of Lionel of Este which, in the opinion of Niccolò III., was inferior to one painted immediately afterwards by Jacopo Bellini (Vasari, *ub. sup.*, pp. 46 *sq.* ; Hill, *ub. sup.*, pp. 138 *sq.*). On Aug. 16, 1441, Pisano apparently returned to Mantua (cf. *antea*). On the 9th of the same month the Council of Ten had enacted that all the Veronese *fuorusciti* must return before the end of the following month if they wanted to benefit by the amnesty. Pisano did not obey even this second command. On Feb. 7, 1442, the Council of Ten published a list of those Veronese who had not yet returned but who were

but partially accounted for by supposing that leisure was
required for making the dies of the numerous medals produced
about this period. Of these we can only say that they are
famous, and that they deserve to be so ; for Pisano's pro-
ficiency in frescoes and panels was greatly inferior to that
which he attained as a medallist.[1] It has been argued with
almost successful ingenuity that Pisano did not survive 1455.[2]
He certainly did not die before, as there are payments to him
for a picture by order of the Duke of Ferrara in that year.[3]

allowed to do so until the end of March. In this list is mentioned " Pisano
pictor." (See Vasari, *ub. sup.*, p. 42 ; Hill, *ub. sup.*, pp. 61 *sq.*) Only now Pisano
thought fit to go to Venice and seek pardon. On Oct. 17, 1442, his case came
before the Council of Ten. The public prosecutor asked that Pisano's tongue—
with which he had slandered the Venetian Government—should be publicly cut
between the columns in the Piazzetta, whereupon he should be banished from the
dominions of Venice. The Council, however, was more leniently disposed to-
wards the artist, and simply forbade him to leave Venice and to sell anything
without its permission. (See "Archivalische Beiträge" in *Italienische For-
schungen*, iv. 120 *sq.*). Only a month later, on Nov. 21, Pisano asked the
Council of Ten for permission to go to Ferrara to settle his affairs there ;
this was granted to him on condition that he should not go either to Verona or
to Mantua ; he was, moreover, not to stay away for more than two months
(Biadego, *ub. sup.*, vol. lxvii. pt. ii. p. 842). Both of these restrictions seem
afterwards to have been removed ; for after Pisano, on Feb. 15, 1443, had left for
Ferrara, he seems to have remained there until Nov. 1443 (Vasari, *ub. sup.*,
pp. 48 *sq.*) ; and he is also mentioned in that year in the Veronese *Estimi* as
living in the Contrada di San Paolo, where, as we have seen, he already had his
home in 1422. He is also mentioned in the *Estimi* of 1447, and there exist other
documents which prove that he was at Verona in 1445 and in 1446 (Biadego,
ub. sup., vol. lxvii. pt. ii. pp. 845 *sq.*). He continued, however, to work for Lionel,
and received payments from him in 1445 and 1447 (Vasari, *ub. sup.*, pp. 51 *sq.* ;
Hill, *ub. sup.*, p. 141). In 1448 Pisano went to Naples and entered the service
of King Alfonso I., who on Feb. 14, 1449, granted him a yearly salary of 400
ducats (*ibid.*, pp. 59 *sq.* ; Hill, *ub. sup.*, pp. 194 *sqq.*).

[1] There are 28 known medals by Pisano : (1) Nicolas Piccinino ; (2–10) Lionel
d'Este, with different obverse (1444) ; (11, 12) Sigismund Malatesta (1435) ;
(13) Pietro Candido Decembrio ; (14) Vittorino da Feltre ; (15) Filippo Maria
Visconti (died 1447) ; (16) John Palæologus (1438) ; (17–21) Alfonso of Arragon
(1448) ; (22) Francesco Sforza, Lord of Cremona ; (23) Gio. Francesco Gonzaga ;
(24) Cecilia, daughter of the foregoing ; (25) Lodovico Gonzaga III. ; (26) Mala-
testa Novello, Lord of Cesena ; (27, 28) Inigo d'Avalos. Porcellio, in his verses,
alludes to a medal of himself by Pisano (*Tre Carmi*, *ub. sup.*, p. 20). [* As to
Pisano's medals, see now especially the already quoted monograph by Mr. Hill.]

[2] *Il Pisano*, *ub. sup.*, pp. 6–8.

[3] In a memorial of 1455, in the archives of Modena, we read : "Pixiano
dipintore, de dare adi XVII. de Agosto Duc[i] cinquanta d'oro." Payment for

The last undertaking in which he may have been busy at
Verona is a series of greatly injured compositions in a chapel
at Santa Maria della Scala, now used as a bell-room. Within
a comparatively short period twenty-eight frescoes there were
recovered from whitewash, in a ruined or nearly ruined con-
dition. A signature was found which gave rise to animated
debate according as the fragments were assumed to mean
" Stefanus " or " Pisanus." To discuss the merit of the
frescoes in their present state is useless, and all we can do is
to take them as representing the school of Pisano.[1] One
circumstance favours the belief that he had a share in them—
the circumstance that four rounds in the thickness of the
windows reproduce the medals of John Palæologus, Lionel of
Este, Sigismund Malatesta, and the freebooter Piccinino.[2]

It was almost a necessary consequence of Pisano's importance
in the eyes of artistic patrons that other Veronese painters
should be overlooked; and yet any amount of neglect would

a picture ordered by the Duke. (Favoured by the kindness of the Marchese
Campori.) [* The correct date of this record is 1445. See Vasari, *ub. sup.*, p. 51.]

In a letter from Carlo de' Medici to Giovanni de' Medici, dated Rome, Oct. 31,
without the year, we find that Pisano's medals were on sale at Rome. Carlo writes
that he has bought thirty in silver: "da un garzone del Pisanello che morì a
questi di" (Gaye, *Carteg.*, i. 163). It is a pity we do not know the year of the
missive. [* It is undoubtedly 1455; but, as Prof. A. Venturi remarks, " che morì
a questi di" might refer to " garzone," not to " Pisanello." Flavio Biondo speaks
of Pisano in 1450 as still living; whereas Bartolommeo Facio in 1455–6 mentions
him as dead. See Vasari, *ub. sup.*, pp. 62 *sqq.*; Hill, *ub. sup.*, pp. 211 *sqq.*]

* [1] These paintings are now proved to be by Giovanni Badile; see *postea*,
p. 167, n. 3.

[2] We have seen what remains of all the paintings by Pisano. At Venice and
Rome, as well as at Mantua, nothing is left; at Verona little. We register as
missing the following, premising that panels assigned to Pisano at San Francesco
of Perugia are, as has been shown elsewhere, by Bonfigli or Fiorenzo (*History of
Italian Painting*, 1st ed., iii. 150). Facius mentions a St. Jerome adoring the
Crucifix and a Wilderness in which are many animals.

Guarino, in his eulogy, alludes to portraits as distinct from medals; and to a
St. Jerome in his possession, which may be the same alluded to by Facius. (See
the lines in *Il Pisano, ub. sup.*, pp. 14–16.)

Basinio (*Tre Carmi, ub. sup.*, p. 35) describes a portrait of Vittorino da Feltre
as distinct from the medal, and speaks of medals of persons hitherto unknown
to have been portrayed by Pisano, *e.g.* Giovanni Aurispa and Paolo Toscanella.

* An Adoration of the Shepherds ascribed to Pisano was in 1632 in the
collection of Roberto Canonico of Ferrara (Campori, *Raccolta di cataloghi*,
p. 109).

have been justified by the poverty which the Veronese school exhibited.

Stefano da Zevio, when borne on the municipal register at Verona in 1433, was upwards of forty years of age[1]; he was therefore the contemporary and follower of Pisano, rather than his pupil[2]; but, unlike Pisano, who progressed, Stefano disimproved as he proceeded, so that his style at last became a caricature. A miniaturist and grandfather to Girolamo dai Libri,[3] himself a miniaturist, he left but few examples behind[4]; enough, however, to cast suspicion on the praise of Vasari and Donatello. There are fragments of a Virgin and Child, with St. Christopher and seraphs, on the front of a house in the Strada di Porta Vescovo[5]; a Trinity and Glory of St. Augustine,

[1] By this register he is proved to have been born in 1393 (Bernasconi, *Studi, ub. sup.*, p. 226). He cannot therefore be the pupil of Agnolo Gaddi any more than he can be a disciple of Liberale da Verona (see Vasari, iii. 632). [* There can be no doubt that Bernasconi wrongly quotes the document to which he refers; this is obviously an entry in the Veronese *Anagrafi* of 1425, in which Stefano is described as fifty years old (see Gerola, in *Madonna Verona*, ii. 150 *sq.*; Cervellini, *ibid.*, iii. 97 *sqq.*). From this we must infer that he was born about 1375, and it is therefore not impossible in itself that he was a pupil of Agnolo Gaddi, who died in 1396. Stefano is also mentioned in the Veronese *Estimi* in 1425 and 1433; in 1434 he seems to have been staying at Castel Brughier, near Trent; and in 1438 Tommaso Salerno of Verona mentions in his will an altarpiece ordered by him from Stefano for Sant' Anastasia and not yet finished. The fate of this work is unknown. (See Gerola, *ub. sup.*, ii. 151 *sqq.*) It may be pointed out that there is no older authority for the appellation "da Zevio" than Panvinius (*Antiquitatum Veronensium libri octo*, p. 171), whereas the artist in contemporary records is called either simply Stefano or Stefano of Verona (cf. Gerola, *ub. sup.*, ii. 158 *sqq.*).]

[* 2] The record in the Veronese *Anagrafi* of 1425 mentioned in the preceding note proves that Stefano was nearly twenty years older than Pisano.

[3] In the Veronese *Anagrafi* of 1492 we find Franciscus Miniator, fil. q., Stefani a Libris, who is the father of Girolamo dai Libri (Bernasconi, *Studi*, note to p. 30). [* Stefano dai Libri is not identical with the artist now under discussion (Gerola, *ub. sup.*, ii. 163, n. 1).]

[4] Verona. We notice as missing here: frescoes at Sant' Antonio, San Niccolò, on the front of Santa Maria Consolatrice, in the choir and in the Chapel of the Sacrament at Sant' Eufemia; panels, St. Nicholas with saints and a predella in Sant' Eufemia.

Mantua: frescoes in San Domenico, in San Francesco, and on a house-front, and a Madonna in the church of Ognissanti, dated 1463 (?) (Vasari, i. 641 *sq.*, iii. 628 *sqq.*, v. 274; dal Pozzo, *ub. sup.*, pp. 11, 12). [* Cf. *postea*, p. 167, n. 1.]

[5] Verona, Strada di Porta Vescovo [* now called Via XX Settembre], No. 5303. Inscribed to the left of the throne: "Stefanu pinxit"; the lower part obliterated. [* This fresco has now been transferred to the Museo Civico of Verona.]

with copious attendance of saints and cherubs, above the side-portal of Sant' Eufemia at Verona[1]; at Rome and Milan there are pictures on panel unmistakeably his—a Madonna in the Palazzo Colonna,[2] and an Adoration of the Kings dated 1435 in the gallery of the Brera[3]; in a church at Illasi, near Verona, part of a Virgin and Child in fresco.[4] From the contemplation of these pieces we rise with the conviction that the author was bred in a school of illuminators of which Verona was the cradle and the nursery. Without the power to shake off the rigid rules of a very old craft, he blindly followed the beaten path, exhausted every trick of minute finish, and forgot the sound principles of draughtsmanship, modelling, and selection; clinging to embossment as a means for simulating relief, he made no use of the simpler process of chiaroscuro; his canvases and wall-paintings were wanting in correctness of drawing as well as in staidness and dignity of expression; and if ever they had attraction, they derived it from the rosy pallor of flesh gently heightened with grey, or the frequent introduction of birds and flowers.

Beneath Stefano again are Giovanni Badile, Girolamo Benaglio, and Cecchino, who need only be mentioned in proof

[1] Verona, Sant' Eufemia. St. Augustine sits in a recess, under a canopied throne, at the sides of which we read: "Stefanus pinxit." Some of the saints that are preserved are in the soffit of the recess. The front of the wall above, and the lower part of the fresco, are deprived of painting. The head of St. Augustine, too, is nearly gone.

[2] Rome, Palazzo Colonna, No. 130. Small panel, tempera. The Child takes a rose from the Virgin; angels in air seem to pray, others give offerings of roses and flowers, and one at each corner of the foreground plays a musical instrument. The light soft tempera seems to contain a mixture of wax.

[3] Milan, Brera, No. 223. Panel, tempera, m. 0·72 high by 0·47, inscribed: "Stefanus pinxit 1435," and catalogued as Stefano Fiorentino (!) This is the composition of which the original type was given by Gentile da Fabriano, with embossments and no relief by shadow. The draperies all end in trains; as usual, a multitude of animals. [* This painting is now officially ascribed to Stefano da Zevio.]

[4] Illasi, near Verona. Virgin and Child and angels, and two saints in pattern framings; parts of fresco, now in a chapel to the right in the parish church. At the Virgin's feet a peacock. This is the lowest phase and the latest of Stefano's art, yet cited as a proof of the existence of an older Stefano (see Maffei, *Verona Illust.*, and Bernasconi, *Studi*, p. 220). [* In San Fermo at Verona there are some fragments of frescoes by Stefano, mentioned also by Vasari (iii. 631). Cf. Gerola, *ub. sup.*, ii. 154.]

of the weak state to which the art of Verona was reduced at the time of Mantegna.[1] But it is important to bear in mind that, small as the place may be to which they are entitled in the annals of Verona, some of these, such as Girolamo Benaglio and his followers, Francesco Benaglio[2] and Moroncini, introduced new models of proportion into the school, a larger cast of the human frame and limbs, a new technical treatment, colour of more lively tints, and shadows of greater intensity than before. Of Badile there are records extending from 1418 to 1433,[3] and an authentic picture in the Gallery of Verona.[4] Girolamo

[1] We might think also of Vincenzo di Stefano, of whom Vasari speaks as the master of Liberale da Verona, assigning to him a Madonna in Ognissanti of Mantua, dated 1463, which we learn from dal Pozzo to have been by Stefano (Vasari, v. 274 ; dal Pozzo, p. 12). If we accept Vincenzo as an artist who has existed, we may mention a fresco attributed to him at Verona. It is part of the decoration of the monument of Cortesia Serego, dated "Anno Do. MCCCCXXXII," in Sant' Anastasia. Subject, the Eternal in the midst of cherubs, angels, of which some are obliterated, SS. Dominic and Peter Martyr. The style is that of Stefano exaggerated, as in Nerito, and is not unlike that of Giambono. [* It is not unlikely, as Dr. Gerola ingeniously suggests, that Vasari, when speaking of Vincenzo di Stefano, made one person of that name out of Stefano da Zevio and Niccolò Solimano of Verona. The Madonna at the Ognissanti of Mantua mentioned above seems to be identical with a still extant fresco by the latter artist, signed "Nicolaus de Vona pinxit 1465." See Gerola, ub. sup., ii. 155 sqq.]

* [2] Francesco Benaglio was really the father of Girolamo Benaglio. See postea, p. 168, n. 1.

[3] Bernasconi, Studi, pp. 224-5. [* Giovanni Badile belonged to a family which for a period of about two hundred years from the fourteenth century onwards yielded a great number of painters ; one of its scions was Antonio, the master of Paolo Veronese. Giovanni is first mentioned in 1409, and made his will in 1448. He is the author of the frescoes in the Cappella Guantieri in Santa Maria della Scala at Verona, mentioned antea, p. 164; they were ordered in 1443. See Simeoni, in Nuovo archivio veneto, ser. ii. vol. xiii. pp. 152 sqq., and Thieme and Becker, Allgemeines Lexikon der bildenden Künstler, ii. 335.]

[4] Verona Gallery, No. 373 ; originally in San Tommaso Cantuariense. Virgin and Child between SS. Anthony, George, James, Peter Martyr, a bishop, and Thomas ; a kneeling patron at the Virgin's feet; inscribed : "Johes Baili"; m. 0·94 high by m. 2·0 long, wood. This is a light washy tempera with short and deformed figures, showing the art of Stefano in the last stage of its decline. [* It seems probable that the above signature is an eighteenth-century forgery. Until 1803 this polyptych was in San Pietro Martire at Verona. See Gerola, ub. sup., ii. 166 sqq.] In the same manner, same gallery, No. 364, St. Nicholas presenting a patron to the Virgin and Child in presence of St. Andrew. No. 374, inscribed : "Hoc opus fecit fieri sor Lucia de Frachanzanis, MCCCCXXVIII." Virgin and Child between SS. Martin and George ; in pinnacles, the Virgin, St. Gabriel, and St. Michael.

Benaglio, who was more prolific, inscribed one of his altar-pieces with the words: "Hieronymus Benalius q. Francisci anno 1450,"[1] and Cecchino's Madonna in the cathedral of Trent[2] is supposed to be of the same period. Of Francesco Benaglio it is stated that he completed a fresco at Santa Maria della Scala in 1476[3]; but there is no chronology of his life,[4] and an altar-

[1] Verona. This was a fragment representing four singing angels (dal Pozzo, *ub. sup.*, p. 10). His manner is illustrated by the following: Verona Gallery, No. 368, panel with St. Cecilia between SS. Tiburtius and Valerianus, under niches in front of a skirting into which medallions of emperors are let in. Nos. 353, 354, SS. Rustico and Fermo; the figures slender and affected, of a dull tempera tone. No. 372, Virgin and Child between SS. Catherine and Maria Consolatrix. No. 385, Virgin and Child between SS. Sebastian and Biagio. No. 369, Virgin and Child between SS. Peter and James. All these are in the same feeble style. By the same hand, No. 380, Virgin and Child between St. Denis and Mary Magdalen, with the Eternal in a gable; catalogued Antonio Badile, and of the school. No. 360, under the name of Francesco Benaglio, and dated 1487, a Virgin, Child, and saints between SS. Sylvester and Benedict, with the Crucifixion in a lunette and a predella representing the Entombment, the symbols of the Passion, and SS. Catherine and Lucy, from the church of San Silvestro. Recorded in the *Ricreazione Pittorica* (*ub. sup.*, p. 17) is a Marriage of St. Catherine by Girolamo Benaglio in the church of San Piero Maggiore at Verona. See also dal Pozzo, *ub. sup.*, p. 260. [* Recently discovered documents prove that Girolamo Benaglio was the son of Francesco Benaglio; he is stated to be twenty-three years old in 1492. The signature reported by dal Pozzo was therefore either incorrectly read by him or a forgery. No authenticated works by Girolamo are known to exist. See Simeoni, in *Nuovo archivio veneto*, ser. ii. vol. v. pp. 255 *sqq.*; Gerola, *ub. sup.*, ii. 178 *sqq.*]

[2] Trent Cathedral, sacristy. Virgin and Child between SS. Vigilius and Sisinius. Wood, tempera, inscribed on the intermediate pilaster: "Cechinus de Verona pinxit." Dr. Bernasconi adds the ciphers 1454, which are not on the picture (*Studi*, p. 234). [* It has now its place in the Museo Diocesano at Trent. Cecchino witnessed two wills in 1439 (Biadego, *ub. sup.*, vol. lxviii. pt. ii. p. 243, notes 2 and 3), and appears to have been still living in 1464 (Zannandreis, *Le vite dei pittori . . . veronesi*, p. 39). He was dead in 1480, as Dr. Gerola kindly informs me.]

[3] Dal Pozzo describes it as representing four saints at the sides of a miraculous Virgin, and inscribed: "Francescus Benalius pinxit, 1476." The four saints were SS. Bartolommeo, Zeno, Girolamo, and Francesco (dal Pozzo, p. 10, and *Ricreazione Pitt.*, p. 114). The altar of the miraculous Virgin was renewed and the figures were removed in 1738 (Persico, *Descr. di Verona, ub. sup.*, pt. i. p. 211). [* Cf., however, Gerola, *ub. sup.*, ii. 177.] Persico also says that there were frescoes all but obliterated in his time on the façade of Santa Maria della Scala also by F. Benaglio.

* [4] Francesco Benaglio is described as being forty years of age in the Anagrafi of 1472. In 1475, with another painter named Martino, he helped two Veronese noblemen to take vengeance on the noble Cristoforo Sacramoso by painting the

piece with his signature bears no date. We may gather from his works that he would not have forsaken the elementary manner of Girolamo but for the coming of Mantegna. In a fresco filling the principal space in the Cappella Lavagnoli at Sant' Anastasia of Verona, a number of lanky saints are set in a stiff cluster before some houses and a landscape of water and islands.[1] The painter seems bred in the atelier of Girolamo Benaglio. Defying at once all rules of perspective and draughts-manship, yet careful to a fault in his execution, he rises to the level of Dierick Bouts in the Flemish or of Matteo of Gualdo in the Umbrian school. He clings distantly to the traditions of Pisano, and has perhaps a dim notion of the budding greatness of the Paduans. If Francesco Benaglio be the author, he also left us the Madonna under the portico leading to the Cortile dei Tri-bunali at Verona,[2] and the saints in the pilasters at the entrance of the Pellegrini chapel in Sant' Anastasia.[3] In a spirit more nearly related to the Paduan, and under the influence perhaps of Mantegnesque examples, he may have carried out the decoration of the altar sacred to St. Vincent Ferrerio in the same church, unless we should suppose it due to the bolder hand of Falconetto or Liberale.[4] That he gradually adopted Mantegnesque masks and accessories is clear in the Madonna with a choir of boys on

front of his house with obscene subjects. The two artists were punished by four months' imprisonment. Francesco Benaglio was dead in 1492. See Simeoni, *loc. cit.*, pp. 252 *sqq.*; Gerola, *ub. sup.*, ii. 179 *sqq.*

[1] Verona, Sant' Anastasia. The subject is obscure, the fresco injured; above it, a Crucifixion and other things, probably by Moroncini; the rest of the chapel whitewashed.

[2] Verona, portico leading from the Piazza de' Signori to the Cortile dei Tri-bunali. Fresco, Virgin and Child, the latter curly-headed and in benediction; a long lean figure. [* Now in the Museo Civico of Verona.]

[3] Verona, Sant' Anastasia, Cappella Pellegrini. St. Bernardino and another saint in niches, with medallions of emperors and saints in the pediments and skirtings.

[4] Verona, Sant' Anastasia. Fresco of St. Vincent Ferrerius above a carved Crucifixion. At each side of St. Vincent Ferrerius, SS. Peter and Paul imitating statues on brackets; in an imitated recess soffit, angels; and on the imitated arch, medallions of emperors; below, at the sides of the Crucifixion, remains of saints, as well as remnants of figures in niches on the imitated pilasters at the sides. The whole of this decoration is assigned to Mantegna, but the art is that of a Veronese of the old school assuming the Mantegnesque. The colour is dull and dirty, and there is much accessory ornament embossed.

a wall of the Via de' Scrimiari,[1] as well as in two figures of the
Veronese Gallery.[2] His last and most absolute phase of repro-
duction is that illustrated in San Bernardino, where a Madonna
with attendants and children is a counterpart of Mantegna's at
San Zeno.[3] He might claim, indeed, as author of this and other
pieces, the name of the Zoppo of Verona.[4]

Still lower in the scale of Veronese art is Domenico de'
Moroncini,[5] whose signature is appended to a Madonna in a
house of the Contrada Cantarane at Verona,[6] and whose frescoes
in the Cappella Lavagnoli at Sant' Anastasia give a sort of
superiority to those of Francesco Benaglio.[7]

From this point the Veronese school assumes a more de-

[1] Verona, Via de' Scrimiari. Virgin and Child in a throne with falling garlands
of leaves and four children singing open-mouthed; to the right and left much
injured and in part obliterated (engraved in Pietro Nanin's *Affreschi di Verona*,
fol. Verona, 1864).

[2] Verona Gallery, Nos. 344 and 345. St. Francis and St. Bernardino, panel
temperas, originally in San Clemente of Verona (knee-piece). The figures are thin
and feeble, as in Sano di Pietro or Vecchietta; the tempera flat and light.

* [3] We now know that this work was completed as early as 1462. See Simeoni,
Verona, pp. 153 *sq*.

[4] Verona, San Bernardino. Virgin enthroned; the Child, adored by a kneeling
figure of St. Bernardino; at the sides, SS. Peter, Paul, Francis, Anthony, Louis,
and Buonaventura. The throne and pillars of the court imitate those of Man-
tegna; the figures are dry and unrelieved by shadow; the dresses in lively and
sharp contrasts. The picture, on the whole, is half Umbrian, half Mantegnesque.
It is inscribed: "Franciscus Benalius pinxit." In the same spirit, under the name
of Marco Zoppo, is the following: Verona Gallery, No. 350, wood, tempera, half-
length Virgin with the Child and the boy Baptist on a parapet, and two boy-
angels. The red-brick tone of thick substance has, no doubt, suggested Zoppo's
name, but the painter is Francesco Benaglio. [* This picture is now labelled
"Francesco Benaglio?"] Amongst missing pieces is the following: Verona,
San Lorenzo, the Virgin, Mary Magdalen, and Disciples wailing over the dead
body of Christ (Persico, pt. i. p. 75). [* This painting is probably identical with
one which now belongs to Signor Cesare Laurenti of Venice and which is repro-
duced in *Madonna Verona*, v., plate facing p. 194.]

* [5] Dr. Gerola suggests (*ub. sup.*, ii. 108 *sq*.) that Domenico de' Moroncini
is identical with Domenico Morone.

[6] Verona, Contrada Cantarane, No. 5381 [* now 51 Via Niccolò Mazza].
Virgin adoring the Child between St. Christopher and Mary Magdalen, inscribed:
"Opus Dominici de Moročini." Wall-painting, with some of the fanciful char-
acter apparent in Liberale. [* This fresco is dated 1471.]

[7] Verona, Sant' Anastasia, Cappella Lavagnoli. Crucifixion, and the Call of
James and Andrew to the Apostleship. The drawing is very incorrect indeed.

Besides the above we note: Verona Gallery, Nos. 399, 400, tempera on panel,

cided character, and has marked currents and subdivisions. Imitation of Mantegna, superficial in Liberale, Falconetto, and Giolfino, becomes searching in Bonsignori and Caroto. Domenico Morone, Girolamo dai Libri, Francesco Morone, and Paolo Morando feel the spur of emulation, and strive as draughtsmen to rival Mantegna ; whilst, as colourists, their style is altered by the influence of Montagna.

Liberale enjoyed advantages unknown to some of his contemporaries. He was born in 1451, and trained to be a miniaturist.[1] Having left Verona at an early age,[2] he went round the convents ; found employment first amongst the Benedictines of Mont' Oliveto near Siena, and then accepted service from the governors of the Siena cathedral. For several years

representing SS. Bartholomew and Roch, probably by Moroncini. [* These paintings belong to the same polyptych as those mentioned *antea*, p. 170, n. 2.]

Moroncini's art is continued by Dionisio Brevio, of whom there is a Pietà, No. 375, and a Nativity, No. 299, in the gallery under notice. Brevio is a painter of the middle of the sixteenth century ; and dal Pozzo notices an Adoration of the Shepherds by him, signed : "Dionysius Brevius Veronensis fecit anno 1562 " (dal Pozzo, *ub. sup.*, Aggiunta, p. 5). [* According to Dr. Gerola, it is not certain that the two above-mentioned pictures in the Verona Gallery are by Brevio. An authentic work by him is a painting of St. Michael in the chapel of the Stringa family at Caprino, near Verona ; it is signed and dated 1531, and stands near to G. F. Caroto. See Gerola, in Becker and Thieme, *ub. sup.*, iv. 600.]

Less modern is Bernardino da Verona, of whom there are notices at Mantua (D'Arco, *ub. sup.*, pp. 38–9, and Gaye, *Carteg.*, i. 334–6), and the possible author of a Virgin and Child annunciate, SS. Zeno and Benedict in San Zeno, ascribed by old guides to Bernardino da Murano. The style is an approximation to that of the Veronese Domenico Morone, or Liberale, so far at least as one can judge from the miserable condition of the surface. [* These paintings are now in the Museo Civico of Verona (Nos. 363 and 366). The Bernardino da Verona mentioned above was probably a brother of Francesco Bonsignori. See Tea, in *Madonna Verona*, iv. 137 *sq.*]

[1] Liberale's full name is "Liberale di Maestro Giacomo dalla Biava da Monza." In the account-books of Siena (Milanesi, *Doc. Sen.*, ii. 384 *sqq.*) he is commonly called "Liberale di Jacomo da Verona." Vasari's statement that he studied under Jacopo Bellini cannot be supported, for obvious reasons (Vasari, v. 274). He was born in 1451, as is proved by the registry (*Anagrafi*) of Verona for 1492, in which he and his family are described as follows : "Liberalis pictor [aged] 40 ; Zinevria, eius uxor, 25 ; Lucretia, eorum filia, 2 ; Hieronyma, eorum filia, 1 ; Joannes famulus, 16 " (Bernasconi, *Studi*, p. 245). [* The various statements as to the age of Liberale contained in the Veronese *Anagrafi* do not tally with each other. It seems, however, very likely that Liberale was born about 1445. See Gerola, *ub. sup.*, iii. 27.]

[* 2] He was still at Verona in 1465. Gerola, *ub. sup.*, iii. 28.

previous to 1477 he pored over graduals and antifoners, painting
all the subjects of the New Testament in succession, and wasting
a prodigious amount of patient labour in minutiæ and details.[1]
His miniatures are justly considered masterpieces of their kind,
being bright and careful, and unusually spirited in movement ;
but when he came back to Verona, and abandoned vellums
for panels, the faults evolved by his training became disagreeably
apparent. We shall find little interest in following his progress
step by step at Siena or at Chiusi, where the miniatures of the
Benedictines are now preserved ; to speculate on the course
of his journeys, or inquire whether he visited Florence or Venice,
would be as useless as it is to ask when he turned homewards.
It is sufficient to state that Liberale was umpire for the municipal
council of Verona on a question of art in 1493, and that there
are dim signs of his existence till 1515.[2] Of all the pictures
which he finished one alone bears his name and the date of
1489, and it is obviously not the first that he undertook when
he gave up miniatures. We may therefore assume that he
was living between 1480 and 1490 at Verona, when he delivered
the Adoration of the Magi in the Duomo, to which Giolfino
furnished the wings and lunette. One might fancy that the
artist was a comrade of Lucas of Leyden, he exaggerates
attitude and face so quaintly, and such is the fritter of his
drapery. His action is strutting ; his drawing very careful, yet
unsound and puffy ; his bright colours thrown together without

[1] Liberale and his apprentice, Bernardino, received from the monks of Mont'
Oliveto for three years' labour, to Dec. 28, 1469, 1,324 lire, 15 soldi, and 4 denari
(Vasari, ed. Le Monnier, Annot., ix. 169). From 1470 to April 1476 Liberale
received payments from the superintendents of the Siena duomo (Milanesi,
Doc. Sen., ii. 384-6, and Vasari, ed. Le Monnier, Annot., vi. 180, 213-6, 219-21,
345 and foll.). Particularly fine are the miniatures of Mont' Oliveto, now at
Chiusi. There is also a very fine and animated miniature of Christ supported
in the tomb by the Virgin and others, assigned to Mantegna, in possession of
Don Domenico Ricci at Treviso. It shows Liberale's art more advanced and
expanded than at Chiusi. [* The present owner of this miniature is not known
to the editor.] A miniature of the Adoration of the Shepherds by Liberale was
of old in the Moscardi collection at Verona (Persico, ii. 34).

[2] Bernasconi, *ub. sup.*, pp. 238 *sq.*, and Vasari, ed. Sansovino, v. 274, n. 1.

* Liberale was back at Verona in 1488 (Fainelli, in *L'Arte*, xiii. 220), and is
mentioned in the Veronese *Estimi* of 1492, 1502, 1515, and 1518, and in the
Anagrafi of 1492, 1502, and 1518. He married thrice, the last time in 1525 when
about eighty years old. He was dead in 1529. See Gerola, *ub. sup.*, iii. 31 *sqq.*

attention to harmony or distance, and the background full of
exuberant detail[1] ; like most Veronese, he is fond of intro-
ducing rabbits, dogs, and other animals. In the same violent
and restless way Liberale composed the Nativity, Epiphany, and
Death of the Virgin, a predella in the bishop's palace at Verona,
reminding us of Filippino Lippi in figures of the Virgin and
Child, of the northerns in homely ugliness of masks, and of
Taddeo Bartoli in vehemence of movements and sharpness of
tinting. An an executant he gains breadth and freedom, and
the fault of minuteness seems to leave him.[2] His aim now is
to copy Mantegna as faithfully as the peculiarities of his style
will allow ; and of this we have a notable instance in the
Madonna of Casa Scotti at Milan, where but for the sombre
olive of the complexions and the copious detail we might almost
admit that the name of the great Paduan is appropriate. It
has seldom indeed been the good fortune of persons who gain
a dishonest livelihood by forging signatures to come so near
the mark as in this case. With the words " Andreas Mantinea
p. s. p. 1461," in gold letters on the Virgin's pedestal, many
persons might without incurring grave reproach be deceived,
and yet it is very clear that Liberale was the painter. The
composition, heads, and drawing are all Mantegnesque in
Liberale's inferior manner ; the arrangement is cold and formal,
the outline lacks scientific correctness, the drapery is cut into
zigzags, detail is minutely carried out and profuse, colour deep,
hurtling, and in oil.[3] Still more marked in its imitation is

[1] Verona, Duomo, Capp. Calcasoli (dal Pozzo, p. 233; *Ricreazione*, p. 7).
Small panel, oil.

[2] Verona, Vescovado. In the Nativity he shows that he has seen Filippino's
pictures. The detail of a female with a fowl in her hand and a dog with a rat
is very trivial. The passion and grimace in the Death of the Virgin are almost
German in their realism.

[3] Milan, Casa Scotti ; formerly in possession of the Duca Melzi, and assigned
by Geheimrath Dr. Waagen to Mantegna, who says (Raumer's *Taschenbuch*,
ub. sup., p. 526) it is probably that done by Mantegna for the Abbot of Fiesole,
though Vasari describes that of Fiesole as " dal mezzo in sù " and this is a full-
length (Vasari, iii. 394). Arched panel. Virgin enthroned in a high stone
chair, the back of which is capped with a medallion imitating bronze and
representing the Presentation in the Temple. In a frieze beneath the medallion
an imitated relief of the Judgment of Solomon, and in other parts of the same
frieze, which runs round the whole throne, other subjects, as *e.g.* the Salutation

the panel with three angels bearing the symbols of the Passion,
seen by the authors in the house of Signor Antonio Gradenigo
at Padua[1]; what betrays Liberale is a shiny livid flesh-tint,
garish contrasts in dresses, and a rudeness of extremities to
which Mantegna was a stranger. As he gains confidence and
enjoys an experienced freedom of hand, his style becomes more
characteristic; his figures assume a better proportion, and are
more strongly relieved by shadow, his faces are less coarse,
and the old incorrectness of drawing in some measure disappears.
Of this improvement we have an example in the Glory of
St. Anthony at San Fermo[2]; in that of St. Jerome in the
chapel alla Vittoria[3] ; and even in that of St. Metrone at Santa
Maria del Paradiso[4] at Verona. In some of the saints at the
Vittoria, as in a St. Sebastian at the Brera[5] and its replica in

at the base. On the arms of the chair four angels playing and singing; at the
foot of the throne a pink in a flower-pot, and two boys playing instruments;
distance, sky and landscape. This is evidently the centre of a larger picture.
In the sky some modern has painted in a Virgin and Angel annunciate. [* The
editor agrees with Dr. Malaguzzi Valeri (*Pittori lombardi del quattrocento*, pp.
45 *sqq.*) in ascribing this work to Butinone in view of the close resemblance of
style which exists between it and the picture by Butinone at Isola Bella.]

[1] Padua, Casa Antonio Gradenigo. Lunette panel, assigned to Mantegna,
but suiting the description given by Vasari of part of an altarpiece by Liberale
in the Cappella del Monte di Pietà at San Bernardino of Verona (Vasari,
v. 274 *sq.*). The colour is lustrous olive in flesh and horny. The heads recall
those subsequently painted by Caroto.

[2] Verona, San Fermo, Cappella Sant' Antonio. St. Anthony of Padua on a
pedestal, between St. Nicholas of Bari, St. Catherine, and St. Augustine, all but
life-size, with a distance of sky and trees. Wood, oil, with a good mass of shade,
a bold easy handling, good proportions, and fair masks, the whole outlined
without excessive angularity.

[3] Verona, Cappella del Comune alla Vittoria. St. Jerome on a pedestal
between St. Francis and St. Paul; landscape distance, figures life-size, in panel,
oil. Same character as above, but more mannered in outline. [* This picture is
now in the Museo Civico of Verona (No. 625).]

[4] Verona, Santa Maria del Paradiso, often called San Vitale. Arched panel,
oil, figures life-size. St. Metrone on a pedestal between St. Anthony of Padua,
and St. Dominic under an arch, through which a distance of sky is seen. The
figures are greatly repainted, especially in the flesh parts; but the character was
evidently that of the foregoing.

[5] Milan, Brera, No. 177. Panel, in oil, figures life-size, m. 1·80 high by m. 0·95.
The saint is bound with his arms behind his back to a gnarled and leafless tree.
In the distance a canal and gondolas, betraying Liberale's acquaintance with
Venice. The hip drapery is papery; the form bony, but freely drawn from a
common model ; the face looking up, well foreshortened.

the Museum of Berlin,[1] we are distantly reminded of wild types peculiar to Botticelli and Filippino, or of bony nude like that of the Pollaiuoli. It is only when we revert to subjects of grieving that the more disagreeable aspect of Liberale's art recurs. He is passionate, conventional, and grimacing in three or four representations of Christ Entombed, the best of which is in San Leo at Venice,[2] the most careless in the Torrigiani gallery at Florence,[3] the most ambitious—a fresco—in Sant' Anastasia at Verona.[4] In the latest years of his career he was neglectful, and gave himself up to a conventional *bravura* that diminishes the value of his works. Of this class we might mention several, such as the Assumption of the Magdalen in the sacristy of Sant' Anastasia,[5] the Holy Family and Nativity

[1] Berlin Museum, No. 46A. Replica of the foregoing, same size.

[2] Venice, San Leo. Above the side-portal, panel in oil of Christ in the tomb, bewailed by four angels. This panel is probably the same which Vasari mentions in the Cappella del Monte di Pietà at San Bernardino of Verona, and of which the lunette has been noted in Casa Gradenigo at Padua. The drawing is all in curves, mannered, and incorrect. (Vasari, v. 274, 308.)—Another example of the same kind, with a greater number of figures, is in Verona, San Lorenzo. Wood, oil, greatly repainted, and inferior to the above.

[3] Florence, Casa Torrigiani. Wood, very defective, but inscribed: "Libālis V." The tone is dark olive ; had Liberale never done better than this, he might be called the Margaritone of Verona.

[4] Verona, Sant' Anastasia, chapel de' Buonaveri, third altar to the right of the entrance. The subject here is done in fresco. The Saviour is about to be lowered into the tomb in a winding-sheet by eight figures. Above is a statue of the Eternal in a glory of painted angels ; the whole in an imitated recess, in the vaulting of which saints are placed at intervals. Of all the frescoes in this chapel mentioned by Vasari (v. 275), this is all that remains. The ceiling, or what there is of its paintings, is very much below the parts above described ; but even this is damaged by dirt and dust.

[5] Verona, Sant' Anastasia. Arched panel, once on the altar of the chapel just described (Vasari, v. 275). The Magdalen on a cloud between two angels, all in tortuous movement. Below, St. Catherine and a female saint with a scapular. The colour is grey and brown without modulations, the figures life-size. There is something reminiscent of Signorelli and the Sienese in the treatment. The foreground is slightly injured.—In this church are assigned to Liberale an altar in the Cappella Conti with gilt and coloured statues, and a basement on which there are three scenes from the Passion—the road to Calvary, the Saviour dead on the Virgin's knees, and the Sermon on the Mount—and ten figures of saints. The altar is inscribed: "MCCCCCX mensis Marci." This is a very rough production in a very dark place, and not at present in the character of Liberale's usual pieces. (Persico, i. 18.)

in the Verona Gallery,[1] the Madonna with Saints in the Berlin
Museum,[2] and a couple of house-fronts.[3]

[1] Verona Gallery, No. 275, m. 0·75 high by m. 0·70. Wood, half-lengths of
the Virgin and St. Joseph adoring the Child between them on a red cushion; a
poor specimen of Liberale.—Same Gallery, and once in San Fermo Maggiore,
No. 430, m. 1·40 high by m. 1·55. Adoration of the Shepherds, with St. Jerome
to the left. Here too we trace an exaggerated reminiscence of Signorelli's art.

[2] Berlin Museum, No. 1183. Wood, oil, 5 ft. 3 in. high by 4 ft. ½ in. Virgin
enthroned with the Child erect on her knee between St. Lawrence and St.
Christopher, in the foreground two kneeling monks; inscribed: "Liberalis
Veronensis me fecit 1489." This is an unpleasant piece, with much Sienese
smorphia, of an unbroken semi-transparent olive tinge. The forms are bony
and defective, the masks ugly, the throne grotesque.

We may notice also the following: Verona, Dr. Bernasconi [* now Museo
Civico, No. 176]. Adoration of the Magi. This is supposed to be one of the
doors of the organ at Santa Maria della Scala, once painted by Liberale
(Vasari, v. 275 sq.). It is now too much repainted to warrant an opinion.
Of an Adoration of the Magi in monochrome in the sacristy at Santa Maria
della Scala there is nothing to be said. There are, however, other organ-doors
(canvas, tempera, with figures above life-size) in San Bernardino of Verona,
assigned by Persico (i. 116) to Giolfino, and by Dr. Bernasconi to Domenico
Morone (Studi, p. 240). They hang near the clock on the wall of the church,
are dated "Ano Dm̄i MCCCCLXXXI" (not 1483), and represent on one side St.
Francis and St. Bernardino, on the other St. Louis and St. Buonaventura. The
rude energy and the peculiar forms of the heads, as well as the air of the figures,
are those of Liberale. Two angels playing in the imitated pediment above the
first-named saints are also boldly thrown off like Liberale's in the Cappella
Buonaveri. Morone is more under control than the painter of this piece. The
two last-named saints now hang apart; all four are repainted in oil.

[3] Verona, fronts of houses on Piazza delle Erbe; engraved in Nanin, ub. sup.,
Nos. 9, 10. (1) Coronation of the Virgin, and the temptation of Adam and Eve;
(2) an Eternal and fragments above a Holy Family which is probably by Caroto.
The first of these façades is very obviously by an illuminator. One mentioned
by Vasari is lost (Vasari, v. 279). [* In addition to the works by Liberale
mentioned by the authors we may notice the following: (1) Budapest, Picture
Gallery, No. 96. The Virgin and Child. (2) Fiesole, Villa Doccia, collection
of Mr. H. W. Cannon. No. 4, St. Sebastian; No. 5, St. Anthony of Padua;
No. 6, The Virgin and Child with Saints. (3) London, National Gallery.
No. 1134, Madonna with two Angels; No. 1336, The Death of Dido. (4)
Munich, Aeltere Pinakothek. No. 1495, Pietà. (5) Rome, collection of the
late Dr. L. Mond. The Visitation. (6) Stockholm, University Gallery. The
Virgin and Child with four Angels. (7) Verona, Museo Civico. No. 204, The
Nativity; No. 377, Pietà; No. 723, Madonna with two Angels; No. 798, St.
Sebastian.]

Of missing works the following is a list: (1) Verona, San Bernardino, Cappella
della Compagnia della Maddalena. Frescoes. (Vasari, v. 276.) (2) Santa Maria
della Scala. Virgin, Child, SS. Peter, Jerome, and two other saints. (Ricreaz.,
p. 113, and dal Pozzo, p. 251.) (3) Sant' Elena. Virgin and Child, St. Catherine

It has been said of Giovanni Maria Falconetto that he was overrated as an architect and underrated as a painter.[1] In the former capacity he certainly acquired fame ; in the latter the public of his time believed that he had no extraordinary merit. He was born in 1458 and died in 1534[2] ; and during the long course of his career he never apparently handled the brush except when forced to drop the compass. Vasari illustrates this leaning to a particular study by relating that when Falconetto was at Rome, struggling to acquire the principles on which the old Romans built, he hired his services for a certain number of days a week to masters who gave good wages, and spent the rest of his time measuring and copying old edifices.[3] He gained such a thorough insight into the methods of the ancients that he was enabled to revive them subsequently in his own country. He was therefore no creative genius. As a painter he shows a spirit not unlike that of Liberale for its force and energy, but altered so as to suit the habits of a decorator. For appropriate distribution and judicious setting with the aid of linear perspective, he is to be commended ; and his tact in making personages and architecture subordinate to each other might lead us to believe that the Anonimo is right in calling him a pupil of Melozzo da Forlì,[4] but he differs from Melozzo in this, that his figures are

and St. Elena, dated 1490. (Persico, i. 49.) (4) San Giovanni in Monte. Circumcision. (Vasari, v. 277.) (5) San Tommaso Apostolo (?). Panel. (Vasari, v. 278 *sq.*) (6) San Fermo, Cappella San Bernardo. St. Francis, and scenes from his life in a predella. (Vasari, v. 279.) (7) Galleria San Bonifacio, previously in Casa Moscardi. Virgin giving the Breast to the Infant Christ. (Persico, ii. 32.) (8) Casa Vincenzo de' Medici. Marriage of St. Catherine. (Vasari, v. 279.) (9) Bardolino on the lake of Garda (ch. of). Altarpiece. (Vasari, v. 278.)

[1] Bernasconi, *Studi*, p. 257.

[2] *Ibid.* and Vasari, v. 325.

* Vasari's statement that Falconetto was 76 years old in 1534 (the year of his death according to the same author) is contradicted by the Veronese *Anagarfi.* These are not always in agreement with each other when giving the age of Falconetto ; but the earlier of those mentioning him (dated 1472, 1481, and 1489) point with remarkable consistency to about 1468 as the date of his birth (cf. Gerola, *ub. sup.*, iii. 117). He was still living in 1533 (see Gonzati, *La Basilica di S. Antonio,* i. 162), but is recorded as dead in 1541 (Gerola, *ub. sup.*, iii. 118).

[3] Vasari, v. 319. If it be true that he lived twelve years in Rome, as Vasari says, he must have been there till close upon 1420. [* Compare the preceding note.]

[4] Anonimo, p. 10.

sacrificed to the space in which they are enclosed ; and the space itself is arranged in a somewhat servile imitation of classic models. The earliest attempt of this kind is that which he made for the chapel of San Biagio at SS. Nazaro e Celso during the year 1493.[1] The knack of bringing plain walls to look highly ornamented is not possessed by many, and requires fertility of expedients and familiarity with the intricacies of architecture. Falconetto is at home in these respects. He makes the cupola appear higher than it is in reality by simulating a series of curved recesses containing saints in perspective above the cornice ; the rest of the surface he divides into panellings framing prophets and foreshortened angels, subordinate to the Eternal in the centre. A handsome frieze runs round the under edge of the cornice ; and as the chapel opens by arches—on one side into the church, on the other into the apse, and at the two remaining points into subsidiary chapels—there is room for further deceptions by creating artificial niches and brackets in lunettes and spandrils, and introducing bas-reliefs and statues.[2] All this reminds us of Melozzo and Palmezzano, and there is no denying that the effect it produces is imposing from the breadth of the parts, the correctness of the distribution, and the science with which perspective is applied ; but Falconetto's are inferior to Melozzo's productions of a similar kind, because the human frame is treated too much as a block, and classic forms are misapplied or overcharged.

It is scarcely matter for surprise that Falconetto's habit of

[1] See *antea*.

* It is proved by contemporary records that these frescoes were executed in 1497-9. Biadego, in *Nuovo archivio veneto*, ser. ii. vol. xi. pp. 120 *sq.*

[2] Verona, San Biagio. The cupola is all monochrome. In the pendentives and beneath figures of the Evangelists by Morando we read : " Jo. Maria Falconetus pinxit." In the lunette to the right, as you enter, there are four monochromes round a circular window, *i.e.* the Sacrifice of Abraham, the Death of Abel, Adam and Eve, and at each side of the window two niches containing St. Jerome and St. Anthony the Abbot. Below that, on brackets, St. Jerome and another, St. Roch and St. Sebastian, the two latter all but gone. There are also here and there figures of angels. In the lunette above the entrance arch an Annunciation by Morando, and two saints in episcopals in niches ; and below, the same arrangement as before, but much damaged from abrasion and scaling. In the lunette to the left, a Child on a pedestal supporting the frame of the circular window, and two saints. Lower down, an Adoration by some unknown hand, and a panel with the Madonna and Saints by Mocetto. This panel partly conceals an inscription closing with the date MCCCCLXXXXIII.

copying the antique should have conveyed to superficial observers the impression that his work was Mantegna's. There is a large house-front in his manner on the Piazza San Marco,[1] and remnants of another, called the Casa Tedeschi,[2] at Verona, respecting which these erroneous impressions prevail; and yet the art displayed is very much below Mantegna's, and only suggests his name because the theme and costumes are of the old time and the treatment is monochrome. It is characteristic of the figures that they are neither correct in action nor in outline; and, aping the antique, they are long, lean, exaggerated in movement, and without style in draperies. In other paintings by Falconetto, he shows affinity with Liberale and Pisano, and this is a feature apparent on more than one of his church frescoes, for instance in the saints and victories in San Fermo Maggiore,[3] in the Annunciation above the altar of the Emilii chapel at the Duomo,[4] and the religious allegories executed in 1509–16 for San Pietro Martire of Verona. The latter, indeed, are Falconetto's masterpieces, fanciful—which may be due to the caprice of the person who ordered them—but free and bold in contour, and less deformed by mannerism than usual. We may note in a Madonna, transfixed by an unicorn, a soft inclination of head, an affected grace of movement, and a face moulded in the Umbrian fashion; in certain portraits an air of nature, and in the treatment a finish and flatness that betray some connection with the Veronese miniaturists.[5]

[1] Verona, house on Piazza San Marco, corner of the Vicolo di San Marco, No. 835 [* now 1, Piazza San Marco]. The representations are Roman contests, victories, sacrifices, and allegories, imitating the classic; hasty and incorrect in drawing, all on blue grounds, the greater part of which are bare to the red preparation.

[2] Verona, close to Santa Maria della Scala. There is little here besides broken outlines and pieces of a Roman harangue.

[3] Verona, San Fermo Maggiore, first altar to the right of the entrance. Outer wall, representing two saints seated, and two victories in the spandrils of the arch.

[4] Verona, Duomo, Cappella Emilii. Fresco of the Annunciation. (The two panels of St. James and St. John here are in the manner of Francesco Morone.) [* The neighbouring chapel (the Cappella Calcasoli) contains large decorative frescoes by Falconetto, brought to light after the publication of the first edition of the present work, and signed " Io. Maria Falconetus de Verona pi. M.D. III. die primo Septembris." See Meyer, in *Kunst-Chronik*, ser. i. vol. xi. coll. 81–85, 99–104.]

[5] Verona, Oratorio del R. Liceo Scipione Maffei, of old San Giorgio e San Pietro Martire. Lunette, fresco, with figures above life-size, representing the

In pictures on panel, of which a few by our artist are preserved, we also observe some singular varieties [1]: Augustus and the Sibyl, in the Museum of Verona, a caricature of old statuary, grotesque in the action, and false in the drawing of the parts [2]; a Virgin and Child with Saints, much repainted, beneath a fresco of the Pietà in the Maffei chapel in the Duomo—a mixture of Liberale, Mantegna, and Bellini.[3]

Falconetto's closing days were exclusively devoted to architecture. Having been a partisan of the Imperialists during their sway at Verona, he was obliged to retire to Trent after their surrender in 1517.[4] From thence he returned after a couple

Annunciation, surrounded by allegories too childish for description; at the corners two kneeling portraits of the patrons, Hans Weineck and Gaspar Künigl. Several figures of animals in fair drawing prove that Falconetto clung to the study which characterized Pisano and Stefano. The figures are outlined very strongly and hardly, and yet with boldness. The Virgin recalls Pisano's in the panel of the Madonna with St. Catherine at the Museum of Verona (No. 359).

[1] We have not seen : Verona, San Giuseppe. Virgin and Child between SS. Augustine and Joseph (Persico, i. 90), dated 1523.

[2] Verona Gallery, No. 358, from the Santissima Trinità, m. 1·52 high by 1·53. Wood, tempera, full of gold embossment. Poor as this is, it still has the air of a work by Falconetto ; and yet we might desire to think it is by some imitator of his manner.

[3] Verona, Duomo, Cappella Maffei, mentioned by Vasari (v. 318). The Pietà, a lunette with ten figures, has been assigned to Liberale ; but the forms are a little less rough than his. Still it is difficult to judge correctly of a fresco painted at a considerable altitude, ill-lighted and dusty.

The altarpiece now on the side-wall of the chapel represents the Virgin and Child enthroned, between SS. John the Baptist, Jerome, Andrew, and a saint in episcopals. Wood, figures all but life-size, greatly repainted. The Baptist is very like one of Liberale's figures. The predella, representing the Expulsion of Joachim, the Appearance of the Angel to Joachim, and the Nativity of St. John, is probably by Bonsignori, to whom some guides assign it (Rossi, *Nuova Guida di Verona*, 8vo, 1854, p. 23). It has a decided Mantegnesque character. [* The *pala* has now its place in San Giovanni in Fonte; the predella is in the Cappella di San Michele in the cathedral.] We may add notices of the following : (1) Berlin Museum, No. 47A. Death and Assumption of the Virgin. On gold ground, wood, figures one-third of life-size. Here is the slender class of personage and the bold pose of the manner of Liberale ; the form a little mannered in outline, and detailed in Falconetto's usual way. [* Count Carlo Gamba has proved that this is a work by Andrea del Castagno, finished in 1449 for the church of San Miniato fra le Torri at Florence. See Crowe and Cavalcaselle, *Hist. of Paint. in Italy*, ed. Douglas, iv. 134, n. 5.] (2) Verona, Sant' Elena. Christ at the Tomb. Ascribed to Falconetto, not to be admitted as a genuine work without hesitation.

[4] This is what Vasari tells, and it may be true ; but contemporary documents

of years to Padua, where he was patronized by Alvise Cornaro, and there he built houses, lodges, and some of the city gates; his last employment being that of superintendent of the chapel of the Santo, where his sons were also engaged.[1]

Of Giolfino, who was Falconetto's contemporary, a very short sketch will suffice. It would serve no useful purpose to enumerate and to criticize minutely his pictures and frescoes in Verona. We may describe them generally as productions of a low class; the earliest from 1486 upwards carefully treated but coarse, the later ones bold, vulgar, and freely handled. Liberale and Pacchia, or Beccafumi, are the artists of whom his chief productions remind us. He is coarsely Raphaelesque at last, after the fashion of Gaudenzio Ferrari.[2]

Vasari has related of Francesco Bonsignori that he was born

only prove that Falconetto was at Trent before 1517. He painted the organ of the cathedral in that town in 1507–8, and restored an altarpiece in the same church in 1514 (Cervellini, in *Madonna Verona*, iii. 138). On the other hand, he is mentioned in the Veronese *Anagrafi* of 1517 and the *Estimi* of 1518 (Gerola, *ub. sup.*, iii. 118, 116).

[1] Consult Vasari, Bernasconi, *Studi*, and Gonzati's *La Basilica, ub. sup.*

[2] The last date of Giolfino is 1518. Vasari only knew him as Niccolò Ursino (vi. 374). [* We now know that he was born about 1476 and died in 1555. See Gerola, in *Madonna Verona*, iii. 42.]

Works that we might notice are the following : (1) Verona Museum, originally in San Francesco di Paola, No. 240. Half-length Virgin and Child. (2) Duomo. Wings and lunette of Liberale's Adoration of the Magi. (3) Santa Maria della Scala. Behind the pulpit, frescoes of a brownish tone; injured, but of a broad style. (4) Same church, a Descent of the Holy Spirit, dated 1486, repeated in (5) Sant'Anastasia, Cap. Minischalchi. This recalls Pacchia on account of the exaggerated movement of the figures; the colour is dull, melancholy, and unbroken; inscribed "MDXVIII," with a monogram N.I.V. (Nicolaus Julphinus Veronensis) interlaced. In a predella is a scene from the life of St. Dominic. [* The signature and date on the Pentecost in Santa Maria della Scala are undoubtedly forgeries; see Gerola, *ub. sup.*, iii. 41 *sq.*] (6) Again in Sant' Anastasia, the Redeemer in air, and below, SS. Erasmus and George, done with great freedom, but much injured. (7) San Bernardino, Cappella degli Avanzi, or di Santa Croce. Christ before Pilate, Christ in the act of being crucified, and the Resurrection; in another part of the chapel, the Capture. These are all done very freely and boldly, the last-named with great care on a surface of great polish and smoothness. (8) Verona Gallery, No. 249, originally in San Matteo. Arched panel. Virgin in Glory, St. Matthew and St. Jerome, and a bust of a patron in prayer. Panel with life-sized figures dulled by varnishes. (9) Santa Maria in Organo, Cappella Santa Croce, to the right of the choir as you enter. Hexagonal chapel, with frescoes of the Last Supper, the Fall of the Manna, the Communion of the Apostles; in lunettes six saints, and in semidome ten

in Verona in 1455, and was taught at Mantua by Mantegna. After a certain time his proficiency was such as to attract the attention of the Marquis Francesco Gonzaga, who, in 1487, gave him a house and a salary.[1] We might be led by this narrative to believe that Bonsignori was Mantegna's pupil, which would be a grave mistake. Those productions of his manhood which bear the dates of 1483 to 1488 are of the Veronese school, and would prove that he underwent Mantegna's influence after he had acquired a manner of his own. Even before 1483 he finished a certain number of compositions in which local teaching may be discerned. The Virgin and Child in a landscape between St. Anthony the Abbot and the Magdalen, in the church of San Paolo at Verona, is to be classed amongst his elementary productions.[2] Thin regular forms in the Virgin and Child, combined with rigidity and smorphia, remind us of Girolamo Benaglio ; a resolute pose in the Magdalen recalls Liberale, whilst overweight of head, a grim but expressive face, and large rude extremities are properly characteristic of Bonsignori himself. The tempera is copiously moistened with vehicle but dull in tone ; the outline, if incorrect, still careful and bold. Bonsignori here is a better artist than Benaglio, with less vehemence and

angels ; outside the entrance arch the Ascension, and on each spandril a prophet. These are in Giolfino's Raphaelesque style. (10) In the nave of the same church four scenes from the Old Testament, and three rounds, reminiscent in style of works by Peruzzi or Daniel da Volterra. (11) In the same style, the front of Casa Pasquini, opposite the Via Ponte Rofiol, No. 1758, representing a frieze with gambols of cupids, the Seasons, and other figures (engraved in Nanin, No. 36). Also : (12) Verona, Santo Stefano [* now Museo Civico, No. 2062]. Virgin and Child, and boy Baptist, recalling the Raphaelesque, SS. Jerome, Placida, Francis, Maurus, and Simplician ; a feeble dull piece (figures life-size). (13) Berlin Museum, No. 1176. Canvas. Virgin and Child between four Saints. Much movement may be noted in the figures here, the angels recalling those of Moretto da Brescia.

Giolfino had a brother, Paolo Giolfino. By him is a Virgin and Child between four Saints (No. 304) in the Gallery of Verona. The style is similar to that of Niccolò Giolfino, but poorer. [* Dr. Gerola has shown (*ub. sup.*, iii. 37 *sqq.*) that there never was a painter called Paolo Giolfino.]

[1] Vasari, v. 299 *sq.* The pictures of this painter being usually signed Bonsignorius, show that Vasari is wrong in calling him Monsignori. [* This form occurs, however, occasionally in contemporary records. See Biadego, *loc. cit.*, xi. 123 ; Tea, in *Madonna Verona*, iv. 137.]

[2] Verona, San Paolo, described in old guides as by an unknown painter, but mentioned as Bonsignori's by Vasari (v. 304 *sq.*).

FRANCESCO BONSIGNORI

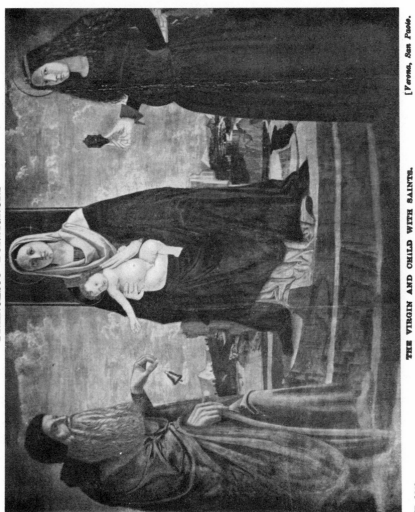

THE VIRGIN AND CHILD WITH SAINTS.

[*Verona, San Paolo.*]

IL 182]

spirit than Liberale.[1] A crucified Saviour, in the gallery of
Verona, presents a specimen of good ordinary nude, of fair and
slender proportion, whilst the profile bust of a donor in the right-
hand corner of the picture, well drawn, with a true harmony of
parts, broadly modelled and neatly blended in a silver-grey key
of tempera, gives promise of that degree of perfection which
Bonsignori afterwards exemplifies in the portrait of the National
Gallery.[2] These pieces are, we think, the natural forerunners of
that which bears the painter's name and the date of 1483 in the
house of Dr. Bernasconi at Verona, a small panel half the size of
life, in which the Infant, lying on a marble table with his feet
towards the spectator, is adored with joined hands by the Virgin.[3]

No longer confined to the narrow circle of Veronese art,
Bonsignori now exhibits some acquaintance with the models
of Montagnana, Montagna, and Buonconsiglio, drawing nude
with a certain knowledge of the laws of foreshortening and pro-
portion, and with the broken energetic line of the Paduans, but
with his full share of vulgarity and coarseness in masks and
extremities. His drapery, though angular or tortuous, is cast
with a certain judgment ; his colours are brown, smooth and
glossy, as colours are in which copious vehicle is used. It is not
to be asserted that Bonsignori up to this point had lessons from
either of the Vicentines Montagna or Buonconsiglio ; for the
former visited Verona later, and Buonconsiglio, as far as is
known, never came to Verona at all ; but he is more like them
than he is like Mantegna ; and this is quite as apparent in a
large Madonna with Saints, painted for San Fermo of Verona in
1484, as in pictures of an earlier time. There is a good profile
of a patroness at the edge of the frame of this altarpiece, which
illustrates Bonsignori's usual attention to careful drawing and
accurate shading ; but the figures are not less short and bony

* [1] As Mr. Berenson has shown (*Lorenzo Lotto*, pp. 39 *sqq.*), this and other works
by Bonsignori reveal a strong influence from Luigi Vivarini. It seems therefore
probable that Bonsignori studied for some time at Venice under that painter.

[2] Verona Museum, No. 361. Canvas, m. 1·15 high by 0·80, catalogued School
of Mantegna. The left side of the torso repainted ; distance, hills and sky ; the
whole dulled by varnishes.

[3] Verona, Dr. Bernasconi [* now Museo Civico, No. 148]. Panel with half-
length Virgin, one-half the life-size. Tempera, on a dark green-brown ground,
upon which one reads in the upper part to the left : "Franciscus Bonsignorius
pinxit, 1483 " ; the flesh of an olive complexion.

and not less vulgar in face than those of other altarpieces of the
same period.[1] An improvement may be seen in a bust-portrait
of 1487 in the National Gallery, where we are reminded of
Masaccio by the breadth of the modelling, and of Ghirlandaio by
the precision with which the forms are given and shadows are
defined ; but of Mantegna's teaching there is no trace.[2] That
some impression had been made upon Bonsignori by the works
of Mantegna after 1484, is proved by a Madonna with Saints,
dated 1488, in San Bernardino of Verona, where the Infant
Christ erect on the Virgin's knees, and a couple of angels at the
sides of the throne, imitate the slender type of the great Paduan ;
but the change is very partial, and is not to be observed in
the wild thickset frame and coarse extremities of the attendant
St. Jerome, nor in the homely squareness of the standing
St. George.[3] We may therefore assume that up to 1488 at least
Bonsignori was not at the court of the Gonzagas. The frequent
recurrence of his Christian name in the Mantuan correspondence
of the years 1490 and 1491 might lead us to suppose that he was
already employed at that time in the decoration of the country
palace of Marmirolo ; some uncertainty might be caused by our
inability to distinguish Bonsignori from Francesco Mantegna[4] ;

[1] Verona, San Fermo, wall to the left on entering the portal [* now Museo
Civico, No. 271]. Canvas, distemper, with figures just under life-size. The
Virgin adores the Child lying on her lap. To the left St. Onofrio, growling and
showing his teeth, and St. Jerome; to the right SS. Augustine and Sebastian;
distance, sky ; at the bottom of the picture a female profile seen to the shoulders ;
on a cartello : " Franciscus Bonsignorius Vŏnensis p. 1484."

[2] London, National Gallery, No. 736. Wood, tempera, 1 ft. 4¼ in. high by 11¾ in.,
formerly in the Cappello Museum at Venice; inscribed on a cartello : " Franciscus
Bonsignorius Veronensis p. 1487 " (Maffei, *Verona Illustr.*, *ub. sup.*, pt. iii.
ch. vi.). The cartoon for this portrait, squared for use, being larger (2 ft. 11 in.
by 2 ft. 4½ in.), is in the collection of the Archduke Albrecht at Vienna, under the
name of Gentile Bellini. [* It is now officially ascribed to Bonsignori. This
likeness may have been painted in Venice, as the sitter is proved by his dress to
be a Venetian senator. Bonsignori is probably also the author of the great
polyptych above the second altar to the right in SS. Giovanni e Paolo at Venice ;
see Berenson, *ub. sup.*, pp. 43 *sqq.*, and *antea*, i. 196, n. 4.]

[3] Verona, San Bernardino, second altar to the right. Wood, mixed tempera
and oil, figures life-size ; inscribed on a cartello: " Franciscus Bonsignorius
Vŏn. p. MCCCCLXXXVIII." The Virgin's head is renewed, those of SS. George and
Jerome retouched, also the head of the angel on the arm of the throne to the right,
and the left leg of the Infant Christ. Through two windows the sky is seen.

[4] Gaye, *Carteggio*, i. 298 and 309.

but these doubts are removed in the correspondence of 1495–6, where Bonsignori, as Francesco da Verona, works in the new palace of Gonzaga, and is sent to the Giarole near Fornovo to sketch the ground on which the Marquis Francesco was defeated by the French.[1] He was busy, in 1506, at the Last Supper in San Francesco of Mantua, including portraits of the Marquis and his family, and went to Venice with one of Francesco Gonzaga's agents to copy a geographical model of Italy in the ante-chamber of the ducal palace.[2]

A sufficient number of Bonsignori's masterpieces at Mantua has been spared to justify the opinion that at the close of the fifteenth century he diligently studied and came at last to imitate Mantegna. One of the most interesting proofs of this is the lunette in the Brera at Milan, representing St. Louis and St. Bernardino holding the Name of Christ, a canvas once on the pulpit in the Franciscan convent of Mantua, in the refectory of which Bonsignori executed the Last Supper.[3] His style, if we judge of it by this specimen, was cleared of its old coarseness ; his figures were drawn in truer proportions and more perfect shape ; he evidently knew more of anatomy and perspective ; he draped his personages better, and gave them a calmer and more amiable air; yet whilst following Mantegna's models, he preserved a certain impassiveness and monotony, a coldness and accuracy that make him of kin with Spagna or Timoteo Viti. Several pieces of almost equal merit illustrate this second phase. The best are the Virgin and Child with Saints at Lady Layard's in Venice,[4] the Christ carrying his Cross in the Doria Gallery at

[1] Gaye, i. 331–3, 335–6 ; D'Arco, *Delle Arti, ub. sup.*, ii. 36, 39. [* Bonsignori was surely in the service of the Marquis in 1492, as is proved by a letter from him, published by Braghirolli (*Lettere inedite di artisti*, p. 21.)

The Kaiser Friedrich Museum at Berlin possesses a full-length figure of St. Sebastian by Bonsignori (No. 46 C), signed "Zoane Batista de Antonjo Banbasato a fato fare 1495 (?)."]

[2] Vasari, v. 301 ; D'Arco, *Delle Arti*, i. 57, and ii. 68, 63 *sq.*, 71. Sansovino, *Ven. Desc.*, p. 323. The fresco is lost.

[3] Milan, Brera, No. 162. Canvas, tempera, lunette, m. 1·10 high by 1·70; the figures quite Mantegnesque, the colour pale and cold. Note high finish and a good definition of form.

[4] Venice, Lady Layard. Oblong on coarse canvas, with figures a little over half life-size, oil. The Virgin stoops over the Babe in swaddling clothes which she presses to her breast. To the left a young friar and aged saint; to the right St. Anne and a young saint with curly locks and the palm of martyrdom ; half-

Rome,[1] and replicas in possession of Count Paul Stroganoff at St. Petersburg [2] and the Marquis Campori at Modena.[3] Their chief feature is a Leonardesque simplicity of shape, a certain want of animation, caused by careful surfacing and outline, and the absence of strong shadow or modulations. We might assign to the same period an interesting portrait of Isabella, Marchioness of Mantua, under Mantegna's name at the Uffizi,[4] and a profile ascribed to Piero della Francesca at the Pitti,[5] in which the Mantegnesque of Bonsignori is combined with some of the softness peculiar to Lorenzo Costa. Costa, we shall see,

lengths, not quite free from restoring, and a little blind in consequence. The imitation of Mantegna is very apparent in the saints to the right and in the Babe. The same groups—of other saints (Bernardino, Francis, Elizabeth, and another)— and a similar Virgin and Child are in possession of Count Colloredo at Goritz, having been originally in the palace of the Gonzaga in Mantua. This piece, however, is much repainted, and we cannot say that it is not an old copy.

[1] Rome, Doria Gallery, No. 164. Panel, in oil; figure a little under life-size ; bust, on dark ground. Christ with face three-quarters to the left, smooth in surface, hard, unbroken, and recalling Palmezzano, under the name of Mantegna.

[2] St. Petersburg, Count Paul Stroganoff. Panel, oil, same size as foregoing, called Beltraffio, the face retouched.

[3] Modena, Marchese Campori, under Bonsignori's name. Life-size, well preserved, softer in tone, more finished, and with something recalling Costa in the treatment. [* This painting is now in the Gallery of Modena. Several other versions of the same composition are in existence. Prof. A. Venturi gives good reasons for ascribing some at least of these pictures to Giovanni Francesco de' Maineri of Parma, who worked about 1500 (see L'Arte, x. 33 sqq.). In this connection we may mention the bust of a man in armour (perhaps Lodovico Gonzaga), formerly in the Sciarra collection in Rome, and now belonging to Mr. Widener of Philadelphia. In spite of its Mantegnesque air, it is surely a work by Bonsignori, coming close to the busts in the National Gallery and at Bergamo; the signature "An. Mantinia pinx. anno MCCCCLV" is of later date. Cf. Morelli, Die Gal. z. M. u. Dr., p. 231.]

[4] Florence, Uffizi, No. 1121. Wood, life-size. Bust with front face, in gala dress, with a cincture and a jewel on the forehead. Distance, a landscape touched in gold. Dress, blue and gold check pattern. Very careful, but not by Mantegna, to whom it is assigned, the manner being that of Bonsignori in the Mantegnesque style. On the back of the panel the words : " Duchessa Isabella Mantovana moglie del Duca Guido." Injured by varnishes and retouching. There is much here of Bonsignori's cold carefulness of finish. [* This is a portrait of Elisabetta Gonzaga, who was married in 1489 to Guidobaldo I., Duke of Urbino. It is now labelled "Veronese School." See Delaruelle, in L'Arte, iii. 147 sqq.]

[5] Florence, Pitti, No. 371. Panel, bust, m. 0·45 high by 0·35 ; profile to the left of a female, with a cincture and jewel, in gala dress, her hair falling out of a net, on green ground (repainted); the outline very fine; well-treated tempera with minute hatchings.

was a Ferrarese, tempted to settle at Mantua by the Gonzagas. His manner affected Bonsignori very materially, and it is to his influence that we attribute the last change in Bonsignori's style. The period in which this change occurred is not easy to define accurately, but it no doubt took place shortly after the arrival of Costa in 1509.[1] In a portrait of a man in the Pitti, attributed to Giacomo Francia, we observe well-proportioned forms and a melancholy expression rendered with a regularity of outline recalling the Leonardesques. The spirit in which this handsome work is done is closely related to that displayed in the portrait of Isabella at the Uffizi ; the finish is more skilful, the tone warmer, but the hand seems that of Bonsignori under the charm of Costa's creations.[2] A more striking proof of the extent to which the painting of one master may affect those of another, is to be found in the Christ going to Calvary, attended by the Marys, at the Museum of Mantua,[3] where Bonsignori divests himself entirely of the characteristic features of his youth, and throws upon his canvas a series of small slender figures, to which in most cases he gives a tender and not unpleasant conventional air, suggesting reminiscences of the Umbrian school and of Costa. Better executed is the Vision of Christ to the nun Ozanna, a large canvas in the Mantuan Museum,[4] and the Virgin and Child

* [1] Costa probably came to Mantua in 1506.

[2] Florence, Pitti, No. 195. Bust, wood, m. 1·3 high by 0·17, oil, Figure of a man, full face in front of a window, in a cap. The face of a regular oval, of soft melancholy expression, softly tinted, with much blending, but without modulations. [* This is a portrait of Guidobaldo I., Duke of Urbino. Delaruelle, *ub. sup.*]

[3] Mantua Gallery, originally in Oratorio della Scuola Segreta (D'Arco, i. 57). Canvas, oil ; injured by time and restoring. Christ has fallen under the weight of the cross. The Magdalen supports the transverse beam. In rear the Virgin in a fainting fit. This is a conventional picture in arrangement, wanting in life and power. The treatment is cold and careful. [* Closely allied to this work is a beautiful head of a female saint in the Museo Poldi-Pezzoli at Milan (No. 628).]

[4] Mantua Gallery, originally in San Vincenzo. Canvas, oil, figures all but life-size. In the centre the nun with her feet on a monster, attended by five kneeling companions. On clouds to the right and left of the central figure are Christ carrying his cross and an angel with a lily. The figures are well proportioned and not ungraceful. There is something of the Peruginesque and of Costa, especially in the drapery, which falls and winds so as to give the form in the Umbrian fashion. The figures all seem portraits, very carefully done, and light in tone.

In the same mixed style of the Mantegnesque and Costa are six small subjects from the triumph of Scipio in one frame, belonging to the heirs of the Susanni family at Mantua. [* Present whereabouts unknown.]

between Saints, delivered to the chapel of San Biagio at Verona in 1519,[1] the last effort of Bonsignori previous to his death.[2]

More abundant in production but of the same stuff as Bonsignori, Giovan Francesco Caroto fills a large place in the annals of Verona. Born in 1470 and apprenticed early to Liberale, he was soon removed to Mantua, where he took an active share in the later productions of Mantegna's atelier.[3]

He is described as so perfect an imitator that his panels were accepted as Mantegna's own; and this is perfectly credible.[4] In a number of Madonnas belonging to Continental collections, his manner closely resembles that of his master, and apart from certain childishly realistic features, they are interesting examples of Caroto's youth. The Virgin and Child with the young Baptist, in the Gallery of Modena, for instance, represents the Virgin in a landscape adorned with lemon-trees, the Child on her knee

[1] Verona, San Biagio. This picture was ordered in 1514 and delivered in 1519 (*Di San Biagio*, etc., *ub. sup.*, p. 63), and a predella was made for it by Girolamo dai Libri. The Virgin is in air with the Infant Christ; below, SS. Biagio, Sebastian, and Juliana; a child at St. Biagio's side holds the card. Canvas, oil. The figures are graceful enough; the drapery and nude are fair; the colour, though dulled by restoring, being warm and blended. We are reminded of Costa and Francia in their Raphaelesque phase.—In the same manner: Mantua (near), Chiesa delle Grazie, Cappella Zibramonti. Canvas, oil, representing St. Sebastian; all but life-size, but much injured by scaling, and possibly done with the help of an assistant.—Less in the character of the master: Verona, Duomo, sacristy. St. Lawrence and St. Stephen. Two arched panels, too poor to be by Bonsignori. [* As for a portrait by Bonsignori in the Galleria Lochis at Bergamo, see *antea*, p. 109, n. 2.]

Missing: (1) Portraits of Frederick Barbarossa; Barbarigo, Doge of Venice; Francesco Sforza and Maximilian, Dukes of Milan; Emperor Maximilian; Ercole Gonzaga, afterwards cardinal; Federico Gonzaga; Giovan Francesco Gonzaga; Andrea Mantegna; Count Ercole Giusti (Vasari, v. 300 *sq.*, 307); and the King of France (D'Arco, ii. 36). (2) Virgin and Child, half-lengths (Vasari, v. 305).

[2] Vasari, v. 305. Bonsignori died in 1519. He had two brothers, ascribed to one of whom (Fra Girolamo Bonsignori) is a fresco of the Virgin and Child, cut from the wall, now in the sacristy of San Barnaba at Mantua. There is a Lombard character in this work, which dates from the first years of the sixteenth century; the forms are good and well rendered, the faces are pleasing, and the colour is soft. This Lombard character might be expected of a man who, as we know, copied the Last Supper of Leonardo at Milan (Vasari, v. 306, and vi. 491). [* As a matter of fact, Bonsignori had four brothers, all of whom were active as artists. For notices of them see Tea, *loc. cit.*, pp. 137 *sqq.*]

[3] Vasari, v. 280. [* The Veronese *Anagrafi* prove that G. F. Caroto was born about 1480. In 1502 he is mentioned in the *Estimi* of Verona. See Simeoni, in *L'Arte*, vii. 65 *sq.*] [4] Vasari, *ub. sup.*

raising her veil. One of her hands, armed with a thimble, holds a needle, at which she is looking, whilst the other grasps a piece of muslin. There is some art, perhaps too much apparent art, in the arrangement; but the movements, suggesting study of antique statuary, and the dry slender proportions of the figures as well as the drawing, drapery, and modelling, are very manifestly adapted from Mantegna. The Infant Saviour and Baptist are quarrelling for a twig, and grimace in the true Mantegnesque style.[1] The same subject is repeated, with more ease, in Casa Maldura at Padua, the young Baptist being omitted[2]; and simpler forms of the Virgin and Child illustrating this period of Caroto's art are in the Staedel Gallery at Frankfort[3] and in the Berlin Museum.[4] The treatment—of which the best test is at Frankfort—is hard in flesh and garish in drapery, the faces being of a monotonous red-yellow with little half-tone, the dresses strongly contrasted and confusedly frittered in fold. We may believe that the painter of these pieces produced works on Mantegna's designs that might and did pass for Mantegna's, and Caroto is possibly the assistant to whom we partly owe less grand but gayer creations by Mantegna, such as the Noli Me Tangere and the Madonna with Saints of the National Gallery, the Virgin with half-lengths in the Museum of Turin, and the miniature of the Circumcision in the library of the same city.[5] On his return to Verona, which took place previous to 1508, Caroto's manner

[1] Modena Gallery, No. 492. Wood, oil, m. 0·50 high by 0·40. In a scroll beneath the Infant Christ's arm : " I. Franciscus Charotus MCCCCCI." The only parts of this picture not repainted are the red tunic of the Virgin, the landscape and lemon-trees. [* Closely allied to this work is a Madonna belonging to the Hon. Evelyn Saumarez.]

[2] Padua, Casa Maldura. Canvas, oil, figures one-quarter of nature. The Saviour here holds a pair of scissors. Inscribed to the right : " Io. F. Charotus f." Flesh restored and colour much altered by various causes. [* This picture is now in the Academy of Venice (No. 609).]

[3] Frankfort, Staedel, No. 21. Wood, oil, 1 ft. 10 in. high by 1 ft. 5 in. ; inscribed on the pedestal on which Christ stands : " F. Charotus." Some of the opaqueness here is no doubt caused by restoring. This panel was in the Baranowski collection.

[4] Berlin Museum, No. 40. Wood, oil, 2 ft. 3½ in. high by 1 ft. 6½ in. The Child on a parapet, a dish of fruit near him. Below the parapet two half-lengths of angels playing instruments; very Mantegnesque in air—not quite so opaque as at Frankfort, but dulled by varnishes. [* It seems doubtful whether this picture is by Caroto. There is a strong Venetian element in it; Morelli (*Die Gal. z. M. u. Dr.*, p. 19) ascribes it to Basaiti]

[5] National Gallery, Nos. 639 and 274. Turin Museum, No. 164 (and see *antea*).

took a local tinge more reminiscent of Liberale's and Giolfino's than it had been before [1] : we shall find that his heads are broad, round, and high in forehead ; the cheeks being full, the lips thick and tumid, the nose protuberant, the eyes large, open, and distant, the brows high and arched—features conspicuous from the slender character of the frames and the weakness of the limbs.

Another marked peculiarity of Caroto's drawing is a frequent abuse of curves, exaggerating the projection or depression of muscles according as they are prominent in the calf and thigh or lost in the joint at the knee and ankle. This tendency gives his outline an artificial swell which is very unsatisfactory. This and other habits of Caroto might be illustrated with great copiousness in the Virgin adoring Christ and attended by saints, a picture with fair modelling in the flesh tints, and two or three other canvases of the same calibre, in the Museum of Verona [2] ; but to judge of the painter more fully we must examine his frescoes in the Spolverini chapel at Sant' Eufemia of Verona, where he produced scenes from the book of Tobit with some of the power of the moderns. The compositions are skilfully balanced, and the personages are natural in movement and expression, but the colour especially is entitled to commendation for a warmth and blending distantly like Correggio's. Three archangels between St. Lucy and another female on the altar enable us to detect that Caroto was not unacquainted with the

[1] The author of the *Ricreazione* describes a Glory of St. Catherine between SS. Roch and Sebastian, dated 1502, in the church of Santa Caterina, annex to the Ognissanti (suppressed) at Verona (p. 163, and dal Pozzo, p. 225). Caroto's presence at Verona in 1508 is proved by the existence of frescoes of that date in San Girolamo (Annunciation), inscribed "A.D. M.D.VIII. I.F. Carotus. fa.," which have not been seen by the authors. [* Compare on these frescoes Gerola, in *Bollettino d'arte*, i. fasc. vii.] Unseen, too, the SS. Sebastian, Roch, and Job in San Tommaso Cantuariense at Verona (dal Pozzo, p. 265, and Bernasconi, *Studi*, p. 294). [* This painting is not by Caroto but probably by Girolamo dai Libri.]

[2] Verona Museum, No. 260. Canvas, oil. Virgin and Child between SS. Joseph, Francis, Chiara, and Anne ; m. 1·70 high by 1·25—of a later date. No. 262, St. Francis between SS. Bernardino, Anthony, and Chiara, with the Ecce Homo in a cloud above. Canvas, oil, m. 2·07 high by 2·05, from the Minorites of Isola della Scala. No. 325, Virgin and Child between SS. Joseph and Mary Magdalen. Canvas, oil, m. 2·0 high by 2·05; injured by restoring, inferior to the foregoing. No. 300, Christ washing the Feet of the Apostles; above, the Virgin and King David in glory; from the Minorites of Isola della Scala, m. 3·0 high by 2·15, injured by cleaning.

manner of Francia and Costa ; the attendant saints recall Peruzzi
and Timoteo Viti [1] ; and the prevalence of a certain mistiness in
the modelling, both in fresco and oil, reveals a new phase in the
expansion of his practice. In this phase he remains for some
years, and shows himself prolific, as we perceive in the Visitation
and Christ's Parting with his Mother at San Bernardino,[2] the
Virgin in the Brà, and several house-fronts at Verona.[3] We are
not informed as to the time when he visited Milan and Casale,
where he executed works of magnitude for the Visconti and

[1] Verona, Sant' Eufemia, Cap. Spolverini, wall to the left of entrance. Lunette
bare. Lower course : the angel shows the fish to Tobias, and Tobias with the fish.
Next lower course ; Tobias returns to his father and heals his blindness. The
limbs of the figures generally are weak. A figure of David to the right of the
entrance is also fairly done by the same hand. This is all that remains of the
frescoes of the whole chapel, and even this remnant is in bad condition.

The altarpiece, canvas, oil, is signed : " F. Carotus, p." The figures are feeble
in the legs, which was an objection made by the critics of Caroto's own time (Vasari,
v. 281). [* This painting is now in the Museo Civico of Verona (No. 343).]

The manner of Caroto at this period is illustrated in a St. Catherine, full-length,
originally at the Madonna di Campagna, now in Verona Museum, No. 251, m. 1·80
high by 0·85, in which we mark a skilful rendering of momentary action with rich
colouring, all reminiscent of the manner of Bazzi. The piece is injured by restoring.

[2] Verona, San Bernardino, Cap. della Croce. The parting of Christ from the
Virgin. Canvas, oil, figures life-size.

Same church, chapel near the choir. Visitation, and a male and female at the
sides. Fresco, a frieze with arabesques and busts of saints, much injured, but
of bright rich tone, carefully drawn and tasteful. The draperies have still some
Mantegnesque character.

[3] These are assignable to Caroto, and might be of the period under notice.
(1) Verona, in Brà, No. 2988. Virgin and Child. Fresco in a round, life-size,
half-length, freely and boldly drawn, and well proportioned ; somewhat damaged
(Nanin, pl. 26.) (2) Via della Scala, No. 1310. House-front, once the property of
Palermo, professor of medicine at Padua. There remain a portrait (?) of himself
in a round between the windows of the first floor, and other figures ; well drawn
and richly coloured (Nanin, pl. 11 and 12.) (3) San Tommaso, Ponte Acqua
Morta, No. 4800. Frescoes, representing the delivery of Verona to the Venetians
in 1517 (Nanin, pl. 7 and 8). These have been assigned to Mocetto, but their
colour leaves us in doubt whether they are his or Caroto's. [* They are now in
the Museo Civico of Verona (Nos. 461, 454, and 476).]

Verona, Santa Maria in Organo, left side of the nave as you enter. Here are four
scenes from the Old Testament, and four rounds in the soffits of the arches—
namely, the Redeemer and St. John, and two Benedictines. These frescoes are
almost as broadly treated as those which are now about to be noticed. Assigned
to Caroto also are landscapes in oil on the doorposts, which if not by him are of
his school. There are traces, too, of a fresco by the same hand in a side-street
leading to this church.

Montferrat[1]; but in 1528, the date of the Virgin in Glory adored by Saints at San Fermo, he enters boldly into the ways of the sixteenth century, and produces an effective cento of the Raphaelesque and Michelangelesque.[2] It would cost too much space to describe all the pieces of this style which fill the galleries of Verona and Mantua.[3] It is enough to sketch the career of

[1] Vasari, v. 282 *sq.* [* G. F. Caroto went to Casale some time before July 1516, when the Marquis Guglielmo of Monferrato gave him some land in recognition of his services. The following year, Caroto witnessed a document at Casale. The Marquis Guglielmo died in 1518, whereupon Caroto, according to Vasari, left Casale, which, however, he is proved to have revisited. From the time of his first sojourn at Casale dates a Pietà in the collection of Signor Vincenzo Fontana of Turin, signed on the back " F. Carotus P. MDXV." See Baudi de Vesme, in *Archivio storico dell' arte*, ser. ii. vol. i. pp. 33 *sqq.*—G. F. Caroto is mentioned in the Veronese *Anagrafi* of 1529, 1541, 1545, and 1555. He made his will on April 29, 1555, and died the same year, not in 1546 as Vasari states. Simeoni, *ub. sup.*, vii. 65 *sq.*—From 1527 date a Nativity of the Virgin (signed " F. Kroto 1527 ") in the Frizzoni collection at Milan and a Massacre of the Innocents in the Galleria Carrara at Bergamo (No. 137); they formed originally a predella above the altar of the Compagnia della Madonna in San Bernardino at Verona. See Frizzoni, *Le Gallerie dell' Accademia Carrara*, p. 26.]

[2] Verona, San Fermo, Cappella del Sacramento. Virgin and Child, St. Anne in clouds between four boy-angels; below, SS. John the Baptist, Peter, Roch, and Sebastian, the latter colossal and heavy in the Michelangelesque manner; inscribed : " 1528, F. Kroto." The drawing is a little strongly marked and monotonous, the figures are slight and motionless, the colour somewhat raw. [* The editor understands from Dr. Gerola that a signed and dated picture of the same year, representing the Annunciation, is in the Villa Alberto Monga at San Pietro Incariano, near Verona. A Holy Family in the Crespi collection at Milan is inscribed with Caroto's monogram and the date 1530.]

[3] The list is as follows: (1) Verona, Palazzo Vescovile, from ch. del Nazaret. Resurrection of Lazarus, inscribed with Caroto's monogram and the date " MDXXXI." Canvas, oil, a little injured in the dresses. [* From the same year dates a Holy Family in the Museo Civico of Verona (No. 114, signed " Fr. Caroto MDXXXI "). According to information given me by Dr. Gerola, there is a signed and dated picture of 1540, representing the Madonna and Saints, in the parish church of Bionde di Visegna, near Verona.] (2) Sant' Anastasia, fourth altar to the right (erected, according to Persico, p. 17, in 1542). Virgin and Child in air ; below, St. Anthony and St. Martin sharing his cloak. The character of this piece is that of one by a man in his old age, but still possessed of freedom and power. It recalls Torbido in the redness and depth of its tones, and a pupil of Pordenone, such as Pomponio Amalteo. Figures life-size (canvas, oil), the horse out of drawing. (3) San Giorgio. St. Ursula and a winding procession of the virgins, the head of which is on the foreground; inscribed : " Franciscus Carotus, p. a. d. M.D.XXXXV." Above, the Saviour in glory. The latter is like a figure by G. Ferrari ; the rest remind us by turns of Viti and Peruzzi. All here shows great mannerism ; the colour, too, is feeble, and injured by restoring and repainting. But there are

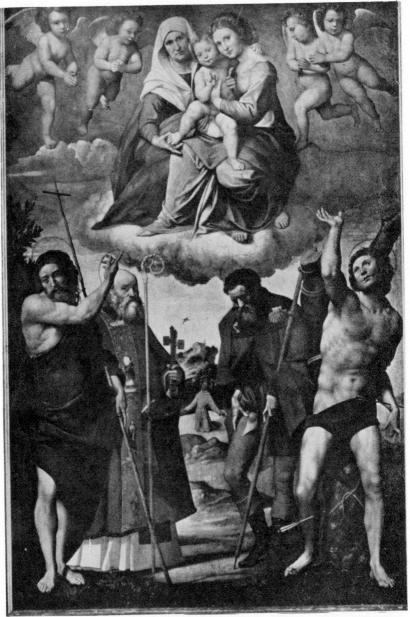

THE VIRGIN AND CHILD WITH SAINTS.

Caroto with broad lines. His monogram and the date of 1531 are on a Resurrection of Lazarus in the palace of the Bishop of Verona ; a Virgin in Glory at San Giorgio is inscribed 1545.[1] His brother and follower, Giovanni Caroto, and Antonio Brenzone just deserve to be mentioned.[2]

several things by Caroto in this church, *e.g.* SS. Sebastian and Roch, with a lunette of the Transfiguration, and a predella with the Sermon on the Mount, the Entombment, the Resurrection, and saints and angels in pilasters. The flesh is of a misty red, like Puccinelli's (Brescianino) of Siena. The drawing is in the character of Bugiardini. High up on the wall of the choir are also two canvases with thin neat figures in a low tone of colour. These are difficult to criticize, but might be youthful efforts of the painter. They are not free from injury.

[1] We add to the foregoing list the following : (1) Verona Museum, No. 446. Canvas, oil, m. 2·25 high by 2·0. Virgin and Child between SS. Zeno and Pietro Martire, formerly in the Sala del Consiglio ; inscribed : "... I .. die 15 ... Mā . Joannes Franciscus de Charotus .. on p. 1498." ; a piece with a forged signature. (2) Mantua, Santa Maria della Carità. Canvas, m. 2·10 high by 1·47. St. Luke, St. Michael, St. John Evangelist, and another saint erect. Figures of small character, washy in tone. This picture is either by Caroto or one of his assistants, and recalls Costa and Viti.

Mantua, Royal Palace. Arched canvas, with life-size figures. The Virgin and Child. Below, St. Mary Magdalen, St. John Evangelist writing on his knee, St. Francis, and a saint in armour. Feebler than the foregoing, but in the same style, by a pupil of Caroto or Costa.

St. Petersburg, Leuchtenberg collection. St. Anthony the Abbot between St. Roch and St. Mary Magdalen. 3 ft. 2½ in. high by 3 ft. 9 in. Assigned to Caroto, but by some follower of Cima, perhaps by Girolamo da Udine. [* See *postea*, iii. 79, n. 2.]

* The following is a list of works by G. F. Caroto not mentioned by the authors : (1) Bergamo, Galleria Lochis, No. 170. The Adoration of the Magi. (2) Bergamo, Galleria Morelli, No. 2. The Judgment of Solomon. (3) Budapest, Picture Gallery, No. 180. St. Michael. (4) Budapest, M. Sandor Lederer. The Virgin and Child. (5) Dresden, Picture Gallery, No. 66. Madonna with two Angels. (6) Fiesole, Villa Doccia, collection of Mr. H. W. Cannon, No. 9. The Virgin and Child with St. John. (7) Florence, Uffizi. The Circumcision; The Flight into Egypt ; The Massacre of the Innocents (signed "I. Franciscus Charotus V. P."); St. Joseph between two Shepherds. Originally in the church of the hospital of San Cosimo at Verona (Vasari, v. 280). (8) London, collection of the late Dr. L. Mond. The Virgin and Child with St. John. (9) Lütschena (near Leipzig), collection of Baron Speck von Sternburg. The Virgin and Child. (10) Trent, Cathedral. The Virgin and Child with Saints. Signed F. K. (11) Verona, Museo Civico. No. 92, The Virgin and Child with St. John. No. 108, Pietà. No. 112, The Temptation of Christ. No. 119, The Virgin and Child. No. 154, The Fall of Lucifer. No. 341, Sofonisba. (12) Vienna, Baron Tucher The Virgin and Child. Signed.

[2] There are no dates of Giovanni's life, but he was evidently an assistant to his brother. [* He was born about 1489, and died between 1562 and 1567. See Trecca, in *Madonna Verona*, iv. 190 *sqq.*] (1) Verona, San Paolo. Virgin and Child between

We now direct our attention to another set of Veronese headed by the Moroni, comprising Girolamo dai Libri and Paolo Morando.

Domenico Morone, by his townsmen called Pelacane, because his father was a tanner, was born at Verona about 1442. He was registered in the list of Veronese burgesses in 1491, and was one of the masters requested in 1493 by the municipality to report upon the merit of certain statues ordered for the outer ornament of the Council Hall. He painted the library of the convent of San Bernardino in 1503, and frescoes which have perished at Santa Maria in Organo in 1508.[1] In scanty proportion to these proofs of Domenico's existence are the pictures which he produced. There is no Veronese of name of whom we know so little. Remnants of frescoes without date in the Cappella Sant' Antonio at San Bernardino, rescued from whitewash some time ago, were laid out according to Vasari for Niccolò de' Medici by Domenico Morone,[2] but the fragments hardly allow of a safe

SS. Paul and Peter. Canvas, inscribed: "1513 Joannes" (retouched). [* According to Signor Trecca (ub. sup., p. 196) the castellino shows on one side the Caroto monogram and on the other a sign (⚹ ?) and the inscription "MDXVII-IOANES."] A heavy imitation of Giovan Francesco Caroto is here to be noticed; there is a mock grace in the Virgin and affectation of a dancer in the Child. The figures are colossal and greatly repainted. (2) Verona, San Giovanni in Fonte. Virgin and Child between SS. Stephen and Augustine, with a kneeling patron. Canvas, oil, inscribed on a scroll: "Joannes, ⚹ MDXIIII." [* The signature occurs on a leaf behind the Virgin's head, and is, according to Mr. Baron (in The Burlington Magazine, xviii. 42), simply "IOANNES."] Affected picture, draperies in zigzags, surface enamelled. (3) Verona Museum, No. 265, m. 1·70 high by 1·17, from Santa Maria in Chiavica. Virgin and Child, SS. Lawrence and Jerome. Sharply contrasted in the dresses, the Virgin distantly like Raphael's Madonna di Foligno, red flesh with dark shadows. (4) Verona, Santo Stefano. Virgin and Child between SS. Peter and Andrew. Canvas, figures life-size. This picture is Veronese, not quite in the manner of the foregoing, having broader forms and a low-toned rich key of colour; the grouping good and drawing clever.—Dal Pozzo (Pitt. Ver., p. 247) notices a Virgin and Child with St. Nicholas and another, containing portraits of Caroto and his wife. This picture is missing. [* A fragment of it is in the Museo Civico of Verona (No. 239). Baron, loc. cit., p. 43.]

Of Antonio Brenzone, there is in the Duomo at Verona a Virgin and Child between SS. Jerome and George in niches (figures half life-size), inscribed : "1533 Antonio Brenzone." The treatment is that of a disciple of Francesco Caroto. [* Dr. Gerola points out that, as there is no "pinxit" after "Antonio Brenzone," this might be the name of the donor. We have no records of a painter of that name.]

[1] For the foregoing facts see the proofs in Bernasconi, Studi, pp. 238 sq. [* Compare also Gerola, in Madonna Verona, iii. 104 sqq. Domenico Morone was still living in 1517.] [2] Vasari, v. 308.

opinion. Four Evangelists are in the ceiling, SS. Louis and Buonaventura in the pilasters of the inner arch ; the front and soffits of the entrance are filled with monochrome relief, ornaments and medallions, saints in niches, and a Virgin and Child in an imitated pediment ; five lunettes contain scenes from the legend of St. Anthony of Padua; all this is in a sad state of decay, and in a great measure renewed.[1] The decorative plan is a good one, but overcharged with florid detail ; a strong Umbrian look, apparently derived from the school of Piero della Francesca, may be observed in the group of Virgin and Child, recalling Fiorenzo de Lorenzo ; puffy projection in flesh contrasts with thin scantling of the joints, broad flanks with narrow chests ; the figures are short, the heads square, and the feet large ; straight and parallel folds in the drapery close with an angular eye, and balloon as they fall. These are all features that distinguish Francesco Morone, Girolamo dai Libri, Michele da Verona, and Morando ; a more modern and fresher spirit is to be found in the saints and angels. It is not unlikely that Domenico was assisted by his son and disciples in this vast undertaking.

We shall find a large Glory of St. Bernardino at the Brera in Milan, catalogued as by Mantegna. An illegible inscription and a false date leave us in ignorance of the painter's name and the time in which he laboured. The treatment is that of a man following in the footsteps of Piero della Francesca and Mantegna, the figures and architecture closely related to those of the Perugian Bonfigli. A grave and dignified mien and fair proportions are given to the saint, whose slender forms are pretty well rendered, but the heads are square and of a distinct type, i.e. a broad high forehead, large eyes with round pupils and curly hair in the fashion of Bonfigli and Fiorenzo. The drapery is sharply outlined and cut up into a confused tangle of folds, and a heavy

[1] Verona, San Bernardino, Cappella Sant' Antonio. SS. Helen and Elizabeth, on the front pilaster as you enter, are all but gone. Above are SS. Catherine and Ursula, and in the spandrils monochromes of Abraham leading Isaac and the Sacrifice of Abraham. St. Mark on the ceiling is the least injured of the four Evangelists. St. Buonaventura on the pilaster of the inner arch is least damaged of the personages inside the chapel, and most recalls Francesco Morone. Of the subjects in the lunettes, one is the Cure of the Man with the Broken Limb, in which some bits of old work remain (in some of the kneeling females); another, the Miracle of the Ass, where the portrait of the kneeling patron is still visible. The painting in the arch, ceiling, and lunettes is new.

red flesh tint of unbroken surface is strongly relieved by dark grey shadows. This is a clever composition, probably by Domenico or Francesco Morone, and not dissimilar from the wall-paintings in the chapel at San Bernardino.[1]

Turning from these examples to the frescoes in the library at San Bernardino, which bear the date 1503, we are led to believe that, whoever else may have designed the subjects, they were executed by journeymen such as Michele da Verona and Morando.[2]

It is apparent, therefore, that we can only judge of Domenico approximatively. Looking at the remains in the chapel of Sant' Antonio, he is a fair second-rate representative of fifteenth-century art; his figures of low stature with broad aged masks of the stamp of Piero della Francesca. If we measure him by the standard of other works superior to those of Sant' Antonio, he is a Veronese, with some of the spirit of the Mantegnesques and Piero della Francesca.[3] But taking Domenico in connection

[1] Milan, Brera, No. 163. Canvas, distemper, m. 3·85 high by 2·20. In a lunette four angels beneath garlands of leaves and fruit; a bird and a rabbit are on the foreground, and on a cartello is an illegible inscription with the false date of 1460. The surface is altered by oil, varnishes, and restoring. There is something in the treatment also akin to the organ-doors of San Bernardino; only that in these we find in addition some features peculiar to Liberale. (See *postea*.) [* The picture in the Brera Gallery is now labelled "*Maniera di Mantegna*."]

[2] Verona, San Bernardino, library, afterwards refectory, now out of use. Above and inside entrance, three bust figures of Popes between four medallions with monochrome profiles. Lower down and at some distance from the sides of the entrance, four saints erect; opposite wall, the Virgin and Child and angels between ten saints, two of whom are SS. Francis and Chiara, severally presenting a male and female patron; on the side-walls saints in couples on polygonal pedestals, and medallions. The portraits are the best part; the drawing of the extremities especially is very faulty, the outlines are continuous and wiry; the drapery is trite and formless. The action, too, is awkward even when well meant. The careful execution and the defects we have noted prove the presence here of young hands—of Michele in the Madonna with Saints, of Morando in the other pictures.

[*3] We now know something more about the work of Domenico Morone. His style is strongly Squarcionesque in a little Madonna in the Kaiser Friedrich Museum at Berlin (No. 1456, not shown), signed "Yhs Dominicus Moronus pinxit die XXVIIII Aprillis MCCCC(L)XXXIIII." With this work we may associate another Madonna in the Galleria Tadini at Lovere. The next dated painting by him which has come down to us is a large canvas belonging to Signor B. Crespi of Milan, signed "Dominicus Moronus Veronesis pinxit MCCCCLXXXIIII." This picture, which was executed for the Marquis of Mantua, represents the fight between the Gonzaga and the Bonaccolsi at Mantua in 1328. It is not only of

DOMENICO MORONE

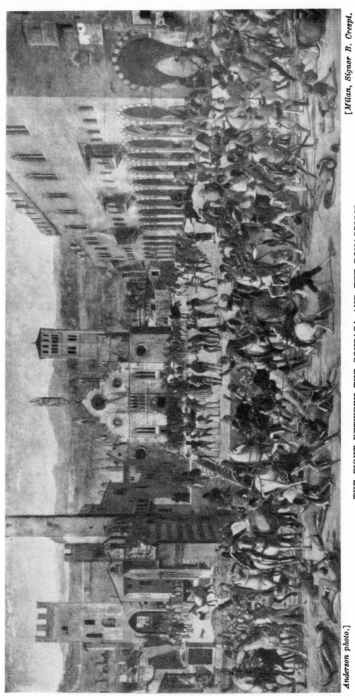

THE FIGHT BETWEEN THE GONZAGA AND THE BONACCOLSI.

II. 196]

with his son, of whom we shall now treat, he forms one of a partnership which gave an impress to the most important branch of Veronese painting. Through their industry, and under their lead, a new and powerful style was based on the precepts of Mantegna, without any servile imitation of his peculiarities.

Francesco Morone was born in 1473, and lived till May 1529.[1] As a draughtsman he studied Mantegna, as a colourist Montagna; but he tempered the hardness of both with a cold softness acquired from the Umbro-Ferrarese who dwelt at the Mantuan court in the sixteenth century. For some time assistant to his father,[2] and afterwards an independent master of large practice, he gained a name second only to that of Morando; and he finished a multitude of pictures and frescoes of which it would be superfluous to describe more than a few. The earliest is a crucified Saviour between the Virgin and Evangelist, an arched panel dated 1498 in the Cappella della Croce at San Bernardino, with attendant saints now in the Museum of Verona.[3] The

interest because of the subject, but also admirable in its spirited rendering of the battle. Allied in style to it are two tournament scenes (originally no doubt adorning a *cassone*) in the National Gallery (Nos. 1212, 1213). In 1498 Domenico worked in the Cappella di San Biagio in SS. Nazaro e Celso at Verona (cf. Biadego, *loc. cit.*, pp. 110 *sq.*), though we are unable to assign to him any of the extant paintings in that chapel. Two frescoes until recently in the little church of San Niccolò di Tolentino at Paladon, near Verona, and now in the Museo Civico of that town, are signed and dated works by Domenico, executed in 1502; they come very close to the frescoes in the library of San Bernardino (cf. Simeoni, in *Madonna Verona*, iii. 67 *sqq.*).—As already remarked (*antea*, p. 170, n. 5), Dr. Gerola thinks it probable that Domenico Morone is identical with Domenico de' Moroncini.

[1] See the proofs in Bernasconi, *Studi, ub. sup.*, pp. 239, 280. [* It seems more probable that Francesco was born in 1470-71. See Gerola, in *Madonna Verona*, iii. 104, n. 4, and 110 *sq.*]

*[2] A picture of the Madonna and Saints originally in the monastery of Santa Maria delle Grazie at Arco and now lost was inscribed "Dominicus Moronus de Verona et Franciscus filius pinxerunt A.D. MCCCCLXXXXVI die XVI Aprilis" (Gerola, *ub. sup.*, iii. 106).

[3] Verona, San Bernardino, Cappella della Croce. Arched panel with life-size figures. The Saviour is on the cross in a landscape, between the Virgin and Evangelists; signed with a renewed inscription as follows: "Franciscus Moroñ 1498"; the blue mantle of the Virgin repainted, the flesh injured by retouching and changed by time. Two wings—a St. Bartholomew and a St. Francis—are in the Verona Museum, Nos. 291 and 285, wood, m. 0·60 high by 0·40. They are better preserved, and show the painter's usual sharp and hardish colour.—The Saviour washing the Feet of the Apostles, once in the same chapel and now in

next is a large altarpiece of the Virgin and Child between
St. Augustine and St. Martin, commissioned for a chapel at
Santa Maria in Organo in 1503.[1] A similar picture at the
Brera was done in 1504.[2] These are all large pieces in which a
garish contrast of strong tones in dresses gives additional
frigidity to an even and unbroken flesh tint, the light of which
is ill blended with dark purple-grey shadows. Skilful arrange-
ment is marred here and there by florid accessories ; figures of
good proportion and form, not undignified in mien or in action,
and often appropriate in expression, produce a sense of littleness
by tall slender stature and paltriness of shade ; gentleness is
sometimes carried to the verge of meaningless tenderness. The
masterpieces of Francesco Morone are in the sacristy at Santa
Maria in Organo, where the walls and ceiling are filled with
incidents freely adapted from Mantegna's in the Camera de'
Sposi at Mantua. The room is quadrangular, and divided into
sections with lunettes like Peruzzi's in the Farnesina ; the centre
compartment of the ceiling representing a well-opening with a
balustrade in perspective from which angels look down, whilst
the Saviour in benediction floats in the heaven, the lunettes and
the course beneath them containing half-lengths of popes,
Olivetan monks, and female saints. This sacristy is one of
the grand monuments of local art in the Venetian provinces,
second only to Mantegna's creations in the display of perspective

the Museum (No. 305), has been assigned by Vasari to Morone (v. 310), but is by
Morando. [* Cf. *postea*, p: 208, n. 1.]

[1] Verona, Santa Maria in Organo. Canvas, oil, figures almost life-size. Virgin
and Child in a Roman chair, beneath a bower with flowers. At her sides two
angels playing, and in the foreground the two saints in episcopals. On the carpet
at the Virgin's feet the words : " Franciscus filius Domenici de Moronis pinxit
MDIII." A piece has been added to the canvas all round. The execution is very
careful.

[2] Milan, Brera, No. 225. Canvas, m. 1·7 high by 1·25 ; inscribed : " Fr. čiscus
f. lius Domenici de Moron pižit Ann. Dï MCCCCCII" (? 1504), and :
" Veronæ columen Zeno tutela decusq Gregorius Moriens hoc tibi reddit opus.
Attamē G Liscæ Leonardi gloria tecum vivet qž steteris culta tabella diu." The
faces are similar in masks and shape to those at Santa Maria in Organo. The
colours are dimmed and blackened by time.

* According to Dr. Malaguzzi-Valeri (*Catalogo della R. Pinacoteca di Brera*,
p. 131) the signature is to be read : " Franciscus filius (?) d. dominici de Morone
pižit Anno dōi MCCC . . II (1502 ?) pl. . . . oct." This picture was originally
in San Giacomo della Pigna at Verona.

FRANCESCO MORONE

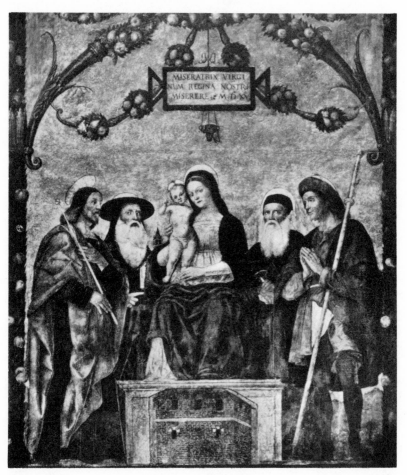

THE VIRGIN AND CHILD WITH SAINTS.

science and foreshortening, and in the geometrical distribution
of the space. Characteristic is the Umbrian stamp of the
decoration as well as its chastened design. Clean outline, good
modelling, and individuality are conspicuous in the slender
shapes, and the fall of the dress is unusually free and graceful.
Though we are in the dark as to the time in which this beautiful
sacristy was adorned, there is ground for believing that it was
finished in the first years of the sixteenth century.[1] At a much
later period, Morone and Girolamo dai Libri undertook the
ornament of the organ-shutters in the same church—the latter
composing the Nativity with two Saints; the former, four
figures of SS. John Evangelist, Benedict, Daniel, and Isaiah.
How these shutters came to be removed into the parish church
of Marcellise is hard to say. It is clear that when the two
masters laboured together at these pieces, Morone had enlarged
his style; for his figures are more firm in position, and their
drapery is better cast than of old.[2] To confirm the opinion that
these are comparatively late productions, it is enough to cast
a glance at the Virgin and Child with Saints reproduced in these
pages—a fresco drawn by Morone on the wall of a house near
the Ponte delle Navi at Verona, in 1515. The graceful ease and
correct drawing, the mild repose and softness of the personages,
and the copious gatherings of drapery, clothing form with pro-

[1] Verona, Santa Maria in Organo. It may be that the form of this decoration
was invented for Morone by Fra Giovanni of Verona, who finished the tarsie of
the choir in 1499. The frescoes are in part restored, especially so in the lights
of the white dresses; and much scaling or abrasion is noticeable in the mono-
chomes and ornament, and in the flesh generally. A portrait, said to be that of
Fra Giovanni, above a side-door, is either not by Morone, or has been repainted so
as to assume a new character. The stalls in the sacristy are assigned by Vasari
to this friar.

[2] Marcellise, near Verona. Two canvases with life-size figures of the above-
mentioned saints in couples in landscapes. Above that containing the two
prophets, two angels in flight hold a tablet between them. The foregoing was
in the printer's hands when the following was communicated to us by the kindness
of Signor Gaetano Milanesi: "On the 12th of November, 1515, M° Francesco
Morone and M° Girolamo the miniaturist agree with the abbot of the monastery
of Santa Maria in Organo to paint the doors of the organ—i.e. inside, the Nativity
and two prophets; outside, four large figures; price 60 ducats. They also agree
to paint a picture with five figures. The contract is signed by both painters, and
appears at length in the MS. 'Libro de' Debitori e Creditori del Monastero di
Santa Maria in Organo di Verona,' signed B., including the years 1510–20, now
in the *Uffizio dell' Ispettore del Demanio*, p. 119."

priety, indicate a long and careful study of the best masterpieces
of Mantegna.[1]　As a colourist Morone remains throughout un-
changed.　The latest dates of his works are those of 1520, on
a canvas of the Virgin attended by saints in the Carrara Gallery
at Bergamo[2]; and of 1523, on a fresco with a similar subject
outside the lateral portal at San Fermo of Verona.[3]　But there
are numerous specimens of his skill in various parts of Verona[4];

[1] Verona, Ponte delle Navi.　The date is on a tablet hanging in the festoon
above the Virgin's head, with an inscription to this effect : " Miseratrix Virginum
regina nostri miserere.　MDXV."　The head of St. Joseph is damaged, and the
fresco is split downwards so as to spoil that figure.　Beneath the principal subject
is a view of the bridge and people on it.　The original drawing for this fresco is
in the Uffizi under the name of G. Bellini.　[* The fresco of the Madonna and
Saints is now in the Museo Civico of Verona (No. 560).]

[2] Bergamo, Carrara (No. 188).　Canvas, with life-size half-lengths of the
Virgin, Child, SS. Joseph, Vincent, Anne, and Francis.　On the hem of the Virgin's
bodice : " Francisc. Moro."　Lower down in the right-hand corner : " Franciscus
Moronus Verõs 1520 pinxit."　This picture is much injured and blackened by
restoring.

[3] Verona, San Fermo.　Virgin and Child between SS. Elizabeth and James,
inscribed : " MDXXIII.　Franciscus Moronus p."　The fresco is all but gone.

[4] (1) Verona, Duomo, Cappella Emilii.　Panels of St. James and St. John, life-size,
the former with a patron, embrowned by time but of Morone's best and fairly pre-
served ; sometimes falsely assigned to Caroto (but see Vasari, v. 310).　The Christ
carrying his Cross, which formed the centre of the altarpiece to which these figures
belonged, is no longer in the chapel.　(2) Verona Gallery, No. 259, m. 1·65 high
by 1·0.　St. Catherine with a patron, in the manner of the canvases at Marcellise.
No. 330, from Santa Maria della Vittoria Nuova.　The Saviour in glory between
the Virgin and Evangelist, arched.　This picture, assigned to Morone, is probably
by Morando.　It comes out of a church where frescoes exist, of which numerous
guide-books assert that they are by Morone.　We shall see that these also are by
Morando and Michele da Verona.　[* Cf. postea, p. 208, n. 1.]　(3) Casa Bernasconi
[* now Museo Civico, No. 182].　Virgin and Child.　Half-length, canvas, oil, in the
usual character of F. Morone.　(4) Four canvases in one, originally part of the
organ at Santa Chiara of Verona.　St. Sebastian and another saint, St. Anthony
the Abbot and another, St. Bernardino with a patron, and St. Chiara with two
patronesses.　These pieces seem done in Morone's atelier.　[* They are now in
the Museo Civico of Verona, No. 135.]　(5) In Brà at Verona, full-length Virgin and
Child enthroned.　Fresco by Morone, in his early manner.　(6) Via San Tommaso,
No. 1562.　Trinity between St. John the Baptist and St. Anthony.　Fresco, free and
bold, by F. Morone.　[* This fresco is now in a most ruined state in the Palazzo
Municipale della Gran Guardia Vecchia at Verona; for a reproduction, see
Biadego, in Nuovo archivio veneto, ser. ii. vol. xi. pl. 6.]　(7) Strada Porta Vescovo,
No. 320 [* now Via XX Settembre].　Virgin and Child between St. Roch and
another saint.　There are but fragments of this work, but they seem to be by
Morone.　(8) Piazza San Marco.　Here are also dim marks of a fresco of the Virgin,
Child, and two Saints, traditionally ascribed to Morone.　(9) Padua, Gall. Comunale,

PIETÀ.

a charming Madonna, half-length, in the Museum of Berlin,[1] and another in the National Gallery.[2]

Contemporary with Morone, but bred by his father, a Veronese miniaturist of whom no vestige has been preserved, is Girolamo dai Libri, born in 1474, dead in 1556.[3] The first picture which he exhibited is the Deposition from the Cross, in the church of Malcesine on the lake of Garda, executed at the age of sixteen for the chapel of the Lisca family in Santa Maria in Organo at Verona. The annexed reproduction of it will give an idea of the character of this composition, in which the Saviour reminds us of Signorelli. The grouping is good and the action well intended, but serious drawbacks are to be found in heavy outline and excessive detail, as well as in stiff or conventional attitude and over-abundant broken drapery. The regular shape and mild aspect of St. Benedict, and the soft character of the Virgin, are exceptional features in a piece conspicuous for the old type and strained movement of the figures ; the distant view of Verona in the background is an appropriate illustration of Girolamo's education in the school of a miniaturist, commendable for patient detail but excessively minute ; the colours are a gay intertress of intense bright tones without unity of general effect, such as a

No. 36. Virgin and Child, originally in the Capo di Lista collection, inscribed : " Franciscus Moronus f." There are two heads of angels in the upper corner.

[1] Berlin Museum, No. 46. The Child lies on the arm of the Virgin and looks at the spectator. Canvas, 1 ft. 6¾ in. high by 1 ft. 3½ in., inscribed " Franciscus Moronus p." on the hem of the Virgin's dress. This little piece recalls Montagna. Same gallery, No. 46B. Virgin and Child between two saints, also in the character of Montagna, injured, inscribed : " Franciscus Moronus p." Canvas, figures three-quarters of life.

[2] London, National Gallery, No. 285. Wood, 2 ft. high by 1 ft. 5 in. Virgin and Child, half-length. [* The following are also works by Francesco Morone : (1) Bergamo, Galleria Morelli, No. 52. The Virgin and Child. (2) Soave (near Verona), Parish Church. The Virgin and Child between SS. Roch and Joachim. (3) Verona, Museo Civico, No. 348. St. Francis receiving the Stigmata. (4) Verona Cathedral, Chapter Hall. The Virgin and Child. (5) Verona, SS. Siro e Libera. The Assumption of the Virgin.—See also *postea*, p. 208, n. 1.]

It has been said (Bernasconi, *Studi*, p. 281) that there was an altarpiece by Morone in the cathedral of Trent. This must be a mistake, the author of the statement having probably taken for a Morone the altarpiece of Verla.

[3] Vasari says 1472 (v. 327); Bernasconi (*Studi*, p. 289) says 1474, taking the statement from the census of 1492 (*Anagrafi*), in which Francesco dai Libri, aged forty, declares his son Girolamo to be aged eighteen (*Studi*, note to p. 230). In another census (1529) Girolamo gives his own age as fifty-four (*ibid.*).

youth might produce who had not learnt to infuse atmosphere into the scenes he endeavours to depict. The flesh is without modulation, of a rosy tinge, with purple frosting to mark the transition of semitone into light grey shadow.[1]

Little time elapsed before Girolamo perceived the advantage of a broader style, and, struck by Caroto's art in applying certain rules of the Mantegnesques, fell to imitating that master. He did not carry imitation to any prohibited length, but he used for his faces the flat oval mould with the high forehead and large tearful eye peculiar to Caroto. This we see to a slight extent in the Nativity at the museum at Verona, which was done for Santa Maria in Organo, and in the Madonna with Saints at Sant' Anastasia. In the first, however, he still remains a miniaturist in finish and copious detail ; he is not unmindful of the laws of distribution in appropriately setting the Virgin, the Baptist, St. Jerome, and St. Joseph in adoration round the recumbent and foreshortened figure of the Infant Christ. He cleverly adapts the main lines of his landscape to those of his groups, and models the parts with great carefulness of blending and polish of surface, but he wants freshness and light; and the aged air produced by hard prominences of bone in the figures is as disagreeable as the dull effect created by neutralizing strong tints by juxtaposition, and shading flesh with dull grey.[2]

At Sant' Anastasia the subject is the favourite one of this time, the Virgin enthroned between two saints ; the treatment bolder and more skilful than before, but the general features the same as of old.[3]

A deeper study of the pure Mantegnesque is to be found in the Virgin and Child with four saints, a large altarpiece now in the Hamilton Palace near Glasgow, warmly praised by Vasari when at San Leonardo of Verona.[4] Here is the form as well as

[1] Malcesine, church of. Canvas, oil, figures life-size, repainted in sky, and indeed in all the blues, retouched in some heads, especially in that of the Magdalen and the male near her.

[2] Verona Gallery, No. 290. Canvas, oil, m. 2·18 high by 1·52 broad. In the foreground two rabbits and the head of a lion. (See engraving in Rosini.)

[3] Verona, Sant' Anastasia. Canvas, oil, figures life-size. Virgin and Child between St. Augustine with a kneeling penitent and another saint. Looking out at the bottom, two profiles, male and female, of the donors.

[4] Hamilton Palace, staircase. Canvas with life-size figures ; originally in San

the spirit of a greater art ; and the Infant Christ, standing on the Virgin's lap with a carnation in one hand, is reproduced from the models of Mantegna, with due attention to his principles in giving regularity to the human proportions, careful arrangement to the draperies, and a simple flow to the outlines. The landscape itself, of the rocky character peculiar to the great Paduans, is enriched in Girolamo's own manner with a beautiful tree immediately in rear of the throne, and distant spurs of hills finished with all the patience of a Fleming. And yet, with all this, the first impression of the picture is marred by the flare of colours and the leaden purple of the flesh.

Later again Girolamo dai Libri was the companion of another Veronese, as is clearly apparent at Marcellise, where the Nativity of old on the shutters of the organ at Santa Maria in Organo is scarcely to be distinguished from a piece by Francesco Morone.[1] This phase has its illustration in the Madonna and Saints at the Museum of Berlin,[2] and in the Virgin and Child between Lorenzo Giustiniani and St. Zeno at San Giorgio of Verona.[3] In the last particularly Girolamo shows that some of his angularities and roughnesses are worn away. His personages are more pleasing, more composed in face, and better draped, and Morone himself is in a fair way to be distanced as a colourist and a landscapist.

Leonardo (Vasari, v. 328 *sq.*). Virgin and Child enthroned in front of a tree, on the branch of which is a peacock ; distance, a hilly landscape ; at the sides of the throne, St. Catherine, St. Leonardo with the manacles, a bishop, and St. Apollonia with the pincers. Three boys kneel and play instruments ; thin faces, grotesque in expression. Foreground, rock. The disharmony of the colours may be in part due to cleaning. [* This picture is still at Hamilton Palace.]

[1] Marcellise, near Verona (ch. of). Canvases, life-size, of the Saviour on the ground adored by the Virgin and St. Joseph, in a landscape, with eight angels in the sky, of St. Catherine and St. Mary Magdalen, much damaged. (Vasari, v. 329, and see *antea*.)

[2] Berlin Museum, No. 30. Canvas, 6 ft. 9 in. high by 4 ft. 7½ in. ; from the Solly collection, but originally in the Cappella Buonalini at Santa Maria in Organo (dal Pozzo, p. 247). Virgin and Child between St. Bartholomew and St. Zeno, with thin half-lengths of angels playing and singing at the foot of the throne. This picture is injured, but is almost to be confounded with a work of F. Morone. The angels are repeated in the following picture at San Giorgio.

[3] Verona, San Giorgio. Canvas, oil, figures life-size ; inscribed : " XXVI. Men. Mar. XXVIIII. Hieronimus a Libris pinxit." Virgin and Child on a throne in front of a lemon-tree. The Child presents a girdle to Lorenzo. Below, three angels in half-length ; distance, landscape. Lunette with the Eternal and cherubim repainted. The Child is paltry and angular in shape ; the Virgin's blue mantle is retouched.

It is not improbable that before 1526, when the altarpiece of San Giorgio was painted, Girolamo felt the superiority of Morando, whose premature death in 1522 was so great a loss to Verona. The new brightness which he acquires becomes constant, and is accompanied by a modern freedom of treatment in every branch of practice.

He displays this superiority in the conception at San Paolo of Verona, where St. Anne almost reminds us of the types familiar to Morando; and the Virgin, St. Joseph, and St. Joachim are presented in dignified and natural instant action with a soft composed air, and in draperies of unusually simple cast. A broad landscape of picturesque lines adds to the interest of the scene, and harmony of tone is as nearly attained as can be expected from Girolamo's known habits as a colourist.[1] A little below this example is that of the National Gallery in London, where the liveliness of contrasted tints and the grey of the flesh almost deserve to be qualified as raw.[2] Other specimens of the same period are the Virgin and Child belonging to Dr. Bernasconi, and the predella of Bonsignori's altarpiece at San Biagio, dating from 1527.[3]

The culminating point in Girolamo is reached with the Madonna and Saints finished in 1530 for the church of the Vittoria Nuova, and the Virgin in glory with St. Andrew and

[1] Verona, San Paolo. Canvas, oil, figures of life-size, arched. At the foot of a lemon-tree St. Anne with the Virgin and Child in front, the Child presenting a branch with fruit to St. Joachim on the right; on the left St. Joseph; distance, landscape; at the edge of the picture a male and female donor in profile, the dress of the latter a little scaled.

[2] London, National Gallery, from Santa Maria della Scala at Verona, No. 748. Canvas, 5 ft. 2 in. by 3 ft. 1 in. Virgin and Child on the lap of St. Anne under a lemon-tree, and three angels playing instruments. This picture is treated very much in Morone's manner. (Vasari, v. 328.)

[3] Verona, Dr. Bernasconi, formerly belonging to Signor Pietro Tortima at Lonigo. [* Now Verona, Museo Civico, No. 138.] Virgin and Child on a marble seat in a landscape, figures half life-size. The figures are a little short and small.—In the same style: (1) Verona Gallery, No. 252. Canvas, m. 1·85 high by 1·45. Virgin and Child between SS. Sebastian and Roch. This is much in the manner of F. Morone, but not very pleasing. No. 253, Baptism of Christ. Canvas, m. 1·85 high by 1·42, feeble. (2) Verona, San Biagio, in SS. Nazaro e Celso. Predella with a scene from St. Biagio's life, the Martyrdom of St. Sebastian, and the Decapitation of St. Juliana. (See Di San Biagio, etc., p. 63.) The compositions are good. [* Cf. Biadego, loc. cit., xi. 124 sq]

St. Peter for Sant' Andrea, both in the Museum of Verona. In these altarpieces he attains his greatest breadth of hand, his fullest freedom of touch and of drawing, his utmost power of light and shade, and an attractive richness of tone.[1] Beginning as a miniaturist, emulating in succession the Mantegnesque of Caroto and Morone and the modern Veronese of Morando, he ascends to a high place amongst the professors of painting in the north; and throughout his long career he never incurs the reproach of being a plagiarist or a servile copyist.[2]

It was Vasari's opinion that Paolo Morando, had he lived, would have acquired great celebrity.[3] He is little known at the present day outside of Verona, and has received but curt notice from historians ; and yet he was one of the best masters in the school of Verona, until Paolo Veronese became famous. He was born in 1486, and is correctly described as the companion or

[1] Verona Museum, No. 339, from Santa Maria della Vittoria Nuova. Canvas, m. 3·38 high by 1·80 ; inscribed : " De precationẽ vestrā audivi, etc. . . . Hieronibus a libris Veronẽsis pix̌it MDXXX." No. 92, from Sant' Andrea. Arched canvas, m. 3·10 high by 1·75. Distance, a landscape, on which is the Baptism of Christ.

[2] (1) Mezzane, ch. of. Marriage of St. Catherine and St. Paul, with portraits below of the donor, his wife, and two children (of the Della Torre family). Panel, figures a little under life-size. This piece is much injured, and hence a difficulty in justifying the name of Girolamo dai Libri, to whom it is assigned. (2) Quinto, ch. of San Gio. Batt. Virgin and Child between the Baptist and Evangelist, inscribed: " Don. Vicen. Facius hujus sacelli rector hãc iconā ære suo laboratum dicavit. 1526." This panel is given to Jacopo Bellini, and has an air of Girolamo dai Libri, but is much damaged by scaling and repainting.

We know nothing of Girolamo's miniatures; but there is a Funeral of the Madonna, a small panel in the Layard collection in Venice (canvas, oil), assigned to Carpaccio, which seems done in the miniature style by some Veronese of his stamp, if not by Girolamo himself. [* In the opinion of the editor this picture is too decidedly akin to Carpaccio to allow of its ascription to Girolamo or one of his followers. On the other hand, there are miniatures by Girolamo to be found in the Museo Civico of Verona and elsewhere.—Here we may also notice the following works by him not mentioned by the authors : (1) Bergamo, Galleria Morelli, No. 50. St. John. (2) London, collection of the late Dr. L. Mond. St. Peter and St. John. These paintings recall Francesco Morone, and are probably—as Dr. Gerola suggests—identical with the pictures of the same saints mentioned by Vasari (v. 310 sq.) as being in Santa Maria in Organo at Verona and attributed by him to Morone.—Same collection. The Nativity.—Girolamo is also mentioned in one of Bandello's novels. (Parte II, Nov. X.).]

Of Girolamo's relations who were painters there are only written notices. See Bernasconi, Studi, for Calisto dai Libri, etc. [* Cf. di Canossa, in Atti dell' accademia . . . di Verona, ser. iv. vol. xii.]

[3] Vasari, v. 317.

assistant of Francesco Morone, when Francesco was the partner of his father.[1] The canvases and frescoes which he finished in considerable numbers at a very early age were all more or less distinctly impressed with the teaching of the Moroni; they occasionally recall Caroto when he was Mantegnesque, and they remind us of Girolamo dai Libri in the richness of their land-scapes. But Morando, or as he is more usually called, Cavazzola, had an unmistakeable individuality which gives him a distinct stamp. He may claim, and justly claim, to have infused new life and health into the Veronese school, especially by a novel system of colouring. That he was a disciple of the Moroni is proved almost conclusively by the frescoes of the library at San Bernardino of Verona, where he was probably employed by Domenico with Michele da Verona.[2] His fresco of the Sibyl prophesying to Augustus on a house in the Via del Paradiso is described by Vasari as a youthful effort; it has been reduced by time to a mere stain. A Virgin and Child once in the collection of Dr. Bernasconi is said to have been done on the verge of man-hood; that also is not traceable.[3] The Annunciation and two saints of 1510 in SS. Nazaro e Celso are therefore the oldest of his frescoes with which we can become acquainted.[4] In these we may equally commend the proper distribution of space, the subordination of the figures to the laws of perspective, the

[1] He was the son of Thaddeus Cavazzola, the son of Jacopo de Morando. He was registered by his father in the municipal census of 1514, being then aged 28. (Bernasconi, *Studi, ub. sup.*, p. 274). He was registered in the brotherhood of Santa Libera at Verona in 1517 (*ibid.*, pp. 402, 403). He died in 1522.

[2] *Antea.*

[3] Verona, Via del Paradiso. In the absence of the fresco see a line-engraving of it in *Di Paolo Morando*, etc., folio, Verona, 1853, plate vii. The text of this work is by Aleardo Aleardi, the plates by Lorenzo Muttoni.

The Virgin and Child is engraved in the same work, plate i. The Virgin (half-length) gives the breast to the Infant Christ, who holds a carnation in his left hand. A carpet behind intercepts a landscape of hills; inscribed: "Morandus Paulus f. Taddei." [* This picture is now in the Museo Civico of Verona.]

[4] Verona, SS. Nazaro e Celso, Cappella San Biagio; engraved in Aleardi, pl. xii. The saints at the sides are SS. Biagio and Benedict. The fresco was paid 9 gold ducats (Aleardi). [* Cf. Biadego, *loc. cit.*, xi. 119 *sq.*] We mention it first, not having seen the Virgin and Child, half-length (Aleardi, pl. iii.), in possession of Conte Bandino da Lischa, inscribed: " AD. MCCCCCVIIII. Paulo Morando F." [* This picture is now in the collection of Don Guido Cagnola at Gazzada, near Varese.] Unseen by the authors likewise is the Virgin and Child between St. John the Baptist and St. Benedict in the church of Calavena

regular proportions and contours, and a certain decorous calm
in attitudes and actions well suited to a religious subject. They
are creations on the models of Francesco Morone, better draped,
of greater breadth and more pleasing air than his ; yet still
without selection in form, and coarse especially in the extremi-
ties and articulations. A robust and handsome peasant-girl
may create an impression of health and youth, and yet be ill
suited to represent the mother of Christ; the rawness and
sharpness of Veronese colour in Morando's contemporaries extend
here to Morando himself, and his treatment falls short of perfec-
tion by lack of rounding in the light bricky flesh tint and its cold
grey shadow. Mainardi in the Florentine school, Tamagni in
the Umbrian, hold the same position in comparison with the
first-rates of Italian art as Morando occupies here. In a chapel
contiguous to that of San Biagio, he painted a large fresco of the
Baptism of Christ, in which his manner exhibits much the same
aspect as that of the Annunciation. There is something Umbrian
in a group of spectators to the left of the Evangelist, most of
them wearing cylinder hats, exceedingly like those of the present
day ; a company of angels on the banks of the stream stand in
soft attitudes of wonder and sympathy. It may be objected that
the conception and execution are cold, monotonous, and conven-
tional ; the Eternal in the sky with a triangular nimbus is a
revival of an old and disagreeable type ; but the landscape is
very charming and sunny, and improves upon those of Girolamo
dai Libri. The Evangelists in the ceiling, by the same hand,
have much the air of those by Francesco Morone[1] ; and in this
respect are but counterparts of others done at this period in
Santa Maria della Vittoria Nuova.[2] But the influence of Morone

(Aleardi, pl. iv[a]). In the pendentives of the ceiling of the chapel of San Biagio,
the four Evangelists are by Morando. [* A Virgin and Child with the Infant
St. John in the collection of the German Emperor at Berlin is signed " A.D.
M . D . X . IIII . M . O͡c—Paulus M. P."]

[1] Verona, SS. Nazaro e Celso. (Aleardi, vi[a], vi[d], and xxvii.) [* These frescoes
have now been transferred to the Museo Civico of Verona (Nos. 462–6).]

[2] Verona, Santa Maria della Vittoria Nuova. Much injured frescoes, in part
retouched, and the blues scratched off.

We believe that Morando painted the Saviour in glory between the Virgin and
Evangelist, once in this church and now No. 330 in the Verona Museum, under
the name of Morone. It is quite in the character of the " Lavanda dei Piedi,"
once in San Bernardino, and of which we shall now treat.

on his younger companion is still clearer in a series of panels
once forming part of Francesco's Crucifixion in the Cappella
della Croce at San Bernardino, and a Christ washing the Feet of
the Apostles at the Museum of Verona. In Vasari's time the
" Lavanda dei Piedi," as it was called, was attributed to Morone,
and yet it has the marked stamp exemplified in Morando's frescoes
at SS. Nazaro e Celso, though timid and careful in treatment
and cold in the juxtaposition of sharp bright tints.[1] The canvases
of San Bernardino, now hanging together at the Museum, are
nine in number : four are half-lengths of saints of a very decided
portrait character [2] ; five are subjects from Christ's Passion. The
best is the Deposition from the Cross, dated 1517, a well-arranged
scene of passionate grieving.[3] Almost as good is the Christ
carrying his Cross, accompanied by Simon and the executioner.[4]
The Saviour crowned with Thorns is a free and even grand com-

[1] Verona Museum, No. 305, m. 2·85 high by 2·20. (Aleardi, pl. viii.) A
disciple kneeling with two water-vessels in his hand, in the right foreground, is
described by Vasari (v. 310) as F. Morone's likeness. The colour is thin, purply,
and done at one painting with little or no glazing.

* Count Gamba (in *Rassegna d'arte*, v. 37 *sq.*) and Mr. Berenson (*North Italian
Painters*, p. 268) claim that the Baptism and the Evangelists once in SS. Nazaro
e Celso, the Eternal and the Evangelists in Santa Maria della Vittoria Nuova, the
Saviour in Glory and the " Lavanda dei Piedi " in the Verona Gallery, are by
Francesco Morone, not by Paolo Morando. These paintings are undoubtedly
closely allied in style to the authenticated works by Morone, as is also remarked
by the authors. Moreover, a contemporary record proves that Francesco Morone
in 1499 had done work for which he was to receive payment both from the Con-
fraternity of San Biagio and the Monastery of SS. Nazaro e Celso : could not the
work in question be identical with the frescoes which originally were in SS. Nazaro
e Celso in a chapel next to that of San Biagio (see Biadego, *loc. cit.*, xi. 111 *sqq.*) ?
It may also be pointed out that, according to the very reliable Zannandreis (*ub.
sup.*, p. 84), the " Lavanda dei Piedi " was originally dated 1503, by which time
Morando was only about seventeen years old.

[2] Verona Museum. No. 293, panel, m. 0·60 high by 0·46, St. Joseph (half-
length, Aleardi, pl. xiv[a]), really a portrait (Vasari, v. 315 *sq.*), which we find
repeated in a St. Eleazar, part of the Virgin in glory, dated 1522, No. 333 in the
Museum. No. 292, Baptist. This is the model of Morando's Christs. No. 294,
St. Buonaventura, also a portrait (Vasari, v. 316), used for the St. Louis in the
altarpiece of 1522. No. 295, Bernardino da Feltre, profile, also a portrait (Vasari,
v. 316, and Aleardi, pl. xiii[b]).

[3] Verona Museum, No. 392, m. 2·35 high by 1·55, inscribed: " Paulus M. p.
MDXVII." (Aleardi, pl. xix.)

[4] Verona Museum, No. 394, m. 2·33 high by 1·07, inscribed : " Paulus V. p."
(Aleardi, pl. xiv.)

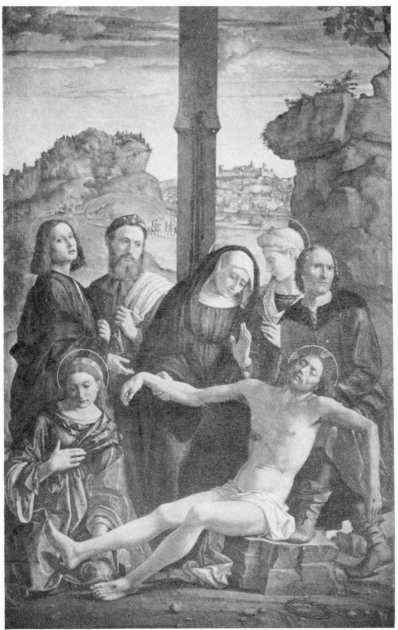

PIETÀ.

position[1]; the Agony in the Garden less attractive from the
prevalence of old types resembling those of Girolamo dai Libri[2];
the Flagellation excessively raw in tone.[3]

Throughout the series Morando's power as a composer is
considerable ; he frequently achieves success in chastened form
and well-sought movement; his landscapes are simple and
spacious. But he also has defects that cannot be unobserved.
Models if not vulgar are still nothing more than models ; and
Morando, in grouping two or three of these into a picture,
invariably reminds us of the academy ; he sets these figures
in motion, and with realistic skill copies what he sees; but
the models are not under any impulse of their own will, their
muscles have not the tension of instant action, their faces do
not express the thought of a moment; and Morando for this
reason produces something akin to the modern *tableau vivant*.
His men are short and unselect, and by no means clean and
lithe in limb or joint; his masks are often repeated, the same
being used for the Saviour, the Baptist, or St. Roch ; his
drapery, though broad and ample, is gathered into multiplied
folds like Caroto's, and would be disagreeable but for the
delicacy with which it is occasionally treated and coloured.
In the Saviour carrying his Cross the cold and snake-like
brightness peculiar to the Veronese is combined with an
undeniable richness, the vehicle by some means giving extra-
ordinary polish to the surface ; flesh of a broad and warm rosy
mass in light is fused into greenish grey with a purple semitone,
which balances tints of opposite effect in the scale of harmony.
Strong as these shades are in themselves, they are deadened
by still stronger ones, which, being more glaring and sharply
set in threes against each other, act as counterpoise and give
them brilliancy and transparency. Thus scarlet and emerald-
green are united in the half-tints and reflections by a com-
plementary colour of equal force, blue skies of the purest
ultramarine serving as foils to the dresses and foregrounds.

[1] Verona Museum, No. 308, m. 1·75 high by 1·10. (Aleardi, pl. xvii.)
[2] Verona Museum, No. 390, m. 2·33 high by 1·07, inscribed : " Paulus Morandus."
(Aleardi, pl. xiii.)
[3] Verona Museum, No. 303, m. 1·75 high by 1·10, inscribed : " Paulus p."
(Aleardi, pl. xviii.)

The pictures usually are full of light, relieved on a pure and limpid horizon, with masses of chiaroscuro both spacious and well modelled, and a correct use of linear and aerial perspective. It was no common gift in Morando that he should produce finish by such subtle methods. It is no common honour to him that he should have first illustrated the principles on which the art of Caliari is founded. Of his great power in this respect we have an excellent example in the St. Roch of our National Gallery, a masterpiece clever in movement, excellent in proportion, rich in tone, and most effective in chiaroscuro.[1] Specimens of almost equal value might be cited at Verona, such as the Incredulity of St. Thomas, once at Santa Chiara[2]; the Adoration of St. Paul, in the sacristy of Sant' Anastasia,[3] where the figures are unusually free from the fault of shortness and vulgarity; the Virgin and Child with the young Baptist and an angel, in the National Gallery[4]; the same subject in a grander form in the collection of Dr. Bernasconi,[5] recalling the Madonnas of Raphael and the frescoes at Santa Maria in

[1] London, National Gallery, No. 735. Canvas, 5 ft. 1¾ in. high by 1 ft. 9½ in.; inscribed: "Paulus Morädus V. P." The date, "MDXVIII," is in part obliterated. Formerly in Santa Maria della Scala at Verona (Aleardi, pl. xx.), then in the Caldana and Bernasconi collections.

* From 1518 dates also a charming little Madonna in the Frizzoni collection at Milan, signed "Paulus Veronensis p. MDXVIII." A Virgin and Child with an Angel in the Staedel Museum at Frankfort (No. 49B) is dated "XVIIII," i.e. 1519.

[2] Verona Museum, No. 298; m. 1·40 high by 1·63. In the distance the Descent of the Holy Spirit and the Ascension (Aleardi, pl. xvi.). In the same style, St. Michael, St. Paul, St. Peter, and the Baptist, Nos. 302 and 307, half-lengths (Aleardi, pls. ix. and ixᶜ).

[3] Verona, Sant' Anastasia, sacristy. St. Paul in a ruin, between St. Denis and St. Mary Magdalen, who recommend the kneeling males and females of a religious order. Canvas, figures all but life-size (Aleardi, pl. xi.). [* Count Gamba (ub. sup., v. 38) and Mr. Berenson (ub. sup., p. 268) ascribe this picture to Francesco Morone.]

[4] National Gallery, No. 777; formerly belonging to Conte Lodovico Portalupi of Verona. Canvas, knee-piece; inscribed on a laurel-tree in upper corner to right: "Paulus V. p."

[5] Verona, Casa Bernasconi [* now Museo Civico, No. 85]. Canvas, knee-piece; inscribed on pilaster to right: "Paulus Morandus V. p." (Aleardi, pl. xxv.).

In the Bernasconi collection [* now Museo Civico, No. 117] a lunette, canvas, of somewhat careless execution, representing the Deposition from the Cross, with some Raphaelesque character, reminiscent of Francia and Costa.

Organo.[1] In the Madonna of the Bernasconi collection particu-
larly Morando rises above the ordinary level in conception and
arrangement, whilst keeping to his usual style in the execution.
It may be that at this time, *i.e.* about 1520, he had seen and
studied engravings of Raphael.[2] His latest altarpiece, the Virgin
in glory with Saints, dated 1522, in the Museum of Verona, is
the finest production of this school in the first quarter of the
sixteenth century, being composed and executed on the great
maxims of the Raphaelesques ; [3] and it may be said of Morando
at last that he held the same position in his native place as
Garofalo and Mazzuola at Ferrara, Gaudenzio Ferrari in
Lombardy, and Giulio Romano at Mantua.

To close this chapter on Veronese painting we must revert
for a while to an earlier period than that of Morone, Morando,
or Girolamo dai Libri. There are Veronese artists who deserve
to be chronicled, although Verona preserves but a few of their
works.

[1] Verona, Santa Maria in Organo. Frescoes, life-size, of St. Michael and the
Angel and Tobias ; much injured by damp, but originally well coloured ; the
angel Raphael especially damaged (Aleardi, pl. xv.).

[2] Verona, Sant' Eufemia, on the outside of a chapel (No. 516, Via Sant' Eufemia).
An Angel and Tobias taking the Fish (Aleardi, pl. xxii.). Fresco, inscribed :
" Societas Angeli Rafaeli fieri fecit. MVXX." This fresco is but a stain.

[3] Verona Museum, No. 333; from San Bernardino. Virgin and Child in
Heaven amidst Angels and Virtues, and adored by SS. Francis and Anthony.
Below, SS. Elizabeth, Buonaventura, Louis, Ivo, Louis of Toulouse, and Eleazar;
m. 4·40 high by 2·67. At the bottom a profile of the Countess Catherine de'
Sacchi ; in the right-hand corner the date of 1522 (Aleardi, pl. xxvi.). The best
part of this picture is the lower, the upper having been finished in the atelier
and recalling to mind the works of Bagnacavallo. There is less light than usual
in this fine and freely handled picture.

In the same style is a fresco, half-length of San Bernardino (Aleardi, pl. xxiii.)
in San Bernardino, above the door of the court. Not seen : Verona, collection
of Dr. Giuseppe Bresciani, John the Baptist in the Wilderness (Aleardi, pl. ii.).
[* This picture belonged subsequently to the heirs of the Avv. Malenza of
Verona (Bernasconi, *ub. sup.*, p. 411).—The following works by Cavazzola remain
to be mentioned : (1) Dresden, Picture Gallery, No. 201. Male portrait. (2) Milan,
Prince Trivulzio. Christ bearing the Cross. Signed " P. Morandus pinxit."
(3) Milan, Marchese Trotti-Belgioioso. Portrait of Giulia Gonzaga.]

A pupil of Cavazzola may be noticed, by whom a Virgin and Child, in the
possession of Dr. Bernasconi, bears the inscription : "A. d. V–ndri p. 1518." His
style is that of Morando in miniature. [* This picture is now in the Museo Civico
at Verona (No. 157). Antonio da Vendri was born about 1485, and was still living
in 1545. Trecca, *Catalogo della Pinacoteca Comunale di Verona*, p. 27.]

Girolamo Mocetto, best known by his copperplates, is one of these.[1] He was journeyman to Giovanni Bellini,[2] and perhaps to one of the Vivarini. There is something of Bartolommeo Vivarini's character in the short square stature of the saints in his glass windows at SS. Giovanni e Paolo of Venice[3]; but in pictures such as the Virgin and Child with Saints in the chapel of San Biagio at Verona, the Madonna in the gallery of Vicenza, and the portrait in the Modena Museum, his style, whilst keeping its own stamp, varies according as it is altered by the examples of the Bellinesques and Antonello. His figures are always short and broad; his drapery is cut into angles, and sometimes crushed to a multiplicity of folds. In San Nazaro he displays some of the garishness of the Veronese[4]; at Vicenza he is careful in drawing, and shows a nice sense of proportion and a good deal of blending in rich flat tones[5]; at Modena he has some of the brightness and taste which distinguishes the

* [1] Girolamo Mocetto was a native, not of Verona, but of Murano, where his great-grandfather worked as a glassmaker. Girolamo was born before March 7, 1458; he was living at Venice in 1514, and made his will in that town in 1531. There existed also a Mocetto family at Verona; they may have been related to the Mocettos of Murano, and it was perhaps through one of them that Girolamo got his commissions from Verona. (See Ludwig, in the Berlin *Jahrbuch*, xxvi. Supplement, pp. 69 *sqq*.) If it was certain that Mocetto is the author of the paintings which once adorned the front of a house near the Ponte Acqua Morta at Verona (see *antea*, p. 191, n. 3, and *postea*, p. 213, n. 1), then it would be proved that Mocetto was in that town in or shortly after 1517. That he visited Verona is, however, probable also for other reasons.

[2] Vasari (iii. 163) says Mocetto was considered the author of a Dead Christ, signed with Bellini's name, in San Francesco della Vigna at Venice, and supposed to have painted it as journeyman to Bellini.

[3] Venice, SS. Giovanni e Paolo (see *antea*).

[4] Verona, San Biagio. Wood, oil, figures half life-size. Virgin and Child between St. Biagio and St. Giuliana; in a pediment a Bellinesque head of the Saviour; a bust monochrome between two escutcheons, of old inscribed: "Hiers Moceto faciebat." The Child is plump and Bellinesque, St. Giuliana not without smorphia. The flesh tints are ill relieved by grey shadow and without semitone. This and the sharp contrasts of the dresses may be due to the bad condition of the work from cleaning and restoring. On close inspection one sees how the signature has been changed, and "faciebat" altered into "fecit." The date of 1493 on the wall behind the picture was taken by Lanzi for that of the picture itself (Lanzi, ii. 107).

[5] Vicenza Gallery, No. 204. Wood, all but life-size. The Virgin holds the Child erect on her knee, in front of a green hanging. In the left-hand corner we read: "Hieronimo Moceto p." The drapery here is better than at Verona; the art a cross between Bellini and Antonello; the hands are small and slender,

Venetians of the fifteenth century, and recalls Cima.[1] Two dates give us the measure of the time during which he laboured, that of 1490 on his print of the Calumny of Apelles,[2] that of 1514 in the Latin history of Nola, in which he engraved four plans and views of that town.[3]

We have said that Michele da Verona was perhaps a partner of Cavazzola in the decorations of San Bernardino at Verona. The proofs of his existence are in canvases and frescoes bearing his name,[4] one of which is a vast Crucifixion with the ciphers of 1501, once in the refectory of San Giorgio at Verona, but now above the portal inside Santo Stefano of Milan. Previous to the completion of this picture he doubtless composed the fresco of the Virgin and Evangelist with angels above the first altar to the left in Sant' Anastasia of Verona, a piece in which the personages have the rude shape and slenderness of those by Girolamo Benaglio.[5] He soon exchanged this manner for

the features generally small, and the heads of a round oval, with a high forehead. Light and shade are fairly defined.

[1] Modena Gallery, No. 298. Wood, m. 0·205 high by 0·155. Originally at Cataio. Bust of a chubby-faced boy with long hair falling from a black cap, in a red vest and green coat ; ground blue ; signed : " Hiers. Moceto p."

There is a small panel in the Galleria del Comune at Padua (No. 130), representing St. Catherine, full-length, in a landscape. Here we have Mocetto's mixture of the Veronese style and the Bellinesque of Cima. Again, at Santa Maria in Organo of Verona, there is a full-length Virgin and Child between SS. Catherine and Stephen, assigned by Maffei (*Veron. Illustr.*) to Caroto, by others to Girolamo dai Libri (Rossi, *Guida*, p. 244). This also is a picture with Mocetto's mixture of the Bellinesque and Veronese. He also might claim to be the author of the frescoes on the house No. 4800 at San Tommaso, Ponte Acqua Morta, in Verona, though he divides the claim with Caroto. See *antea*, p. 191, n. 3. [* The types and forms in these paintings correspond to those of Mocetto. See Baron, in *Madonna Verona*, iii. 85.]

* [2] There is no such date on this engraving.

[3] D'Agincourt engraves a Massacre of the Innocents by Mocetto (pl. clxii.). This and a companion piece are in Paris. [* They are now in the National Gallery, Nos. 1239, 1240.] (See *Gazette des Beaux-Arts*, anno 1859, for an article on Mocetto by M. E. Galichon ; see also Cicognara and Zanetti.)

* [4] Michele da Verona was born in 1470, and made his will in 1536 ; he was dead in 1544. Mazzi, in *Madonna Verona*, v. 169, 171 ; Trecca, *ub. sup.*, p. 28.

[5] Verona, Sant' Anastasia. The figures are placed about a carved crucifix of wood, some of the angels raising a curtain supposed to hang over the crucifix. The Virgin and Evangelist are almost obliterated. The colours are dull, the outlines coarse, recalling those of the Sienese Benvenuto and Girolamo di Benvenuto.

another, as we see at Milan, where the Crucifixion is a copy
in many respects of Jacopo Bellini, without skill in arrangement
or in drawing, but not unsuccessful in a distance representing
the city of Verona.[1] The same subject is almost literally repeated
on a vast canvas done for Santa Maria in Vanzo of Padua in
1505 [2]; but the background, in which a view of Sant'Antonio
is preserved, is evidence of the presence of Michele at Padua.
It is not unlikely, therefore, that he had some share in the
series which adorns the school of the Santo.[3] In 1509 he was
again residing at Verona, having finished at that time the
Eternal with Angels and Prophets and the four Evangelists in
the church of Santa Chiara.[4] A great improvement now mani-
fests itself in his mode of treating subjects and figures; he
distributes space with more effect, draws holy personages with
more nature and in better proportions, and comes near Morone
and Cavazzola in freedom of hand as well as in a gay trans-
parence of tints. Of this transformation there are specimens in
the chapel of the Vittoria Nuova[5] and in Sant'Anastasia at

[1] Milan, Santo Stefano. Canvas, m. 3·35 high by 7·20. The scene is depicted
as if visible through the pilasters of a ruined arch, on the plinths of which one
reads : " MCCCCCI die II. Junii, per me Michaelem Veronensem." This piece is
almost entirely repainted; the figures are paltry and lean, draped in over-abundant
dress. Especially like Jacopo's figures in the Crucifixion of Verona are the Christ
and the thieves, a soldier with his arms outstretched in front of the central cross,
and the fainting Virgin with the Marys. The vestments are all of bright tints.
[* This picture is now in the Brera (No. 160). The influence of Carpaccio is
very noticeable in it.]

[2] Padua, Santa Maria in Vanzo. Canvas, figures of life-size, almost all repainted,
but inscribed : " Die XXVIII Martii MCCCCV. op. Michaelis Voñ."

[3] Padua, Scuola del Santo. St. Anthony appears to the beato Luca Belludi.
Cold composition, with long, lean, paltry figures of ill-favoured appearance. But
even Filippo da Verona might have done this.

[4] Verona, Santa Chiara. Christ in the semidome of the altar is like that
of Francesco Morone in Santa Maria in Organo, sacristy. In the spandrils, two
prophets; in the niches of the pilasters, the four Evangelists; and above the
cornice, the Eternal between two angels; inscribed: " Hic fecit Michaele (!) die
iii Augūm MCCCCCVIIII." The freshness of the work is gone, the surface having
been rescued from whitewash.

[5] Verona, Santa Maria della Vittoria Nuova. Lunette fresco, with life-size
figures of the Eternal in an almond-shaped glory between six angels playing
instruments; above, four angels sounding trumpets and one with a scroll. This
fresco is also injured by time and restoring, but seems of the same date as that
of Santa Chiara.

MICHELE DA VERONA

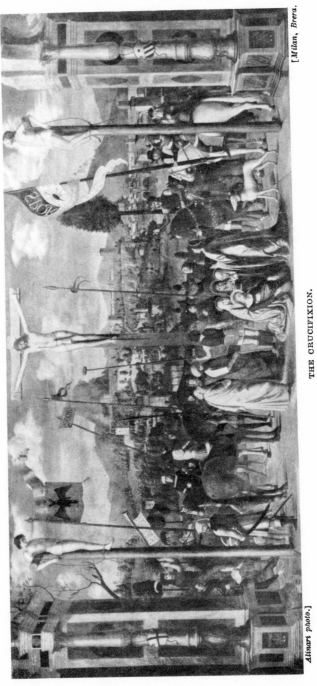

THE CRUCIFIXION.

II. 214]

Verona,[1] as well as in a country church at Selare.[2] The final expression of his powers is to be found in an altarpiece of 1523, a canvas of the Madonna enthroned between four saints, in the church of Villa di Villa, near Este, where he displays a not unpleasant mixture of Morone, Cima, and Buonconsiglio.[3]

Still lower in the scale of Veronese art, an imitator of Cima, of the stamp of Pasqualino, is Filippo da Verona, whose panels and wall-paintings are to be seen at Turin,[4] Bergamo,[5] Padua,[6] and Fabriano.[7]

[1] Verona, Sant' Anastasia, fourth altar to the left. Lunette with the Descent of the Holy Spirit, assigned by different writers to Liberale, to Girolamo dai Libri, Morone, and Michele.

[2] Selare (church of). Eternal, Angels, four Evangelists, St. Zeno, St. Bovo, and a kneeling patron, with inscriptions, one of them mutilated, the other to this effect : " Zuan e Felipo e fradali di V̌lati a fato far questa opā p vodo e devotio adì 8 Octobrio 1517." These frescoes are given to Girolamo dai Libri, but, so far as one can judge from the remains, are by Michele.

[3] Villa di Villa. Virgin and Child with an angel playing the viol at the foot of the throne, between SS. John the Baptist, Andrew, Lawrence, and Peter. Canvas, figures life-size, inscribed : " MDXXIII die p. Augusti Michael Veronensis pinxit." The blues are abraded in the sky and in the Virgin's mantle. The Virgin and Child remind us of Morone, but the group recalls Bellini and Cima. The colour is dull, monotone, and grey in shadow. The tone generally is of a low olive like that of early Girolamos, or Montagnana, or even Carpaccio. It is in consideration of this that we have named Michele da Verona in connection with a Dead Saviour under Mantegna's name in the Casa G. B. Canonici at Ferrara. See *antea* in Carpaccio.

* The following works by Michele da Verona have not been mentioned by the authors : (1) London, National Gallery, No. 1214. The Meeting of Coriolanus with Volumnia and Veturia. (2) Verona, Museo Civico, No. 397. The Virgin and Child (bearing the forged signature of Carpaccio).

[4] Turin, Accademia delle Belle Arti. Virgin and Child with a Saint in prayer. Half-lengths ; inscribed on a cartello : " Philipus Veronēsis p." The figures are poor and dry in form and outline, and raw in tone.

[5] Bergamo, Lochis, No. 187. Replica of the foregoing, inscribed : " Phillipus Vōnensis p."

[6] (1) Padua, Santo. Virgin and Child and St. Felix presenting a friar ; at the opposite side St. Catherine ; dated " MCCCCCVIIII " ; fresco injured by restoring, figures as above. (2) Same church, first pilaster to the right of high portal. Annunciation and two friars holding the name of Christ between the Virgin and angel. This fresco is altogether repainted. (3) Same edifice, third cloister. Life-size figures of St. Anthony and the Marriage of St. Catherine. A better and broader fresco in treatment than the foregoing, light brick in flesh tint, and recalling the works of followers of Carpaccio. (4) Padua, Eremitani, to the left of high

For note 7 see next page.

Vasari relates of Francesco Torbido that he went as a youth
to Venice to study under Giorgione. Having quarrelled and
come to blows with some adversary there, he withdrew to
Verona and gave up his profession altogether for a time; but
being soon after inclined to resume the pencil, he did so under
the counsel of Liberale, who loved him and made him his heir.[1]
Any one who sees Torbido's frescoes will say that he was a
Veronese, but not unmistakeably a pupil of Liberale. He is not
free from the restlessness of Giolfino, and as a colourist he takes
after Morone and Girolamo dai Libri, but we discern the habits
of the Venetian in the method of turning half-tones into deep
shade, after the fashion known as Giorgionesque. He imitated
various painters without being able to conceal his individuality;
and throughout his career he seems to fill the part of a man who
assumes a dress to which he is not entitled, and who thus
deceives the casual spectator. When he is most originally
Veronese he is but a second-rate; when he imitates the Venetians
he rivals Pomponio Amalteo, or other disciples of Pordenone,
or reminds us of Cariani; when at last he works on the cartoons
of Giulio Romano, he is Raphaelesque. In all cases he has an
impetuous style related to that of Liberale and Giolfino, but
he poorly conceals under this impetuosity a considerable share of
shallowness. It is but natural that the fate of such a man's
pictures should be to pass under other names than his own, and
this we find is especially the case with Torbido's easel-pieces or
portraits, or rather with such as may on close examination

portal. Two angels at the side of a Glory of the Virgin (by an older hand);
and below, two female martyrs with three angels playing instruments; dated
" MDXI." This is also by Filippo.

　　[7] Fabriano, San Niccolò, porch leading to the sacristy. Wood, figures life-
size. Virgin and Child between SS. Peter and Nicholas of Bari; inscribed:
"Opus Philippi Veroneñ anno salutis 1514." [* This picture is now in the
Palazzo Comunale at Fabriano.]

　　[1] Vasari, v. 291 *sq.*

　　* From records in the Veronese *Anagrafi*, it seems likely that Francesco
Torbido (whose family name was India) was born about 1483. A native of
Venice, he settled in Verona about 1500, and continued to live in the latter town
up to 1545. He then went to Venice for a stay of some years, but was back at
Verona in 1557. Contemporary records prove that Torbido's daughters inherited
the property of Liberale. See Gerola, *ub. sup.*, iii. 32 *sq.* and iv. 145 *sqq.*; Da Re,
in *Madonna Verona*, i. 94.

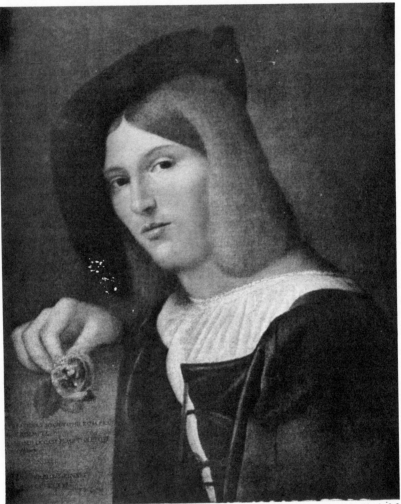

PORTRAIT OF A YOUTH.

be assigned to Torbido. There is, for instance, a Woman taken in Adultery at the Hermitage in St. Petersburg, of which we at once see that it is Veronese. The adulteress stands before the accuser, and in front of Christ; two spectators looking on from behind. Nothing can be more marked than the types of the Saviour, of the accuser, and the spectator to the right. The latter has the dry and prominent features characteristic of the Manteguesque ; the accuser is in the mould of those by Girolamo dai Libri ; but the adulteress recalls Giorgione and Palma, and the man looking over Christ's shoulder is Giorgionesque altogether. The treatment scents of Morone and Girolamo dai Libri ; it is careful, spare, unbroken, but Venetian also in this : lights are brought down to the texture and glow of half-shade, and there are no half-tints in the picture.[1] These tricks reveal an imitator of the Venetians ; but the tone, instead of being brightened and cleared, is darkened to a dull opacity by glazing, betraying the use of a dirty palette ; and here we see that Torbido is a stranger to the rules by which Giorgionesque depth was united to richness, and strives to attain effects without knowing the means by which alone they are attainable. In the same style, and with a forged name of Giorgione, are a laurel-crowned Flute-player in the Gallery of Padua, with a Veronese landscape distance,[2] and a portrait of free handling belonging to the Earl of Warwick.[3] In Munich, where we have Torbido's name with the date of 1516, the flesh is less sombre than in the above examples, but the treatment is still monotonous in tone, empty, feeble in modelling and ineffective in relief, and fails to produce the clearer glow of the Giorgionesques.[4] This is the case again

[1] St. Petersburg, Hermitage, No. 12. 2 ft. 8¼ in. high by 2 ft. 3 in. (Rocco Marconi according to Dr. Waagen, *Hermitage, ub. sup.*, p. 30.)

[2] Padua Gallery, No. 455. Canvas, bust, life-size ; on a wall to the left the words " Zorzon 49." This picture was in the bishop's palace at Padua.

[3] Earl of Warwick. Canvas, half-length, exhibited without a name at the Dublin International Exhibition. Represents a man with his right hand on a book on a stone table, his left on the hilt of his sword. He is dressed in yellow silk, and wears a black cap and long hair. His expression is grinning, his features dry and bony. Distance, a landscape with various accessories, a quail and a toad.

[4] Munich, Pinak., No. 1125. Canvas, 1 ft. 11 in. high by 1 ft. 7 in. ; inscribed : " Quod stupeas &ᵃ . . . Fračus Turbidus pinxit MCCCCCXVI." Bust on a brown ground ; flayed and slightly glazed up by a restorer.

in a Flute-player and two Listeners, called Pordenone, in the
Casa Maldura at Padua, where we should waver between Torbido
and Cariani, were it not for the recollection of the Munich
portrait.[1] At a later period Torbido assumed rather the manner of
Titian than that of Giorgione or Palma, especially in his likeness
of a grey-bearded man in a fur coat at the Museum of Naples [2];
but in this phase also he puts all in half-tone with slight substance
of colour, and leaves an impression of dullness on the eye.

Judging of Torbido from the various specimens that have
been described, we may assign to him the portrait known at the
Uffizi as General Gattamelata with his Esquire, a half-length
in armour with his right hand on a double-handed sword, and a
helmet and mace on a balcony before him.[3] It is needless to
point out that the catalogue is wide of the mark in placing this
piece under Giorgione's name; it has the double character of
Venetian art engrafted on the Veronese; the flesh tint is raw
and dusky, laid in at one painting with rusty dark shadows,
to relieve the monotony of which a red touch here and there
is given in half-tone and reflections, the surface dirty and without
light. This is the unmistakeable work of Torbido, illustrated by
his strong and not unmannered outline, effective enough in
chiaroscuro, but sharp in contrasts of tints, regular in propor-
tions, and in this resembling Bonsignori, but wanting the power
and modulation of the Venetians.

[1] Padua, Casa Maldura, No. 81. Canvas, oil. The man in front holds a flute in
his left hand; to the left a spectator in armour, in head like that to the left
of the Christ in the Woman in Adultery at St. Petersburg; to the right a man in
a hat with the type of a mulatto—query, Torbido himself, who goes by the name
of Il Moro ? Busts, on dark ground, injured and repainted. There is a canvas of
the Woman taken in Adultery at Padua, in the Casa Conte Giovanni Cittadella, with
no less than eighteen figures. The surface is injured by repainting, but the
picture might be by Rocco Marconi, or Campi of Cremona, as well as by Torbido.
[* The editor does not know where the two last-mentioned pictures are at present
to be found.]

[2] Naples Museum, Room VIII., No. 65. Canvas, oil, life-size; half-length of a
man near a parapet with a letter, standing. On the wall the words: "Franc*
Turbidus detto el Moro V. faciebat." As regards merit this portrait is equal to
one by P. Amalteo.

[3] Florence, Uffizi, No. 571. Canvas, half-lengths, life-size, green ground.
[* The editor agrees with Count Gamba (*ub. sup.*, v. 39 *sq.*) that this picture offers
many parallels to the forms and the technique of Cavazzola, to whom it is now
officially ascribed.]

Conspicuous in pictures and frescoes at Verona is the regularity of proportion already noticed at Florence.[1] In a Virgin and Saints at San Zeno the figures are drawn with freedom and boldness of foreshortening, but in the restless method of Liberale and Giolfino; their colour spare and inharmonious.[2] In the Nativity, Presentation, and Assumption of the Virgin, frescoes done by Torbido in 1534 in the choir of the Verona cathedral, the drawings of Giulio Romano are used with an energetic ease[3]; and in the same way as he takes the cartoons of Giulio at Verona he assists Romanino at Trent; that is, we may believe to be his the figure of a man with snakes, a female with a child, an old woman, in niches on the great staircase of the Castello.[4] That Torbido was in Friuli about 1535, we know from his frescoes in the choir of the church of Rosazo, where he painted SS. Peter and Paul, the symbols of the Evangelists, the Virgin and Child, the Transfiguration, Peter walking on the water to meet Christ, and the Call of James and Andrew to the Apostleship. He had evidently taken a fancy for the Raphaelesque from its success the year before at

* [1] Dr. Gerola has discovered a record which proves that in 1526 Torbido had not yet executed the altarpiece which, according to Vasari (v. 293), was ordered from him by Giacomo Fontanella for a chapel in Santa Maria in Organo at Verona, but that he at the above date had completed some frescoes in the same chapel. Of these, there still remain the figures of St. Peter the Martyr and St. Francis, though they at present are hidden behind canvases of a more recent period. The *pala* mentioned by Vasari is lost; the lunette which crowned it belongs now to the Augsburg Gallery (No. 271). It represents the Transfiguration of Christ.

[2] Verona, San Zeno, first altar to the right of portal. Virgin, Child, St. Sebastian, St. Christopher, and other saints, male and female. Canvas, life-size. The Resurrection and two prophets are above this, and the Virtues with their symbols, the latter too high to warrant an opinion as to whether they are by Torbido or not. In Sant' Eufemia the Assumption of St. Barbara is assigned to Torbido, but it seems the work of an assistant.

[3] Verona, Duomo, inscribed: "Franciscus Turbidus p. MDXXXIIII." See Vasari, v. 292.

[4] Trent, Castello. The bases of the niches are whitewashed; the lunettes are by Romanino. [* The only painter who is recorded as having received payment for the frescoes on the great staircase of the Castello at Trent is Romanino, though it seems likely that these paintings in great part were executed by his assistants (Schmölzer, *Die Fresken des Castello del Buon Consiglio*, pp. 42 *sqq.*). It would, however, be surprising to find Torbido among the latter as late as about 1532, the date of the frescoes in question.]

Verona, for here again he is altogether in the character of Giulio Romano.[1] We have proof that he was still alive during 1546, in a letter of Pietro Aretino.[2]

[1] Rosazo. These frescoes are almost ruined by repainting, as is likewise the Transfiguration, probably by Torbido, in a neighbouring refectory. On a cartello in the Transfiguration of the choir we read: "Franc. Turbidus faciebat MDXXXV."

[2] Aretino, *Lettere*, iii. 308, and Temanza, *Life of Sansovino*, p. 31.

* On Jan. 2, 1547, the Scuola della Trinità at Venice ordered three paintings from Torbido ; six months later they were valued by Pietro degli Ingannati and Giampietro Silvio. During this year Torbido was commissioned to execute yet a fourth painting for the same Scuola and in 1550 he repaired a painting in the house of that brotherhood. One of these pictures, representing the Creation of the Birds, is now in the depot of the Ducal Palace at Venice. See Ludwig, in the Berlin *Jahrbuch*, xxvi. Supplement, p. 103 ; "Archivalische Beiträge," in *Italienische Forschungen*, iv. 136 *sqq.*

It appears from the records of the monastery of San Domenico at Verona that Torbido died in 1561 or 1562 (Gerola, *ub. sup.*, iv. 148). In addition to the works by this painter noticed hitherto, the following may be mentioned : (1) Fiesole, Villa Doccia, Mr. H. W. Cannon, No. 12. The Virgin and Child with Angels, St. Anthony the Abbot and a Donor. (2) London, collection of the late Dr. L. Mond. Portrait of Girolamo Fracastoro. (3) Milan, Brera, No. 99. Male portrait, signed "Frs Turbidus V. faciebat." (4) San Martino Buonalbergo (near Verona), San Giacomo del Grigiano. The Virgin and Child between SS. Catherine and James, signed "F. Turbidus inv." (5) Verona, Museo Civico. No. 3, The Virgin and Child. No. 49, The Archangel Raphael and Tobias. No. 210, The Virgin and Child with Saints and Donors. (6) Verona, San Fermo, second altar to the right. The Trinity, the Virgin and Child, and Saints. (7) Verona, 11 Via Stella. Frescoes on the house-front.

CHAPTER VII

FERRARA, the seat of a ducal court, was well attended by painters during the whole of the fifteenth and sixteenth centuries. The dukes were very strongly possessed with the fancy for building and decorating palaces; and they required a host of craftsmen to carry out the plans suggested by their fondness for display. Schifanoia, Belfiore, Belriguardo, the Castel Nuovo, Migliaro—town and country residences of the reigning family—were to the full as costly to the Estes as Mantua, Goito, Cavriana, Marmirolo, San Sebastiano, and the Tè to the Gonzagas. But Ferrara was not the cradle of a school until the dukes had called to their service Pisano and Piero della Francesca. What Pisano may have done to favour the progress of art appears to be infinitesimal; Francesca's influence was more lasting, and taken in conjunction with that of Mantegna, which was not the less felt though it was more distant, continued for upwards of half a century.

The Ferrarese are very like the Veronese in some respects; they are not first-rates, and their painting has a strong northern stamp; but they are more independent in their ruggedness and more powerful in the expression of passion. They adopt alternately the African types of Francesca and the grimacing ones of Mantegna, but they add to these something of the sadness and dryness of the Flemings. In Galasso these characteristics are combined with the comparative helplessness of the antiquated Christian time. Cossa and Tura, though but little younger, are abler and more spirited in this path, altering the technical treatment of detail and distance after the transalpine fashion; it is not improbable that they were struck by the originality of

221

Van der Weyden, whose visit to Ferrara in the middle of the century is now placed beyond a doubt.[1] With Stefano and Ercole Roberti Grandi, we come upon Paduan features in their strength and bitterness; Costa and Ercole di Giulio Grandi introduce a younger and fresher blood by imitating the Peruginesque. From first to last the Ferrarese are no colourists.

Galasso, who impressed Vasari with a false idea of age,[2] was the son of a shoemaker at Ferrara. His name appears in the account-books of the house of Este from 1450 to 1453 in connection with the decoration of the palace of Belriguardo,[3] and between 1450 and 1455 he composed the Assumption and finished a portrait of Cardinal Bessarion at Santa Maria in Monte of Bologna[4]; that he was dead in 1473 we learn from an original record.[5] To suppose with Bumaldi that he lived in 1390 and laboured in the church of Mezzaratta at that period is difficult; and Bumaldi's statement can only be explained if we assume that two men with the same patronymic existed in the fourteenth and fifteenth centuries.[6] Yet Galasso may have left some frescoes at Mezzaratta, for there are fragments reminiscent

[1] " E a dì xxxi de decembre duc. vincte d'oro per lei a Filippo de Ambruoxi et compagni per nome di paulo de Pozio de bruza per altri tanti che el deto paulo pagò a M° Ruziero depinctore in bruza per parte de certe dipincture de lo Illu. olim nostro S^re che lui faceva fare al deto M° Roziero come per mandato de la sua olim Signoria registrato al registro de la camera de l'anno presente." Memorial of 1450. (Favoured by the Marquis Campori). [* See also Campori, in *Atti e memorie delle RR. Deputazioni di storia patria per le provincie modenesi e parmensi*, ser. iii. vol. iii. p. 540.]

[2] Vasari, ii. 139 *sqq.*

[3] We are indebted for these facts to the Marquis Campori, from whom we have records of the date stated. Galasso is here called: " Maestro Galasso de Matheo Caligaro."

* Contemporary documents prove that his full name is Galasso di Matteo Piva (see A. Venturi, in *Rivista storica italiana*, i. 614). From this it follows that Vasari is wrong in calling him Galasso Galassi, and that the monogram G.G. occurring on some pictures which will be noticed below cannot be regarded as his signature. See also Venturi, in the Berlin *Jahrbuch*, ix. 13, and Campori, *loc. cit.*, p. 545.

[4] Cron. Fra Girolamo Borselli, in Muratori, *Rer. Ital. Scrip.*, tom. xxiii. p. 888.

[5] *Ricordi di Cosimo Tura*, 8vo, Ferrara, 1866, by L. N. Cittadella, p. 191.

[6] *Minervalia Bonon.*, by Giov. Antonio Bumaldi, 12mo, Bonon. 1641, p. 239.

Let us recollect that there is a painter of the name of Gelasio, for a notice of whom see Crowe and Cavalcaselle, *A History of Painting in Italy*, ed. by L. Douglas, iii. 214 *sq.*

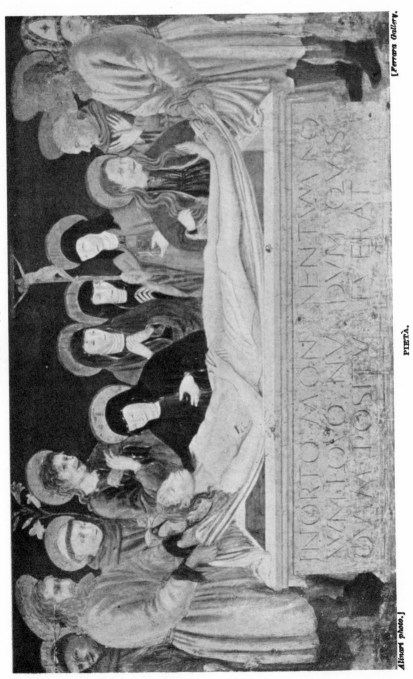

PIETÀ.

of him in that building which obviously have no earlier date
than 1450.

A great deal more has been made of Galasso than he deserves.
That he felt the influence of Piero della Francesca, as Vasari
observes,[1] will be confirmed by a glance at the halls of the
Schifanoia ; that he ever lived in Venice, or even that he mastered
the technica of oils, is doubtful.[2] In his first panels—for instance,
in the Trinity at the Museum of Ferrara,[3] or in the Entombment
and the Virgin and Child with a donor and patron saint belonging
to the Costabili collection [4]—the sour severity of the fourteenth
century and a vehement expression are concomitants of bad
drawing, affected or spasmodic action, and skinny flesh. In
later pieces traditionally assigned to the same hand, such as the
Christ on the Mount belonging to Professor Saroli,[5] the Cruci-
fixion of the Marquis Strozzi at Ferrara,[6] or the Epiphany of

[1] Vasari, iii. 89 *sq.*

[2] *Ibid.*, iii. 90.

[3] Ferrara, Pinac., Sala III. Panel, tempera, figures one-fourth of life, on
gold ground, with the monogram $G \pm G$. Subject, the Eternal enthroned and
holding the cross with the dead Saviour upon it.

[4] (1) Ferrara, Costabili, No. 33. Panel, figures a little under life-size. Christ
is let down into the sepulchre in his winding-sheet by two figures, in presence
of the Virgin, St. Francis, St. Bernardino, and others. Some faces grimace like
those of Crivelli. The gold ground is now painted over, and the rest is much
injured by abrasion. (2) Same Gallery, No. 78. Virgin, Child, donor, and patron
saint. Panel, tempera, about one-third of life-size.—The Virgin and Child
between SS. John the Baptist and Jerome in the same collection, assigned by
Rosini to Galasso, and engraved as such by him, is by Sano di Pietro of Siena.

* The Costabili collection exists no longer. No. 33 is now in the Gallery of
Ferrara ; the editor has not been able to trace the other two pictures.

[5] Ferrara, Professor Saroli. Canvas, tempera, figures all but life-size. To the
left hand Christ on his knees, and the angel with the cup to the right. The
three apostles in a landscape with birds, animals, and distant episodes. The sweat
on the Saviour's brow trickles like tears down his face. The tempera is dull ; the
drapery and drawing are broken in the Flemish manner ; the figures are
grotesquely long, dry, and bony. The outline is rude and uniform, the hands and
feet common and out of drawing. Of course there is no perspective of any kind.
The piece is made less attractive still by copious varnishing and some retouching.

* The Saroli collection was subsequently in the hands of Signor Lombardi of
Ferrara, and belongs now to the Duca Massari-Zavaglia of that town.

[6] Ferrara, Marchese Strozzi. Canvas, tempera, with small figures ; on a predella
and side-pieces are (1) Christ on the Mount ; (2) the Capture ; (3) the Flagella-
tion ; (4) Christ dead on his Mother's Knees ; (5) Christ carrying his Cross ;
(6) the Entombment ; (7) the Resurrection. A little better than the foregoing,

Mr. Barker in London,[1] the same defects are clothed in the new but not less repulsive garb of the Flemings.

Cosimo Tura is not more attractive than Galasso, but of a more consistent fibre. Irrespective of art he was a man of weight and wealth in the place of his birth.[2] Having been employed from 1451 upwards in some of the numerous pictorial undertakings of the Duke of Ferrara, he rose to a fixed appointment in the ducal service in 1458.[3] For twenty-five years at least, if not till the end of his life, he clung to this service, and made his fortune in it. In 1457 he furnished patterns for arras ; somewhat later he worked in the ducal studio,[4] and when Borso I. visited Milan in 1461 he induced Gian Galeazzo Sforza to apprentice one of his dependents with Tura.[5] Under Ercole I. Tura lost none of his repute ; he decorated the library of the Picos of Mirandola,[6] ornamented the new chapel at Belriguardo

but by the same hand, in the same collection and similar manner, a small panel of Christ on the Mount.

* The editor cannot state with certainty where these pictures and the portrait-group noticed *postea*, p. 231, n. 2, are to be found at present. They may be in the collection of the Marchese M. Strozzi of Florence, who is the owner of some paintings mentioned by the authors as belonging to the Marchese Strozzi of Ferrara.

[1] London, Mr. Barker ; formerly in the Costabili collection. Small panel with two G's interlaced—a different monogram from that on the Trinity in the Gallery of Ferrara. But the style is that of the pictures immediately foregoing, and like that also of pieces in the Schifanoia decoration assignable to Galasso. [* This picture belongs now to Mr. John Stogdon of Harrow.] The same interlacement of two G's is to be found on a panel, representing St. John the Baptist, which with its fellow, St. Peter, is in the Cappella della Consolazione in Santo Stefano of Bologna. This, however, is a more careful work than that of Mr. Barker.

* [2] We learn from a record of 1431 that Tura was born before that year, but that he was then only a child. See A. Venturi, in *Archivio storico dell' arte*, ser. i. vol. vii. pp. 52 *sq.*

[3] MS. records favoured by Marchese Campori, and also Cittadella, *Ricordi*, *ub. sup.*, p. 8.

* The account which the authors give of Tura's work in the service of the Dukes of Ferrara has been largely supplemented by Prof. A. Venturi, in the Berlin *Jahrbuch*, ix. 3 *sqq.*

[4] *Ibid.*

[5] Cappelli, in *Atti e memorie delle RR. Deputazioni di storia patria per le provincie modenesi e parmesi*, ser. i. vol. ii. p. 312. [* Cf. A. Venturi, in *Archivio storico lombardo*, ser. ii. vol. ii. p. 228.]

[6] Gyraldi Ferrar., *Op.*, Lugd. Bat., 1696, ii.

* Prof. A. Venturi (in the Berlin *Jahrbuch*, ix. 10 *sq.*) shows that it is probable that the paintings in the library at Mirandola were executed in 1465-7, that is to say before the reign of Ercole I. (1475-1505).

in 1471,[1] and painted the likeness of the Duke and Beatrix of
Este, as a present for Lodovico Moro of Milan, in 1473 [2]; during
1481 he composed pictures for Ercole's studio which were
afterwards put aside for those of Bellini, Titian, and Pellegrino.[3]
Tura had also private commissions. The standard ordered of
him in 1456 for the guild of tailors, the Nativity done for
Vincenzo de' Lardi, superintendent of the cathedral at Ferrara,
the frescoes of the Sacrato chapel completed before December 20,
1468, in San Domenico, have not been preserved; but the doors
of the cathedral organ which he finished in 1469 are still in
existence,[4] and afford a clear insight into the quaintnesses of his
manner. Having long since been diverted from their original
use, they now hang on the walls of the choir in the Duomo, and
represent the Annunciation and St. George discomfiting the
Dragon.[5] The scene in the first instance is laid in a double-
arched porch, the soffits and sides of which are panelled in
marble of various kinds, painted with allegorical figures and
embellished by two large festoons of fruit; the Virgin on one
knee looking down with her hands joined in prayer, parted from
the angel by a pillar. An iron rod runs across from cornice to
cornice of the double arch, and on it are perched a cat and a
bird; through the arch we see the sky, rocky hills, and little
figures.

* [1] Tura was commissioned to paint this chapel in 1469. Shortly after having
begun the work he seems to have gone to Brescia to study how Gentile da
Fabriano had carried out a similar task. In 1472 the paintings and stucco reliefs
in the chapel at Belriguardo were valued by Baldassare Estense of Reggio and
Antonio Orsini of Venice; the elaborate deed of appraisement makes it possible
for us to form an idea of the magnificent sight presented by the chapel. The
palace of Belriguardo was destroyed in the beginning of the seventeenth century.
See A. Venturi, *ub. sup.*, ix. 15 *sqq.*

* [2] The portrait of the Duke was painted in 1472, and that of Beatrix in 1485.
Ibid., pp. 21, 28.

[3] MS. records favoured by Marquis Campori. The paintings of the studio
were "nude figures in oil." [* Cf. A. Venturi, *ub. sup.*, ix. 26 *sq.*]

[4] Cittadella's *Ricordi*, pp. 24, 29; *ibid.*, p. 8; *Documenti*, p. 145; and Baruffaldi,
Vite de' Pitt. Ferraresi, 8vo, Ferrara, 1844, i. 65 and ii. 545. A record of June 11,
1469, in the latter work, states that "Magister Cosme del Turra" was paid
111 lire for the painting of these doors.

The frescoes of San Domenico cost the Sacrati family 1,000 lire. (L. N. Citta-
della, *Documenti, ub. sup.*, p. 145.)

[5] Ferrara, Duomo. Panel, tempera, figures of life-size; the Annunciation
much damaged, especially in the flesh, the St. George much abraded.

There is no lack of feeling in Tura's mode of treatment, artificial though it be ; but he sacrifices mass to detail and to accessories. His composition of the queen's daughter striding away from the dragon seems a caricature of Pollaiuolo; leanness and tallness are naturally united to an awkwardness which might almost be called contortion.

In a great number of productions of this time searching power is united to the vulgarity of Van der Weyden, and drapery or colour reminds us of the Mantegnesques and Flemings. These features characterize an allegorical female figure called Spring now in the Layard collection [1]; its companion in the Costabili collection called Autumn [2] ; St. Jerome penitent, the subject of a piece in the National Gallery [3]; but we pass over these and others equally important [4] to dwell for a moment on the Virgin

[1] Venice, Lady Layard; formerly in the Costabili collection. Panel, mixed tempera, figure under life, in a niche, the seat ornamented with bronze dolphins. The drapery better than usual, of polished surface.

[2] Ferrara, Costabili Gallery. Panel, figure with a hoe and a bunch of grapes; much injured. Two others almost ruined belong to the Marquis Strozzi.

* The last-mentioned pictures now form part of the collection of the Marchese M. Strozzi of Florence. They are surely too feeble for Tura himself, and can only be classed as belonging to his school. The Autumn is at present in the Kaiser Friedrich Museum of Berlin (No. 115A). Dr. Bode has given good reasons for ascribing it to Francesco Cossa (see the Berlin *Jahrbuch*, xvi. 88 *sqq.*).

[3] London, National Gallery, No. 773. Wood, tempera, 3 ft. 3½ in. high by 6 ft. 10½ in.; formerly in the Certosa at Ferrara, then in the Costabili collection, last in possession of Sir Charles Eastlake. St. Jerome kneeling in a landscape. On a neighbouring tree a woodpecker and other birds. Very energetic exhibition of lean forms; well-preserved panel. [* This is only part of the picture which originally was in the Certosa. Another fragment of it, representing a Crucifix, belongs to the Brera (No. 447), formerly in the Barbi-Cinti collection. See C. Cittadella, *Catalogo istorico*, iv. 308 ; Baruffaldi, i. 76, n. 1.]

[4] (1) Ferrara, Costabili Gallery. St. Bernardino in a niche. Panel, figure almost of life-size, injured slightly, but a fine work. [* The present owner of this picture is not known ; and even as far back as 1882 it had ceased to form part of the Costabili collection. See Harck, in the Berlin *Jahrbuch*, ix. 39.] (2) St. Anthony Abbot in a niche, and a Bishop in benediction. Small panels that recall Ercole Roberti Grandi's imitation of Mantegna. [* The St. Anthony belonged in 1888 to Dr. Levis of Milan ; the Bishop is now in the Museo Poldi-Pezzoli in that town (No. 600). Harck, *ub. sup.*, ix. 38. A Virgin Annunciate in the collection of Prince Colonna of Rome belonged undoubtedly to the same altarpiece as these pictures. See A. Venturi, in *Archivio storico dell' arte*, ser. i. vol. vii. p. 90.] (3) St. George of the same size is now in possession of Mr. Barker in London, who has also a small St. Michael and a half-length Madonna under life-size. [* The Madonna is at present in the National Gallery (No. 905). The St. George and the

and Child in the Lochis Gallery at Bergamo, which exhibits a
very graceful boldness of movement for Tura,[1] and the small
panel in the Correr Museum, in which the dead Saviour is
represented lying on the lap of the Virgin. Here Tura's skill as
a composer, or in rendering the anatomy of the human body, is
very respectable ; he has something of the gnarled strength of
Dürer, and more than enough of coarseness in addition.[2]
Nowhere, however, are the master's peculiarities more perfectly
displayed than in the Virgin and Child with Saints at the
gallery of Berlin.[3] The Virgin sits adoring the Child, her blue
mantle lined with the brightest green; St. Apollonia to the left
dressed in an emerald-green tunic heightened with gold, her
mantle of shot stuff lined with scarlet; St. Catherine to the right

St. Michael can no longer be traced.] (4) Ferrara, Conte Giovanni Battista
Canonici. Half-length of St. Bernardino in a niche. This is the old type familiar
to us in Galasso. [* Present whereabouts unknown.] (5) Ferrara, San Girolamo.
High up on a wall in the sacristy of this church, a life-sized St. Jerome in an arch-
way, with the lion at his feet. Canvas, tempera, Mantegnesque in look. [* This
picture has now its place in the Ferrara Gallery (Sala III.).] (6) Ferrara Gallery,
Sala III. Panel. St. Jerome in cardinal's dress in an archway. Figure two-
thirds of life-size, of a milder nature than Tura, and suggestive of some young
follower of his manner, as Lorenzo Costa or Ercole di Giulio Grandi.

[1] Bergamo, Lochis Gallery, No. 233. Virgin and Child in a Roman chair, on
gold ground, knee-piece, in character between Crivelli and Mantegna, but with the
peculiar features of Tura. Panel, tempera, injured by repeated varnishing.
[* Professor C. Ricci suggests that this picture—of which the lower part is lost—
a fragmentary St. Dominic in the Uffizi (No. 1557), a Franciscan saint (probably
St. Anthony of Padua) in the Louvre (see postea, p. 230, n. 1), and the SS.
Sebastian and Christopher in the Kaiser Friedrich Museum of Berlin (see postea,
p. 229, n. 3), originally formed a polyptych in the church of San Luca in Borgo at
Ferrara. See Rassegna d'arte, v. 145 sq.]

[2] Venice, Correr, Sala XVI., No. 10. Small panel, m. 0·48 high by 0·33. The
Virgin is seated on the marble tomb ; in distance, a man with a ladder, and beams
of wood ; farther off, the high rock of Golgotha and the Crucifixion ; on a tree, an
ape. The colour is highly blended and enamelled, and the finishing is wonderful.

In the style of Tura, but assigned to Mantegna, is a St. George engaging the
Dragon—a small panel in the house of the Contessa Biella at Venice. It may be
by one of Tura's disciples. [* Its present whereabouts is not known to the editor.]
Under Mantegna's name likewise the following : Florence, Galleria Pianciatichi.
Two small panels with St. John the Baptist and St. Peter. They are truly Manteg-
nesque in style. [* These pictures belong now to the Metropolitan Museum of Art
at New York.]

[3] Berlin Museum, No. 111. Canvas, 10 ft. high by 7 ft. 6½ in. ; originally in the
church of San Lazzaro at Ferrara, afterwards in San Giovanni Battista in that
town (Baruffaldi, ub. sup., i. 74 sq.).

in a green mantle turned with grey; lower down the foreground, St. Augustine in episcopals with an eagle on a glass ball at his feet, St. Jerome with a small brazen lion near him, both in parti-coloured dresses like the females. The throne is one of the quaintest of structures; it rests on crystal pillars, and has the form of a niche curved in the shape of a cockle-shell; the landscape distance is seen through the crystal pillars, as well as through the arches of the edifice. In lunettes in the background are bas-reliefs of prophets imitating stone, others on the throne imitating gilt metal, representing various scenes from the Genesis and the life of Samson. Nothing can be more striking than this profuse mixture of strange architecture, gilding, mosaic, glass, bronze, and gold; white stony light in the flesh is contrasted with red-brown shadow, and there is a metallic rigidity in the lean shapes and papery stiffness in the draperies.

In this and in all other specimens of his art, Tura is consistent; and there are few painters in whom such constant features recur. Bred in the same school as Galasso, he had no idea of selection; leanness, dryness, paltriness, overweight of head and exaggerated size of feet and hands, were almost invariable accompaniments of his pictures. In most of them it would seem as if well-fed flesh had become withered by want of nutrition, and had fallen together in wrinkles the depths of which are unfathomable. About the articulations these wrinkles are stretched along the bones and indicated by lines, and the bones themselves remorselessly obtrude; and yet this false mode of representation is worked out patiently, carefully, and with considerable boldness. In his method of drapery Tura reminds us of Mantegna, of Francesca and Dürer; because, though his folds are broken at every angle, and even at a right angle— which is the strangest and most ungraceful that can be imagined —they never produce the impression of incorrectness in the form which they clothe;[1] they are altogether without amplitude in order that the under form may not be concealed; and their scantiness adds to the dryness of personages in themselves dry to a fault. In distributing space as well as in representing the

[1] They frequently take the form of a T at the close, and make what in Italy is called the padlock fold.

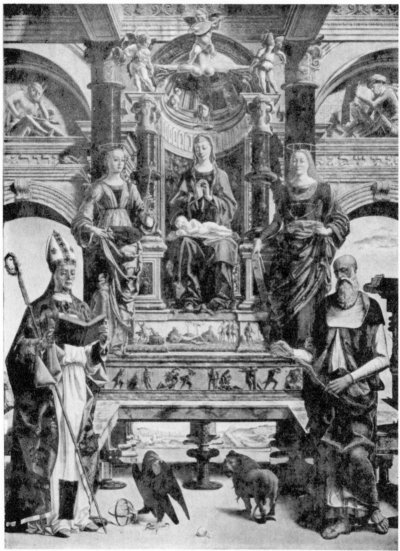

THE VIRGIN AND CHILD WITH SAINTS.

parts within it, Tura is accurate and scientific, and shows him-
self acquainted with the laws of geometry and perspective
familiar to Piero della Francesca ; in some modes of action he
foreshadows the precepts of the high art of the sixteenth century,
and exhibits considerable vehemence of action ; his colouring is
substantial, enamelled, and of great depth, but without brilliancy
or light. One might almost suppose that he had been at Padua,
and had seen that figure in the Baptism of the Proselyte at the
Eremitani which stands reading with its back to the spectator ;
he may have derived his peculiar and not very pure taste for
architecture from the models in that very chapel—models which
recall those of Bonfigli and followers of Piero della Francesca.
There too he might imbibe the principles which regulate his
arrangement of tints, and learn to pit the colours of flesh, of
dresses, and of architecture against each other, so as to present
something like a neutral whole. Tura obtains this result by the
most violent contrasts, treating the figures in many cases as mere
properties, or bits of tone.[1] That with such characteristics as
these his work should sometimes be assigned to Mantegna is not
remarkable; we have instances of this in Venice and in Florence,[2]
in the Museum of Berlin,[3] and in the collection of the late Mr.
Bromley.[4] Yet these are not less genuine productions of the

* [1] As Professor A. Venturi remarks (in the Berlin *Jahrbuch*, ix. 5 *sq.*), it seems
likely that Tura studied not only in Padua, but also in Venice; for he bequeathed
in 1471 part of his property to the poor of that city, and this would point to his
having lived there for some time. We also know from the records of the court of
the Este that Tura sometimes went to Venice from Ferrara to buy colours or on
other business (see *ibid.*, pp. 14, 22). As a matter of fact his works are not with-
out traces of Venetian influences. The great altarpiece at Berlin, for instance, is
markedly reminiscent of the Vivarini.—There exist no records proving Tura's
presence at Ferrara in 1453-6. Professor Venturi therefore suggests that he
spent these years away from his native town, perfecting himself in his art.

[2] See *antea*.

[3] Berlin Museum, No. 1170B. Panel, tempera, on gold ground, 2 ft. 4½ in. high
by 1 ft., from the Solly collection under Mantegna's name. St. Sebastian bound by
the elbows to a tree. No. 1170C. Same size. St. Christopher. These are no
doubt by Tura or Cossa, more probably by the first ; especially noticeable are the
tortuous outlines and exaggerated forms. [* In the current catalogue these
pictures are ascribed to Tura. See also *antea*, p. 227, n. 1.]

[4] London, late Bromley collection, previously belonging to Lord Ward. Small
panel, about 12 in. by 8, of St. Jerome seated in a cave with the lion at his feet and
the cross in his left hand.—Tura is sometimes confounded with Zoppo, as we see in
the Man of Sorrows, No. 590 at the National Gallery. See *antea*, p. 52, n. 2.

master than the vast lunette at the Louvre representing the
Deposition of Christ, or other pictures,[1] to enumerate which would
involve much and needless repetition.[2]

Tura's was a long, industrious, and successful life. Having
been launched with sufficient means to secure independence, he
was lucky afterwards in securing the fruits of his labours, had
a house—a present from the Duke of Ferrara—in the Contrada
di San Pietro, others in the Contrada di Boccacanale and the Via
di Ognissanti, an atelier in a tower near one of the city gates,

[1] Paris, Louvre, No. 1556. Lunette, wood, m. 1·32 high by 2·67. The scene
is laid in a panelled arch. Note the tinny drapery, the metallic flesh with
white and purple lights, and the ugly projections of bones in the faces. The
foreshortenings are bold and studied. A long split divides the picture horizon-
tally. This, we are told, is the lunette of a Virgin and Child, No. 772 in the
National Gallery, lately belonging to the collection of Sir Charles Eastlake (wood,
7 ft. 11 in. high by 3 ft. 4 in.), in which we find the usual overabundance of
architectural and ornamental features in the archway and throne. Two angels
play musical instruments at the Virgin's sides, and at the bottom of the steps two
angels play on a portable organ; on the front of the organ, it is said, was the
signature of Tura, but this signature is removed. The latter piece was formerly
in the Casa Frizzoni at Bergamo, and is a very fanciful production of porcelain
texture, in the colours suggesting the use of varnish vehicles. The angels are
slender, the Virgin like that of Bartolommeo Vivarini in his feeble late period.
Perhaps Tura allowed some pupil to paint this picture, which, at all events, is
much inferior to the lunette above described. [* The polyptych of which the two
above-mentioned pictures formed part was formerly in the church of San Giorgio
fuori le mura at Ferrara; it is minutely described by Baruffaldi, ub. sup., i. 77 sqq.
To the right of the central compartment, now in London, was one representing
SS. Maurelius and Paul and a kneeling monk; this panel is at present in the
collection of Prince Colonna of Rome. (Cf. A. Venturi, in Archivio storico
dell' arte, ser. i. vol. vii.˙p. 90; the monk is here erroneously identified as the
bishop Roverella.) The panel to the left of the Madonna is now lost; it showed
SS. Peter and George and the kneeling Lorenzo Roverella, bishop of Ferrara (d. in
1474). The altarpiece furthermore contained two figures, of SS. Bernhard and
Benedict, and a predella representing scenes from the life of the last-mentioned
saints; all these compartments are also lost.—In a half-length of the Madonna
and Infant Christ by Tura, now belonging to the Venice Academy (No. 628),
the group of Mother and Child closely resembles that in the central panel of
the Roverella ancona.]—In the Louvre, No. 1557, m. 0·72 high by 0·31, a small.
panel representing a Franciscan saint reading, on gold ground, is by Tura,
but injured (in the cheek) and split. [* Cf. antea, p. 227, n. 1.—The following
works by Tura may also be mentioned here: (1) Boston, collection of Mrs. J. L.
Gardner. The Circumcision. This little tondo is a companion picture to the
Adoration of the Magi at Cambridge and the Flight into Egypt in the Benson
collection (see below). (2) Caen, Hôtel de Villo, Musée Marcel. St. James. (3)
Cambridge (U.S.A.), Fogg Museum. The Adoration of the Magi. (4) Ferrara,
Picture Gallery, Sala III. St. Maurelius before the Judge; The Martyrdom of

earned money and lent it, made ventures in the timber and other trades, and died between 1494 and 1498,[3] leaving large legacies to the poor of Venice.[4]

Much less is known of Francesco Cossa than of Tura. His name first appears in a record of 1456, from which we learn that he was an assistant to his father, Cristofano del Cossa, then charged to illuminate the carving and statues on the high altar of the bishop's palace at Ferrara.[5] But in later years he transferred his residence to Bologna, where he is justly cele-

St. Maurelius (cf. *postea*, p. 232, n. 1). (5) London, collection of Mr. R. Benson. The Flight into Egypt. (6) Modena, Picture Gallery. St. Anthony of Padua. Painted, it appears, in 1484. Venturi, in the Berlin *Jahrbuch*, ix. 29 *sq.* (7) Richmond, collection of Sir Frederick Cook. The Annunciation and two Saints. (8) Rome, collection of Prince Colonna. The Virgin adoring the Child. (9) Vienna, Imperial Gallery, No. 90. Pietà.—An arras in the Vieweg collection at Brunswick, representing the Deposition from the Cross, is obviously copied from a design by Tura.]

² Ferrara, Marquis Strozzi. In this gallery we have a canvas tempera of a nobleman holding a falcon on his wrist, near his wife and son, in a room with two windows. The figures are life-size and inscribed : " Ubertus et Marchio Thomas de Sacrato." This piece has lost its freshness from varnishes, but is very finished in outline and treatment. This may be by Tura, or of the youth of Lorenzo Costa. [* Cf. *antea*, p. 223, n. 6.]

Forlì, San Mercuriale, sacristy. The Visitation, canvas, in oil, much injured, is assigned to Tura, but seems more like a piece by Baldassare Carrari.

It is a mistake to suppose that the miniatures on silk at the Hôtel Cluny in Paris are by Tura; and as to miniatures in general, it has been supposed that Tura had a share in those of the chorals and antifoners of the Ferrarese cathedral, but these are proved to be by other hands (see a letter of Luigi Napoleone Cittadella to Cav. Gaetano Giordani, in the *Gazzetta Ferrarese* of April 29, 1862, and Don Giuseppe Antonelli's records, in Gualandi, *Memorie, ub. sup.*, ser. vi. p. 153).

Long lists of pictures alleged to have been done by Tura are to be found in Baruffaldi, *ub. sup.*, i. 67–122, but there is too great a tendency in the author and his annotators to assign low-class works of doubtful origin to known authors, and criticism on this nomenclature would be a waste of time and space.

* ³ It is now ascertained that he died in April 1495. A. Venturi, in the Berlin *Jahrbuch*, ix. 32.

⁴ Cittadella (*Ricordi*, pp. 8–15, and *Notizie*, p 569) cannot explain this legacy to the poor of Venice. Tura leaves no such bequests to the poor of Ferrara, but he puts by a sum of money for building a church there. [* Cf. *antea*, p. 229, n. 1.]

⁵ Cittadella, *Notizie, ub. sup.*, p. 52. [* Cittadella's transcript of this document is not quite correct. It really records that, in pursuance of an agreement concluded on his behalf by his father (who was a builder), Francesco in that year had decorated the wall around the high altar of the cathedral of Ferrara with a representation of the Pietà and with paintings imitating marble. Cf. A. Venturi, in *L'Art*, year xiv tome i. p. 76. Francesco Cossa was probably born about 1435. In a codex of the sixteenth century, after two epigrams on Cossa's death,

brated for two great creations, the Virgin and Child with saints and a donor reproduced in these pages, and the Madonna del Barracano, both masterpieces of one period.

That Cossa issued from the same school as Tura is evident from his pictures, which closely resemble Tura's in searching outline, correct distribution of space, and brown tinge of tempera; but his art is of a higher and more elevated class, especially in architectural and accessorial detail. Severe grandeur and dignity of mien dwell in the figures ; a sculptural breadth distinguishes the draperies, but models of stone seem studied in preference to nature ; the outlines are clean and firm, rendering nude and extremities with accurate perspective and anatomy ; relief is obtained by correct shading, modelling, and contrasted tints ; and the faces, strongly marked in the fashion of Piero della Francesca, are of a nobler cast than Tura's. But even Cossa was not free from northern or Netherlandish peculiarities ; and something in his air or technical treatment recalls Roger van der Weyden. What Cossa may have done at Ferrara is uncertain.[1] His Madonna at Bologna was painted in 1474 for Domenico de' Amorini and Alberto de' Catanei, and is remarkable for a very fine kneeling portrait of the latter personage, in the style of Piero della Francesca, Mantegna, and Melozzo. Nothing can be more effective than the drawing and the massive projection of shadow

ascribed to Lodovico Bolognini (d. in 1508), it is stated that Cossa was forty-two years old when he died ; and we know that his death occurred in 1477. See *ibid.*, p. 101, and *postea*, p. 234, n. 1.]

[1] Ferrara Gallery, Sala III. Here are two small circular panels under Cossa's name, representing the Death and the Capture of St. Maurelius. The compositions are lively, the figures like those of Tura, to whom these pieces are assigned by Baruffaldi (i. 77). We miss the large altarpiece at San Giorgio fuori le mura at Ferrara, to which these two compositions belonged. They are in style like the two panels (Nos. 1170B and 1170C) under the name of Mantegna in the gallery of Berlin. (See *antea* in Tura.) [* There can, indeed, be no doubt that the two *tondi* at Ferrara are by Tura, to whom they are now officially ascribed.]

Under Cossa's name there were several small panels in the Costabili collection, all of them unauthenticated.

* We shall see (*postea*, p. 250, n. 2) that the frescoes on the east wall of the great hall of the Palazzo Schifanoia at Ferrara are by Cossa and that they were finished by 1470. Professor A. Venturi (in *Der Kunstfreund*, i. 133) suggests that Cossa moved to Bologna disgusted at the poor payment which he received for these paintings and at Borso's refusal to grant him a more adequate fee.—An Annunciation in the Massari-Zavaglia collection at Ferrara is a work by some follower of Cossa (see A. Venturi, in *L'Arte*, vi. 135 *sq.*).

FRANCESCO COSSA

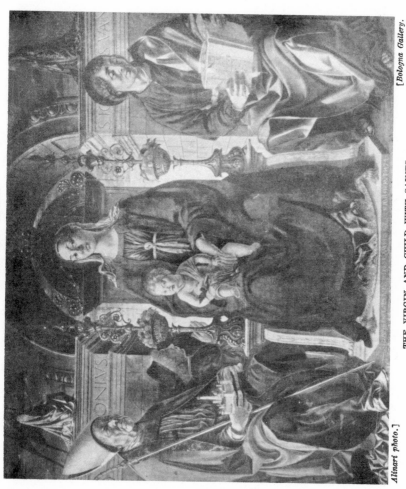

THE VIRGIN AND CHILD WITH SAINTS.

II. 232]

in the head. A very dignified containment is shown in the face of St. Petronius to the left, and the modelling throughout is grand. We may object to the marked fleshy type of the Virgin, unmistakeably derived from Piero della Francesca, but its imposing gravity is undeniable. Less realism would improve the Evangelist, but the truth of the realism is very great. We admire, too, the searching character of the drapery, though we feel that it is too tortuous. We see everywhere a pure ring of metal in the work, excellent relief by light and shade, and a very delicate play of reflections.[1]

The Virgin of the Barracano at Bologna is a sacred image concealed—except on high festive occasions—from public gaze. When these occasions present themselves,[2] the wall is found covered with a fresco of the Virgin and Child in a highly ornamented throne, within an archway of similar architecture. At the sides of the throne angels devotionally hold candelabra, whilst lower down a male and female look up to the Virgin's face. The story runs that Giovanni Bentivoglio instructed Cossa to restore a miraculous Madonna which attracted many worshippers during the fifteenth century, and caused his own portrait and that of Maria Vinziguerra to be added at the bottom of the fresco.[3] It appears from examination that the heads of the Virgin and Child are all that Cossa thought fit to leave untouched, and the handling of that fragment proves it to have been done by Lippo Dalmasio ; but it appears also that some third person subsequently repainted the portrait usually supposed to be Giovanni Bentivoglio, raising it above the level of that of Maria Vinziguerra, and transforming it from a bust into a knee-piece.[4]

[1] Bologna Gallery, No. 64. Canvas, figures life-size ; inscribed : "D. Albertus de Cattaneis iudex et Dominicus de Amorinis notarius de for ppo fi fecerunt 1474 Franciscus Cossa Ferrariensis f." Near the head of Alberto, but almost obliterated : " Misĕr Alb. de Cataneis." The sky is dimmed by varnishing and retouching, the Virgin's dress and that of St. Petronio in part scaled and repainted, and parts of the flesh are abraded.

* [2] This painting is now always on view.

[3] See *Archivio patrio di antiche e moderne rimembranze felsinee*, etc., by Giuseppe Bossi, Bologna, 1855.

[4] Bologna, alla Madonna del Barracano. The portrait of the male is not like that of Giovanni Bentivoglio in Costa's altarpiece of 1488, in San Jacopo Maggiore at Bologna. The hands are repainted over the red framing of the throne which is seen through their half-abraded tint. The toes of the near angel also appear

Cossa, therefore, is the artist to whom we owe the frame of the Virgin and Child, the angels, the portrait of the female in profile, and the architecture. With the exception of the Child, which owes its awkwardness to the preservation of Lippo's head, the whole fresco is characterized by precision of outline, firmness of modelling, and all the qualities previously observed ; the masks and dresses remind us as before of Piero della Francesca and the Mantegnesques, though comparatively gentler and of a more yielding aspect than before ; the architecture is highly ornate, too much so indeed, and as florid as that of Bonfigli in the panels of San Francesco at Perugia. A new feature is apparent in the distances, where rocks are depicted in the shape of overhanging tables perforated with caves and crowned with temples and cities. It was this feature which subsequently received embellishments from Lorenzo Costa and Grandi.[1]

through the blue dress. It is likely that the original portrait of Bentivoglio was a bust profile like that of the female at the opposite side, and that the present one, which is much blackened, was done much later than the time of Cossa, and done in oil. The inscription, too, which purports to be " Johann. Benti Bononiæ dominus," etc., is also modern and of a different character from the lower one, which is genuine and runs so : " Opera de Francescho del Cossa da Ferrara MCCCCL. . . ." The date should be 1472, as is proved by records (Bianconi, *Guida di Bologna*, 1825, p. 230; Laderchi, *Pittura Ferrarese*, 8vo, Ferr. 1856, p. 32). The figures are life-size, the colour in parts abraded. The female to the left is aged, of masculine features; the hands are in part obliterated. The general tone is cold and a little rusty, and the tints are not free from a certain rawness. Lamo states that by the side of the high altar of the Madonna del Barracano there were two life-size figures in fresco of St. Lucy and St. Catherine by Cossa (*Graticola*, p. 12).

* [1] We learn from the letter of a contemporary that Cossa fell a victim to the plague which ravaged Bologna in 1477, while he was engaged in painting a chapel in the cathedral church of San Pietro; this chapel belonged to the Garganelli family, as is proved by Lamo, *Graticola*, p. 31. At the time of his death, Cossa had completed the frescoes of the ceiling (see Frati, in *L'Arte*, iii. 301). These paintings exist no longer ; they are described by Lamo, *ub. sup.* Vasari attributes them through a confusion to Costa (iii. 136, 143).

The following extant works by Cossa have not yet been mentioned : (1) Berlin, Kunstgewerbe Museum, No. 82-1459. The Virgin Enthroned (stained glass ; formerly at Bologna). (2) Budapest Gallery, Nos. 99 and 100. Two Angels. (3) Bologna, San Giovanni in Monte. Circular window in entrance wall, St. John at Patmos. Window in south aisle, The Virgin and Child with Angels. (4) Dresden, Picture Gallery, No. 43. The Annunciation (see *postea*, p. 237, n. 1). (5) London, National Gallery, No. 597. A Dominican Saint (probably St. Vincent Ferrer). Central compartment of a polyptych of which the other parts are divided between the Brera and the Vatican Gallery ; cf. *postea*, p. 238, n. 1. (6) Milan, Brera,

A page might be filled with the names of other painters who illustrate this period at Ferrara. There are few of whom pictures are preserved except Baldassare Estense of Reggio.[1]

Baldassare is supposed to have been an illegitimate scion of the house of Este, because all mention of his sire was omitted in contemporary records, whilst he bore the title of Estensis, and received unusual promotion in the service of the dukes.[2] Having taken a likeness of Borso I., he was ordered in 1471 to present it in person to the Duke of Milan.[3] From 1469 to 1504 he

No. 449. SS. Peter and John the Baptist. (7) Paris, collection of M. J. Spiridion. SS. Lucy and Liberalis. (8) Rome, Vatican Gallery. Miracles of a Dominican Saint.—The profile of a boy in the collection of Mr. W. Drury-Lowe at Locko Park stands at any rate near to Cossa.

[1] One other there is, Antonio Aleotti d'Argenta, of whom a small panel representing the Redeemer and inscribed with the name (written from right to left), and the date of 1498, is in the Costabili collection at Ferrara. [* It belongs now to the Municipal Gallery in that town (Sala III.).] There is a record of the year 1498 at Ferrara, in which Aleotti is bound over to keep the peace as against his wife. (See Cittadella, *Notizie*, p. 590.)

* By this painter we have, moreover, a signed Madonna between SS. Anthony and Michael in the Galleria Comunale at Cesena and a polyptych in the Municipio of Argenta. See Thieme and Becker, *Allgemeines Lexikon der bildenden Künstler*, i. 252.

We know from contemporary records that a painter called Michele Ongaro (*i.e.* the Hungarian) was working at Ferrara between 1415 and 1459. The only extant painting by him seems to be a figure of Ceres now in the Gallery of Budapest (No. 101, signed "Ex Michaele Pannonio"). This work shows the artist as a feeble imitator of Tura; it is obviously a companion piece to the Spring in the Layard collection and the Allegories belonging to the Marchese Strozzi (cf. *antea*, p. 226). For notices of this painter, see Cittadella, *Notizie, passim,* and A. Venturi, in *L'Arte*, iii. 185 *sqq.*

[2] Laderchi, *Pitt. Ferrar.*, p. 38; Cittadella (L. N.), *Notizie, ub. sup.*, p. 581.

* It is proved by a document of 1489 that Baldassare was the son of Niccolò III. of Este (died in 1441). See A. Venturi, in *Archivio storico dell' arte*, ser. i. vol. i. pp. 42* *sq.*

[3] MS. favoured by Marquis Campori.

* See also Campori, in *Atti e memorie delle RR. Deputazioni di storia patria per le provincie modenesi e parmensi*, ser. iii. vol. iii. pp. 567 *sq.*, and Motta, in *Archivio storico lombardo*, ser. ii. vol. vi. pp. 407 *sq.*

Baldassare had previously lived for many years in Lombardy, and had been in the service of the Dukes of Milan. We see from the earliest record of him that in 1461 he received a passport from Francesco Sforza. In 1469 he went from Milan to Ferrara with a letter of warm recommendation from Galeazzo Maria Sforza to Borso I. d'Este, who immediately engaged him. See A. Venturi, in *Atti e memorie della R. Deputazione di storia patria per le provincie di Romagna*, ser. iii. vol. vi. pp. 377 *sq.*, and Motta, *ub. sup.*, ser. ii. vol. vi. pp. 404 *sqq.*

was a salaried officer at court, residing first in the Castel Nuovo,[1]
and afterwards in the Castel Tedaldi, of which he was the
governor.[2] One of his medals with the date of 1472 has been
preserved, whilst his frescoes in the Rufini chapel at San
Domenico of Ferrara have perished.[3] His portrait of Tito
Strozzi, dated 1483, is still in the Costabili collection, and his
will, drawn up in 1500, is kept amongst others in the archives
of Ferrara.[4] The portrait of Tito Strozzi is a profile of a man
in years, of portly presence, in a black cap and coat, much
damaged by scaling, abrasion, and varnishes, a tempera on
canvas, of good outline and finish.[5] It is the counterpart as
regards treatment of another portrait of a corpulent man, of
olive complexion, in possession of Professor Bertini at Milan[6]—
a profile with some monotony of contour, but precise in touch,
and of a good and well-modelled surface. From these specimens
we might think Baldassare capable of producing the likeness
ascribed to Ansuino da Forlì in the Correr Museum at Venice.[7]

[1] He painted a canvas for the Castel Nuovo which has perished. (MS.
favoured by Marquis Campori.) [* See also Campori, loc. cit., p. 568.]

[2] Cittadella, Notizie, pp. 581–2.

* In 1472 Baldassare's name was cancelled from the list of the salariati, but
he continued to work for the Duke (Campori, ub. sup., pp. 568 sq.; A. Venturi,
ub. sup., p. 380). He subsequently went to Reggio, where we find him in 1489
and 1493, and where he was governor of the Porta Castello (A. Venturi, ub. sup.,
pp. 381 sqq., and Archivio storico dell'arte, ser. i. vol. i. pp. 42 sq.). In 1497 he
was back at Ferrara, and the following year he was again included among the
salariati. Campori, loc. cit., p. 570.

[3] The contract is in Cittadella, Ricordi, ub. sup., pp. 26, 27.

[4] Cittadella, Notizie, p. 582. From this it appears that he was of Reggio, and
therefore we think that Baldassare da Reggio of some records, and Baldassare
d'Este or Estensis of other records, are one person.

[5] Ferrara, Costabili. Canvas, tempera, on dark ground, with the initials
" D. T.," and on the lower border: " B . . . as pix. c. P. ano . 493. . . ."
It is impossible to say why Laderchi read the date 1499, and Rosini 1495.
[* This painting is now in the collection of Mr. Herbert Cook at Esher. The
date can no longer be deciphered. The date 1483 given in the text is probably a
misprint. See Cook, in The Burlington Magazine, xix. 228 sqq.]

[6] Milan, Professor Bertini. Panel, bust in a low key of tone without
modulations, assigned to Tura. [* This portrait is perhaps identical with one
which now belongs to the Museo Poldi-Pezzoli at Milan (No. 627).]

[7] Venice, Correr Museum, Sala XVI., No. 9. Panel, tempera, m. 0·49 high by
0·35. In the distance to the left hand a castle, a river with two boats, two men
on horseback and a servant. Concealing the landscape in part, a green curtain;
on a parapet, a book and a diamond ring, the cognizance, we are told, of Ercole I.
(Laderchi, p. 38, and Bellini in Baruffaldi, i. 70); on the side, an escutcheon; on the

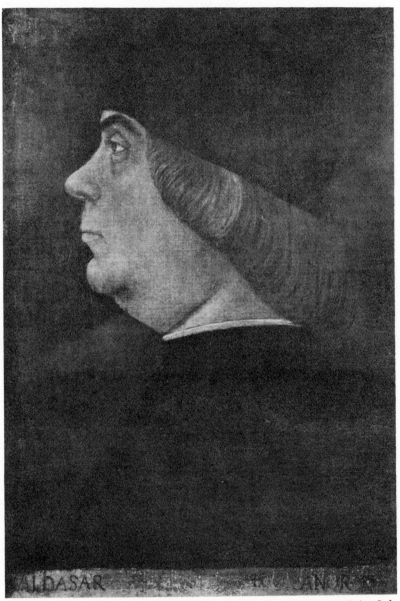

PORTRAIT OF A MAN.

What we admire in this fine creation is a share of Francesca's grandeur, a certain calmness and dignity in the set of the head and its expression, extraordinary precision and firmness in the outline, and a glossy blending of silver light into blue-grey shadow. The mode of indicating wrinkles in the flesh with tenuous lines is familiar to us in Francesca and Melozzo.

The authorship of Baldassare might be confirmed by the inscription on the upper border, which has been mutilated and retouched to suit the Venetian market. Another panel by an unknown hand betraying Ferrarese characteristics akin to these is the Annunciation, doubtingly ascribed to Pollaiuolo, in the Museum of Dresden,[1] and we may class in the same catalogue the St. Dominic attributed to Zoppo at the National Gallery, upper border: "O BATTA FUSSAP....." which may originally have read "Baldassare"; on the lower border the initials "A. F. P." [* The ring contains a ruby, not a diamond; moreover, the stone is not engraved with the emblematic flower of the Estes. See A. Venturi, in *Archivio storico dell' arte*, ser. i. vol. i. p. 42 *.— Professor Venturi gives good reasons for thinking that the Death of the Virgin in the Massari-Zavaglia collection at Ferrara is identical with the picture containing the Twelve Apostles which Baldassare in a letter of 1502 states he had painted for the nuns of Mortara. Cf. *postea*, p. 247, n. 1.]

Baruffaldi mentions several pictures by Baldassare which are not preserved: St. Thomas Aquinas and St. Catherine of Siena in the church of the Angeli at Ferrara, inscribed "Baldassaris Estensis opus"; a sacred subject in Santa Maria della Consolazione; and a Funeral of a Nun, the Fall of Simon Magus, and the Samaritan Woman at the Well in private hands at Ferrara, inscribed: "Bal. E. f." (Baruffaldi, i. 92–3.)

* Baldassare was particularly active as a portrait painter. For notices of his portraits, see A. Venturi, in Thieme and Becker, *Allgemeines Lexikon der bildenden Künstler*, ii. 387 *sq*.

[1] Dresden Museum, No. 43. Panel, 4 ft. 11 in. high by 4 ft. The Annunciation was inscribed for some time with the words: "Andreas Mantegna Patavinus fecit. An. 1450"; but the inscription was a forged one, and since its removal the picture is under the name of Pollaiuolo with a (?), having also been assigned to Baldovinetti. The art is that of a follower of Tura or Cossa, and seems that of a careful young painter. The movement of the Virgin is hard and stiff, her figure heavy and overweighted with drapery; the head is cast in Tura's and Cossa's mould, and shows much breadth at the cheekbone; yet the face is paltry, and reminds us of Costa's in 1488. The folds are branching at top as in Costa. The angel, still in the same style, is a better and more agreeable figure. The flesh tints are of a reddish hue in light, streaked with yellowish hatchings and shaded with green, all carefully modelled, with the point of the brush. The result is a clear metallic semi-silvery treatment, that shows the progress of Ferrarese technica under Costa and Ercole di Giulio. In the dresses the tints are raw and sharp in contrasts. [* This picture was formerly in the Chiesa dell' Osservanza at Bologna.]

with its two companion figures in the Barbi-Cinti collection at Ferrara.[1] But of these it would be unsafe to say more than that they are all similar, and seem due to an artist who follows in the footsteps of Tura and Cossa,[2] and resembles Costa and Ercole di Giulio Grandi in their early period.[3]

[1] London, National Gallery, No. 597; from the Costabili collection. Panel, tempera, representing St. Dominic on a pedestal, with Christ in a glory between six angels in the sky.—Ferrara, Signor Barbi Cinti, Strada Boccacanale a San Guglielmo. St. Peter and St. John the Baptist, erect, panel, temperas. The execution is the same as at Dresden, but of a later period of the same master's career, the figures being more dignified and meaning, the forms being more searched and the shadows more precisely defined.

* The panels seen by the authors in the Barbi-Cinti collection are now in the Brera (No. 449). A predella belonging to the Vatican Gallery shows exactly the same characteristics of style as the pictures in London and Milan, and with them no doubt originally formed one altarpiece, as Dr. Frizzoni was the first to recognize (*Zeitschrift für bildende Kunst*, ser. i. vol. xxiii. pp. 299 *sqq.*). The predella in the Vatican represents certain miracles of a Dominican saint, who is obviously identical with the saint seen in the National Gallery painting, which occupied the centre of the polyptych. These miracles have been variously interpreted as relating to the legends of St. Hyacinth or to those of St. Vincent Ferrer. It seems, however, impossible that St. Hyacinth is represented in this altarpiece, as he was canonized only in 1594, whereas the Dominican, both in the central panel and in the predella, has a nimbus. The attitude of the central figure and his attribute (the opened book) are, moreover, peculiar to St. Vincent Ferrer in Italian fifteenth-century art. Dr. Frizzoni suggests (*ibid.*) that this altarpiece was the one dedicated to St. Vincent which Vasari (iii. 133, 142 *sq.*) mentions as being in the Griffoni chapel in San Petronio of Bologna, ascribing the predella to Ercole Roberti and the rest to Lorenzo Costa, whom Vasari in this passage repeatedly confuses with Cossa. If it is true, as stated by MM. Lafenestre and Richtenberger (*Rome—Le Vatican*, p. 9), that the Vatican predella was bought from the Aldrovandi family, then Dr. Frizzoni's conjecture would be all the more likely to be correct ; for we know that the altarpiece of the Griffoni chapel came subsequently into the possession of the Aldrovandi family. See *Pitture, scolture ed architetture di Bologna*, p. 243.

*[2] In view of the close resemblance which these pictures show to the authenticated works by Francesco Cossa, they are now universally accepted as being by him.

[3] Berlin Museum, No. 112 A, assigned to a follower of Tura [* now to the Ferrarese School, about 1480]. Virgin and Child between four saints, Francis, Jerome, Bernard, and George. Wood, 5 ft. 3 in. high by 5 ft. 4 in. In this piece there is something of the school of Tura, but something also of that of Ercole Roberti Grandi.—Ferrarese also, but also of a painter whose name remains obscure, is in the Dresden Museum (No. 59 A) a female nude on a dolphin, a yellowish cloth on her head. [* Morelli ascribed this picture to Jacopo de' Barbari (*Die Galerien zu München und Dresden*, p. 257) ; and his view seems to be fully borne out by its numerous points of contact with Barbari's style—such as the design, the folds of the drapery, the facial type, the forms and the proportions of the figure.]

Baldassare was utterly unknown to Vasari, yet he is now better known than Stefano da Ferrara, whom Vasari mentions as Mantegna's friend.[1] Stefano filled the walls of the chapel of the Santo at Padua with frescoes in the latter half of the fifteenth century, but in consequence of the renewal of the edifice by Andrea Briosco in 1500 these frescoes were destroyed.[2]

Looking round Italian galleries, we find nothing assigned to Stefano except at the Brera of Milan, where he is the alleged author of two productions of different schools; one of these, however, is Ferrarese, and has a stamp of distinct originality.[3] It represents the Virgin with the Child on a hexagonal throne, supported by pillars, and decorated with bronze reliefs; two female saints on the throne at the Virgin's sides, two males in the foreground, the architecture and the landscape seen through the pillars—all in the manner of Tura. The figures themselves are much like Tura's and Cossa's—bony, dry, pinched in face and limb, prominent in bone, and disfigured by large extremities; the drapery, too, is Ferrarese in cast; but there is something Mantegnesque besides, a broader sweep of fold in the dresses of the male saints, an easier pose and movement, less

[1] Vasari, iii. 407. Baruffaldi (i. 156) cites a register of deaths at Ferrara which records the death of "Mastro Stefano Falzagallon," and his burial in 1500 at Sant' Apollinare of Ferrara. There is, of course, no proof that this is the painter mentioned by Vasari.

[2] M. Savonarola, De laud. Pat., lib. i. coll. 1145 and 1170, in Muratori, Script., vol. xxiv.; Anonimo, p. 9; Gonzati, La Basilica, i. 57–8, 156–7. Vasari (iii. 407) assigns to Stefano the "Madonna del Pilastro" in the Santo at Padua. That is a Giottesque fresco of the Virgin and Child between the two St. Johns, done at latest in the beginning of the fifteenth century, and certainly not by a painter who could have been Mantegna's friend.

* It seems likely that Vasari described Stefano as a friend of Mantegna simply because he painted in the Santo. As a matter of fact, Stefano must have belonged to a much older generation than Mantegna; Savonarola notices his frescoes in the chapel of the Santo in his Commentariolus de laudibus Patavii, which was composed about 1440, and mentions him along with Altichiero and Jacopo d'Avanzo (cf. antea). Moreover, the frescoes mentioned above had to be restored by Pietro Calzetta in 1470 (see antea, p. 71, n. 3). Taking these points into consideration, it also follows that Stefano Falzagalloni cannot possibly be identical with the author of the paintings in question. Cf. A. Venturi, in the Berlin Jahrbuch, viii. 76.

[3] The other so-called Stefano at the Brera, No. 453—Virgin and Child between SS. Peter, Nicholas, Bartholomew, and Augustine—we shall speak of when treating of Rondinello.

overcharge and exaggeration, a purer taste in architectural detail, and in the bas-reliefs a reminiscence of the carving of Niccolò and Giovanni Baroncelli, the Florentines to whom we owe the Crucifixion, Virgin, Evangelist, and St. George in the Ferrara Duomo.[1] The Mantegnesque here again varies from that of Ercole Roberti Grandi or Bono ; it has its own peculiar impress, and confirms the belief that this Madonna at Milan is correctly attributed to an independent artist, who may be Stefano, a man of less power than Tura or Cossa, but differing very little from them in form or technical habits. That such a painter should have left so little behind is curious ; yet there are few things like the Brera Madonna to which we can point, at best such a piece as the small St. John the Baptist in the Casa Dondi-Orologio at Padua catalogued as by Mantegna.[2]

The Ferrarese school, we see, is involved in obscurity, and has its spectral shadows like many others. It receives better light, however, as we proceed ; chiefly through the Grandis and Costas.

[1] Milan, Brera, No. 428. Canvas, m. 3·23 high by 2·40. The Virgin's mantle is renewed and her face a little repainted ; on the base of the throne are the Massacre of the Innocents, the Presentation, and the Adoration. Monochrome on gold ground.

* Prof. A. Venturi was able to prove that this picture was originally in the church of Santa Maria in Porto outside Ravenna (later in Ravenna itself), and that it is mentioned in old descriptions of that town as a work by " Ercole da Ferrara," i.e. Ercole Roberti (see the Berlin *Jahrbuch*, viii. 78). Subsequently Prof. C. Ricci found a contemporary record (published in the *Rassegna d'arte*, iv. 12), from which it appears that Ercole had finished the altarpiece under notice before March 26, 1481. The figures in the foreground represent St. Augustine and the B. Pietro degli Onesti ; the two females kneeling on each side of the Madonna are St. Anne and St. Elizabeth.

[2] Padua, Casa Galeazzo Dondi-Orologio. Small panel, tempera. Shrivelled figure of St. John the Baptist, erect, looking at the crucifix which he holds in both hands. The distant landscape is Ferrarese in treatment. Note the large extremities, the tenuous wrists and ankles, the dull tone. [* This picture is now in the Kaiser Friedrich Museum at Berlin (No. 112 c). In view of its close affinity to the altarpiece at the Brera, it must also be ascribed to Ercole Roberti.] Assigned to Stefano are the following : (1) Bologna, San Giovanni in Monte. Virgin and Child enthroned between two angels ; injured (the heads of Virgin and Child). This picture, compared with that of the Brera, appears to be by another painter ; feebler too, but greatly damaged ; it slightly recalls the works of Costa in 1488. (2) Ferrara Gallery, Sala VI. Virgin and Child between St. Anthony and St. Roch, from Santa Maria in Vado, dated 1531. This piece is by a follower of Garofalo.

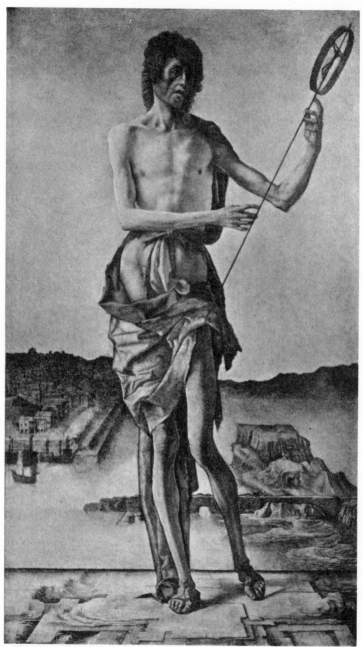

ST. JOHN THE BAPTIST.

There were two artists called Ercole Grandi in the Ferrarese service,[1] of whose skill Ferrara and Bologna possess specimens in divergent styles and of varying merit ; one Ercole is a close follower of Mantegna, the other a disciple of Costa. Vasari knows but of one, yet unwittingly commingles the history of both. Whilst he affirms that Ercole is a friend and pupil of Costa, he only describes pieces without relation to Costa in manner.[2] The latest researches made in the archives of Ferrara and Bologna show that Ercole de Rubertis, alias Grandi,[3] and his brother Polidoro entered into partnership with the gold-beater Giovanni da Piacenza at Ferrara in 1479.[4] He was salaried by the Duke of Ferrara, and frequently employed in adorning chests; he built a triumphal car, decorated the Duchess's garden-lodge, and finished a view of Naples in 1490–93 ; and took in 1494 the likeness of Hercules I. for Isabella of Mantua.[5] His death

[1] "Hercules unus, et alter, pictores ambo Bononienses cives . . . an Hercules dictus communiter de Ferraria fuerit unus ex istis duobus, nec ne, de qua re valde ambigo." Bumaldi, *Minervalia* (1641), *ub. sup.*, pp. 242 *sq.*

[2] Vasari, iii., lives of Ercole of Ferrara and Costa.

[3] According to Prof. A. Venturi (in *Archivio storico dell' arte*, ser. i. vol. ii. p. 340, n. 8), the only document in which the family name Grandi is given to Ercole Roberti dates from 1530, when the artist had been dead for more than thirty years ; whereas in the numerous records of Ercole dating from his lifetime he is never called Grandi. But is it quite certain that the records of payments made from the exchequer of the Duke of Ferrara to "Ercole de' Grandi" in 1489 and 1495 refer, not to Ercole Roberti, but to Ercole di Giulio Cesare (see *ibid.*, vol. i. pp. 194 *sq.*) ?

[4] L. N. Cittadella, *Notizie, ub. sup.*, pp. 583–9. According to a record in *Documenti (ub. sup.*, p. 125), by the author of the *Notizie*, Ercole Roberti Grandi was the son of Antonio, "civis Ferrarie."

[5] It is proved in the records published by Prof. C. Ricci, *loc. cit.*, p. 12, that Ercole Roberti during the spring of 1481 alternately stayed at Ravenna, Bologna, and Ferrara. According to Raffaello Maffei, a contemporary of Ercole Roberti, this artist also visited Hungary. See Harck, in the Berlin *Jahrbuch*, v. 124.

[5] MS. records favoured by the Marchese Campori. He also contracts in the same year for an Annunciation for the church of Santo Spirito of Ferrara. (L. N. Cittadella, *Documenti, ub. sup.*, p. 125.)

[*] A full account of the works which Ercole Roberti executed for the Duke of Ferrara is given by A. Venturi, in *Archivio storico dell' arte*, ser. i. vol. ii. pp. 343 *sqq.* The artist is first mentioned in the records of the Ferrarese court in 1486. He was in 1494 dismissed from his charge at court for having accompanied Prince Alfonso on his breakneck escapades by night. Luzio, in *Emporium*, xi. 347.

previous to 1513 is proved by documentary evidence.[1] Ercole Grandi—the son, according to Baruffaldi, of Giulio Cesare Grandi—was in the service of the Duke of Ferrara from 1492 to 1499 [2]; he is thought to be the same whose death in 1531 is certified by an epitaph in the church of San Domenico at Ferrara.[3] It might be interesting to ascertain which of the two Grandis is the follower of Mantegna, which the disciple of Costa; it may be supposed that the latter would be younger and live longer than the former. We shall therefore assume that Ercole Roberti Grandi is not the disciple of Costa; and, starting from these premisses, we shall be able to lay it down as a fact that Ercole Roberti Grandi is the artist of whose works Vasari usually speaks.[4]

[1] L. N. Cittadella, *Notizie, ub. sup.*, p. 589, and see also in *Documenti (ub. sup.*, p. 124) by the same author, where Lucia de' Fanti is mentioned as "uxor q. mag. Herculis de Robertis."

[*] Ercole Roberti was still living towards the end of 1495, but is recorded as dead on July 1, 1496. A. Venturi, *loc. cit.*, pp. 355 *sq.*

[2] MS. favoured by the Marquis Campori. L. N. Cittadella, *Notizie*, pp. 422–3. The latter author in *Documenti (ub. sup.*, p. 363) prints a letter from the Duchess Eleanor of Ferrara to the Abbess of the Murate at Florence, dated Ferrara, Nov. 2, 1492, in which the former recommends "Hercule prestante pictore nostro dilectissimo," who accompanies the prince (afterwards Alfonso of Ferrara) to Rome. Signor Cittadella believes this Hercules to be Ercole di Giulio.

[*] It seems more probable that he was Ercole Roberti, who is known to have been a great favourite at court. Cf. A. Venturi, *loc. cit.*, pp. 352 *sq.*—Professor Venturi states (in *Archivio storico dell' arte*, ser. i. vol. i. pp. 194 *sq.*) that Ercole di Giulio is recorded to have received payments from the exchequer of the Duke of Ferrara in 1489, 1495–6, and 1506–7 (see however *antea*, p. 241, n. 3). In 1499 Ercole di Giulio executed the design for the pedestal of the equestrian statue of Ercole I. which was to be erected at Ferrara (Cittadella, *Notizie*, p. 422); and he is no doubt also identical with the "M. Hercule di Grandi" who in 1495 supplied various designs for the church of Santa Maria in Vado at Ferrara (*idem, Documenti*, pp. 341 *sq.*).

[3] "Sepulcrum egregii viri Herculis Grandii pictoris de Ferraria, qui obiit de mense Julio MCCCCCXXXI." Baruffaldi, *ub. sup.*, i. 145.

[*4] In the light of recent research it appears that Vasari confuses not Ercole Roberti and Ercole di Giulio Cesare, but Lorenzo Costa and Francesco Cossa. He states that Ercole of Ferrara was the pupil of Lorenzo Costa—in the first edition of the Lives he says, of Lorenzo *Cossa*—and that the master of Ercole executed the altarpiece of the Griffoni chapel at San Petronio of Bologna and the frescoes on the ceiling of the Garganelli chapel at San Pietro in that town. Now, the latter paintings are at present proved to have been the work of Francesco Cossa (see *antea*, p. 234, n. 1), and the Griffoni altarpiece was very likely also by him (see *antea*, p. 238, n. 1). There seems to have existed a tradition at Bologna that Ercole Roberti was the pupil of Francesco Cossa; Pietro Lamo writes in

Pietro Lamo, in his quaint old language, tells us that when Michelangelo was in Bologna, he went to see the frescoes of Ercole Grandi in the Garganelli chapel at San Pietro, and was heard to exclaim : "This is a little Rome for beauty."[1] The period during which this chapel was decorated might be inferred from an entry in the baptismal registers of the cathedral of Bologna, in which Ercole of Ferrara, painter and moulder, appears anno 1483, as godfather to the son of Bartolommeo Garganelli.[2] It is a natural presumption that Ercole, who is reported to have left his own likeness beside that of Domenico Garganelli in the chapel of San Pietro,[3] was on friendly terms with other members of the same family. Vasari's description of the Garganelli frescoes is copious and lively, and makes us regret their total destruction ;[4] but his subsequent statement that the same hand produced the predellas of Costa's altarpiece in the Cappella Griffoni and on the chief altar of San Giovanni in Monte at Bologna, and the preservation of the latter in the gallery of Dresden, give us an invaluable clue to Grandi's education.[5] We see at once that Ercole Roberti's style was based on that of Mantegna, and that he must have spent his youth, and not a little of his manhood, in studying Paduan masterpieces.

1560 (*Graticola*, p. 31) " di sopra nela volta de dita capella E tuta depinta *di ma del M° derco da frara Ebe nome franc° Cossa da frara* (*i.e.* di mano del maestro di Ercole da Ferrara ch'ebbe nome Francesco Cossa da Ferrara)." It is probably this tradition which finds a confused expression in Vasari's pages, while at the same time he ascribes some works of Cossa's to Costa. All the paintings which Vasari mentions as being by Ercole of Ferrara are by Ercole Roberti, with the single exception, we may believe, of the predella of the Griffoni altarpiece, which is probably by Cossa (cf. *antea*, p. 238, n. 1). It seems that Vasari gives no clue whatever to the biography of Ercole di Giulio Cesare.

[1] Lamo, *Graticola di Bologna, ub. sup.*, p. 31.
[2] Gualandi, *Memorie*, ser. v. p. 203.
[3] Vasari, iii. 145.
[4] As we have seen above (p. 234, n. 1), Francesco Cossa began the painting of this chapel, but had only executed the frescoes of the ceiling when he died of the plague in 1477. The decoration was completed by Ercole Roberti. Vasari mistakes Cossa for Costa when dealing with these frescoes (iii. 136, 143 *sqq.*; cf. *antea*, p. 242, n. 4).
[4] A sheet containing sketches for the fresco of the Crucifixion is in the Print Room at Berlin ; a copy of a portion of the same painting belonged in 1889 to Dr. J. P. Richter. See A. Venturi, in *Archivio storico dell' arte*, ser. i. vol. ii. p. 342.
[5] Vasari, iii. 145.

At Liverpool we have a small panel exactly like those of
Dresden, in which the dead Christ lies in the lap of the Virgin in
a landscape full of Mantegnesque incident—the Saviour, a mere
mummy, but a studied nude, the Virgin looking over him with
intense grief, and holding him with a tenacious grasp that
displays the very skeleton of her hand. The flesh seems rapidly
painted with quick dryers in strata, the result being uniformity
of tone and a horny transparence. In the distance, which is but
a film of colour, the figures are put in with spirited touches at
the last; the vestments glossy and raised in surface, but of a
coarse varnishy substance, heightened with hatched or gilt
lights of extraordinary fineness.[1] Still more Mantegnesque is
the predella in the Dresden Museum representing the Capture
and the Procession to Golgotha. Ercole's aim here is to contrast
the perfect repose of the Saviour kneeling on the mount to the
left and the foreshortened apostles asleep at the hill-foot, with
the restless action of Judas and his band effecting the capture.
Judas himself embraces Christ, whilst the guard run in with
seven-league stride to catch him ; a soldier throws a lasso over
his head, and at the same moment Peter smites off the ear of
Malchus. Nothing can be more obvious than the imitation of
Mantegna, especially in the first of these episodes, which recalls
the masterly foreshortenings in the Christ on the Mount of Mr.
Baring's collection,[2] and Bellini's similar subject in the National
Gallery. A careful outline of great tenuity, but of a broken and
cutting character, defines every part with surprising minuteness.
The principle of impulsiveness is carried out in action and ex-
pression in long, wiry, and vulgar figures. The heads, of a crabbed
and often repulsive form, seem the natural precursors of those pro-

[1] Liverpool, Walker Art Gallery, Roscoe collection, No. 28, under the name of
Mantegna, to whom it was still assigned by Dr. Waagen. Wood, 1 ft. 2 in. high
by 1 ft. The Crucifixion is in the distance, some of the figures almost obliterated.
The Virgin's tunic, originally red, is flayed down to the whitish preparation.

* Lamo states (*ub. sup.*, p. 13) that the predella by Ercole at San Giovanni in
Monte showed the Madonna with the dead Christ in her arms between the
Procession to Golgotha and the Capture of Christ. We may therefore safely assume
that the Pietà at Liverpool originally formed part of the same predella as the two
paintings at Dresden. The Print Room at Berlin possesses a study for the figure
of Christ in the Pietà; it was formerly in the collection of Herr A. von Beckerath
(see A. Venturi, *loc. cit.*, p. 343).

* [2] Now in the National Gallery.

duced by Costa and Mazzolino ; the scanty drapery, intended to be
in motion, appears as if cast upon a wet mould in the shape of
zigzags and polygons. The colour, of red and dusky hue in flesh,
of positive and glaring tints in dresses, becomes neutralized by
juxtaposition to a dim twilight ; the distance, a thin wash of
varnish, illustrates a theory that tone loses substance as objects
recede. The costume is made up of the antique and middle ages.
All this yields a quaint mixture of Paduan dryness and grimace
with the vehemence of Liberale.[1]

The Procession to Golgotha is more markedly Mantegnesque,
particularly in a soldier stopping to give one of the thieves a
drink. In the right-hand corner a group of women and children
of plump and even bloated complexion supplies the contrast
furnished in the Capture by the calm of the Saviour on the
Mount.[2] Of a broader style with similar features, but still
more reminiscent of Mantegna in the landscape, is Ercole's
Christ on the Mount, in the Gallery of Ravenna, to some extent
a counterpart of an episode in the predella at Dresden[3] ; less

[1] Dresden Museum, No. 46; once in San Gio. in Monte at Bologna (see Bottari,
Lett. Pitt., iv. 380, and Vasari, iii. 145). Wood, 3 ft. high by 4 ft. 2 in. The drawing
of the episode of Christ on the Mount is in the Friedrich August collection at
Dresden. [* Dr. Harck considers this as a copy from the picture. See the Berlin
Jahrbuch, v. 126 *sq.*]

[2] Dresden Museum, No. 45. Same size as the foregoing. An old copy in
red and black chalk, long catalogued under Mantegna's name, is in the collection
of drawings at the Louvre (No. 220).

* A splendid sketch for the group of Christ, Judas, and the soldier behind
the Saviour is in the Uffizi. Harck, *loc. cit.*, p. 126.

[3] Ravenna Gallery, No. 194, without an author's name. The Saviour kneels
between two tall hummocks in a landscape with trees and a city ; the disciples
sleep below, and the band of Iscariot is in the distance. Small panel, much
injured by abrasion. The landscape is copied from that of the Eremitani in
Mantegna's Call of James and Andrew to the Apostleship. From this work we
see that Grandi painted the flesh with thin colour, and made much use of the
white underground. The lights in the trees are touched in gold.

* Prof. C. Ricci (in *Rassegna d'arte*, iv. 50 *sq.*) has ascribed this picture
to Bernardino da Cotignola ; and it certainly recalls the style of this master
very much in the manner in which the foliage is executed, the design of the
landscape, the *staffage*, etc. As far as the editor can see, it is related to Ercole
Roberti's style only in so much as the figures of Christ and the apostles
reproduce those in the painting from the predella once in San Giovanni in Monte
at Bologna, and now in Dresden; but they may, of course, have been copied by
Bernardino da Cotignola. Nor is the editor struck by **any particular** resem-

powerful, but of not less certain derivation, the Crucified Saviour
between the Virgin and Evangelist in the Correr Museum at
Venice[1] ; a so-called Lucretia, in the Gallery of Modena[2] ; and
a neat little allegory in the house of the Conte Ferdinando
Cavalli at Padua, representing a ship crowded with people near
a rocky shore on which three horsemen stand.[3] These are all
panels showing the gradual expansion of Ercole Roberti's art,

blance between the landscape in the picture at Ravenna and the Call of St.
James in the Eremitani. The Agony in the Garden is now also officially attri-
buted to Bernardino de Cotignola.

[1] Venice, Correr Museum, Sala XVI., No. 8. Wood, m. 0·54 high by 0·30, under
the name of Mantegna. A very glossy picture, freely executed, and full of
Mantegnesque grimace, with a very fine distance and groups.

* The editor agrees with Morelli (*Die Werke italienischer Meister*, p. 132)
that the form of the hands, the draperies, the landscape, and other particulars
prove this picture to be an early work by Giovanni Bellini. See also Fry,
Giovanni Bellini, pp. 14 *sq.*

[2] Modena Gallery, No. 50. Wood, m. 0·48 high by 0·34, assigned to Man-
tegna. The Lucretia is heavy of head, and square, in the mode subsequently
common to Mazzolino ; the two captains to the left hand affected in movement,
with spindle legs ; in fact, the character of Ercole is distinct ; the flesh restored
all over, and of a reddish tone.

[3] Padua, Conte Ferdinando Cavalli. Small panel, gay in tone, and full of
gloss.

* This picture, which probably represents an incident of the expedition of
the Argonauts, is now in the Museo Civico of Padua (No. 424). It recalls, no
doubt, to a certain extent Ercole Roberti ; but on the whole it comes much
closer to Bernardino Parentino—note, for instance, the landscape, the treatment
of the foliage, the types of the figures, and the drawing of the horses. We may
perhaps therefore rather ascribe it to this painter, who was notoriously influenced
by Ercole Roberti.

The following paintings by Ercole Roberti still remain to be noticed:
(1) Berlin, Kaiser Friedrich Museum. No. 1128, The Virgin and Child. No. 112 E,
St. Jerome. (2) Bologna, Pinacoteca. St. Michael. (3) London, National
Gallery. No. 1127, The Last Supper. No. 1217, The Israelites gathering the
Manna (cf. *postea*, p. 265, n. 2). No. 1411, The Nativity and Christ in the
Tomb (cf. *postea*, p. 262, n. 1). (4) London, collection of Mr. Robert Benson.
SS. Jerome and Catherine. (5) Lyons, Picture Gallery, No. 64. St. Jerome.
(6) Milan, collection of Cav. A. Noseda. St. John the Baptist and St. Jerome.
(7) Paris, Louvre, No. 1677. St. Michael and St. Apollonia. (8) Richmond,
collection of Sir Frederick Cook. Medea. (9) Rome, collection of Comm.
Blumenstihl. Pietà.

Morelli (*Die Galerien zu München und Dresden*, p. 178) and Dr. L. Venturi
(*Le origini della pittura veneziana*, pp. 164 *sq.*) justly note that Jacopo Bellini
exercised a marked influence upon Ercole Roberti, as is evident, for instance,
from the long and slender figures in many of his works, and from the setting
of the picture of the Israelites gathering the Manna now in the National Gallery.

and proving that he retained the same distinct peculiarities of manner throughout.[1]

It is not unlikely that towards the close of the fifteenth century the majority of the painters we have named served under the dukes of Ferrara in the upper hall of the palace of Schifanoia. The two faces of that hall which still contain frescoes must have been completed between 1471 and 1493 [2] ; but the number of hands employed as masters or journeymen can no longer be ascertained. Galasso, Zoppo, Tura, Cossa, and Costa are those whose style is most conspicuous, but the share assignable to each of them is unequal and variable. The plan of the decoration was due to one man, its execution to many. The walls are divided into three courses, the short side of the rectangle into three, the long side into four, quadrangular sections : in the middle course the signs of the Zodiac ; above each sign the heathen god or goddess presiding, and scenes incidental to his or her attributes ; below each sign episodes of the public and domestic life of Duke Borso at each of the indicated seasons. Thus, if we start from the right side of the short face seen from the principal doorway, we find first

[1] Ferrara, Professor Saroli. Here is a picture representing the Death of the Virgin, which was once in San Guglielmo at Ferrara, and is ascribed by some persons to Mantegna. The Virgin lies on the tomb, surrounded by the apostles, and on the gold ground above is a glory of angels, within which the soul goes up to heaven. This is an ugly picture, full of skinny grimacing figures, with all the faults of the Ferrarese, and something of the manner which Grandi might have had in his earliest period, but query is it by him or the young Costa, or even Coltellini ?

* There is no proof that this painting, which now belongs to the Duca Massari-Zavaglia of Ferrara, formerly was in San Guglielmo in that town. On the other hand, Professor A. Venturi has given good reasons for thinking that it originally had its place in Santa Maria delle Grazie, the church of the nuns of Mortara, in which case it seems likely that this is the picture containing the Twelve Apostles which Baldassare d'Este painted for those nuns, as we learn from a letter written by him in 1502. See A. Venturi, in the Berlin *Jahrbuch*, viii. 79 *sqq.*, and in *Atti e memorie della R. deputazione di storia patria per le provincie di Romagna*, ser. iii. vol. vi. pp. 384 *sqq.*

[2] Cittadella (L. N.), *Notizie, ub. sup.*, p. 337.

* The reasons which Cittadella here adduces for thinking that the frescoes in question were executed between 1471 and 1493 are fallacious ; see the same author's *Ricordi . . . di Cosimo Tura*, p. 23, and Harck in the Berlin *Jahrbuch*, v. 113 *sq.* Moreover, it is now proved that these paintings were completed by March 1470. See *postea*, p. 250, n. 2.

Aries, or March, with Minerva, drawn by unicorns between
two groups illustrating the science of the legist and the economy
of weaving. Below the sign, which in itself is also a display
of pictorial skill, Borso stands in front of a triumphal arch
giving judgment in a cause, and then goes on a hawking ex-
pedition. Next comes the Bull, presided over by Venus,
the deities in every case being on cars with teams of animals,
fanciful and real; and beneath, Borso making a present to his
fool, riding out hawking, and witnessing a donkey-race. And
so we proceed round the hall, seeing in succession the Gemini,
Cancer, Lion, Virgin, and Balance, the four last being on the
long face, lighted by windows looking out on the inner court.[1]

[1] Ferrara, Schifanoia. Whitewashed in the middle of the eighteenth century,
recovered in 1840. Subjects and condition: upper course: Aries: a large hole
in the centre. Bull: fairly preserved; Venus with Mars at her knees, drawn by
swans; on the banks right and left, couples in dalliance, the three Graces, doves,
rabbits, and other emblems of fecundity. Gemini: Apollo, with crown and orb,
on a car with four horses, Aurora holding the ribands; gambols of children, and
a group of poets to the right and left (the dress of Aurora gone). A space
between the corner and the first compartment on the long face is wanting.
Cancer: Mercury drawn on a car by two eagles; at the side, incidents illustrative
of music, shepherd-life, and the *ars mercatoria*; Argo decapitated in the distance.
The foreground, figure to the right of the car, and the drapery of the man on
the left-hand foreground colourless. Lion: Jupiter on a car drawn by two
lions. Left, wedding, supposed to be that of Bianca d'Este with Galeotto Pico
della Mirandola; right, priests playing cymbal, drum, etc. The dresses in the
latter group colourless. Virgin: Ceres on a car, incidents of the harvest, in
the distance rape of Proserpine, in fair preservation. Balance: allegory of
concupiscence, a female on a car drawn by apes. Left, the cave of Vulcan with
the Cyclops at their forge; right, a couple on a couch; in the distance infants
(preserved). Middle course, all in grounds now black, but originally blue. The
dress of the Virgin in the sign of that name colourless. Lower course: Aries:
Borso giving judgment; colours of dresses in most cases abraded; figures on
horseback in distance, mere outlines; faces of Borso and the man in peasant-
dress before him injured. Bull: dresses discoloured, face of the fool and sleeves
of his dress abraded; genuine. Here there remain but two figures of mowers
and a distant bridge with figures, much abraded. On the long face in the
angle, before we come to the sign of Cancer, a troop of horsemen with lances
(the art is that of a very poor painter). Cancer: Borso returns from hawking
in the plain of Ferrara. He receives a petition in a portico; a piece in the
middle of the foreground and another in the house to the right (distance) scaled
away. Lion: Borso, in front of a richly decorated arch, receives a peasant with
a paper, in the presence of his court; to the right horsemen of the suite, to the
left the same, and in the foreground three women washing, the latter group by
a very inferior hand; the distance and many dresses are colourless. Virgin: to

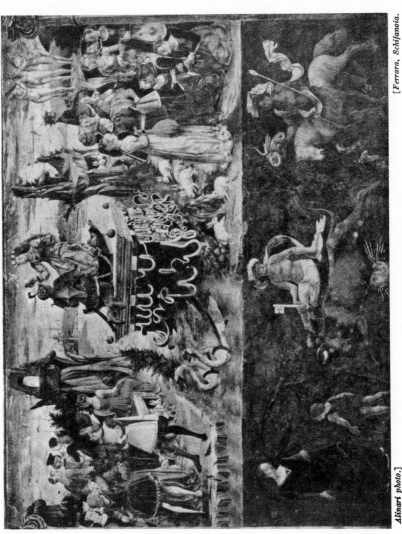

[Ferrara, Schifanoia.]

Alinari photo.]

TWO UPPER SECTIONS OF APRIL.

II. 248]

In the upper course of Aries, the Bull, and Gemini we have already had occasion to note some affinity with Piero della Francesca.[1] In no other part of the hall is space more accurately divided and filled up; the groups are well set, the forms and movements cleverly rendered, and the treatment comparatively free and bold. We observe the fleshy lip, the high cheek-bone, the flattened nose of Francesca, with a brown tinge of colour in flesh, a deep dullness in the shades of dresses, and a rusty darkness in shadows. These and other features point to the authorship of Cossa, assisted perhaps in the Bull and Gemini by Galasso. Cancer and Lion are very different indeed in merit from these; they are unattractive from the exaggerated character and rigidity of the forms and masks, as well as from their incorrect drawing and sombre tones. This, perhaps, is the unadulterated type of Galasso. A little better, and therefore perhaps by Cosimo Tura, are the Virgin and the Balance, the latter chiefly remarkable for the coarseness of its allegorical allusions. Returning to Aries, and following the same order for the lower as for the upper course, another style is apparent. In Aries, we have said, Borso gives judgment in a cause, and starts on a hawking expedition. One disadvantage under which the artist labours in representing the scene arises from the unpicturesque fit of the dress. Nothing could be more disheartening for the draughtsman than the tight hose, shell jackets, and skull-caps of the period. Yet he dwells with extraordinary minuteness and patience on their detail, finishing every part with sedulous care, and giving a very decided portrait-character to the heads. His skill in arrangement is much less than that of his rival in the upper course; the personages are stiff and stilted, the architecture poor in taste and defective in perspective, the tone dull and dusky; there is an obvious overcharge of subordinate incidents. We admire the detail, but miss the great maxims of composition; finish and accessories are considered more important than effect

the right Borso, attended by his court, receives an envoy from the Bolognese, and to the left goes out hawking; the whole much injured, and the figure of Borso on horseback all but obliterated. Balance: Borso, to the left, receives a Venetian ambassador; to the right, goes out hawking; much injured.

[1] *History of Painting in Italy* (1st ed.), ii. 549.

by light and shade, or brilliancy of tint; Tura's art seems
modified by the hand of young Lorenzo Costa. In the next
fresco, illustrating the sign of the Bull, where Borso makes a
present to his fool, the portrait-character of certain figures
recalls Benozzo. Throughout the whole of this lower course,
excepting in Cancer, and in small portions intercalated by poorer
hands, the manner is that of Tura and Costa.[1] In the middle
course Aries and perhaps the Bull are also by Tura or Costa;
the Gemini are by Cossa; Cancer by Galasso; Lion by Galasso
or Tura; the Virgin and Balance by Tura or Costa.[2] We leave
the hall of the Schifanoia with the impression that the Ferrarese
school yielded productions not on a level with those of the best
second-rates, certainly with no higher claims to critical attention
than those of Bonfigli of Perugia.

What doubts there may be as to Lorenzo Costa's early
career relate chiefly to the question whether he went in his

[1] In Cancer, defects common to Galasso are partly covered by finish re-
minding us of Zoppo.

* [2] The theory of the authorship of the various frescoes in the Palazzo Schifanoia
set forth by the authors requires to be corrected on some points. Dr. Harck,
by whom we have an elaborate monograph on these paintings (published in the
Berlin *Jahrbuch*, v. 99 *sqq.*) came after lengthy investigations to the conclusion
that, judging from the peculiarities of style, the frescoes dealt with above may
be divided into three main groups: (i) the paintings on the short or east wall—
artistically the finest of the whole series—illustrating the months of March, April,
and May, and moreover one compartment on the north wall, viz. the right-hand
portion of the lower course of July; (ii) June, the uppermost section of July,
and the left-hand portion of the lowest course of the same month (these frescoes
are the poorest of all in the room); (iii) August and September, and the middle
course of July. Dr. Harck thought he recognized in the frescoes of group (i)
the style of Francesco Cossa; and the subsequent discovery of a document has
shown that he was right with regard to the paintings on the east wall. The
record in question is a letter which Cossa on March 25, 1470, addressed to
Borso I. after all the frescoes in the hall of the Schifanoia Palace had been
completed and valued. Cossa declares in this letter that he alone painted the
three compartments towards the ante-room (*i.e.* on the east wall)—which must,
of course, not be interpreted as meaning that he had no assistants—and com-
plains that as regards remuneration he has been put on a level with the other
painters who had worked in the same room, not excluding "the most wretched
journeyman in Ferrara." Cossa's request for a more adequate payment was,
however, not entertained by the Duke. (Cf. A. Venturi, in *Der Kunstfreund*,
i. 129 *sqq.*, and in *Atti e memorie della R. Deputazione di storia patria per le
provincie di Romagna*, ser. iii. vol. iii. pp. 384 *sq.*) Dr. Harck's arguments for
discerning groups (ii) and (iii) are very convincing, though his suggestions for

youth to Florence to study the works of Lippi and Benozzo
Gozzoli, or whether his apprenticeship to art was with Tura
or Cossa.[1] Of his birth in 1460 at Ferrara, as well as of his
education in his native place, there are satisfactory proofs.[2]
We may therefore assume that after he had spent some years
in local ateliers he left home and wandered to Florence, re-
turning subsequently to take a part in the frescoes of the
Schifanoia, where alone a trace of Benozzo's influence can be
discerned.[3]

It is quite uncertain when he painted the martyred St.
Sebastian in the Costabili collection at Ferrara, but in no other
production is his treatment so defective. We have no reason
to contest the genuineness of the signature on the base of the
pillar to which the saint is bound ; it purports to be the name
of Lorenzo Costa in Hebrew characters, and is acknowledged
as such by persons competent to give an opinion [4] ; but if this

naming the authors are open to criticism. All these frescoes bear more or less
the stamp of Tura's style, but not even those of group (iii) seem worthy of the
master himself, and it is still less possible to ascribe to him those of group (ii).
Moreover, we know that Tura was busily engaged elsewhere during the years
when the Schifanoia frescoes were executed. We may therefore consider groups
(ii) and (iii) as works of various followers of Tura. That Baldassare Estense also
had some share in the Schifanoia frescoes is proved by an autograph list of
paintings executed by him between 1469 and 1471, where it is stated that he
retouched thirty-six heads of Borso and other portraits at Schifanoia. (See *ibid.*,
p. 408.) Costa cannot be the author of any of the frescoes, as they were finished
in 1470, when he was still a child. As to Zoppo, there exists no record proving
that he was connected with the court of Ferrara; nor is the editor struck by
any particular affinity to Zoppo's style in the lowest course of July.—We may
add that it is not correct to state that only the east and the north walls still
contain frescoes; for there remain a few fragments of paintings on the two other
walls.

 [1] Vasari says (iii. 131 *sq.*) that Lorenzo studied for some months the works
of Lippi and Benozzo.

 [2] The register of deaths at Mantua contains an entry of the death of Lorenzo
Costa of fever at the age of seventy-five in the year 1535. [* D'Arco, *Delle arti e
degli artefici di Mantova*, i. 62.]

 * [3] Cf., however, *antea*, p. 250, n. 2.

 [4] Ferrara, Costabili Gallery. Wood, tempera, under life-size, inscribed in
Hebrew characters : " Magister Laurentius Costa." The colour is of a cold iron-
grey, and more like metal than flesh ; the tempera is glossy, yet finished with
fine hatching.

 * This painting is now in the Dresden Gallery (No. 42 A). As also noted by
the authors, it comes very close in style to Tura. Now, according to Professor

be so Costa is a pupil of Tura, and not unacquainted with the
works of Ercole Roberti or Stefano. Large grinning faces,
with broad shoulders and hips, large hands and feet and flesh-
less limbs, broken outline and mechanical cast of drapery, are
clear evidence of Ferrarese teaching, whilst in the pose of an
armed soldier in the distance traditions of Mantegna are pre-
served.[1] Another picture, equally Ferrarese in appearance, and
as surely the creation of a young painter, is the Martyrdom
of St. Sebastian in the Marescotti chapel at San Petronio of
Bologna, where the saint is drawn on a curious antique pedestal
surrounded by his executioners.

It is not yet absolutely proved when Costa was in Bologna
for the first time ; but Italian historians seem inclined to admit
that he was employed there by the family of Bentivoglio as
far back as 1480 ; they even state that he painted scenes from
the *Iliad* and from Greek history in the Bentivoglio Palace in
1483[2] ; he may therefore have had numerous commissions at that
period, and perhaps have finished, among other compositions, the
Martyrdom of St. Sebastian in the Marescotti chapel.[3]

In a portrait of Canon Vaselli, who was patron of the altar,
as well as in the martyr and his torturers, Costa repeats the
defects which make his St. Sebastian at Ferrara so unattractive,
and again suggests reminiscences of Mantegna. The fleshless
and angular character of the personages, their uniform tint and
light shading, all betray the youth of a Ferrarese artist, the
draperies alone showing a tendency to imitate the Umbrians ;

Schubring (*Kunst-Chronik*, ser. ii. vol. xiii. col. 57), the first word of the signature
should be interpreted as " finisher " instead of " Magister." If Professor Schubring
is right, we may suppose that this work was for the most part executed by Tura
and that Costa only gave the finishing touches to it.

[1] Ferrara, Professor Saroli. It may be possible that the Death of the Virgin
in this collection should be an early Costa ; admitting this, Costa would prove
to be a disciple of Ercole Roberti. See *antea.*

[2] See the authorities in Baruffaldi, *ub. sup.*, i. note to 106–14 ; Laderchi, *ub.
sup.*, p. 42 ; and Vasari, iii. 135. The Bentivoglio Palace was destroyed in 1507.
[* That Costa was in the service of the Bentivoglii in 1480 is not proved. Cf.
A. Venturi, in *Archivio storico dell' arte*, ser. i. vol. i. p. 244, n. 1.]

[3] Bologna, San Petronio, Cappella Marescotti. Canvas, tempera, figures under
life-size. The scene is in a landscape. The best figure is in the foreground,
an archer winding his crossbow. A cartello on the pedestal contains strange
characters that have not yet been deciphered.

but as yet Costa would be unable to produce what we are inclined to consider his in the decorations of the Schifanoia. In subsequent years the Marescotti chapel was again the scene of his labours, but not till his style had undergone great and remarkable changes. By what steps and under what advice these changes took place is not quite certain, but the record of them is already clear in the votive Madonna placed in 1488 on one of the walls of the Cappella Bentivoglio in San Jacopo Maggiore at Bologna. The Virgin here is seated on a richly ornamented throne with bas-reliefs and trophies on its pillars and base, statuettes on crystal orbs at its sides, and two angels playing instruments on its pinnacle. At the Virgin's knees Giovanni Bentivoglio and his spouse, and on the floor below their family of eleven children. A great improvement is here apparent in the tasteful arrangement of the architecture and skilful correctness of the perspective. The drawing is much more satisfactory than that of earlier examples, the proportions are better, extremities are more in keeping, and the outlines are clean and free from objectionable breaks ; but the portraits are Ferrarese in air, and still recall Tura or Cossa. Much dignity is given to the Virgin, whose oval face expresses serenity ; and the drapery is cast with something like ease. The likenesses are individual and very fairly worked out, yet on the whole the altarpiece is not without hardness ; its flesh tones are dusky and uniform, and the shadows have too little depth to produce perfect relief.[1] Costa was not confined to the mere furnishing of a votive Madonna, he also composed the landscapes which surround an equestrian statue of Annibale Bentivoglio on the wall to the right of the entrance, and in 1490 he finished the Triumphs of Life and Death on the wall to the left of the doorway. We shall not attempt to describe the minutiæ of allegories which were invented by some scribe in the pay of the Bentivoglii ; it was natural that the creation should be represented in the one, and the car of death followed by kings and beggars in the other ; enough that Costa carried

[1] Bologna, San Jacopo Maggiore. Canvas, tempera, on the wall to the right of the entrance to the Cappella Bentivoglio. On the pedestal, beneath a monochrome representing a sacrifice, a tablet bears the words: " Me, patriam et dulces cara cum conjuge natos comend. precibus Virgo beata tuis. MCCCCLXXXVIII. Laurentius Costa faciebat." The figures in general are short. The distance and the arch in which the throne stands are thrown out of harmony by restoring.

out these fanciful subjects with appropriate power and dis-
tributed the parts with judgment, eschewing alike confusion and
extravagance, and giving to the human and to the brute form
its fair proportion.[1] Though still Ferrarese in its impress, his
art already begins to assume the steadiness and softness which
finally became its chief characteristics, and which in a still
higher measure were a source of attractiveness in the pictures of
his friend Francesco Francia. Some considerable time elapsed,
however, before Costa substituted the newer Umbrian for the
older Ferrarese habit. In the Annunciation which he painted
between 1490 and 1495, at the sides of the Martyrdom of
St. Sebastian in San Petronio, his manner gains breadth and
boldness ; his figures are fairly drawn with extremities of select
shape, but they still remind us of Mantegna by a certain kind
of regularity, and by their peculiar cast of drapery ; there is
devotional tenderness in movement and gesture, but the flesh
tints are still uniform and dusky. If at the same period Costa
had the commission for the Apostles, which fill imitated niches
in the chapel, it is not unlikely that he left that portion of the
work to his disciples.[2] He was busy elsewhere in more interest-
ing labours, and especially in composing the great Madonna with
Saints exhibited in 1492 on the high altar of the oratory of the
Baciocchi at San Petronio.

He could not have imagined anything more sumptuous than
the florid decoration of the sanctuary and throne in which he

[1] Same church and chapel. The landscapes on canvas about the statue of
Annibale are disfigured by repainting, and the inscriptions are in part obliterated.
The Triumphs are also on canvas, and, according to Lamo, were done in 1490
The figures are under life-size. (Lamo, *Graticola*, p. 36.)

* A picture of the Virgin and Child between SS. James and Sebastian in the
Pinacoteca at Bologna (No. 392) is inscribed "Laurentius Costa f. a. 1491." This
painting strongly recalls the little Madonna by Ercole Roberti in the Kaiser
Friedrich Museum at Berlin (No. 112 D).

[2] Bologna, San Petronio, Cappella Marescotti. Canvas. The figures of the
Virgin and angel erect, in front of an archway, are in good perspective. The
Twelve Apostles, in niches round the chapel, are not in good condition ; some are
spotted, others are restored in oil. The whole chapel must have been finished
before 1495, when Canon Vaselli caused the following inscription to be placed
on the footboard of the seats : "Donum quodcumque pio heret sacello. Donati
cuncta Christo donatus de Vasellis bononiensis hujus excelse canonicus ecclesie.
dono. dedit, opus vero jacobi et fratrū filiorū M. Augustini de Marchis de Crema
bononiem. MCCCCLXXXXV."

placed his personages. He is prodigal of stone carving, of marble relief inlaying and gold ground, balancing the coldness of the one against the glitter of the other, projecting shadows with careful attention to the forms, noting the reflections of surrounding objects in the steel armour of a saint, and those of the armour itself on a marble pillar. Against this clear and variegated ground he throws the sombre warmth of deeply contrasted dresses and of ruddy flesh tints, even in the latter pitting coldish light against reddish half-tone and high surface shadows. His medium now is oil of strong varnishy polish; the figures are more calm, composed, and easier in motion than before; the Virgin slender, with a round oval face of gentle aspect; St. Jerome, Bellinesque; and St. George not unlike a creation of Giovanni Santi. St. Sebastian is hard in outline, not quite correct, especially in the hands, but boldly set in the left-hand corner of the picture in the fashion of Buonconsiglio; the draperies are almost Umbrian in cast, though still overladen. In all this Costa approximates to Francia, but remains Ferrarese in the sharpness of his tints and in the overcharge of ornament and architectural detail. He recalls Melozzo in three graceful angels playing instruments in a lunette.[1] In a graver mood about this period the sitting St. Jerome in San Petronio was produced, a picture of much coarser stuff than the Madonna of the Baciocchi chapel, but of such sternness that it might entitle Costa to be called the Van Eyck of Ferrara.[2]

From this time forward Costa became more completely Umbrian, and commingled the breadth of his own style with the softness of that of Francia, yet without Francia's careful blending and finish, or his delicacy of tone. He thus painted in 1497 the Virgin and Child with Saints at the Segni chapel in San Giovanni in Monte of Bologna, and the Glory of the Madonna on the high altar of the same church—two pieces

[1] Same church, Cappella Baciocchi, formerly de' Rossi. Panel, oil. Virgin and Child enthroned between SS. Sebastian, James, Jerome, and George (the two centre saints kneeling), and inscribed: "Laurentius Costa MCCCCLXXXXII."

[2] Same church, on an altar, late of the Castelli. St. Jerome in a stone chair under a portico; he stops writing and looks down at the lion to the right. Panel, figure of life-size. Some barbarian in 1866 struck a nail into the middle of the panel to hang a small picture on. The hands here are coarse, bony, and cramped; the colour dark, rough, and in oil, and not free from retouching.

which seem done in company with Francia himself.[1] In 1499
he furnished the predella to Francia's altarpiece at the Miseri-
cordia, an Adoration of the Magi, now at the Brera ;[2] and he
produced likewise the lunette frescoes in the Bentivoglio chapel
at San Jacopo Maggiore, where his breadth of treatment in
setting and draping numerous figures of the Virgin and of
saints almost reminds us of Perugino.[3] The course of Costa
and Francia during these years was to a certain extent parallel ;
Costa, we think, was of use to Francia between 1480 and 1490,
and doubtless gave him many useful hints and much instruction.
Between 1490 and 1500 Francia rivalled and excelled his friend,
and Costa willingly followed where at first he had been the
leader.[4]

[1] Bologna, San Giovanni in Monte, Cappella Ercolani e Segni, of old Chedini;
done according to Vasari (iii. 136) in 1497. Virgin and Child enthroned, between
SS. Augustine, John the Evangelist, and two other saints; originally a fine work,
but dimmed by time and ill lighted.

In the same church, high altar. The Virgin between the Eternal and Christ,
with seven angels, two of whom hang the crown over the Virgin's head; at the
sides, SS. Sebastian, John the Evangelist, John the Baptist, Augustine, Victor, and
another saint. This also is a brown picture with a rich landscape distance, still
more in Francia's manner than the foregoing. [* The frame of this painting was
ordered in August 1500 (Gerevich, in *Rassegna d'arte*, vii. 183).]

[2] Milan, Brera, No. 429. Small panel, m. 0·67 high by 1·79. The Virgin to the
left in a chair, St. Joseph near her leaning on his staff; inscribed: "Laurentius
Costa f. 1499." This predella was once in the Misericordia at Bologna, and
belonged to Francia's Nativity in that church (see *postea*). The colour is olive,
the figures lean and slender, the landscape Umbrian. Laderchi in speaking of
this predella makes two mistakes (*Pitt. Ferr.*, pp. 46, 48). He supposes the
inscription to contain an allusion to Costa's being assistant of Francia, and he
supposes the picture to be the predella of Costa's altarpiece in the Pinacoteca of
Bologna, representing St. Petronius between two saints. The Adoration in the
St. Petronius is an imitated bas-relief on the pedestal of the throne.

[3] Bologna, San Jacopo Maggiore, Cappella Bentivoglio. Lunettes: (1) To the
left hand of entrance and at the sides of the window, five saints. (2) Above the
altarpiece of Francia, and an Annunciation by Cignani, a Vision of the Apocalypse
by Costa, with two figures to the right hand added by Felice Cignani in the
eighteenth century. (3) Virgin and Child between six saints, much injured and
restored. No doubt the cupola also was by Costa, but its ornaments were renewed
by Cignani. These paintings are so much in Francia's spirit that they have been
assigned to him by Kugler (*Handbook*, p. 265), yet they are undoubtedly Costa's,
the figures having his Ferrarese type and being draped in his peculiar fashion;
as to colour there is nothing to be said, the frescoes being in a bad state of
preservation.

*[4] There exists a record proving that Costa visited Rome in 1503. Venturi,
loc. cit., pp. 297 *sq.*

We know of no similar change of parts except in the relations of Raphael to Perugino or Timoteo Viti. The master in both cases shrank to the second place, and lost something of his power in doing so. It is not to be concealed that in the slender and dry figures of three or four sacred pictures done by Costa in 1502, 1504, and 1505, he fell to a lower rank than he had before held.[1] The Virgin and Saints of 1505 in the National Gallery is neatly arranged, graceful in the movement of the personages, and lively in colour; it reflects a ray of the greatness of the Bellinesques, but has not the masculine force of the Madonna of 1488.[2]

[1] Bologna, Pinacoteca, No. 65; originally Santissima Annunziata of Bologna. Panel, oil, figures three-quarters of life-size, gold ground. St. Petronius enthroned between SS. Francis and Dominic; on the step of the throne a bas-relief of the Adoration of the Magi; inscribed: "Laurentius Costa p. MCCCCCII." The figures are lean and dry, the tint generally dark and reddish. In this piece Costa may have been assisted by journeymen. No. 66. Lunette of Christ supported by angels in the tomb. This piece is catalogued in the Bologna Pinacoteca as by Costa. [* It is now labelled "School of Lorenzo Costa."]
 Berlin Museum, No. 115. Panel, 5 ft. 10 in. high by 4 ft. 5 in. Christ in his winding-sheet, bewailed by Simon, Nicodemus, and the Marys; inscribed: "Laurentius Costa. MCCCCCIIII." Not free from restoring, but carefully executed; the figures slender. No. 112. Presentation in the Temple. Wood, 9 ft. 10 in. high by 8 ft. 4 in.; inscribed: "Laurentius Costa f. 1502." Somewhat coarse, and retouched, but in the character of the foregoing. No. 114. Wood, 4 ft. 6 in. high by 3 ft. 1 in. Presentation in the Temple. Restored and feeble. [* In the current catalogue of the Kaiser Friedrich Museum this picture is ascribed to a Modenese master about 1520.]
 [2] London, National Gallery, No. 629. Wood, transferred to canvas. Virgin, Child, and angels, between four saints. Centre, 5 ft. 5½ in. high by 2 ft. 5 in.; sides, 1 ft. 9½ in. and 3 ft. 7 in. high by 1 ft. 10½ in.; inscribed: "Laurentius Costa f. 1505." This picture, originally in the Oratorio delle Grazie at Faenza, and subsequently in the Ercolani collection at Bologna, passed through the hands of Mr. Wigram at Rome, Mr. Van Cuyck, and M. Reiset before it came into English hands.
 We may add to this: (1) Bologna, Santissima Annunziata. Marriage of the Virgin. Panel, oil, figures half life-size; inscribed: "Laurentius Costa f. 1505"; of a dull tone, and much below the Madonna of the National Gallery. We are reminded here of Manni, Chiodarolo, and Amico Aspertini, the figures being small and coldly executed. (2) Sacristy of the same church. The Entombment; six figures in Costa's manner and imitating Francia, feeble, and by the painter's journeymen, possibly by the young Mazzolino, the figures being slender and highly coloured. [* These two pictures are now in the Pinacoteca at Bologna (Nos. 376 and 171).] (3) Bologna, San Martino. The Assumption. Arched panel, with figures less than life-size, assigned to Perugino, but by Costa in Francia's manner, perhaps with the assistance of Ercole Grandi or Timoteo Viti. [* Costa received a rate of payment for this work in 1506 (Gerevich, *loc. cit.*, p. 183, n. 2).]

In the oratory of Santa Cecilia alone Costa keeps a respect-
able level. Like the Brancacci at Florence and the Eremitani
at Padua, this chapel illustrates an entire period. After its
rebuilding by Giovanni Bentivoglio in 1481,[1] it was decorated in
succession by Francia, Costa, Chiodarolo, and Aspertini[2]; Costa's
share consisting of two frescoes, in one of which Pope Urban is
shown instructing his convert Valerian in presence of the faith-
ful, whilst in the other St. Cecilia distributes his wealth to the
poor. The compositions are good, animated, and telling; the
figures well set and expressive, of slender proportions, and not
without feeling; drapery cast in the Umbrian mould. Costa's
art, in fact, is to that of the Bolognese what Pinturicchio's was
to the Perugian. He is second only to Francia, with less
delicacy and harmony of tone, but with a more powerful
Ferrarese key of colour. Historians are unfortunately silent as
to whether during his stay at Bologna Costa came to Ferrara.
When we consider that the two cities are little more than
twenty-five miles apart, it seems not unlikely that Costa should
pay Ferrara an occasional visit without giving up his usual
residence at Bologna.[3] He would thus have constant oppor-
tunities of performing the commissions entrusted to him at
Ferrara, and so have finished at different dates the frescoes
at the Schifanoia,[4] those of the choir at San Domenico which

[1] Bologna, Santa Cecilia. (See Gualandi, *Guida di Bologna*, 1860, p. 98.)
The architect was Gaspare Nadi. The chapel is a rectangle, the long sides of
which are divided into five fields. The fourth field from the entrance on each side
is by Costa. Both of the frescoes are injured by damp, stains, and dust; both have
landscape distances; and the figures are almost of the size of life.

[2] With regard to the date of these paintings we may note that Anton
Galeazzo Bentivoglio states in a letter of Jan. 8, 1506, that Costa has been at
work for some time in the chapel of St. Cecilia (Luzio, in *Emporium*, xi. 359).
Moreover, Prof. L. Cavenaghi, who restored the frescoes in this chapel in 1874,
discovered the date of 1506 on the portal in the middle distance of the Conversion
of St. Valerian (Frizzoni, *Arte italiana del rinascimento*, p. 379). Towards the
end of 1506 Costa seems to have left for Mantua (cf. *postea*, p. 260, n. 4).

[3] On March 21, 1499, it was arranged that Costa in conjunction with other
painters should decorate the semidome of the choir of the cathedral at Ferrara;
but it is not known whether this scheme was carried into effect (Cittadella,
Documenti, pp. 69 *sqq.*). The same year, on September 11, Costa received pay-
ment from the Duke of Ferrara for a picture (A. Venturi, *loc. cit.*, p. 246; cf.
postea, p. 260, n. 1).

[4] Cf. *antea*, p. 250, n. 2.

have perished,[1] and others of which the locality is now uncertain.[2]
We may believe that his journeys to Ferrara were frequent and
irregular the more readily as his pictures there exhibit the
same changes as those which we have seen at Bologna.[3] In the
noble Madonna enthroned between saints at the Casa Strozzi, an
altarpiece once in San Cristoforo degli Esposti, his broadest style
is displayed with a strong Ferrarese tinge of surface and that
mixture of the Umbrian or Peruginesque in the figures and
drapery which marks his manner in the first years of the fif-
teenth century. Here, too, is the Ferrarese habit of over-
charging the architectural parts with bas-reliefs and medals.[4]
Equally good and of the same time is the Virgin on a rich
throne attended by two saints which passed from the Costabili

[1] Vasari, iii. 132.

[2] Ferrara. Amongst missing pictures are : (1) Portrait of Alfonso of Ferrara
as a child, *b.* 1476. (Baruffaldi, i. 108.) [* This was probably a work by Tura.
See A. Venturi, in the Berlin *Jahrbuch*, ix. 26.] (2) St. Jerome, once in Santa Maria
in Vado. (*Ibid.*, p. 110.) (3) A dead Christ with SS. Sebastian, Jerome, and Peter
Martyr in the Chiesa degli Angeli, of which it is said that part of the St. Jerome
is preserved in the Barbi-Cinti collection. (Laderchi, *Pitt. Ferr.*, p. 50.) [* The
editor does not know where this fragment is to be found at present.] (4) A Holy
Family, once in Sant' Antonio. (Baruffaldi, i. 122.) (5) Two Saints in San Vito.
(*Ibid.*) (6) Two Virgins in Santa Caterina Martire. (*Ibid.*) (7) The Entombment
in Santa Caterina of Siena. (*Ibid.*) (8) A Crucifixion and a Virgin and Child in
Sant' Agostino. (*Ibid.*) (9) A Pietà in San Gabrielli. (*Ibid.*)

[3] It is said that he visited Ravenna, where frescoes ascribed to him were shown
of old in San Domenico. (Baruffaldi, i. 123.)

[4] Ferrara, Marchese Strozzi. Wood, oil, figures life-size. In the spandrils of
the arch behind the throne, medallions with the Virgin and Angel annunciate,
below which, in imitated mosaic on gold ground, the Judgment of Solomon and
the Sacrifice of Abraham ; on the throne-plinth monochromes of Adam and Eve,
the Massacre of the Innocents, the Presentation, the Flight into Egypt, etc. The
saints at the sides are St. Guglielmo in armour and the Baptist. Since the
picture was taken from San Cristoforo it has lost much of its old brown patina.
[* This painting, which is now in the National Gallery (No. 1119), the lunette in
the Massari-Zavaglia collection (see *postea*, p. 260, n. 3), the frescoes on the
ceiling of a room in the Palazzo Scrofa-Calcagini at Ferrara, and a half-length
of St. John the Evangelist in the Budapest Gallery (No. 69) are all obviously by
the same artist. These works are characterized by so much vigour and breadth
of style that it seems impossible that Costa could be their author; they are now
generally ascribed to Ercole di Giulio Cesare Grandi, for whom the National
Gallery *pala* and the Scrofa-Calcaguini frescoes were first claimed by Morelli
(*Die Galerien zu München und Dresden*, pp. 184 *sq.*). But where are we to look
for a clue to Ercole di Giulio's style if we are not to accept as his work the
St. George in the Palazzo Corsini iu Rome ?]

collection into that of Lord Wimborne in England.[1] More in the
Umbrian mode of Pinturicchio are the small panels with legend-
ary incidents in the Costabili Gallery,[2] whilst the lunette Pietà
in the Casa Saroli is in the spirit of Francia.[3]

It was Costa's fortune after the expulsion of the family of
Bentivoglio from Bologna, and therefore after the loss of his
most powerful patron, to receive offers of service from the
Gonzagas of Mantua. The Marquis Francesco offered him a
large salary and a house in 1509, made him superintendent of
the painters at his court, and employed him in Triumphs and
portraits.[4] He remained uninterruptedly at Mantua till his
death in 1535, and produced there about as much as he had
already produced in Bologna and Ferrara together; but in the
course of centuries the calamities which befell Mantua were

[1] Canford Manor, Lord Wimborne, formerly in the Costabili collection. Can-
vas, lately restored by the removal of varnishes and retouches in tempera.
Virgin and Child life-size, with two angels playing instruments on the arms of the
throne, and two others behind them, and the usual accompaniments of bas-reliefs
and statuettes. This picture was formerly in the Collegio del Gesù. The mantle
is fastened at the shoulder with a brooch, representing the eagle of the family of
the Estes. This may therefore be a canvas, purchased by the Duke of Ferrara in
1502, of which there is a MS. record in existence. (MS. favoured by Marquis
Campori.) [* The date of the above record is 1499; A. Venturi, in *Archivio
storico dell' arte*, ser. i. vol. i. p. 246.] In this picture, the Child and the saint to
the right hand turbaned and holding three nails in his hand are quite
Peruginesque.

[2] Ferrara, Costabili collection. (1) A Combat; (2) a female led to the presence
of an armed captain. Free, even neglected in treatment. In the same place,
(3, 4) Angel and Virgin Annunciate, very graceful little pieces. From the same
collection, in possession of Lady Layard in Venice, the Adoration of the Shep-
herds. [* The editor has not been able to trace the four preceding pictures.]

[3] Ferrara, Professor Saroli [* now Duca Francesco Massari-Zavaglia]. Lu-
nette. Pietà, on panel, with half-lengths of SS. Bernardino and Francis at the
corners; said to be a part of the altarpiece belonging to the Marquis Strozzi, and
yet here the treatment and spirit are not of the same period of Costa's career as
the altarpiece in question. The colours are very glossy, and well preserved.

* [4] On Nov. 16, 1506, only a few days after the Bentivoglii had been driven
away from Bologna, Isabella d'Este, Marchioness of Mantua, invited Costa to come
to Mantua (Luzio, in *Emporium*, xi. 427). Costa was not long in accepting the
invitation; in April 1507 we find him at work in the palace of San Sebastiano at
Mantua (A. Venturi, *Archivio storico dell' arte*, ser. i. vol. i. p. 251, n. 5). While
still at Bologna Costa had between 1504 and 1506 executed a painting for the
studio of the Marchioness—no doubt identical with the Poetic Court of Isabella
d'Este now in the Louvre (see *postea*, p. 261, n. 3). Cf. Yriarte, in *Gazette des
Beaux-Arts*, ser. iii. vol. xv. pp. 330 *sqq.*, and Luzio, *loc. cit.*, pp. 358 *sq.*

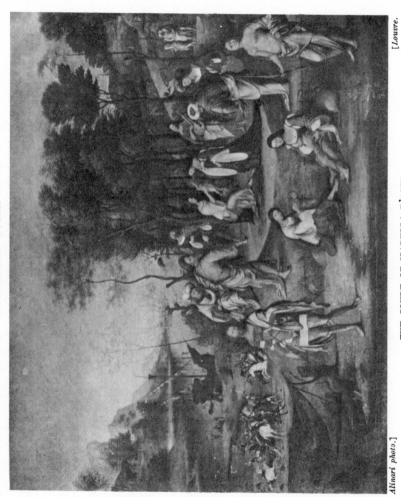

THE COURT OF ISABELLA D'ESTE.

II. 260]

peculiarly fatal to his pictures, and we can almost count them
now on the fingers of one hand.[1] One of them, the Virgin and
Child between two Saints in the Gallery of Ferrara, was pre-
served because it was a commission for a Veronese church ;
another, the allegory of Isabella's poetic court, reproduced in
these pages, was purchased by Cardinal Richelieu, and passed to
the museum of the Louvre ; a third, a small diptych, with the
Nativity and Christ in the Tomb, had its last resting-place in the
collection of the late Sir Charles Eastlake ; a fourth, a Madonna
and Saints of 1525, was presented by Costa himself to the
church of Sant' Andrea at Mantua. In the first of these we
perceive a mixture of the Ferrarese and Mantuan, and some-
thing that recalls Bonsignori[2] ; the Court of Isabella is a
scattered composition half inspired from Mantegna's allegories,
and imitating in a certain measure his classicism of attitude and
slenderness of form, but Umbrian also in the affectation of the
poses, and somewhat monotonous in its yellow-brown tone.[3] The

[1] See the records of his appointment at a salary of 669 lire and notices of his
works at Mantua in D'Arco, *Delle Arti Mantov.*, *ub. sup.*, i. 62, ii. 78–9, 156–9, 182,
and Vasari, iii. 134 *sqq.* According to the latter author the subjects of Costa's
paintings in the palace of San Sebastiano were as follows: (1) the Marchioness
Isabella surrounded by singing and playing ladies of her court ; (2) the fable of
Latona and the frogs ; (3) the Marquis Francesco led by Hercules on the road
of virtue ; (4) Francesco on a pedestal surrounded by his suite ; (5) a sacrifice to
Hercules (this picture contained portraits of Francesco Gonzaga and his sons
Federico, Ercole, and Ferrante); (6) the Marquis Federico as General of the
Holy Church. It is moreover recorded that the Gonzagas once possessed two
pictures of incidents in the story of Coriolanus, a St. John in the Desert, a St.
Sebastian, and eight scenes from the Old Testament by Costa. (D'Arco, *ub. sup.*,
ii. 156 *sq.*, 159, 182.) [* The painting of the Marquis Federico as General of the
Church, signed " L. Costa f. MDXXII," is now in the collection of Prince Clary-
Aldringen at the Castle of Teplitz. Schaeffer, in *Monatshefte für Kunstwissen-
schaft*, i. 765 *sqq.*]

[2] Ferrara Gallery, Sala II. Wood, figures half life-size. Virgin and Child
between St. Jerome and a bishop, perhaps by a pupil of Costa and Bonsignori. A
picture in the Sala III. of the same museum, representing the Virgin adoring the
Child and Saints, is not by Costa. [* Prof. A. Venturi has shown that the former
painting is by Pellegrino Munari of Modena and that it was once in the church
of Santa Maria della Neve in that town. Pellegrino Munari, who is mentioned
also by Vasari (iii. 649 *sqq.*), died in 1523. See *Archivio storico dell' arte*, ser. i.
vol. iii. pp. 390 *sqq.*]

[3] Louvre, No. 1261. Canvas, m. 1·58 high by 1·93; inscribed: " L. Costa f."
[* This is obviously the picture executed by Costa for the studio of Isabella
d'Este between 1504 and 1506 (cf. *antea*, p. 260, n. 4). For an interpretation of

diptych is a pretty little miniature touched with great firmness, highly finished, and of bright and polished surface, betraying as it were some passing impression produced by the study of Venetian art[1]; the Madonna of Sant' Andrea, though greatly injured, still shows how deeply affected Costa had been by Umbrian models.[2]

We might almost conjecture that he had a share in certain frescoes in Mantegna's chapel at Sant' Andrea,[3] and in the room called the Schalcheria at Mantua.[4] We should remember also that he may claim to have been the author of a portrait at the Uffizi which purports to be Isabella of Mantua by Mantegna, and which we have been inclined to assign to Bonsignori.[5] It is a likeness which certainly does not bear the stamp of Costa as

the subject, see Förster in the Berlin *Jahrbuch*, xxii. 171 *sq*. Another painting, also now in the Louvre (No. 1262) and formerly in the studio of Isabella, was probably begun by Mantegna and completed by Costa (see *antea*, p. 115, n. 4).]

[1] London, collection of the late Sir Charles Eastlake. To the left in the Nativity a kneeling figure. In the second composition, Christ in the Tomb supported by angels, with St. Jerome penitent to the left hand; Calvary and St. Francis receiving the Stigmata in the distance. The figures are thin and slender, but in Costa's most chastened manner, the colour powerful and bright. [* This picture now belongs to the National Gallery (No. 1411), where it is ascribed to Ercole Roberti; and in the opinion of the editor the colouring, the forms (note especially the long narrow hands), and the types point decidedly to him and not to Costa as the author of this work.]

[2] Mantua, Sant' Andrea, Cappella San Silvestro. Virgin and Child between SS. Sebastian, Silvestro, Roch, and two others. Canvas, oil, life-size; inscribed: "A. D. MDXXV. L. Costa fecit et donavit." The composition is not without grandeur, and there is life in the figures. The colours have lost their freshness and are now very dim.

[3] Mantua, Sant' Andrea. Four Evangelists in the angles of the ceiling; much injured, and recalling in a certain measure Costa. (See *antea*.)

[4] Mantua, Castello, Schalcheria. Ceiling with ten medallions containing heads of emperors and females, and others simulating bronze reliefs with incidents of Roman history; also fourteen lunettes with hunts and episodes from the fable of Diana. These are well composed and more chastened than the work of Giulio Romano, to whom they are usually assigned. The figures are elegant and slender; the colouring is soft, and on the whole seems a mixture of the styles of Lorenzo Costa and Caroto.

[5] Uffizi, No. 1121. This cannot be the portrait mentioned by the Anonimo as having been sent to Venice to the Marquis Francesco when he was a prisoner there. That portrait was a joint one of Isabella and her daughter. It was in the Anonimo's time in Casa Jeronimo Marcello. (Anonimo, pp. 67, 202.) [* The Anonimo's words are somewhat obscure; but it seems as if they must be interpreted as meaning that two separate portraits were sent to the imprisoned Marquis, one of his wife and one of his daughter. We know from contemporary records that he wanted to have a copy of a much-admired portrait of Isabella

unmistakeably as the fine one at the Pitti, in which the strong
brown tone, broad treatment, and successful modelling of the
master's best period prevail.[1]

Costa, at his death in 1535, left an entire family of craftsmen
in Mantua, some of whom served under Giulio Romano; we
shall not dwell upon their lives and works, which may be found
registered in the local history of Mantua. It is of more interest
to notice the pupils whom Costa left behind on his retiring from

which had been executed by Costa in 1508 (Luzio, *loc. cit.*, pp. 355 *sq.*). It seems
possible that a portrait shown in the Collection of Coins and Medals at Vienna is
a reproduction of that painting (*ibid.*, p. 435).—The above-mentioned picture in
the Uffizi represents, as we have seen (*antea*, p. 186, n. 4), Elisabetta Gonzaga,
Duchess of Urbino.—The following works by Costa may also be noticed: (1)
Berlin, Kauffmann collection, St. Jerome. (2) Berlin, Wesendonck collection. The
Holy Family with Saints. Signed " L. Costa f." (3) Bologna, Pinacoteca, No. 215.
The Virgin and Child between SS. Petronius and Thecla. Originally in Santa Tecla
at Bologna. (4) Budapest, Picture Gallery, No. 124. Venus. (5) Dublin, National
Gallery of Ireland, No. 526. The Holy Family. (6) Florence, Uffizi, No. 1559.
St. Sebastian. (7) Hampton Court, No. 295. Portrait of a Lady. (8) London,
National Gallery, No. 2083. Portrait of Battista Fiera of Mantua. (9) London,
Mr. R. Benson. The Dead Christ; The Baptism of Christ. (10) Mr. H. Yates
Thompson. Two Miniatures in Albani Missal.]

[1] Florence, Pitti, No. 376. Wood, m. 0·19 high by 0·15. Half-length of a man in
a red cap, with falling hair, a chain, and green dress (retouched in the cheek and
hair); inscribed: " Laurentius Costa f." This fine portrait is of a strong tone, a
little raw in touch; the forms are well defined and modelled. It is a question
whether this is not the so-called portrait of Giovanni Bentivoglio, once in the
Isolani collection at Bologna, but described by Lanzi as having the signature
" Laurentius Costa. Franciae discipulus." At all events the addition of " Franciae
discipulus " is not on the portrait at the Pitti, and Lanzi doubted its genuineness
in the portrait of the Isolani collection.

We may catalogue as not seen, or missing, the following: (1) Bologna, alla
Misericordia. St. Sebastian, in oil, dated 1503 (?). (Lamo, *Graticola*, p. 14.)
(2) San Tommaso. Virgin, Child, SS. Proculus, Bartholomew, and others; sold
1832. (Baruffaldi, i. 112.) (3) Santa Maria della Mascarella. Resurrection.
(*Ibid.*) (4) San Lorenzo de' Guerini. Virgin, Child, SS. Lawrence, Jerome, and
angels. (*Ibid.*, p. 113.) (5) San Francesco. Nativity with SS. James and
Anthony of Padua. (Vasari, iii. 136.) (6) Signor Testa, from the Certosa of
Ferrara. Pietà. (Baruffaldi, i. 121.) (7) Biblioteca dell' Istituto di Bologna.
Portrait of Andrea Bentivoglio and Elena Duglioli; not seen. (Litta. cit. in
notes to Baruffaldi, i. 120.) (8) Carpi, San Niccolò, and afterwards in the collec-
tion of Conte Teodoro Lecchi, but not there now. St. Anthony of Padua, be-
tween SS. Catherine and Ursula. (*Cronica del Pad. Gio. F. Malazappi.* Passavant,
Raphael, i. 97, and Campori, *Gli artisti*, p. 168.) (9) Mantua, Sant' Andrea.
Adoration of the Magi, and Nativity; two large pictures. (Donesmundi, *Ist.
Eccles. di Mantua*, lib. vi. No. 46.) (10) Correggio, San Francesco. St. Anthony
the Abbot. (Campori, *Gli artisti*, pp. 168–9.)

Bologna, the most interesting of whom, no doubt, is Ercole di Giulio Grandi.[1]

We have already given an outline of Grandi's life in the attempt to distinguish him from Ercole Roberti Grandi. He is, no doubt, the disciple of Costa ; but even as such he inherits the art derived by Costa from Francia, and not that of Costa's earlier and more exclusively Ferrarese period. There are two pieces which may be cited as typical of Ercole ; these are the martyred St. Sebastian with saints and three kneeling patrons in San Paolo at Ferrara, and St. George fighting the Dragon in the Palazzo Corsini at Rome. At the sides of the St. Sebastian an aged saint leans on a staff and St. Fabian halts in prayer; the martyr himself standing on a bracket bound to the trunk of a tree in a landscape of Venetian air. The principal novelty in this picture is attributable to its combination of Umbrian and Ferrarese features; the bright sharp colour with its enamel surface being distinctly Ferrarese, whilst the slenderness and neatness of the figures with their soft look and gentle movement are Peruginesque in the mode of Costa. This is very noticeable in the St. Sebastian as well as in the two standing saints; the patrons are also small and dry in shape, but well made out and with a good portrait-character, reminding us by precise outlines of Timoteo Viti's altarpiece in the Duomo of Urbino.[2]

The St. George, on the harness of whose horse Ercole placed his monogram, is also Umbrian in the cold gentleness of its aspect[3]; and yet brings up reminiscences of Filippino Lippi, so

* [1] Ercole di Giulio Cesare Grandi offers at present a very difficult problem to art-criticism, the solution of which must be left to future research. If, in common with most connoisseurs of to-day, we do not accept the St. George in the Palazzo Corsini as a work by this master, then there is no painting which can be ascribed to him even on any semblance of documentary evidence.

[2] Ferrara, San Paolo. [* Now Gallery, Sala VII.] Wood, oil, figures under life-size ; in the distance the Flight into Egypt. This picture is correctly assigned to Ercole Grandi. We note here how the saint, leaning on his pole, bends to one side as Costa's figures frequently do. The landscape is strong and sombre in tone. The surface, however, is slightly changed by dust and dirt.

[3] Rome, Palazzo Corsini, Galleria Nazionale, No. 712, with the monogram G_I

on the horse's hind-quarter. Small panel, 2 ft. 4½ in. high by 1 ft. 9½ in., well preserved, oil. We remember that there is a fine Filippino in San Domenico of Bologna.

* Morelli ascribed this picture to Francesco Francia (*Die Gallerien Borghese und Doria Panfili*, p. 253), and has been followed by many critics ; as to the monogram,

gay and lively is the play of its tones. The horse is heavy in shape, but grace dwells in the kneeling female, and a pleasant variety in the lines of the landscape. The finish and polish of this little miniature are very remarkable. If we could conceive Grandi at some period of his youth to have been more distinctly Ferrarese than he appears in the works we have named, he might be mentioned as probable author of the St. Dominic ascribed to Zoppo at the National Gallery, and companion pieces at Ferrara and Dresden.[1] He may also be the painter of the small panel at Dudley House, representing the Gathering of the Manna, of which there is an old copy at Dresden [2]; but in his late manner, and when he imitates Costa, his style is easily distinguished in a number of small pieces which have come into the hands of English collectors from Ferrara or have remained in Ferrara itself.[3] One of his Madonnas we have seen in Casa Nordio at Padua with a forged signature of Giovanni Bellini.[4]

it has been suggested that it might signify "Eques Georgius." In the opinion of the editor, however, the picture under notice differs on many essential points from the style of Francia; while it comes close to the little Nativity ascribed to Ercole in the Ferrara Gallery (Sala III. ; see *postea*, n. 3).

[1] London, National Gallery, No. 597. Ferrara, Casa Barbi-Cinti. Dresden Museum, No. 43. (See *antea* in Baldassare.)

[2] (1) London, Dudley House. Small panel. To the left hand Moses with his rod, seven figures gathering the manna in bags and baskets, a woman with a child, distance of houses with many figures. The personages are all well formed, slender, and in good drawing ; the heads a little round and high in forehead—a Ferrarese peculiarity ; the colours strong and sharp, highly fused and a mere film in the distance. Here we are reminded of the Umbrians and of Timoteo Viti. [* This picture is now in the National Gallery (No. 1217). Morelli (*Die Galerien zu München und Dresden*, p. 181) ascribed it to Ercole Roberti, and his view seems to be fully justified by the types and forms of the figures, their movements, the colouring, etc.] (2) Dresden Museum, No. 47. Wood, 1 ft. high by 2 ft. 4 in.

[3] (1) London, Mr. Barker. St. Michael with the balance, erect, in a landscape. Wood, oil, figures one-quarter life. St. Francis ditto, the latter spotted in flesh. [* Present whereabouts unknown.] (2) Venice, Lady Layard. Small panel, oil. Virgin and Child between St. Dominic and St. Margaret; in a landscape, in front, a monkey. From the Costabili collection. Warm in tone and treated with a certain ease. (3) In the same collection, Moses and the Israelites coming into Egypt, with some dancing females that recall those of Mantegna. Israelites gathering the Manna. These are two small canvas temperas, from the Costabili collection, of which there are six companion pieces still in that repository; namely: 1°, the Death of Abel; 2°, the Expulsion; 3°, the Creation of Eve; 4°, the Temptation;

For note 4 see next page.

To Panetti and Coltellini, the last of the Ferrarese of whom we shall treat in this place, but a few lines can be devoted. We are told of the first that he was born about 1460.[1] He died in 1511–2.[2] He was a contemporary of Costa, and according to Vasari the master of Garofalo.[3] His earliest productions betray the teaching of Bono Ferrarese. As he progressed, he came nearer to Costa in his Umbrian phase; his figures are dry and bony, as well as rigid and stilted; but they are outlined with extreme precision and carefulness. Peculiarly his own is a varnishy surface of reddish flesh tone, hardened by the use of grey shadow and a minute finish in rich and varied landscapes that gives to these portions of his pictures undue importance.

5°, Moses striking the Rock; and 6°, the Lord appearing to Moses. With the exception of the latter, which seems to have been done anew by a pupil of Garofalo, these are all in the character of Grandi. Adam in the Temptation is injured. [* At present No. 1 is in the Galleria Morelli at Bergamo; Nos. 2–5 belong to the Marchese Visconti-Venosta of Rome, while No. 6 is untraceable. Prof. A. Venturi suggests (*L'Arte*, iii. 201) that these are the eight pictures of subjects from the Old Testament ascribed to Costa in the inventory of the works of art belonging to the Marquis of Mantua in 1665 (D'Arco, *ub. sup.*, ii. 182).] (4) Ferrara Gallery, Sala III. Nativity. Small panel, in oil. The Child lies on the ground in a landscape between the Virgin and a kneeling shepherd, St. Joseph to the right hand seated in thought. In the sky are three angels. The style is like that of the foregoing, that of Grandi approaching to that of Mazzolino; the colours gay, lively, and glossy. [* Closely allied in style to this picture is a large Annunciation in the collection of Sir F. Cook at Richmond.] (5) Ferrara, Signor Francesco Mayer. Same subject, small panel, but here the shepherd and St. Joseph stand.

⁴ (1) Padua, Casa Nordio. Virgin and Child in front of a green curtain, St. Joseph behind to the right hand. Panel, half-length; signed: "Joannes Bellinus F. 1408." Figures one-third of life. There are other Madonnas of the same kind; *e.g.*: (2) Padua, Conte Leon Leoni. The Virgin with the Child on her lap offering a piece of fruit, the Child holding a bird; distance, landscape with St. Jerome in a cave to the right hand; half-length, half-size of life; purchased from the General of the Camaldoles at Rome in the nineteenth century. (3) Rome, Gallery of the Capitol, No. 142. Female portrait, three-quarters to the left, in a red dress with slashes, her hair in a net. This seems to be by our Grandi, though ascribed to Giovanni Bellini. [* This picture is now labelled Ercole di Giulio Grandi.] (4) London, National Gallery, No. 73. The Conversion of St. Paul. Wood, 1 ft. 11 in. high by 2 ft. 3 in. This looks almost too modern for Ercole, but if by him must have been one of his last productions. (5) Naples, Signor Gaetano Zir. Two small panels with allegorical subjects, one of them a dance in which seven males and females take part. These panels are very carefully finished, not free from retouching, and recall at once the schools of Mantegna and Francia. The treatment is like that of an artist accustomed to the use of the graver.

¹ Baruffaldi, i. 181–94. ² See notes *postea*.

³ Vasari, vi. 458.

In this and the use of strong contrasts in dresses he recalls the Cremonese. In other respects he may remind us of the Faventine Bertucci, or the followers of Pinturicchio. One of his youngest efforts is in the sacristy of the Duomo at Ferrara [1]; the only one of his works in foreign galleries is the Dead Christ bewailed by the Marys in the Museum of Berlin.[2] Of Coltellini we may

[1] Ferrara, Duomo, sacristy. Wood, oil, with figures one-third of life-size. Virgin and Child enthroned, with two small figures of donors kneeling at the sides, and a landscape distance; inscribed: "Dominicus Panetus." Low-toned dull picture; ugly types, recalling the Flemings.

[2] Berlin Museum, No. 113. Wood, 6 ft. 3 in. high by 4 ft. 7 in., originally in San Niccolò of Ferrara; inscribed: "Dominici Paneti opus." The kneeling figure to the right hand is that of the donor; distance, landscape.—We add the following: (1) Ferrara Gallery, Sala II. Canvas, figures half-life. Annunciation, inscribed: "Domenicus Panetus pingebat." This is better than the old organ-shutters now in the choir of Sant' Andrea at Ferrara, representing the Virgin, the Angel, St. Andrew, and St. Augustine (canvas). [* The latter are at present also in the Ferrara Gallery (Sala II.).] (2) Ferrara Gallery, Sala VI. Visitation. This is an Umbrian composition in the fashion of Santi's at Fano. (3) Sala VII. Half-lengths of St. Helen and St. Stephen; these last very glossy and finished in Panetti's best manner. (4) Sala VIII. St. Andrew erect. Panel, oil, life-size. This is the best of Panetti's works, of better form and face than most; inscribed: "Dominicus Panetus." (5) Ferrara, Galleria Costabili. Here are eight pieces by Panetti: 1°, Transit of the Virgin, canvas, figure one-quarter of life-size; 2°, Presentation in the Temple; 3°, half-lengths of St. Job, St. Anthony, and a bishop, fragment; 4°, Deposition, small panel; 5°, Virgin and Child, the Child injured; 6°, St. Jerome, half-length, fine for Panetti; 7°, Virgin and Child, the latter holding a chalice, the former a book; 8°, Virgin and Child, half-length, behind a parapet, hard ruddy tone. [* The Deposition (4°) belongs now to the Ferrara Gallery (Sala III.); where the other of the last-mentioned paintings are to be found at present is not known to the editor.] (6) Ferrara, Conte Mazza: 1°, Virgin and Child; 2°, Virgin and Child between the Baptist and two Saints, St. Jerome and three other saints, fragments. [* These pictures can no longer be traced.] (7) Ferrara, Professor Saroli [* now Duca Massari-Zavaglia]. Ecce Homo. (8) Rovigo Gallery, No. 152. Nicodemus holding the Nails and supporting the dead Saviour; St. John the Baptist and St. Lucy. Panel, oil, figures half life-size; the Baptist injured. (9) Louvre, No. 1401. Nativity; a cold painting, recalling the styles of Francia and Costa, a little more modern in air than Panetti.

Domenico Panetti was the son of Gasparo "de Panetis" of Ferrara; the date of his birth is uncertain. He married in 1503, the year in which, according to Baruffaldi (ub. sup., i. 187, 193), he painted a St. Job, inscribed "Dominicus Panetius 1503 Klis Aprilis"; and a Virgin and Child between SS. Anthony, Job, Peter, and Vito, signed "Dominicus Panetus cepit anno Nativitatis Domini MDIII. Kalendis Aprilis." [* This picture is now in the Kauffmann collection at Berlin. See Harck, in Archivio storico dell' arte, ser. i. vol. i. p. 103.] In 1509, to the order of Alfonso I., he painted the frescoes in the chapel of San Maurelio at San Giorgio extra muros of Ferrara. In 1511 (Sept. 5) he received

notice the Christ on the Lap of the Virgin at Dresden, assigned
to Squarcione, in which the hard bony forms and broken drapery
are almost Flemish in aspect; the distance of rocks being cut
up into strange and incongruous shapes very characteristic of
the Ferrarese.[1] The oldest authentic panel by this painter is the
Death of the Virgin, dated 1502, in possession of Count Mazza
at Ferrara, a quaint and unattractive cento of the Ferrarese and
Flemish.[2] In a Madonna with Saints, finished four years later,
at Sant' Andrea of Ferrara, his style is a mixture of that of Costa
and Francia[3]; and in 1542, the date of a Virgin and Child with
Saints in the Ferrara Gallery, he is a follower of Panetti and
Garofalo.[4]

payment for a banner representing, on one side, a skeleton of Death, on the other
a Virgin and Child. The banner was done for the brotherhood della Morte at
Ferrara. In February (17th) 1513 his widow had married again. (See the records
in L. N. Cittadella, *Documenti ed Illustrazioni risguardanti la Storia artistica
Ferrarese*, 8vo, Ferrara, 1868, pp. 46–8.)

[1] Dresden Museum, No. 149 A. Wood, 2 ft. 5 in. high by 1 ft. 10 in. [* In
the current catalogue of the Dresden Gallery this picture is ascribed to an unknown
Ferrarese painter of the sixteenth century.]

[2] (1) Ferrara, Conte Mazza. A raw hard dry piece, without relief, brownish
yellow in flesh, the dresses in deep heavy tints, the masks repulsively ugly;
inscribed : " Michael de Cultellinis MCCCCCII." In the sky, the Virgin's soul in the
arms of Christ. Small panel. [* This painting belonged subsequently to Signor
Santini of Ferrara, and is now in the Pinacoteca at Bologna.] (2) Ferrara, Signor
Mayer. Life-size figure of St. Peter. Panel as above.

* The Kaiser Friedrich Museum at Berlin possesses a picture of the Risen Christ
between four Saints (No. 1115 A), signed " Michaelis Cortelini opus. MCCCCCIII.
pestis tempore."

[3] Ferrara, Sant' Andrea. The Virgin and Child between SS. Michael, Catherine,
John, and Jerome ; inscribed : " Michaelis Cortelinis MCCCCCIIIIII." [* This picture
was in 1903 in the Santini collection at Ferrara, which has since been dispersed;
its present whereabouts it not known to the editor. It is reproduced in *L'Arte*,
vi. 144.]—Baruffaldi mentions a Martyrdom of St. Lawrence in this church, dated
1517, which has perished (i. 159).

[4] Ferrara Gallery, Sala VI. ; originally in Santa Maria del Vado. Virgin and
Child and young Baptist, with several saints, and lower down SS. Agatha,
Appollonia, and Lucy, dated " MDXLII." This picture has no name, but may
well be by Coltellini. An autograph inventory of the effects which Coltellini gave
his daughter as a dowry in 1532 exists in the archives of Ferrara (see Cittadella,
Notizie, ub. sup., p. 601 ; and for notices of Coltellini's family, the same author's
Documenti, etc., *ub. sup.*, p. 117).

CHAPTER VIII

FRANCESCO FRANCIA [1]

ACCORDING to a sixteenth-century tradition, Francesco di Marco Raibolini, commonly known as "il Francia," was born at Bologna in 1450.[2] Having been apprenticed to a goldsmith, he slowly rose to eminence in his profession, matriculating in 1482, and steward of guild in 1483.[3] Appointed master of the mint to the reigning family of the Bentivoglio, he gained a respectable name as an artist in dies, silver ornaments, and niello.[4] At what period he directed his attention seriously to painting has not been ascertained, but he was probably no stranger even as a journeyman to a practice common amongst Italian goldsmiths, and familiar to such men as Pollaiuolo, Verrocchio,

[1] Before treating of Francia, it would be necessary to touch on Antonio da Crevalcore, of whom Bumaldi (*Minervalia, ub. sup.*, p. 243) gives us some notices. He was a painter of fruit and flowers, and lived, says the author above quoted, about 1480. The half-length Madonna with the Child on a parapet, St. Joseph and a profile of a donor, in the Gallery of Berlin (No. 1146), is the only one of his pictures with which we are acquainted. It is signed: "Opra de Antonio da Crevalcore 14. 3" (? 93). His style here is not unlike that of Bernardino of Perugia.

[2] Vasari (iii. 533) states this as a fact; but further: no goldsmith could be steward of his guild before the age of thirty, and Francia held this office in 1483: see *postea*, and see also Calvi (J. A.), *Memorie*, etc., *di F. Raibolini*, 8vo, Bologna, 1812, p. 6.

[3] *Ibid.* He was steward of the goldsmiths (Massaro) in 1483, 1489, 1506–8, and 1512, and "steward of the four arts" in 1514.

[4] He was not only mint-master to the Bentivoglio, but also to Julius II. at Bologna (Vasari, iii. 535 *sq*.). Two niello pax by Francia are in the Academy of Arts at Bologna; but see as to this, and as to the dies for Bolognese coins by Francia, Cicognara's *Memorie*, and Gaetano Giordani's essay on the "Money of Julius II." in the Almanack of Bologna for 1841.

and Botticelli.[1] The goldsmith's atelier was never exclusively
confined to works of silver, gold, or bronze, and it was open to
every person who was free of that guild to be a sculptor or a
painter.

Francia, according to some, may have been taught by Marco
Zoppo, but if we compare the styles we see nothing to confirm
such a theory.[2] It is much more likely that Francia was
encouraged to the study of tempera and oils by Lorenzo Costa ;
and that he owes to that master his first instruction in the
secrets of colour. From Costa he derived something of the
Ferrarese quality in producing ruddy flesh and glossy sharpness
of contrasted tints ; from the goldsmiths, polished surface, clean
outline, silvery reflections, and chiselled detail. A short interval
of probation enabled Francia to equal and then to surpass Costa ;
and ten years before the close of the century he was to be reckoned
the most able draughtsman and composer, not only at Bologna,
but in all the cities on the banks of the Po. From the day on
which his name first emerged into notoriety, he showed a distinct
Umbrian character in the form of his art, and it has been justly
said by Vasari that his panels and those of Perugino displayed
a novel spirit and softness.[3] Of the mode in which this new
spirit expanded in Perugino, we have had occasion to speak ; it
was the fruit of a happy combination of Umbrian and Florentine
habits. How it expanded in Francia would be a mystery if we
did not know that towards the close of the fifteenth century the
pictures of Perugino were carried to Bologna. It may be the
fortune of future historians to prove that ties of friendship united
Francia and Vannucci ; at present we see no cause for Francia's
adoption of the Peruginesque style except in Francia's study
of Perugino's works. But the Umbrian in Francia was not
an early impress; it came some time after he had begun seriously
to paint, and there are two or three pieces which very clearly

[1] Vasari says that Francia " having known A. Mantegna and other painters,
determined to try if he could not succeed with colours." He might chance to meet
Mantegna at Bologna, who, as we know, visited that city in 1472.

[2] Malvasia (*Felsina Pittrice*, i. 35) holds that Zoppo was the master of Francia,
and Baldinucci (*Opere*) shares this error, which has been accepted by Calvi,
ub. sup., p. 8.

Vasari, Proemio, iv. 11.

FRANCESCO FRANCIA

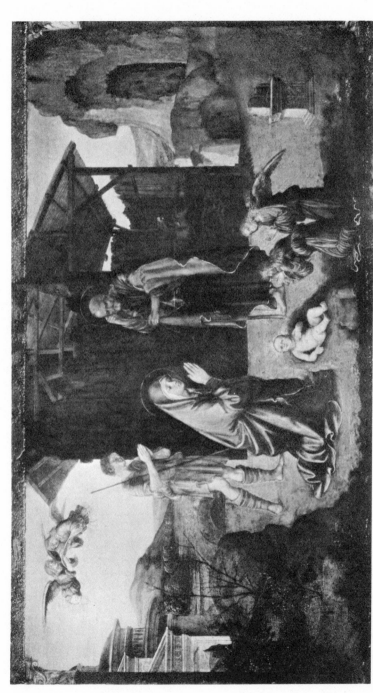

Hanfstaengl photo.]

[*Glasgow Gallery.*

THE NATIVITY.

IL. 270]

illustrate his pre-Peruginesque period.[1] A likeness assigned to
Raphael in the Northwick collection is one of these[2]; the Virgin
and Child with St. Joseph in the Berlin Museum is another;
St. Stephen kneeling in deacon's dress at the Borghese Gallery
in Rome is a third.[3] The two first are peculiarly interesting
as proof of the intimacy which existed between Francia and
Bartolommeo Bianchini, a Bolognese senator, not unknown in the
sixteenth century as a collector and a contributor to light literature
and poetry. In a Life of Codrus he eulogizes Francia's talents
with the fulsome flattery of that age. He is represented holding
a letter on which his name appears. At Berlin the parapet on
which the Virgin supports the standing Child bears a motto
allusive of the friendship which united him to Francia.[4] It is
characteristic of all these pieces, but especially of those at Berlin
and at Rome, that they betray the hand of a goldsmith not only
in the metallic surface, tone, and reflections of the flesh, but in
the cleanness of the contours; the hairs of the head might be

[1] Florence, Uffizi. It has been usual to assign to Francia a small cartoon, half-
length portrait of a man in a cap, in this collection (Vasari, Com. iii,. 557, 563),
and a probable date, 1486, has been given to it; on a tablet to the left hand of the
head one reads: "M[r] Alex[r] Achillin[o] an. XXIII." The drawing is Bolognese, but
has not the sharpness and firmness of outline we expect from Francia. The
tablet and its inscription are comparatively modern, and the date is a mere
presumption.

[2] England, late Northwick collection. Panel, bust, 1 ft. 3⅜ in. broad by 1 ft.
9⅜ in. Portrait, three-quarters to the right, injured by flaying; distance, landscape.
[* This picture is now in the National Gallery (No. 2487).]

[3] Rome, Borghese Gallery, No. 65. Wood, figure one-third of life-size; the
saint kneels in profile in an opening between two pillars, with a landscape dis-
tance. The hands and face are a little abraded; inscribed on a cartello to the left
"Vincentii Desiderii votum Frācie expressum manu."
We note also in this gallery, besides No. 61, Virgin and Child, panel, and
No. 57, half-length of St. Anthony, a little under life-size, a well-preserved figure
—not by Francesco, to whom it is assigned, but by Giacomo. A Virgin and Child,
also called Francesco Francia, is in the manner of Boateri.

[4] Berlin Museum, No. 125. Wood, oil, 1 ft. 9 in. high by 1 ft. 3¾ in., from the
Solly collection. The Virgin holds the Child erect on a stone parapet, St. Joseph
at her side; distance, a hilly landscape; inscribed: "Bartholomei sumptu Bianchini
maxima matrum. Hic vivit manibus Francia picta tuis." The surface is of a
vitreous enamel—perfect preservation. [* With these works we may also class
a Crucifixion in the library of the Archiginnasio at Bologna. A Nativity in the
Glasgow Gallery (No. 369), which shows the artist while still in possession of very
undeveloped powers and strongly influenced by Ferrarese painting, belongs
obviously to an even earlier stage of his career.]

counted if one had but the patience ; the colour is even and flat,
without transition from light to shade, stippled with all but
imperceptible streaks in the prominences, and fused to a varnish
enamel ; the red glare of the flesh betrays a Ferrarese education.
When his experience became enlarged in 1490, Francia painted
in a very different style, and the Virgin enthroned amidst Saints,
which he finished at that time for Bartolommeo Felicini in the
church of the Misericordia outside Bologna, shows that he had
mastered the art of religious composition, the rules of architecture,
and the science of perspective.[1]

What he presents to us here is a quiet Umbrian scene of
worship ; the Virgin on a marble throne with the Infant stand-
ing in benediction on her lap, an angel at her feet playing the
lute, six saints on the steps and foreground, between the square
pillars and beneath the arches of an ornamented portico, a
kneeling patron devoutly looking up. In the distribution there
is symmetry and order ; in the figures, comeliness, regularity
of proportion, and plumpness of flesh ; the forms are gentle,
well if not searchingly made out, and of some elevation ; they
are fairly relieved with shadow, very fine in outline, and softly
modelled ; and the drapery of Umbrian fitness, here and there
overcharged with folds. A reddish tinge in the flesh, some
abruptness in the transitions, and a certain sharpness in the
contrasts of tints, produce a metallic rawness that recalls Costa ;
the handling is that of the Ferrarese, but of a smoother grain,
producing surface of extreme polish. It is a delicate and some-
what feminine style, the devotional feeling of which is much
on the surface, and wants life and glow, commingling in equal
parts the tenderness of Perugino and Spagna, the smoothness
of Credi, and the ruddiness of the Ferrarese, with a veil of

[1] Bologna, Pinac., No. 78, formerly in the Misericordia. Wood, oil, figures all
but life-size. The saints are SS. John the Baptist, Monica, Augustine, Francis,
Proculus, and Sebastian ; inscribed : " Opus Franciæ Aurificis MCCCCLXXXX⁰."
There is some doubt whether we have not to add four ciphers to the date, because
there is faint trace of these on the signature, but they may have been added at
a later time, and Vasari states that the picture was done in 1490 (iii. 537). There is
a reddish stare in the picture, in consequence of varnishes and partial restoring.
There was a predella to this piece with the Nativity, the Baptism of Christ,
St. Francis receiving the Stigmata. In the upper ornament was a Christ between
two Angels. (Calvi, *ub. sup.*, p. 15.)

coldness over all. Francia, in fact, is to Perugino what Cima was to Bellini ; he is at home in quiet scenes where he introduces a pretty pleasant Madonna, a kindly Babe, and saints of small and elegant stature, but he has neither the fervency of Vannucci nor the power of Conegliano. When Raphael at a later period declared that Francia's Virgins were the most beautifully devout that he was acquainted with, he was indulging in flattery. When Michelangelo said to Francia's son that his father's living creations were better than his painted ones,[1] he gave vent to the same scorn with which he had already treated Perugino; there was as little cause for the exaggerated praise of the first as for the excessive abuse of the second. And yet we can understand why Raphael should find much to praise and Buonarroti to abuse. As a portraitist Francia excels ; he frequently introduces a kneeling patron into his altarpieces, and always with capital success ; and here the praying profile of Bartolommeo Felicini is quite life-like and extremely well rendered. In technical treatment Francia is a perfect master of the method of oil, using much colour tempered with abundance of vehicle, laying in the parts full, retouching them afterwards with semi-transparents, and finishing them with glazes.

Such was his art in 1490, and such it remained till the opening of the sixteenth century.[2] We see the same combination of softness and strong tone in the beautiful Virgin with the Child and Angels at the museum of Munich, which King Maximilian II. obtained from the Zambeccari collection in Bologna in 1833[3] ; in the Annunciation at the Brera, which has something of the spirit of Giovanni Santi[4]; in the similar

[1] Vasari, vii. 170. In the first edition of Vasari are some very sharp expressions against Francia and Costa, supposed to have been uttered by Michelangelo. These were withdrawn in the second edition.

[2] From 1492 dates a Madonna with an Angel in the collection of the late Dr. Ludwig Mond (signed "Opus Francisci aurificis MCCCCLXXXXII"). The grouping of the Mother and Child in this painting closely resembles that in the altarpiece just dealt with.

[3] Munich, Pinak., No. 1040, curiously catalogued as doubtful. [* This is no longer the case.] Wood, 2 ft. high by 1 ft 6 in. The Virgin supports the Child erect on a table ; he holds a bird; in rear two angels.

[4] Brera, No. 448. Wood transferred to canvas, m. 2·37 high by 2·27. The Virgin stands as she receives the message from the kneeling angel. Here and there are some retouches.

subject, with an attendance of monkish saints, belonging to
M. Reiset in Paris [1]; and in the Virgin and Child with St. Joseph
dated 1495 in the collection of the Earl of Dudley.[2] In 1499
Francia painted the great altarpiece at San Jacopo Maggiore
for Giovanni Bentivoglio, in which the Virgin sits enthroned
with adoring angels at her side and playing angels at her feet,
attended by SS. Florian, Augustine, John the Evangelist, and
Sebastian.[3] This was the most important and the finest
picture that he had yet completed, exhibiting all the qualities
of his previous ones, with a deeper feeling and a purer harmony
of proportions. He seemed as he proceeded to mitigate in some
measure the glare of his tone, to cast his drapery more effectively
and simply, to gain firmness in the flow of his outline, freshness
in form, and ease in movement, and to blend his light into
semi-tone and shadow with a clearer and more silvery warmth.
He never imagined up to this time a more charming group of
the Virgin and Child; and the Child especially is the most
beautiful that he had as yet created. He had not conceived

[1] Paris, M. Reiset, from the Northwick collection. Wood, figures three-
quarters of life-size. The Virgin to the right, the Eternal in the sky; on the
foreground a demon in female shape, a Carmelite, three friars, and angels;
the episodes are all well arranged. The Ferrarese impress is still strong.
[* This picture is now in the Musée Condé at Chantilly, No. 17.]

Of the same period but injured by restoring is the Crucified Saviour (Louvre,
No. 1436) between the Virgin and Evangelist, with St. Job lying at the foot
of the cross, signed " Francia Aurifaber." This picture was once in San Giobbe
at Bologna, and was sold in London with other pictures belonging to Conte
Cesare Bianchetti.

[2] London, Dudley House. Virgin, Child, and St. Joseph; inscribed: " Jacobus
Cambarus Bonon. per Franciam aurifabrum hoc opus fieri curavit 1495." The
distance is a landscape. Francia was intimate with Jacopo Gambaro, a gold-
smith and die-sinker at Bologna, with whom he stood godfather to the child of
a mutual acquaintance in 1500; but there was another Jacopo Gambaro of whom
Bumaldi speaks in the *Minervalia* as living in 1498 at Bologna. (*Minerv.,
ub. sup.*, p. 101; see also Vasari, Com., iii. 556). The head of the St. Joseph in
the picture before us is retouched. In this collection is a Virgin and Child by
Francia, of soft style and clear tone, in the painter's later and more ordinary
manner. [* The last-mentioned painting is now in the collection of Sir George
Otto Trevelyan at Wallington Hall (Cambo, Northumberland); while the Holy
Family of 1495 at present belongs to Count Jean Palffy of Pressburg.]

[3] Bologna, San Jacopo Maggiore, Cappella Bentivoglio. Wood, oil, figures
life-size; inscribed in a cartello: " Johanni Bentivoglio II. Francia Aurifex
pinxit"; done in 1499 (Lamo, *Gratic.*, p. 36); well preserved. In the upper part
of the picture is a half-length Ecce Homo.

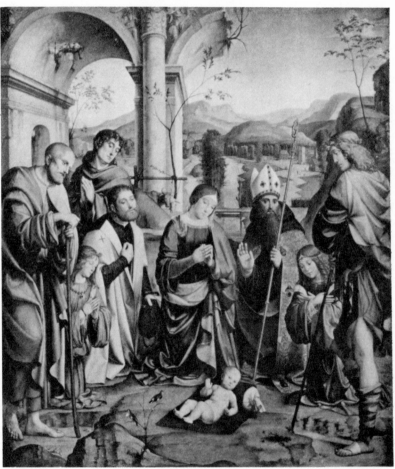

THE NATIVITY.

anything finer or grander than the St. Sebastian, nor anything more naturally innocent and fresh than the angels, ingeniously combining in their production the type of Perugino with the thought of Cima and Bellini. For Francia the Bentivoglio Madonna may justly be called a picture of style. Yet it was not so perfect in its way but that he was enabled immediately after to compose a better. His masterpiece at this time, indeed, is the Nativity executed for the church of the Misericordia at the request of Monsignor Anton Galeazzo Bentivoglio, proto-notary of Bologna and red-cross knight. This pious churchman and his retinue of saints and angels are placed with great skill in kneeling and standing attitudes round about the Virgin adoring the Infant Christ, in front of a ruined arch in an exquisite landscape.[1] On the lines of Credi, but with more life and breadth and grandeur, he gives to his personages a more masculine character and greater expressiveness than he had ever done before, shining as usual in portrait, yet not without nun-like or monkish coldness in some parts, and as yet not free from rawness in his argentine tints. To this piece, which was followed by equally beautiful ones of a Pietà[2] at the museum and of the Virgin and Child with Saints at the Misericordia of Bologna,[3] Costa furnished the predella with the

[1] Bologna, Pinac., No. 81. Wood, oil, figures life-size. It has been said that this picture was done after Anton Bentivoglio's return from the Holy Land (Vasari, iii. 537 *sq.*), but this is proved to be untrue by Calvi, *ub. sup.*, p. 19. The Virgin kneels in the centre of the picture with the Infant on the ground before her; to the left, the kneeling patron, an angel, St. Joseph, and St. Francis; to the right, St. Augustine, an angel, and a standing figure leaning on a staff. This picture was carried off by the Bentivoglii when they were expelled by Julius II. from Bologna to Milan, and it was brought back only in 1816. (See Rosaspina, *Pinacoteca della Pontificia Acc. d. B. A. in Bologna.*) On a panelling beneath the foreground one reads: "Pictorum cura opus mensibus duobus consumatum Antonius Galeaz. Io. II. Bentivoli fil. Virgini dicavit." The date of the completion of the altarpiece is on the predella by Costa, the Adoration of the Magi, of 1499, No. 429 at the Brera. (See *antea.*)

[2] Bologna, No. 83. Wood, oil. Christ supported on the tomb by two angels, the counterpart of Perugino's Christ in the collection of the late Lord Taunton, and better preserved.

[3] Bologna, Pinac., No. 80, from the Misericordia, done for one of the Manzoni family. (Vasari, iii. 543, and Lamo, *Gratic.*, p. 45.) Virgin and Child enthroned in a court opening out on a landscape, an angel at the foot of the throne; left, St. Augustine and St. George; right, St. John the Baptist and St. Stephen. Wood, oil, figures of life-size.

Adoration of the Magi of 1499, which gives us the comparative measure of the two men and testifies to their common friendship.

It is a proof of the popularity which Francia had acquired that his panels are almost as numerous in modern galleries as those of del Sarto or Perugino. Even of those illustrating the period on which we are now dwelling, there are numerous specimens abroad as well as in Italy. The Virgin adoring the Infant before her, a panel of life-size in the gallery of Munich, affords a rare example of dignity in Francia's works; it is also distinguished by a more tender blending and harmony of silvery tone than any we have hitherto met with.[1] The Virgin annunciate attended by Saints in the Santissima Annunziata at Bologna, an altarpiece of 1500, exhibits his more usual carefulness and coldness of treatment.[2] The Madonna with Saints and Angels painted in 1500, for San Lorenzo of Bologna, keeps its place

[1] Munich, Pinac., No. 1039. Wood, oil, 5 ft. 4 in. by 4 ft.; inscribed: "Francia Aurifex Bono. . . ." It was originally in the Mantuan collection, and remained there till 1786 (D'Arco, ii. 214). It belonged in the beginning of the nineteenth century to Baron St. Saphorin, Danish envoy at Vienna; it afterwards came into the gallery of the Empress Josephine at Malmaison, and was bought from that gallery for Munich in 1815. There is a copy of it (No. 126) in the Museum of Berlin [* now on loan to the Gallery at Osnabrück], another copy in the Pinacoteca of Bologna.

[2] Bologna, Santissima Annunziata, outside the Porta San Mammolo. Wood, oil, figures life-size. The Virgin stands in the centre of the picture, looking up to the angel in the air, whilst the Infant Christ in benediction appears in a glory in the sky. At the Virgin's side, standing, are SS. John the Evangelist, Francis, Bernardino, and George. On a cartello, beneath which is the escutcheon of the Franciscans, a cross and two arm-bones, one reads: "Francia Aurif. B. pinxit. MCCCCC." In the upper part of the frame, the Eternal. This picture has been taken to the Bologna Pinacoteca (No. 371). The colour is still a little raw. From the same church, and taken to the Bologna Pinacoteca, we have further two large pictures (Nos. 372 and 373): the Virgin and Child enthroned between St. Paul and St. Francis, with the young Baptist holding the cross in the middle of the foreground. Wood, oil, figures about life-size; inscribed: "Joannes Scappus ob immaturum Lactātii filii obitum pientissime—affectus hoc Virgini q paulo—dicavit." This piece was in the second chapel; it is much in the manner of the Madonna and Saints at the Hermitage, about to be described, but less ably executed, and probably done partly by some of Francia's pupils, the figures being colder and shorter in stature than usual. The colour is injured and scaling in parts. In the third chapel was the Crucified Saviour, with the Magdalen at the foot of the cross, the Virgin and St. Francis to the left; St. Jerome kneeling and another saint standing to the right hand. Wood, oil, figures almost of life-size. Here also the execution is in part that of Francia's disciples, and the inscription, "Francia Aurife," is of dubious authenticity.

amongst the better productions of the master by freedom of touch and expanded form, in spite of short proportion in the figures.[1] It surpasses in many respects the Virgin in Glory with Saints executed two years later for the church of the Osservanza at Modena and now at Berlin,[2] and is about equal to the Madonna and Saints in San Martino of Bologna.[3] In the pleasing Peruginesque manner likewise we have the Virgin and Child with St. Francis of the Zambeccari collection at Bologna, where gloss and finish are still united to a slight rawness. This charming picture bears the date of 1503, and closes, so to speak,

[1] St. Petersburg, Hermitage, No. 19. Wood, oil. The Virgin is enthroned with the Child in benediction. In front St. Lawrence and St. Jerome, and two playing angels; inscribed: "D⁸ Ludovicus de Calcina Decretorū Doctor Canonicus S. P. Bon. redificator auctor Q̄s domus et restaurator huius Eclesiæ fecit fieri p. me Franciam aurificē Bonoñ. anno MCCCCC." In the upper corner, two prophets reading, in monochrome; the colour is still a little raw and sharp in the transitions. This picture was taken to Rome by Cardinal Ludovisi; it passed afterwards into the Ercolani collection at Bologna (Calvi, *ub. sup.*, p. 27). In the same collection, No. 68, much injured in the flesh parts, half-length of the Virgin and Child. In the distance on one side the Resurrection, on the other the Transfiguration. Wood, transferred to canvas, with a doubtful signature.

[2] Berlin Museum, No. 122. The Virgin and Child in glory with angels between SS. Geminiano, Bernard, Dorothea, Catherine, Jerome, and Louis, in a hilly landscape. Wood, oil, 8 ft. 4 in. high by 6 ft. 6 in.; inscribed: "Francia Aurifaber Bonoñ. 1502." The total repainting which this piece has undergone makes it appear a weak example of the master. It was painted for Santa Cecilia of Modena, and after the demolition of this church, in 1737, passed to that of Santa Margherita (Campori, *Gli Artisti, ub. sup.*, p. 393, cites the authorities for these facts). In the same gallery we have the following: No. 121 [* now on loan to the Kaiser Friedrich Museum at Magdeburg]. The dead Christ on the Virgin's knees; a lunette, copy of that in the altarpiece, No. 180, at the National Gallery. No. 123 [* now in the Provinzialmuseum at Hanover]. Virgin, Child, and youthful Baptist; a pallid and mannered copy by a scholar of Francia. No. 126 [* now in the Museum at Osnabrück]. Virgin adoring Christ; copy of No. 1039 at Munich. No. 127 [* now in the Town Gallery at Hildesheim]. St. John the Baptist and St. Stephen; also probably a school-piece. [* A full-length figure of St. Roch which in 1905 was in a private collection at Naples is signed "Francia aurifaber MCCCCCII." See Colasanti, in *Rassegna d'arte*, v. 188 *sq.*]

[3] Bologna, San Martino. Wood, oil. Virgin enthroned and two angels on the foreground, SS. Roch, Sebastian, Bernardino, and Anthony of Padua. Through the base of the throne and at sides one sees a landscape; above, Christ in the tomb between two angels; below, Christ carrying his cross; inscribed: "Francia Aurifex p." This fine work is only below that of the Bentivoglio chapel and others of that period. The figures are rather too lean, the shadows are dark. One would think that Costa laboured here with Francia.

an epoch in Francia's pictorial development.[1]　But that we have
no warrant historically for supposing that he now visited
Florence, we should almost suppose that he did so, when we
look at the dramatic composition of Christ deposed from the
Cross and bewailed by the Marys in the Gallery of Parma.
There we see the Saviour in the lap of the Virgin, St. John
raising the lifeless head, the Magdalen embracing the feet,
Mary Salome with outstretched arms looking down, Nicodemus
in passive grief with his back to the spectator, the whole depicted
in a landscape of varied lines.[2]　The Peruginesque here is that
of Perugino's grand time when he most combined Umbrian
softness with the energy and power of the Florentines.　The
scene is rendered with an intense expression of affliction unusual
in Francia, with considerable facility in the grouping, with great
nature in the representation of instant action, and with little of
the frigidity which is his predominant feature.　Powerful colour
and gloss still betray the Ferrarese origin of Bolognese art,
although the tones are fused with capital success.　But now
came forth a new and strongly contrasted series in which
conception was regulated by most engaging grace—a grand
Coronation of the Virgin in the Duomo of Ferrara, which reminds
us of Fra Bartolommeo, with kneeling and standing saints in the
landscape below[3] ; an Assumption at San Frediano,[4] a Madonna

[1] Bologna, Zambeccari collection.　Wood, oil, figures almost of life-size;
inscribed: "Francia Paulo Zambeccaro pinxit. MCCCCCIII."　The Virgin holds
the Child in benediction on her lap; in his left hand is a bird ; near him, right,
St. Francis with the cross and book; distance, landscape.　The Virgin here
resembles that of Munich.　The transition of light into half-tint is still somewhat
raw (but since writing these lines we find the picture has been sold).

[2] Parma Gallery, No. 123, and originally done for Parma (Vasari, iii. 541)
Wood, arched, oil ; inscribed : "Francia Aurifex Bonon. f."　In the middle of the
picture and behind the group is the cross.

[3] Ferrara, Duomo.　Wood, oil, arched, but cut down at top, and otherwise.
injured.　On the foreground SS. George. Stephen, Bartholomew, and John the
Baptist ; SS. Peter, Augustine, and Paul erect ; in the middle of the foreground
the Infant Christ, foreshortened, with his head to the spectator, between the
kneeling St. Catherine and another female saint.

[4] Lucca, San Frediano.　Wood, oil.　The Virgin in glory with angels, receiving
the blessing from Christ ; below and erect, SS. Anselmo, Augustine, David, and
Solomon, and St. Anthony kneeling with his back to the spectator before the
tomb.　In a predella four monochromes.

at Casa Mansi, of Lucca.[1] In a Nativity at Forlì [2] also Francia illustrates a milder treatment and tone, finishing with extraordinary care, losing all rawness, and producing a clear bright light, and movements and expressions attuned in the greatest perfection to the height of religious composure. Following the same sweet vein he produces the Virgin with the Child and St. Anne enthroned amidst saints, and its lunette Pietà, in the National Gallery ; rising to a high level as a composer, reminding us as ever of Perugino, but suggesting at the same moment memories of Leonardo.

This, the time in which young Raphael became imbued at Florence with novel principles, is also the time when Francia's impersonations display additional repose and noble sentiment, when to power he unites exceeding harmony, when his hand acquires a cunning hitherto unattained, especially in the skill with which half-tint is used and subtle glazes are applied, when a better sense of atmosphere is conveyed, when modelling and contrasts of light and shade yield their truest and best results.[3]

By what causes, we may inquire, was this last purification of Francia's style brought about ? It might be considered due to his study of Raphael, but it was more probably owing to the personal influence of Raphael himself. In 1491 Francia counted

[1] Lucca, Casa Mansi. Wood, oil, figures half life-size. Virgin and Child, half-length, in a landscape. The Virgin's face a little injured.

[2] Forlì, Museo Civico, No. 98. Christ adored by the Virgin, St. Joseph, two angels, and two shepherds. This is a picture originally painted for Paolo Zambeccaro (Vasari, iii. 543 *sq*.). Wood, oil, figures half life-size.

[3] London, National Gallery, Nos. 179, 180. The first : wood, oil, 6 ft. 6½ in. high by 6 ft. ; inscribed : " Francia Aurifex Bononiēsis p." Originally in the Buonvisi chapel at San Frediano of Lucca. The Virgin is enthroned, with St. Anne and the Child, in front of a pillar between two arches, through which the sky appears. In front of the throne the boy Baptist with the cross pointing upwards ; at the sides, SS. Sebastian, Paul, Lawrence, and Romualdo. The second : 3 ft. 2 in. high by 6 ft., lunette, wood, oil, containing the Saviour on the Virgin's lap and two angels. [* The chapel for which this altarpiece was painted was founded in 1510. Williamson, *Francesco Raibolini*, pp. 111 *sq*.]—In this gallery also we have ; No. 638. Virgin and Child with two Saints, half-lengths. Wood, oil, 2 ft. 8 in. high by 2 ft. 1½ in., from the Beaucousin collection. This piece was originally of a clear bright tone, but was glazed in the National Gallery with a glaze of burnt sienna.

amongst his disciples Timoteo Viti, a youth of twenty, who had come from Urbino to perfect himself in the goldsmith's art.[1] For several years this youth remained at Bologna. In 1495 he went home to marry and settle, with the blessing of Francia to cheer him in his progress.[2] A correspondence was probably kept up between them, and thus no doubt it happened that pictures of Francia were sent to Urbino.[3]

Viti more than once, we are inwardly assured, conversed with Raphael of the kind master at Bologna; on the other hand, Francia may have heard from Timoteo what promise young Raphael was giving of growing talents and fame. He may even have recommended his works to the attention of the Bentivoglii. Certainly Giovanni Bentivoglio received a picture of the Nativity from Sanzio,[4] and letters were exchanged between Raphael and Francia. Writing in 1508 to Bologna, Raphael acknowledges the receipt of Francia's portrait, promises his own, and sends the drawing of a Nativity, hoping that he may get in return that of Francia's Judith. He states that " Monsignore il Datario and Cardinal Riario were both expecting their Madonnas, which no doubt would be equally beautiful, devout, and well done as previous ones." [5] It is clear from this that the two masters were on friendly terms, though it remains uncertain whether they met. Vasari suggests that they merely corresponded; but as Raphael went in 1505-6 from Florence to Urbino, he may have taken Bologna on his way, and we are the more inclined to think that he did so, as Francia then became still more strongly Raphaelesque than before, and much more so than was possible from a mere acquaintance with Raphael's works.[6]

He had painted numerous decorations in the houses of the Bolognini and Polo Zambeccari,[7] and in the palace of the

[1] Malvasia, *Felsina Pitt.*, *ub. sup.*, i. 55.

[2] *Ibid.* and Pungileoni, *Elogio Storico di Timoteo Viti*, 8vo, Urbino, 1835, p. 5.

[3] He painted for the Duke of Urbino some horse-trappings and a Lucretia, of which there is not a trace at this time (Vasari, iii. 544 *sq.*).

[4] Baldi, in Passavant's *Rafael von Urbino, ub. sup.*, i. 96.

[5] *Ibid.* and Vasari, Com., iii. 553.

[6] Passavant (*ub. sup.*, i. 95) is also of opinion that Raphael and Francia were personally acquainted and met at Bologna in 1505-6.

[7] Vasari, iii. 543 *sq.*

Bentivoglii, which was destroyed in 1507.[1] But his only extant frescoes at the present time are those in the oratory of Santa Cecilia, which were done before Costa's departure to Mantua in 1509.[2] They represent the Entombment of St. Cecilia and her Marriage with Valerian.[3] In the one, St. Cecilia seems to sleep as she lies outstretched in the winding-sheet ; her forms regular and softly yielding, her youthful and pleasing head crowned with roses, and her hands and feet beautifully formed ; she seems to have gone to a sweet rest unhurt by the boiling oil in which she perished ; four youths hold her suspended over the opening of the vault, two of them nearest the spectator stretching the sheet between them with muscular exertion of limb ; to the left a Cardinal, a youth with a torch glancing upwards in the true Umbrian style, a Pope, a female, and an aged man looking down at the saint's face; to the right two women and a young torch-bearer ; in the air an angel carrying the martyred soul to heaven, and floating lithely over a quiet landscape. Tenderness and affected grace are carried almost to excess even in the figures most strongly engaged in the action, and some necessary coldness arises from that cause ; the left-hand group is skilfully arranged and composed of personages individually interesting, whilst that to the right is ill balanced and throws the composition out of focus ; but the feeling evinced in every part is of a very select kind, and a wonderful resignation and melancholy are infused into the slender actors in the scene. Great, perhaps excessive, care is displayed in the casting of the drapery, and the drawing is of a pure and finished outline. Opposite to this St. Cecilia, united to Valerian, stands under the arches of

[1] He painted portraits there, an imitation of a bronze relief, and a Judith about to decapitate Holophernes. *Ibid.* and Bumaldi, *Minervalia, ub. sup.*, p. 250. Some of the portraits, by the extracts quoted in Bumaldi, appear to have been done in 1502.

[2] For 1509 read 1506 ; see *antea,* p. 260, n. 4. [* There also exists in the Palazzo Comunale at Bologna a fresco of the Virgin and Child protecting that city, which was executed by Francia in 1505 in fulfilment of a vow made by the magistrates of Bologna during the earthquake which devastated the town in the beginning of that year. See Malaguzzi-Valeri, in *Archivio storico dell' arte,* ser. ii. vol. i. p. 125 ; C. Ricci, in *La Vita italiana,* nuova serie, anno iii. vol. ii. pp. 881 *sqq.*]

[3] Bologna, Oratory of Santa Cecilia. Francia's two frescoes are at the bottom of the chapel right and left of the altar. They have been engraved for the Arundel Society.

a chapel opening out on a hilly landscape, the high priest between them looking at the bride benignantly, and a bevy of handsome women to the left and three men to the right witnessing the ceremony. There is something most engaging in the modesty of St. Cecilia, as well as in the timid bearing of the girl at her side looking on, whilst another holds the hand on which Valerian is to place the ring ; a charming nobleness is infused into the mien and movement of these dames, and there is an unusual variety for Francia in their expression ; fine are the proportions, simple and flowing the draperies ; one or two of the males have the modest bearing and honest look of Raphael's creations ; the composition is better and more masterly than in the Entombment, the drawing is more perfect in outline. In composing and carrying out such a work as this, Francia cannot but have been guided by maxims derived from personal acquaintance with Raphael. The taste is much too pure, the style much too chastened, the colour much too soft and harmonious, the feeling much too genuine, to have been acquired without some such new and subtle influence.[1]

Even Francia's portraits in the first years of the sixteenth century exhibit a gradual change from the Peruginesque to the Raphaelesque. Looking at his fine likeness of Vangelista Scappi at the Uffizi, it is obvious that Perugino was the master whom he then admired and imitated. A pleasing head, well furnished with falling locks, covered with a silk cap, the vest, the cloak, all black, the distance a landscape of Umbrian character, with the minutiæ only suggested, yet without much atmosphere ; the face self-complacent in smile, of ruddy tone with transitions into greenish grey, and good modelling and relief ; Peruginesque in the thought, the treatment and mechanism, but Peruginesque only as Francia could be, and without Perugino's power.[2] Not

[1] Francia's admiration for Raphael is expressed in a sonnet, in which he says :

> "Tu sol, cui fece il ciel dono fatale,
> Che ogn' altro excede, e sora ogn' altro regna,
> *L'excellente artificio à noi insegna*
> Con qui sei reso ad ogn' antico uguale."

> Malvasia, *Fels.*, vol. i. p. 46.

[2] Florence, Uffizi, No. 1124. Wood, oil, half-length, life-size ; the left hand gloved ; in the right hand a letter with the words "S° Vangelista Scappi." There is some restoring in the distant trees to the left.

so, however, the head of a man of forty, with a distance of hills, in the Liechtenstein collection at Vienna, known for a time as a Raphael in possession of the Marquis Bovio at Bologna. To say that this bust is not by Sanzio is merely to echo the opinion of critics generally, to call it by Francia's name is no heresy; yet it emulates the Raphaelesque after Raphael, under the influence of Leonardo and the Florentines, began to surrender the Peruginesque. If we remember that the Bovios are an old Bolognese family, the picture may be assumed to represent, not a Duke of Urbino, but a gentleman of Bologna. The treatment most reminds us of Raphael's in the Madonna of Blenheim, the Madonna of Vienna, or the Doni at the Pitti. The landscape is full of Raphaelesque depth and vapour ; an easy composure and lifelike readiness, very truthful modelling, and rich transparent colour are prominent qualities ; what betrays Francia is the finish and minuteness of the hair and other parts, in which the clean touch of the goldsmith is apparent. The panel is, in fact, as much evidence of the friendship which united Raphael and Francia as the letters which they interchanged.[1]

The loss which Francia incurred by the expulsion of the Bentivoglio family was severe, and Raphael kindly alludes to it in 1508, when he tells his friend to "take courage" and assures him that he feels his affliction as if it was his own. But Francia speedily found favour with Julius II., as he had done with the previous rulers of Bologna; he remained master of the mint, made the dies for the Pope's new money, and painted

[1] Vienna, Liechtenstein collection. Wood, oil, bust, under life-size, in a black cap, with long hair, a green vest, parti-coloured supervest, and brown coat. On the back of the panel we read: "Galleria del Marchese Bovio in Bologna in Strada San Stefano. Rittratto di un Duca di Urbino di 1ª maniera di Rafº Sanzio di Urbino." All the lower part of the face and part of the distant hills to the left is rubbed down. A third portrait by Francia is No. 23 in the Staedel Gallery at Frankfurt, but so injured that the landscape alone betrays the hand of Francia. There was once also a portrait, said to be that of Francia himself and supposed to be that which he sent to Raphael, in the Harrache Gallery at Turin, but this picture has been mislaid. A portrait in the collection of Earl Cowper at Panshanger has been noticed in the Life of Perugino (*History of Italian Painting*, 1st ed., iii. 255). It has something of Francia's manner, derived, however, from him by Francesco da Imola, who entered his atelier in 1508. In a sonnet by Girolamo da Casio (Calvi, *ub. sup.*, p. 54) there is loud praise of two female portraits by Francia.

pictures as before.[1] From this time till his death his manner under-
went no further changes.[2] We admire him in his Peruginesque and
Raphaelesque phase in the Annunciate Virgin between Saints at
the Museum of Bologna ;[3] in the predellas with scenes from the
life of the Virgin and of Christ which decorate that gallery and
the Museum of Dresden ;[4] in the Presentation in the Temple at
Cesena.[5] We observe with what tenderness and melancholy
softness he still labours in 1509, when he finishes the Baptism of
Christ at Dresden, and its counterpart at Hampton Court.[6] We
find him feeble in a Madonna and Saints dated 1515 at Parma,[7]

[1] See the record of payments for dies, Nov. 21, 1508, in Annot. Vasari, iii. 536, n. 1.

[2] That Francia died in the manner described by Vasari, that is, because
Raphael's St. Cecilia, which came to Bologna in 1514-6, convinced him of his
own inferiority as a painter, is now rejected, and properly so, by historians.

[3] Bologna, Pinacoteca, No. 79. Wood, oil, figures life-size. The Virgin stands
in prayer between SS. Jerome and John the Baptist in a landscape ; the Virgin of
tender air, very reminiscent of the types in the frescoes at Santa Cecilia. This
picture was ordered for the company of San Girolamo at Bologna (Vasari, iii. 543).
The Baptist recalls Credi ; the angel, Mariotto and Fra Bartolommeo.

[4] (1) Bologna, Pinacoteca, No. 82. Wood, oil ; predella with the Nativity, the
Virgin giving the breast to the Saviour, attended by saints, and the Redeemer
crucified. The figures are graceful, the colouring harmonious and clear. (2) Dresden
Museum, No. 49. Wood, oil, 1 ft. 6 in. high by 2 ft. 1 in. Quite in the spirit of
Raphael's youth, and recalling his predella with the same subject (1503) in the
gallery of the Vatican at Rome. Even to do so small a thing as this, Francia
must have done more than casually study Sanzio's works. There is a copy of this
Adoration, No. 512, at Schleissheim, under the name of Baldovinetti. [* In the
current catalogue of the Schleissheim Gallery this picture is correctly described as
a copy after Francia.]

[5] Cesena, Municipal Gallery. Wood, oil, 6 ft. 4 in. high by 4 ft. 7 in.; inscribed :
" Francia Aurifex." The Virgin in the temple is accompanied by St. Joseph with
the doves and the prophetess Anna ; Simeon to the right accompanied by an old
man with a book. This piece, in the character of the Adoration at Dresden, is
much injured by scaling and restoring.

[6] (1) Dresden Museum, No. 48. Wood, 7 ft. 5 in. high by 6 ft.; inscribed :
" Francia Aurifex Bon. f. M. VIIII." Originally at Modena ; damaged in the
bombardment of Dresden in 1760. (2) Hampton Court, from Mantua, No. 456.
Wood, oil ; inscribed : " Francia Aurifex Bon."; with some variety in the placing
of the angels and landscape. Both pictures clear and silvery. In a small pre-
della with the same subject which belonged to the late Lord Taunton at Stoke,
the hand of an assistant is seen in the execution.

[7] Parma Gallery, No. 130. Wood, oil, almost size of nature. Virgin and Child
with the infant Baptist below, pointing upwards ; at the sides, SS. Benedict,
Joseph, Scolastica, and Placida; inscribed : " Francia Aurifex Bononiensis f.
MDXV." There is much frankness in the touch and treatment, but the finish is
not so clear and sharp as usual.

and still powerful in the Pietà of the same year in the Museum of Turin.[1] He died at an advanced age on the 5th of January, 1517, leaving several sons behind him.[2]

[1] Turin Museum, No. 155. Wood, oil, m. 1·61 high by 1·30 ; inscribed : "F. Francia Aurifex bononiensis f. MDXV " in gold letters. This is a fine composition of Christ supported by the Evangelist and Magdalen, bewailed by the Virgin. In rear a monkish saint with a lily, and Nicodemus. The colour was very clear no doubt, before it was altered by restoring.

Of other works by Francia we still may notice the following : (1) London, Baring collection [* now collection of Earl of Northbrook]. The Virgin, Child, and St. Anthony of Padua. This picture with its inscription seems an old imitation ; the inscription runs : " F. Francia Aurifex faciebat anno MDXII." (2) In the same gallery, a half-length of Lucretia stabbing herself. This is a feeble picture of Francia's school. A genuine Francia representing this subject is said to exist in a private gallery at Modena. (3) London, Mrs. Butler Johnston. St. Francis receiving the Stigmata. This seems a picture by Francia's pupil Timoteo Viti. ⌊ * Cf. *postea*, p. 294, n. 3.] (4) Paris, Louvre, No. 1435. Nativity ; a beautiful little miniature, which might lead one to call Francia the Italian Memling. (5) Vienna Academy, No. 505. Virgin and Child between two Saints ; all renewed with the exception of the Virgin's head. The inscription, too, is new : " Opus Franciæ Aurificis MDXIII." (6) Vienna, Imperial Gallery, No. 47. Virgin, Child, St. Francis, and St. Catherine, and the young Baptist in the foreground; signed : " Francia Aurifaber Bonō." This picture is so entirely repainted that no opinion can be formed of its original value. (7) Modena Gallery, No. 476. Annunciation. See the proofs that this picture is not by Francia (*antea*, p. 76, n. 3). (8) There is notice of a picture of 1511 in the Casa Pertusati at Milan—Virgin and Child (not seen), and of an Eternal, dated 1514, in the Ercolani Gallery at Bologna (not seen). (9) Naples Museum. Virgin, Child, and young Baptist; feeble productions of a follower of Viti or Orazio Alfani.

* In addition to the paintings by Francia noticed above we may enumerate the following : (1) Bergamo, Galleria Lochis, No. 221. Christ carrying the Cross. (2) Brescia, Galleria Martinengo. The Virgin and Child with St. John the Baptist. (3) Brescia, San Giovanni Evangelista, first chapel to the left. The Trinity with four Saints. (4) Budapest, Picture Gallery, No. 75. The Virgin and Child with St. John. (5) Cirencester (Gloucestershire), Miserden Park, collection of Mr. A. W. Leatham. Portrait of Federico Gonzaga as a boy. Painted in 1510. See Cook, in *The Burlington Magazine*, i. 186. (6) London, National Gallery, No. 2671. Pietà. (7) London, collection of Mr. Robert Benson. The Virgin and Child with St. Francis. (8) London, Mrs. J. E. Taylor. The Virgin and Child with St. Francis and St. Jerome. (9) London, Sir J. Wernher. The Virgin and Child with St. John and some Virgin Martyrs. (10) Lütschena, Baron Speck von Sternburg. The Virgin and Child. Signed and dated 1517. (11) Madrid, Casa Fernan Nunez. St. Sebastian. (12) Milan, Museo Poldi-Pezzoli, No. 601. St. Anthony of Padua. (13) Milan, Crespi collection. St. Barbara. Signed. (14) Milan, Dr. Gustavo Frizzoni. St. Francis. (15) Paris, collection of M. H. Heugel. Portrait of Bernardino Vanni. (16) Paris, collection of the Comtesse de Pourtalès. The Virgin and Child with St. John and an Angel. (17) St. Petersburg, late Leuchtenberg collection. The Virgin and Child with SS. Anthony and Barbara (reproduced in *L'Arte*, vi. pl. facing p. 336).

[2] See the authorities in Vasari, Annot., iii. 547, n. 3.

Of these Giacomo and Giulio followed the paternal profession; but though their art had a natural affinity to that of Francesco, they never brought it to any very great perfection. We may believe indeed that both Giacomo, who was born before 1486, and Giulio, who was born in 1486, were assistants to their father as long as he lived, and that their workmanship impressed certain pictures of Francesco with a stamp of comparative inferiority. Giacomo painted his best frescoes in the oratory of Santa Cecilia, coming third after his father and Costa;[1] he also finished numerous altarpieces[2] and portraits.[3] At Santa Cecilia his figures are short, coarsely outlined, and comparatively without life or expression. After 1526, the date of an altarpiece representing the Virgin and Child with Saints in the gallery of Bologna, he strove to keep pace with the spirit of his time in

[1] Bologna, Santa Cecilia. Giacomo Francia's subjects, composed probably by Francesco, are the Baptism of Valerian and the Martyrdom of St. Cecilia in boiling oil; both frescoes are much injured, abraded, and discoloured.

* Dr. Frizzoni (*Arte italiana del rinascimento*, pp. 382, 389 *sq.*) ascribes these paintings to Cesare Tamaroccio, who, according to Lamo (*Graticola*, p. 34), worked in Santa Cecilia, and by whom there is a signed picture of the Virgin and Child with St. John the Baptist in the Museo Poldi-Pezzoli at Milan (No. 551, inscribed " Cesar Tamarocius ") which exhibits close analogies with the two above-mentioned frescoes.

[2] (1) Bologna, Santo Stefano, assigned by Malvasia (*Felsina*, p. 57) to Francesco Francia, but described by him as executed in 1522, really therefore by Giacomo. The subject is Christ on the cross between St. Jerome and St. Francis, with the Magdalen grasping the foot of the cross. Here Giacomo's art is a miniature of his father's. The colour is scaling in many parts. Wood, oil, figures all but life-size; distance, landscape. (2) Florence, Galleria Antica e Moderna, No. 64. Wood, oil, figures all but life-size. Virgin and Child enthroned between the kneeling SS. Francis and Anthony of Padua, in a landscape. The forms are square and short, the masks lifeless, the drawing and colour hard and raw. (3) Bologna, Pinac., No. 84, from San Francesco. Wood, oil, life-size. Virgin and Child and young Baptist, attended by SS. Francis, Bernardino, Sebastian, and George; inscribed : " I. Francia Aurifex Bonon. fe. MDXXVI." (There are not two I. before the word Francia, as the commentators of Vasari [iii. 559] affirm.) (4) Some gallery, No. 87. Arched panel. Virgin in Glory ; below, SS. Peter, Francis, Mary Magdalen, and six maidens. Here the figures are not without a stamp of grandeur, and the colour is well blended and enamelled. (5) No. 85. Virgin and Child enthroned between St. Paul and Mary Magdalen, and the young Baptist. Arched altarpiece. (6) Milan, Brera, No. 436. Virgin and Child, young St. John, and two boy-angels, SS. Sebastian, Jerome, Stephen, and Anthony the Abbot, life-size. (7) No. 437. Virgin and Child, two boy-angels, two saints in armour, SS. Justina, Catherine, and four others ; life-size, panel; inscribed: " Jacobus Francia p. MDXLIIII." Fine works, next to which in value are the following :

free handling and rapid execution, and then his art fashioned itself pretty much after that of Bagnacavallo.[4] He died in 1557. There are also some extant pieces, the joint production of Giacomo and Giulio,[5] and a Descent of the Holy Spirit at Bologna by Giulio alone.[6]

If it were worth while to dwell at any length on the lives of the contemporaries of the younger Francias, we should find some amusement in describing the eccentricities of Amico Aspertini, an artist who was born at Bologna about 1475 and died in 1552. He also was employed in Santa Cecilia of Bologna, and produced various altarpieces in which we see that his manner was derived in part from that of Ercole Roberti Grandi, and from that of the second-rate Umbrians of Pinturicchio's school. He was a free and bold third-rate, of a quaint and fantastic character.[7]

(8) Berlin Museum, No. 271 [* now on loan to the Wallraf Richartz Museum at Cologne]. Small allegory of Chastity. (9) No. 281. Virgin, Child, young Baptist, SS. Mary Magdalen, Agnes, Dominic, and Francis; inscribed : "I. Francia." (10) No. 293 [* now in the collection of the University of Göttingen]. The Virgin with the Child erect before her on a parapet, and St. Francis; signed : "F. Francia." (11) Bologna, Chiesa del Collegio de' Spagnuoli. St. Margaret with St. Jerome and St. Francis; feeble. We omit other pieces of a similar kind.

 ³ (1) Florence, Pitti, No. 44. Bust of a beardless man in a cap, holding an apple. A little raw in colour, and coldly executed, but precise in outline (retouched). (2) No. 195. (See *antea* in Bonsignori.)

 ⁴ Bologna, Pinacoteca, No. 84, *supra.*

 ⁵ (1) Bologna, Pinac., No. 86. Arched panel, with SS. Frediano, James, Lucy, and Ursula, and a portrait, inscribed : "I. I. Francia." (2) Parma, San Giovanni Evangelista. Nativity, inscribed : "I. I. Francia Bon. MDXVIII."; injured by restoring, but fairly done. A saint in glory, with a viol, and another saint reading; St. Joseph and other figures and portraits, inscribed : "I. I. Francia Bon. MDXVIIII." On the altar the words "Antonius Ferratus &ª condiderunt"; on the base, three injured half-lengths of saints. (3) Berlin Museum, No. 287. Virgin in glory and saints, inscribed : "I. I. Francia, Aurifi bonon. fecer. MDXXV," from San Paolo in Monte of Bologna.

 * To these may be added : (4) Modena Gallery. The Assumption of the Virgin, signed "I. I. Francia. B. M.D.XIII." Formerly above the high altar of Santa Maria Maggiore at Mirandola.

 ⁶ Bologna, Pinacoteca, No. 88. Descent of Holy Spirit, with SS. Gregorio and Petronius ; retouched.

 ⁷ Vasari has written the Life of Amico Aspertini (v. 179 *sqq.*), and states that he learnt his art by going round Italian cities and copying everything that fell in his way. His earliest works are in Santa Cecilia of Bologna, after which he painted frescoes in San Frediano of Lucca (*post* 1506). In 1514 he painted the front of the library of San Michele in Bosco, which was subsequently repainted

Chiodarolo is the name of another modern Bolognese who works in a feeble style, imitating the Umbrians as well as

by Canuti. He tried his hand as a sculptor in rivalry of Properzia di Rossi, and produced the Dead Christ in the Arms of Nicodemus at San Petronio of Bologna in 1526. There are records of works undertaken at Bologna in 1527 for one Annibale Gozzadini. In 1530 he married, and he died in 1552, having shown unmistakeable symptoms of insanity. His frescoes in the Cappella della Pace at San Petronio, carried out in competition with Bagnacavallo and Innocenzo da Imola, have perished, as well as the decorations of several house-fronts. He certainly visited Rome. (See Vasari, v. 179 and foll., and Gualandi, *Memorie*, ser. i. 33, and iii. 178.) The general character of his art is this : his compositions are ill put together, with here and there a group or an episode of compact arrangement. He is fanciful in the choice of accessories, in which he uses embossment like Pinturicchio. He also embosses the hems of his draperies, which are bundled and confused like those of the earlier Ferrarese. His figures are strange in action, and have many of them the pug face derived from Ercole Roberti Grandi ; his types are ugly, vulgar, and trite in expression ; as a colourist he takes after the Ferrarese, being red and fiery in flesh tone. His frescoes at Santa Cecilia—the Funeral of SS. Valerian and Tiburtius, and their Decapitation—are much injured and in part obliterated. Of another fresco in the same place, representing St. Cecilia before the Emperor, it is not certain whether Amico is the author. [* Dr. Frizzoni (*ub. sup.*, pp. 381, 390) ascribes this painting to Chiodarolo.] The subjects which he painted in the chapel of Sant' Agostino at San Frediano of Lucca are : 1°, the story of the Volto Santo, in which there is a fair group of a man kneeling before a saint ; 2°, baptism of a proselyte, with much embossment of statues and other accessories (greatly injured) ; 3°, lunette above No. 2, Christ taken from the cross ; 4°, St. Frediano tracing the course of the river ; 5°, the Nativity (very feeble and much damaged by damp) ; 6°, lunette with an almost obliterated subject ; 7°, ceiling, with the Eternal and angels, reminding us of Mazzolino's art ; 8°, pilasters with Raphaelesque orna-ment, on one of which the inverted name of Aspertino, *i.e.* "I.M.A.G.O. f." ; 9°, soffit of arch with scenes from the Passion, and figures reminding us of some in Raphael's "Disputa del sacramento" ; one of the scenes is Christ on the Mount, a Peruginesque composition.

Of other extant works the following is a list : (1) Berlin Museum, No. 119. Nativity, signed : "Amicus bononiensis faciebat." Wood, tempera, 3 ft. 8½ in. high by 2 ft. 7 in., from the Solly collection. An Umbrian picture with dry figures and hideous heads. (2) Madrid Museum, No. 524. Rape of the Sabines. Small panel, assigned to the Sienese school [* now to the Umbrian school together with its companion-piece, No. 525, representing the Continence of Scipio]. (3) Bologna, Pinac., No. 297. Panel, oil. Virgin and Child, SS. John the Baptist, Jerome, Francis, George, Sebastian, and Eustace, and two portraits of patrons. This also is Umbrian in character, and not unlike Manni in style. (Much injured.) [* Signed "Amici pictoris bonon. tirocinium."] (4) Bologna, San Martino Maggiore. Virgin and Child, SS. Lucy, Augustine, and Nicholas giving their dowry to three young girls. (5) Ferrara, Palazzo Strozzi [* now Florence, Villa Strozzi, Marchese M. Strozzi]. Predella with the Visitation, Nativity, Presentation, and Sposalizio ; reminiscent of Ercole Grandi. [* For further notices of Amico Aspertini, see

Francia and Costa,[1] and Boateri is a weak artist of the same class.[2]

What honour may have accrued to Francia from the proficiency of his numerous pupils is due in no small degree to Timoteo Viti, to whom he expresses an almost paternal affection in a page of his journal. Timoteo was the son of Bartolommeo della Vite and Calliope, the daughter of Antonio da Ferrara ; he was born at Ferrara in 1467, and brought up to be a goldsmith.[3] In Francia's atelier between 1491 and 1495 he learnt to paint, and returned a master to Urbino.[4] There are few men of subordinate rank whose career is more clearly traced. After his

Lisetta Ciaccio in Thieme and Becker, *Allgemeines Lexikon der bildenden Künstler*, ii. 188 *sqq.*]

Amico had a brother named Guido, of whom we have one picture in the Pinacoteca of Bologna (No. 9), the Adoration of the Magi, a composition treated in Amico's manner and coloured in ruddy Ferrarese tints.

[1] Of Giovan Maria Chiodarolo we know nothing, but that according to tradition he painted one of the frescoes in Santa Cecilia of Bologna—Angels crowning St. Valerian and St. Cecilia. This much injured wall-painting, recalling the style of Francia and Costa and the Umbrian of Pinturicchio, is a cold and feeble work. In the same style we have No. 60 in the Pinacoteca at Bologna, a Nativity—a poor work of a follower of Francia and Costa, but as likely to be by young Timoteo Viti as by Chiodarolo.

[2] Boateri is only known by a Holy Family in the Pitti at Florence (No. 362, wood), inscribed : " Jacobus de Boateris." This is an exact imitation of Francia, and there is a counterpart of this picture under the name of the latter in the Scarpa collection at La Motta in Friuli. [* This collection was sold by auction at Milan on Nov. 14 and 15, 1895.]

[3] *Tavola alfabetica delle vite degli artefici descritte da Giorgio Vasari*, published separately, 8°, Florence, Le Monnier 1864, *ad. litt.*, and Laderchi, *Pitt. Ferrarese*, p. 29. Pungileoni's date of 1470 is incorrect. See *Elog. Stor. di T. V., ub. sup.*, p. 1.

[*] Laderchi's statement that Timoteo Viti was born at Ferrara in 1467 is not to be relied upon. There is every reason to think that he was born at Urbino, where both Bartolommeo della Vite and Antonio da Ferrara were living ; and if, as Vasari says (iv. 494), he was aged twenty-six when he left the school of Francia—*i.e.* in 1495—then the date of his birth would be about 1469.

[4] Judging by his later works we might properly recognize as youthful productions of Timoteo Viti the following : (1) Ferrara Gallery, Sala VIII. The Assumption of St. Mary of Egypt, and St. Zosimus in the landscape below, once in Sant' Andrea of Ferrara. This small panel has something of Francia and Costa, and is not unlike a Nativity, No. 60, in the Bologna Gallery, assigned (*antea*) to Chiodarolo. It is varnishy in treatment with slender and affected figures, very carefully executed. (2) Ferrara, Conte Mazza [* subsequently in the Santini collection ; reproduced in *L'Arte*, vi. 142]. Crucified Saviour between the Virgin and Evangelist. Small panel. (3) Ferrara Professor Saroli [* now

marriage in 1501 he practised with but little interruption at
Urbino for fifteen years. There was not an occasion for pictorial
display that did not give him an opportunity to exhibit his
talents. When Cæsar Borgia treacherously seized the city and
expelled Guidobaldo in 1502, Viti designed the scutcheon of the
usurping prince.[1] In obedience to the will of Giam Pietro
Arrivabene, Bishop of Urbino, who died in 1504, he was in-
structed to set up an altarpiece in a mortuary chapel in the
cathedral, the walls of which were covered with frescoes by
Girolamo Genga[2]; both artists laboured together at the
tabernacle of Corpus Christi in the same cathedral during the
year 1505.[3] In 1509 Viti took part in the adornment of
triumphal arches erected to celebrate the meeting of Eleonora
Gonzaga with her bridegroom, Francesco Maria.[4] His election
to the office of " priore " in 1508, and to that of " primo priore "
in 1513, are evidence of the respect and esteem of his fellow-
countrymen[5]; he became the professional adviser of the Duke
Francesco Maria,[6] and furnished pictures for his palaces at
Urbino and Urbania.[7] Of all his works the most important
and the best is the altarpiece commissioned by Elizabeth Gonzaga
and Alessandro Ruggeri for the chapel of Giam Pietro Arrivabene
at Urbino in 1504. It represents the bishop and the Duke
Guidobaldo kneeling at the sides of an altar, whilst above them
St. Thomas à Becket and St. Martin sit enshrined in a ruined
arch.[8] Nothing can exceed the precision and carefulness of
finish in the outline and modelling ; there is no lack of pro-

Duca Francesco Massari-Zavaglia]. Virgin, Child, and young Baptist. Small
panel.

* The circumstance that Timoteo Viti was probably not—as supposed by the
authors—a native of Ferrara makes it *a priori* seem less likely that he was the
author of these works. See also A. Venturi, in *L'Arte*, vi. 141 *sq.*

[1] Pungileoni, *Elog. Stor. di T. V., ub. sup.*, p. 10.

[2] *Ibid.*, pp. 11, 12. [3] *Ibid.*, p. 13. [4] Vasari, iv. 498.

[5] Pungileoni, *ub. sup.*, pp. 18, 105. [6] Vasari, iv. 498.

[7] *Ibid.*, pp. 496 *sqq.*, but most of these works are lost, and particularly an
Apollo with the Muses. (Vasari, iv. 498, and Baldi in Passavant, *Rafael*, i. 9.)

* Eight pictures of this series are now in the Palazzo Corsini at Florence
(Nos. 407-14); two of them—Apollo (No. 409) and Thalia (No. 407)—are by Viti,
the others by Giovanni Santi. See Calzini, in *L'Arte*, xi. 227 *sqq.*

[8] Urbino, Duomo, sacristy. Wood, oil, 4 ft. 9 in. broad by 6 ft. 5¾ in. The face
of Arrivabene in profile, aged about sixty, is injured in part by abrasion. The
picture was ordered on the 15th of April,.1504. (Pungileoni, *ub. sup.*, pp. 11-13.)

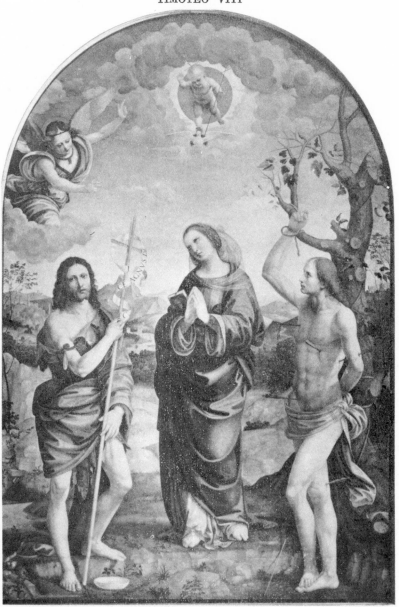

THE ANNUNCIATE VIRGIN BETWEEN TWO SAINTS.

portion or appropriate movement in the figures, no fault to be found in the drapery, which is of Umbrian cast: but the delicacy of the whole piece is cold and chilling ; it reveals a patient and passionless spirit like that of Sassoferrato. We admire on close inspection the blending and gloss of the parts, the pearly ashen-pink of the flesh light and the grey of its shadows; but at a distance all effect disappears, and emptiness is revealed. We meet with the same frigidity and precision of treatment in later pieces, such as the Magdalen ordered about 1508 for the chapel of Lodovico Amaduzzi in the cathedral of Urbino,[1] and the Annunciate Virgin between Saints at present in the Brera at Milan.[2] The masters of whom we are reminded in every instance are Francia and Pinturicchio, only that Viti is much beneath those masters in power, seldom revealing anything like inspiration, rarely rising above the level of ordinary model-painting, and frequently indulging in triteness, vulgarity, and posture.

As a landscapist he has a class of faults natural to a man of his fibre. He is copious in detail, but the very richness which he displays gives prominence to the emptiness observable in other respects. As he grew older Viti adopted the Raphaelesque as evolved in the art of Spagna—a change of which we have an example in the figure of St. Apollonia at the Santissima Trinità of Urbino[3] ; whilst in the Noli Me Tangere and Saints, finished

[1] Bologna, Pinac., No. 204. This picture was exchanged for another by the Marchese Antaldo Antaldi, and represents the Magdalen erect in prayer in a wilderness of rocks (the rocks retouched), figure life-size. On a dry bough to the left is a cartello on which we read: "Di epi et ma. Ma. Lo. Amatutius archip sci cipri. dica." The chapel of San Cipriano in the Duomo was founded by Amaduzzi in 1508. (Pungileoni, p. 19.)

[2] Milan, Brera, No. 507. Wood, oil, m. 2·60 high by 1·82; formerly in San Bernardino degli Osservanti outside Urbino, and at the altar of the Buonaventura. The angel is in the sky, whilst below the Virgin stands on a foreground of rock between St. John the Baptist and St. Sebastian bound to a tree. This is a form of Annunciation already used by Francia (see *antea*). The figures are plump, coarse in limb and extremities, and cold in expression. Their proportions are short and thickset. There is some sharpness and rawness in the contrast of light, half-shade, and shadow. The surface has been cleaned, which is most apparent in the St. Sebastian.

[3] Urbino, church of the Santissima Trinità. Canvas, oil, almost life-size. The saint stands in a landscape holding a book and pincers. Injured in the landscape, mantle, and tunic; a piece has been sewn on to the right side of the picture. [* This picture is now in the Gallery of Urbino.]

in 1518 for the brotherhood of Sant' Angelo at Cagli, he unites
to the Raphaelesque a little of the hardness and conventionalism
of Santi and Palmezzano.[1] It was about this time, or perhaps
just before, that Timoteo proceeded to Rome, and became
Raphael's assistant[2]; and there is not the slightest reason to
doubt the correctness of the judgment which assigns to him the
execution on Sanzio's cartoons of the prophets above the sibyls
in the church of the Pace, and even the draperies in the sibyls
themselves. If we had space to dwell at length upon the
grounds which have led criticism to accept the authorship of
Timoteo in these frescoes, we might prove conclusively that it is
not Raphael's hand that worked out the parts we have men-
tioned, and that amongst his disciples no other than Timoteo
could have completed them as they are; but there is no differ-
ence of opinion on the question, and it is therefore sufficient to
state the fact[3]; whereas in another case it has not yet been
hinted that Viti was the painter. The panel in which we
believe his hand may be found is that of St. Luke at the easel,
painting the Virgin and Child in the presence of a youth. The

[1] Cagli, brotherhood of Sant' Angelo Minore. Wood, oil. St. Michael tramp-
ling on the dragon, and weighing the souls, and St. Anthony the Abbot, in front
of a ruined arch, through which a landscape is seen. In the foreground of this
landscape is the Magdalen kneeling and yearning for the touch of the Saviour,
who bids her hold back. The St. Anthony is good, St. Michael seems to be
dancing, the Magdalen looks copied from Raphael. The colour is a little raw,
the balance of light and shade incorrect, and the composition is affected and
conventional; there is little or no atmosphere. On the basement of the arch
and between the two figures of saints one reads: "Timotheo Viti Urbina opus."
This work was painted on the 2nd of May, 1518. (Pungileoni, *ub. sup.,* p. 50.)

[2] Pungileoni has proved by documents, such as receipts acknowledged, records
of purchases of land, registries in the brotherhood of San Giuseppe at Urbino, of
which the painter was a member, that Viti was in Urbino in 1501, 1503, 1505-9,
1513, 1515, 1516, 1518, 1519, and 1520-23. It is possible that he should have
been in Rome in 1514-15, 1516-17, or in 1519-20. (See the long and somewhat
confused Life of Pungileoni, *ub. sup.*) In favour of the last of these dates, it is to
be noted that the chapel of the Pace was still unfinished in 1519. See the will of
Agostino Chigi, in Passavant. *Rafael,* ii. 168.

[3] Rome, Santa Maria della Pace. Vasari contradicts himself when speaking
of these frescoes. He says (Life of Raphael, iv. 341) the sibyls and prophets
were the finest things of the master; (Life of Timoteo Viti, iv. 495) that the
sibyls were Viti's in invention and execution. There is no doubt that the prophets
and sibyls are both done from Raphael's cartoons, the former entirely, the latter
in the draperies, by Viti. See also Passavant, *Rafael,* i. 192, ii. 165.

picture is in the Academy of Rome, and there are two versions
current respecting it. According to one class of judges it is an
injured Raphael; according to another it is partially by Sanzio
and partially by one of his disciples.[1] We believe the author to
be Timoteo Viti, because in such parts of it as are preserved
Timoteo's mode of colouring is obvious. The yellow lights,
the pearly half-lights, and the grey shadows are as clearly
characteristic of his style as the cold and careful finish and
gloss of the surface. The heavy forms of the Virgin and
Child appearing as a vision to St. Luke are his as contra-
distinguished from Raphael's—they have his usual rotundity
and plumpness, the superficial air, without the life and inspira-
tion, of Sanzio ; they are of ice as compared with such elevated
creations as the Madonna of Saint Sixtus. The action and
movement of St. Luke are as cold and lifeless as they well
can be ; there is an indication and surface of action without
life and strength to carry out that action ; and it is hard to
tell why the brush does not slip from the hand of St. Luke,
and the paint-pot fall to the ground. In the cast of the drapery
Raphael's manner is imitated, in the motion of the figures his
turn is aped, but the result is timidly imperfect. We may
conclude, in fact, that a sketch of Raphael was enlarged by Viti
to the life-size of this picture, and that in this way, and with
Timoteo's knowledge of Raphael, a false air of the great master
was produced by the poorer art of his assistant. A more genuine
specimen of Viti when under Raphael's influence is the Madonna

[1] Rome, Academy of San Luca. Professor Cav. Ferdinando Cavalleri has
written a pamphlet of twenty-two octavo pages to affirm the authenticity of this
picture. It was given by Pietro da Cortona to the church of Santa Martina in
Rome, which was ceded in 1588 to the Academy of Painters. The original piece
was afterwards removed to the Academy, and a copy was placed on the altar (see
Passavant, ii. 416). The Virgin, Child, the arms, hands, and feet, the yellow
mantle and green sleeves of St. Luke, are all by one hand, the flesh being pale,
yellowish in light, sky-blue in half-tone, grey in shadow, of strong substance and
gloss in Viti's manner. The head of St. Luke and the youth beside him, which
may or may not be the portrait of Raphael, are of another tone, which may be
owing to the copious retouches which the picture has received. None of the
figures are set on the ground according to the true laws of perspective. A cartello
in the left-hand corner is a blank slashed with a knife ; it was introduced there
by Scipione of Gaeta, a restorer of the eighteenth century, whose name was after-
wards erased by Federico Zuccaro.

with Saints in the Museum of Berlin—a very soft, formal, but
kindly mixture of the Umbrian of Sanzio and his father, with
Timoteo's own peculiar coarseness in the size of the extremities.[1]
In a similar way we detect his peculiarities in the thin rubbed
tone of the Penitent Jerome of the Berlin collection,[2] and the
St. Francis belonging to Mrs. Butler Johnston in London.[3]

After Raphael's death Viti no doubt returned to Urbino,
where he died on the 10th of October, 1523.[4]

[1] Berlin Museum, No. 120. Wood, oil, 5 ft. 8½ in. high by 4 ft. 10 in.; formerly
catalogued as by Santi, and with a false inscription of "Jo Sanctus Urbi. p."
Subject, the Virgin and Child, the young Baptist, and a boy in prayer, St. James
the Younger and St. James the Elder.

[2] Berlin Museum, No. 124. Arched, 1 ft. 3¼ in. high by 10½ in. St. Jerome
kneels before the Cross. [* This picture is now on loan to the Provinzialmuseum
at Münster.]

[3] London, Mrs. Butler Johnston. Small panel. [* Bought at the Munro sale
in 1878 by Mr. Cassels.]

[4] It is proved of Timoteo that in 1520 he empowered an agent to ransom his
wife's relative, Federico Spaccioli, at Pesaro, for 50 scudi. Of his pictures, lost
or otherwise unaccounted for, the following list may be made : (1) Urbino, Duomo,
altar of Santa Croce. The Virgin and Child, St. Crescentius, St. Vitale, and an
angel playing a viol (Vasari, iv. 494). Pungileoni (p. 7) and Passavant (*Rafael*,
i. 376) state that this picture was in the Brera. It is not there now, nor was it
ever catalogued. [* This is not correct. The picture in question has been at the
Brera since 1811, though it was not on view for some time. It is now exhibited
in the Sala XXV. as No. 508.] (2) Urbino, Sant' Agata and Cappuccini. Pictures
the subjects of which are not given (Vasari, iv. 497, and Pungileoni, *ub. sup.*,
p. 17). (3) Urbino, brotherhood of San Giuseppe. Virgin, Child, and St. Joseph
(Pungileoni, note to p. 46). Two crosses, done in 1520 (Pungileoni, p. 107).
(4) Marciolla, near Urbino. Two Angels playing the Lute (*ibid.*, p. 8). (5) Rome,
Santa Caterina da Siena. Frescoes, and a cataletto, which, however, was also
assigned to Peruzzi (Vasari, iv. 495, 596). (6) Rome. Liberation of Andromeda
(Pungileoni, note to p. 63, but see also Bottari, *Lettere Pitt.*, iii. 480). (7) Pesaro,
San Francesco. Holy Family and St. Francis, and in the distance a Procession of
the Kings (Pungileoni, p. 14). (8) Forlì, San Francesco, with Genga. A chapel
containing the Assumption, since destroyed (Vasari, iv. 496, and Pungileoni, p. 48).
(9) Città di Castello. Pictures (Vasari, iv. 496).

* Extant paintings by Timoteo Viti hitherto unmentioned are: (1) Bergamo,
Galleria Morelli, No. 30. St. Margaret. (2) Gubbio Cathedral. Coronation of
Mary Magdalen. (3) Formerly High Legh Hall (Knutsford, Cheshire), and after-
wards in the Rodolphe Kann collection, Paris, and now sold. The Agony in the
Garden (reproduced in *Gazette des Beaux-Arts*, ser. iii. vol. xxiii. p. 187). (4)
Milan, Brera, No. 509. The Trinity adored by St. Jerome and a Donor. Formerly
in SS. Trinità at Urbino. (5) Urbino Gallery, St. Sebastian, SS. Joseph and Roch.

CHAPTER IX

PAINTERS OF PARMA AND ROMAGNA

PARMA, we may believe, was never without artists, but till the advent of Correggio they were men of acknowledged mediocrity; and yet it would be unfair to assume that they did not share to some extent in the progress of the age. It is hardly doubtful that the Canozzi, who became famous at Padua, had considerable influence on Parmese painting; they brought with them some of the qualities of the Mantegnesques, but they introduced also the trick of tarsia, and it is curious to observe that pictures of the fifteenth century look as if they had been executed under all the disadvantages to which the wood-inlayer is subject. We have spoken casually of Bernardino Loschi as a man affected in his style by the Canozzi and by Costa. This Bernardino was the son of Jacopo Loschi, whose name is in records of 1449, and who died at Carpi in 1504.[1]

He was fortunate enough to compose for the Servi at Carpi in 1496 a Virgin and Child famous for its miracles; and the Gallery of Parma still possesses a very unattractive Madonna by him dated 1471, in which we observe something like the formlessness peculiar to the San Severini or Guidoccio of Imola.[2] There is nothing characteristic in this production, if we except its ugliness,

[1] Jacopo d'Illario Loschi paints, 1488, for San Giovanni of Parma, a standard and an altarpiece (Affò, P. J., *Vita del Parmigianino*, 4to, Parma, 1784, p. 6); paints in 1496 the miraculous Virgin of the Servi at Carpi, still existing in 1707 and since lost; is mentioned at Carpi in records of Jan. 1, 1500, and June 3, 1504; is noted in a record of Jan. 23, 1505, as dead. (Campori, *Gli Artisti, ub. sup.*, pp. 293-4.)

[2] Parma Gallery, No. 58. Panel, tempera, figures almost life-size. Two angels at the Virgin's side play viols, two others in prayer in a quaint sort of balconies; in the sky the Saviour in benediction; inscribed: "Opus Jacobi de Luschis de Parma MCCCCLXXI. die XVI. Junii." This panel is much injured by time and retouching.

but the length and slenderness of the figures. They are the prototypes of numerous others on walls or panels in churches at Parma, commissioned we may suppose of Loschi and his father-in-law, Bartolommeo Grossi.[1]

Bernardino Loschi, who continued the art of his father, as we see by his altarpiece of 1515 in the Gallery of Modena,[2] was born at Parma before 1488, was the author of several pictures and frescoes in the churches and castle of Carpi, and died in the service of Alberto Pio of Carpi in 1540.[3]

Contemporary with Jacopo Loschi was Filippo Mazzuola, whose birth is uncertain, but who died in 1505, a man with some claim to attention, if only because he was the father of Parmigianino.[4] There are large compositions in his native place which afford a perfect insight into his style—the Virgin and Child

[1] Parma, San Francesco. There are records of 1462 which prove that Jacopo Loschi and his father-in-law painted in this church. (We are obliged to Signor Carlo Malaspina for this and other intelligence respecting Parmese painters.) San Francesco is now a prison, and we have already noticed some old paintings there (*Italian Painting*, ed. Douglas, iii. 256, n. 1). In the convent church there is a Virgin and Child between SS. Francis and John the Baptist and a kneeling donor—a fresco much in Loschi's manner. In the same style : (1) Parma, Santa Barbara, St. Anne and the Virgin giving the breast to the Child; fresco, with figures under life-size, *circa* 1440–50. (2) Parma, Santissima Trinità, from San Barnaba. Virgin, Child, and St. James. Fresco, sawed from the wall, figures under life-size. (3) Parma, Duomo, 4th chapel in the right aisle. Here are frescoes with incidents from the legends of SS. Fabian and Sebastian, lately rescued from whitewash, done after 1400 (Affò, *Storia della Città di Parma*, Parm. 1792), much. restored. (4) Same church, Cappella Baganzola, built 1420–23 (Angelo Pezzana, *Storia della Città di Parma*, 8vo, Parm. 1837–59). Frescoes with scenes from the lives of SS. Christopher and Catherine, also rescued from whitewash, but restored previous to the whitewashing and subsequently. Both chapels are assigned to Loschi and Grossi, and the style is truly that of Loschi's altarpiece.

[2] Modena Gallery, No. 477. Wood, m. 2·35 high by 1·68. Virgin, Child, SS. Nicholas and Anthony, and four angels; inscribed: "Alberto Pio principe opt. aspirante Bernardinus Luscus Carpen. fecit. 1515." Done for the Scuola di S. Niccolò at Carpi. [3] Campori (*Gli Artisti*, pp. 294 *sqq.*).

[4] See the pedigrees of the Mazzuoli in Gualandi, *Memorie, ub. sup.*, ser. vi. p. 122. [* Nine children of Filippo Mazzuola were baptized at Parma between 1490 and 1505. It is furthermore recorded that the wife of the painter Francesco Tacconi of Cremona (who was staying at Parma for some time towards the end of the fifteenth century) adopted Mazzuola and his wife as her children, and bequeathed the whole of her property to them. She, however, altered her will in 1494, when she constituted her own son Jacopo Tacconi her sole heir. See Ricci, in *Napoli nobilissima*, vii. 5. There existed also relations as regards their art between Mazzuola and Tacconi; cf. *postea*, p. 297, n. 4.]

between two Saints in the Gallery of Parma dated 1491,[1] the
Baptism of Christ in the Duomo of 1493.[2] These and the Dead
Christ on the Virgin's knees in the Naples Museum, which was
finished in 1500, have all the same character.[3] The figures are
usually lean and dry, and curiously stiff, at the same time ill
drawn and short in stature; sometimes they have a gentle air,
they are almost always regular in the division of the proportions.
Round heads, curt extremities, and styleless draperies are like-
wise recurring features. We are reminded of the school of tarsia
by the sharpness and abruptness of the contrast between the
lights and the spare dark shadows that cling to the contours, as
well as by the mapping of the dull tints in vestments. Mazzuola
was no colourist, and his tempera is invariably raw and of a sad
grey tone; he was not master of any rules of perspective. His
manner thus far is a mixture of the local one and of that of the
Canozzi, with a slight approach to Cima's.[4] Some improvement

[1] Parma Gallery, No. 46. Virgin and Child enthroned, between St. Francis
and St. John the Baptist; inscribed : "Filipus Mazolus 1491"; the chin and neck
of the Virgin and other parts injured and restored; distance, sky. This may be
the picture noticed by the Anonimo at San Domenico of Cremona (Anon. ed.
Morelli, p. 34).

[2] Parma, Duomo, formerly in the baptistery. Arched panel, with life-size figures
of Christ and the Baptist, with five saints at the sides, and the Eternal above;
inscribed : "Fillippus Mazolus p." and "Tempore d. Karoldi de Bucanis. P. Posti
d. Johš de Cribellis. d. Marci de colla de Lodovici de arietis, d. Andree de Vagiis,
baptiste de clericis. Hoc opus fecit fieri Caplani canonicoř senarii numeri baptis-
terii Parmensis &ª año Dn MCCCCLXXXXIII." The figures are long and slender and
defective, the surface much injured by scaling and dirt; there is a split along the
body of the Baptist, and copious retouches in other parts.

[3] Naples Museum, Room XI., No. 22. Panel, oil, figures half the size of life;
inscribed on a cartello: "Filipus Mazola pinxit 1500"; at the Virgin's sides, the
Magdalen, SS. Catherine, Monica, Apollonia, and Barbara; distance, landscape.
In the same gallery (Room XI., No. 26), the Virgin adoring the Child between
SS. Agnes and Chiara; the figures are better than in the former painting, and
more in the style of the altarpiece at Berlin (see *postea*, p. 298). Figures half life-
size; a cartello on the foreground bears the signature "Filipus Mazolla p.p."

[4] There is reason to think that Mazzuola studied in Venice for some time,
probably before 1490. We have by him a free copy of Bellini's Resurrection of
Christ which originally was in San Michele di Murano (see *antea*, i. 160, n. 2);
this copy, signed "1497 Filipus Mazolus," is now in the Strassburg Gallery
(No. 225). The Museo Civico of Padua possesses a Madonna by Mazzuola (No. 411),
bearing a mutilated inscription which may perhaps originally have read "Filipus
Mazolus dis. Joanis Bellini p." This picture reproduces a composition by Bellini
which also appears in the Madonna in the Scalzi, whether this be an original
work by the master or not (see *antea*, i. 184, n. 4). The immediate model of

may be found in his Madonna of 1502 at the Berlin Museum,
which evinces more study and displays better forms than the old
ones.[1] In a bust of the Redeemer of 1504 belonging to the
Raczynski collection at Berlin, the regular mask of the Bellin-
esques is reproduced[2]; and in two bust portraits at Milan and
Rome, respectable power is revealed in drawing, in modelling,
and in light and shade.[3]

Mazzuola in most but not in all respects seems, however, to have been Francesco
Tacconi's version of the same composition now in the National Gallery (No. 286),
dated 1489. (See Moschetti, in *Bollettino del Museo Civico di Padova*, x. 151 *sqq.*)
In Mazzuola's portraits and in the picture of Christ at Agram it is possible to trace
the influence of Antonello.

[1] Berlin Museum, No. 1109. Wood, 7 ft. 9 in. high by 3 ft. 9 in.; inscribed in a
cartello: "D. M.COCOC2. Philipus mazola parmensis p." Subject, Virgin and Child
under a dais with two angels, between SS. Catherine and Chiara; injured by
cleaning.

In the same collection, No. 206, half-length portrait of a man, in style not
unlike a portrait (No. 55) in the same gallery, signed "Me fecit B'nardinus de
Comitibus," or a Madonna of 1500 by the same Bernardino in the Lochis Gallery.
Of this last-mentioned Madonna with the Child in a landscape, there is a replica
under Garofalo's name (No. 1115 in the Gallery of Schleissheim). [* This picture
is now in the Gallery at Augsburg (cf. *postea*, p. 394).]

[2] Berlin, Raczynski collection [* now in the Kaiser Friedrich Museum at Posen],
No. 57. Wood, 1 ft. 11 in. high by 1 ft. 1½ in.; bust, in benediction; on the parapet
a cartello with "Filipus Mazola parmensis p. MCCCCIIII." [* From the same year
dates a picture representing the Conversion of St. Paul, which originally was in
the Monastery of the Franciscans at Cortemaggiore and now belongs to the Gallery
at Parma (No. 51).]

[3] Milan, Brera, No. 417. Bust of a man in a black cap and vest on a green
ground. On an opened letter cartello on the parapet: "Flipus Mazollus Par-
mensis." Wood, m. 0·44 high by 0·28. This portrait is much in the style of that
of Bonsignori in the National Gallery, though of a lower class.

Rome, Palazzo Doria. Wood, tempera, all but life-size, bust of a man in a
black cap and red vest, with a Latin motto " . . . me Deus et sit fort . . ." on
his collar, and on the parapet "Fili. Mazola." Here Mazzuola is in the path of
Melozzo. The panel is damaged by cleaning and is darkly olive in complexion.

* Yet another portrait by Mazzuola is to be found in the Vieweg collection at
Brunswick (inscribed " Alex. de Richao. F. M. Par. p."; see Harck, in *Archivio
storico dell' arte*, ser. i. vol. iii. p. 172). A portrait in the Galleria Borromeo
at Milan is perhaps also by him (see *postea*, p. 354, and Morelli, *Die Galerie zu
Berlin*, p. 130).

The following are also works by Mazzuola: (1) Agram, Strossmayer collection.
Christ at the Column (signed " Filipus Mazola p. p."). Frizzoni, in *L'Arte*, vii.
435 *sq.* (2) Cortemaggiore, San Lorenzo. The Virgin and Child with Saints
(dismembered polyptych). Ricci, in *Napoli nobilissima*, vii. 5 *sq.* (3) London,
National Gallery, No. 1416. The Virgin and Child with two Saints (signed
" Philippus Mazola p. p.").

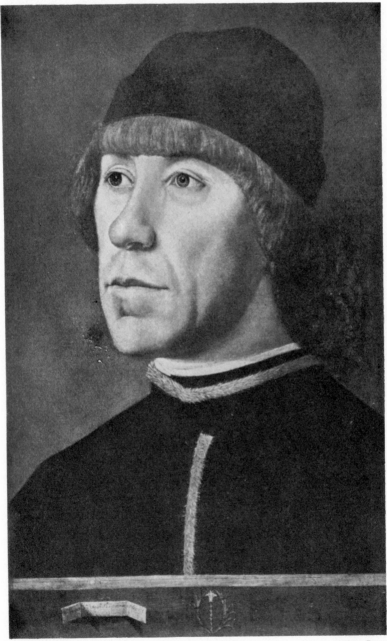

PORTRAIT OF A MAN.

Mazzuola's pupil, Cristoforo of Parma, earned his livelihood as a journeyman at Venice from 1489 to 1492,[1] and painted an altarpiece in 1495 which still hangs in the sacristy of the Salute. Previous to visiting Venice he no doubt completed the Madonna with Saints in the royal gallery of Parma.[2] The figures are an improvement on those of Mazzuola—mild, thin, gentle, and not without a feeble sort of grace ; and Cristoforo seems to exhibit some of the tenderness and smorphia which mark the works of Francesco Francia and Rondinello. The action of his personages is timid and embarrassed, the draperies are overcharged, and the colours are cold and neutral. At the Salute a subject of the same nature is represented much in the same manner, but with more sombre shades of colouring which recall Buonconsiglio, and with changes in contours that prove the influence of Cima and Bellini.[3] In 1496 Cristoforo was a master in his native place of Parma, where he was known by the sobriquet of " il Temperello " or Caselli.[4] Here he rises to greater dignity. The saints and angels round his Madonna of 1499, in the Sala del Consorzio dei Vivi e dei Morti at Parma, have some of the grace of Cima with an

[1] Gaye, *Cart.*, ii. 71 ; he began with a salary of three ducats a month, which was increased in 1492 to eight ducats.

[*] In 1489 Cristoforo, together with Gentile Bellini, witnessed the will of Giovanni Mansueti's wife (see Ludwig, in the Berlin *Jahrbuch*, xxvi. Supplement, p. 63). He is mentioned in Grapaldi's *De partibus aedium* (lib. ii. cap. viii.), which was first published at Parma about 1494.

[2] Parma Gallery, No. 50. Tempera. Virgin and Child in an archway between SS. John the Baptist and Jerome ; figures under life-size.

[3] Venice, Santa Maria della Salute, sacristy ; engraved in Zanotto, *Pinacoteca Ven.*, fasc. 2. The colour, tempera of much substance, is injured in the lower parts of the picture. Subject, the Virgin and Child, with a bishop kneeling at her feet, attended by St. Christopher and a bishop ; inscribed : " Cristoforus Parmensis pinxit MCCCCLXXXXV "; figures half life-size. [* This triptych was executed for the church of San Cipriano at Murano. Cristoforo moreover painted the shutters of the organ of Santa Maria del Carmine at Venice with the figures of the Virgin Annunciate, St. Gabriel, Elijah, and St. Albert (Sansovino, *Venetia*, p. 263 ; Boschini, *Le Ricche Minere*, Sest. D.D., p. 44) ; these paintings are now lost. The signed picture of St. Peter enthroned in the church of Almenno San Bartolommeo, near Bergamo, also probably dates from the time of Cristoforo's stay at Venice.]

[4] He is mentioned as " Cristofano Castelli " by Vasari, vi. 485. [* The Caselli and the Temperelli were both Parmese families. It appears that Caselli was the original family name of the painter, and that later in his life he was also called Temperelli. Ricci, *La R. Galleria di Parma*, p. 107.]

excess of corpulence, and are freely treated considering their peculiar style. The withered Baptist on the right is also one of Cima's types, whilst the bishop to the left and the bust of the Eternal in a lunette are of Mazzuola's less elevated stamp. The Virgin and Child alone betray some acquaintance with methods of contour common to Montagna and Canozzi; and indeed the whole arrangement presupposes Caselli's knowledge of Paduan maxims for distributing space and balancing the various parts of a picture; the colour, far from being treated in the fashion of the Venetians, is without modulation and full of gloss, and preserved in keeping by contrasts of light and shade rather than by contrasts of tints. In this, and in the masks and shape of angels, we see the germ that expanded fully in Correggio.[1] We cannot ascertain where Caselli acquired this novel breadth, but there are two panels representing winged boys playing instruments in the

[1] Parma, Sala del Consorzio dei Vivi e dei Morti, originally in the Duomo; mentioned with praise by Vasari, vi. 485, and ordered on the 10th of March, 1496, for a chapel in the cathedral. The Virgin and Child are on a high throne between six angels playing instruments, and attended by SS. Ilario and John the Baptist; at the foot of the throne ten angels in adoration; inscribed: "Christophori 14. Caselli 99. opus." Figures life-size, wood, oil; in the sky the Eternal with the orb in a glory of ¦cherubs. The price of the piece was 55 ducats of gold. [* This picture has now its place in the Gallery at Parma.]

[2] Parma, San Giovanni. Sacristy, wood, once part of the organ; much injured and blackened. [* These panels are now in the Gallery at Parma (Nos. 48 and 49).]

[3] Parma, Duomo, southern transept. That this was done in 1499 is stated in the dictionary of Orlandi.

[4] Parma, San Giovanni Evangelista. The Virgin (all repainted) in the middle of the picture, the kings to the left, and St. Joseph to the right; signed with a new signature: "Christophorus Caselli opus, 1499." The figures are small and paltry, the colour of full substance and high in the shadows, the tints of dresses strongly contrasted, the composition arranged, unnatural, and lifeless. We are reminded here of Bertucci of Faenza and Tiberio, as well as of Araldi, whose fresco of the Virgin, Child, and Donor in the Duomo of Parma has been mistaken for a work of Caselli. It is therefore not unlikely that in this piece Araldi was Cristoforo's assistant. [* See *postea*, p. 301, n. 6.] In the same mixed style is a Visitation in the upper sacristy of the canons of the Duomo at Parma (panel, in oil, with figures of half life-size), inscribed: "Ms. Cabrielo Mandrio f. f." There is also in San Francesco of Osimo a large Madonna under a-baldaquin, attended by SS. Bernardino, Jerome, Ursula, the Magdalen, Anthony, and three other erect saints, with St. Francis and a captain in armour kneeling at the sides, of which we are not certain whether to ascribe it to Caselli or to Rondinello. It bears the inscription (a forged one) of "Gio. Piero Perugino." The composition is good, and

CRISTOFORO CASELLI

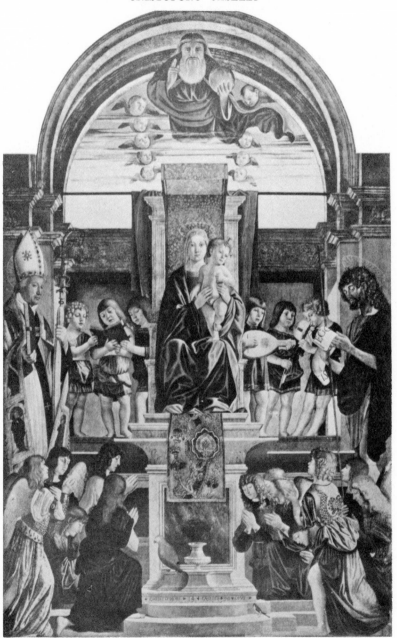

THE VIRGIN AND CHILD WITH ANGELS AND SAINTS.

sacristy of San Giovanni at Parma which almost conclusively prove that he must have been inspired by the grand freedom and science of Mantegna as shown in the works of the Mantuan period.[2]

Of the same year, 1499, we have an Eternal on gold ground in a chapel to the right of the choir in the cathedral of Parma,[3] and a repainted Adoration of the Magi in San Giovanni, in which we are reminded of the school of Palmezzano and the Faventines.[4] The latest date recorded of Caselli is 1507.[5] Of his pupil Alessandro Araldi, whose panels are exclusively confined to the city of Parma, we can only say that they show a decided leaning to the Umbrian models of Francesco Francia and the Peruginesques of the lowest class, and that in his most ripe productions he saved himself much trouble and thought by appropriating the forms and arrangements of other and greater men.[6]

the style is reminiscent in part of Luigi Vivarini and Montagna, the colour dull and sombre (injured and spotted) as in Caselli.

[4] This painting is by Antonio Solario; see *postea*, p. 437, n. 3. From 1502 dates a picture of the Nativity of Christ by Caselli in Santa Maria at Castell' Arquato, near Piacenza. Ricci, *La R. Galleria di Parma*, p. 108.

[5] Parma, Duomo, round. Monochrome of Christ in the Tomb between two angels, under the arch of the monument erected in 1507 to Bart. Montino, canon of Parma and apostolic protonotary.

[6] We know from contemporary documents that Caselli was commissioned to execute various works of little importance between 1515 and 1521. He died in June 1521. Ricci, *ub. sup.*, pp. 108, 106.

[6] Alessandro Araldi, according to Zaist (*Notizie Istoriche de' Pittori &ª Cremonesi*, 4to, Cremona, 1774, i. 100), was a native of Casal Maggiore ; but this is an error, for according to Padre Affò (*Life of Parmigianino*) he was born at Parma about 1465. His first public work (as we are informed by reports kindly furnished by Dr. Luigi Ronchini and Signor Carlo Malaspina) was an altarpiece furnished in 1500 for San Quirino of Parma, in payment of which he received a small sum and a present of clothes. He painted a fresco of the Virgin and Child and a Donor in the Duomo of Parma in 1509 ; the Last Supper, the Capture, and other scenes from the Passion in the choir of San Paolo of Parma in 1510, which have perished. In 1514 he finished the Annunciation of the Carmine now in the Gallery of Parma, and in 1520 he received an order, which was never carried out, for an altarpiece in the Duomo. He made a will in 1528; and a banner done for the company of San Cosimo e Damiano was presented to that company by his heir, Filippo Pozzioli, in 1530. The following is a list of his works : (1) Parma, Duomo. Fresco, Virgin and Child, St. Joseph, and a kneeling donor with the bishop's mitre at his feet; life-size (the blue mantle of the Virgin and the distance abraded); inscribed : "Alex . nder D. Araldus pinxit. 15 . 9 " (1509). The fresco is on the wall to the right as you enter the Duomo, and is usually

East of Parma and Bologna, and chiefly in the cities of Forlì, Ravenna, and Rimini, we trace the influence of Giovanni Bellini commingled with that of Palmezzano, the chief representative of this class being Niccolò Rondinello, the best artist of Ravenna in the first years of the sixteenth century. It was fortunate for Rondinello that he was enabled in his youth to attend the schools of the most eminent Venetians. He is described—and, no doubt, correctly described—by Vasari as

assigned to Caselli. The forms are imitated from those of the Bolognese school of Francia, but outlined more strongly and in a more broken manner, the figures small in stature, bony, angular, and short in the limbs, the drapery of cutting folds ; the Child square in the fashion of the Veronese Caroto, the treatment like tarsia, the colour (much abraded) dull and raw. [* This fresco seems really to have been executed by Giovanni Pietro Zarotti in 1496 (Ricci, *ub. sup.*, p. 108).] (2) Parma Gallery, No. 45. Annunciation. Wood, oil; inscribed : " Alexander Araldus faciebat 1514"; from the Carmine. The Virgin is affected, especially in the air of the head, the colour much abraded, raw and hard, the landscape the best part of the work. (3) Same gallery (No. 180), in the same style, but under the name of Giovanni Bellini, a Christ erect in benediction with a book, on green ground. [* Now labelled "Mocetto (?)."] (4) Parma, San Paolo, a chamber in the lunettes of which are various subjects. Ceiling, blue ground, arabesques and monsters, angels playing instruments, and medallions representing the Samaritan Woman at the Well, Moses receiving the Tables, Adam and Eve, a cento of imitation from Raphael and Michelangelo, and the Sacrifice of Abraham, recalling a composition of Bazzi. In other divisions, Judith decapitating Holophernes (reminiscent of Costa), Sermon of Paul, Massacre of the Innocents (copied from Raphael), the Miraculous Draught of Fishes, the Marriage Feast in Cana, the Judgment of Solomon. In the angles of the ceiling, gambols of children. The lunettes contain allegories of obscure meaning, feebly composed, but inspired from Mantegna, Costa, and Francia ; on the chimney-piece is the inscription : "Transivimus per ignem et aquam . . . MDXIIII." (5) Finally we have, in San Sepolcro of Parma, St. Ubaldus between the Archangels Michael and Raphael, with the Virgin annunciate and a Pietà in the pediment ; a fresco in the Cusani chapel, long concealed under another picture. But this fresco may be in part by Lodovico da Parma, a poor dependent in art of Araldi, to whom we may give the following : (1) Parma, ex-convent of San Paolo, Cella di Santa Caterina. Fresco, representing St. Catherine before Maximian. [* Signor Corrado Ricci ascribes this painting and the figures of SS. Catherine and Jerome in the same room to Araldi ; cf. *Le gallerie nazionali italiane*, i. 42 *sq*. See also the article on Araldi by the same writer in Thieme and Becker, *Allgemeines Lexikon der bildenden Künstler*, ii. 54 *sq*.] (2) Church of San Pietro, beneath the organ. Fresco of the Virgin and Child with St. Joseph to the right (all but gone). (3) Collegio delle Scuole Tecniche a San Paolo, façade. Fresco, much abraded, a Pietà. (4) Pinacoteca, No. 122. Annunciation, with the angel and the Eternal in the sky, and two saints, Catherine and Sebastian, to the left of the Virgin in an open archway. The character of Lodovico's paintings is that of a follower of the Bolognese school on the level of Melanzio and Tiberio d'Assisi.

having been one of Giovanni Bellini's most industrious assist-
ants.[1] During his stay at Venice he contributed to the
production of pictures which Bellini did not disdain to sell
as his own, and painted Madonnas which might well pass for
school-pieces out of his master's atelier ; and it is not without
interest to find amongst the treasures of the Doria Palace at
Rome a Virgin and Child with Rondinello's signature, the exact
counterpart of another in the same collection signed by Giovanni
Bellini.[2] Such a striking concordance as this would not be
explained by the mere supposition that Rondinello copied
Bellini. We may presume that Bellini employed him on the
principal parts of the panel to which he appended his name,
and that Rondinello used the same design subsequently. The
two pictures are alike in workmanship and composition, that
which Bellini signed being less correct in outline and in
colouring than it would have been had he done it entirely
with his own hand, that of Rondinello being more paltry in
shape and darker in tone. What distinguishes Rondinello in
this and other productions of the same sort is a certain help-
lessness in the setting of his figures, want of breadth and size
in the figures, broken contours, and poor, cornered or tortuous
drapery.[3] His handling testifies to no delicacy or subtlety
of means, and his colour is uniform and sombre. There is

[1] Vasari, iii. 170 *sqq.*, v. 253, vi. 323.

[2] Rome, Palazzo Doria, No. 126. Virgin and Child with St. John the Baptist to
the right hand, inscribed : "Joannes Bellinus." Rondinello's copy (No. 163) is
without the figure of the Baptist. The Child is varied in the movement of one
arm, and holds a bird fastened by a string. The distant landscape is also varied ;
on a parapet: "Nicolaus Rondinelo"; wood, oil, below life-size ; much injured
by restoring.

[3] Same gallery, No. 159. Wood, oil, almost life-size. Virgin, half-length, with
the Child on her lap ; green ground. This picture is much dimmed by time and
restoring. The name of Rondinello is said to be concealed by the beading of the
frame.

But there are other copies of Bellini's Madonna at the Doria Palace which
may be by Rondinello, *e.g.* (1) Rovigo Gallery, No. 3. Virgin and Child in front
of a green hanging which half conceals a landscape. On a cartello fastened
to the parapet, the false inscription : "Gentilis Bellinus eques. 1483."
(2) Ravenna, Rasponi Gallery. Replica of the above, but probably a copy
from Rondinello by one of the Cotignola. [* The collection of Count
Ferdinando Rasponi of Ravenna was sold by auction at Ravenna on Oct. 25,
1880.]—Reminiscent of Rondinello at the school of Bellini is a half-length
Virgin and Child, signed "Joannes Bellini," in Dudley House, London. (See *antea.*)

evidence in his works—and this is an advantage in the case
of a man respecting whom we have not a single date [1]—that
he was particularly impressed by one class of Bellinesque
models. In Bellini's altarpieces of 1505, and upwards, we
observe a marked breadth of head and a vigorous compression
of the horizontal facial lines. This peculiarity Rondinello
took with him when he left Venice and transferred his easel
to Forlì and Ravenna. At first he preserved a grateful re-
membrance of the lessons learnt in Venice, reproducing the
masks of Cima and Bellini ; but his earlier impressions were
rapidly superseded by others, and in the course of time he
became as much an imitator of Palmezzano as of the Venetians.
In a half-length Virgin giving the breast to the Child at the
Forlì Museum he is not wanting in feeling, nor is he forgetful
of the laws of appropriate composition and proportion. His
principal figure has a broad high forehead, which suggests
reminiscences of Cima ; his drapery is cast in the Bellinesque
fashion, but the colour, of a deep varnish-brown and freely
impregnated with vehicle, is altogether unbroken.[2] On the
same technical principle, with the mask peculiar to Bellini in
1505, he produced a male portrait ascribed to Giorgione in the
gallery of Forlì, a likeness in which nature is not enlarged
and ennobled as it might have been by the genius of a first-
rate artist, in which monotony is created by general tinting,
but in which a sombre glow proves attractive.[3] It is charac-
teristic of Rondinello's progress from this time forward that
he gains more and more freedom of hand without altering his

* [1] We now know records proving that Niccolò Rondinello was at Venice in
1495. In that year he got into trouble there for having married without
observing all the formalities prescribed by the law. See Ludwig, in the
Berlin *Jahrbuch*, xxvi. Supplement, pp. 6 *sqq*.

[2] Forlì, Galleria Comunale, No. 131. Wood, oil, under life-size. Virgin
and Child in front of a green curtain, at both sides of which landscape. (The
blues are all repainted.) On the parapet a twig, cherries, and nuts, beneath
which the words "Nicolaus Rondinelus." The hand and head of the Child are
injured.

[3] Same gallery, No. 110. Wood, oil, 1 ft. 3 in. broad by 1 ft. 8½ in. Bust likeness
of a young man in a black toga, three-quarters to the left in a landscape, called
"Portrait of the Duke Valentino " by Giorgione. The colour is deep and of full
body, but unbroken and highly fused. It is not free from restoring. [* This
picture is now officially ascribed to Palmezzano.]

technical process. His flesh is commonly of a red-brown tinge with olive-brown shadow and little or no transitions ; it is laid in with copious substance and vehicle at one painting with a sweeping touch, then scumbled with half-transparents and finished with light glazes. The burnish thus attained is dark and untransparent ; the vertically compressed form of heads becomes usual, and is accompanied by plumpness and fleshiness ; the eye is covered by a long horizontal lid ; the nose broad in barrel and nostril.

The first example of this treatment is the St. Sebastian at the Column in the cathedral of Forlì, where, however, the influence wielded by Palmezzano is already noticeable in the head, the broken outline, the drapery and architectural distance.[1] In other pictures assignable to Rondinello at the Brera there is an obvious mixture of the schools of Venice and the Romagna.[2] In this fashion too we have four Angels and an Annunciation in San Pietro Martire of Murano,[3] in which we are reminded of Pier Maria Pennacchi.

[1] Forlì, Duomo. Wood, oil. The saint is bound to a pillar, and stands under an arch on an octagonal pedestal. Distance, houses and landscape. The drawing is broken in Palmezzano's fashion, and the drapery cast in Palmezzano's manner.

[2] (1) Milan, Brera, No. 452. Wood, oil; classed in "school of the Bellini"; m. 1·75 high by 1·75; originally at San Giovanni Evangelista of Ravenna (Vasari, v. 254). Subject, St. John Evangelist in front of an altar, on which a picture of the Virgin and Child is placed. St. John wields a censer before the kneeling Galla Placidia. Angels minister at each side. This is a well-preserved picture by Rondinello, coloured as stated in the text; the Virgin and Child Bellinesque, St. John reminiscent of the high-priest in Bellini's Presentation at Castle Howard. The angels are square and short in head as described. (2) Same collection, No. 453, under the name of Stefano da Ferrara. Wood, oil, m. 2·69 high by 2·18. Virgin enthroned between SS. Peter, Bartholomew, Nicholas, and Augustine, and three angels in front playing instruments. Same character as the foregoing, but broader in treatment.

* Both these paintings are now catalogued under Rondinello. The Brera Gallery also contains a picture by Rondinello representing five saints (No. 454), which originally was in San Giovanni Evangelista at Ravenna (Vasari, v. 254).

[3] Murano, San Pietro Martire, but originally in Santa Maria degli Angeli. Four panels, in each of which is an angel ; two play instruments, two are in prayer. In Santa Maria degli Angeli are two panels by the same hand, hanging in the spandrils of the great arch of the nave. They represent the Virgin and the Angel Annunciate.

As Rondinello grows older he loses more and more Venetian character, and in several votive altarpieces at Ravenna he boldly assumes the manner of Palmezzano.[1]

[1] (1) Ravenna Gallery, No. 7. Virgin and Child, SS. Thomas, Magdalen, Catherine, and Baptist, and two angels playing instruments ; injured in part (arm of Child, cloak of Virgin). This piece, in which the Baptist strongly reminds us of Palmezzano, belongs to a religious corporation (La Congregazione di Carità) at Ravenna. Wood, figures life-size. (2) Ravenna, Santa Croce, originally in Santo Spirito (Vasari, v. 254). [* Now Gallery, No. 6.] Virgin, Child, and SS. Jerome and Catherine: greatly injured. (3) Casa Lovatelli, originally at San Giovanni Battista (Vasari, iii. 171 *sq.*). Virgin and Child, SS. Albert and Sebastian. Wood, life-size, full length; much injured and repainted, but with marks of having been one of Rondinello's boldest productions. (4) San Domenico, choir. The Virgin, the Angel annunciate, SS. Dominic and Peter Martyr, each on a separate canvas, and represented standing under archways ; genuine pieces by Rondinello, but dimmed by age and dirt. Figures life-size. These may be parts of one of the altar-pieces mentioned by Vasari (v. 254). The other of which he speaks, namely that to the left of the high altar, is by Benedetto Coda. [* The four above-mentioned figures originally adorned the shutters of the organ of San Domenico (Ricci, *Raccolte artistiche di Ravenna*, p. 10).—The following are also works by Rondinello at Ravenna: (1) Gallery, No. 8. The Virgin and Child with two Saints. (2) Monte di Pietà. Madonna (fragment of a fresco). (3) Casa Nadiani-Monaldini. SS. Peter and Mary Magdalen.]

We may mention here Baldassare Carrari, a pupil, we believe, of Palmezzano and a disciple of Rondinello. He is the painter of a Coronation of the Virgin with an attendance of saints (amongst whom St. Mercuriale), No. 105 in the Communal Gallery of Forlì. This piece is inscribed : " Baldassar Curulis foroliviensis fecit R[di] hujus ēdis abate Dm̃ Fhilipus MDXII." It was originally in San Tommaso Apostolo. The upper part recalls Rondinello, the lower Palmezzano. By the same hand apparently we have the following : (1) Ravenna, Rasponi Gallery [* cf. *antea*, p. 303, n. 3], No. 10. Martyrdom of St. Bartholomew, spirited in the fashion of the school of Signorelli (predella); and, unnumbered, a second predella representing the Baptism of Christ between four angels. (2) Forlì, San Bartolommeo [* now Communal Gallery, No. 107]. Christ on the Virgin's lap, with the Magdalen, Evangelist, Nicodemus, and Joseph of Arimathea. There is a replica of this in Ravenna, Chiesa della Croce [* now in the Ravenna Gallery]. See also *antea*.

* The earliest record of Carrari dates from 1489, and in 1519 we know he was dead. In addition to those mentioned by the anthors the following works are also by him : (1) Forlì, San Mercuriale, first chapel to the right. The Baptism of Christ (fragment of a fresco executed in 1498). (2) London, collection of Mr. Robert Benson. The Adoration of the Magi. Signed " Baldasar Forliviensi pinsit." (3) Longana (near Ravenna), Sant' Apollinare. St. Apollinaris between SS. Sebastian and Roch. (4) Milan, Brera, No. 466. The Virgin and Child between SS. James the Greater and Laurence. Signed " Baldasara Forliviensis pinxit." Originally in Sant' Apollinare Nuovo at Ravenna.—For notices of this painter, see Grigioni in *Arte e storia*, new series, vol. xv. pp. 91 *sqq.*, and in *Rassegna bibliografica dell' arte italiana*, i. 237 *sqq.*

NICCOLO RONDINELLO

II. 306]

THE VIRGIN AND CHILD WITH SAINTS.

Benedetto Coda of Ferrara, whose habitual place of residence was Rimini, is of the same genus as Rondinello, but of lower rank. He is justly described by Vasari as a Bellinesque of small merit ;[1] we might almost add, a disciple of Rondinello. Being a Ferrarese by birth,[2] he imported into his style something of Francia; and his figures may be distinguished by their regularity as well as by a feeble sort of tenderness. Some of his panels bear the dates of 1513–1515. They are exclusively to be found in Rimini, Ravenna, and Pesaro.[3]

[1] Vasari, iii. 172.

[2] *Ibid.*, v. 183.

[3] The following is a list and description of them : (1) Rimini, Duomo. Marriage of the Virgin, with life-size figures ; inscribed on a cartello : " benedicti" Laderchi (*Pitt. Ferrar.*, *ub. sup.*, p. 60) says it was signed "Opus Benedicti, 1515." This is a picture of fifteen figures, including a couple of children seated at the corners of the foreground. The forms are slender, affected, and feebly like those of Francia's school, and seem to have been produced by one who had seen the frescoes of the oratory of Santa Cecilia at Bologna. The colours are saturated with vehicle and sombre in hue as in Rondinello. (2) Rimini, Chiesa de' Servi, formerly in San Domenico. Virgin and Child between SS. Francis and Dominic, with three angels playing instruments at the base of the throne; inscribed on a cartello : " MDXIII opus Benedicti faciebat " (*sic*). The altarpiece is injured by splitting and scaling. The angels are like those in the pieces assigned in these pages to Rondinello at the Brera. For the rest, the style is that above described. (3) Rimini, Duomo, sacristy. Six panels, one-quarter of life-size, representing the Meeting of St. Francis and St. Dominic, St. Anthony, Peter and Paul, a young saint and a bishop in couples, and a saint in episcopals. These are wrongly assigned to Perugino ; they are poor things by Benedetto Coda. (4) Pesaro, Scoletta di San Giovanni, originally at the Padri Riformati fuor di Porta d'Arimini. Arched panel, with the Assumption and two Saints (male and female) in a foreground, m. 1·60 broad by 2·90, figures life-size. Umbro-Bolognese in character as above, feeble, and without effect of light and shade. (5) Ravenna, San Domenico. Arched panel, made square. Virgin and Child between SS. Dominic and Jerome ; on the steps of the throne, St. Joseph and St. Francis in converse ; on a cartello to the left hand : "Opus benedicti arifiensis"; figures life-size. This is Benedetto's best production, taken, we believe, by Vasari for a Rondinello (Vasari, v. 254). It is more broadly handled than the foregoing, yet in the same style, a mixture of the Raphaelesque of the Bolognese school and the Venetian of Palma Vecchio.

Vasari mentions Bartolommeo, son of Benedetto Coda (Vasari, iii. 172), and Lanzi (*History of Painting*, iii. 27) assigns to him a Madonna between SS. Roch and Sebastian in San Rocco of Pesaro on which he observed the date of 1528. This Madonna, which still exists, is by an imitator of the Raphaelesque style, and looks like a work of Coda's school. On the cartello but one letter—B.— remains. In the sacristy of the Duomo at Rimini is a Descent of the Holy Spirit (panel, life-size, split horizontally in three), attributed to the father of Benedetto. It is by a follower of Coda. In the church of the Madonna del Rosario, between Pesaro and Gradara, is a Virgin and Child between SS. Dominic and Paul, and

Of a more distinctly local class at first was the manner of Francesco Zaganelli, born at Cotignola in the duchy of Ferrara, but a resident subsequently in Ravenna. He was a pupil of Rondinello,[1] but not of Rondinello alone, for in an altarpiece of 1505 at the Brera, representing the Virgin between two saints and a kneeling patron, he shows himself acquainted with the school of Palmezzano.[2] In the first period, to which this picture belongs, Zaganelli gives promise of slender talents; his thin dry forms are drawn with a finished and careful contour, but are curiously stiff and lifeless; the dresses are broken into rectilinear sections, and the colours lie dead and flat. At this level we have already seen Bertucci of Faenza, to whom Zaganelli at this stage has some resemblance, and the teaching of Palmezzano is betrayed in part by the cast of draperies and in part by the arabesques on gold ground in the architecture. A similar dilution of Palmezzano is noticeable in a second altarpiece at the Brera, done, according to some authors, by Zaganelli in company with his brother Bernardino, but without any sign of distinct treatment on that account.[3] We shall see that Bernardino was frequently

around this principal scene a framework of fifteen scenes from the Passion. This also is of Coda's school. But with reference to the name Bartolommeo, we may notice a Resurrection of Lazarus with figures of life-size, in the church of the Esposti of Fano, signed on a cartello " Bartholom ⁓ et Pom ⁓ et filius fanen. f." Also a similar subject in the church of San Francesco at Filotrano, inscribed : " Pompeus Morgantis Fanensis 1543." These are all productions of a very worthless and uninteresting kind, nor is it of much interest to inquire whether Bartolommeo of Fano is the same of whom Lanzi in his index says that he signed himself " Bartolommeo Ariminensis," was the son of Benedetto Coda, and lived in 1543.

[1] Vasari, v. 255. We shall see that Francesco's name was Francesco di Bosio de' Zaganelli di Cotignola. (See *postea*.)

[2] Milan, Brera, No. 455. Wood, oil, m. 1·44 broad by 1·13; originally in the Minori Riformati of Civitanova. Virgin, Child, SS. Francis, Nicholas, and a kneeling patron; inscribed : " Hoc op' f. f. Petrus Marinatie et ego Franc' Cotingnolensis feci feci A. D. M⁰· 1505." The painting has undergone cleaning and restoring.

* Of earlier date than this painting is a joint work by Francesco Zaganelli and his brother Bernardino executed for the church of the Padri Osservanti at Cotignola, and now the property of the Brera (No. 457). It represents the Virgin and Child with three angels and SS. John the Baptist and Florianus, and is signed " YHS. Franciscus & Bernardinus fratres Cotignolanj de Zaganelis faciebant 1499."

Milan, Brera, No. 458. Wood, oil, m. 2·30 broad by 1·50 assigned to Bernardino M chesi (?). [* Now catalogued under Francesco and Bernardino Zaganelli.]

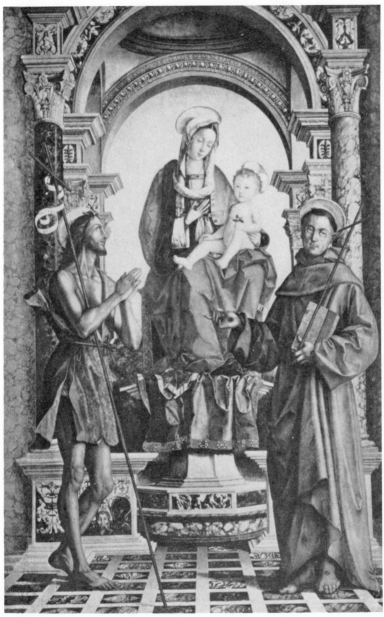

an assistant to Francesco, and that when he worked alone he
was a man of small attainments.[1] From these comparatively
poor beginnings Zaganelli gradually ascended to a more com-
manding height by studying the masterpieces of Francesco
Francia. Though still a feeble artist, he produced two pictures
in 1509 in which a marked improvement is discerned. In the
Adoration of the New-born Christ at the National Gallery of
Ireland, the figures are more cleverly set and better outlined
than of old; they have a calm and kindly movement, and
pleasant faces ; the draperies are more judiciously arranged
and the colours, though injured from various causes, are in better
tone.[2] It was not strange that, after contemplating the saintly
creations of the Bolognese, Zaganelli should learn to express
a deeper and more genuine feeling. In the second creation of
the same year, now at Berlin, he composes the Annunciation
in the fashion of Francia, the Virgin standing on a pedestal
between two saints and looking up to the angel who is wafted
to her presence from heaven. In this as well as in the tender
glance and movement, or slender proportions of both these
apparitions, the change in Zaganelli may be detected ; whilst
in the Baptist at one side a reminiscence of Rondinello, and in
the arabesques of the archings, or the rectilinear style of drapery,

Virgin and Child enthroned between SS. John the Baptist and Francis. This seems
to be the altarpiece described as by Francesco and Bernardino Zaganelli in Beltrami,
Forestiere . . . *nella città di Ravenna*, 1783 (quoted by Baruffaldi, *Vite de' Pitt.
Ferr.*, ii. 514, and by Lanzi, iii. 26). Both authorities agree in saying it was in the
Minori Osservanti of Ravenna, and that the date of its execution was 1504. The
surface is also injured by cleaning. Vasari mentions (v. 255 *sq.*) a Christ carrying
his Cross left unfinished by Zaganelli. An unfinished picture with this subject is
No. 460 in the Brera Gallery, but is only a school-piece.

[1] L. N. Cittadella publishes (in *Documenti, ub. sup.*, p. 154) a record, dated 1509,
in which the brothers "Francesco and Bernardino de Zaganellis de Cotignola"
exchange certain lands for others.

[2] Dublin, National Gallery, No. 141. 5 ft. 11 in. high by 5 ft. The Infant
Christ on a pedestal in a chapel, through the arches of which the sky is seen, is
adored to the right by St. Francis and St. Anthony of Padua, to the left by the
Virgin and St. Joseph. On a cartello on the pedestal we read: "B . . narɖs
mediāna pm̄s. q. his ossa reliqᵗ h.c testamēti jure dedit superist
. . narɖs c oĺ. pin . ebat ano ɖ 1509, 7 Aprilis." This picture, once in the
church of the Riformati at Imola (Lanzi, iii. 26), has been through the hands of
Mr. Van Cuyck in Paris, Mr. Wigram, and Mr. Nieuwenhuys. At Mr. Van Cuyck's
it was transferred to canvas and the sky was repainted. The colours are blind
from restoring.

the effects of Palmezzano's precepts are apparent.[1] The writhing
St. Sebastian with hands bound high above the head to a tree, a
life-size figure in the Costabili Gallery at Ferrara, throws some
further light on the progress of our artist. He did this in 1513,
with firmness and mastery of drawing and comparative lightness
of tone, felicitously repeating one of the bold postures peculiar to
Paris Bordone, imitated in later years by Guido and the Caracci.[2]
Of the same time, and better, is the Eternal in glory adored
from earth by companies of saints, an altarpiece that once
adorned the fifth chapel in San Biagio of Forlì.[3] During his
visits to Bologna Zaganelli had evidently paid some attention to
the modifications wrought amongst the younger disciples of its
school by Raphael ; and amidst the angels who flit about the
Eternal and support the floating folds of his garments, there are
some whose attitudes are those of Innocenzo da Imola in his
Raphaelesque period. Where this influence is less apparent and
the master's old habit is preserved, there is still some advance
to note ; the forms without the amplitude of the moderns, the
drapery still in the customary cast, are bathed in a fresher atmo-
sphere, and the colours, if cold in the grey and purple enamel of
the flesh, or in the sharp tints of landscape, are lively and clear.

But the most important and most freely treated of all
Zaganelli's sacred pieces is the Virgin and Child with the

[1] Berlin Museum, No. 1164. Wood, 6 ft. 4 in. by 5 in., from the Solly collection.
The Baptist to the left recommends a kneeling patron. St. Anthony of Padua
(right) stands in prayer. The cartello at the Virgin's feet is abraded and contains
but the words " 1509. Aprilis."
 Of the same character as this of Berlin, and somewhat reminiscent of Bart.
Montagna, is a Virgin and Child enthroned between St. John the Baptist and
St. Sebastian, a small panel in the hands of M. Reiset in Paris. [It is now in the
Musée Condé at Chantilly (No. 22).]
 [2] Ferrara, Costabili, all but life-size; inscribed : " Xhristus. 1513 Franciscus
de Zaganellis Chotignolensis pinxit." [This picture is now in the Gallery at
Ferrara (Sala II.).]
 [3] Forlì Gallery, No. 135. Arched panel, with life-size figures, much injured
by time and restoring. The Eternal, in heaven, is attended by angels. Below,
SS. Buonaventura, John Evangelist, and a female saint, Jerome, Mary Magdalen,
and yet another ; inscribed on a cartello : "A. S. 1514 (?) Franchischus Chotigno-
lensis pinxit."
 A Baptism of Christ of 1515, once in San Domenico of Faenza (Laderchi, *Pitt.
Ferrar.*, p. 59), is missing. [* This picture and the accompanying lunette con-
taining a Pietà are now in the collection of Mr. David Erskine at Linlathen, near
Dundee.]

portraits of the Pallavicini family executed in 1518 for the
church of the Nunziata outside Parma.[1] In none of his previous
performances are greater skill in arrangement and better drawing
to be found, though it cannot be denied that coarseness of shape
and vulgarity of features are united to freedom of hand. The
drapery is more easy in fold, yet not altogether free from hard-
ness ; the flesh tints in the portraits are of a pleasant warmth but
slightly relieved with grey, and of a hard enamelled finish still
recalling Palmezzano.

In the same style, but Leonardesque in the regularity of the
divisions and the modelling of the parts, is the fine bust of Christ
by Zaganelli and his brother Bernardino, the property of Signor
Mylius at Genoa, a panel which might give the artists a right to
a good place amongst the second-rates of the Romagna were it
not that the features are laboured down to a pinched smallness
and the face worked up to an empty uniformity.[2] In the latest
things of the master, which exist at Ravenna and Rimini, there
are marks of haste or declining power. His chronology ceases
after 1518.[3]

[1] Parma, ch. of the Nunziata, outside the Porta Nuova. Panel, with life-size
figures of the Virgin and Child between SS. John the Baptist, Bernardino, and
John Evangelist; inscribed, beneath the feet of an angel playing a viol, on the
throne-step : "Xh 1518 Francescho da Cotignola mi dipinse." This
part of the picture hangs in a bad state, being dimmed by age and dust, in a dark
place to the right of the entrance. Two other panels with the old frame are in
the choir. These contain bust portraits of Rolando Pallavicini and his daughter (?)
reading a book, and a bust likeness of Pallavicini's wife Domicilla. The first
is inscribed " Ro . . . Pall . . . dicavit," the second " Domicilla conjux." In a
note to Vasari (v. 123) this work is given to Girolamo Marchesi of Cotignola.

[2] Genoa, Signor Federico Mylius. Wood, m. 0·28 broad by 0·33. Front face
with long curly hair, ground dark ; inscribed : " Franciscus Bernardinus Bosii.
Cotignolani f." Well preserved, though slightly rubbed down. A crown of thorns
is on the head, and copious tears fall down the cheeks ; the signature is on the
tunic hem, which runs across the breast. [* Present whereabouts unknown.]

[3] (1) Ravenna, Galleria Rasponi, No. 8. [* Cf. *antea*, p. 303, n. 3.] Half-length
of the Virgin with the Child erect, clinging to the hem of her bodice, and playing
with a bird, a charming group better in thought than in handling. The pro-
portions and masks recall Francia ; a highly finished piece with thin flesh colour
(half-life). (2) Ravenna, Sant' Agata. In the choir an arched panel with eight
figures, all but life-size, of the crucified Saviour, the Magdalen grasping the foot
of the cross, the fainting Virgin, and the Marys, a friar, St. Francis, and another
saint. This picture, much praised by Vasari (v. 255), is much injured, especially
in the figure of Christ, by retouching ; there is much exaggeration in the move-
ments of the lean saints, and in this we are reminded of Lotto. The colours are

Of Bernardino Zaganelli we possess but one genuine production, a St. Sebastian belonging to Signor Frizzoni of Bellagio on the lake of Como, perhaps originally part of an altarpiece in the Carmine at Pavia dismembered at the close of the eighteenth sombre and sharply contrasted. [* This picture is now in the Ravenna Gallery, No. 13.] (3) Ravenna, San Girolamo, ex-Gesuiti. Arched panel, with life-size figures; subject, the Marriage of St. Catherine, with St. Sebastian, St. John Evangelist, a friar, and St. Roch. In a predella, St. Bartholomew, the Virgin's soul carried to heaven by two angels, cloth of St. Veronica, SS. Catherine and Paul. This panel is high up above the chief portal and of a dull tinge ; the Infant Christ is blackened by restoring—a poor piece, not unlike an early one by Girolamo Marchesi, which might of itself prove that Girolamo was of Zaganelli's school. This may be the altarpiece mentioned by Vasari (v. 255). (4) Ravenna, San Romualdo, or Classe, sacristy. Resurrection of Lazarus. Arched canvas, in oil, ill composed, worse drawn, and most affected. (Vasari, v. 255.) (5) Ravenna, San Niccolò. Nativity, much injured and scaled, a school-piece. (Vasari, v. 255.) (6) In the same character and in the same place, but originally in Sant' Apollinare, two life-size figures (wood) of SS. Sebastian and Catherine. The exaggeration in the action of the figures in these works is not unlike that of the feeble disciples of Signorelli. [* These three paintings are now in the Ravenna Gallery, Nos. 10–12.] The Nativity seems to have been painted by Zaganelli for the Franciscans of Cremona. The Anonimo (ed. Morelli) notices such a subject done as a night-scene after the fashion of Correggio, the light emanating from the Infant Christ (Anon., p. 37). (7) Rome, Villa Albani. Lunette panel with the Saviour supported in his tomb by two angels, perhaps part of the Baptism of Christ, of 1515, originally in San Domenico of Faenza (Laderchi, ub. sup., p. 59). [* Cf., however, antea, p. 310, n. 3.] The figures are half the size of life; the Christ, Bellinesque, with draperies in the fashion of Palmezzano. (8) Rimini Gallery. Same subject with four angels, assigned to Giovanni Bellini, recalls Rondinello and Coda, but is probably by Zaganelli. This, however, is a tempera, and perhaps a picture of Zaganelli's youth. (See antea.) [* This painting, which is far beyond Zaganelli's powers, is now universally accepted as a masterpiece by Giovanni Bellini. See antea, i. 147, n. 4.] (9) Ferrara, Costabili collection [* now dispersed]. Same subject, a school-piece. (10) Naples Museum, Room VI., No. 25, under the name of Cosimo Rosselli. [* Now under that of Francesco Zaganelli.] Marriage of the Virgin, figures all but life-size, in the manner of Francesco and Bernardino Zaganelli. [* In addition to those noticed by the authors we may also notice the following works by Zaganelli : (1) Amsterdam, Rijksmuseum, No. 2741. The Entombment of Christ. From the Rasponi collection in Ravenna. (2) Bologna, Pinacoteca, No. 236. The Virgin and Child with two Saints. (3) London, Holford collection. The Virgin and Child with SS. Helen and Constantin. (4) London, late Abdy collection (sale at Christie's, May 5, 1911, No. 94). The Virgin and Child, signed "Frāciscus da Chodignola." (5) Milan, Brera, No. 456. Pietà. Originally in San Domenico in Lugo (6) Milan, Brera, No. 458. The Entombment of Christ. From the oratory of Santa Maria in Acumine at Rimini. (7) Verona, Museo Civico, No. 118. The Entombment of Christ.]

The following are missing : Ravenna, Sant' Apollinare. (Vasari, v. 255.)

century.[1] It is a figure alike defective in shape, in character, and in colour, the work of a patient but unskilful craftsman who might be a useful assistant in his brother's workshop, but has no claim to rank as an independent artist.

With Girolamo Marchesi of Cotignola, the pupil, we think, of Zaganelli, art in the Romagnas enters upon its last phase.[2] Girolamo began as a cold and diligent imitator of Zaganelli and Francia. His first altarpieces at San Marino are a feeble echo of those masters, with a germ of exaggeration in addition ; his Nativity of 1513 in Lord Ashburton's collection shows that he clung for a long series of years to this early style.[3] But having followed the young Bolognese, who had learnt to worship the latest creations of Sanzio and Buonarroti, he rapidly acquired the superficial breadth and freedom of the great schools, to which he added a peculiar weight and vulgarity essentially his own. In one form of his art he recalls Innocenzo da Imola and Bagnacavallo, as in a Marriage of the Virgin at Bologna; in another form, as in a Virgin and Child with Saints, he shows himself the precursor of the Caracci, aping the boldness of the

Virgin, Child, SS. John the Baptist, Apollinare, Jerome, and others ; Virgin and Child, SS. Peter and Catherine.

* Towards the end of 1513 Francesco Zaganelli settled in a house belonging to the Monastery of San Vitale at Ravenna. It is proved by contemporary records that the rent for this house was paid until 1531, and in 1533 and 1534 by his widow Cecilia. See Ricci, in *Rassegna d'arte*, iv. 49; *Raccolte artistiche di Ravenna*, p. 12.

[1] Pavia, Carmine and Bellagio. The altarpiece at the Carmine was in six parts ; the principal course representing St. Sebastian between SS. Nicholas and Catherine ; the upper course, Christ between two angels, the Virgin and the angel annunciate. It is so described by Francesco Bartoli in *Notizie delle pitture e sculture chiese &ᵃ di Pavia*. MS. finished at Venice in 1777. [* See also the same author's *Notizia delle pitture . . . d'Italia*, ii. 8 *sq.*] The St. Sebastian, which we suppose to have belonged to the above, is now in the collection of Signor Frizzoni at Bellagio, and represents St. Sebastian in a hip-cloth at the column. Distance, a landscape with figures on horseback. Wood, oil; inscribed: "Bnardinū Cotigloa p." [* This painting is now in the National Gallery (No. 1092). The altarpiece of which we may assume that it formed part was ordered in 1506 by the foreign students of the University of Pavia for their chapel in the Carmine and was executed at Pavia. See Ffoulkes and Maiocchi, *Vincenzo Foppa*, p. 192.]

[2] For notices of this painter see Vasari, v. 182 *sq.*

* [3] Yet another picture by Marchesi which is reminiscent of Zaganelli belongs to the Gallery at Budapest (No. 73, signed "Hieronymus de Marchesijs da Cotignola faciebat"). It is a free copy of Bellini's Pietà in the Vatican Gallery.

later Raphaelesques and Michelangelesques, almost reaching the
level of the Veronese Francesco Caroto. Specimens of his skill
at this period are to be found with the dates of 1516, 1518,
and 1526 at Berlin and Bologna. Vasari relates of him that he
was chiefly known in Bologna as a portraitist, one of his studies
of interest, if we could but discover it, being after Gaston de
Foix, when he lay wounded at Ravenna in 1512. His will,
dated Bologna, August 16, 1531, is still preserved.[1] His last

[1] Gualandi, *Memorie, ub. sup.*, ii. 12.

[2] Here follows a notice of Girolamo's works as mentioned in the text or noticed
by historians; and first as to those of which we may speak with authority. (1) San
Marino, San Francesco. 1°.;Virgin in prayer in a landscape, between St. Augustine
and St. Anselmo, and receiving a benediction from the Eternal in the sky; on a
cartello : " Hieronimus cotignol. fac." ; figures almost life-size. 2°, Virgin and Child
enthroned between SS. Catherine, Francis, Marino, and another; two angels on
the throne-step play instruments; wood, oil, figures of life-size. The last of these
pictures is erroneously assigned to Giovanni Bellini ; both are feeble and careful,
in the manner of a disciple of Francia. (2) London, Lord Ashburton, but originally
in Santa Maria delle Grazie at Pesaro. Virgin adoring the Child, attended by four
saints, a bishop, Jerome, and two females; inscribed : " Jeronim̃ Cottigōl. junipera
sfortia patria a marito recepto ex voto p. MCCCCCXIII." This altarpiece is said by
Laderchi (*Pitt. Ferrar.*, p. 103) to contain portraits of Ginevra Sforza and Con-
stanzo II., her son. The figures are of life-size ; style, a mixture of Francia,
Rondinello, and Zaganelli ; colour, rosy, clear, and empty ; the inscription is
renewed or new altogether. [* This picture is now in the Brera Gallery at
Milan.] (3) Louvre, No. 1381. Wood, m. 0·53 high by 0·50. Bust of the
Saviour carrying his cross, inscribed : " Hieronymus Marchiegius Cotignola . . ."
The date 1520 in the catalogue is doubtful, and the style of the picture
shows it to be of an early time. This is a lean suffering Christ, with a
rigid expression of pain ; the colour is dull without modulation and much rubbed
down. The most remarkable thing is the execution, which is most minute and
finished. (4) Bologna, Pinac., No. 108. Marriage of the Virgin. Arched panel
with many figures nearly large as life—imitation of Innocenzo da Imola and
Bagnacavallo, free and bold, overcharged with people and heavy in tone. (5) Same
gallery, No. 278. Panel, life-size, from the suppressed Company of San Bernardino.
Virgin kissing the Infant Christ, the boy Baptist below, and at the sides SS. Fran-
cis and Bernardino. This is still more freely treated than the last, the boy
St. John in the Raphaelesque manner, the Virgin not unlike a creation of Caroto.
The colouring is dull and purple in shadow. This piece is said to have been done
in 1520 ; it looks more modern. In the same manner : (6) Berlin Museum, No. 290,
dated 1516. Panel, 2 ft. 6 in. high by 1 ft. 11 in. Marriage of the Virgin. [* This
picture is at present on loan to the Communal Gallery at Erfurt.] (7) No. 268.
St. Bernard and his Disciples, inscribed : " Hieronymus Cottignol's F. MDXXVI."
Wood, 6 ft. 5 in. high by 4 ft. 11½ in. (8) Bologna, Pinac., No. 288. The Angel appear-
ing to St. Joseph, Nativity, and Flight into Egypt ; three small panels in one
predella, it is supposed of the Sposalizio, No. 108. This predella is boldly handled,

days were spent in visiting the Roman States and Naples ; and,
if we believe Vasari, he painted a portrait of Paul III. (1534–49).
Having been entrapped into a marriage with a woman of ill fame,
he is said to have died of a broken heart at Rome in the sixty-
ninth year of his age.[2]

but heavy in the shape of the figures. (9) Bologna, Santa Maria in Vado, hospital
Martyrdom of St. Sebastian ; much injured, with a signature of which the word
"Hieronimus" alone is legible. Allegorical figures of Justice and Fortitude in
the Cappella Varano of this church we have not seen. The same may be said of the
Virgin giving the breast to the Child, attended by SS. John the Baptist, Anthony
the Abbot, and a patron, once in San Tommaso of Forlì ; of the Four Evangelists at
San Michele in Bosco at Bologna (Laderchi, *Pitt. Ferrar.*, p. 103). At Rome
and Naples and Rimini nothing of this painter's hand is to be observed.

* The paintings which Marchesi executed in the Duomo of Rimini between
1513 and 1516 were destroyed by an earthquake in 1672. See Grigioni, in *L'Arte*
xiii. 291 *sqq.*

CHAPTER X

THE MILANESE

THAT travellers should invariably, and almost exclusively, connect Milan with the names of Bramante and da Vinci is due to the lustre which these great artists shed on the Milanese school. During the fifteenth century Florentine taste was partially introduced into Lombard edifices by Michelozzo and Filarete, but the understructure of Lombard architecture was northern ; and the master universally acknowledged by painters was Mantegna. It was under Mantegna that Vincenzo Foppa—the oldest craftsman of any repute in Milan—was formed. It is to the influence of Mantegna that we owe the early works of Suardi, Butinone, Zenale, and Civerchio; but when the more attractive art of Umbria and Florence was carried to Milan at the close of the century, the Mantegnesque period came abruptly to an end ; those who clung to the Paduan manner lost their market, and success attended only those who consented to follow the lessons of Bramante and Leonardo.

When Cosmo de' Medici sent Michelozzo to rebuild his palace at Milan he displayed a natural preference for modern forms; but his choice of Foppa to decorate the walls was a silent admission of the talents of Mantegna.[1] When Francesco Sforza engaged the Florentine Filarete to plan the great

[1] The Medici palace at Milan was rebuilt by Michelozzo in 1456 and passed in later times to the family of Vismara. See Vasari, ii. 447 *sq.*, and Calvi (G. L.), *Notizie sulla vita e sulle opere dei principali architetti, &c., in Milano*, 8vo, Milan, 1859, 1865, 1869, parte ii. p. 60.

[*] We have no proof that Michelozzo was the architect of the Medici palace at Milan. See Ffoulkes and Maiocchi, *Vincenzo Foppa*, pp. 42 *sq.*

hospital at Milan, he also manifested a desire to favour the introduction of a new style into his dominions ; but his selection of Foppa proves that he considered a pupil of Mantegna capable of the most important pictorial enterprises. We learn from the annalists that Foppa adorned the Medici palace about 1456 with scenes from the legend of Trajan, with busts of emperors and portraits of Francesco and Bianca Maria Sforza ; [1] we learn from the same source that he designed some frescoes in the portico of the hospital illustrating the ceremony of its foundation; and we are further told that he was one of those who covered the court and inner rooms of Francesco Sforza's palace dell' Arengo with mural subjects.[2] The number and magnitude of these commissions would alone testify to the high esteem in which the artist was held.

Vincenzo Foppa was born at Foppa, in the province of Pavia, and taught in a Northern school.[3] Nothing certain is handed down respecting him before his engagement at Milan in 1456,[4] and even then we know little of his most important works.[5] Fortunately some small panels of a sketchy character

* [1] It seems likely that these frescoes were begun between 1462 and 1464. Ffoulkes and Maiocchi, *ub. sup.*, pp. 42 *sqq.*

[2] Vasari, ii. 457; Lomazzo, *Trattato, ub. sup.*, p. 405; Calvi, *Notizie*, ii. 61-2, 87, 96, 131.

[3] There were at Milan in the fifteenth century Ambrogio Foppa, called Caradosso, sculptor; Bartolommeo da Foppa, a painter, not known by his works; and Vincenzo. Foppa is a village in the territory of Milan, to which Bartolommeo is distinctly traced ; and it is not unlikely that it was the native place of Vincenzo and Caradosso. Compare Campori, *Gli Artisti., ub. sup.*, p. 209, with Ridolfi, *Marav.*, i. 341, and Calvi, *Notizie*, ii. 55-6. In records of 1471 and 1474, preserved at Genoa, Vincenzo is called " Vincentius de Fopa de Brisia." See *postea.*

* Miss Ffoulkes and Monsignor Maiocchi (*ub. sup.*, pp. 277 *sqq.*) prove conclusively that Vincenzo Foppa was a native of Brescia.

* [4] Cf. *antea* n. 1.

* [5] The history of the first twenty or thirty years of Vincenzo Foppa's life remains obscure even after the publication of Miss Ffoulkes's and Monsignor Maiocchi's great work on this artist. As already stated, he was no doubt a Brescian by birth. The earliest legal document in which he is mentioned dates from 1458 and proves that he was living in Pavia at that time (Ffoulkes and Maiocchi, *ub. sup.*, p. 26); but in 1468 Galeazzo Maria Sforza speaks of him as having, with his wife and children, resided in that town for the past twelve years (*ibid.*, p. 74). As Francesco Sforza, in 1461, recommended Foppa to the Doge of Genoa as being, from Sforza's own experience, very skilful in his art, Foppa must necessarily have done some work for Sforza before that date, presumably in

are preserved in the Carrara Academy at Bergamo, which, in
spite of the injuries they have received, tell with sufficient
accuracy how he painted. One of the panels, without a date,
is a St. Jerome kneeling before the Cross and beating his breast
—a wild dweller in the wilderness, with the square head and
coarse extremities of a churl. Nothing can exceed the care-
fulness of the execution. In the midst of modern smears and
varnish the lights still shimmer with shell-gold in sharp
hatching ; the drapery is angular and straight and singularly
without purpose ; whilst the buff-brown tinge of the tempera,
even where best preserved, repels the eye.[1] The second panel,
bearing the name and the date of 1456, is less grimly unattractive
though it has also suffered from age and retouching. It repre-
sents the Crucifixion and Golgotha seen through the aperture
of an arch and portico ; the Saviour on the cross between the
thieves, of good proportions and suitable action, is coloured
in blended liquid tones. Medallions with profiles in the
spandrels of the arch, the arch itself, divulge a taste cultivated
by the study of antiques, whilst the landscape of tinted green
relieved with yellow touches is like that of Bono Ferrarese.[2]
Filarete and Campagnola both say that Foppa was a disciple
of Squarcione ; there is no reason to doubt that they were well
informed.[3] Some years previous to this time Mantegna com-
menced the chapel of the Eremitani, and established his reputa-

the Castello at Pavia and the Arengo Palace at Milan (*ibid.*, pp. 24 *sqq.*). Probably
the earliest extant painting by Foppa is a most charming little Virgin and Child
with Angels in the collection of Cav. A. Noseda of Milan (*ibid.*, pp. 5 *sqq.*).

[1] Bergamo, Lochis, No. 225. Wood tempera, on a cartello in the foreground a
repainted inscription as follows : " Opus Vincentii Foppa." To the right the lion,
distance, hills and rocks.

* This picture belongs to a more advanced stage of Foppa's practice than the
Crucifixion of 1456 in the Carrara Gallery.

[2] Bergamo, Carrara, No. 154. Wood tempera, quite small ; on the panellings of
a marble skirting we read : " Vince. ‖ civ . s ‖ Bri . ie . sis ‖ pin . it ‖ MCCCCLVI ‖ die ‖
. mensis ‖ Aprilis ‖." The first part being obviously " Vincen. civis Brixiensis
pinxit " [* or perhaps rather " Vincencius Brixiensis pinxit "]. There is some-
thing of miniature in the distance, the tempera, where it is preserved, of fluid but
stiff impasto. The outlines are mostly retouched.

[3] " Fu tenuto in pregio ne medesimi tempi Vincenzo pittore bresciano,
secondo che racconta il Filareto e Girolamo Campagnuola anch' egli pittore
padoano e discepolo dello Squarcione " (Vasari, iii. 639).

* It will be seen that the authors refer "anch' egli pittore padoano," etc., to

tion. The greatest master of the North attracted disciples from all parts of Lombardy; and we must believe that Foppa was recommended to the Sforzas by the skill which he derived from the Squarcionesques.[1] Looking at Foppa's later productions, especially the martyred St. Sebastian in the Gallery at Milan, which is the only fragment saved from an entire cycle in Santa Maria di Brera,[2] we find it is not free from antiquated defects, particularly in the realism of detail with which expression is given to the faces ; but it has the prominent peculiarities of the Paduan school as shown in the careful setting and measurement of the figures in their places. Each of the personages, taken apart, appears studied from nature and the antique and moves with appropriate action ; the skeleton and fleshy development of form are correctly rendered, but the frames are too long for perfect proportion, and the shape depicted is far from any known standard of selection ; there is much of the Paduan in the raw and rusty tinge of the colours, in the papery crumple of draperies and in architectural accessories, but the clearest reminiscences of Mantegna are in the posture of the saint bound to a pillar at the mouth of a triumphal arch, or in the soldier leaning on his sword behind two bowmen ; and it seems obvious that Foppa saw Mantegna's St. James going to Martyrdom. Another remarkable circumstance connected with Foppa's progress as exhibited here is his acquaintance with perspective. The arch, which so much reminds us of Mantegna, is drawn with some correctness of vanishing lines, and the

"Vincenzo"; yet these words may perhaps more aptly be referred to "Girolamo Campagnuola." Filarete, in his *Trattato*, never states that Foppa was a pupil of Squarcione (Ffoulkes and Maiocchi, *ub. sup.*, p. 4).

* [1] Foppa's Madonna in the Noseda collection shows a close affinity of style to the works by Stefano da Zevio and allied Veronese paintings; while in the Bergamo Crucifixion the artist is no doubt largely influenced by the art of Jacopo Bellini. Cf. Ffoulkes and Maiocchi, *ub. sup.*, pp. 5 *sqq.*

[2] Milan, Brera, No. 20. Fragment, m. 2·68 h. by 1·73. This fresco is highly praised by Lomazzo (*Idea del Tempio*, pp. 108 *sq.*). It formed one of a series in Santa Maria di Brera, of which two other numbers were St. Roch visited by an Angel (Bianconi, *Guida di Milano*, 12mo., 1787, pp. 391 2) and a Glory of Angels in the Vaulting (Lomazzo, *Idea*, *ub. sup.*). The St. Roch was transferred to canvas in the last century and is now missing. The condition of the fragment at the Brera is imperfect, the head of the youth in the distance being blackened and the outlines of the remaining figures freshened up (cf. Passav., *Kunstblatt*, 1838, No. 66).

knowledge so displayed is respectfully touched on by Lomazzo, who couples Foppa's name with that of Leonardo.[1]

In the Crucifixion of 1456 Foppa calls himself " civis Brixiensis." He seems to have lived at Brescia at two different periods —in youth and old age. He certainly gained a respectable position there before being called to Milan ; but he liked change, and we find him in 1461 residing at Pavia, attracted thither no doubt by the vicinity of the Certosa in which, during 1465, he painted a chapel.[2]

At Pavia he married, and received numerous commissions. It was probably an accident that prevented him from carrying out a contract signed in 1461 with the superintendents of the cathedral of Genoa. In 1462 he laboured in the Carmine of Pavia.[3] Occasional visits to Milan gave variety to his life,[4] and

[1] Lomazzo (*Idea*, pp. 36, 68, 108 *sq.*) not only praises Foppa's perspective, but says that he had seen manuscript rules in Foppa's hand for measuring human and equine proportions. He adds (*Tratt.*, p. 275) that Dürer, in his book on " Simmetria " was a mere plagiarist of Foppa.

[2] Calvi, *Notizie, ub. sup.*, ii., note to p. 144.

[*] Cf. Ffoulkes and Maiocchi, *ub. sup.*, pp. 70 *sq.* As we have seen (*antea*, p. 317, n. 5), Foppa appears to have settled at Pavia about 1456.

[3] As to Foppa's marriage, see Calvi, *Notizie*, ii. 62. [* It seems likely that Foppa married at Brescia. Cf. Ffoulkes and Maiocchi, *ub. sup.*, pp. 18, 136 *sq.*, 185 *sq.*] The contract for frescoes in the Duomo of Genoa is dated Jan. 2, 1461, and is published in Santo Varni, Comm. dell opere di Matteo Civitali in *Atti della Soc. Ligure di storia patria*, iv. 1–34. [* There can no longer be any doubt that Foppa in 1461 painted some frescoes in the chapel of St. John the Baptist, though he subsequently gave up the work which he had begun. He resumed it in 1471, but did not even then bring it to an end. He may have done so between 1478 and 1483. (Ffoulkes and Maiocchi, *ub. sup.*, p. 29–31, 8 *sq.*, 133.)] The frescoes in the Carmine of Pavia are now obliterated. They bore the inscription, " Vincentius Foppa pinxit, 1462 " (Ribolini in Calvi, *Notizie, ub. sup.*, ii. 63).

[*] So far as we know, there never were any frescoes by Foppa in this church ; on the other hand, it contained in the seventeenth century an altarpiece signed "Vincentius de Fopa pinxit anno 1462 de mense madii." Ffoulkes and Maiocchi, *ub. sup.*, p. 32 *sqq.*]

[* 4] In June 1462 Francesco Sforza ordered his representative at Pavia to find Vincenzo Foppa and immediately send him to Milan. The following month Foppa rented for four years a house with a workshop at Pavia. In March 1463 Foppa was again summoned by Francesco Sforza to Milan, where he soon afterwards began the frescoes in the Medici palace, and probably also those in the hospital. It seems beyond doubt that the so-called Gian Galeazzo Sforza reading Cicero in the Wallace collection (No. 538) is one of the paintings with which Foppa adorned the Medici palace ; and there is considerable evidence to prove that a drawing in the Print-room at the Berlin Museum is a study by Foppa for his fresco of the Justice of Trajan in the same building, or at any rate reproduces that composition. (Ffoulkes and Maiocchi, *ub. sup.*, pp. 37 *sqq.*) In 1468 Foppa

we see him start to deliver a Pietà to the Milanese church of San Pietro in Gessate, or—in the time of Galeazzo Maria—to value frescoes in the Castello of Porta Giovia. He may in the course of these or similar journeys have executed works at Milan of which the authorship subsequently became obscure.[1]

Renewed negotiations with the Genoese dragged their slow length along from 1471 to 1474. They failed for causes unknown and now of little interest to us, but they brought the artist in contact with new patrons, and amongst them, with one whose name is coupled with those of almost all the celebrities of the time.[2] Giuliano della Rovere, then cardinal of San Pietro

was appointed honorary member of the household of Galeazzo Maria Sforza; in that year he was also elected a citizen of Pavia. In 1469 he offered to execute frescoes in the Campo Santo at Pisa ; but as the work had already been entrusted to Benozzo Gozzoli, his services were not accepted. (*Ibid.*, p. 74 *sqq.*)

[1] The Pietà in San Pietro in Gessate at Milan was assigned by Sormani (*cit.* in Calvi) to Bramantino. It is described at length by Albuzzio (MS. of last century cited by Calvi, *Notizie*, ii. 3) as Foppa's. It hung over the altar of the first chapel to the left of the portal. [* This picture—signed "Vincentius de Phop pinxit"—is now in the Kaiser Friedrich Museum of Berlin (No. 133). It was probably executed after 1495. See Ffoulkes and Maiocchi, *ub. sup.*, pp. 195 *sqq.*] Foppa valued the frescoes of the Castello of Porta Giovia with the assistance of Stefano de' Magistri, Gio. Batt. Montorfano, and Cristoforo Moretti. See the documents in Calvi, *ub. sup.*, ii. 66–69, 247–8, by which the date of the event is fixed at an interval between 1467 and 1476. [* It is now proved to be 1473 (Ffoulkes and Maiocchi, *ub. sup.*, p. 80).] In the style of the St. Sebastian at the Brera is a life-size figure of a female martyr in an arched recess of a house (inner court) at No. 9, Piazza San Sepolcro, in Milan. The work is greatly injured and abraded.

[2] Genoa. Ufficio di San Giorgio, *Manuale di Decreti del 1471 al 1474.* "July 12, 1471. 1°. Receipt of V. de Fopa for 40 ducats in advance for painting the chapel of St. John the Baptist. 2°. 1474. Receipt of the same for 10 ducats." See the original in L. T. Belgrano's contribution to *L'Arte in Italia*, i. 72. There is reason to doubt that Foppa ever painted anything in the chapel (see the same authority.) [* Both of the above receipts date from 1471 (see Ffoulkes and Maiocchi, *ub. sup.*, p. 78). For reference to the work done by Foppa in the chapel of St. John, cf. *antea*, p. 320, n. 3. In the summer of 1475 Vincenzo Foppa, in conjunction with other painters, set to work at the colossal *ancona*, with which Galeazzo Maria Sforza wished to adorn the chapel of the Castello at Pavia. After the death of the Duke in 1476 the great work was, however, discontinued, and we have no clue to the fate of the pictures which Foppa executed for this *ancona*. Foppa and the other artists at work in this chapel in July 1475 also undertook to paint an extensive series of frescoes in the church of San Giacomo at Pavia ; these were completed towards the end of 1476, but no longer exist (see Ffoulkes and Maiocchi, *ub. sup.*, pp. 93 *sqq.*) Foppa, presumably, soon after 1476, executed the large polyptych for the high altar of the church of Santa Maria della Grazie at

in Vincoli, chose Foppa and Brea to paint a picture in the cathedral of Savona, in the neighbourhood of which he had been born, and of which he became bishop in 1499.

It has not been ascertained exactly when Foppa received this order; but a letter written to him in the winter of 1489 in the name of the ducal government, in terms of unnecessary rudeness, urges the completion of a painting in the Duomo of Savona, and the altarpiece may have been commissioned immediately before.[1] Since its first exhibition, it has found its way in an injured condition into Santa Maria di Castello at Savona, and bears the date of 1490. We are accustomed to the monumental shape of works of this kind in North Italy ; but more taste and delicacy of ornament might have been expected from a man of Foppa's training. Seven large panels are enclosed in a heavy framing of pilasters, the outermost of which are sunk into niches containing statuettes. Half-lengths—eight in number—fill arched openings in a frieze above the first course. A storied tabernacle rises from the centre

Bergamo, of which ten panels are now to be seen in the Brera (No. 307), while the greater part of the predella has found its way to the Vittadini collection at Arcore, near Monza. (See Ffoulkes and Maiocchi, *ub. sup.*, p. 118, and *postea*, p. 359, n. 3.) Subsequently the artist may have gone to Genoa, and there completed the frescoes in the chapel of St. John the Baptist in the cathedral and painted a (now lost) altarpiece for the Spinola chapel in the church of San Domenico in that town. We know that he was at Pavia in May 1483, and in 1485 he must have stayed in Milan, as his fresco, once in Santa Maria di Brera, dates from that year. (See Ffoulkes and Maiocchi, *ub. sup.*, pp. 133 *sqq.*, and *postea*, p. 322.) In 1488 and during the first months of 1489 Foppa was back in Liguria, where he executed various altarpieces which have been lost, and also an *ancona* for the Certosa of Santa Maria di Loreto above Savona, which is now in the Gallery of that town. This work was completed on April 9, 1489. A few days afterwards the artist was arrested at Genoa at the instigation of one of his creditors ; he was, however, almost immediately released. Apparently he felt so indignant at the treatment which he had endured that he now cut short his sojourn in Liguria and went to Brescia, leaving unfinished altarpieces behind himself both at Genoa and at Savona. At Brescia, during the summer of 1489, he executed some paintings in the new *loggetta* on the eastern side of the Piazza Maggiore. He subsequently went to Pavia, and it was there that he, in November of the same year, received the order from the Duke of Milan to complete the altarpiece in the Duomo of Savona, as will shortly be related. (Ffoulkes and Maiocchi, *ub. sup.*, pp. 153 *sqq.*)]

[1] Erasmo Trivulzio to Vincenzo Foppa, Nov. 3, 1489, in Calvi, *Notizie*, ii. 66. [* This letter is really addressed to the Duke of Milan ; Trivulzio relates in it that he, following out his instructions, has requested Foppa to complete the Savona altarpiece, if he wants to avoid disagreeable consequences. Cf. Ffoulkes and Maiocchi, *ub. sup.,* p. 169.]

of the frieze, and wooden saints stand on the pinnacles. In the central panel, the Virgin sits enthroned under a guard of angels with the infant Christ blessing the bishop of Savona; at the sides are the Baptist and Evangelist. In the second and third courses are the Doctors of the Church and the Evangelists. A predella contains the Decollation, the Dance, the Epiphany, the Vision of Patmos, and the Evangelist rising out of the Cauldron. The Madonna and the left side of the altarpiece are Foppa's, and it is a striking feature in those parts that they display a style much akin to that of Bramantino Suardi, Butinone, and Zenale. Yet, when compared with the best creations of those masters, the Savona altarpiece has a distinct originality and greater power. A mild expressiveness adorns faces of soft and regular mould ; and the saints, of long and slender stature, recall those of Foppa in his earlier period. Perspective of successful application gives reality to foreshortenings and architecture ; and in such fragments as preserve their old patina, the colour is light and warmly blended, whilst the vestment tints retain traces of vivid richness. The predella is grimed to indistinctness ; but what we know to be Foppa's proves that, in the course of years, he had shaken off the roughness of his earlier Mantegnesque form and gained that general sort of mastery which accompanies long practice and observation.[1] The style of the

[1] Savona. S. M. di Castello. We have alluded to this altarpiece as an alleged work of Catena (see *antea*, i. 253, n. 1), P. Tommaso Tortoroli, in his *Monumenti di Pittura, Scultura, &c., di Savona*, 8vo, 1848, pp. 85 *sqq.*, having assigned it to that painter and having, in addition, transcribed the inscription : " Anno Salutis IC90 Die Augusti . Iul. Eps Os. Ien. Cardin. P. ad Vincula. Maiorem Nitent. Vin . . - Catena. pinsit." On reference to the picture itself it appears that Tortoroli wilfully forged the name of Catena. There are two inscriptions on the altarpiece ; one on the central panel as follows : " Anno Salutis 1490 die v Augusti Iul. Eps. Ostien. Card. S. P. ad Vincula. Maiora. Nitent. Vicencius. pinxit " ; the other on a book in the panel containing St. John the Evangelist as follows : " Ludovicus brea niciensi* pinxit hāc partē 1490 die X augusti cōplecta." The condition of Foppa's portion of the altarpiece is this. In the lunette, the red dress of St. John is all repainted—that of St. Matthew, on the contrary, is preserved ; but the flesh of the St. Matthew is but one modern smear. Similarly treated are the St. Jerome and St. Gregory in the next lower course, but in the latter figure there are intact bits in the white tunic and the gilt embroidery of the pivial. Both these figures are seated. The Baptist on the principal course is all new and repainted. The head of the Madonna is retouched, and more or less the whole of the panel, which in many places is almost black.

Savona altarpiece is so characteristic that it enables us to class
amongst Foppa's genuine productions pictures hitherto ascribed to
Bramantino, such as the Adoration of the Kings, which wandered
from the Fesch and Bromley collections to the National Gallery,
and a fresco of the Virgin and Child between two kneeling
Saints, dated 1485, at the Brera. Bramantino's figures rarely
possess the staidness which accompanies those of Foppa. His
outline is more curt and incisive, his drapery more sharply
cornered ; and these are subtle differences, the more necessary
to observe as Bramantino took something from Foppa's works.

The Adoration at the National Gallery is marked by those
very peculiarities which distinguished Foppa from Bramantino.
Composed on the pyramidal principle, its blended colours are
light and clear, and its groups are made up of slender shapes,
like those of the Savona altarpiece. Fifteenth-century taste
appears in the slight embossment of the ornamental detail and
gilding.[1]

The Brera fresco is still more in Foppa's style—a fragment
torn from the wall to which it was affixed and cracked miserably,
yet of wonderful surface still. We admire the accuracy and
freedom of the outline, the blending of the half-tones and
shadows in flesh, and the vividness of the tints of dresses. The
Virgin supports the seated Child on an oriental carpet, resting
her finger on a book. SS. John the Baptist and John the
Evangelist kneel on consoles at her side. An arch in fine
perspective neatly picked out in coloured marbles is inlaid with
medallions. The fresco is carried out with great ease of hand,
and fully imbued with Foppa's feeling. His gentleness and
calm expressiveness are apparent in the Virgin ; his pleasant
cast of form in the infant Christ ; a certain dryness or smallness
disfigures the prophets. The art presented to us in a mutilated

The best-preserved parts are the angels playing instruments and the carpet
at the Virgin's feet. All the backgrounds are new—the nimbuses raised and
gilt. [* This altarpiece was injured by fire in September 1909. See Ffoulkes
and Maiocchi in *The Athenæum*, Jan. 8, 1910, p. 49.]

[1] London National Gallery, No. 729. Wood, 7 ft. 10 in. high by 6 ft. 11 in.
tempera whole figures, small life size. The impast is fluid yet substantial. As
a technical curiosity we note the grey dress of the king, whose spurs a page
removes. The surface was gilt and painted over, and the lights struck off
afterwards by the removal of the paint from the gold.

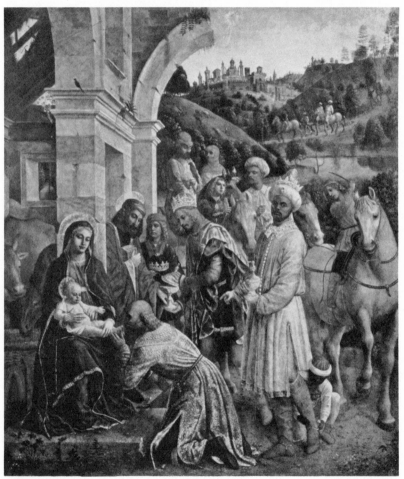

THE ADORATION OF THE MAGI.

aspect at Savona appears in the fullness of its strength, and not without a touch of those modern charms which adorn Luini or Borgognone.[1]

When Foppa, in his old age, returned to Brescia to pluck the reward of a long and industrious life, he painted frescoes in conspicuous situations and in numerous churches. Much—the greater part—of what he did perished, but the four Evangelists and Doctors at the Carmine, though faded to an extraordinary degree, display the style which we saw at Savona, London, and the Brera.[2]

It seems that Foppa preserved a very grateful recollection of a city in which he had spent some fortunate years of his youth.[3]

[1] Milan. Brera, No. 19. The fresco is injured by a serpentine split in the plaster and by abrasion of the background; and St. John the Baptist is discoloured by eruption of salt. On the consoles upon which the prophets kneel we read : " MCCCCLXXXV DIE X OCTVB." The figures are but little under life-size.

[2] Brescia—Carmine. Third chapel to the right after entering the portal. Here are four Evangelists and four Doctors in the angels of a ceiling, much injured, but, in such small parts as remain untouched, of a warm colouring. The crucified Saviour of the same series (on the altar) is quite renewed. (Cf. Ridolfi, *Marav.*, i. 431, and O. Rossi, *Elogi Historici Bresciani*, 8vo, Brescia, 1620, p. 508.)

Amongst the works at Brescia assigned to Vincenzo Foppa, one representing St. Ursula and her virgins, attended by SS. Peter and Paul, was long in San Pietro and is now in the house of the rector of Seminario. It is not by Foppa, but by Antonio da Murano (see *antea*, i. 29). The Trinity in San Pietro is cited as a companion picture to St. Ursula by Ridolfi (*Marav.*, i. 341), and O. Rossi (*Elogi, ub. sup.*, 508), but is now missing. A long series of frescoes in the suppressed church of San Salvatore is by the younger Vincenzo Foppa. [* An artist called Vincenzo Foppa the younger never existed; see *postea*, iii. 321, n. 1.] Another series in the library of the suppressed monastery of San Barnaba, bearing the date of 1490, represents scenes from the lives of St. Augustine and members of the Hermit Order. It is in very bad condition, particularly on account of modern repaints, but the general character of the compositions is not such as to justify us in attributing them to Foppa, and they are by some inferior Lombard hands, perhaps by assistants to Foppa in his old age. [* The room adorned by these frescoes is now the dormitory of the Instituto Pavoni. Miss Ffoulkes and Monsignor Maiocchi (*ub. sub.*, pp. 167 *sq.*), ascribe the paintings under notice to Giampietro da Cemmo, in view of their affinity to the works by this artist, especially the frescoes in San Rocco at Bagolino. The resemblance between the paintings at San Barnaba and in Bagolino is also pointed out by the authors (*postea*, iii. 254, n. 1).] A Christ carrying his Cross, attributed to Vincenzo Foppa the elder in the Galleria Martinengo at Brescia, is a poor modern copy of some picture by the younger Foppa. [* See *antea*.]

[*3] As we have seen (*antea*, p. 317, n. 3), Foppa was actually born at Brescia.

At the very time of his squabble with the agents of Giuliano
della Rovere he was in treaty with Brescia for a new grant of
citizenship, offering to reside there permanently with the privilege
of decorating the public edifices and opening a school. His
petition to that effect and the votes of the Brescian Council in
his favour have been preserved and bear date in 1489 and 1490.
He accepted a yearly grant of 100 livres clogged with no more
severe conditions than that, when he went again on leave, he
should not practise outside the town. The first official work to
which he was called in November 1490 was a fresco on the south
wall of the *loggetta* in the old Piazza which long since perished.
He died in 1492 and was buried in San Barnaba of Brescia.[1]

[1] We owe to the kindness of Signor P. da Ponte of Brescia a record dated
November 26, 1490, in which V. F. acknowledges the receipt of payment for
paintings done, "super pariete a meridie parte" in the *loggetta* of the Piazza
Vecchia. From the same source a permission of leave for a month to visit Pavia,
under the conditions placed in the text (but compare Calvi, *Not.* ii. 68, and
Zamboni (B.), *Memorie intorno alle pubb. fab. di Brescia*, Brescia, 8vo, 1778,
p. 32), and finally a petition dated December 18, 1489, in which certain citizens
of Brescia pray for the grant of Foppa's offer, "to repatriate and exercise the arts
of painting and architecture." Zamboni, *ub. sup.*, preserves Foppa's epitaph in
San Barnaba as follows : "Excellentis ac eximii pictoris Vincentii de Foppis civ.
Brixie 1492. [* We have seen (*antea*, p. 321, n. 2) that Foppa in 1489 executed
frescoes in the *loggetta* in the Piazza Maggiore at Brescia ; and in October 1490
the General Council at Brescia resolved that he should continue the decoration
of this building (Ffoulkes and Maiocchi, *ub. sup.*, p. 184). Zamboni must be guilty
of some error in reporting the epitaph printed above ; for Foppa undoubtedly
did not die in 1492. It appears that he was still living at Brescia in May 1515 ;
but he was dead in October 1516. His appointment to the community of Brescia
was cancelled in 1495. See *ibid.*, pp. 185 *sqq.*]

In addition to the above the following is a list of works of which no account can
now be given : (1) Brescia, Disciplina de' SS. Faustino e Giovita. Fresco of the
the Passion (Luigi Chizzola, *Guida di Brescia*, 8vo, Brescia, 1760, p. 30). (2) San
Girolamo. Christ taken to Calvary (*ibid.*, p. 38). (3) San Niccolò. A Holy Family
with St. Nicholas of Tolentino (*ibid.*, p. 65). (4) A Christ carrying His Cross met
by S. Veronica with the Cloth (*ibid.*, p. 65). (5) S. Clemente. Frescoes of saints
at the sides of a sculptured Saviour on the Cross (*ibid.*, p. 130). (6) Santa
Maria Calchera. Lanfranco appearing in a Vision to Paola Oriani. (O. Rossi,
Elogi Historici di Bresciani, 4to, Brescia, 1620, p. 202). (7) Ognissanti. Christ
going to Calvary, S. Veronica and other Saints (*ibid.*, p. 141). (8) Bergamo,
Santa Maria delle Grazie. Distemper, Madonna attended by four Saints in niches
(Anonimo, ed. Morelli, p. 52). [* Cf. *antea*, p. 321, n. 2, and *postea*, p. 359, n. 3.]

* The following extant works by Foppa have not yet been mentioned : (1)
Allington Castle, Maidstone, collection of Sir Martin Conway. The Dead Christ.
(2) Arcore, near Monza, collection of Donna Erminia Vittadini. The Annunciation.

As immediate successors to Foppa at Milan we number Butinone, Zenale, and Bramantino ; and, if it were necessary to follow a rigid chronology, we should first sketch the lives of the former ; but Bramantino is by far the most interesting person in the annals of local Milanese art ; his connection with Bramante is not clear, and it is desirable to throw some light on these and other points respecting which much confusion exists.

Of Bramante's residence in Central and Northern Italy there is little reliable information. His birth, though usually assigned to 1444, is a matter of conjecture ; his master is unknown ; and proofs of his early training are altogether wanting.[1] But tradition gives him a residence at Faenza in 1474 and a wavering chronology affixes the date of 1486 to faded frescoes in Bergamo.[2]

(3) Basle, collection of Herr Reinhold Sarasin-Warnery. SS. Gregory and Bartholomew. (4) Berlin, Kaiser Friedrich Museum. The Virgin and Child. (5) Milan, Castello Museum. The Virgin and Child. (6) Milan, Castello Museum. The Martyrdom of St. Sebastian (cf. *postea*, p. 337, n. 1). (7) Milan. Castello Museum. SS. Francis and John the Baptist (formerly in the church of Santa Maria del Giardino at Milan). (8) Milan, Museo Poldi Pezzoli. The Virgin and Child. (9) Milan, Borromeo collection. The Annunciation. (10) Milan, Crespi collection. The Virgin and Child. (11) Milan, collection of Signor Bernasconi. Pietà. (12) Milan, collection of Dr. G. Frizzoni. The Virgin and Child. (13) Milan, collection of Prince Trivulzio. The Virgin and Child ; Two Saints. (14) Milan, collection of Cav. A. Noseda. St. Paul. (15) Newport, Rhode Island, collection of Mr. Theodore Davies. The Virgin and Child. (16) Orzinuovi, Oratorio dei Morti. Processional Banner. (17) Paris, collection of M. Cheramy. Ecce Homo. (18) Philadelphia, collection of Mr. John G. Johnson. The Virgin and Child. (19) Settignano, collection of Mr. B. Berenson. The Virgin and Child. (20) Versailles, collection of M. L'Abbé Lefèvre. The Infant Christ adored by the Virgin, Angels, and St. Benedict. Signed "Vincentius de Foppa." For the share which Foppa may have had in the frescoes in the Portinari chapel in Sant' Eustorgio in Milan, see *postea*, p. 395.

[1] Vasari (iv. 164, 147) says Bramante died (1514) aged seventy ; he pretends that his master was Fra Carnovale. The earliest work of Bramante, according to his biographers, is Santa Maria della Riscatta, near Urbania (Castel Durante) [cf. Pungileoni, *Memorie int. alla vita di Bramante*, 8vo, Rome, 1836, p. 14. Pagave, *Memorie per la vita di Bramante*. MS. in the Ambrosiana of Milan], but Heinrich von Geymüller confirms our belief (private communication) that little absolutely characteristic of Bramante can be discovered in this simple octagon edifice. [* See also Von Geymüller, *Les projets primitifs pour la basilique de Saint-Pierre de Rome*, p. 26.]

[2] Pagave, MS. Pungileoni, *ub. sup.*, p. 26. Calvi, *ub. sup.*, ii. 5. The Anonimo ed. Morelli, p. 47, registers as works of Bramante a Pietà in San Pancrazio which Pasta believed to be by Lorenzo Lotto (Pasta, *Pitture di Bergamo*, p. 53, cit. in Anon., p. 181), and allegorical figures "done circa 1486" in the Palazzo del Podestà. On the latter edifice, now the public library, there are traces or spots of fresco ; and one head—of an angel—might justify the date given ; but

Nothing is certain except Bramante's presence at Milan in 1487.[1]
Under these circumstances we are bound to receive with sus-
picious caution all that is stated respecting him as a beginner.
When we stand on the vantage-ground of records we find that
he was known as an architect and engineer; yet we learn from
various sources that he practised as a painted. If we had
confirmatory proof of a statement made by Calvi that the
municipality of Pavia refused in 1487 to carry out Bramante's
design for a new Duomo, because its adoption would have been
too costly, we should attribute great importance to it as showing
that at the earliest-known date of Bramante's stay in Milan he
was capable of the highest duties to which an architect of any
period can be called.[2] Of Bramante's visit to Pavia in 1488 in
connection with the new Duomo we have distinct evidence in
the accounts which describe his journey thither.[3] After 1488,
Bramante built the sacristy of San Satiro at Milan;[4] in 1491 he

the fragment is too small to justify us in drawing any conclusions as to the
author of the painting. [* The authors confuse the Palazzo del Podestà (or del
Pretore) with the Palazzo della Ragione; it is the latter building which is at
present the public library, while the former now contains the law-courts. The
Anonimo's date for the frescoes, which he ascribes to Bramante, cannot be
accepted; according to a note in Marin Sanudo's *Itinerario* of 1483, these
paintings were executed when Sebastiano Badoer was pretore, *i.e.* in 1477. See
Frizzoni, in *Notizia d'opere di disegno*, pp. 125 *sq.*]

[1] The earliest contemporary record of Bramante proves that he was at
Milan in 1485 (see Von Geymüller, *ub. sup.*, p. 34). There is, however, every
reason to think that he came to Lombardy at a much earlier date. The frescoes
at Bergamo which the well-informed Anonimo ascribes to Bramante were, as we
have seen, executed in 1477; and it is now practically certain, that he began
the rebuilding of San Satiro at Milan about 1479 (see Beltrami, in *Rassegna
d'arte*, i. 33, 37, 100 *sqq.*).

[2] Calvi (*ub. sup.*, parte ii. pp. 155 and 178) cites as authority the manuscript
Memorie of the Milanese Albuzzio. Pungileoni, *ub. sup.*, pp. 71-2, mentions a
section-drawing preserved at Pavia, and copies the signature upon it; but we
cannot vouch for the originality of either.

[3] Pungileoni, *ub. sup.*, p. 72.

[4] Compare the concurrent testimony of Cesare Cesariano, *Vitruvius Com.
translato in volgare*, fol. Milan, 1521, pp. v. and lxx., and Anonimo ed. Morelli,
p. 40. But that he should also be the architect of San Satiro, is not proved by
these authorities. See also Lomazzo, *Trattato*, p. 97; Vasari, vi. 513; and the
records cited in *Raccolta di Varie Lettere, &c., di Alessandro Astesani* 8vo,
Milano, 1810, pp. 22-36. De Pagave, in his Life of Bramante MS., *ub. sup.*, cites
Astesani's records, adds others of his own, and strives without success to extract
from them that Bramante was the architect of San Satiro. The controversy can

took part in one of the consultations to which the erection of the
cathedral periodically gave rise; in the following years, at the
request of Lodovico Sforza, on whose behalf he had already
reported on engineering works at Ossola, he began the cloisters,
or *canonica*, of Sant' Ambrogio.[1] Later commissions were given
for building the choir and sacristy of Santa Maria delle Grazie,
and for running a covered way from the town wall to the counter-
scarp of the Milan citadel.[2]

Bramante's edifices, so far as they are certified to be his, are
in classic style. His art was that which received its first polish
from Piero della Francesca and Laurana, and charmed the taste
of Perugino and Raphael. Whether it was all his own before he
came to Milan is hard, even now, to say. Vasari attributes his
success as a perspective draughtsman and designer to the teaching
of Bramantino and to a close study of Milanese church forms,
but there is grave cause to doubt the correctness of these state-
ments.[3] His talents were certainly recognized at the close of the
century by the greatest of the Florentines; and the genius which
the subsequently displayed at Rome justified the favourable opinion
of Da Vinci.[4]

But whilst Bramante practised as an architect and engineer,
he did not, as we might infer from Vasari's narrative, abandon
painting altogether. On his first visit to Rome Alexander VI.
employed him to draw his escutcheon, and there is every reason
to believe that this class of adornment was one to which he was
accustomed.[5] It was well known, in fact, that he had decorated
the fronts of several mansions at Milan, that he had made

only be solved by a close study of Bramante's style, of which we cannot claim to
to be competent judges at present.

* Bramante had a considerable share in the rebuilding of this church.
Cf. Beltrami, *ub. sup.*

[1] See the extracts from the accounts in de Pagave MS., and Pungileoni,
ub. sup., pp. 18, 76, and 78.

[2] Serviliano Latuada, *Descriz. di Milano*, iv. 373; Astesani, *ub. sup.*, p. 26;
Frat. G. Ravegnati Mediol. ord. Pred., *Historia cenobii Div. Mar. gratiarum*,
p. 35. Manuscript cit. in Pag. MS., *ub. sup.*; Pungileoni, *ub. sup.*, p. 20; Anonimo,
ub. sup., p. 39. Ces. Cesariano *Vitruv.*, xxi., *à tergo*.

[3] Vasari, vi. 513.

[4] Da Vinci, in one of his manuscript Sketchbooks, notes: "Edificii di
Bramante." Amoretti, *Mem. Stor. di Lionardo da Vinci*, 8vo, Milan, 1804, p. 79.

[5] Vasari, iv. 152 *sqq.*

drawings for prints, and even that he had completed pictures.
Four Evangelists in a Milanese church were long preserved as
examples of his boldness in foreshortening. His bust portraits
of Pietro Suola and other captains, his allegorical full-lengths,
Democritus as "the laughing philosopher," and "Heraclitus in
tears," were celebrated ornaments of the Panigarola-Prinetti
Palace ; nor was it favour, but sterling merit that recommended
him to the Panigarola family, from whose ranks an architect
arose in the sixteenth century only less known than Bramante
himself.[1] It is a source of no small regret that of all Bramante's
pictorial creations nothing else should remain but the smeared
fragments in the Panigarola residence of which little more can
be said than that they were originally of Umbro-Florentine
character, and that they still scent of the styles of Melozzo,
Santi, and Signorelli.[2] One print, of which two impressions
exist, gives a fair idea of his manner. It represents a chapel
with a monument in the centre of the floor and persons kneeling,
standing, or on horseback in the fifteenth-century costume.
The architecture differs little from that of Bramante's Milanese
edifices, and the detail is like that of Caradosso; whilst the
figures are Umbrian or Lombard in shape and action.[3]

But this very same class of architecture and similar moulds
of form are observed in frescoes or panels assigned to a certain
period of Bramantino's career, and this fact alone leads us to

[1] Lomazzo, *Trattato*, pp. 227, 270, and 384, cites as by Bramante of Urbino,
the four Evangelists (now under whitewash) in Santa Maria della Scala at Milan ;
figures on the façade of a mansion in the Piazza de' Mercanti, and frescoes in the
Panigarola palace in the same city. As to Ottaviano Panigarola, the architect,
see notice of him in Cesariano's *Vitruvius, ub. sup.*, p. 110 *a. t.*, and in Anon.
ed. Morelli, pp. 173–4.

[2] Milan Casa Prinetti, formerly Panigarola. What remains of the subjects
noticed in the text is retouched and disfigured with varnishes. The proportions
are those of life. [* These frescoes are now in the Brera Gallery (nos. 489–96).
Originally, all the figures, except Democritus and Heraclius, were represented
full-length. See Ricci, *Gli affreschi di Bramante nella R. Pinacoteca di Brera.*

As paintings by Bramante we may also accept the Christ at the Column in the
church at Chiaravalle (see *postea*, p. 347), the fresco of Argus in the Castello at
Milan and possibly the portrait group, formerly ascribed to Jacopo de' Barbari,
in the Naples Gallery (see *antea*, i. 234, n. 3).]

[3] The two copies of this print, of which a line-engraving is in Rosini's history,
are in the British Museum and in the Casa Perego at Milan. On the plinth of the
monument in the centre of the chapel are the words: "Bramantus fecit in
Mlo." [* See also Hind, *Catalogue of Early Italian Engravings*, pp. 40 *sqq.*]

conclude that Suardi, though he was first taught in the local schools of Milan, afterwards became journeyman to Bramante.

Bramantino was christened Bartolommeo by his father, "Dominus" Albertus of Porta Orientale, in the parish of Santa Babilla at Milan ; and in notarial records of the sixteenth century he bore the name of " Bramantino de' Suardis." [1] He lived a life of many vicissitudes, visited many centres of artistic culture, and assimilated many styles—studying first in the antiquated schools, then with Foppa ; purifying his manner at last under the influence of Bramante, Leonardo, and the moderns. It is credible that, previous to Bramante's settlement in the Lombard capital, Suardi was a master-builder and painter. It is probably untrue that Bramante owed anything to his teaching. At a certain period, and under circumstances now obscure, he became Bramante's assistant. [2] We may fancy that matters befel in this wise: that Bramante, being in the enjoyment of a most extensive practice, was unable to attend personally to the whole of it and that he occasionally substituted Caradosso when called upon for sculptural, and Suardi when called upon for pictorial, decorations. The result of this, unfortunately, was that Suardi received the *sobriquet* of Bramantino, and annalists learned to confound the works of Bramante with those of his Milanese subordinate. Controversy first took place on points of authorship, it soon extended, and with great acrimony, to the question whether Milan had not given birth to more than one Bramantino. [3] The

[1] See minute of a contract under date 1513, *postea*. The name too is " Bartolommeo, detto Bramantino Milanese," in Lomazzo (*Idea*, p. 16.) " Bartholomeo seu Bramantino " in Cesariano (*Vitruv.*, lib. 3, p. xlviii., *a. t.*). But that Bramantino's name was Suardi was known to Sormani (*Milano*, 1753, i. 156).

[2] " Sotto lui (Mantegna) . . . e sotto V. Foppa e Bramante divennero famosi B. Zenale il Buttinone, Bramantino. . . ." (Lomazzo, *Idea*, p. 150). " Fiorì doppo lui (Bramante) Bartolomeo detto Bramantino Milanese suo discepolo " (*ibid.*, p. 16). " Che dopo lui [Bramantino] Bramante divenisse . . . eccellente nelle cose di architetura, essendo che le prime cose che studiò Bramante furono quelle di Bramantino " (Vasari, vi. 513).

[3] De Pagave, in his manuscript life of Bramante (Ambrosiana), argues in favour of the existence of an old Bramantino of Milan, whom he calls " Agostino di Bramantino Milanese." The same theory is strangely countenanced by one of the commentators to the Le Monnier edition of Vasari's lives (Vasari, xi. 279) and by Passavant (*Kunstblatt*, No. 68, 1838). But there is nothing more certain than that Agostino di Bramantino is a pupil of Suardi, and properly called " discepolo di Bramantino " in Lomazzo's *Trattato*, pp. 270 and 681.

chief offender and primary cause of confusion was Vasari, and, in order to clear up the mystery which he created, we must listen to what he says in certain passages. Speaking of Piero della Francesca in the first edition of the lives, he remarks that " Nicholas V. took Piero to Rome, where he designed two subjects in the upper *camere* of the palace in competition with *Bramantino of Milan*—subjects which were broken up by [order of] Julius II., together with others by *Bramantino of Milan*, an excellent painter of those days, to make room for Raphael's prison of St. Peter and miracle of Bolsena. But," he continues, " as I cannot write the history of *this man*, nor describe his works which have perished, it does not seem to me unnecessary, since the occasion presents itself, to make note of him as I have heard that the portraits which perished with his frescoes in the *camere* were so natural and so fine that they only wanted speech to give them life. Of these a large number were perpetuated by Raphael, who ordered to be copied—amongst others—the likenesses of Niccolò Fortebraccio, Charles VII. of France, Francesco Carmignuola, Giovanni Vitellesco, Cardinal Bessarion, Francesco Spinola, Battista da Cannetto—all of which were given to Giovio by Giulio Romano, the pupil and heir of Raphael of Urbino, and by Giovio were placed in his museum at Como. I have seen," he adds, " at Milan, above the door of San Sepolcro, a Dead Christ, foreshortened, by the same, in which though the whole figure hardly surpasses one *braccio* in size it goes to the verge of the possible as regards freedom of hand and appropriate treatment. By the same again and in the same city are *camere* and *logge* in the house of the " Marchesino " Ostanesia, with many things done with skill and power, especially of foreshortening ; and outside the Porta Vercellina, near the Castello, he drew on certain stables now ruined and destroyed, ostlers rubbing down horses, one of which was so lifelike and so well done that another, taking that one to be alive, was constantly in the habit of kicking at him.[1]

In the second, or Giuntina version of Vasari, the words " Bramantino of Milan " in the first sentence are altered to " Bramante of Milan "; and this reading prevailed in all subsequent editions.

Numerous writers gathered from Vasari's words that history

[1] Vasari, *Vite*, Firenze, Torrentino, 1550 ; i. 361.

was bound to recognize Bramante or Bramantino of Milan the
contemporary of Piero della Francesca under the Pontificate of
Nicolas V. (1447-55) and Bramantino who lived in the Pontificate
of Julius II., neither of whom was to be confounded with Bra-
mante of Urbino, the architect of San Pietro at Rome.[1] Yet in
that part of his book which Vasari devoted to the Lombards we
find a sufficient correction of his previous assertion when he says
that Bramantino, having been employed in the Camere at Rome
by Nicholas V., returned to Milan to paint the Christ above the
portal of San Sepolcro,[2] thus giving us to understand that Bra-
mante or Bramantino of Milan, the alleged companion of Piero
della Francesca, and Bramantino who worked at the Camere in
the Pontificate of Julius II., were one person. This very
material correction had but one fault : it involved Vasari in a
glaring error of chronology, as the same artist could scarcely
have been in the pay of Nicholas V. and Julius II., who lived
half a century apart. The real solution we may consider to be
this : that Vasari did not intend to convey, though he may
accidentally have done so, that the person whom he calls Bramante,
or Bramantino da Milano, competed with Piero della Francesca
under Nicholas V., the gist of both of his statements when taken
in conjunction being that one painter—a Milanese—executed
frescoes in the Camere where Francesca had once laboured, and
that these frescoes were taken down at Julius II.'s bidding when
Raphael came to Rome. We shall find the more reason to
accept this explanation, because the pictures attributed to the
Bramantini of Milan are of the close of the fifteenth century and
are assignable to one person ; and there is no documentary
evidence of the existence of two Bramantes or two Bramantinos
at different times.[3] There is more apparent than real plausibility
in the proof which some authors like Calvi adduce for believing
in old Bramantino of Milan. He ascribes to that fabulous
personage a fragment in Sant' Ambrogio of Milan, and supports
his theory by the assumption that the date on one of the walls is
1428. But few will accept this reading of the date in preference

[1] The latest of these authors is Calvi, who in *Notizie*, ii. 1-28, writes a life of
old Bramantino out of the materials for the life of Suardi.

[2] Vasari, vi. 511.

* [3] Cf. *postea*, p. 340, n. 2.

to that of 1498, which is the more probable one ; and we may agree that the frescoes in question are by Zenale.[1]

Amongst the earlier productions which traditionally pass for works of Bramantino one or two have an antiquated air which gives them a fictitious stamp of age. One is a Crucifixion, much injured by repaints, in the church of Sant'Angelo at Milan ; the other is a Circumcision in bad condition at the Louvre, which once belonged to the Milanese convent of the Oblati. It would be difficult to find two pieces more strongly impressed with Lombard character than these, and we may justly express surprise that any one should accept the author as a worthy rival of the great Francesca. But we may go further, and say that nothing in these pictures discourages the belief that they were painted by Bartolommeo Suardi. As to the time in which they were produced, the date of 1491 on the Circumcision gives us a most decided clue, and the Crucifixion was finished but a few years earlier.

As an example of an art which, if we may not admire, we can at least dissect, the Crucifixion is most valuable, and affords a proof of the low powers which supported certain Lombard craftsmen at the close of the fifteenth century. Christ crucified between the Thieves is adored by St. Francis, St. Catherine, and St. Buonaventura ; whilst the Virgin faints in the arms of the holy women, and John the Evangelist looks up as the soldiers dice for the garment. The figures are coarsely vulgar, ill-proportioned, bony, and badly drawn. The square and massive heads—some of them with copious serpentine looks—offer a variety of type which clung to the Lombards till after Leonardo's time. The drapery, of deep harsh tone, is broken into numerous and very acute angles ; and the surface has the raw and sombre gloss which distinguishes the period of transition from tempera to oil mediums. In the distance of high, pointed hills, giving room to a mere patch of sky, there are Roman edifices and Roman personages such as are seen in the landscapes of the Christian miniaturists ; and reminiscences of the same traditional habits are suggested by the lines of gilding on the dresses, buildings, and background. One feature characterizes this, as it does all the works of Suardi. A cross-light reflected from

[1] Calvi, *Notizie*, ii. 12. See *postea* in Zenale.

below breaks each body into well defined parts, the greatest
breadth of space being in half-tone, whilst light and shade are
reduced to streaks.[1]

With more skill in drawing and better selection of masks
and proportions, the Circumcision is more resolute in touch and
drawn with less massive outlines than the Crucifixion, but by
the same painter in a later phase of his progress. It is a votive
altarpiece representing the performance of the well-known rite
in presence of St. Jerome, St. Catherine, and two bishops. The
infant, in its mother's arms, shrinks in terror from the high
priest, whilst Father Lampugnano, in the white robes of the
Umigliati, kneels at the Virgin's feet. What there is of affected
grace in the Virgin's pressure of the child seems partially
derived from Leonardo, but the raw and dusky grey of the
complexions and the harsh contrasts of vestment tints are
reminiscences of the older Lombards. Peculiar to Suardi is
the projection of sun-rays all but parallel to the plane of the
picture and the consequent predominance of shade over light.[2]

It is unknown when the Christ of Pity above the portal of
San Sepolcro at Milan was finished. Lomazzo, who copied it
and wrote a sonnet in its praise, speaks of the foreshortening
of the limbs of the Saviour as perfect, and seems justified in
his encomiums by the warm sentences of Vasari. Unhappily,
when the fresco was taken down in 1713 and sealed anew into
its place the lower parts were so injured that it was thought
advisable to remove them. As the piece now stands, Christ
is supported up to his middle in the tomb by the Virgin, John

[1] Milan, Sant' Angelo. Wood, arched tempera, figures under life-size, greatly
injured by coarse repaints. This Crucifixion, which Passavant rightly conjec-
tures to be by Suardi (*Kunstblatt*, No. 68, anno 1838), is assigned by Calvi (*Notiz.*
parte ii. pp. 7 *sqq.*) to "old Bramantino." [* Cf. *postea*, p. 337, n. 1.]

[2] Louvre, No. 1545. Wood, m. 1·35 high by 2·23. Originally belonging
to the Oblati of the Canonica in Porta Nuova at Milan (manuscript Life of
Suardi, by de Pagave at the Ambrosiana) inscribed on the hexagonal pedestal
of the Virgin's throne: "Anno 1491 fr ia lapugnanus pp .iumil can." Two
vertical splits disfigure the panel, which, besides, is unevenly cleaned and
restored, so that the general tone remains inharmonious. The shadows are very
dark. Particularly repainted is the white robe of the kneeling patron and the
red one of the kneeling high priest. According to de Pagave, this picture had
an upper course in which the Eternal was represented between two angels.
[* Cf. *postea*, p. 337, n. 1.]

the Evangelist, and Mary Magdalen, whilst Nicodemus and Joseph of Arimathea stand back in the character of spectators. Behind the group, distant Golgotha appears through the opening of an arch. The form of Bramantino's art, in this as in earlier examples, is not to be mistaken. The flanking light which remains a salient feature is made more than usually telling by the care with which reflections are introduced, whilst additional attraction is produced by tones more free from rusty sombreness than before. A welcome concentration of power is found in the clever setting of the figures, in the flow and accent of contour, in the marking of flesh-projection by hatchings. Foreshortening is well carried out, and drapery of papery break looks studied in its detail. Comparatively select proportions distinguish the Saviour from the personages of vulgar clay, and flexibility is successfully imparted to his frame. With all these improvements Lombard type is preserved in the mould of the heads, in their homely realism of expression, and their serpentine tresses.[1]

Thus far Bramantino exhibits the progress that was to be expected from a Milanese craftsman rising by industry and patient labour out of the ruck of his class. It is quite possible that a man with the feeble talents exhibited in the Crucifixion of Sant' Angelo should in the course of years rise to the comparative excellence of the Circumcision at the Louvre. It is also possible that, under the personal superintendence of Vincenzo Foppa, or by a judicious study of Foppa's works Suardi acquired the skill which we discern in the Pietà of San Sepolcro.

We shall now accompany Bramantino's progress as new influences reacted on his style. We shall see that, whilst preserving his individuality, he became possessed of a taste for architectural ornament of a purer standard than that to which he was first accustomed; that certain affectations of posture and action crept in to stamp his impersonations with another

[1] Milan, San Sepolcro. Fresco, with figures of life-size in a grotesque framing of the eighteenth century. See Vasari, *ub. sup.*, and Lomazzo, *Trattato*, p. 272, and *Rime*. In a poem in the latter (p. 182) he states that he copied the Pietà for Philip II. of Spain. [* In 1872 this fresco was removed to the interior of the church, and placed to the left of the entrance over the door leading to the crypt. See also *postea*, p. 337, n. 1.]

feeling. We shall find, in fact, that he was under the charm of Umbrian polish—the polish, no doubt, of Bramante.

To this period we shall assign the Martyrdom of St. Sebastian in the church of that saint at Milan, a picture to which something has been added in substance by repaints, but in which so much of the Umbrian is commingled with the Milanese that Lanzi and others inclined to consider it by Bramante. The most conspicuous peculiarity in it is that with which we are most familiar in Suardi, and the cross-light with the narrow strips of sun and deep shadow which run in shimmering lines along the frame of St. Sebastian are contrasted with most carefully wrought reflections. The saint stands on a pedestal in front of the pilaster of a classic colonnade through which a landscape of Umbrian line appears. His proportions and pose are alike good; his form is modelled with a finish hitherto unknown to Suardi. In the four archers in stilted posture who shoot or have shot their arrows, action is better felt than rendered ; but even in this we detect the painter's effort to create something more delicate and select than of yore. The quiver and fragments of cornice on the floor, the pedestal as well as the pilaster of the archway, all reveal study of the classic as contradistinguished from the antiquated embellishments of the Crucifixion of Sant' Angelo.[1]

We may believe that Suardi now began really to deserve the

[1] Milan, San Sebastiano. Wood, figures of life-size. A winged angel flies down to the saint. The colouring can scarcely be judged of, so heavily is the picture repainted, but is of glossy texture with dark warm shadows, the dresses of deep strong tone. Lanzi (ii. 472), following Carlo Torre (*Ritratto di Milano*, 4to, 1674, p. 145), gives this picture to Bramante ; Calvi (*Notiz.* ii. 10) gives it to " old Bramantino."

* The painting under notice is now in the Castello Museum at Milan ; it has been transferred to canvas and freed from the repaint with which it was covered.

On many points the account which the authors give of the earliest phase of Bramantino's career does not agree with the conclusions arrived at by recent criticism. Neither the Sant' Angelo Crucifixion nor the Louvre Circumcision are at present accepted as being by Bramantino. Prof. Suida (in the Vienna *Jahrbuch*, xxv. 68) considers the former picture the work of some older Lombard artist. The Circumcision is ascribed to Zenale by Herr von Seidlitz (in *Gesammelte Studien*, pp. 76 *sq.*), Mr. Cook (in *The Burlington Magazine*, v. 180), and (with a query) by Mr. Berenson (*North Italian Painters*, p. 302). Prof. Ricci (*ub. sup.*, p. 39) finds in it an affinity to Civerchio, while Prof. Suida (*loc. cit.*, p. 71) thinks it is by some artist, at present nameless. As for the St. Sebastian in the Castello

name of Bramantino, which he owed either to his fondness for
Bramante's style, or, as we should more readily believe, to his
aptitude for carrying out the pictorial designs of that artist.
More than ever it was the fashion to combine the sister arts in
edifices, either by executing ornament simulating plastic relief,
or reliefs in the midst of pictorial adornments. Bramante, we
saw, was one of those who accepted commissions of this kind in
conjunction with others for building and fortification. It was a
natural consequence of his rising importance in all these branches
that he should require assistants, and it might appear to him
that, amongst these assistants, Suardi was the best. It seems,
indeed, not unlikely that we owe to this period of Suardi's con-
nection with Bramante the designs on the front of the mansion
known in olden time as the Casa Scaccabarozza, called by Lomazzo
Casa de' Pirrovani and known at the present day as the Casa
Castiglione. This house was supposed by Calvi to date from
the year 1465, because, amongst the portraits of the Milanese
dukes and duchesses which it contains, the latest are those of
Francesco and Bianca Sforza; but this is an argument of little
weight, even to those who hold—as Calvi holds—that old
Bramantino really existed. The building was no doubt adorned
at the close of the century, and probably during the reign of
Lodovico Moro, with frescoes. Of four allegories representing
Amphion, Janus, the Po, and the "valour of Italy," little or
nothing remains; but an architrave beneath the first story
windows is finely filled in with monochrome foliage on blue
ground; and a frieze beneath the eaves contains rounds parted

Museum, the style of this picture in its present condition points very definitely to
Vincenzo Foppa as its author. See Ffoulkes and Maiocchi, *ub. sup.*, pp. 147 *sqq.*

Among Bramantino's earliest works are at present classed a Nativity in the
Ambrosiana collection at Milan (cf. *postea*, p. 348, n. 2), and Jupiter and Mercurius
visiting Philemon and Baucis in the Wallraf-Richartz Museum at Cologne (No. 558).
The Ambrosiana picture is closely related to the art of Butinone, though in it
already the influence of Bramante begins to be visible; in the Cologne picture it
has become predominant. That Bramantino had studied the works of Bramante
before executing the boldly foreshortened figure of Christ at San Sepolcro may also
be taken for granted, though it may well be that the picture in question dates
from a comparatively early period of Bramantino's activity. An important, rather
early work by our artist is a Christ as the Man of Sorrows in the collection of
Conte Lucchino del Mayno at Genoa, a variation of Bramante's rendering of the
same subject at Chiaravalle. See Suida, *loc. cit., passim.*

by fanciful impersonations of deities and monsters and gambols of children. Medallions in arch spandrels inside the building comprise busts of Cæsars and likenesses of the Visconti and Sforza; and one of the rooms on the ground-floor has an upper frieze in which nymphs, captains, monsters, fountains, and arabesques are cleverly commingled. There is much in the manner of this decoration to remind us of the Bramantesque, more to recall the individuality of Suardi; and it is not a little striking to find a man who began with so little promise, not only producing designs both graceful in thought, and spirited in execution, but figures equally well-proportioned and foreshortened. Though form is rendered with some dryness and angularity, it is marked with considerable force, and the treatment is at once free and resolute. Characteristic again is the projection of light from below with complicated reflections and reverberations; whilst skill is shown in defining outlines on the sunny side by the shadows cast on the surface next them.[1] An artist at this height of his practice was precisely fitted to assist Bramante when, wandering from Milan after the fall of Lodovico Sforza, he courted employment at the Vatican; and it is not improbable that, very shortly after Bramante had settled at Rome and discovered that a noble career was open to him, he called his old disciples to his side and offered to share with them some of his new prosperity. In their uncertainty as to the fate of Lombardy under French rule, they too might have reason to rejoice that such an offer had been made.

At all events Bartolommeo Suardi, who was now very commonly known as Bramantino, visited Rome in the first years of the sixteenth century and received the same patronage as was extended to Bazzi, Peruzzi, Signorelli, Pinturicchio, and Perugino. He was employed by Julius II. in the Camera dell' Eliodoro,

[1] Milan, Casa Castiglione. [* Now Casa Silvestri, 16 Corso Venezia.] These frescoes are assigned by Calvi (*Notizie*, ii. 16) to old Bramantino. They are, we may believe, by Suardi; and, if Suardi were assisted by any one, it would be by Bramante of Urbino giving him sketches and designs. The frescoes are attributed to "Bramantino" by Vasari (vi. 513) and by Lomazzo (*Trattato*, p. 271), the same who in his *Idea* (p. 133) gives them to "Bramante." The cause which may explain the destruction of several figures in the mansion are given by Calvi (*ub. sup.*, p. 18), who proves how the front was altered in 1651. [* Many critics of the present day consider that these frescoes are by Bramante.]

and, though historians neglected to describe the subjects of his frescoes, they told how the portraits which adorned them were copied, at Raphael's request, before he took them down to clear the walls for the Prison of St. Peter and the Miracle of Bolseno.[1]

A sketch-book at the Ambrosiana containing elevations and measurements of Florentine and Roman buildings has been assigned to Bramantino on account of its style and of the Milanese dialect in which the explanatory notes are written. Vasari mentions a book of the same kind in which Bramantino drew many of the monuments of Milan and Pavia. That of the Ambrosiana induces us to believe that Bramantino was at Rome as early as the opening of the century. He alludes in one of the pages to Cardinal Giuliano della Rovere and thus incidentally proves that his notes were made before the conclave of 1503 which raised Giuliano to the papal chair. In 1507 Bramantino was still at Rome, the client of Bramante, the casual associate of Cesariano, Signorelli, and Pinturicchio, and it is highly improbable that he should have returned to Milan before the French were expelled from Lombardy by the Spaniards and by Julius II. Whilst returning to the North after the occurrence of that mighty event he doubtless made those sketches of Florentine monuments which fill some pages of the Ambrosiana sketch-book and renewed acquaintance with da Vinci, whose name he wrote on one of the margins.[2]

[1] Vasari, iv. 330 and iii. 492,

[2] Milan, Library of the Ambrosiana. The cardinal of San Pietro in Vinculis—della Rovere—is mentioned in the annotations of the second page. There are sketches of the Baptistery of Florence at pp. 41 and 75. Most of the sketches are from Roman buildings. See also Calvi (*Notizie*, ii. 6), and Vasari's description of Bramantino's book of drawings, once in possession of Valerio Vicentino (vi. 511 *sqq.*). See also Lomazzo, *Trattato*, p. 407; Temanza, *Life of Sansovino*, p. 6; Vasari, vii. 490, and C. Cesariano, *Vitruv.*, *ub. sup.*, xlviii. *à tergo*. [* We now know that Bramantino went to Rome somewhat later than the authors suppose. Contemporary records prove that he was in Milan in February and June 1503 (Suida, *loc. cit.*, p. 1). As for the sketch-book in the Ambrosiana, Prof. Suida, a learned authority on Bramantino, doubts that it is from his hand (*ub. sup.*, xxvi. 297. There is no proof that Bramantino was at Rome in 1507; but we know that on December 4, 1508 he received payment for paintings to be done in the Vatican (*ibid.*, p. 295). Among the works which Bramantino executed at Milan at the beginning of the sixteenth century we are probably justified in classing the designs for a series of tapestries, representing allegories of the months, which belong to Prince Trivulzio of Milan. There is evidence that these tapestries cannot be dated

During the last years of his stay in Rome Bramantino might
have found it hard to struggle against the superiority of numer-
ous and very able rivals, had it not been that, in a city frequented
by Italians of many provinces, he could always reckon on support
from Milanese patrons. We have a curious instance of the
steadiness with which men of the same districts clung to each
other in the relations which were kept up between Bramantino
and the Cistercians after his return to Lombardy. The Cistercians
of Rome were affiliated to the monastery of Chiaravalle, near
Milan ; and in 1513, rather than employ a Roman painter, they
instructed their brethren to contract with Bramantino for a
picture. A draught minute under date September 28, 1513, is
still preserved in the record office of the notaries of Milan in
which the Cistercians of Chiaravalle promise to pay to Barto-
lommeo commonly known as Bramantino de' Suardis of the Porta
Orientale the sum of eighty ducats for a Dead Christ in the lap of
the Virgin with attendant saints. The Pietà then ordered was sent
to Rome and filled a place of honour on the high altar of San
Sabba, being subsequently transferred to Santa Croce in Gerusa-
lemme, after the translation of the Cistercians to that church.
At Santa Croce the Pietà lay forgotten in the crypt till such time
as Cardinal Francesco Barberini removed it into the Barberini
collection, amongst the treasures of which it has since been lost.[1]

before 1501 (Suida, *ub. sup*, xxv. 36 *sqq.*) Prof. Suida would further ascribe to the
period 1500–1504 the designs made by Bramantino for certain *tarsie* formerly
in San Domenico at Bergamo, and now in San Bartolommeo in that town (*ub. sup.*,
xxv. 44 *sqq.*) ; and the same critic holds that some works by Bramantino, which
the authors consider as having been executed after his stay in Rome, were done
before it. With regard to the frescoes which Vasari states Bramantino painted in
the Camera dell' Eliodoro, Prof. Suida remarks that the persons represented in them
lived in the earlier half of the fifteenth century. Bramantino, therefore, cannot
have known them ; but Piero della Francesca, who, according to Vasari, painted in
the same room, may well have had occasion to see them. Moreover, Julius II.
would hardly have had any interest in their portrayal. We may therefore suppose
that Bramantino completed or restored the paintings by Piero della Francesca in
the Camera dell' Eliodoro (Suida, *ub. sup.*, xxvi. p. 296).

[1] The minute is in Latin, but too long to print. See as to the fate of the Pietà,
de Pagave, Life of Suardi MS., *ub. sup.*, and in the same the statement of payment
at the rate of 5 lire per ducat at Martinmas of 1515. [* It seems exceedingly
likely that the above-mentioned picture is identical with one which now belongs
to Dr. M. Berolzheimer, of Munich. (Suida, *ub. sup.*, xxvi. 312 *sqq.*) With this
work we may associate a little Madonna belonging to M. V. Goloubew, of Paris.]

We are not without means of judging what change was operated in Bramantino's style by his visit to Rome and Florence, for the barrenness of that visit to critics of this age is compensated by copious productions of a later time at Milan. One circumstance, highly characteristic of the modification in the painter's manner, is noted by Lomazzo, who says that in his youthful days he designed drapery from models made of paper and pasted canvas on the system familiar to Mantegna and Bramante, whereas later, and particularly after his return from the South, he used another method which made his folds too soft and drooping.[1] This variation, which is but one of many produced by the extension of Suardi's experience, is perceptible in several of his works, and we shall have ample occasion to notice them. During his travels Suardi also improved his knowledge of the science and practice of perspective, and we doubtless owe to his mature years those written rules which Lomazzo cites, where he says, as a critic might say of the artists of this day, that one class applied perspective scientifically by compass and rule, a second less scientifically by interposing between the eye and object a trellice of squares or a pane of grass ; a third unscientifically—and that was a numerous class—by merely copying nature.[2]

The chief feature of such works as we may suppose to date immediately after 1513 is identity of style with pictures by Signorelli and his disciples ; and this we find displayed most pregnantly in a small Epiphany in the Layard collection at Venice. The Virgin sits in front of a ruin, whilst one of the kings comes forward with a vase, and the rest of the dramatis personæ are distributed in various movements about the space. What reminds us of an older bias in the master is the stiff but correctly balanced distribution, the side-light and its accompaniments of reflections, the remnant of hardness in broken drapery, and the classic in architecture or in cups and caskets of antique shape which strew the ground. Lombard type is still conspicuous in the dress and mould of the human form as well as in the sharp and angular line of the peaks which fill the landscape ; but there is something novel in the action which betrays the influence of the Umbro-Florentines ; and this is peculiarly apparent in the

[1] Lomazzo, *Trattato*, p. 457. [2] *Ibid.*, pp. 276–7, and *Idea*, p. 150.

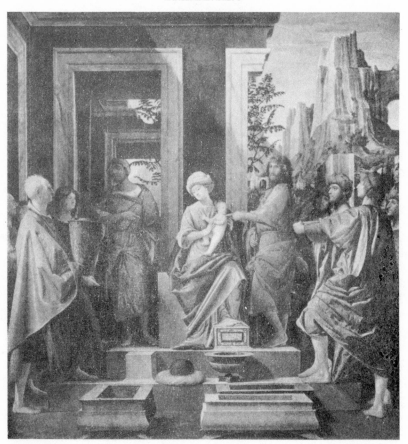

THE ADORATION OF THE MAGI.

attitudes of the two figures that poise each other at each side of
the foreground ; were the colour less solid and grey it would
give additional charm to a touch which in crispness and strength
rivals that of Signorelli.[1]

Illustrative again of this phase in Bramantino is the Madonna
with Saints which passed from the church of San Michele to the
collection of the Duca Melzi at Milan. Here also the figures are
thrown into twilight against a clear sky and relieved by half-
tints and reflections. The classic is enshrined in a temple of the
the middle distance ; but the elegant smallness and slenderness
of the shapes and the serenity of the regular, youthful faces
suggest study of Fra Bartolommeo or Mariotto. Grace mingled
with affectation in the gesture of the hand or the inclination of
the head in the Virgin, gravity of deportment and mien in the
kneeling saints at the sides, give interest to the composition.
Yet there is something grotesque in the large toad which
symbolizes Satan at St. Michael's knees ; and clever fore-
shortening barely reconciles us to the quaintness of laying the
bound heretic at the side of St. Ambrose. Most striking as a
contrast to Bramantino's older habit is a soft run and metallic
precision of contour, recalling Piero della Francesca and Leonardo,
a prevalent tendency to festoons of fold and a silvery surface of
enamelled colour.[2]

Shortly after this picture was finished, Bramantino probably
composed the Flight into Egypt, in the sanctuary of the
Madonna del Sasso at Locarno, a panel in which the grimace of
sentiment is carried further than we have hitherto seen it. In
strange and unnatural motion, the guiding angel turns and tosses
his head to heaven to glance downwards again at the Virgin on

[1] Venice, Lady Layard, small panel in oil. The Virgin wears the headdress
(a white cloth) peculiar to her in all the pictures in which Bramantino has
hitherto represented her. The Child is small and stilted. The faces are of the
unselect or vulgar type with which we are now acquainted. The heads of a
personage to the left of the Virgin introducing one of the kings and of one to the
right pointing to her are untouched. [* Prof. Suida (*ub. sup.*, xxv. 18) thinks that
this picture was executed shortly before 1500.]

[2] Milan, Duca Melzi. Wood, three-quarters of life-size. The Virgin sits on a
throne in front of a red hanging held up by two angels. The two saints kneel on
a chequered floor at her sides ; distance—houses and sky. The colour is fused to
a fine enamel, but the surface is not quite free from abrasion and retouching.
[* This picture is now in the Ambrosiana collection at Milan (Sala D, No. 18).]

the ass behind him. In an attitude of similar strain, the Virgin
holds the Infant and looks round at Joseph ; languid bend of
head, swelling flesh, drooping vestment folds and loose drawing
are features of Bramantino's art at this time, whilst in the
copious incidents of a distance that Breughel might have envied,
the form of Piero della Francesca is carried into the sixteenth
century with modern richness of texture and blended argentine
tones.[1] Whether at the time of completing this piece Bramantino
was at Milan or on the banks of the Lago Maggiore we have no
means of ascertaining. We may believe that he visited Locarno
at least in 1522, designing with the aid of his journeymen a series
of wall-paintings in the church of Nunziata. What remains of
these frescoes, a Virgin and Child with saints on one of the walls
and a Descent of the Holy Spirit in the cupola, is rudely handled
and probably executed by assistants ; but the spirit is that
which appears in the Flight into Egypt, betraying more and
more approximation in Bramantino to those modern affecta-
tions of grace which we find in Gaudenzio, Solario, and Marco
d'Oggione.[2]

Two or three typical productions suffice to guide us to the
mutations of Bramantino's art between 1513 and 1522 ; we have
no materials of equal value from which to trace the vicissitudes
of his daily life. Maximilian Sforza, after his accession to the
duchy in 1513, might have extended some patronage to the painters

[1] Locarno, Madonna del Sasso. Wood, a cartello, in the foreground, is not free
from suspicious repaint, on which is written : "Bramantino." The masks of the
Virgin and Child are of the same mould as those in the Madonna of Duca Melzi ;
but the treatment suggests a later date of execution. New colour disfigures the
lake dress of the angel and the red dress of St. Joseph. The distance is rocky and
cuts, in varied outlines of slabs, points and castellated buildings, on the sky.
There is water in the middle ground, a bridge and small figures. See, as to the
foundation of the church of the Madonna del Sasso in 1487, Nessi (Gian-Gaspare),
Memorie storiche di Locarno, 8vo, Locarno, 1854, p. 100.

[2] Locarno, church of the Nunziata. Fresco of the Virgin and Child (life-size)
enthroned in a niche between St. Francis to the left and three Franciscan friars
(mere fragments). To the right on a *cartello* at the Virgin's feet is the following :
"1522 Adi . . . V B F." The dress of the Virgin is colourless. The forms of
St. Francis are vulgar, the head broad, the feet and hands large and coarse. The
Virgin is thin and long-waisted, without shoulders. Her head is large and flat,
her hands broad and heavily painted. Of the Descent of the Holy Spirit (in
tongues of fire) parts are repainted, especially the angels which are very badly
treated. See also Nessi, *ub. sup.*, p. 109. [* This fresco is now destroyed.
(Suida, *ub. sup.*, xxv. 67.)]

of the State but for the troubles which signalized his reign and
the shortness of his lease of power. In was not till Francesco
Maria II. was installed in 1522 that Bramantino derived
advantage from official support. When Milan was besieged by
the French in 1523, Bramantino distinguished himself as an
engineer; he displayed personal courage in exposing himself to
danger ; and he exhibited zeal in animating the Milanese to oppose
the enemy.[1] In memory of this Francesco Maria, in 1525, gave
Suardi a patent as architect and engineer, having special reasons
for remembering his past services in the attitude of menace taken
just then by the Imperialists under the Marquis of Pescara.[2]

From that time till after 1529, and perhaps till close upon
1536, Bramantino's practice continued, conforming with every
year more narrowly to the prevalent style of the Leonardesques.
We have lost much that he did, in various churches and edifices,
but we still have traces of him in others. His hand is apparent
in Santa Maria delle Grazie, where St. Peter, martyr, and a
female with a burning heart, kneeling, are set as monochromes at
the side of a carved Virgin within a lunette above the cloister-
entrance to the church, and, in a Madonna between St. Louis and
St. James, a lunette fresco above the door leading from the
sacristy to the same cloister. In both wall-paintings we find
Bramantino's salient features and that sort of art which
characterizes the façade of the Castiglione mansion.[3] Breadth
and ease of handling in the Madonna might point to the later
period of the master's career, that period to which we should
assign a fragment at the Brera representing the Virgin and Child
under a portico guarded by two angels, where, as in earlier works,
the lights are edged about a wide expanse of semitone in which

* [1] On Jan. 22, 1525, Bramantino, together with other persons, were exiled to
Susa, by order of the French governor, Chiandio. (Suida, *ub. sup.*, xxv. 1.)

[2] The record is in précis in Pagave, Life of Bramantino MS., *ub. sup.* The
patent is dated May 1, 1525. [* See also Suida, *ub. sup.*, xxvi. 291 *sq.*]

[3] Milan, Santa Maria delle Grazie. The two frescoes are monochromes, but in
the first the figures are full-length, in the second half-length.

* Prof. Suida (*ub. sup.*, xxv. 25), dates these frescoes shortly before 1500. Their
design of drapery is certainly more closely allied to that of the earlier than to the
later work of Bramantino.

In the great cloister of Santa Maria delle Grazie, six lunette frescoes, repre-
senting scenes from the legend of St. Dominic may also be ascribed to Bra-
mantino. (*Ibid.*, p. 48 *sqq.*)

reflections are cunningly playing.[1] The broad form and large round head of the Virgin contrasting with smallness of extremities, the puffy fleshiness of the infant Christ, are all features peculiar to Bramantino's closing years though found in connection with cornered and intricate drapery : the whole piece reminiscent of Gaudenzio Ferrari but also recalling the Pietà at San Sepolcro, the Madonna of Casa Melzi, and the Flight into Egypt at Locarno. There are not a few bits in Milan that seem assignable to the same time and hand ; for instance, a Boy with Grapes and a St. Martin sharing his Cloak, at the Brera, the first Luinesque and graceful, the second careless and decorative[2] ; a Virgin and Child in the Vescovado[3]; an Annunciation and Nativity in the Museo Poldi-Pezzoli[4]; a Crucifixion, scenic and hasty, removed from the church of Villincino to the Brera[5]; and a series of monochromes representing children playing, once part of an organ-screen at Santa Marta, and now in

[1] Milan, Brera, No. 15. Fresco ; life-size, m. 2·40 high by 1·35. The shading is made out in flesh and drapery with black line hatching of more or less density according to the requirements of each part, the tinge which results from this treatment being brick-red. [* Formerly in the Palazzo del Broletto at Milan.]

[2] Milan, Brera, No. 16. Life-size, m. 0·50 high by 0·65. Of old assigned to B. Luini. Cupid with Grapes, in a lunette (fresco). [* This fresco was originally in the Villa Pelucca, near Monza. There exists seven companion-pieces to it by Luini ; of these, two are in the Brera (Nos. 746 and 747), two in the Louvre (Nos. 1357 and 1358), one in the Musée Condé at Chantilly (No. 25), and one in the Wallace collection. For many reasons it seems not impossible that the *putto* here ascribed to Bramantino is also by Luini. See Frizzoni, in *L'Arte*, xi. 327 *sqq.*] No. 17, " Bramantesque school." Wood, m. 0.90 high by 0·98 ; half-length, the head of the poor man only appearing above the edge of the panel. [* Originally in the Monastero delle Vetere at Milan ; now officially assigned to Bramantino.]

[3] Milan, Vescovado. [* Now Brera, No. 279.] Virgin, not quite full-length, with the Child erect on her knee. Small figures are in the distance. This small panel seems cut down at the sides. See also Baldinucci, *Opere*, edition of Turin, 1813, vol iii. of *Notizie di Professori del Disegno*, pp. 171 *sqq.*

[4] Museo Poldi-Pezzoli, Nos. 636 and 646. Annunciation and Nativity. Small panels.

[5] Milan, Brera, No. 309. Canvas, with figures of life-size. In the middle, the crucified Saviour with the Magdalen grasping the foot of the cross. Between the two thieves an angel kneels on a cloud to the left. A fiend kneels similarly to the right of the Saviour. In the foreground the Virgin swooning in the arms of the Marys, the Evangelists, and three other figures. The colours are very thin and hastily put in, with grey shadows and deep vestment tints. The figures half in shade—the distribution geometrically good ; the masks and forms derived from the Leonardesque school—a clever picture of rapid decorative execution, with sketchy,

the Casa Sormani.[1] In each of these examples we may find something of the power which was shared amongst the numerous followers of da Vinci—the power of scientific distribution in all cases ; and besides this, in the monochromes of Casa Sormani, a natural echo of similar conceptions in carvings of Donatello or the della Robbia. Less grateful as a reminiscence of the painter is the half-length of Christ at the Pillar in the monastery of Chiaravalle, a figure in which coarse muscularity is exhibited in the fashion of Signorelli, and a circling frizzle of copious locks appears caricatured from Antonello.[2]

The general aspect of all these works, suggesting as they do some connection between Bramantino, Gaudenzio, and the elder Luini, might lead us to think that there was some sort of association at Milan of which these three painters were members. Many frescoes of a fragmentary character in the depot of the Brera are said to confirm that belief.[3] There is almost proof of it in the Luinesque air of the Roman incidents and figures of giants which still adorn the present residence of Don Francesco Melzi at Milan.[4] Under influences such as these it was possible for Bramantino to rise occasionally to the excellence exhibited in neglected drawing. [* This picture was in 1851 lent by the Brera to the church of Villincino, and re-claimed in 1861. From where it originally came to the Brera is not ascertained. Malaguzzi Valeri, *Catalogo della R. Pinacoteca di Brera*, p. 185 *sq.*]

[1] Casa Sormani, from Santa Marta. Five panels with monochromes : (1) Three cupids playing the viol. (2) Three cupids playing harp, cither, and mandolin. (3) Three cupids standing round a music-desk. (4) One cupid playing an instrument. (5) Two cupids playing violoncello and one holding the music. All the figures under life-size, somewhat dimmed by age and repaints. [*.Mr. Berenson (*ub. sup.*, p. 196), ascribes these pictures to Civerchio.]

[2] Chiaravalle. Second chapel to the left of the portal; panel. Christ to the hips, a little under life-size ; a landscape with water and vessels seen through an opening to the right. The colour is unpleasantly brown and grey. We hesitate between Bramantino and some assistant in his school. [* In view of the resemblance which this picture shows to the frescoes by Bramante now in the Brera, we may safely ascribe it to the latter artist. Bramantino's Christ in the collection of the Conte del Mayno at Genoa is no doubt inspired by the painting under discussion ; and yet how different it is !]

* [3] The frescoes alluded to by the authors correspond in part no doubt to those which formerly were in the Villa Pelucca, near Monza, and at present are shown at the Brera. They are painted by Luini or his pupils, though the influence of Bramantino is very noticeable in some of them.

[4] Milan, Don Francesco Melzi, No. 25, Borgo Nuovo. On the outer front, ornament. In a hall, twenty-four lunettes with scenes from Roman history. In a court, a lunette representing two giants supporting and measuring a large

the "Head of St. John the Baptist on a Charger," in the Gallery
of the Ambrosiana, or that of a head of St. Jerome in the same
collection, where the influence of Leonardo is fully displayed in
precise outline, clean form, rich blending, and effective modelling.[1]

That there should be a tendency to assign to Bramantino a
considerable number of panels for which no pedigree could other-
wise be found is natural enough when we consider the variety of
changes which he underwent and the usual absence of his
signature. We must reject from the list of his genuine pro-
ductions the Nativity at the Ambrosiana, though it has something
of his manner, the Nativity in the Casa Sormani, the Crucified
Saviour in the Casa Borromeo, the Allegory and a large Madonna
in the Museum of Berlin, and the Epiphany in the National
Gallery which, we have seen, is probably by Vincenzo Foppa.[2]

At what date exactly Bramantino died we cannot tell. We

sphere (monochrome). This house is called by de Pagave Casa Imbonati. [* It
is now the seat of the R. Accademia Scientifico-Letteraria.]

[1] Milan, Ambrosiana, Sala D, No. 20. Head of the Baptist pleasing and
youthful, with luxuriant locks of hair, colour of full texture, and slimy impast.
Sala E, No. 1. Bust of St. Jerome. technically treated as above.

* This painting is now commonly held to be a work by Andrea Solario.
As late works by Bramantino not mentioned by the authors, we have to
catalogue : (1) Birolo (near Villa Maggiore Certosino, province of Milan),
chapel in possession of Prince Trivulzio. The Virgin and Child, with
Saints. Formerly in Santa Maria del Giardino, at Milan. (2) Isola Bella,
Palazzo Borromeo. St. John the Evangelist. (3) Mezzana (near Somma, province
of Milan), Madonna della Ghianda. Pietà; the Pentecost. (4) Milan, San
Barnaba, Sacristy. Pietà. (5) Milan, collection of Conte Sola-Busca. Lucretia.

[2] (1) Milan, Ambrosiana, Sala D, No. 19. Wood; small; unpleasant in masks
and form, and much discoloured by cleaning—of olive tinge, and cold in flesh-tone.
Some figures are short, others immoderately long and dry—outlines defective,
drapery broken. In some movements there is much smorfia. This is a work at
least of Bramantino's atelier and related in some measure to the Epiphany in the
Layard collection. [* Cf. antea, p. 337, n. 1.] (2) Milan, Casa Sormani. Nativity.
Arched panel with figures under life-size ; in the air three angels of slender build
with a scroll; on the right kneels St. Francis. The treatment is Lombard as
above, recalls the school of Bramantino, and, at the same time, Pinturicchio,
Signorelli, and della Gatta. (3) Milan, Casa Borromeo. Christ Crucified and two
likenesses of patrons. This is of more modern make than the foregoing, and
recalls to mind the works of Altobello Meloni. (4) Berlin Museum, No. 1237.
Wood tempera, 5 ft. 7¼ in. high by 3 ft. 7½ in. ; from the Solly collection. The
Virgin, with the Child in benediction in her lap, attended by St. Peter Martyr and
St. Dominic, presents a rose to kneeling male and female votaries. This piece has
been retouched, altered and varnished, and might be by a follower of Borgognone
such as Giovanni Ambrogio Bevilacqua. The nimbs are raised and gilt; No. 54,

only know that he was living in 1529, and that there are records of his heirs in 1536.[1]

Bernardino Jacobi and Bernardino Martini of Treviglio were distinguished by their contemporaries as Butinone and Zenale,[2] a distinction the more necessary to remember as, in addition to bearing the same Christian name, they were partners in one business. Hardly a fresco in early years was ordered of the one without being ordered of the other ; and it was rare to find either painter working on his own account. Both are described as disciples of Foppa and masters of architecture and perspective[3] ; both, in their beginnings, favoured the art of the old guilds modified by Paduan taste. When Butinone and Zenale laboured in common, Butinone ranked first, as if he were the elder ; and Zenale was born in 1436.[4]

Allegory. See *Hist. of Italian Painting*, 1st ed., ii. 565. [* The former picture is no longer shown at the Kaiser Friedrich Museum ; the latter is at present labelled Melozzo da Forlì.] (5) London, National Gallery, No. 729. See *antea* in Foppa.

[1] See de Pagave, Life of Suardi, *ub. sup.*, and Vasari, Le Monnier ed., *Com.*, xi. 281. The following is a list of works assigned to Bramantino of which no further account can be given : (1) Milan, San Pietro in Gessate. Christ taken down from the Cross. (Lomazzo, *Trattato*, pp. 271-2 ; assigned by Torre [*Ritratto di Milano, ub. sup.*, p. 319] to Bramante.) [* This picture is identical with Foppa's Pietà, now in the Kaiser Friedrich Museum at Berlin (see *antea*, p. 321, n. 1).] (2) Milan, San Francesco. Screen of the organ (*ibid.*, p. 316), representing (*a*) the Madonna, (*b*) the Nativity. (Baldinucci, iii. 171, *ub. sup.*, ed. of 1813.) (3) Milan, Osteria del Rebecchino. Paintings whitewashed in the eighteenth century. (*Ibid.* and Scannelli, *Microcosmo*, Cesena, 1657, p. 27.) (4) Milan, Sant' Eufemia. Chapel. (*Ibid.*) (5) Milan, Sant'Ambrogio, in the Scaldatoio, or little refectory. The Descent of Christ to Limbus. (*Ibid.*, also Torre, *ub. sup.*, p. 194 and de Pagave MS.) (6) Milan, Ospitale. Sopra la porta all'incontro della Chiesa di San Celso, Un "Annunziata." (Scannelli, *ub. sup.*, p. 271.) (7) Milan, Cortile della Zecca. In una facciata, la Natività di Cristo. (*Ibid.*) (8) Milan, San Satiro. De Pagave assigns (upon the authority of old guides) to Bramantino the Four Evangelists in the pendentives of the cupola of the church. Calvi proves by a document (*Notizie, ub. sup.*, ii. 281) that these figures were by one Raimondi and by Antonio da Pandino, the latter a contemporary of Suardi's, whose skill is only known to us by a glass window in the Certosa of Pavia, representing St. Michael and the Dragon. (9) Milan, Santa Liberata. Tavola, on high altar, of the Resurrection between S. Leonardo and S. Liberata. (Torre, *Ritratto, ub. sup.*, p. 213.) [* This picture now belongs to the Kaiser Friedrich Museum at Berlin (No. 90B) ; it is not, however, by Bramantino.] (10) Milan, Casa Latuada, originally Bramantino's house. Frescoes. (Lomazzo, *Tratt.*, p. 271.)

[2] See *postea* a record, the text of which is published in Locatelli (Pasino), *Illustri Bergamaschi*, 8vo, Bergamo, 1867, parte i. p. 407.

[3] Lomazzo, *Idea del Tempio*, p. 150 ; but the same author, in his *Trattato* (p. 317), says that Zenale was taught by "Civerchio il Vecchio."

[4] Calvi, *Notizie*, ii., note to p. 115.

Milanese annals only register three pictures bearing Butinone's
signature : one of them, a small panel in the Castelbarco collection
at Milan, representing the Virgin and Child between S. Bernar-
dino and a martyred deacon ; another a Madonna amidst angels
with St. John the Baptist and St. Giustina in the Borromeo
collection at Isola Bella ; a third, a Holy Family, no longer pre-
served, in the Carmine of Milan.[1]

The Castelbarco Madonna is suspiciously inscribed with the
date of 1454. It is so thoroughly disfigured by retouching that
we can scarcely assign to it any artistic value. Overweight of
head and shortness of stature characterize the figures.[2] In the
Madonna of Isola Bella, the Paduan manner, acquired by Foppa
from the fountain-head, seems taken by Butinone from a less
healthy source. The gentle air which occasionally flatters the
eye is marred by affectation and strain, and conventional posture
coincides with coarseness of shape. Drapery of angular break
swathes the limbs, copious gilding and mottos cover hems and
borders, and strange design in furniture betrays a grotesque
fancy. Footstools with scooped sides : walls and floors of chec-
quered patterns and pillars of varied tints ; friezes in relief,
medallions or statuettes or consoles—all remind us of the Squar-
cionesques, Zoppo, Schiavone, and Crivelli.[3]

Gaspare Vimercati, a captain of note, returning from a
successful campaign in France in 1464, signalized his gratitude
for past successes by rebuilding Santa Maria delle Grazie at
Milan. A votive Madonna adored by himself in armour, was
painted by Butinone and placed on the high altar. The
Dominicans, who in time forgot their devotion to the founder,
removed the picture into the choir and subsequently parted with
it altogether ; they preserved, because less portable, some remains

[1] Fornari, "Cronaca del monastero, &c., del Carmine" in Calvi, *Notizie*,
ii. 108. This picture was inscribed "Bernardinus Butinonus de Triviglio pinxit
1484."

[2] Milan, Casa Castelbarco. Wood ; figures three-quarters the size of life.
On the foot of the throne is a repainted inscription : "Bernardinus Butinonus de
Trevilio 1454." The young Baptist stands on the seat of the throne to the right
behind the Virgin. [* This picture is now in the Brera Gallery at Milan (No. 249).
Of the date one can at present only make out the figures 145..]

[3] Isola Bella, on the Lago Maggiore, Palazzo Borromeo. Small panel, inscribed
on the footstool : "Bernardinus Betinonus de Trivilio pinxit." Retouched here
are the four angels behind the Virgin, the flesh of the infant Christ, and the
head of the Madonna. St. John holds and S. Giustina reads a book. [* Allied
in type to the figures of the Madonna and S. Giustina is a head of a girl by
Butinone in the collection of the Contessa Sola-Busca, in Milan. See Suida, in
Monatshefte für Kunstwissenschaft, ii. 489.]

of wall-paintings in the church, and frescoes in the cloisters, of the convent—the latter a Virgin and Child in a lunette, a bust of St. Dominic, and medallions of two saints of the Order. Previous to recent retouching the cloister frescoes displayed some of the rude force that marks Butinone and Zenale.[1] A better specimen of united effort is preserved in the Griffi Chapel at San Pietro in Gessate, an oratory adorned about 1480 with scenes from the life of St. Ambrose and subsequently white-washed. When the walls were scraped in 1861 the painters' names were found together beneath a composition depicting a criminal before the proconsul Ambrose. That colour should have been preserved after such treatment was not to be expected ; there is much in the style to recall the Squarcionesque and Ferrarese or Sienese of the period.[2]

The best example is that of 1485 in San Martino of Treviglio —a lumbering, monumental piece in the shape of a gabled front parted into fields by cornice and pilaster. In the lower course

[1] Milan, Santa Maria delle Grazie. What remains in the church is remnants of figures of saints. But consult Calvi, *Notizie*, ii. 104–5. The altarpiece was probably painted before 1467, date of G. V.'s death. The cloisters are now barracks. In 1869 the frescoes there were smeared over and almost ruined. The Flagellation—also a fresco in the cloisters—seems by the same hand as the composite altarpiece in the church, attributed to Bramantino and others. [* The convent of Santa Maria delle Grazie is no longer used as barracks. Extensive works of restoration have lately been carried out in it and in the church. They have brought to light a large series of frescoes·some of which may confidently be ascribed to Butinone (*e.g.* the figures of monks on the pilasters in the church); others may be by Zenale. See Malaguzzi-Valeri, *Pittori Lombardi*, pp. 47 *sqq.*]

[2] Milan, San Pietro in Gessate. There are three chapels in this church containing work of the fifteenth century. That of Sant' Antonio and that of the Madonna are said to have been painted by Butinone and Zenale ; but of this a word later. What remains in the Griffi chapel has been described in the text. The figures are life-size. Beneath the throne on which the judge sits an empty space divided by pillars contains remnants of figures in varied action. The colouring substance is gone, the surface is rough, raw, and dead ; but the drawing has the force of that in a predella at Treviglio, which we shall presently examine. On a bare space beneath the throne are the lines : "Opus Bernardini Butinoni et Bernardi de Zenalis de Trevilio." Consult Lomazzo, *Trattato*, p. 271, and Calvi, *Notizie*, ii. 107, 108. [* The above signature is now much faded. This chapel has recently been restored, and now presents a series of most interesting, though greatly injured frescoes. The date of their execution is not about 1480, as the authors state. The donor, Ambrogio Griffi, in 1487 commissioned Foppa to paint the chapel, to which the latter agreed ; but he never even began the work, though in 1489 Grifi made an attempt to get him to fulfil his engagements. Grifi died in 1493, and the frescoes by Butinone and Zenale may have been painted between that year and 1489. See Malaguzzi-Valeri, in *Rassegna d'arte*, vii. 145 *sqq.*]

St. Martin shares his cloak with the naked beggar who bends abjectly before him. Under arches hung with Paduan festoons stand St. Peter and two companions, St. Sebastian with St. Anthony and St. Paul. In the upper course, the Virgin sits with the Child on a marble throne seranaded by two boys, whilst two angels hold the crown suspended above her head, and two cherubs adore her presence on the arm-supports. In porticoes at the sides stand St. Lucy, St. Catherine, and St. Mary Magdalen, St. John, St. Stephen, and a third saint, partly concealed by the open work of an iron parapet. The gable contains a medallion of the suffering Saviour. For a long time this costly shrine stood on the high altar of the church ; but, showing marks of wear, was removed and set up in the choir with careless forget-fulness of its original shape. The ceremonies of the altar had gradually tarnished the surface ; subsequent washing only served to bring out the bleach produced by time ; but nothing probably injured the general aspect more than the fresh and brilliant gild-ing of the arabesque gold grounds. We may find some difficulty in distinguishing the hand of Butinone from that of Zenale ; but a certain concentration of power and life in the scenes of a predella representing the Four Doctors of the Church, the Nativity, Cruci-fixion, and Resurrection—might point to the former, whilst the more yielding nature of angels in other parts of the altarpiece may suggest the latter. We should thus attribute to Butinone the Paduan character derived from the Mantegnesques or Crivelli, and to Zenale a tendency to gentleness in impersonation which led him ultimately to assimilate some of the feeling of Leonardo. The work as a whole is more remarkable for architectural detail, perspective, and distributed space than for drawing. Tints of careful blending, contour of patient finish, and ornament of minute application give unfortunate prominence to casual defects. Males of fair proportion and females of pleasant mould would gain attraction if the minutiæ of flesh and articulations were better given. The poor rendering of human or equine nude is not compensated by effective light and shade ; and rich and bright costume is marred by brittle fold.—Unpleasant differ-ences arose between the painters and their patrons as to the price of this piece, but in 1507 the vicar of the archbishop, to whom the matter was referred, gave judgment in favour of the former.[1]

[1] Treviglio, San Martino. The order for the altarpiece is dated May 26, 1485 (in full in Locatelli, *ub. sup.*, i. 407). The sentence of the vicar of the arch-bishop of Milan is in Calvi, *Notizie, ub. sup.*, ii. 111-112. Wood, temper, figures of life-size. Besides the injuries already mentioned, there are the follow-

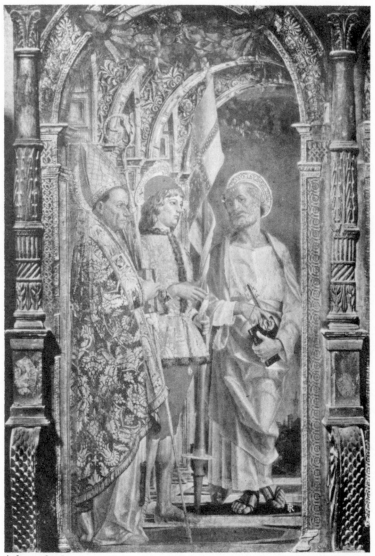

THREE SAINTS (LEFT PANEL IN LOWER COURSE OF POLYPTYCH).

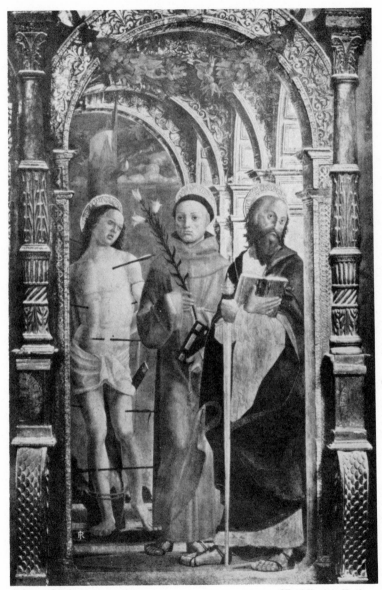

THREE SAINTS (RIGHT PANEL IN LOWER COURSE OF POLYPTYCH).

II. 352*b*]

During their residence at Treviglio, Butinone and Zenale accepted orders for pictures, amongst which we should number those described by Albuzzio at Mozzanica. At the time when Foppa left Pavia they were temporarily employed there ; but when ordered to Milan in 1490 to prepare the palace of Porta Giovia for Lodovico Sforza they had resumed their habitation in Treviglio.[1]

Amongst the productions to which chroniclers assign the names of our artists, one is a Virgin and Child between a bishop and St. Jerome in Sant' Ambrogio of Milan. Injured as it is by

ing: the Ecce Homo and St. Sebastian are damaged by abrasion ; the lower course containing St. Martin is feebler than the rest. Much of the ornament is raised.

* Though we agree with the description of Butinone's and Zenale's characteristics given by the authors, we cannot subscribe to their opinion as regards the authorship of the various parts of the Treviglio altarpiece. We find, if we try to distinguish the share of each painter in this work, firstly, that of the three panels in the lower course those at the sides of the St. Martin differ considerably from each other in style. That to the right—the inferior of the two as regards quality—comes close to the triptych by Butinone in the Brera ; we may therefore ascribe this panel to Butinone and the other to Zenale. If this be right the left-side panel, in the upper course, is undoubtedly by Zenale ; and this artist may also have had some share in the right-side panel, which is a much finer picture than the one underneath. It has, however, also many points of contact with the latter painting, and it seems likely that it in great part was executed by the same artist, *i.e.* Butinone.

In the predella, the Nativity and the Crucifixion seem to be by Butinone and the Resurrection and the Four Doctors by Zenale, who probably also designed the frame of the whole. The authorship of the Madonna and the St. Martin is very difficult to determine ; in any case the head of St. Martin certainly recalls that of St. Catherine by Zenale. It is interesting to note how reminiscent this altarpiece is of Mantegna's San Zeno triptych. Cf. von Seidlitz, in *Gesammelte Studien zur Kunstgeschichte*, p. 67 *sqq.* ; Catalogue of the Milanese Exhibition, B.F.A.C., p. xxiii. ; Malaguzzi-Valeri, *Pittori Lombardi*, p. 34 *sqq.* ; Suida in *Repertorium*, xxv. 334 *sq.* ; Cook, in *The Burlington Magazine*, v. 93, 180 ; Berenson, *North Italian Painters*, pp. 182, 302. (It must be added that the editor is acquainted with this work only through photographs.)

Allied in style to Butinone's predella paintings at Treviglio is a little triptych, containing thirteen Biblical subjects, in the Museo Municipale at Milan (see Malaguzzi-Valeri, in *Rassegna d'arte*, iv. 38 *sq.*) ; and Prof. Suida (*Repertorium für Kunstwissenschaft*, xxv. 335) would also associate with these the following pictures : (1) The Circumcision in the Carrara Gallery at Bergamo (No. 160) ; (2) the Marriage at Cana in the Borromeo collection at Milan (No. 39) ; and the Incredulity of St. Thomas in the Malaspina collection at Pavia, and a legendary subject in the Liechtenstein collection at Mödling. Dr. Malaguzzi-Valeri (*ub. sup.*, pp. 33 *sqq.*) and Prof. Suida (*loc. cit.*, p. 333) further ascribe to Butinone or Zenale some frescoes in a room on the second floor of San Martino at Treviglio.

[1] Calvi, *ub. sup.*, ii. 112, 119, 134, 241.

cleaning and retouching, this altarpiece bears the impress of their hand.[1]

Butinone alone is supposed to be the author of a bust portrait in the Casa Borromeo at Milan, in which a man of mature years stands in a black pelisse with long hair falling from beneath a red cap. The words on a *cartello* are all but illegible ; but the clear precision of the drawing and the studied modelling of the parts would prove Butinone to have been capable of successful efforts as a portraitist, and, like Filippo Mazzuola, able to copy nature faithfully without infusing into the copy the breath of life.[2]

Butinone, it has been stated, was living in 1507 ; we lose sight of him after that time.[3] At Bergamo, Lovere, and Pavia, we find panels ascribed to him, without the true mint-mark upon them.[4]

[1] Milan, Sant' Ambrogio. Wood ; figures three-quarters of life-size. Three panels parted by pilasters : in the centre the Virgin and Child, to the left a bishop in white and red, to the right St. Jerome, on the plinths of the pilasters the Four Evangelists. The colours are dim, grey, and opaque, though lately enlivened with new paint. The drapery of St. Jerome is so involved that one cannot see how he could move without falling. [* Reproduced in *The Burlington Magazine*, v. 185.]

[2] Milan, Casa Borromeo. Bust at a parapet, the face three-quarters to the left. On a *cartello* are remains of an inscription : ". . . Leonardus de . . . 1468." The flesh-tint is brownish, but a little uniform. [* There is reason to think that this is indeed a work of Filippo Mazzuola, whose style, as we have seen, it also recalled to the authors. Cf. *antea*, ii. 298, n. 3.]

[3] Butinone's latest dated work is a Madonna of 1500 in Santa Sofia at Milan (Suida, in *Monatshefte für Kunstwissenschaft*, ii. 489 *sq.*).

[4] (1) Bergamo, Casa Asperti. Figures of prophets. Not original and much repainted. (2) Bergamo, Lochis, No. 45. Virgin and Child, half-length, with the false signature on a parapet: "Bernardus B.," a modern piece much retouched. (3) Lovere, Tadini collection. Nativity, canvas, repainted and later than the time of Butinone. (4) Nativity, small panel, greatly injured. (5) Pavia, Malaspina collection. Nativity, wood ; ruined, and not like a Butinone.

Lomazzo (*Idea*, 17) mentions a treatise on perspective and (*Tratt.*, p. 652) an album containing drawings of rustic buildings, which had once belonged to Cesare Cesariano, and Gaudenzio Ferrari, both by Butinone. We may consult for the painter's works, besides the authors named, Passavant, *Kunstbl.* No. 67, of 1838, whose judgment, however, was not then as sure as it afterwards became.

[* The following paintings by Butinone are still to be mentioned : (1) Berlin, Kaiser Friedrich Museum, No. 1144. Pietà. (2) Milan, Brera, No. 250. The Virgin and Child. (3) Milan, collection of the Duca Scotti. The Virgin and Child enthroned with Angels (cf. *antea*, p. 173, n. 3). (4) Milan, Collection of Cav. Aldo Noseda. Two Saints (round pictures, companion pieces of one in the Parma Gallery). (5) Milan, Fratelli Grandi (1902). The Coronation of the Virgin with Saints (fresco formerly in the apse of the church of Santa Agata in Monte, at Pavia) reproduced in Malaguzzi-Valeri, *ub. sup.*, p. 111. (6) Parma, Gallery No. 434. A Saint (cf. *antea*).

We saw how difficult it was to distinguish the hand of Zenale from that of Butinone. In the rare examples which he painted alone, Zenale sometimes showed affinity to Borgognone, as we perceive in a small Madonna at the Ambrosiana.[1] Sometimes he followed the early manner of Bramantino, as we observe in a broader and more powerfully wrought Annunciation belonging to the Borromeo collection at Milan.[2] A more copious illustration of his first manner might have been found in the frescoes with which he adorned a chapel in San Francesco of Brescia, had not these, like so many others, perished before our time.[3] At what date he began his labours at Santa Maria delle Grazie of which Vasari and others tell is uncertain. Four scenes from the Passion and numerous monochrome ornaments in the church and convent of that name disappeared without leaving a wreck behind[4]; but some of them were doubtless in course of execution as da Vinci composed his renowned Cenacolo; and a hearty friendship arose between two painters who spent their busiest hours in the same building. In despair, it was thought, of his inability to realize the superhuman excellence which he thought due to a perfect semblance of the Redeemer, da Vinci, one day, left the refectory of the Grazie and applied to Zenale for counsel and consolation. Zenale, whose good fortune we may envy, returned the visit, feasted his eyes with the greatest masterpiece of the age, and then oracularly said: " St. James the elder and St. James the less were so fine that it was hopeless to think of surpassing them. To fancy that the Christ could be conceived in nobler lineaments was to covet attributes little short of divine; and his advice, under the circumstances, was to leave

[1] Milan, Ambrosiana. Wood; small. Virgin, with a book, holding the Child dimmed by time and neglect, on the framing a prayer, and below, the name of Zenale.

[2] Milan, Casa Borromeo, Nos. 50 and 52. Two panels with figures half the size of life. To the left the angel with the lily, to the right the Virgin seated, both in arched interiors; the head of the Virgin damaged, that of the angel retouched. But the whole of both panels is spoiled by repainting. [* This is probably a late work by Foppa, as will be seen from the types, the forms, etc. Cf. Frizzoni, in L'Arte, xii. 256.]

[3] Brescia, San Francesco. These frescoes were inscribed: "Bernardus de Senalis de Treviglio pinxit." (Averoldo [Giul. Anton.] Scelte pitture de Brescia, 4to, 1700, p. 99.) They were in the chapel of the Immaculate Conception and represented scenes from the New Testament.

[4] Milan, Santa Maria delle Grazie. Consult Vasari, iv. 151 sq., v. 514, and Lomazzo, Trattato, pp. 212, 271. St. John the Baptist with the kneeling donor, Gaspare Vimercati, in this church is wrongly given to Zenale by Passavant (Kunstbl., 1838, No. 67), being by Marco d'Oggione. [* See also antea, p. 351, n. 1.]

the face of the Saviour as it had then been wrought, that is, imperfect if contrasted with unapproachable ideals, yet noble if considered as a work of human hands." The word "imperfect" was afterwards explained, wrongly, we believe, to mean that Leonardo left the head of Christ in the Cenacolo unfinished.[1]

In daily intercourse with da Vinci, Zenale learnt to admire his superior powers, and became in time the humble imitator of his style. He acquired the various gifts for which Leonardo was known, and rose to be a man of mark amongst the Milanese. It was said of him that he was a master of chiaroscuro and architectural design ; that he knew the minutest subdivisions of proportion in the human frame as well as Leonardo or Bramante. Every subtlety of perspective, all the rules for drawing with high and low centres of vision on flat and curved surfaces, were familiar to him. As proofs of these gifts, his admirers were wont to cite the cycle with which he adorned Santa Maria delle Grazie, the semi-circular spaces in which he painted incidents from the life of the Magdalen in the Carmine, the Annunciation on the organ-screen of San Simpliciano, the martyrdoms of St. Peter and St. Paul in a chapel dedicated to those saints at San Francesco of Milan—all of them lost.[2] In the midst of lavish encomium we still find something to restore the balance of just appreciation. The Resurrection—one of the scenes of the Passion which attracted attention at the Grazie was admired for the beauty of certain foreshortenings and effective contrasts of light and shade ; but the force of these foreshortenings and the *furia* of these contrasts only compensated for want of searching in the modelling of flesh. Zenale, in fact, had faults as well as qualities in the eyes of his countrymen.[3]

We are now shorn of large means for forming a judgment, but important productions of Zenale exist in which he shows himself a true disciple of da Vinci. In the Hermitage at St. Petersburg there hangs a small half-length of the Madonna, which once was an ornament of the Litta collection. The Virgin gives the breast to the infant Saviour, who plays with a finch. Grouping and design in this piece divulge the superior

[1] Vasari, iv. 29; Lomazzo, *Trattato*, pp. 50–51.

* [2] With regard to the frescoes in Santa Maria delle Grazie, see, however, *antea*, p. 351, n. 1.

[3] Lomazzo, *Trattato*, pp. 100, 212, 266, 270, 271, 274 ; Vasari, iv. 150 *sqq.* In the *Idea del Tempio* Lomazzo says that Zenale held, it was necessary to finish distant objects as much as nearer ones, because being small in proportion distant objects had a tendency to escape the eye of the spectator (p. 107).

excellence of a great master; the treatment betrays a subor-
dinate. Leonardo might have made the sketch, which he lent,
to be turned to account by his disciple. In doing so the disciple
failed to realize the noble grandeur, the pure contour, the subtle
modelling, and balanced light and shade of Leouardo's creations,
though he lavished upon it care, accuracy, and finish after the
older Lombard fashion.[1] Presumption is altogether in favour
of Zenale as the painter, for it is difficult to find another artist,
except Boltraffio, who could manifest so much timid dependence
and yet preserve so clearly the stamp of Lombard teaching.
That he should be named amongst the claimants to the author-
ship of such a picture may be found more natural when we
compare it with the votive Madonna assigned to him at the
Brera. It is not proved, but there can be little doubt, that this
was once in San Francesco Grande, previous to being placed in
Sant' Ambrogio ad Nemus, from whence it passed to the Public
Gallery. It contains the kneeling figures of Lodovico and
Beatrix Sforza with their two children, and dates no doubt
about 1496. We can scarcely hesitate to believe that the
sketch was given by Leonardo, because his drawing of the boy
Maximilian Sforza at the Ambrosiana was used for the occasion ;
but the execution, again, is as certainly that of one of his scholars.
There is nothing so curious as to find a characteristically Lombard
masterpiece marked by a certain form peculiar to the Florentines
—such as the bone and bladder of Verrocchio's school in the
infant's shape, or the lucid enamel and cold patience of Credi
in the treatment. Coincident with this are Leonardesque masks
marred by squareness and vulgarity, and, crowning all, antiquated
type, incorrect drawing, and overladen ornament. The portraits
are so superior to the rest that we might believe them to be
taken from da Vinci ; and, were all in the same key, we should
say the whole is copied; but there is too much of the Lombard
in the work to warrant such a supposition.[2]

[1] St. Petersburg, Hermitage, No. 13A. The Virgin's head is almost in profile.
She wears a knotted kerchief on her head. In the background are two arched
windows. The colour is warm grey, laid in technically on the Lombard system.
[* Compare the next note.]

[2] Milan, Brera, No. 310. Wood, m. 2·30 high by 1·65. The head of the
Virgin is wide at the cheek-bones, and cast in the mould of Boltraffio's (*e.g.*
Milan, Museo Poldi-Pezzoli. Virgin and Child ; and London, National Gallery,
No. 728). Her hair is twisted into screw-curls falling in strings, her hands are
cramped and ugly. The attendant saints are square, with fleshy corrugations
in the faces, and large extremities. The drapery is of the angular Lombard class.
See the line-engraving in Rosini, *Stor. della Pittura*, pl. xciii. Consult Calvi,
Notizie, ii. 121, and Lanzi, ii. 484 (who gives the picture to Leonardo). See

In frescoes under the atrium of Sant' Ambrogio the same peculiarities of style, and some of the same portraits, are repeated. They are those assigned by Calvi to old Bramante in spite of the significant presence in them of Lodovico Sforza and his boy Maximilian. There may be differences of opinion as to the manner, there can be none as to the period of the execution. In 1498 Maximilian Sforza was about seven years old; 1498 is the date of the fresco; seven the age of the boy at Lodovico Sforza's side. Zenale—for he doubtless laboured here—has now no greater merits than of old. His subjects, which are only preserved in fragments, are the Baptism and Ordination of St. Ambrose; and in the latter the portraits of the Moro and his son occur.[1]

A Crowning of Thorns in the Borromeo collection at Milan, bearing Zenale's name and the date of 1502, shows that he was altogether at that time in the Leonardesque current. It has the same coldness and carefulness of treatment, the same mixture of Milanese vulgarity with Leonardesque form which we have previously noticed; but the drawing is less defective

also Gerli's copies of Leonardo's drawings (*Disegni di Leonardo*), Tav. vii. [* This painting—the *Pala Sforzesca* as it is nowadays usually styled—was never in San Francesco Grande, but was intended from the beginning for Sant' Ambrogio ad Nemus. Mention is made of it in a letter to Lodovico il Moro, dated Jan. 21, 1494; but it cannot have been completed until a later date, as Francesco Sforza, who is represented in it as an infant, was not born until Feb. 4, 1495. We have no documentary clue to the author of this work. On the evidence of style it has been ascribed to several artists beyond Leonardo and Zenale. Morelli held it to be by Bernardino dei Conti (*Die Galerien Borghese und Doria Panfili*, p. 247); while Dr. Malaguzzi-Valeri has attributed it to a special *Maestro della pala Sforzesca* invented by him (see *Rassegna d'arte*, v. 44 *sqq.*). It is now also officially catalogued under the latter heading. Undoubtedly by the same artist as this painting is a Madonna with St. James and a Donor in the collection of Signor L. Cora, of Turin (cf. *ibid.*). Herr von Seidlitz ascribes both these works, as well as the drawing of Maximilian Sforza (which is surely not by Leonardo) and the Madonna Litta at St. Petersburg to Ambrogio de' Predi, who was court painter to Lodovico il Moro as far back as 1482 (see the Vienna *Jahrbuch*, xxvi. *passim*).]

[1] Milan, Sant' Ambrogio. Cloister or portico in front of the church. Monochromes. To the right St. Ambrose's Baptism, three youths in presence of a large attendance (those to the right obliterated with the exception of the heads). To the left St. Ambrose placing the mitre on the head of a priest, in presence of several dignitaries, amongst whom Giovanni Galeazzo, Maria Filippo Visconti, Lodovico il Moro and his boy Maximilian (part gone also). A frame of lyres, cornucopia, and medallions runs round the frescoes, and on the border of that above the Baptism are fragments of the inscription: "Opera venerādi .. cum canonicorum ... pictura hecfacta est 149⁰ (? 8, the last cipher being half eaten away). But see Calvi, *Notizie*, ii. 11.

than before.[1] A profile portrait bust in the same collection still
more completely illustrates Zenale's intimacy with Leonardo's
rules[2]; there is no lack indeed of such illustrations at Bergamo,
Milan, Berlin, and Hanover.[3]

[1] Milan, Casa Borromeo, No. 30. Wood, figures one-third of life-size. In-
scribed: "Bernardus Zenalius trivil. pinxit. Anno D͞ni MDII medio." Christ in the
middle of this picture crowned with thorns, with a man kneeling at his side to
the right, to the left a man striking him with a staff; in rear a captain and
soldier—all in an interior. The whole picture is said to have been cleaned quite
lately. It was much smeared with repaints.

[2] Milan, Casa Borromeo, No. 70. Wood; a fine profile bust to the right with
dark-brown ground, the cap and vest red, the sleeve brown. A noble portrait,
of sombre enamel tone, well drawn.

[3] (1) Bergamo, Lochis Gallery, No. 53. Wood. Life-size figure of St. Ambrose
much injured by restoring, somewhat leaden in flesh tint. (2) No. 131. Wood,
oil. Half-length Virgin, turned to the right, giving the breast to the Infant.
Behind her a trellice of roses and a distance of houses with a miniature St. Joseph
in a doorway and two ducks in a canal. Inscribed: "Bernai . . . Zinala." The
figures are but little under life-size, in Zenale's style slightly crossed with that
of Borgognone. Indeed there is so much of Borgognone's type in the child, and
of his gentleness in the forms, that one might almost think the picture his. The
surface is marbly and injured by cleaning, the outlines black, and the modula-
tions of half-tone red. More in the known manner of Zenale is (3) the Virgin
and Child in the Berlin Museum (No. 90A) under the name of Leonardo da
Vinci [* now catalogued under "Lombard School, c. 1500"], a rude and
ill-drawn work. (4) In Milan, Brera (No. 307), we have the following, all
in Zenale's manner: St. Louis and S. Bernardino. Wood, each m. 1·26 high
by 0·40. S. Chiara and S. Bonaventura. Same size as foregoing. St. Jerome
and St. Alexander. Wood, each m. 1·37 high by 0·39. Virgin and Child and
four Angels. Wood, 1·65 high by 0·80. St. Vincent and St. Anthony of Padua.
Each m. 1·37 high by 0·39. These are only catalogued as of the Milanese school.
[* The above panels formed part of the great polyptych executed by Vincenzo
Foppa for Santa Maria delle Grazie at Bergamo (cf. *antea*, p. 321, n. 2). They are
now arranged in the original way, *i.e.* in two tiers: the centre of the upper row
is occupied by a representation of St. Francis, which was ceded by the Brera
authorities to a village church in 1848, but reclaimed in 1896. The doubts which
have been expressed as to whether this panel belonged to the Bergamo *ancona*
(see Ffoulkes and Maiocchi, *ub. sup.*, pp. 127 *sq.*) have been met by Dr. Frizzoni
(*L'Arte*, xii. 254) and Prof. Suida (*Monatshefte für Kunstwissenschaft*, ii. 480 *sq.*).
The greater part of the predella of this altarpiece is now in the Vittadini collection
at Arcore. Ffoulkes and Maiocchi, *ub. sup.*, pp. 118 *sqq.*] (5) Hanover, Provinzial-
museum, No. 214. Wood (assigned to Leonardo), 1 ft. 5½ in. high by 1 ft. 6 in.
Christ and the young Baptist playing together as children—much injured by
restoring. (6) Pavia, Malaspina Gallery. The Nativity here, assigned to Zenale,
is more modern.

* We may safely ascribe to Zenale two paintings representing St. Michael, a holy
bishop and a donor, in the ·Frizzoni-Salis collection in Bergamo, and the portrait
of Andrea Novelli in the Casa Borromeo at Milan. Cf. v. Seidlitz, in *Gesammelte
Studien*, p. 76; Cook, *ub. sup.*, vi. 199; and Suida, in *Repertorium*, xxv. 340 *sq.*

In 1501 Zenale sent in a trial picture for a projected decoration of the cupola at Santa Maria sopra San Celso of Milan.
The superintendents rejected it for reasons with which we are
unacquainted. From this time forward, architectural plans
absorbed more of his time. We hear of little else that he did
pictorially, except an altarpiece in San Francesco of Cantú in
1507, and wall-paintings at Varese. In 1515 he succeeded
Dolcebuono, Cristoforo Solari, and Cesariano as architect of
Santa Maria sopra San Celso. In 1519 he made a new model,
and was appointed architect of the Duomo of Milan. He was
frequently consulted by clients from distant parts of Lombardy,
as, for instance, when the altar of Santa Maria Maggiore of
Bergamo was rebuilt in 1520–23, and when designs were wanted
in 1525 for the tarsie of San Domenico of Bergamo.[1] In 1524
he wrote a treatise on perspective. He died of stone on the
10th of February, 1526, aged 90, and was buried in Santa Maria
delle Grazie.[2]

Though slightly esteemed by Lomazzo, Ambrogio Borgognone
was one of the best of those artists who remained imbued with
Lombard style after Bramante and da Vinci settled in Milan.
His real name is Ambrogio Stefani de Fossano, and it is
characteristic of the ignorance which prevailed against him
that Lanzi attributed three periods of his life to different artists,
distinguishing the " histories of St. Sisinius at San Simpliciano
by Ambrogio Borgognone " from the Mantegnesque " altarpieces
of Ambrogio da Fossano " at Pavia, and these again from the
" Leonardesque production of Ambrogio Egogni at Nerviano." [3]

* [1] These tarsie are now in San Bartolommeo, at Bergamo. Prof. Suida (in the
Vienna *Jahrbuch*, xxv. 60) ascribes to Zenale the designs for those representing
St. John the Baptist with a lamb and the head of the same saint.

[2] Consult Calvi, *Notizie, ub. sup.*, parte ii. 122–4, 125–8 ; Vasari, vi. 513 *sq.* ;
Locatelli, *ub. sup.*, i. 23 ; Tassi, *Pitt. Bergam., ub. sup.*, i. 68–9, 87–8 ; Anon.
ed. Morelli, pp. 50 and 181 ; and Lomazzo, *Idea, ub. sup.*, p. 17.

[3] Consult Calvi, ii., note to p. 246 ; Lomazzo, *Trattato*, p. 679 ; and Lanzi ii.,
pp. 491 and 474–5.

* Of late years it has become more and more customary, especially in Italy, to
call this artist *Ber*gognone, as it is this appellation, and not *Bor*gognone, which
is warranted by the signatures of the painter and contemporary documents
referring to him. His brother, Bernardino, however, signs a picture in the Brera
(No. 254) " Bernardinus Borgognonus p. 1523 " ; and Lomazzo also uses the form
Borgognone. Dr. Frizzoni thinks that Bergognone is a popular corruption of
Borgognone (see *L'Arte*, iii. p. 323, n. 1).

Miss Ffoulkes and Monsignor Maiocchi have discovered that there existed two

It has been assumed that Borgognone, in the reign of
Galeazzo Maria, painted some parts of the Castello at Milan;
but there is no more solid foundation for this assumption than
for believing that in 1473 he designed the facade of the Certosa
of Pavia.[1] There is more truth apparently in the statement that
he furnished the drawings for the tarsie with which Bartolommeo
Polli, in 1486, adorned the stalls of the choir at the Certosa—a
series of ornaments with half-lengths of the Saviour, the Virgin,
Apostles, and Saints, in which the skill of the draughtsman and
carver are both uncommon. That a man of immature talent
should have produced anything so beautiful is not to be con-
ceived; we must therefore believe that Borgognone at the time
was a master of the craft and in the vigour of manhood.[2]

In a fresco of 1485 at the Brera we observed something of the
spirit of Borgognone clinging to a work by Foppa. It is not
improbable that Borgognone received the elements from Foppa
and then had lessons from Zenale. In his earliest days, averse
from technical innovation, he clung to the old medium of
tempera; but when forced, at a later period, to yield to prevailing
fashion, he treated pictures in oil in the method of tempera. His
manner was at first timid and stiff, though very like that of
Butinone and Zenale in form, costume, perspective, and archi-
tectonic detail. It subsequently gained but a small amount of
freedom. The delicacy manifested in faint complexion and
slender limb often verges upon coldness ; and we miss at all
times the fire which carries expression beyond grimace and action

painters called Ambrogio Bergognone : one, the celebrated master, who was a
Milanese, and the son of Stefano; the other a Pavese, and the son of Giorgio.
The latter artist was in 1481 apprenticed to the painter Leonardo Vidolenghi, of
Pavia; he died between 1513 and 1518. Miss Ffoulkes and Monsignor Maiocchi
suggest that he may be the author of a Madonna and Child with Saints and a
Donor in Buckingham Palace, signed "Ambrosii Bergognoni 1510." See *L'Arte*,
xii. 203 *sq*.

[1] Calvi, ii. 41, 79, 148, 162-3 ; *Visita alla Certosa di Pavia*, 12mo, Milan,
1865, p. 10.

[2] *Visita*, p. 41.

* Bartolommeo Polli received payment for two of these stalls in 1486; but the
work dragged on, and was still unfinished in 1498. See Magenta, *La Certosa di
Pavia*, pp. 383 *sqq*.

The earliest record of Ambrogio di Stefano Borgognone dates from 1481, in
which year he is mentioned in the list of members of the painters' guild at Milan.
Beltrami, *Ambrogio Fossano detto il Bergognone*, p. 15.

beyond posture. Like Francia, Costa, or Perugino in the mea-
sured calm of devotional subjects, his dramatic incidents recall
those of Crivelli or Alunno; and the Crucifixion at the Certosa,
though one of his fine creations, is remarkable for vulgar and
exaggerated expression. It would be difficult to find a painter
more attentive to the production of a clear pallor, but the
contrast between this pallor and strong vestment colours is very
striking, and the more so where space is almost entirely surren-
dered to light. The most startling impression produced by his
picture is due to the juxtaposition of flat surface in flesh and
drapery on the one hand, and petty detail in landscape distances
on the other ; and it is curious to observe that these distances
are finished with the patient minuteness and sturdy uniformity
of the Mantegnesques and Flemings. In some capital pieces
produced for places of honour at the Certosa of Pavia, he nearly
reached the mean to which we are accustomed in works of a high
class, displaying unusual breadth and power of selection com-
bined with a certain force of chiaroscuro and accuracy of drawing ;
but in monumental compositions which seem executed about the
same time at the Certosa these advantages are lost, and large
planes upon which light and shade are not concentrated produce
a startling sense of void.

　　After a long stay at Pavia, Borgognone returned to Milan,
where he soon felt the charm of Leonardo's style. The remnants
of his frescoes at San Satiros show how much he owed to that
master, and we derive similar impressions on a smaller scale
from a series of small panels at Lodi, in which the softness and
freshness of Luini are successfully rivalled. But the most
important proofs of his progress are to be found in the vast
Coronation of the Virgin which fills the semidome of the choir at
San Simpliciano, in the half-length of saints and the general
decoration of a ceiling in the sacristy of Santa Maria della
Passione, and in fragments at Sant' Ambrogio, of Milan. We
should be surprised to find, at the close of the fifteenth century,
the fervid religious spirit of the fourteenth ; but there is a sub-
stitute for this at San Simpliciano in the serenity and composure
of personages whose form and attitudes remind us of Perugino,
Francia, and da Vinci. At Santa Maria della Passione we have
space divided after the fashion of Peruzzi, and a lively impress

of modern culture. In Sant' Ambrogio a Christ after the
Resurrection, in the choir, and Christ disputing with Doctors,
in the atrium, are so clever and so closely allied to Luini in
style that they are frequently assigned to this favoured pupil
of Leonardo.

The length of Borgognone's residence at the Certosa of Pavia
has not been accurately measured.[1] There is some evidence that
his altarpiece at Sant' Eustorgio, in Milan—a Virgin and Child
with Saints, of which the parts are separately preserved—was
painted in 1485. In 1486 he gave the drawings for the stalls of
Bartolommeo Polli, and we presume that he was then the guest
of the Carthusians.[2] His Crucifixion in the chapel of the San-
tissimo Crocifisso at the Certosa is dated 1490, and the large
frescoes of the apses were probably finished between 1490 and
1494. A stay of many years was required to complete the works
that fill the edifice; and, though we ascertain that his brother
Bernardino helped him in most of his undertakings, the number,
size, and importance of his productions are still remarkable.[3] In
the chapel of St. Ambrose, the titular saint is enthroned amongst
attendant martyrs. St. Sirus in majesty, with Saints—a capital
piece—is the subject represented on the altar of the chapel of
that name; and four Patriarchs in fresco adorn the ceiling. St.
Augustin, a large panel in the old sacristy, was doubtless the
centre of a framing which comprised the Doctors subsequently
taken to fill up the gaps in the dismembered altarpiece of
Perugino, the four Evangelists appended to the Transfiguration
of Macrino d'Alba, St. Peter and St. Paul, and two pinnacles
with Angels in the new sacristy.[4] Christ carrying his Cross with

* [1] Contemporary records testify to Borgonone's presence at the Certosa
between 1489 and 1494. He was there also in 1502 and 1512. See Ffoulkes and
Maiocchi, *loc. cit.*

* [2] That Borgognone executed the designs for Polli's tarsie is only a conjecture.
See also *antea*, p. 361, n 2.

[3] Calvi, ii. 250.

* [4] The reconstruction attempted in this passage is incorrect. The Doctors
and the Evangelists belonged originally to an altarpiece which seems furthermore
to have contained two pictures now in the Museo Borromeo at Milan (Nos. 49 and
48), representing respectively the Madonna and Child and the Saviour. (See
Zappa in *L'Arte*, xi. 60 *sq.*) The figures of SS. Peter and Paul and the Angels
probably formed part of an *ancona* representing the Virgin and Child with SS.
Peter and Paul (Beltrami, *op. cit.*, p. 76). Both these altarpieces are mentioned
in the manuscript notes of the Padre Matteo Valerio.

a suite of Carthusians,[1] St. Jerome with St. Christopher and the Doctors and Evangelists ; the Virgin and Child between St. Sebastian and St. Roch,[2] are mentioned in the annals of the monastery.[3] But we have a goodly list besides ; the Virgin adoring the Child above the door, and four busts of Carthusians in the vaulting of the Cappella di Santa Veronica; a Virgin giving the breast to the Infant, and half-lengths of Saints and Apostles in the refectory ; a Virgin and Child erect above the entrance to the Cappella della Santissima Annunziata; the Ecce Homo over the arch leading into the Cappella del Rosario ; Prophets and Saints in the ceiling of the choir; monochromes of Patriarchs and Prophets in the centre ceiling of the transept, and busts of Apostles high up on the sides of the nave ; St. Paul and St. Peter on the pulpit, and a banner of which a portion found its way into the National Gallery.

Borgognone returned to Milan in 1494 and worked for two years at San Satiro.[4] He went to Lodi in 1498, to paint the tribune of the church of the Incoronata, valued in 1500 by Jacopo de' Motti and Antonio Cicognara.[5] In 1508 he received an order for an altarpiece still extant in Santo Spirito of Bergamo, an order followed or preceded by others of a similar kind. His presence at Pavia in 1512 is testified by the signature of his name in a public record.[6] His feeble panel of the Assumption at the Brera was done in 1522 for the church of the Incoronata at Nerviano, and proves him to have been incapacitated by age or sickness. In 1524 he filled the portico of San Simpliciano at Milan with scénes from the legend of St. Sisinius which Lanzi was still able to admire [7] ; and it is said that an Assumption

* [1] This pathetic work is now in the collection of the Communal School of Painting at Pavia. In the background is a view of the Certosa, with the façade still under construction. From the state in which it is represented, we may conclude that the picture cannot have been painted after 1497. (Beltrami, *ub. sup.*, p. 81.)

* [2] Two figures of St. Sebastian and St. Roch in the Scotti collection at Milan are possibly fragments of this altarpiece. [3] Calvi, ii. 250-2.

[4] Records of payments are cited by Calvi, ii. 24, 245, 253-4.

[5] *Ibid., ibid.*, pp. 133-4, 203, 254. Gualandi, *Memorie*, ser. ii. p. 172. These frescoes fell when the choir of the Incoronata was altered.

* See also Beltrami, *ub. sup.*, pp. 20 *sq.*, 133 *sq.* In 1502 Borgognone was again at the Certosa. (Ffoulkes and Maiocchi, *loc. cit.*, p. 204.)

[6] Calvi, ii. 246.

[7] *Ibid., ibid.*, pp. 255, 258 ; Lanzi, ii. 474, 491.

* That these frescoes were executed in 1524 is only a suggestion of Calvi's.

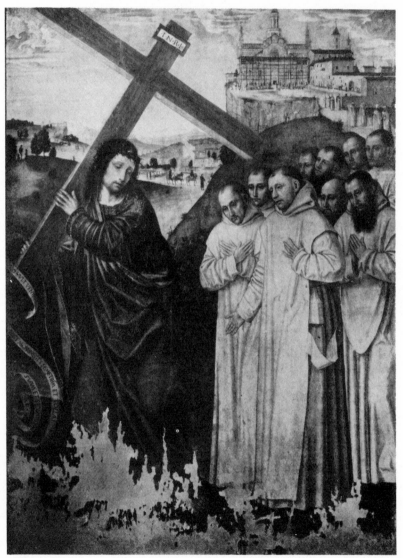

Anderson photo.] [*Pavia, Communal School of Painting.*

CHRIST CARRYING THE CROSS.

which has disappeared from the church of Cremeno in Valsassina
was dated 1535.[1] But in the absence of confirmation as to the
latter statement, we may conclude that Borgognone lived till
1524, after which he produced nothing that can be considered
authentic.

Characteristic of Borgognone's earliest development is an
altarpiece at the Ambrosiana of Milan, a tempera on panel with
figures almost as large as life. The Virgin sits enthroned with
the Child in her lap under a conical dais surrounded by choirs of
seraphs floating in the air of a chapel. To the left St. Ambrose,
two bishops, and St. Jerome, recommending a kneeling patron;
to the right three female saints and a bishop. The name of each
personage is written in the hem of his garments; the gilt throne
plinth, and a cushion with flowers at its foot ornamented with
gold. Tasteful architecture in good perspective tells of lessons
from Foppa, Butinone, and Zenale, in whose schools Borgognone
might also learn the correct laws of foreshortening applied to
airy figures of angels. Whilst some forms are short and plump,
that of the Virgin and those of the saints are slender and feminine,
with slight padding of flesh, upon thin frames of gentle regularity.
What rescues the work from triviality is a freshness and finish
effective in spite of minuteness and excess of gilding. The warm
clear light of skin shaded with silver grey contrasts with rich-
toned vestments, all treated with tempera of blended impast
(the whole cooled down by modern cleaning).

Another altarpiece, in which dry nature is rendered with a
certain tenderness of feeling, is a Nativity (under life-size) in the
first chapel to the left of the portal in Santa Maria presso San
Celso at Milan; a large panel inscribed, "Opa de Ambrosio de
Fossano Dicto Bergognono," with lively disparities in the size
and setting of the figures, and a wooden stiffness in the Infant
Christ more appropriate to a Fleming like Memling than to an
Italian. Two seraphs and a young devotee kneel round the
Saviour, who lies on the ground; in rear, the Virgin, on her
knees, with the Baptist and another saint erect at her sides, a
rocky landscape and a sky with three angels singing from a scroll.
The surface of this piece has been injured by abrasion and re-
touching, and the signature is altogether new. On the altar of
the Brivio chapel at Sant' Eustorgio, of Milan, rests a Virgin and

[1] Ticozzi, *Dizionario degli architetti*, etc.; Calvi, ii. 258. [* The picture under
notice is still in the church of Cremeno; according to Sen. Beltrami, *ub. sup.*,
p. 130, it is, however, surely not by Borgognone. It shows no signature, merely
the date MDXXXIII.]

Child (half-life) enthroned under a dais with a couple of angels supporting the crown in air. This damaged work, in which the Infant Christ is altogether renewed, is supposed (Calvi, ii. 250) to have been executed in 1485, and is the central panel of three which once hung together. The two remaining parts are on the walls of the chapel—St. James damaged, St. Uldric with repainted mantle.[1] It is not more easy to judge of a piece so injured than it is to criticize two figures of saints—a bishop and a cardinal—at the Ambrosiana, of which we can only guess that they were originally by Fossano.

Most important as a clue to Borgognone's passionless character is the Crucified Saviour at the Certosa of Pavia inscribed : " Ambrosius Fosanus pinxit 1490 Maij 14." Angels, wailing, shrieking, and praying flutter round the Saviour. The Magdalen grasps the cross, St. John looks up in an attitude of woe, and to the left the Virgin swoons between two of the Marys. There is no fault to be found with the distribution or setting of groups, nor is there any lack of expression in the heads. The short, thickset form in angels is avoided, and the calmness of the principal figures recalls Francia and Costa ; but expression is marked by grimace as strong and as vulgar as that of the Mantegnesques ; and all sense of pleasure vanishes before sharp contours, bony shapes, and draperies of parallel fold. The rich and highly finished landscape, with its details of lane and path and house and incident, is that which Alunno and Crivelli liked. The colours, moistened with highly resinous mediums, are of melting enamel, but touched in the fashion of tempera and in the spirit of Memling. Borgognone received for this piece 100 ducats, or 540 lire. (Wood. See Anonimo di Brera in Calvi, ii. 251.)

Of the same year though undated (Calvi, ii. 251, notes the payment of 480 lire in 1490) is the altarpiece in the Cappella di Sant' Ambrogio at the Certosa, in which St. Ambrose enthroned is accompanied by SS. Marcellinus and Protasius and SS. Satirus and Gervasius. We might judge, from the second of these figures, that this was one of Borgognone's fine productions, but there are much cleaning and much repaint of flesh to be noticed, and the arched top has been made square without any very apparent purpose.

In better preservation, but of the same class and time, is the St. Sirus with SS. Theodore and Lawrence, and SS. Invenzio and Stephen in the Cappella San Siro at the Certosa (wood, life-size).

* [1] These three pictures are now reunited. A picture of St. Jerome in the sacristy of Sant' Eustorgio is also by Borgognone.

St. Sirus, or, as he is called in the lines which run along a foot-stool, "Sanctus Syrus primus epûs et patronus Papie," sits in majesty, and gives the benediction. The scene is a quiet one, suited to the genius of Borgognone. It is one in which he exhibits more than usual power and breadth of treatment. The saints are well-arranged and posed ; they are of good proportion and easy movement, with extremities of more careful finish and contour than elsewhere. Light and shade are suitably contrasted, colours are properly harmonized, and drapery is more fitly cast. Perugino is the model which Borgognone follows.

The patriarchs Abraham, Isaac, Jacob, and Joseph in rounds, in the ceiling of the Cappella San Siro, are frescoes framed in appropriate ornament.[1]

St. Augustine, with book and crook of life-size on panel in the old sacristy at the Certosa, is a fine one in the style of the fore-going ; and the same opinion may be held as to the Four Doctors cut down to half-lengths in the altarpiece of Perugino, and the Four Evangelists (scaled) in the altarpiece of Macrino d'Alba. The St. Peter and St. Paul (under life-size), and two pinnacles with angels in prayer (regilt grounds) in the new sacristy, are all damaged.

High up in the lunettes at the bottom of the transepts of the Certosa are large frescoes by Borgognone. In the south transept, angels at the side of a circular window, and below the Virgin and Child with SS. John the Baptist and Jerome, and SS. Benedict and Bernard adored by Gian Galeazzo Visconti and his three sons, Filippo, Gabriele, and Galeazzo (background injured) ; in the north transept, beneath the window as before, the Coronation of the Virgin with St. George and St. Fortunatus in panoply and St. Peter Martyr and St. Ambrose, adored by the Dukes Francesco and Lodovica Sforza. In such large wall-paintings as these Borgognone really appears to disadvantage, in spite of the finish of which he is prodigal, and it is here that he produces the sense of void to which allusion has been made. The busts of Apostles at right angles to these votive frescoes in the transept are no exception to this opinion. In every instance pallid tone coincides with faint shadows, and, most painful of all chances, bleach or modern smears increase the ineffectiveness of the whole.

Though injured in many parts, the Madonna adoring the Infant Christ above the door leading from the Cappella di Santa Veronica to the cloisters is distinguished by a very pleasing head.

* [1] These are apparently by Jacopino de' Motti. Cf. *postea*, p. 388, and Magenta, *La Certosa di Pavia*, p. 283.

Five angels kneel around the Saviour in adoration. The four Carthusians in medallions inside are repainted.[1]

At regular intervals in lofty positions round the circuit of the Certosa church are half-length monochromes of the Twelve Apostles in ornament attributed to Bernardino Borgognone (Calvi, ii. 252). These figures are bold and sketchy, and probably by the designer of the ornament, whose style betrays some relation to the school of Bramantino.

In the great cloister, a Virgin and Child between S. Chiara and another female saint (originally feeble) is injured by time and restoring. The Virgin giving the breast to the Child (round) and twenty-two medallions of doctors and Carthusian bishops (frescoes) adorn the small cloister or refectory. Some of these on the wall to the right are not by Borgognone. Of the remaining works in the Certosa it is needless to speak in detail.

The fragments of a standard (silk, attached to wood, each 2 ft. 1 in. high by 1 ft. 4 in.), Nos. 779–80 at the National Gallery, comprise busts in profile of nine men (left) and a numerous group of women (right) kneeling. The standard was executed for the Certosa by Borgognone, and in the course of years fell asunder. A fragment representing the Eternal belonged in 1868 to Cavaliere Bertini at Milan. The portions in the National Gallery were bought at Milan of Signor Giuseppe Baslini. All three formed part of the Molteni collection.[2]

In Casa Bottigella, at Pavia, we find a large altarpiece on panel (figures less than life-size) under the name of Borgognone, subject, the Virgin between St. Benedict and St. Stephen, St. John the Baptist, and a bearded saint, in a vaulted chapel. On the foreground kneel the patron introduced by the beato Domenico of Catalonia and the patroness recommended by the beata Sibillina of Pavia ; the names of the patrons written at

* [1] It would appear that they are by Jacopino de' Motti. (Magenta, *ub. sup.*, p. 265.)

* [2] According to Valerio, Borgognone painted for the Certosa " una ancona con Santo Cristoforo e Santo Giorgio" (Beltrami, *ub. sup.*, p. 77). Dr. Frizzoni (in *Archivio storico dell' arte*, ser. ii. vol. i. p. 320) suggests that this picture is identical with the Madonna between the two above-mentioned saints, now in the Raczynski collection at Posen. The Madonna between the two SS. Catherine in the National Gallery (No. 298, see *postea*, p. 373) was no doubt also originally in the Certosa (Beltrami, *ub. sup.*, p. 75).

Three charming pictures—a Madonna with St. Claire and a Carthusian Monk in the Brera (No. 259), a Madonna with a Carthusian Monk in the late Stroganoff collection in Rome, and a Madonna with a view of the Certosa in the background —were in all likelihood painted by Borgognone for cells in the Certosa.

foot as follows : " Io. Matheus Botigella miles ducalis consiliar."
" Blanca vicecões vxor eius." Pieces of pilaster framing
contain small whole-lengths of St. Peter Martyr, St. Francis, St.
Dominic, and St. Sebastian. Bits of a predella comprise half-
lengths of a bishop reading, two female saints, St. Barbara and
St. Ursula, and an episode—the murder of a child. This tempera,
originally in the suppressed church of San Tommaso of Pavia, is
below the level of Borgognone's usual productions, and is
executed with more than his usual coldness. It may have
been painted by de Rossi of Pavia, an artist who sometimes
passes for Luini.[1] The same person, whoever he may be, is
doubtless author of two small panels in one frame ascribed to
Borgognone in the Museum of Turin (No. 134, Baptism of a
Proselyte by St. Ambrose, and a male and female, perhaps
Domenico of Catalonia and Sibillina of Pavia, converted by St.
Ambrose, each panel m. 0·31 h. by 0·32). These predellas were
bought at Pavia, and may have belonged to the Bottigella altar-
piece. No. 135. A Virgin and Child in the Turin Museum, is a
copy, or an original disfigured by modern smears.

Of all the frescoes which Borgognone finished in 1495 at
Milan, none remain but a faded and half obliterated one in the
right transept of San Satiro. It was recovered from whitewash
in 1857, and once represented three female saints in niches. The
fragments, of successful execution, are inscribed beneath the
centre spacing : " Amb. osij b. r-gognoni 14. . ." [2]

The largest and most valuable of the later Milanese frescoes
is the Coronation of the Virgin in the semidome at San Simpli-
ciano of Milan, a subject of which an outline may be found in
Rosini's Atlas (Tav. CL.). The three principal figures of the
Eternal (with outstretched arms) behind Christ, who crowns the
Virgin, are colossal, and double the size of those in the choirs of
angels and rows of saints ranged in stories around. The mantles
of the Eternal and of Christ, the Virgin's tunic, and the whole of
the blue sky, are repainted ; and there are many spots in which
the tints have faded or scaled away, but the effect of the whole is
still preserved. There is a passive gentleness in all the imper-
sonations which reminds us of Perugino and Francia ; and one
feels that Borgognone had now launched into imitation of
Leonardesque art. The figures round the larger group are in
converse, in quiet natural action, well set, and suitably diversified.

* [1] This painting is now in the collection of the Communal School of Painting
at Pavia.

* [2] This painting and other frescoes executed by Borgognone in San Satiro have
now been removed to the Brera (Nos. 22-4).

The ceiling of the sacristy at Santa Maria della Passione is a decoration of another kind. It is a rectangle with a blue-starred heaven bordered with a " greca " interrupted by medallions containing raised and gilt angels. The curve, which unites the ceiling to the walls, is broken into lunettes, twenty-eight in number, furnished each of them with a likeness in half-length of a brother of the Order of San Giovanni Laterano. Of these some are obliterated. Those that remain are drawn from life and fairly rendered ; the whole is boldly executed in Borgognone's latest and most Luinesque spirit. Nine panels with life-sized apostles or saints in couples by Borgognone are scattered about the chapels of this church. They are greatly injured, but in his best style.

The Luinesque frescoes which, we saw, adorn Sant' Ambrogio comprise some slender but noble and graceful figures. The wall-surface has been recently sawed through and the subjects were prepared for transfer to another place.[1]

The most charming of Borgognone's cabinet-pictures are the small predellas in oil—the Visitation, Presentation in the Temple, Annunciation, and Epiphany (wood about one-fifth of life-size) —at the Incoronata of Lodi. In the first the Virgin and Elizabeth embrace each other kneeling, St. Joachim and St. Joseph standing to the right and left. The flesh-tones are seriously damaged. There are eight figures in the presentation, some of which are repainted ; but those which keep their old patina, and especially the infant, are very soft and Luinesque in air. The background is the octagon of the Incoronata itself looking towards the high altar, with the inscription copied from that on the cornice : " Locus publicæ olim Veneri damnatus Virgini maxime erecto templo consecrataque ara castus religiose salutatur. laud. populi impensis anno salutis MCCCCLXXXVII." The Annunciation and Epiphany are also injured. All are executed with the softness and finish of Memling. It is clear that Borgognone had diligently studied Leonardo when he produced these pieces. They are full of grace in movement and grouping, and the turns of the head recall similar ones in Luini. The colours are sweet and pleasant.

In Santo Spirito of Bergamo we find a large composite altar-piece, arched at the top and inscribed in a medallion at the base with the words : " Dominicus Tassus et pure et caste dicavit MDVIII." In the central panel the Virgin and Child enthroned

* [1] The Christ after the Resurrection has now its place in the Cappella del Battistero in the left aisle ; the Christ disputing with the Doctors is to the left of the high altar.

are adored by the kneeling apostles. The upper semicircle is circumscribed by a square, in the angle of which are carved heads. At the sides of the Virgin are St. John the Baptist and St. Augustine ; above which are half-lengths of St. Jerome and St. Francis receiving the Stigmata. In the lunette, which has three fields, is the Eternal with outstretched arms between the angel and Virgin annunciate. The framing is regilt, the picture itself in all its parts blind from retouching ; all the blues without exception are new. But for this the altarpiece would be one of Borgognone's best.

Similarly damaged are a number of panels in the Sacristy of Santo Spirito which possibly formed part of an altarpiece in San Domenico of Bergamo (Anonimo ed. Morelli, p. 49 ; Calvi, *Notizie*, ii. 247). They are five in number: Christ in the tomb supported by the Marys (3) half life-size ; St. Louis and St. Stephen, full length, three quarters of life ; and half-lengths of St. Agatha and St. Lucy.[1]

In the Lochis collection (No. 229), a Virgin giving fruits to the infant Christ, half-length, trofoil at top (wood, quarter life), with a background of red cherubs, is a graceful production. A pretty miniature in the same collection (No. 219) represents St. Ambrose expelling Theodosius from the Temple : a small piece (wood), not free from retouching.

The Assumption painted in 1522 for the church of the Incoronata at Nerviano, is No. 308 at the Brera (wood, m. 2·71 high by 2·45) and inscribed : " Ambrosii b̄gogoi 1522 " (whence Lanzi's " Egogni "). It is dull-toned, feebly executed, dimmed by time, varnish, and retouching. No. 260, Christ at the Column in this Gallery (wood, m. 0·50 high by 0·40), is a figure of regular shape but somnolent aspect.

Two sides of an altarpiece in Casa Litta, at Milan, are more worthy of the master than the pictures of the Brera. They are portraits of a male and female donor, with their patron saints near them. In the distance of that which contains the lady is the Martyrdom of St. Peter the Martyr. The figures are little under the size of nature, of lucid enamel tone and noble in air. The flesh-tint in the female in damaged.[2]

A very fine profile bust of Bishop Novelli, in the Borromeo mansion at Milan, illustrates Borgognone's talent as a portrait-painter (wood, oil). It bears inscribed in the framing the words: "Andreas Novellis Episcopus Alben . et Comes." The proportions

* [1] These pictures are now in the Galleria Carrara at Bergamo (Nos. 376, 374, 378, 375, and 377).

* [2] These pictures are now in the Louvre.

are not quite those of nature, and the person is aged about 60, in a skull-cap and a close red-and-white dress. The finish of this work is beautifully clear, and its tone is very charming and silvery. It is cleverly modelled and drawn with great correctness and purity.[1] In the same place (No. 48) is a Christ with orb and sceptre, once in the Certosa of Pavia, and no doubt part of an altarpiece, a clever fragment less than life-size; a Madonna (No. 41), half-life, giving the breast to the infant Christ and adored by a dame on her knees, pretty and Luinesque, but injured by cleaning and restoring;[2] and a small panel with the Virgin and Child (No. 49) highly finished, full of grace and feeling, but also rubbed down.

In the Scotti Villa at Oreno, near Vimercati, there are two or three single panels with a saint in each by Borgognone.[3]

The Berlin Museum is unusually rich in specimens of this master. No. 52 (wood, 5 ft. 10 in. high by 4 ft. 4 in.) is a Virgin and Child enthroned between St. John the Baptist and St. Ambrose. Two angels fly at the sides of a conical dais. This is a pallid, flat-surfaced piece, faded from washing, with figures of the slender type peculiar to Borgognone's early period. On a cartello we read: " Ambrosij bergognoni ops." The picture is probably that mentioned as having been in Santa Liberata of Milan (Calvi, ii. 257). Prettier and pleasanter is No. 51 (wood, 3 ft. 10 in. high by 1 ft. 9 in., from the Solly coll.), the Virgin and Child between two adoring angels.

A charming example of melancholy expressiveness is the Virgin and Child in heaven (full length, half-life) in the palace of the Duke of Anhalt at Dessau. The extremities are not well drawn, the figures are short, and the gildings are obtrusive; but the delicate pallor and feeling of the faces are attractive. The panel is injured by the regilding of a gold-ground striped with clouds, a vertical split, and other defects (wood, m. 0·85 high by 0·60). The Virgin adoring the infant Christ, a canvas tempera (No. 68, 5 ft. 3½ in. high by 3 ft. 10 in.) in the Dresden Gallery, may once have been by Borgognone. It is now so

* [1] That this portrait in reality is a work by Zenale we may conclude from the close resemblance it shows to the figure of a bishop by this artist in the Treviglio altarpiece. See Suida, in *Repertorium für Kunstwissenschaft*, xxv. 340 *sq.*

* [2] Cf. *antea*, p. 363, n. 4.

* [3] Mr. Berenson (*North Italian Painters*, p. 174) mentions the following pictures by Borgognone as belonging in 1907 to the Duca Scotti of Milan : (1) Madonna; (2) St. Anthony the Abbot; (3) St. Paul; (4) the Eternal. Some of these are no doubt identical with the paintings here alluded to by the authors.

dimmed by repaints that we can no longer see the master's hand.[1]

In the Imperial Gallery at Vienna (No. 69), is a noble profile of a man in long hair falling from beneath a green cap. Round his neck is the collar of the Golden Fleece, his dress is green, with sleeves strewed with yellow flowers. On the dark green ground are the words : "MĀX RŌ REX," beneath which : " Ambrosius de p.dis mlanen. pinxit 1502." This Lombard panel, darkened by time and other causes, may have been by Borgognone. We are bound, however, to remember that there were other Milanese painters called Ambrogio, amongst them Ambrogio Bevilacqua, of whom later.[2]

At the National Gallery the Marriage of St. Catherine, with two Saints (No. 298, wood tempera, 6 ft. 7 in. high by 4 ft. 3 in.), is an altarpiece originally in the chapel of Rebecchino, near Pavia, an annexe to the Certosa.[3]

A feeble Borgognone is the altarpiece of the Virgin and Child with four Angels and the two St. Johns—once in the Bromley collection.

Mr. Fuller Russel, at Greenhithe, is said to possess a Dead Christ bewailed by Angels by Borgognone (Waagen, *Treasures*, Supplement, p. 284).

In the Louvre (No. 1181) wood, m. 0·97 high by 0.73) is a Presentation in the Temple by Borgognone, which once formed part of the collection of Duca Melzi.

We have further written notices of a Baptism of Christ signed : "Ambrogio da Fosano Br̃gognone " at Melegnano.[4] Christ in the lap of the Virgin and other pieces mentioned as having been purchased "for the National Gallery " (Calvi, ii. 246–7), we believe perished at sea.[5]

* [1] Morelli (*Die Galerien zu München und Dresden*, p. 334) ascribed this picture to Ambrogio Bevilacqua, and it is now generally accepted as his work.

* [2] This painting represents the Emperor Maximilian, and is by Ambrogio de' Predi.

* [3] Cf. *antea*, p. 368, n. 2.

* [4] According to Sen. Beltrami (*ub. sup.*, p. 104) this picture is signed : " Ambrosio di fosano bergognone ine lo . . . de mediolano pinxit 1506 (?) trige . . . s Februarii."

* [5] The following works by Borgognone may still be mentioned : (1) Arcore, collection of Donna Erminia Vittadini ; The Virgin and Child ; St. Anthony the Abbot. (2) Arona, SS. Gratiniano e Felino. The Virgin and Child with eight Saints and a Donor. (3) Bergamo, Galleria Carrara : No. 407, St. Jerome ; No. 408, St. Paul ; No. 410, St. John the Evangelist. Galleria Morelli : No. 40, St. John the Evangelist ; No. 43, St. Martha. (4) Bergamo, collection of Signor Frizzoni-Salis : Resurrection ; SS. Peter and Paul. (5) Budapest, Picture Gallery, No. 112 : Pietà.

No family was held in better odour of art amongst the
Lombards than that of the Solari, and there is scarcely an edifice
in Milan or Pavia that is not connected with their name. As
early as 1428 Giovanni Solari received his first commission as
a builder in the Certosa of Pavia. He lived to see his son
Francesco a sculptor of some fame, and his son Guiniforte an
architect of celebrity. Whether he was allied by blood to
Cristoforo il Gobbo or Andrea Solario we have no means of
ascertaining, but they too commanded respect as craftsmen
at Milan towards the close of the fifteenth century.[1]

About the year 1490 Cristoforo il Gobbo was induced—some
say because of the heavy competition amongst Milanese artists
at that time—to wander to Venice, whither he was accompanied
by his brother Andrea. It is hard to understand how a painter
of purely Lombard education could hope to find settled occupa-
tion at Venice at this period. It was a period of fierce rivalry
between the workshops of Vivarini and Bellini, when strangers
from the South like Antonello da Messina, strangers from the
hills like Cima, and strangers from the Lowlands like Previtali
and Catena outbid and jostled each other.[2] Yet Solario soon

(6) Crescenzago, Parish Church : Triptych—St. Catherine with a Donor, St. Cecilia,
and St. Agnes, each with three Nuns. (7) London, National Gallery, No. 1077 :
Triptych. (8) London, collection of the late Sir C. Turner : The Virgin and Child
with six Saints and a Donor. (9) Milan, Brera : No. 25, The Coronation of the
Virgin ; No. 257, St. Roch, above the Madonna and Child with St. John ; No. 251,
SS. Ambrose, Jerome, and Catherine ; in a lunette, the Pietà ; No. 721, Ecce
Homo. (10) Milan, Ambrosiana : SS. Elizabeth and Francis ; SS. Christopher and
Peter the Martyr. (11) Milan, Museo Poldi-Pezzoli ; No. 474, St. Catherine ;
No. 640, The Virgin and Child with Angels. (12) Milan, Crespi collection : the
Holy Family with Angels. Collection of Dr. G. Frizzoni, Head of a Saint and
two Angels. (13) Oldenburg : No. 42, the Virgin and Child. (14) Rome, collection
of the Marchese Visconti Venosta : the Virgin and Child.

[1] For the Solari, Giovanni, Francesco, Guiniforte, and Cristoforo il Gobbo, as
well as for Andrea Solario, consult Calvi, *Notizie*, ii. 37, 42, 75–8, 124–7, 144,
167, 186, 219–34, 256, 271–80. [* For notices of the architects and sculptors
of the Solari family, see now also Malaguzzi-Valeri, in *Italienische Forschungen
herausgegeben vom Kunsthistorischen Institut in Florenz*, i. 59 *sqq*.] Andrea is
mentioned by Vasari at the close of the Life of Coreggio, iv. 120 *sqq*. ; he is
noted by Lomazzo, *Idea del Tempio*, p. 149, as a follower of Gaudenzio Ferrari
and Luini, and by Cesariano (*Vitruv.*, p. cx. *à tergo*).

[* 2] Antonello, as we shall see, was not in Venice at this time. Catena was a
Venetian by birth (cf. *antea*, i. 254, n. 1), and Previtali and he were surely
not practising as independent masters in Venice at so early a date as about 1490.

found employment, and Venetian taste showed itself capable of sympathy with the softness and smile of the Leonardesques.[1]

In 1495 Andrea Solario furnished a Virgin and Child with St. Joseph and St. Jerome to San Pietro Martire of Murano, and thus introduced into Venice a new and hitherto unknown style. His picture long remained on the altar for which it was ordered, but was removed after years to the Gallery of the Brera. It could have found no more appropriate home, for in the weighty forms of the principal figures we detect school models familiar to Luini and Boltraffio, whilst the broad masks and widely parted eyes remind us of Zenale, and meanders of contour which escape analysis yet impart character tell of Lombard teaching. Distinctive also of the master's habits, as illustrated in this first altarpiece, is the curious contempt for proportion which prompts small heads and broad shoulders or small hands with large arms, and—tokens significant of Leonardesque influence—glossy surface, puffy skin, flowing drapery, and precise touch or contour. Peculiarly Solario's own is overdone meekness in look and attitude, want of transparence in sombre flesh tints, and a general air of coldness.[2] We thus arrive at the conclusion that Solario was taught amongst the Milanese, that he was no stranger to the lessons of Leonardo, and that he acquired some of the secrets of manipulation and conventionalism of form inherited from the Florentine workshop of Verrocchio. But it was scarcely to be expected, at the same time, that he should remain unimpressed by Venetian example, and it is clear that

* [1] Among the earliest extant works by Andrea Solario we must class : (1) A Madonna, formerly in the Scuola di San Pasquale di Baylon at Venice, and now in the Brera (No. 283; cf. *antea*, i. 187, n. 9). (2) A Madonna with four Donors, in the Johnson collection at Philadelphia. (3) A Madonna, in the Museo Poldi-Pezzoli at Milan (N. 658). (4) Christ at the Column, in the collection of Sir Frederick Cook, at Richmond. The last-mentioned picture is a copy after Antonello, whose influence is, moreover, very noticeable in the portrait of a Senator in the National Gallery. The three Madonnas, on the other hand, are more or less reminiscent of Luigi Vivarini.

[2] Milan, Brera. No. 285, wood, m. 1·02 high by 0·87. Inscribed in the left-hand corner of the stone seat on which the Virgin rests: " Andrea Mediolanensis 1495. F." The picture is noted by Boschini, *Le R. Min.*, Sest. della Croce, p. 24, and by Ridolfi, *Marav.*, i. 53; but Ridolfi gives the date falsely as 1493. In the air above the Virgin's head are two heads of cherubs, behind the figures a distance of water and verdure. The picture was given to the Brera by Prince Eugène. It was repaired and retouched and thrown out of its original harmony,

his palette, though technically Lombard and Florentine, was not without admixture of Venetian tricks; for his drapery tints, in the depth and richness of their shades, and his landscapes in the gaiety of their tones, are distinctly reminiscent of Previtali.

We may believe that Solario left Venice with his brother in 1495; yet we have no proof of his retirement from thence till 1499, when he finished the St. Catherine and Baptist in the Museo Poldi-Pezzoli, at Milan, in both of which there is visible trace of Leonardo's lessons.[1]

In a Crucifixion of 1503 at the Louvre, in which numerous and not inexpressive figures are grouped with considerable skill, we find Solario's deep, red, and uniform flesh-tints combined with enamel surface and filmy glaze,[2] whilst in the highly finished portrait of Cristoforo Longoni—a panel of 1505 at the National Gallery, a tinted landscape, again reminds us of Previtali. A portrait of such power and finish as this, when clear of the dimness of age and retouching, would alone have aroused attention at Milan.[3] In other creations of this time we discern the tendency to repeat—in Leonardesque form, and not without disagreeable gloss and hardness—the subject of Christ carrying

[1] Milan, Museo Poldi-Pezzoli, Nos. 657 and 653. Wood, arched; figures seen to the knees and about one quarter the size of nature. In both panels there is a landscape background; on that of the Baptist are the words: "1499 Andreas Mediolanensis f." It is not possible to say whether both are executed in the same year. The St. Catherine is older and more silvery than the Baptist, but the latter may have been altered by restoring.

[2] Louvre, No. 1532. Wood, m. 1·10 high by 0·77, under the name of "Andrea of Milan." Christ on the Cross surrounded by men-at-arms on horseback, one of whom has just given the lance-wound; in the left foreground the Virgin in a swoon, and, near her, the Evangelists looking up; to the right the dicers; in the distance a river with a town on its banks and vessels in the stream; inscribed: "Andreas Mediolanensis f.a. 1503."

[3] London, National Gallery, No. 734. Wood, 2 ft. 7 in. high by 1 ft. 11½ in. Purchased from Signor Giuseppe Baslini of Milan. Full face, half-length, of a man in a black cap and dress at a parapet, behind which is a landscape with houses and trees. On the parapet we read: "Ignorans qualis fueris qualisque futurus sis qualis studeas posse videre diu"; on the wall to the left: "Andreas Solario f. 1505." The surface is blinded by restoring and minute stippling. On the letter in the figures' hands are the words: "Nobili Joanni Christophoro Longono amico."

* From the following year dates a picture of the Annunciation, in the Museum at Cambridge, signed: "Andreas Fitzwilliam de Solario f. 1506."

his Cross, the best specimen of which is in the Borghese
Gallery at Rome, and the feeblest in the Galgani collection at
Siena.[1]

Meanwhile French rule had been established in Lombardy
under the direction of an ambitious and powerful Churchman
who, not content with the cardinal's hat, aspired to the see of
St. Peter ; Cardinal George of Amboise had had occasion to
admire the examples of all the Italian schools, but had probably
devoted more time to politics than painting. When he began
building a chapel at Gaillon after his return from Italy he
remembered how nobly the churches of the Peninsula had been
decorated by the genius of her artists, and he longed to invite
one of these to France. It might be a question with him what
school would best suit the taste of Frenchmen, or what craftsman
would consent to leave his country for a foreign land. Of all the
craftsmen of that age there were none with whom the French
were better acquainted than the Lombards, none more admirable
in their eyes than Leonardo. Confident of the influence wielded
at Milan by his nephew Chaumont, the Cardinal might hope to
win Da Vinci to his purpose; but that the King of France had
already taken steps to secure his services. It happened, we
should think, at that time, that Chaumont had been sitting to
Solario for his portrait and was satisfied with the result, and
Solario was therefore induced to accept a commission from the
cardinal. He left Milan for Paris, with an assistant, about the
middle of 1507, crossed the Alps, perhaps by the Mont Cenis to

[1] (1) Rome, Borghese Gallery, No. 461. Half-length. Wood, under life-size.
Christ, crowned with thorns, carries his cross with the help of a man in profile
on the left, who supports it with one hand, whilst the captain, in a red cap,
presents his full face in half gloom to the right. The ground is black, the red
drapery hard, the flesh glazed like porcelain. [* This picture is signed " Andrea
de Solario pīsit 1511."] (2) Siena, Signor Francesco Galgani. The same subject,
with the figures of the two soldiers right and left in helmets, ruined by abrasion
and of doubtful originality, though bearing fragments of a signature—*i.e.*:
" Andre. S ... edio...." (3) Same collection. The same figure of Christ as the
foregoing, but without the soldiers, pallid glassy, but apparently genuine, much
abraded in surface, and signed in the upper corner to the left : " Ad Mediolañes F
1505." The hand is injured, the face scaled in spots, and the inscription not free
from taint. [* Present whereabouts unknown.] (4) No. 211, at the Berlin
Museum [* now on loan to the Kaiser Friedrich Museum at Magdeburg.] Christ
carrying his Cross (wood, 2 ft. 4½ in. high by 1 ft. 10¼ in.), is a pallid, glassy
school-piece.

Lyons and thence to Paris and Gaillon, by the road subsequently taken by Cellini and Del Sarto.

For two years Solario remained at Gaillon surrounded by men of French nationality, who worked in various parts of the castle at salaries infinitesimally small compared to his. In September 1509 he retired after completing a Nativity and composing subjects for an entire chapel.[1]

The portrait of Chaumont, or Charles of Amboise, found its way to France in Solario's keeping, or after Chaumont's death; it came, a century ago, into the royal collection of France, and was persistently held to be a likeness of Charles VIII. by da Vinci. This honourable name it does not in any sense deserve. It is a fine half-length, in which Chaumont appears in a rich damask vest and pelisse, with a medal in his cap, and the Order of St. Michael at his breast; it is most carefully drawn and minutely finished, but executed with cold precision, and as remarkable for the combination of gay landscape with ruddy, uniform, and sparsely shadowed tints as any that Solario had hitherto produced.[2]

The frescoes and pictures of Gaillon were amongst the first to suffer from the frenzy of the French revolution, and in 1793 the chapel of George of Amboise was razed with pitiless rigour to the ground. But Solario, long in the pay of a powerful dignitary, had formed a large French connection with which he kept up relations after his return to Italy; and thus we account for the number of his masterpieces which found a market in France.

The Madonna "au coussin vert" was painted for the Fran-

[1] The records of Solario's labours at Gaillon were found by M. Deville, who published them in his work *Compte de dépenses de la construction du château de Gaillon*, pp. cxxxvi and 418 *sq.* They are noticed by Mündler, *Analyse*, p. 122, and the substance of them is given in the Catalogue of the Louvre. For the journey he received 70 *écus*, for wages of a year 370 livres, and for the expenses of himself and man per annum 100 livres. The pay of French painters at the time in Gaillon was 4 sous per diem. The Nativity is noted in an inventory of the treasures of Gaillon in 1550. (Deville, *ub. sup.*, pp. lxxi, 540.)

[2] Louvre, No. 1531. Wood, m. 0·75 high by 0·52. Bust, three-fourths to the left, assigned by different critics to Leonardo, Perugino, and Boltraffio, and correctly by Mündler (*Anal.*, p. 122) to Solario. There are marks of restoring on the throat and right cheek, and some want of transparence may be caused by repeated varnishings. The touch is firm but fluid.

ciscans of Blois, who gave it to Mary of Medicis. It fell into
the hands of Mazarin, who sold it to the Prince of Carignan;
and at the sale of that Prince's Gallery it was bought for
Louis XV. and placed in the royal collection.[1]

A beautiful Christ crowned with Thorns, which wandered
into the palaces of the Dukes of Liancourt and La Rochefoucault,
is now one of the ornaments of Baron Speck's country house at
Lütschena, near Leipzig, whilst a second, almost equally fine,
came into the Lochis Gallery at Bergamo. The Baptist's head
in a silver charger, sold at the Pourtalès sale in 1865, bears the
painter's name and the date of 1507.

The Madonna " au coussin vert " charms us more by rich and
glossy tones than by concentration of feeling. The Virgin
smiles, but the smile which hangs on the lips is belied by
the eye. The same rigidity which marks the muscular play of
features pervades the surface generally; the drawing is accurate
but dry, the flesh unbroken and stony; yet the treatment is
polished and fresh, and tender grey half-tones of gauzy texture
almost conceal the streaks of the hatchings. Brilliant contrasts
are produced by the white cloth on the Virgin's head, the green
cushion on which the Infant rests, the marble of the parapet and
the pure sky and clear landscape. The group is gracefully
arranged, and the child clings prettily to the breast which the
Virgin stoops to give.

With greater softness and truer inwardness, the Christ of
Lütschena is a creation of deeper significance than the Madonna
of the Louvre. Resigned suffering abounds in the gentle bend
and placid calm of the face. Tears flow from the downcast eyes,

[1] (1) Louvre, No. 1530. Wood, m. 0·60 high by 0·50. Copied for the cordeliers of
Blois by Jean Mosnier in 1600. On the back of the panel are the words : " Tablou
dandrea Solario achté de M^r le Duc de Masarin par moie Prense de Carignan
A.DS|." No. 92. Cf. Louvre Catalogue, Mündler, *Anal.*, p. 204, and Félibien,
Entretiens. There is a copy of this piece by some old master (2) in the Hermitage
at St. Petersburg, No. 79. [* Others are in the collections of the Earl of Elgin
(Broomhall, N.B.) and Mr. T. Humphry Ward.] Wood, 2 ft. 3⅛ in. high by 1 ft. 7¼ in.
(3) In the Lochis Gallery at Bergamo (No. 6), a small Madonna giving the breast
to the Infant, is catalogued under the name of Andrea Salai, and might be a feeble
adaptation of the Virgin of the Coussin Vert by Solario himself. [* This picture
is now officially ascribed to Solario. A Madonna, by the same artist, presented
some years ago by Cav. A. Noseda to the Museo Poldi-Pezzoli in Milan (No. 602),
shows practically the same group of Mother and Child, but in reverse.]

blood drops from the punctures of the thorns ; but the fettered hands, unwrung by pain, hang loosely on each other, and the rope round the neck is a mere emblem of constraint. Long hair in auburn locks falls to the shoulders and lies on the scarlet mantle. A reed in the right hand is painted with truthful cunning. Finely chiselled features and select forms are combined with natural action ; yellow flesh-lights fade into mellow half-tone and shadow with effect not unlike that of Leonardo, yet the life-blood trickles thinly through the forms, and something of wan coldness strikes the view.[1]

Softer and more velvety, the Man of Sorrows in the Gallery of Bergamo is distinguished by a tender and moving mournfulness, and the frosted bloom of the surface is worthy of the greatest admiration.[2]

Of singular dignity in the regularity and beauty of its features is the head of the Baptist in a silver charger, a picture unsurpassed in the Lombard school for brilliancy, finish, and subtle treatment of detail, and an almost matchless combination of smooth modelling and fine polish. The hair and the reverberations in the vase are masterly.[3] It is only after seeing such works as these that we can confidently assign to Solario the Colombine of the Hermitage at St. Petersburg, a figure

[1] Lütschena, near Leipzig. Canvas, on panel 2 ft. 4½ in. high by 1 ft. 8 in. Purchased from the Friesische Sammlung, in Vienna; on dark ground. In gold letters at the bottom to the left: "Andrea. de Solario . . . a . . ." See Félibien, *Entretiens*, 8vo, London, 1705, tom. i. p. 172. [* Replicas of this picture belong to Mr. Johnson, of Philadelphia, and M. Cheramy, of Paris. A copy of the same composition is in the Borghese Gallery at Rome (No. 280) ; it is the companion picture to a Mater Dolorosa (No. 286), which is copied from Solario's picture in the Crespi collection, at Milan. Both copies are the work of a French artist, Simon de Mailly, called Simon de Châlons ; the Mater Dolorosa is signed and dated 1543.]

[2] Bergamo, Lochis, No. 236. Bust of Christ crowned with thorns, on a black ground, attributed to Cesare da Sesto. It reminds us of the Christ at Lütschena. The head is inclined in the opposite direction, but has the same type, tenderness, and tone. There is, however, more furry softness in the handling.

[3] Paris, ex-Pourtalès collection [* now Louvre, No. 1533]. Wood, life-size ; a repetition of the subject treated by Bramantino at the Ambrosiana (see *antea*) and of the same type. The cup on which the head lies is on a table, and painted against a dark underground. On the table : "Andreas de Solario, fēc 1507," and on the frame : "Alvo virginis latentem christum ex vero agnovi editum indicavi LA/I. El lotus futuræ salutis angelus cruore fidei. Testimonium Sanxi."

of such charm that in the Orleans and Hague collections it was considered worthy of Leonardo and in the Petersburg Gallery worthy of Luini. It is one of Solario's clearest productions, and gay alike in subject and in treatment. Colombine sits in poetic undress under the lee of a rock overgrown with weeds and ivy; the rich festoons of a white dress strewed with yellow blossoms, held by a jewelled brooch, leaving one breast uncovered. A blue tunic falls from the shoulders. The hair, in a profusion of short curls, is brushed off the forehead. In the left hand Colombine holds a flower, at which she is glancing. There is much coquetry in the air of the person, and it is curious to observe that the form was first drawn from the nude, and then sketchily clad with its loose, conventional garments. Leonardo would probably have imagined something less gallant than this beauteous apparition. He would have drawn the right hand more accurately and modulated the flesh with more subtly broken tones. Yet the Colombine is to be prized amongst the best productions, not only of Solario, but of the Lombard school.[1]

A striking feature in Solario's later period is the Raphaelesque element introduced into his Virgins or groups of Virgin and Child. It has been stated, with some confidence, that he accompanied Andrea da Salerno to South Italy, and was employed in 1513 in a "Chapel in the Church of San Gaudenzio" at Naples.[2] This might account for the new direction which he gave to his art. In a Madonna belonging to the late Pourtalès collection there is distinct evidence of Raphaelesque influence in the graceful momentary action of the child, who strides from a balcony over the Virgin's lap and looks round as he hangs

[1] St. Petersburg, Hermitage, No. 74. Wood, transferred to canvas. 1 ft. 5⅜ in. high by 1 ft. 1⅜ in. Some bits of the blue mantle are repainted afresh. Cf. Waagen, *Ermitage, ub. sup.*, p. 54. The picture was purchased by Égalité, Duke of Orleans, with the whole collection of the banker Walckiers, in Brussels. Before coming into the gallery of The Hague it was in the possession of the banker Danoot. [* This picture is now generally ascribed to Leonardo's pupil, Francesco Melzi, because of its resemblance to the Pomona and Vertumnus in the Kaiser Friedrich Museum at Berlin (No. 222), which may reasonably be regarded as a work by the latter artist.]

[2] Calvi, *Notizie*, ii. 277. [* This visit of Andrea Solario to Naples is, to say the least of it, extremely improbable. The report of it may very likely be accounted for by his having been confused with Antonio Solario.]

to her neck. Solario's rendering of movement in this instance is not without affectation, nor is the treatment remarkable for impulsiveness, but the execution is very characteristic, and the landscape equally so.[1] We also detect Solario's determined precision of hand and semi-opaque uniformity of flesh surface in a handsome bust portrait assigned to Antonello da Messina in the Duchâtel collection in Paris.[2] Not less certainly his, but with the Leonardesque smorphia which clings to Luini and Cesare da Sesto is the daughter of Herodias receiving the head of the Baptist from a grim executioner—a picture which formed part of the Orleans Gallery, and subsequently belonged to M. Georges, in Paris. But in this large composition, the general tone is more sombre and empty than usual.[3]

One of the cabinet pieces in which Solario rose to the rarest refinements of thought and treatment is the Holy Family of the Museo Poldi-Pezzoli at Milan, a group of three figures finished in 1515. The scene is a landscape unusually well harmonized in its detail and effect, in which the Virgin, dismounted from the ass who roams in a glade, sits holding the

[1] Paris, Pourtalès collection. Wood, under life-size, half-length. Through openings in the room hilly landscapes with two little figures are seen. The figures are slender and dry, the flesh a little empty and uniform. [* This picture is now in the National Gallery (No. 2504).]

[2] Paris, Comte Duchâtel. Wood. Small bust of a bareheaded youth, whose yellow hair is shorn straight over the brow. A blue vest is partly covered by a dark cloak. [* This portrait is now in the National Gallery (No. 2509). In drawing, modelling, and colouring it shows so close an affinity to the style of Luigi Vivarini that there can be little doubt about its being really a work by this artist. Cf. Berenson, *Lorenzo Lotto*, pp. 86 *sqq.*]

[3] (1) Paris, M. Georges. Wood, with three figures, full length and almost life-size. At a table is the daughter of Herodias, with one hand on the vase over which the Baptist's head is held by the executioner, who stands in rear with a scimitar in his right, an aged spectator between the two. Herodias has a red bodice and skirt, a white sleeve, and blue cenerine mantle. A green cloth lies on the table. (2) Same subject at Hampton Court (No. 285) under the name of Leonardo, is a copy more empty in flesh-tint and feebler in execution than the original of M. Georges. The same subject, without the spectators, in (3) the Imperial Gallery at Vienna, No. 91. Wood, 4 ft. 3 in. high by 2 ft. 6 in. It seems a Flemish copy (?), Franz Floris. [* This picture is now officially ascribed to Cesare da Sesto. A replica of it belongs to the National Gallery (No. 2485). Solario has treated the same subject in a different composition, of which there are versions in the Augusteum at Oldenburg (No. 47, signed " Andreas de Solario f."), in the collection of the Duke of Northumberland at Sion House, and in the Nemes collection at Budapest.]

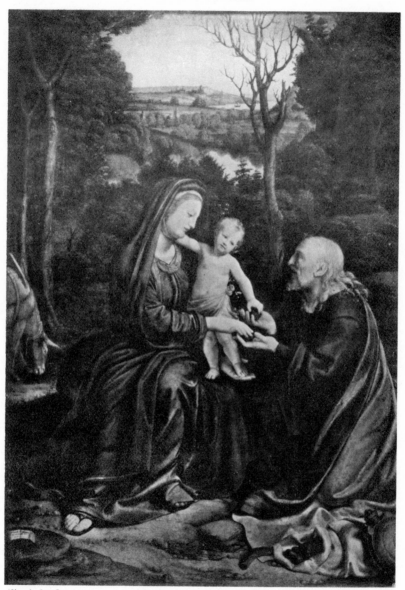

THE HOLY FAMILY.

infant Christ, St. Joseph divested of his water-bottle, presenting
a piece of fruit to the child. We note, with peculiar interest,
how truly Leonardesque the Virgin's type and pose appear;
we mark a decided leaning to Raphaelesque models in St.
Joseph, who much resembles his counterpart in the Earl of
Ellesmere's Madonna of the Palm (Raphael). We detect the
source of Gaudenzio's numerous creations in the figure of
the Saviour.[1]

It was during these years that Solario finished the pretty
Virgin with Christ and the young Baptist in the Leuchtenberg
Gallery at St. Petersburg, the well-known panel upon which a
clumsy forger wrote the words : " Antonius de Solario Venetus
f.," in order to give some colour and life to the legend of the
Neapolitan Zingaro.[2] Solario was a man of great artistic
activity, and he probably finished a considerable number of
works preserved under various names in public and private
collections, amongst which we should dwell on the Virgin and
Child of Mr. Baring miscalled Verrocchio; St. George and
St. Sebastian, two miniature panels in Hamilton Palace near
Glasgow, and the St. Catherine ascribed to Luini in the Pina-

[1] Milan, Museo Poldi-Pezzoli, No. 655. Panel with figures one-fifth of life-size,
inscribed : "Andreas de Solario Mediolañ f. 1515." Some parts of the dresses
have undergone a necessary repair, but the landscape is in admirable preserva-
tion.

[2] St. Petersburg, Leuchtenberg Gallery. Wood, transferred to panel, small
round. 1 ft. 6 in. high by 10⅝ in. The Virgin holds the Infant in the crenelated
opening of a parapet, behind the higher portion of which the young Baptist
stands with a reed cross and fruits. The infant Christ holds a bird with a string.
Ground : a curtain, and through an opening a landscape. On a cartello on the
parapet the signature. See Rosini's *History of Painting*, iii. 28, and Tav. xxxvii.
See also the attempt to prove the signature to be that of Antonio Solario in a
pamphlet of twenty-four pages by G. A. Moschini, called, *Memorie della Vita
di Antonio Solario*, etc., Firenze, 1832." The forgery imposed on Reumont, who
notices the picture then in the hands of the Abbate Celotti, in Venice. Compare
his article in *Kunstblatt*, No 38, anno 1832. Cf. also Waagen (*Ermitage*, p. 374),
who ascribes the panel "to a pupil of Giovanni Bellini." It may be that this is
the piece catalogued in the Carignan collection, and sold in 1742. (Mündler, *Anal.*,
p. 123.) [* The picture seen by the authors in the Leuchtenberg collection is now
in the National Gallery (No. 2503). The signature is certainly authentic; and the
picture has so many features in common with the authentic, recently discovered
paintings by Antonio da Solario that we cannot but accept it as a work by him.
That it shows an influence from Andrea Solario is, however, undeniable. Cf.
postea, p. 437, n. 3.]

kothek at Munich.[1] As a portrait-painter, too, he had a select
practice ; and we may accept as genuine not only the bust of a
man attributed to Cesare da Sesto at the Brera,[2] but the masterly
likeness of Maximilian Sforza in Casa Perego at Milan. There
are few more successful efforts of the kind in the Milanese school
than this portrait of the hapless Sforza, bred a fugitive in the
ante-chamber of an Austrian Emperor, for two years (1512–14)
at the head of the Milanese State, and then a pensioner in Paris
on the bounty of France. He was drawn by Solario in the
splendid costume of his palmy days, in the cap to which a medal
is affixed, bearing the image of a patron saint, in a pelisse with
fur lining, and a richly ornamented jacket. It may perhaps be
thought that this picture could be assigned with equal justice
to Cesare da Sesto ; but the landscape seen through the openings
of the room is altogether in the manner of Solario.[3]

At the close of his life, and at a date little remote, we

[1] (1) London, Baring collection. [* Now collection of the Earl of Northbrook.]
Small panel. The Virgin, behind a parapet of coloured marbles, holds the infant
Christ erect on a chequered carpet on the parapet. In the distance a castle, in
the upper left-hand corner of the picture a green curtain. An arabesque in the
border of the Virgin's dress, which originally read, we should think, " Ave Maria,
etc.," was twisted into " A. Ver . . . etc.," and thus suggested the name of Ver-
rocchio. The picture is by Solario, of lively and well-blended colour, with figures
of a regular and gentle type. The drawing is accurate but dry, the drapery
broken and angular. The date of this piece may be about 1503. It would then
be contemporary with the Crucifixion of the Louvre. (2) Hamilton Palace.
These two small panels represent St. George and St. Sebastian in niches, with the
crown of martyrdom suspended over their heads by angels, St. George at three-
quarters in armour trampling on the dragon, St. Sebastian with the sword and
two arrows in his hands. The flesh is clear, and shaded in silver grey. [* These
pictures were bought at the sale of the Hamilton Palace Collection in 1882 by
Mr. J. E. Taylor (lot 377, " A. Mantegna.").] (3) Munich, Pinakothek, No. 1045,
under the name of Luini [* now catalogued under "Milanese school, 1520–30."]
Wood, 2 ft. 3¾ in. high by 1 ft. 7¼ in. St. Catherine in a landscape (half-length),
with the palm in her right hand, and the wheel at her side. The distance of hills
is painted with Solario's usual clear touch, but it is of a hazy blue, and partly
injured by repaints which impinge on the hair. The drapery is a little involved,
and of a dull red tinge ; the right hand spoiled, the left well preserved.
[2] Milan, Brera. No. 282. Wood, m. 0·42 high by 0·32. Man with long hair
in a black cap and blue vest. [* In the current catalogue of the Brera Gallery
this picture is ascribed to Solario.]
[3] Milan, Casa Perego. Wood, half-length at a parapet. With a red curtain
and an open window, with a landscape as background. [* This picture is
now in the Crespi collection at Milan. That it represents Maximilian Sforza is

should think, from 1515, Solario had an order for a large altarpiece of the Assumption for the Certosa of Pavia. He painted the lower part of it and left the rest to be finished by Bernardino Campi; but he evidently retained his powers to the last, and we detect no diminution of his skill in the life-size apostles whom he placed round the Virgin's tomb.[1]

Abundant illustrations may be found in the domestic annals of the house of Sforza to characterize the relations of Milanese artists with their patrons. The frequency and splendour of pageants or progresses and the number of men whose service they absorbed are less striking than the high-handed authority with which artists were treated. Lodovico Sforza, recently married to Beatrix of Este, was about to present her, in state, to the people of Milan. In December 1490 he issued commands that the castle of Porta Giovia should be prepared for his reception,

not proved; and it shows so close an affinity of style to the portraits by Bartolommeo Veneto that we may safely ascribe it to this artist. Cf. A. Venturi, *La Galleria Crespi*, pp. 81 *sqq.*]

[1] Pavia, Certosa, Sacristy. Three large panels with life-size figures. The Virgin with Angels in the sky and the landscape by Bernardino Campi. The figures have suffered from repainting. This altarpiece is assigned to Solario by Vasari, iv. 120 *sqq.*

* Bernardino Campi certainly finished the above-mentioned painting, and, according to the manuscript notes of Valerio, he did so in 1576 (Magenta, *ub. sup.*, p. 413). It would seem, however, that the authors somewhat overrate his share in this picture. Great parts of the upper half of it display the characteristics of Solario's style.

In addition to the paintings of Solario already noticed, we may enumerate the following: (1) Barnard Castle, Bowes Museum. St. Jerome. (2) Berlin, Kaiser Friedrich Museum, No. 225. Male Portrait. (3) Berlin, collection of the late Herr E. Schweitzer. The Virgin and Child (from the Henckey-Beaulieu collection). (4) Boston Museum. Male Portrait (from the Abdy collection). (5) Boston, collection of Mr. J. M. Longyear. Madonna with St. Roch. (6) Milan, Museo Poldi-Pezzoli. No. 636: St. John the Baptist. No. 637: Ecce Homo. No. 638: St. Anthony the Abbot. (7) Milan, Crespi collection. The Virgin and Child, Ecce Homo, Mater Dolorosa, Christ in the act of Blessing. (8) Milan, collection of Dr. G. Frizzoni. The Virgin and Child. (9) Milan, collection of Cav. A. Noseda. The Virgin and Child. (10) Milan, collection of the Duca Scotti. Portrait of the Chancellor Morone. (11) Milan, Santa Maria delle Grazie, Refectory. Copy of Leonardo's Last Supper. Fresco transferred to canvas; formerly in the monastery of Castellazzo near Milan. (12) Rome, collection of Miss Hertz. Woman playing Guitar. (13) Rossie Priory, Inchture, Perthshire, collection of Lord Kinnaird. Pietà.]

and, without a moment's delay, a circular was despatched to all the guildsmen of the State, ordering them, under penalty of fine, to appear in Milan within twenty-four hours. At the summons, Butinone and Zenale from Treviglio, Troso from Monza, and others from Como, Pavia, Cremona, Tortona, Novara, and Lodi hastened to the rendezvous ; they were told off to their several duties by Ambrogio Ferrari, the Commissioner of Works, and adorned the great hall of the palace " ad istoriam." [1] In the earlier reign of Galeazzo Maria the castles of Milan and Pavia were decorated with almost equal speed by Bonifacio Bembo, Constantino Vaprio, Gadio, and Stefano de' Fedeli ; whilst about the same period Zanetto Bugatti, painter-in-ordinary to the Ducal court, covered Santa Maria delle Grazie at Vigevano with frescoes, and Jacopo Vismara, in conjunction with Bonifacio Bembo, filled with their designs the sanctuary of Caravaggio and the palace of the Countess of Melzi. It was customary to subject even these hasty productions of the brush to a rigid inspection, and, accordingly, Foppa, Montorfano, Gadio, Moretto, and Stefano de' Magistri were deputed to value the work of Stefano de' Fedeli, whilst Vismara and Gottardo Scotto valued that of Zanetto Bugatti, and Gian' Jacopo di Filippo, of Lodi, Raffaele Vaprio and Gregorio Zavattari gave their opinion on the paintings by Vismara and Bembo. Of those we have named, Zenale, Butinone, and Foppa are masters of mark, Bembo and Montorfano are known ; the rest have seldom, if ever, been noticed. We may add to the list Antonio and Stefano da Pandino, Jacopino and Cristoforo de' Motti, Francesco de Vico ; Ambrogio and Filippo Bevilacqua, Bernardino de' Conti, and Civerchio, without exhausting the catalogue of Lombard craftsmen.

Antonio da Pandino painted the apostles in the pendentives of the cupola at San Satiro of Milan, for many generations attributed to " old Bramante " (Calvi, *Notizie*, ii. 24, 281), and a window at the Pavian Certosa with St. Michael over-coming the Dragon, which still bears his signature. There is reason to believe that he was a skilled glazier taught in the early part of the century (1416–1458), by Stefano da Pandino of Milan (Calvi, *ub. sup.*, i. 127, 136, 143–7.[2]

* [1] Calvi, *ub. sup.*, ii. 241.

[2] See also Malaguzzi-Valeri, *Pittori lombardi*, p. 234 ; *idem*, in Becker and Thieme, *Allgemeines Lexikon*, ii. 5.

Gregorio Zavattari bore a name of frequent occurrence in Milanese annals. He valued some paintings in the sanctuary of Caravaggio between 1474 and 1477 (Michele Caffi, *Archiv. stor.*, tom. x. parte i. p. 173, 1869). His namesake Francesco, a glazier in Milan in 1417, was, later, a partner of Cristoforo Zavattari (Calvi, *Notizie*, i. 127; ii. 144, 238), with whom (1444) he executed forty scenes from the legend of Queen Theodolinda in Santa Maria del Rosario, an oratory annexed to the Monza Duomo. Nine years after they were on the roll of the Certosa of Pavia, where (1453) the walls of a chapel were covered with their designs. Though dimmed by age and dust, the Monza frescoes are still visible and authenticated by a signature:

> " Suspice qui transis ut vivos corpore vultus
> Peneque spirantes et signa simillima verbis
> De Zavattaris hâc ornavere capellam
> Preter in excelsum convexe picta truine.
> 1444."

They comprise hundreds of figures and copious details of animal and still life with gold grounds and embossments in a careful style recalling Nelli, Fabriano, Pisano, or the Sanseverini, but with ruder contour and sharper contrasts of tone and less knowledge of drawing than we find even in the juvenile efforts of those masters.[1]

Akin to these in childishness though not directly related to them in manner is a cycle of scenes from the Passion, with separate impersonations of the Redeemer, the Virgin, Baptist, Peter, Paul, and Apostles (half-length) in Sant' Abondio of

[1] Cristoforo Zavattari is recorded as a painter in Milan as early as 1404 and 1409 (Fumagalli and Beltrami, *La Cappella detta della Regina Teodolinda*, pp. 11 and 19). We have no reliable information as to which of the Zavattari painted the frescoes at Monza. The payment for the paintings in the above-mentioned chapel in the Certosa of Pavia was made to Francesco Zavattari; and in that year Ambrogio Zavattari (an artist unknown to the authors) also painted a cross for the cemetery of the Certosa (Magenta, *La Certosa di Pavia*, p. 109, n. 1). In 1456 and 1459, this painter executed various works for the Duomo at Milan. Gregorio Zavattari was the son of Francesco. (Fumagalli and Beltrami, *ub. sup.*) A Madonna signed " A.M.CCCCLXXV." was in 1881 still to be seen in the sanctuary of Corbetta, near Abbiate Grasso, in the province of Milan (Caffi, in *Archivio storico lombardo*, ser. i. vol. viii. p. 60), and in 1479 Gregorio and Francesco Zavattari agreed to execute a series of paintings illustrating the legend of St. Margaret in the now destroyed church of that saint in Milan (Fumagalli and Beltrami, *ub. sup.*).

The frescoes by the Zavattari in the Monza Duomo are reproduced in the work by Fumagalli and Beltrami quoted above.

Como—a cycle as antiquated in conception as any belonging to the Sienese school of the fourteenth century. Like these again in rudeness are : St. Sebastian and St. Roch, signed , "Ambroxius de Muralto pinxit "; a Virgin, Child, and kneeling Patron and the Annunciation inscribed, "MCCCCLXXXVII die X mensis Novembris factum fuit hoc opus " (frescoes) in the Duomo at Lugano ; a Madonna dated April 12, 1476, and signed, "Hoc opus Jacobinus de Valate pinxit "; a St. John the Baptist with other Saints, dated 1471 and 1479, and a coronation of the Virgin with numberless canonized saints, etc., in Zavattari's manner on the walls ; a St. Christopher, fragmentary, with the words : " 1442 die 3. Junii [hoc opus fecit.] Antonius f. magistri Jacobi de Murini de Mortaria, in the façade, at Santa Maria in Selva of Locarno [1] ; the Virgin and Angel Annunciate and a figure pointing to a scroll inscribed : "Ego Iohannes Lampugnanus pinsit anno 1494 " (monochromes) on a house front in the contrada San Domenico at Legnano.

Cristoforo de' Motti of Milan is proved, by a record of February 9, 1468, to have been commissioned at that date to decorate a chapel in the cathedral of Genoa (Santo Varni, *Appunti artistici sopra Levanto*, 8vo, Genova, 1870, p. 78). He stained windows for the Milan cathedral in 1476, designed a St. Bernard on glass, "opus Christofori de Motis 1477," still extant in the Certosa of Pavia, and a series of wall-pictures, in good preservation it is said, at the Madonnina of Cantù—the latter inscribed : "Ambrosius Vigievensis et Cristoforus Motus 1514 p." (Calvi, *Notizie*, ii. 197, 203).[2]

The most notable point in the life of Jacopino de' Motti is that, in company with the Cremonese Antonio Cicognara, he valued Borgognone's frescoes at the Incoronata of Lodi in 1500. Between 1485 and 1490 he executed some of the glass-work of the Pavian Certosa, and in the following years he worked in many chapels of the same edifice, particularly that in the ceiling of which there are medallions of Abraham, Isaac, Jacob, and Joseph. He also finished a Madonna between two canonized bishops for one of the altars in 1491. In 1497 he was ordered from Milan to the Incoronata of Lodi, to value an altar by the sculptors G. P. and A. Donati. He died of plague-fever at

* [1] Part of the building containing the above-mentioned painting of St. Christopher and other frescoes was pulled down in 1884. Monti, *Storia ed Arte nella Provincia ed antica Diocesi di Como*, p. 262.

[2] The glass-painter, Cristoforo de' Motti, is a different person from the author of the frescoes at Cantù. The former was dead in 1493. Magenta, *La Certosa di Pavia*, pp. 343 *sqq.*

Milan on Dec. 18, 1505. From the remains of his frescoes at the Certosa we judge him to have been an artist of the most ordinary power (Calvi, *Notizie*, ii. 201–203, 254).[1]

Giovanni Jacopo di Filippo da Lodi, a contemporary of Foppa and author of an Annunciation (obliterated) above the portal of the great cloisters of the Ospitale Maggiore at Milan, completed an altarpiece for the Gesuati of San Girolamo (missing) in 1472 (Caffi, *Arch. stor.*, 1869, parte i. p. 173; Calvi, *Notizie*, ii. 130).

Troso di Giovanni Jacobi, of Milan, has been considered by many authors (*e.g.* Lanzi, *History of Painting*, ii. 476), as the true painter of the frescoes bearing the signature of the Zavattari in the Duomo of Monza. A deed, from which we learn that he was of age in 1477 (Tassi, *Pitt. Bergam.*, i. 30), proves that he was then practising at Bergamo in partnership with one Giacomo de' Scannardi d'Averaria. During his stay at Bergamo he designed cartoons for Fra Damiano's tarsies in San Domenico (Anonimo ed. Morelli, p. 50) and adorned the front of a mansion in Pòrta Pinta. At Monza, in 1490, he received the commands of Lodovico Sforza to paint in the Porta Giovia palace (Calvi, ii. 242). He subsequently worked largely at Milan, decorating the façade of the Mendozza palace in the Via de' Maravigli (Lomazzo, *Tratt.*, p. 271), with designs "surprising for their beauty" (*ibid.*, and S. Resta to G. Ghezzi, *Lettere Pitt. racc. Bottari.*, Milan, 1822, iii. 505). His latest specialty was "grotesques, arabesques, chimæras, fruit, and birds" (Lomazzo, *Tratt.*, p. 475.)

Zanetto Bugatti enjoyed the emoluments of place at the Courts of Francesco and Galeazzo Maria Sforza. On two important occasions he was charged with the delicate commission of taking the likenesses of marriageable princesses—that of Ippolita Sforza, sent to France in 1460, that of Bona of Savoy taken for Galeazzo at the French Court in 1467. Bugatti's next sitters were Galeazzo Maria, his wife and their children, placed (1473) in the choir of San Celso of Milan. His latest creations were frescoes in Santa Maria delle Grazie at Vigevano. In 1476 he was still living (Calvi, *Notizie*, ii. 192–4, 195).[2]

[1] For notices of this painter see also Magenta, *ub. sup., passim.*

[2] In 1460 Zanetto Bugatti was sent by Bianca Maria Visconti, Duchess of Milan, to study painting under Rogier van der Weyden at Brussels; he was back at Milan in May 1463 (Malaguzzi-Valeri, *ub. sup.*, pp. 126 *sq.*). The paintings in Santa Maria delle Grazie at Vigevano were executed in 1472 (*ibid.*, pp. 114 *sqq.*). Zanetto died before March 9, 1476, at which date Galeazzo Maria Sforza wrote to his ambassador at Venice for Antonello da Messina, whom the Duke wanted

Francesco de Vico would have remained unknown but for the discovery of his name in the books of the Milan Hospital. After the foundation of that edifice in 1456,[1] active measures were taken to secure its being adorned with suitable paintings ; and Foppa was employed to represent the laying of the first stone in a fresco of the portico (see *antea*). One of the minutes of a chapter meeting held in April 1464 contains a resolution ordering portraits of the Duke and Duchess of Milan to be taken as a tribute of honour by an artist of skill. Between that date and 1472, when payments are recorded (MS. Milan Hospital), de Vico completed the two pictures which are now preserved in the hospital church.

The interest in these canvases lies in the subjects rather than in their treatment. One of them represents Francesco and Bianca Maria Sforza kneeling before Pius II., who grants a Bull to build the hospital. The Pope is surrounded by cardinals, the Duke and Duchess in gala dress. In the second canvas the Duchess and her consort kneel at an altar in front of the hospital attended by the Archbishop of Milan and suite. It is a pity that de Vico's power as an artist should be lost in a maze of repaints. We may safely consider him to have been a third-rate Milanese (cf. de Pagave Life of Bramante MS. and Calvi, ii. 62). His manner may perhaps be traced from earlier efforts of the school, of which remains are preserved.

At Cascine d'Olona, within twelve miles of Milan, there is an oratory containing the Crucifixion, Last Judgment, and other gospel subjects. The Four Doctors are in the ceiling, St. Anthony and another saint in a fragmentary state on the façade. A stone within the portal bears words in Gothic letters to this purport : " Ista eleẋia est edifichata et consecrata p. P. paulus de Mantegazis ad onorĕ Sti. Johī Batiste ann° MCCCCLXVIIJ." These frescoes are not well preserved, being in part obliterated and stained, but where time has spared them they divulge an art akin to that of the Milanese of the middle of the fifteenth century, the figures being wooden and shadeless, and outlined with black, stringy contours. They are lower in the scale of art-production than those of the Schifanoia at Ferrara, yet of similar impress, recalling works by persons of the following

to succeed Zanetto as his official portrait-painter (cf. *postea*, p. 421, n. 1). M. P. Durrieu (in *La Chronique des arts*, 1904, p. 232) has made the very plausible suggestion that a picture of the Crucifixion with the portraits of Francesco Sforza, Bianca Maria Visconti, and Galeazzo Maria Sforza in the Brussels Gallery (No. 31) is by Zanetto Bugatti.

*[1] Or rather 1457. (Ffoulkes and Maiocchi, *Vincenzo Foppa*, pp. 38 *sq*.)

of Benozzo and Roselli. Work of the same stamp, but not
without signs of improvement, is to be found in a lunette fresco
of the Epiphany in the right transept of Sant' Eustorgio, in a
fresco of the Flagellation on the walls of the cortile at Santa
Maria delle Grazie, and in a monumental altarpiece alternately
given to Bramantino, Civerchio, and Foppa, in San Pietro in
Gessate, at Milan (see Rosini, *ub. sup.*, Tav. xcvii.; Calvi,
Notizie, ii. 207; and Passavant, *Kunstblatt*, No. 67, 1838).
Amongst the second-rates at Milan there were doubtless some
whose style bore the general impress of the early Bramantinesque
coincident with distinct marks of inferiority. The altarpiece at
San Pietro in Gessate is of this kind, a large canvas tempera
divided into fields by architrave and pilaster. The Virgin and
Child adored by a kneeling couple (supposed to be Mariotto
Obiani and his wife, Antonia Micheletti), between St. Anthony
and St. Benedict, sit enthroned in the lower course; the upper
contains Christ supported on the edge of the tomb by angels,
with St. Sebastian and St. Roch at the sides (condition : dimmed
by varnishing—Virgin's blue mantle retouched). The group of
the Madonna is fairly conceived and not unattractive, the Virgin
comely, and the child of pleasant shape. The drawing is careful
and precise, the architectural background tasteful and appro-
priately filled. The nude in the upper course is dry and wooden
in consequence of the primitive way in which the projections of
bone and muscle are indicated by lines. A dull grey tone
pervades the surface. Without the merit of Foppa or Braman-
tino, this piece reminds us in some points of de Vico ; and it may
be placed in the same class as the Flagellation at Santa Maria
delle Grazie, or the subjects at the Hospital. Examples of the
same sort are to be found in certain wall-paintings at San Pietro
in Gessate, assigned to Civerchio, and forming the decoration of
a chapel dedicated to the Virgin (Calvi, ii. 208; yet in another
place the same author assigns these frescoes to Pisano (*ibid.*,
p. 107). On one of the fields is the Marriage, on the other the
Death and Ascension of the Virgin. The ceiling, much damaged
by damp, is divided into sections containing saints in couples
and angels in medallions. We might attribute the free motion
of certain figures in the Assumption to a man under the influence
of Borgognone, but we distinguish something akin to the manner
of de Vico, in the hardness and ugliness of oblong heads, the
black and broken contour of the frames and drapery, and the
dryness or stilted air of the personages in the foreground of
the same composition.

Giovanni Donato Montorfano is better known to us than

other Milanese artists of the second or third rank, because every traveller who visits Santa Maria delle Grazie to mourn over the ruins of da Vinci's Last Supper feels bound to cast a glance at the Crucifixion on the opposite wall. The blotches on the foreground of that vast and dramatic composition indicate where Leonardo once painted those likenesses of the Duke and Duchess of Milan, which, from the peculiar nature of their technical treatment, were doomed to speedy and complete destruction. There is much richness and variety in the distribution and movement of the life-size figures which are thrown in numbers upon the wall. Besides the chief incidents of the subject *per se* a line of saints occupies a portion of the ground and gives to the whole design something of a formal, unartistic character. Anthony, Peter Martyr, Chiara, and others stand in the middle distance; whilst St. Dominic and a brother of his Order kneel opposite each other in front. Between the latter, a cartello exhibits the words: "1495. Io.Donatus Montorfanu. p." Vasari says truly of this fresco that it is in the antiquated manner (iv. 32 *sq.*), yet the figures, if not remarkable for beauty or expression, are correct in proportion and diverse in character. A dignified calm pervades the forms of the crucified Saviour, whose frame is rendered with studied imitation of the anatomy of nude; but the coldness of the flesh parts, the want of strong shadow, and the realism of embossments, detract from the merit of the picture; and awkward stiffness is produced to the eye by opaque tone, defective drawing of feet and hands, and angular break of drapery folds.

Before acquiring the power undoubtedly displayed in this piece, Montorfano must have had considerable practice; and we may believe that he is the same person whom we discover in records under the name of Batista Montorfano as valuer of the decorations at the Porta Giovia palace in the reign of Galeazzo Maria Sforza.

There are fragments from the ruins of the Milanese church of Santa Maria della Rosa representing single figures of saints, two female (one half gone), and one male in episcopals, now in the court of the Ambrosiana (assigned by Calvi, ii. 250, to Borgognone), which are clearly by the author of the Crucifixion; but we may perhaps most correctly class amongst his works the scenes from the legend of St. Anthony in a chapel at San Pietro in Gessate. Though some writers give these frescoes to Civerchio (Vasari, annot., iii. 653), the tendency of criticism has been to ascribe them to Butinone and Zenale (Passavant, *Kunstblatt*, 1838, No. 67; Calvi, ii., 107, 116); but we

can see by comparison that, though somewhat reminiscent of
Zenale, they are not similar to the fragment in the chapel of
St. Ambrose. Montorfano here has an advantage denied to
him at the Grazie, in the smaller size of the personages and the
more pictorial nature of the subject ; he is for that reason more
successful, though he never rises to a very high level. In both
lunettes of the chapel there are three standing saints, and figures
fill the ribbed vaulting as well as the window slants. One of
the principal episodes on the walls below is St. Anthony driving
out the Devil, the other is St. Anthony communing with his
Disciples and receiving food from an Angel. There are many
points of resemblance between the group of the Possessed Girl
and her Relations, and that of the swooning Madonna in the
Crucifixion at the Grazie, a resemblance of form, of drawing, and
technical execution. In the other frescoes this resemblance is
confined to the features of a landscape and the general order of
distribution. It may be that Butinone and Zenale contracted
for this chapel, but we might then suppose that they entrusted
the execution to Montorfano.[1]

It has not been proved, yet it may be likely, that Ambrogio
da Vigevano, who was de' Motti's partner at Cantù in 1514, was
one of the Bevilacqua mentioned by Lomazzo (*Trattato*, p. 405).
There were two brothers of that name, Ambrogio and Filippo,
both, as partners, employed in the Milan palace (*ibid.*), but the
latter less known than the former. Ambrogio painted a Charity
and scenes incidental to the exercise of charity on the front of
the Milan poor-house in 1486 ; he had for some time a salary in
the Duomo. We are not acquainted with more than one of his
pictures—a Virgin and Child with a kneeling Devotee between
King David and Peter the Martyr at the Brera (No. 255, wood,
m. 1·36 high by 1·38), inscribed : " Jo Ambrosius De Beaquis
Dictus Liberalis pinxit 1502." We still discern beneath the
injuries of time the original feebleness of this panel. It is a
cold, washy production suggesting the influence of Borgognone.
It leads us to give Bevilacqua the Madonna with Saints and
Devotees catalogued in the Berlin Museum (No. 1137) as a
Bramantino. See Calvi, *Notizie*, ii. 236.[2]

* [1] Several artists called Montorfano practised at Milan during the fifteenth and
at the beginning of the sixteenth century. For notices of them see Caffi in *Archivio
storico lombardo*, ser. i. vol. v. pp. 85 *sqq.*, and Malaguzzi-Valeri, *ub. sup., passim.*

* [2] There exist some paintings by Ambrogio Bevilacqua not mentioned by
the authors. See Morelli, *Die Galerien zu München und Dresden*, pp. 344 *sq.* ;
idem, Die Galerie zu Berlin, p. 122 ; Catalogue of the Milanese Exhibition, Bur-
lington Fine Arts Club, p. xxxix ; Malaguzzi-Valeri, *ub. sup.*, pp. 165 *sqq.* ; Pauli,
in Becker and Thieme, *Allgemeines Lexikon der bildenden Künstler*, iii. 559 *sq.*

Of Stefano de' Magistri and Stefano de' Fedeli, of Gottardo Scotto and Jacopo Vismara, we know no more than has been stated in previous paragraphs.[1]

Bernardino de' Conti is a follower of Zenale, of whose life no record has been kept.[2] A profile bust of a Prelate in the Berlin Museum (No. 55, wood, 1 ft. 8 in. high by 1 ft. 7 in.) bears his name: "Me fecit B'nardinus de Comitibus," and the date " MCCCCLXXXXVIII." It is a harsh, sombre panel with flesh shadows of an earthy tinge. Of similar technical treatment, and reminiscent alike of the schools of Zenale and Gian' Pedrini, is a Virgin in profile giving the breast to the Infant at a window with a flower-vase on its sill and a landscape outside. This Madonna is known at Schleissheim (No. 1115) as a Garofalo, and has suffered from flaying;[3] it is the original of a replica of feeble character in the Lochis Gallery at Bergamo (No. 134), inscribed: "Bernardinus de Comitibus pinxit 1501." In both pieces the Child looking round and turning its back to the spectator is outlined in the manner of that which we see ascribed to Leonardo, though really by Zenale, at the Hermitage in St. Petersburg (No. 13A, St. Petersburg, see *antea*, in Zenale). Though an artist of small means, Bernardino sometimes succeeds better than usual when copying or adapting the works of superior masters. We just observed some likeness between parts of a Madonna at Schleissheim, and another at St. Petersburg. A copy of the latter (wood, half-life) in the Museo Poldi-Pezzoli (No. 639) at Milan displays Bernardino's stiffness of impast and sombre key of tone. The same group, apparently by the same hand, is in the Borromeo collection at Milan, and in a round (much repainted, but assigned by Waagen, *Treasures*, iii. 122, to Boltraffio) at Blenheim.[4] At Milan, however, the background is a wall with two windows. Of this class, again, we should register No. 118 at the Carrara Gallery representing the Marriage of St. Catherine, a copy of which, in half-lengths, with the

* [1] For Stefano de' Fedeli see Malaguzzi-Valeri, *ub. sup.*, pp. 227 *sqq.* By Gottardo Scotto there is a triptych, signed "Gotardus (de) Scotis de Mello pinsit," in the Museo Poldi-Pezzoli at Milan; allied in style to it is a picture representing six scenes from the life of the Virgin in the collection of Avv. A. Cologna, of Milan. See *ibid.*, pp. 217 *sq.* As for Jacopo Vismara, see *ibid.*, *passim.*

* [2] It is now stated that this artist died at Pavia in 1525 at the age of seventy-five. See Carotti, in *L'Arte*, iii. 307.

* [3] This picture was subsequently transferred to the Pinakothek at Munich (No. 1044), and has lately been removed to the Augsburg Gallery. It is now labelled, "Milanese School, about 1500."

* [4] The Blenheim pictures are now dispersed.

addition of a St. Jerome, is called Leonardo in the collection of the Earl of Dudley.[1]

Lomazzo mentions, besides Foppa, two painters of the name of Vincenzo; he speaks of Vincenzo Civerchio and Vincenzo Bressano, assigning to the first the miracles of St. Peter the Martyr and the Four Doctors in the pendentives of the Cappella di San Pietro Martire at Sant' Eustorgio, and frescoes in the castle of Milan. Of Vincenzo Bressano he merely notes the talent in producing friezes and foliage ornament (*Trattato*, pp. 317, 405). The loss incurred by the destruction of most of the works ascribed to Vincenzo Civerchio of Milan is under these circumstances serious ; yet we may find some means of correcting Lomazzo in the small fragments which remain. The Doctors at Sant' Eustorgio are seen looking out of circular openings in deep perspective, in the manner of those designed in the semidome of the Eremitani at Padua. It is difficult to shake off the impression that they were executed by Foppa, whom we saw imitating the accessories of Mantegna in a Martyrdom of St. Sebastian; nor can we think it likely that two persons called Vincenzo should have lived at Milan after receiving their education at Padua. We should be strengthened in these doubts by the fact that there are no other frescoes at Milan to be classed with those of Sant' Eustorgio except the frescoes of Foppa ; and further by the fact that the Doctors at Sant' Eustorgio, injured as they have been, still bear marks of the pleasant colouring and natural action which are common to figures by Vincenzo Foppa.[2]

* [1] This picture is now untraceable. In addition to those noticed by the authors, the following are also works by Bernardino de' Conti : (1) Berlin, Kaiser Friedrich Museum, No. 208. Portrait of Margherita Colleoni. (2) Berlin, Schloss. Portrait of Fra Sisto della Rovere. Signed and dated 1501. (3) Florence, Uffizi, No. 444. Male portrait. (4) Hanover, Provinzialmuseum. Male portrait. (5) Fonthill, collection of Mrs. Alfred Morrison. Female portrait. (6) Milan, Brera, No. 271. The Virgin and Child with St. John. Signed and dated 1522. (7) Milan, collection of Signor B. Crespi. Male portrait. Signed and dated 1497. (8) Naples, Museum. The Virgin and Child with St. John. Signed and dated 1522. (9) Paris, collection of Mme Édouard André. Male portrait. Signed and dated 1500. (10) Potsdam, Neues Palais. Free copy of Leonardo's Virgin of the Rocks. Signed and dated 1523. (11) Rome, Vatican. Portrait of Francesco Sforza, aged five. Signed and dated 1496. (12) Rome, collection of the late Comm. Giulio Sterbini. Male portrait. Signed. (13) San Remo, collection of Herr Ad. Thiem (lately). Male portrait. (14) Turin, late Agrogna collection. Portrait of Castellaneus Trivulcius, 1505. (15) Varallo, Istituto delle Belle Arti, No. 9. Male portrait. Signed.

* [2] The frescoes in the lunettes of the Cappella di San Pietro Martire were rescued from whitewash and restored in 1871-3 ; they represent scenes from the lives of the Virgin and St. Peter the Martyr. It seems likely that the

Nor is there any pretext for attributing either to the artist of Sant' Eustorgio, or to Vincenzo Bressano, the wall-paintings of the chapel of St. Anthony or the Obiani altarpiece at San Pietro in Gessate, which, as before remarked, are in the manner of Montorfano, Francesco de Vico, or others of that school. (Lomazzo, *ub. sup.*; Carlo Torre, *Ritratto di Milano*, p. 319; Latuada, *Descriz. di Milano*; Calvi, ii. 207; Passavant, *Kunstblatt*, 1838, No. 67.)

Vincenzo Bressano is probably the person known to us as Vincenzo Civerchio, or, as the Anonimo calls him, " il Forner " of Crema (Anon., p. 55), who appears for the first time at Brescia in 1493 as the successor of Foppa.[1] He spent four years in adorning the choir of the old cathedral, a laborious work which perished early (Zamboni, *Memorie . . . di Brescia*, p. 109, n. 29); and his signature appears to authenticate an altarpiece on a panel in San Barnaba of Brescia, inscribed, " Opus Vincen-ciu de Crema 1495 "; but the massive smears which cover the surface, and the present condition of the syllables of the name, suggest unpleasant suspicions; and it may be prudent to withhold a confident opinion as to the authorship of the picture. In a lunette affixed to the upper framing the Saviour is supported on the sepulchre by the Virgin and Evangelist, whilst, lower down, St. Nicholas stands on a crystal orb, in the transparence of which a quaint demon writhes. A bishop and a female hold a crown in air above the saint's head, and four angels adore his presence. At the sides are St. Sebastian and St. Roch in landscapes of very copious details. The drawing is resolute and cornered, but very poor in the extremities, the colour sombre, rough, and of that olive tinge in flesh which we meet in the works of Liberale da Verona. A vertical split runs down the middle of St. Nicholas, the gold grounds are new, and the signature in the hem of St. Roch's garment is regilt.[2]

pictorial decoration of this chapel was carried out by a company of painters, perhaps under the supervision of Vincenzo Foppa, to whom the Four Doctors of the Church may confidently be ascribed. The chapel was founded by Pigello Portinari, probably in 1462; according to a sixteenth-century chronicler, it was finished in every respect in 1468, the year of Portinari's death. Ffoulkes and Maiocchi, *Vincenzo Foppa*, pp. 57 *sq.*; Malaguzzi-Valeri, *ub. sup.*, pp. 157 *sqq.* For the date of these frescoes see also Suida, in *Monatshefte*, ii. 481 *sq.*

* [1] Foppa, as we have seen (*antea*, p. 326, n. 1), was still living in 1493. There were several painters named Vincenzo in Brescia at the beginning of the sixteenth century (Ffoulkes and Maiocchi, *ub. sup.*, pp. 285 *sqq.*). In Civerchio's will the appellation " Fanonus " is given to him (Caffi, in *Archivio storico italiano*, ser. iv. vol. xi. pp. 329 *sq.*).

* [2] This altarpiece is now in the Galleria Martinengo at Brescia.

Of Civerchio's residence at Brescia during 1504 we have
further proof in a Pietà executed for Sant' Alessandro of
Brescia.[1] In a landscape rich in minutiæ, but harsh in its
contrasts of dark ground and green trees, the Virgin bends over
the dead body of the Saviour on her lap, whilst the Magdalen,
in tears, clasps the feet. St. Paul looks over the Virgin's
shoulder, and St. John stands grieving to the left, the naked Adam
in rear symbolizing original sin. On a cartello we read : " Vin-
centius cremeneñs ⚹ MDIII." Though artistically arranged,
this piece remains ineffective from lack of shadow. The drawing,
of careful finish, is neither bold nor correct, nor is there any
delicacy in the form of extremities. Draperies are purposeless
and frittered away in angular breaks ; flesh of earthy brown
coincides with vestment tints of pallid key, and both are melting,
empty, and unsubstantial. Scenes from the Passion, thrown off
with some spirit in a predella, show no less neglect than the
rest of the picture. Of the same date, and probably by the
same hand, is the Entombment in the Chapel of the Sacrament
at San Giovanni Evangelista, a composition of nine figures in
a landscape, with Golgotha in the distance, assigned (antea, i.
187, n. 9) to Giovanni Bellini. Unauthentic as works of Civer-
chio are the small subjects in the framing of the Annunciation
under Angelico's name in Sant' Alessandro.[2]

Though Brescia conferred on Civerchio the honour, without
the charges, of citizenship (so the word " Civis Brixiæ donatus "
has been interpreted), he did not reside there constantly. He
was back at Crema about 1507,[3] and it was he who painted for
the town-hall the customary St. Mark between Justice and
Temperance, for which two years later the French governor
Ricaud substituted the arms of France (Ridolfi, Marav., ii. 163).[4]
Other productions of Civerchio perished later—amongst them the
Annunciation on the shutters of the organ and a carved figure of
St. Pantaleo in the Duomo of Crema (Anonimo, p. 55 ; Ridolfi,
Marav., ii. 163), a Virgin and Gabriel annunciate in the spandrels,
with the Eternal in the key of the choir arch, besides St. Jerome
and other figures in chapels at San Bernardino (Calvi, ii. 213)
and pictures in San Giacomo of Crema (ibid.).

* [1] In 1498 Civerchio was living in the S. Faustino quarter at Brescia
(Ffoulkes and Maiocchi, ub. sup., p. 248); but in 1500 he is recorded as having
been at Crema (Caffi, loc. cit., pp. 343 sq.), and he may well have settled there
at that period. It is not necessary to assume that the Pietà in S. Alessandro at
Brescia was painted in the latter town.

* [2] Cf. antea, i. 112, n. 3. * [3] Cf. antea, n. 1. * [4] Cf. Caffi, loc. cit., pp. 336 sq.

The earliest of Civerchio's works at Crema is the altarpiece of St. Sebastian between St. Christopher and St. Roch (wood, oil, life-size), on the foreground of which are the painter's monogram, two V's interlaced with C, the date "DXVIIII," and the name : " Vincētius Civertus Cremsis civis Brixie Donatus faciebat." This panel, on the second altar to the left of the portal in the Duomo, was painted for the Braguti family for twenty-nine ducats (Calvi, ii. 212),[1] and is in respect of treatment similar to that of 1504. We discover some slight changes of style in a Madonna attended by Angels and Saints (wood, life-size) in the old Duomo of Palazzuolo. As in earlier pieces, angularity and stilted affectation mark the form and drapery of certain figures, that of the Baptist to the left especially, whilst the opposite one of St. Fedele and the half-lengths of St. Catherine and the Magdalen in the upper course denote an effort to cast off old stiffness and assume the freedom of Romanino ; yet the drapery is not so broad but that it betrays the tendency to angularity, and the colour is not so bright but that it displays the fault of emptiness. On a cartello is the monogram with the words : " Vicentius Civerchius de Crema pinxit MDXXV." St. Sebastian, St. Augustine, and St. Roch are introduced into the plinths ; the daughter of Herodias presenting the head, the Decollation, and the Nativity of Mary into the intermediate fields of a predella. We had occasion to compare this piece with others of a similar manner by Brescianino ; it has been broken out of its old frame and removed from the high altar to the sacristy—a series of operations by which its value was seriously impaired.

Large commissions were given to Civerchio in 1526, the most important of which was doubtless for painting fresco portraits of illustrious citizens in the town-hall of Crema (Ridolfi, Marav., ii. 163 ; Calvi, ii. 213). To the same period are assigned the restoration of an old and miraculous effigy of the Pietà in the Duomo of Crema (Anonimo, p. 55), the Death of the Virgin (1531) in the same place (Calvi, ii. 212),[2] and other pieces which came into the Monte di Pietà (ibid.). The latest authentic picture of Civerchio is the Baptism of Christ, originally executed for Santa Maria of Crema in 1539 and now in the Tadini collection at Lovere (No. 36), a canvas with life-size figures of the Baptist pouring water on the head of the

* [1] This is a mistake; it was executed for the Guild of the merchants of Crema (ibid., p. 337).
* [2] Shortly before 1883 the last-mentioned picture was bought by the Conte Carlo Sanse·erino, of Crema (Caffi, loc. cit , p. 339).

Saviour, three angels holding the garments at the side of the stream, and the dove with boy cherubs floating in air. On a cartello : " Vicentius Civercius de Crema civis Brixie donatus fecit I.D. xxxviiij." In the neglected treatment of the work and its marked exaggeration of earlier feelings, we detect the result of age and carelessness. A Virgin and Child between St. Stephen and St. Lawrence in the same collection (No. 57), with a variety of form in the monogram (the C being placed in the centre of the interlaced V's), is catalogued under the name of Carlo Urbino, which may point to an erroneous nomenclature or to the fact that Carlo Urbino was Civerchio's disciple. Another example in which the monogram is an upturned V with the C in the centre is a canonized monk in the Lochis Gallery (No. 18), a canvas tempera, the true character of which is lost in repaints.

Before his style was reduced to the state in which we find it at Lovere Civerchio probably designed fifteen scenes from the fable of Psyche, of which there are still remains in the house now called Casa Carioni but of old Vilmarcà at Crema (Anonimo, p. 56). The manner in these compositions, and the manner in busts of males and females, which form part of the same decoration, might prove that the artist did not disdain to use designs by Giulio Romano. A triad with angels in Sant' Andrea, and a frieze in Casa Zurla at Crema, are mentioned as works of Civerchio (Calvi, ii. 213-15). A Virgin and Child adored by four Saints was ascribed to this master in the late Northwick collection.[1]

Pavia, the old capital of the Lombard kings and favourite resort of the Sforzas, was too much dependent on Milan to support more than a small band of local craftsmen. It was not overlooked in 1490 when Lodovico il Moro undertook the hurried decoration of the Porta Giovia Palace. In the chequered list of artists ordered to Milan for this occasion we find the names of eight painters residing at Pavia, and a ninth who was a Pavian resident at Cremona. Of the nine, four are known by extant productions.[2]

* [1] Civerchio made his will at Crema in 1544 (Caffi, *loc. cit.*, p. 329).

Among the works by this artist which have not been noticed by the authors we may mention the following : (1) London, collection of Lady Jekyll. The Funeral of St. Jerome. (2) Milan, Brera, No. 248. The Nativity of Christ. Signed. (3) Paris, Louvre, No. 1274. Bust of the youthful St. John the Baptist.

[2] Calvi, *Notizie, ub. sup.*, p. 242.

Agostino da Vaprio is probably identical with Augustino del Maestro Leonardo summoned to Milan as above described, and perhaps disciple of Leonardo da Pavia, whose antiquated Madonna with Four Saints, dated 1466, is preserved in the Palazzo Bianco of Genoa.[1] He shows much of the quaintness of the olden times in a Virgin with Four Saints dated 1499 at San Primo of Pavia; and, though he laboured close upon the end of the sixteenth century, he preserved something of the feeling of Foppa and Civerchio under the modern garb of Borgognone.[2]

Bernardino Rossi, who was completing a contract at Castel San Giovanni near Piacenza when called to Milan, began in a form which slightly recalls Borgognone, and ended as a follower of the Leonardesques. In every phase of change he preserved his mediocrity. There is a decent staidness and fair proportion in one of his frescoes at Santa Maria della Pusterla at Pavia, which bears the date of 1491. In the latest of the wall-paintings which he finished between 1498 and 1508 for the Carthusians of Pavia he inclines to imitation of Luini ; and there is no better proof of this than the Eternal and Prophets or the Angel and Virgin Annunciate on the front of the vestibule leading into the great court of the Certosa. His earlier tendency to borrow from Borgognone may be illustrated in the Madonna of Casa Bottigella, which even now bears Borgognone's name.[3]

[1] It might also be conjectured that this artist was a pupil of Leonardo da Vinci, who mentions one "Maestro Agostino da Pavia" as his friend in a MS. in Paris. (Müller-Walde, in the Berlin *Jahrbuch*, xviii. 106, n 1.)

[2] Agostino da Vaprio is but one of a large family of craftsmen, of whose works no trace has been preserved (see *antea*; and consult Calvi, *Notizie*, ii. 91, 96, 97, 101, 102, 194). The picture in San Primo of Pavia is an altarpiece in three arched compartments, representing the Virgin and Child between a Prior presenting a kneeling Patron and St. John the Baptist; in an arched pinnacle is the Eternal — all on gold ground. On the base we read : "Hoc opus fecit fieri D. io. ambrosius de podio qui ex voto facto beato io. Philippo De Faventia liberatus fuit a mortali infermitate 1498 die 9 Setembris Augustinus de Vaprio pinxit 1498 die 4 Aprilis (ergo n. style 1499)." The figures are half the size of life. In Vaprio's style are an Eternal bust and two groups of angels, fragments of a fresco of the coronation from the church of S. Francesco di Paola in the elementary school of painting at Pavia.

The Madonna of Leonardo da Pavia is a canvas tempera with numerous repaints representing the Madonna enthroned between St. Francis, St. Chiara, a bishop, and St. John the Baptist, inscribed on the throne-step: "Opus Leonardi de Papia 1466." The execution is childishly antiquated.

[3] Pavia, Santa Maria della Pusterla, now Seminario. The Virgin seated in profile with a male and female kneeling at her feet, near whom stands a saint. On a cartello : "Fecit fieri Antonius de Putiio de anno MCCCCLXXXXI Bnardinus de Rubeis pinxit." Two neighbouring figures have been whitewashed. The lost

Lorenzo de' Fasoli, the third on our list, wandered at the beginning of the sixteenth century to the western coast, and took the freedom of his guild at Genoa. What his art may have been previous to this migration we cannot pretend to ascertain ; it afterwards betrayed a decided familiarity with the models of Brea. In the church of the nuns of Santa Chiara at Chiavari there is an altarpiece by Fasolo, dated Sept. 30, 1508, representing a deposition from the cross with St. Chiara, St. Bernardino, and eleven nuns, and a patron with his wife and children (Santo Varni, *Appunti artistici, ub. sup.*, p. 34). In 1513 Fasolo painted the Virgin with the Marys of Scripture and the members of their families for a church at Savona, and this altarpiece, in a favourable place at the Louvre, displays the same class of types and masks as those which Brea derived from Panetti and other followers of Lorenzo Costa. Fasolo here scarcely attains to more than a cold and conventional symmetry ; there is a calm serenity in the attitude and expression of his figures which verges on lifelessness, a patient minuteness in outline and treatment which palls. Borders and detail are gilt after the fashion of Mazone of Alessandria, and some of the masks recall those of Macrino d'Alba. Documentary evidence of the painter's death before 1520 is available.[1]

Lorenzo educated one of his sons to the practice of his craft ; and Bernardino di Lorenzo Fasolo was member of the council in the guild of Genoa as early as 1520. A Madonna which bears his name and the date of 1518 at the Louvre displays an earnest and not unpleasant approach to the tenderness, if not to the strength, of the Leonardesques. In a Holy Family at Berlin

frescoes of Rossi in the Certosa are noted in Calvi (ii. 264), together with others completed in 1511 at Vigano, a church belonging to the Carthusians of Pavia. The small church of the monastery of Santa Maria della Pusterla is filled with monochromes, which may well be (as Calvi states, i. 264) by Rossi. For the altarpiece of Casa Bottigella see *antea*, p. 368 *sq.*, and compare Calvi, ii. 242.

[1] Paris, Louvre, No. 1284. Wood transferred to canvas. Measures 2 ft. 2 in. high by 1 ft. 44 in., inscribed: "Laurentius Papien. fecit MDXIII." The same composition in the style of a disciple of Macrino d'Alba may be found in the Cathedral of Asti. (Cf. Spotorno (G. B.), *Storia Letteraria della Liguria*, 8vo, Genova, 1824–25, iv. 203.) In a memorandum of agreement between the guilds of painters and goldbeaters signed on the 12th–17th of July, 1520, by Bernardino, the son of Lorenzo of Pavia, we find Bernardino's name written thus : "Bernardinus Faxolus qm laurentii," from whence we have to conclude that Lorenzo was dead. (See Professor Santo Varni's *Appunti artistici sopra Levanto*, 8vo, Genoa, 1870, pp. 118–19.)

* For notices of this painter see also Alizeri, *Notizie dei professori del disegno in Liguria*, ii. 235 *sqq.*, and Suida, *Genua*, pp. 81 *sq.* He was born about 1463, was settled in Genoa in 1494, and was dead in April 1518.

the figures are dry and slender, but freely treated in the mode of Pier Francesco Sacchi; but both pieces lack clearness and light.[1]

The last name on our list is that of Antonio della Corna, whose summons to Milan in 1490 was directed to Cremona. The only picture which bears this painter's name is in the Bignami collection at Casal Maggiore, and represents a murder. A frenzied man near a couple lying in bed, having stabbed one of his victims, is about to stab the second. A woman behind him witnesses the act, and through the opening of a triumphal arch in the distance the Crucifixion and the Martyrdom of St. John the Evangelist are depicted. According to the legend, St. Julian killed his father and mother in a fit of jealousy, believing them to be his own wife and her paramour, and this scene della Corna tries to delineate with all its concomitants of rage and sorrow. There is no means, unhappily, of giving pictorial expression to St. Julian's mistake, and for this, if for no other reason, it would have been wise to avoid the subject; but Antonio thought

[1] (1) Paris, Louvre, No. 189. Wood, m. 1·38 high by 0·83, once in the Braschi collection at Rome (Lanzi, ii. 491), inscribed: "Bernardinus. Faxolus. de Papia. faciebat 1518." (2) Berlin Museum, No. 209. Wood, 1 ft. 9¾ in. high by 1 ft. 7½ in., from the Giustiniani collection. St. Joseph and the Virgin in front of a green curtain read together in a book, whilst the infant Christ sleeps on his mother's lap; distance landscape.—For Bernardino's presence at Genoa in 1520 see Spotorno, *ub. sup.*, iv. 202–3. On the 12th–17th of July, 1520, he signed a memorandum of agreement drawn up to regulate the relations of the guilds of painters and goldbeaters at Genoa. See Santo Varni, *Appunti artistici, ub. sup.*, p. 119. [* Bernardino Fasolo was born about 1489; he was one of the "consuls" of the painters' guild at Genoa in 1513, and was still living in 1522. Cf. Alizeri, *ub. sup.*, iii. 185, 245 *sqq.*; Suida, *ub. sup.*, p. 81.] Amongst other works of the same class and style as that of the Louvre we note: (3) Pavia, San Marino, first altar to the right. The Virgin and St. Joseph raise the cloth that covers the infant Christ; in rear to the left St. John the Baptist, to the right St. Joachim, distance architecture—injured panel, with life-size figures. Frescoes of the same school in the chapel to which the altar belongs. Nativity, Annunciation, and saints in couples, of which some are obliterated. In the soffit of the entrance arch the Virtues, abraded and retouched. An art much akin to this again is observable in the Virgin and Child between the kneeling St. Jerome and the standing Baptist, with a background of landscape, pillars, and green drapery held up by angels, an altarpiece in the choir of San Marino with a long inscription, and the date 1521. We may register in the same class the following: (4) Pavia, San Teodoro, transept frescoes (retouched) of 1514, representing scenes from the legend of St. Theodore. (5) Pavia, San Francesco, sixth chapel to the right. Wood, one-third of life. St. Mary Magdalen supports a female making the gesture of benediction, whilst two youths stand and kneel to the right; at the sides St. Francis recommends a kneeling female, and a bishop in prayer. (6) Pavia, Malaspina collection, a St. Jerome. Wood, m. 1·57 high by 0·93.

it afforded a good opportunity for exhibiting knowledge of movement in the stride and action of the assassin and skill at foreshortening in the persons of the victims. He only succeeds in exhibiting a total lack of artistic power and caricaturing the disagreeable features of Mantegnesque art. One point of interest may be found in this, that the picture bears the date CIƆCCCCLXXVII., and a signature as follows :

" Hoc q. Mantenee didici[t] sub dogmate clari
 Antoni Corne dextera pinxit opus."

We shall identify Antonio della Corna with the Pavian of the same name who was noticed amongst the feeble disciples of Mantegna at Mantua, and we may attribute to the same hand the Virgin and Child with Four Saints in the Malaspina collection at Pavia, on which a falsified signature insufficiently vouches for the authorship of Mantegna.[1]

In addition to these, we shall notice Donato of Pavia, who lived at the close of the fifteenth century, and painted the Crucified Saviour between the Virgin, Magdalen, and Evangelist in the Hospital of Savona, and Bartolommeo Bononi, whose Virgin in Glory with saints in the Louvre bears the date of 1507. We may distinguish the paltry creations of Donato from those of Bononi by observing that the first combines much of the old

[1] Casal Maggiore, Bignami collection from the Averoldi Gallery at Brescia. Wood, tempera; figures one-half of life-size. The bed to the right and the figures in it are strongly foreshortened. A wound in the throat of the female, who lies to the right, shows that she has already been despatched. The date in the medallions of the arch is renewed. Zaist, who once owned this picture, described it in his *Notizie* (i. 38). The date as he gives it was written MCCCCLXXVIII.

A Virgin adoring the Child with St. Joseph and St. Jerome (not seen) is said to be in the Casa Martinelli at Soncino, a hard, dry example of Antonio Corna's manner. [* This picture is probably identical with one signed and dated 1494, which is now in the Bagati-Valsecchi collection at Milan. Malaguzzi-Valeri, *ub. sup.*, p. 244.] Pavia, Malaspina collection. Canvas, tempera; 8 ft. 8 in. high by 5 ft. 7 in., with life-size figures of the Virgin, erect on an ornamented pedestal, holding the Infant between the two St. Athonys and two female saints, inscribed with a doubtful signature as follows: " Ændrea. Mͦtiniæ. Patavnus. Pet. 1491." This injured piece is assigned to Mantegna (see *antea*, p. 116, n. 4), and is very dim in surface. The figures are coarse, heavy, and ill-drawn ; the execution is that of a feeble Mantegnesque-like Corna. In this character, and full of grimace, are the Christ Crucified, between two kneeling donors, male and female, with their patron saints, and Christ dead in the Virgin's lap, with four attendant Saints, on two of the piers in the Church of the Carmine at Pavia.

Umbro-Siennese type with elements derived from the school of Borgognone, whilst the second recalls the more modern form of Pier Francesco Sacchi.[1]

Pier Francesco Sacchi is erroneously placed by Lomazzo in the list of those who practised at Milan in the reign of Francesco Sforza. It is quite certain that his works were all executed in the sixteenth century.[2] The earliest date to which we can trace him is 1512, when he painted the Parting of John the Baptist from his Parents for the Oratory of Santa Maria of Genoa, and from that time till 1527 we have numerous extant examples of his style.[3] In 1514 he finished the Cruci-fixion at the Berlin Museum, in 1516 the Four Doctors at the Louvre. He was a member of the Council in the Genoese Guild during 1520,[4] and in 1526 he completed the Glory of the Virgin with Saints at Santa Maria di Castello of Genoa. His last authentic composition is the Deposition of Christ from the Cross in the parish church of Multedo. The petrified figures which he put together in the Crucifixion of 1514 are unattractive,

[1] (1) Savona, Hospitale [* now Town Gallery]. Crucified Saviour with four Angels in flight under each arm of the cross; distance, landscape; inscribed on a cartello: "Donatus comes bardus papiēsis pinxit hoc opus." Dim and injured canvas, distemper, with ill-drawn and affected life-size figures adapted from Borgognone's composition of the same subject dated 1490 in the Certosa of Pavia. [* Another picture by Donato is a Crucifixion in the church of San Giorgio d'Albaro, near Genoa (see Suida, *ub. sup.*, p. 72). This artist is a more interesting and important figure in the history of art than the authors suppose, believing as they do that he lived towards the close of the fifteenth century; as a matter of fact he died in 1451 (Alizeri, *ub. sup.*, i. 246 *sqq.*). Dr. Suida (in *Monatshefte für Kunstwissenschaft*, ii. 476 *sq.*) has rightly pointed out the influence which Donato's works exercised upon Vincenzo Foppa, who from 1461 onwards repeatedly visited Liguria. From what we have said it is obvious that the picture at Savona cannot be imitated from Borgognone.] (2) Paris, Louvre, No. 1174. Wood; m. 1·68 high by·1·14. The Virgin in glory, a kneeling Franciscan recommended by a bishop, and St. Francis; on a cartello on the trunk of a tree: "Opus Bartolomei Bononii Civis Papiensis 1507," from San Francesco of Pavia. The feeble figures are out of drawing and rawly coloured, with a substantial stony impast.

[2] Lomazzo, *Trattato*, p. 405.

*[3] We now know that in 1501, when aged about sixteen, he was apprenticed to the painter Pantaleo Berengerio at Genoa (Alizeri, *ub. sup.*, iii. 141 *sq.*). He died of the plague which ravaged Genoa in 1528 (*ibid.*, pp. 173 *sqq.*).

[4] Soprani (Raf.). *Vite de' Pitt., &c., Genovesi*, 2nd ed., revised by C. G. Ratti. 4to, Genova 1768, i. 375, and Spotorno, *ub. sup.*, iv. 201. As member of the Painters' Guild at Genoa he signed the memorandum of arrangement with the Guild of Goldbeaters of July 12 and 17, 1520 (see Santo Varni's *Appunti artistici, ub. sup.*, p. 119).

from the stony surface of their flesh, the dry smoothness and
thick substance of their impast, and the coarse heaviness of
their outlines. The drawing is cramped, defective, and un-
natural,[1] but as time wore on Sacchi's style gained flexibility,
and he made some progress towards modern ease in the picture
of St. Jerome and St. Martin sharing his Cloak, at the Berlin
Museum. There are few painters whose manner is more
characteristic. He is quite alive to the picturesque features
of feathered hats, trimmed dress, and sashes, but the hardness
and uniformity of his treatment neutralizes their effect, and
the dull harshness of his tones is increased by sombre rawness
and copious detail in landscapes full of accidental upheavals
and obtrusive vegetation.[2] It has been said that Sacchi was
the master of Moretto, because the same types and forms
of tailoring or accessories recur in the pictures of both. It is
true that in the St. Martin at Berlin and Doctors of the Church
at the Louvre Sacchi's fashions are those of Lotto, Moretto, and
Morone, but the styles differ essentially, and the comparison
bears no analysis.

 The Four Doctors seated round a Table were executed for
the church of San Giovanni di Prè, afterwards Sant' Ugo, of
Genoa ; the Crucifixion at Berlin (perhaps) for San Francesco di
Paola of Nervi. The St. Jerome and St. Martin is not traceable
to any particular locality, and was till lately assigned to Zingaro.

 Sacchi nowhere betrays want of pictorial flexibility more
openly than at Santa Maria di Castello, where the Virgin and
Child appear on the clouds in a square sarcophagus supported by
two aged men. Yet neither in the form of Mary nor in that of
the saints on the foreground is there lack of that delicacy of
feeling which distinguishes Borgognone and the Umbro-Peru-
ginesques of the Bolognese and Ferrarese schools. The dusky
flesh is warmer, the landscape and accessories are less obtrusively
marked, than before.

 The most important of Sacchi's compositions is the Deposition
at SS. Nazzaro e Celso of Multedo, where the groups sur-
rounding the lifeless body of Christ, though still defective in

[1] Berlin Museum, No. 53. Wood, 5 ft. 10¼ in. high by 4 ft. 9¾ in. From the
Solly collection. Christ Crucified, the Magdalen, Virgin, John and another female
Saint and a kneeling Donor. Inscribed : " Petri Franči Sachi de Papia opus
1514." This picture is probably the same which Soprani, *ub. sup.*, noticed in
San Francesco di Paola of Nervi, near Genoa. [* The latter painting is still *in
situ*; the Berlin Crucifixion probably comes from Santa Marta at Genoa (Soprani,
ub. sup.)]

[2] Berlin Museum, No. 116. Wood, 6 ft. 4 in. high by 4 ft. 11¾ in. From the
Solly collection. In the distant landscape, scenes from the legend of St. Jerome.

shape and vulgar in expression, are put together with some
feeling for the agonized expression of grief and pain.[1]

Lodi gave employment to few local artists in the fifteenth
century ; and the summons issued in 1490 to so many Lombard
craftsmen was only directed to Maestro Giovanni, or, as we
should probably call him, Giovanni della Chiesa of Lodi.
Giovanni and his son Matteo were men whose style was appar-
ently formed under the Umbrian miniaturists and modified by
subsequent contact with Borgognone. They had had occasion
to meet Borgognone about 1493 at the Certosa of Pavia, and
there felt the influence of his manner. We learn to assign to
them a coronation of the Virgin in the vestibule, an organ screen
and other works, in the church of the Incoronata; and they
probably designed a fresco of the Nativity in San Lorenzo of

(1) Paris, Louvre, No. 1488. Wood, m. 1·98 high by 1·67. The Four Doctors,
inscribed: "Petri Francisci Sachi de Papia opus 1516." [* The predella
which originally accompanied this picture belongs now to the Nobili Cambiaso
of Torre di Prà, near Genoa. Suida, *Genua*, p. 82.] (2) Genoa, Santa Maria di
Castello. Arched panel, with St. John the Baptist, St. Anthony, and St. Dominic
in the foreground. On a predella between St. Margaret, St. Jerome, St. Francis,
St. Dominic, St. Catherine, and another saint is the figure of Christ lying dead on
the ground. On a cartello to the left : " Pet. Francisci Sachi de Papia opus 1526.
mense Aprilis." The figures are life-size. (3) Multedo, church of (near Genoa).
Arched panel with thirteen figures and the incidents of the Crucifixion in the
distance, inscribed : " Petri Francisci Sachi de Papia opus 1527." In the sacristy
of this church is a small panel with several episodes of the Passion, including the
Crucifixion by Sacchi.

[* A picture representing SS. Paul, Anthony the Abbot, and Hilarion, in the
church of San Sebastiano at Genoa, is signed: " Petri Francisci Sacchi opus 1523."
Alizeri, *ub. sup.*, iii. 160-3, 537 *sq.*

To the number of the extant works by this artist should also be added a St.
Paul in the collection of the late Dr. L. Mond, of London.]

In the same style the following : (4) Pavia, Malaspina collection. Christ
Crucified between the Virgin and Evangelist, with the Magdalen at foot of the
cross, much injured, under life-size. (5) Pavia, San Michele. Second chapel ceiling
and arch, soffits, frescoes of the Four Doctors, symbols of the Evangelists and
Prophets. (6) Paris, collection of the late O. Mündler. Holy Family. (7) Milan,
Brera, No. 275. Holy Family, once under the name of Solario. But here, perhaps,
the name of Cesare Magno may be suggested—a feeble follower of the Leonard-
esque manner, of whom there are frescoes in the church of Saronno, signed :
" Cesar Magnus faciebat MDXXXIII," and a Madonna between St. Peter and St.
Jerome in possession of Signor Baslini, at Milan, signed: " Cesar Magnus 1530."
[* This picture is now in the collection of Sir Frederick Cook, at Richmond. See
also Morelli, *Die Galerie zu Berlin*, p. 123, n. 3.]

Lodi.[1] Contemporary with these we notice Albertino Piazza,
commonly called Toccagni, whom Lomazzo by mistake registered
amongst the painters of Francesco Sforza's time. His death at
Lodi in 1529 is noted in a contract in which his sons undertake
to complete a picture which he had left unfinished ; and this
document is one of the few which clearly defines the relation
of Albertino to Calisto Piazza.[2] There is not the slightest
evidence that Albertino ever practised as an independent master
before the opening of the sixteenth century, and the first work
with which his name is authentically connected is that which
he executed after 1513 at the Incoronata of Lodi for the heirs of
Albertino Berinzaghi. It is generally believed that he seldom
painted any panels without the co-operation of his brother
Martino, and there is much to confirm this belief in every
production attributed to his pencil. The brothers furnished not
only the altarpiece, but likewise the frescoes of the Berinzaghi
chapel. They painted in 1519 a Coronation of the Virgin which
hangs in the choir of the Incoronata, and in 1526 two important
creations : the Madonna and Saints with the Majesty of St.
Augustine at Sant' Agnese of Lodi, and the Virgin between
St. Roch and St. John the Baptist at the Incoronata of Castig-
lione d'Adda. Neither of these Piazzas rose above mediocrity.
They are meek, delicate, and feeble. Their slender figures are
not without serenity, their colours not without harmony ; they
show capacity for high finish ; the forms which they reproduce
are well-proportioned, and their modelling is blended with
excessive softness, but there is languor in their movements,
tameness in their tones, and flatness in their shading. We
distinguish two individualisms in their works, an affected grace-

[1] For the Della Chiesa consult Cesare Cantù, *Illustrazione del Lombardo-
Veneto*, 8vo, Milan, 1850, v. 622 ; Calvi, *Notizie*, ii. 133, 242, 252. The Coro-
nation of the Virgin on the wall of the vestibule of the Incoronata is all but
obliterated. The organ-shutters in this church are on canvas, with figures under
life-size. On the outer side are St. Basian (retouched) and St. Albert, and the
arms of Lodi carried by angels. Inside are the Virgin and Child and St. Cathe-
rine. Two fragments of Madonnas on the walls of the choir-loft are attributable
to the same hand, as likewise a Nativity (fresco) with copious retouches above
the first altar to the left in San Lorenzo of Lodi. Tho figures are fairly pro-
portioned but full, the execution careful to an extraordinary extent. At San
Lorenzo the nimbuses and other parts are raised and gilt. These painters may
have executed the frescoes representing gambols of children in the small refectory
of the Certosa of Pavia and an Assumption in a tabernacle in the outer wall of
the same edifice.

* [2] The authors must have misread the evidence of this record, for Calisto
was, without doubt, the son of Martino Piazza.

fulness and a yielding nature, distantly recalling Borgognone and the Bolognese Peruginesques and a leaning to the Raphaelesque, as in Manni or Eusebio of Perugia. Both masters were probably assistants to Borgognone, as Calisto, the son of Albertino, was journeyman to Romanino of Brescia.[1]

[1] For A. and M. Piazza consult Calvi, *ub. sup.*, ii. 96, 130–1, 136–40, and Lomazzo, *Tratt.*, p. 405. Their works are to be registered as follows : (1) Lodi, Incoronata (*post* 1513). Altarpiece in two courses ; wood, figures of half life-size. Virgin and Child between St. Anthony, who recommends the kneeling Berinzaghi, above which Christ's Crucifixion, with the Virgin and Evangelist between St. Roch, St. Sebastian, St. James,, and St. John the Baptist. In a predella the Twelve (half-length on gold ground), the whole dimmed by old varnish. In one of the lunettes of the chapel are St. Catherine and St. Apollonia, frescoes of life-size by the Piazzas. (2) Lodi, Santa Maria della Pace. Life-size fresco : Epiphany. (3) Lodi, Duomo. Altarpiece ; wood, one-third life-size. Virgin and Child with Angels between St. John the Baptist and St. Catherine (part of the red dress of the latter abraded). In the upper brackets the Angel and Virgin Annunciate, Raphaelesque types. (4) Lodi, Incoronata, choir. Coronation of the Virgin, with Angels ; repainted canvas, executed in 1519 as a gonfalone, of cold execution and Umbrian character. (5) Lodi, Sant' Agnese. St. Augustine enthroned, between SS. Martin, Nicholas of Tolentino, Anthony, and Albert. In a second course the young Baptist and the Virgin holding the infant Child, who blesses the donor, Niccolò Galliani, between SS. Catherine, Clara, Theresa, and Agnes. In an arched pinnacle the Eternal and the Virgin and Angel Annunciate in side-brackets. On the predella Christ between the Twelve, half-lengths on gold ground, above the second course the words: " Ven. Fratris Nicolai Galliani jussio Mxx." Wood, a little bleached, the principal figures under life-size. All the grounds, except those of the predella, are blue, dimmed by repaint and varnish. (6) Castiglione d'Adda, Incoronata. Virgin and Child between St. Roch and St. John the Baptist, the twelve in a predella. The Crucified Saviour between the Virgin and St. John, St. Joseph, and St. Basiano, the Eternal with the Angel and Virgin Annunciate from the upper courses. Wood, same style and arrangement as the foregoing, but of bolder handling and suggesting the probable co-operation of Calisto da Lodi, of whom we shall speak amongst the followers of the Brescian school.

* Signed works by Martino Piazza are to be found in the National Gallery (No. 1152, St. John the Baptist) and the Ambrosiana (Sala E, No. 54: The Adoration of the Shepherds). For notices of other paintings of this class, see Morelli, *Die Galerie zu Berlin*, p. 123, n. 1, the Catalogue of the Milanese Exhibition at the Burlington Fine Arts Club, p. lxxvi, and Venturi, *La Galleria Crespi*, pp. 277 *sqq.*

CHAPTER XI

NEAPOLITANS, SICILIANS, AND ANTONELLO DA MESSINA

A GLANCE at the growth and expansion of art in upper Italy teaches us to value highly the influence of Mantegna's teaching, which in that part of the peninsula lying north of the Po extended to the Vivarini, the Bellini, and all the masters of the Lombard and Venetian cities. Not less interesting, and hardly less important, is the influence of Antonello da Messina, who imposed his technical system of treatment on every painter of the Venetian State. What strikes us most in Antonello is the fact that he was born in the South yet preferred the lands and skies of cooler latitudes. In the rich but distant Netherlands he found those elements of culture which suited his taste and inclination : in Venice and Milan he loved to dwell; at Naples or Messina he never had the wish to stay.[1] To what other cause shall we attribute this curious bias in a man of acknowledged genius unless to this—that Naples and Sicily gave no encouragement to native talent? There is reason to believe that South Italy, at a very early date, fostered a school of sculpture of the very highest order; and the researches of historians point to Amalfi as a centre from which the carver's craft was taken up the Continent and across the waters to Constantinople.[2] But what may be true of sculpture in the thirteenth century can by no means be held of painting ; and, at the time of the great Florentine revival, Naples being without skilled workmen of her own, was content to borrow those of her neighbours. The same necessities which made it incumbent on

* [1] Part of the statements contained in this passage are contradicted by facts now known to us. See *postea*.

[2] Consult D. Andrea Caravita's *I Codici e le arti a Montecassino*, 8vo, Monte Cassino, 1869, vol. i.

the Neapolitan dynasts to send for Cavallini, Giotto, and Simone
Martini, were equally felt by their later but less fortunate suc-
cessors. There is nothing more melancholy than the contempla-
tion of pictorial creations ascribed by local patriotism to
Neapolitans, except perhaps the study of examples due to
Italians or Flemings of an inferior order. There is nothing
more painful than to read the lives of men whose existence rests
on no sort of historical basis.[1] One thing is perfectly clear—
what Antonello found in vogue as art in Sicily and Naples was
mostly carried thither from abroad ; and the very oldest Madonna
of which Palermo boasts is by Camulio, a Genoese guildsman of
the fourteenth century,[2] whilst on the mainland the frescoes
attributed to Agnolo Franco are Umbro-Sienese, and those
assigned to Zingaro are Tuscan or Flemish.[3] The testimony of

* [1] For the utter untrustworthiness of De Domenici, author of *Vite dei pittori
. . . napoletani* (first edition, Naples 1742–63) see Rolfs, *Geschichte der Malerei
Neapels*, pp. 2 *sqq.*

[2] Consult Santo Varni, *Appunti artistici sopra Levanto*, 8vo, Genoa, 1870, p. 46.
And see *postea.*

[3] For Zingaro see *postea* ; but, as regards Agnolo Franco, we register the
following list of alleged works, which prove that we are in the dark as to anything
that he may have really done :

Agnolo Franco died, according to De Domenici, *circa* 1445 (*Vite dei
pitt., &c., napoletani*, 8vo, Naples, 1840–8) ; and, with reference to one of the
cycles of frescoes alleged to be his, we have to correct ourselves (*History of
Italian Painting*, 1st ed., i. 32). We made allusion to the Cappella di Sant' Andrea
at San Domenico Maggiore as being attributed to Simone Napoletano. The
Cappella Sant' Andrea is now known as the Cappella Brancaccio, and is said to
have been painted, not by Simone, but by Agnolo Franco. There are two walls
covered with frescoes in three courses. (1) On the left, in a lunette below the
Martyrdom of a Saint in Boiling Oil, is the Miracle of a Saint taken to Heaven
by angels in presence of an archbishop and his clergy, and the Crucifixion between
the Virgin and Evangelist, with St. Dominic and St. Peter Martyr. (2) On the right
Christ at the table of the Pharisee ; his appearance to the Magdalen in the garb
of a gardener, and the Magdalen penitent. These frescoes are all covered with
repaint and oil varnishes. They are, as far as one can judge, of Umbro-Sienese
character. (3) Same chapel. Madonna delle Grazie fresco by another hand, but
without an original touch left. (4) Same church ; Cappella San Bonito, triptych.
Virgin and Child enthroned between St. John the Baptist and St. Anthony the
abbot, and in three lunettes the Eternal and two angels. Wood, under life-size.
This is a rude performance in the style of the Sienese followers of Fungai or
Benvenuto di Giovanni. (5) Naples, Duomo ; Cappella Capece-Galeota. Virgin and
Child with a more modern figure of Rubino Galeota. Wood, completely repainted.
De Dominici pretends that this piece was done in 1414, and Luigi Catalani, who
assumes that the portrait of Galeota is of contemporary execution with the rest

numerous authors unanimously proves that there was a large
trade in pictures between the ports of Flanders and Italy ; and
we have it from Vasari that Flemish merchants took the com-
positions of the best Northerns to the Mediterranean·; but the
traders who imported the choice things of this kind also dealt in
those of the second and third class—all of which found buyers
in Italy ; and it is evidence of the condition of taste in the South
that these were proportionally more numerous at Naples than in
any other part of the peninsula.[1] It is impossible to say
whether the favour extended to Flemish productions led Neapoli-
tans to imitate the Flemings, or whether natives of the Nether-
lands settled at Naples for the purpose of acquiring some breath
of Italian style, the artist in either case becoming partially
dénationalized. It is not doubtful that, by the side of purely
Flemish creations, others exist which commingle Italian and
Belgian features. René of Anjou, during his captivity in Bur-
gundy, is said to have spent his leisure in learning to paint.
Alfonso of Aragon bought an Annunciation by John Van Eyck.
The purest product of unmixed Flemish type extant at Naples,
and the best pictorially as well as technically, is the St. Jerome of
the Naples Museum which, before it came into its present place,
adorned an altar in San Lorenzo. The saint, in his brown frock,
sits in an arm-chair, a raised nimbus round his head, a copious
beard falling from his chin. With one hand he grasps the lion's
paw, with the other he holds a knife and probes the wound.
The lion, with tail outstretched, sits firmly on his quarters. To

of the picture, corrects him by saying it must have been done after the death of
Rubino, on whose tomb (which this Madonna adorns) an epitaph is written
as follows: "Hic jacet Rubini A.D. MCCCCXLV." See Catalani, *Le
Chiese di Napoli*, 8vo, Napoli, 1845, p. 19.

[1] See, *inter alia*, Hirsch and Vossberg's *Caspar Weinreich's Danziger Chronik*,
Berlin, 1855, in which proofs of this statement will be found, and Vasari, ii.
567. [* There can also be no doubt that, during the fifteenth century, Spanish
painters and Spanish pictures in great number found their way to Southern
Italy, then so intimately connected with Spain, both commercially and through
its Aragonese rulers. Spanish painting of that period shows largely an imitation
of Flemish models and much of what was formerly thought to denote a purely
Flemish influence on South Italian painting may in reality have had its immediate
source in Spanish painting, just as pictures in Southern Italy, which used to be
ascribed to Flemish artists, may in point of fact be the work of Spaniards. Thus
far, however, this whole question has not been studied as fully as it deserves.]

the left is a table on which the cardinal's hat is lying; behind
it a desk and a cupboard with a book, a bottle, and an hour-glass.
Shelves' lining the low wall of the hut are strewed with volumes
and manuscripts. The grouping is masterly ; the saint, stern and
admirably draped in cloth of drooping fold ; the lion is grand in
the calm of his repose. Every part is drawn and modelled with
conscious power, and such is the minuteness of the finish in
every line that we can count the hairs of Jerome's beard or the
lion's mane, the nails in the floor, and the veinings of the boards.
The flesh, of a warm and dusky brown, is shaded in deep leaden
olive, and the tone of the whole surface is full of fine gradations.
If there be a defect to note, it is the small size of the room
as compared with the figures.[1]

Of unadulterated Flemish origin likewise, and once a part
of the same altarpiece, is St. Francis distributing the Rules of
his Order in the chapel of San Francesco at San Lorenzo
Maggiore. The saint stands between kneeling votaries, whilst
two angels hold scrolls above his head. It is a picture of the
Van der Weyden school, careful to a fault in outline and detail,
of varied character in the heads, of a dim ruddiness in tone, and
a curious rigidity in pose.[2] Feebler, but in the same style, is an
Entombment in San Domenico Maggiore ; of later date a St.
Vincent in Benediction, with ten scenes from his legend, at San
Pietro Martire. We may consider this last production—a
capital one of its kind—to have been painted by some Italianized
Fleming, if not by a Germanized Italian, in the latter half of
the fifteenth century, its brown but rich and blended colour, well-
distributed groups and broken drapery, almost suggesting the
hand of the author of the St. Jerome, grown older and locally

[1] Naples, National Gallery, Room III., No. 23. Wood, 4 ft. 10½ in. long by
4 ft. ½ in. A date of 1436 on this picture has been spoken of, but does not exist.
Cf. Criscuolo and others quoted in Catalani, *Discorso su' monumenti patrii*, 8vo,
Napoli, 1842, pp. 10, 13.

[2] Naples, San Lorenzo Maggiore. This panel, at one time framed together
with the St. Jerome attributed to Colantonio del Fiore, remained in San Lorenzo,
when the St. Jerome was separated from it (see Catalani, *Discorso, ub. sup.*, p. 11).
[* M. Bertaux once ascribed this picture to Jacomart Baço, a painter of Valencia,
who in 1440 was summoned to Naples by Alfonso of Aragon (see *La Revue de
l'art ancien et moderne*, xxii. 347 *sq.*). The same writer, however, expressed later
(in Michel, *Histoire de l'art*, tom. iii., pt. ii. pp. 776 *sq.*), some doubts as to the
correctness of that attribution.]

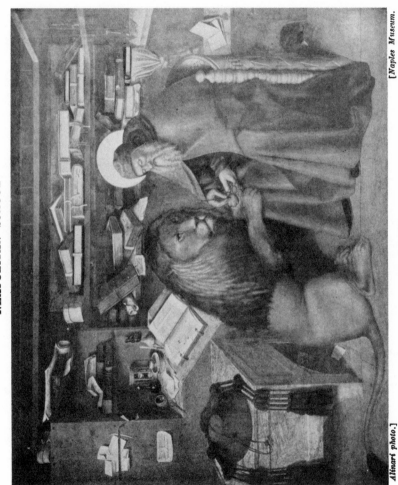

Neapolitan.[1] Belgian again, but most unattractive, is a com-
posite altarpiece in the crypt church of San Severino at Naples,
in the principal course of which the titular bishop sits enthroned
between the Baptist and Evangelist, St. Sosius and St. Savinus.
In the upper course the Virgin helps the Infant Christ to cherries
from a basket, and St. Jerome, St. Paul, St. Peter, and St.
Gregory are placed in half-lengths at the sides. There is much
gravity of mien in St. Severinus and St. Jerome, but the
Evangelist might have been drawn by a Rhenish disciple of
Van der Weyden, and the drapery is altogether Flemish in cast.
Dim tints, sharp contours, and high surface-shadows are
characteristic peculiarities of treatment.[2] That the St. Jerome
should have been ascribed to Van Eyck and Colantonio, the
St. Francis to Colantonio and Zingaro, the St. Vincent and
St. Severin to Zingaro, is due, on the one hand, to the inex-
perience of judges, on the other hand to a wish on the part of
annalists to create a Neapolitan school at the expense of
strangers.[3] The real interest of these pieces, apart from their
intrinsic value, lies in the fact that they found a market in
Naples and suited Neapolitan taste. They explain the reasons
which induced Antonello da Messina to visit the Netherlands,

[1] Naples, San Pietro Martire, third chapel to the right as you enter. Wood.
St. Vincent Ferrerio stands erect with a book, in benediction, in a niche. In the
framing at the sides and base are eleven panels, the uppermost of which, Angel
and Virgin Annunciate, are modern additions (seventeenth century). Amongst
the subjects are : St. Vincent preaching ; St. Vincent in Prayer before an Image of
the Madonna ; he restores to Life a decapitated Child ; he receives the Blessing
of Christ ; Vow of Mariners in a Storm ; St. Vincent cures a Woman possessed of
a Devil ; Death of St. Vincent. The colours are embrowned by age, the composi-
tions are lively and well put together. [* Dr. Bredius (in *Bollettino d'arte*, vol. i.
fasc. vi.), has ascribed this work to Simon Marmion of Valenciennes, the probable
author of the pictures which originally formed part of an altarpiece in the
Abbey Church of Saint-Bertin at Saint-Omer, and now are to be found in
the National Gallery and the Kaiser Friedrich Museum of Berlin. It seems,
however, somewhat questionable whether the Saint-Bertin panels and the
Naples altarpiece show so intimate an affinity of style as to justify Dr. Bredius's
opinion.]

[2] Naples, crypt church of San Severino. Wood, figures nearly life-size;
treatment, mixed tempera and oil. The panels are injured by neglect and
repainting in every part. [* This altarpiece is now in the fourth chapel to the
right in SS. Severino e Sosio.]

[3] De Dominici, *ub. sup.* ; Catalani, *Discorso*, pp. 11, 13 ; and *Chiese di Napoli*,
ii. 166.

and they are the real groundwork for the story wnich Vasari
tells as to the cause of the visit. Two versions of the same
anecdote are in Vasari's pages. In one place he says that Van
Eyck sent an altarpiece to King Alfonso, in another place that
certain Florentines offered one of Van Eyck's compositions to
Alfonso for sale.[1] But he is consistent in stating why Flemish
examples were popular. Van Eyck's panel, he affirms, excited
unusual attention, not only because of its beauty, but because the
medium in which it was executed was new. Crowds of artists
flocked to see and admire it ; and Antonello, amongst the rest,
chanced to see it on a visit to the mainland. The novelty and
charm of a technical treatment hitherto unknown to him were
such that he neglected all other claims upon his time and went
to the Netherlands, where he introduced himself to John Van
Eyck and learnt his secrets. We may reject the letter of this
anecdote, but grant that Antonello saw Flemish altarpieces at
Naples. We may take exception to the statement that Antonello
became personally acquainted with Van Eyck and yet concede
his visit to the Netherlands. We have no direct supporting
evidence of this from Belgian sources, for what little testimony
of the kind there was has been found unsafe and tainted [2]; but
we have a tacit confirmation in Van Mander, and a proof in the
large acquaintance of Flemish models which Antonello's works
betray.

Maurolico of Messina, compiler of a Sicilian chronicle which
has been frequently reprinted, wrote of Antonello, not more than
half a century after his death,[3] that he rose from the Messinese
family of the Antonii, and learnt to paint in a new system. He
adds that he was in the pay of the Venetian Government, and
acquired a name at Milan.[4] Summonte, a writer of the sixteenth

[1] Vasari, ii. 567, i. 114.

[2] MS. of Charles van Rijm in de Bast, *Messager des Sciences et des Arts*, 8vo,
Ghent, 1824, p. 347. Belgian critics doubt altogether the genuineness of this
MS. See Charles Ruelen's critical annotations to O. Delepierre's translation of
Crowe and Cavalcaselle's *Flemish Painters*, 8vo, Bruxelles, 1863, pp. cxxx
and cxliv.

* [3] Maurolico's book was really written about eighty years after Antonello's
death.

[4] Francisci Maurolyci, etc., *Sicanicarum rerum compendium*. The first edition
published at Messina in 1562 ; the latest, from which the present quotation is

century, alludes to Antonello in a letter addressed on March 20,
1524, to Marcantonio Michiel at Venicè. Speaking to a con-
noisseur well acquainted with Venetian artists, friend of Catena,
and almost witness of Raphael's death, he says that, since the
reign of King Ladislaus, no better craftsman had been employed
at Naples than Colantonio, though he failed to acquire the
perfect skill in design attained by his disciple Antonello.
Summonte then proceeds to relate how Colantonio came to
admire the Flemish mode of colouring, and would have visited
Flanders, but that he was prevented by King Raniero (? René),
who taught him in person. There is a striking analogy between
this tale of Colantonio and Vasari's account of Antonello ; and it
seems not improbable that Summonte unwittingly made two
painters out of one.[1]

In the midst of these conjectures, little or nothing is to be
ascertained as to the birth or education of our artist.[2] That he

taken, that in Graeve and Burmann's *Thesaurus antiquitatum et Hist. Siciliæ*, fol.,
Lugd., Batav., 1723, vol. iv. lib. v. p. 263. Maurolico speaks of certain portraits
by Antonello which he had seen at Palermo—an old man and an old woman
laughing.

[1] See an excerpt from the letter in Lanzi, *History of Painting*, vol. ii., note to
p. 11. [* This important document has unfortunately never been printed in full.
The most satisfactory edition of it is that of Von Fabriczy, in *Repertorium für
Kunstwissenschaft*, xxx. 143 *sqq.*]

[2] Grosso-Cacopardo, in *Memorie dei Pitt. Mess.*, Messina, 1821, mentions several
of Antonello's relations without giving sufficient authority for his statements :
Antonio d'Antonio, author of a Martyrdom of St. Placidus in the cathedral
of Messina, now missing (p. 2); Jacobello d'Antonio (p. 4), of whom the
annotators of Vasari (ii. 568) say that he was the painter of St. Thomas Aquinas
in San Domenico (?) of Palermo, a picture which, we shall see, may be assigned
to Saliba [* the annotators of Vasari mention a picture in San Domenico of Messina];
and Salvadore d'Antonio, father of Antonello (p. 4), to whom the annotators
of Vasari (ii. 568) assign a St. Francis receiving the Stigmata by a follower of
Antonello in San Francisco of Messina (see *postea*), and a Madonna in the
Santissima Annunziata of Messina, which seems no longer to exist. To
Jacobello and Salvadore jointly are ascribed by Grosso (*ub. sup.*, p. 13) an
altarpiece in San Michele of Messina, still catalogued in guide-books as of
the school of the Antonii, but not worthy of attention, being of the sixteenth
century. See Murray's *Handbook for Sicily*, by Dennis, *ub. sup.*, p. 498.

* The picture described above as a Martyrdom of St. Placidus seems really to
have represented a full-length figure of that saint, and was probably a work by
Antonello of 1467 (see La Corte-Cailler, in *Archivio storico messinese*, iv.
335 *sq.*); Jacobello was the son of Antonello (cf. *postea*), and Salvadore d'Antonio
was not Antonello's father (cf. *postea*). The editor has been unable to ascertain

studied in Rome, as Vasari states, is not confirmed by his style; that he did not learn much in Sicily is clear.[1]

A portrait in the Berlin Museum has long been considered the earliest of his works. It was supposed to bear the date of 1445, and critics held that a man who could paint in this style at that time must have been in the Netherlands, and might have been personally acquainted with John Van Eyck; a more complete knowledge of extant samples of Antonello's skill, a careful consideration of the masterpieces of the Venetian school,

how many of the pictures which are mentioned by the authors as being at Messina escaped destruction during the earthquake which devastated Messina in December 1908.

It is now proved that the views which were formerly held with regard to Antonello da Messina were to a great extent erroneous. It will be necessary to give here a brief *résumé* of the results of recent research on the subject. A long series of contemporary records of Antonello is at present available; nearly all of them have been found by Dr. La Corte-Cailler (see a paper by him in *Archivio storico messinese*, iv. 332 *sqq.*), or Monsignor Di Marzo (see his book *Nuovi studi ed appunti su Antonello da Messina*). Dr. L. Venturi has ably summarized what is now known of Antonello in *Le Origini della pittura veneziana*.

Antonello was the son of a sculptor named Giovanni; his family name was d'Antonio. The date of his birth is not known, but he cannot have been an old man when he died in 1479, as his parents were still alive at that time; taking into consideration that he was a well-known painter in 1457, we can scarcely go wrong in supposing that he was born about 1430. We first hear of him in January 1457, when at Messina he received a commission for a banner for a church at Reggio, which was to be similar to one he had painted for a church in his native town. In January 1460 we know that Antonello was about to return to Messina from Calabria, where he then was with his wife and children and other relations; this probably means that he cannot then have been undertaking a long journey. There is documentary evidence to show that he was staying at Messina between 1461 and 1465. During the next seven or eight years Antonello seems to have left no traces of his existence in the archives at Messina; it is, however, for various reasons probable that during part, at least, of that period he was staying in Sicily at any rate. We have documentary proofs that he was at Messina in 1473 and 1474. In August 1475 we find him in Venice, where in March 1476 he received an invitation to enter the service of Galeazzo Maria Sforza, Duke of Milan. Antonello accepted the invitation; but by the following month of September he was back at Messina, where he may have gone in order to escape the plague, which was ravaging the north of Italy. He continued to

[1] Amongst the works at Messina that may be taken as preceding Antonello, one only is of any real interest. It is a panel representing St. Bernard, full-length, in the sacristy of the church annexed to the monastery of Santo Spirito, a rubbed and repainted tempera of the beginning of the fifteenth century.

ANTONELLO DA MESSINA

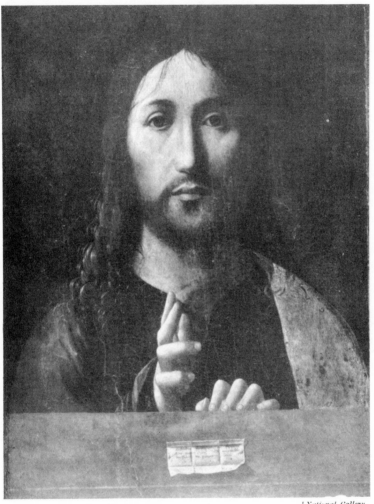

[*National Gallery.*

SALVATOR MUNDI.

but above all minute examination of the alleged signature, will not permit us to believe that the picture was done in 1445.[2]

When and in what part of Italy Antonello settled after he became a master is uncertain, but the oldest of his pictures which we now possess, the Saviour at the National Gallery, appears to have been painted at Naples in 1465.[3]

In the grave and serious task of representing Jesus as the Saviour, Antonello is foiled by difficulties of many kinds. The bust is all that he ventures to depict. Christ stands with his fingers on the edge of a parapet, giving the blessing and gazing into eternity. The face is oval, regularly divided, but low in forehead, with small black eyes of lack-lustre fixity

live at Messina until his death, which occurred shortly afterwards, *i.e.* in February 1479.

It will be seen that the records only bear witness to a very short stay of Antonello's at Venice, in 1476–76; and the evidence of the paintings by him, executed up to 1474, seems to go to prove that he had not been there before, as they show no closer affinity to Venetian painting, while in his later works the Venetian influences are very clearly traceable. Now, in spite of the fact that Antonello probably was the first Italian to master the technique of oil-painting, as is proved by his Christ of 1465, he cannot possibly have introduced that technique in Venice if he did not go there until 1475, considering that Bartolommeo Vivarini painted in oils as early as 1473 (cf. *antea*, i. 41 *sq.*). On the other hand, it seems more than probable that the technical perfection of his works called forth the imitation of the Venetians as soon as they learnt to know them; and his system of design, which was modified by his contact with Venice, in its turn also influenced the Venetians, as will be clearly proved by a study of the works of, *e.g.*, Luigi Vivarini, Montagna, and Cima.

With regard to Antonello's alleged journey to Flanders, it is to be noted, in the first place, that the earliest mention of it occurs in Vasari, whose Life of Antonello is full of inaccuracies, while neither Summonte nor Maurolico alludes to any such journey. Further, it is now held by many authorities that the Flemish element in Antonello's style may have been derived from a study of Flemish art in Southern Italy, where, as we have seen, it was represented by numerous examples. On the other hand, it may be asked whether the acquaintance with the Flemish style of architecture, shown by Antonello in the little St. Sebastian at Bergamo, is not so close as to make it probable that he had himself been in Flanders ; and if the magnificent Deposition in the collection of Mr. H. C. Frick, of New York, really is by Antonello, as there is certainly good reason for believing, it would be all the more likely that he visited Flanders in view of the strong Flemish note in this picture (cf. Fry, in the *Bulletin of the Metropolitan Museum of Art*, ii. 199). Much as our knowledge respecting Antonello has increased, he still offers many problems to the art-historian.

[2] See *postea*.

[3] As we have seen (*antea*, p. 415, n. 2), Antonello was at Messina in 1465.

close under the sides of a broad-barrelled nose. Copious hair falls in equal drooping curls along the cheeks and neck to the shoulders, and a nascent beard tufts the point of the chin. The hands are thin and strained in bend. It is a solemn, but not an elevated mask ; half Flemish, half Italian, small as compared with the breadth of the frame. Through the abrasions of the surface we see corrections of the outline of the fingers placed at first a little nearer to the throat. The colour is warm but not quite clear, solid in light, brownish, uneven, and showing the ground in shade, but without the brightness or pellucid finish of a later period.[1]

At the date of this work Venetian artists were cultivating a style altogether different from that of Antonello. Gentile Bellini was composing the panels of the organ of St. Mark and the Majesty of Lorenzo Giustiniani; Giovanni Bellini was designing his familiar subject of the Pietà, Bartolommeo Vivarini had just completed the Madonna of the Naples Museum. The medium used by all three was tempera.

In a notice of the sculptor Gagino, published by Vincenzo Auria in 1698, there is a description of an Ecce Homo by Antonello dated 1470 in the house of Giulio Agliata at Palermo. We identify this piece as that which successively belonged to the Prince of Tarsia, the Duke of Gresso, Don Dionisio Lazzari, and Signor Gaetano Zir at Naples. It represents a bust of Christ, naked and lashed to the pillar. His straggling hair is bound by a crown of thorns ; the jaw-bones are high and prominent, the temples receding, and a curious disproportion marks the upper and lower parts of the face. The eyelids are drawn up into angles, the nose is long ; a wail seems to issue

[1] London, National Gallery, No. 673. Wood, 1 ft. 4¾ in. high by 1 ft. ¾ in. On a cartellino fastened to the parapet, " Millesimo quatricentessimo sex-stagesimo quinto viij (?) Indi. Antonellus messanéus me pinxit- 𝄐— ." In the *Journal des Beaux-Arts* for 1862 (p. 13) the indiction is given as "Xiij," and this would show that the picture has been subjected to some flaying at the National Gallery. According to the same authority the panel, once at Naples, but since fifteen or twenty years in Piedmont, bears (? bore) the seal of the city of Naples. It was purchased in 1861 from Cavaliere Isola, at Genoa. The surface has been cleaned off in parts, and in this operation the surface has been laid bare in certain places. The ground is a dark-brown green, the dresses with broken T-folds.

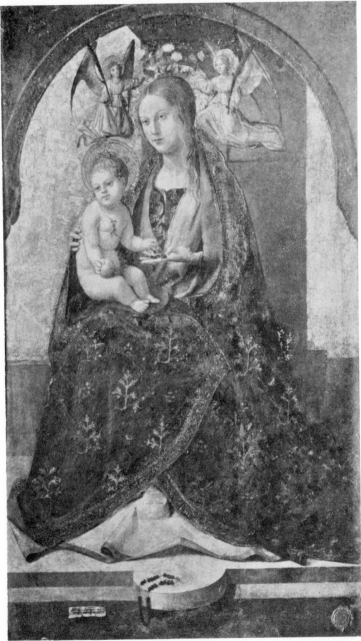

THE VIRGIN AND CHILD.

Detail of a triptych.

from the parted lips, and tears of blood trickle down the wasted cheeks. On a cartello fastened to the parapet are syllables of the name and fragments of a date which seems to read as 1470. Few extant panels have been injured by time and restoring more completely than this; but we can still see an early form of the master's art, a realistic type with all the outward signs and unpleasant contractions accepted by the Flemings as concomitants of grieving. The red and highly blended flesh is copiously impregnated with resinous vehicle, the half-tones and shadows are superposed so as to produce the highest surface in the darkest parts, the nude is well rendered and carefully outlined, and the hair seems to float in the breeze.[1]

In further confirmation of the painter's stay in Sicily during these years is the triptych of 1473 at San Gregorio of Messina, a composite altarpiece, with the Virgin and Child enthroned in the centre and SS. Benedict and Gregory at the sides. Under the green dais above her head two angels hold the crown of glory. With one hand the Child grasps an orange, with the other takes a cherry from its mother, turning its head meanwhile with playful archness. Of the upper course two panels remain, containing half-lengths of the Angel and Virgin Annunciate on gold ground seen at a low angle of vision indicated by precipitate lines of perspective. The Virgin's arms are crossed over her bosom as she sits under a dais; the angel, winged, comes forward affectedly, dressed in a stiff brocaded pivial. In this most interesting example we trace Antonello's Flemish education and the progress of his art. He seems since 1465 to have gained a more natural tenderness, greater blending, and a golden transparence of tone. His drawing is more accurate, his sense of chiaroscuro stronger. Flemish peculiarities in drapery and Flemish plainness have not altogether disappeared; there is still some want of freedom and breadth in rendering movement and extremities, much profusion of gold in the damasking and embroidery of stuffs, as well as in the delicate stamping of the

[1] Naples, late Signor G. Zir. Wood, on dark ground, 11½ in. high by 1 ft. 4 in. In the cartello, "1·7 .ntonellus messa. . . ." According to Auria (*Il Gagino redivivo*, 8vo, Palermo, 1698, p. 17) the Agliata Ecce Homo, which may be considered identical with this one, was signed: "Antonellus de Messina me fecit 1470." [* This picture was in 1908 in the collection of Baron Schickler, of Paris. Cf. L. Venturi, in *L'Arte*, xi. 443 *sq.*]

nimbuses; but the face of the Virgin is pleasant and regular. The manner is a cento of the trans-Alpine and Italian, without being essentially Venetian.[1]

Many pictures at Messina might be accepted as a further proof of Antonello's stay in Sicily if we could consider them genuine; none of them bear the necessary impress except a Majesty of St. Nicholas, attributed to the school of the Antonii— a large panel embrowned by time, surrounded by eight small incidents from the saint's legend in the church of San Niccolò at Messina. In the central panel the Bishop of Bari sits in episcopals on a throne, and, with solemn gravity, gives the Benediction; the composition at the sides are small and sketchy. We are not accustomed to find such free handling or bold finish at one painting in Antonello, nor has he shown himself hitherto so timid in relief by shadow; yet we know of no disciple who could treat the subjects as they are treated here, who has such sombre power in tone or such clever boldness in design and composition.[2]

[1] Messina, San Gregorio. Central panel, 4 ft. 2 in. high by 2 ft. 5½ in. sides, including the upper panels 6 ft. high by 2 ft. Signed on a cartello on the pediment of the Virgin's throne: "Año Dñi m̃° cccc° sectuagesimo (sic) tercio. Antonellus Messanēsis ♭ me pinxit." In the central Virgin the flesh of the Madonna's cheek and forehead and the body of the Child are retouched, the blue mantle with gold flowers repainted. The Annunciate Virgin's head is half new, the mantle and dais have become black, and pieces are scaled out of the parapet and desk. The Annunciate Angel, a Flemish profile with a top-knot, wears a rose-coloured but now abraded pivial. [* This picture is now in the Museum of Messina; it was fortunately only slightly damaged by the earthquake at Messina in 1908. From 1473 dates also a bust of the Man of Sorrows in the Museo Civico at Piacenza, inscribed: "Antonellus Messaneus me pinxit 1473." The picture of Christ in the Spinola collection at Genoa (see *postea*, p. 429) is a replica of this work. A full-length of St. Zosimus in the cathedral at Syracuse is undoubtedly by Antonello, and shows a close resemblance to the figure of St. Gregory in the Messina, only it seems to be an earlier work. Cf. Mauceri, in *Rassegna d'arte*, vii. 75.]

[2] (1) Messina, Museo Civico. Virgin adoring the Child, half-length, originally part of an altarpiece, on gold ground and greatly injured. (2) Same museum. Virgin and Child, half-length. Wood, 1 ft. 8 in. high by 1 ft. 4½. The Virgin, seated, holds the Child asleep. A stamped gilt nimbus surrounds her head; the distance is a landscape. The flesh is retouched, and there is so much repainting generally as to deprive us of a correct opinion. The style is a mixture of Bellini and Cima. (3) Messina, San Niccolò. Wood, the central panel 4 ft. 5 in. high, the surface dimmed by dust and dirt, with the small panels, eight in number, all in a raised frame, like those of the Muranese. The small subjects are: 1°, Birth

Early in 1473, we may believe, Antonello da Messina settled at Venice, and had the good fortune to produce a Madonna with St. Michael, which for upwards of a century was considered the chief ornament of the church of San Cassiano.[1] Matteo Colacio, in a letter written about 1490, praises it with enthusiasm. Sabellico, who described Venice at very nearly the same time, and found little to admire in its edifices but Bellini's altarpiece at San Giobbe, made an exception in favour of San Cassaino.[2] There was a general commotion throughout the artistic world when the picture was exhibited. Bartolommeo Vivarini, with pardonable eagerness, launched into an imitation of the new manner in his Majesty of St. Augustine at SS. Giovanni e Paolo; Giovanni Bellini, with more earnestness and slower step, joined in the race, patiently working his way through various dis-

of St. Nicholas; 2°, St. Nicholas saves a foundering ship; 3°, St. Nicholas rescues a man about to be killed by an executioner with a hammer. Two other culprits kneel hard by; 4°, St. Nicholas presents the youth with the cup; 5°, St. Nicholas throws money into the room of the sleeping girls; 6°, St. Nicholas appears to three youths in prison; 7°, St. Nicholas saves a person from drowning; 8°, St. Nicholas expels the devils. See *Guida per la Città di Messina*, 8vo, Messina, 1826, p. 28.

* [1] It has already been stated (*antea*, p. 415, n. 2) that Antonello was still at Messina in 1474. On August 23 of that year he there agreed to execute a picture which still exists, and the painting of which must have detained him for some time in his native town (cf. *postea*, p. 422, n. 2). It was after this—we do not know exactly when—he went to Venice, where he began the San Cassiano altarpiece in August 1475. It was ordered by Pietro Bon, a Venetian nobleman, and represented the Virgin and Child with several saints. On March 9, 1476, Galeazzo Maria Sforza wrote to his ambassador in Venice, ordering him to invite Antonello da Messina to become court painter to the Duke in succession to Zanetto Bugatti, who had recently died. On March 16 Pietro Bon wrote to the Duke, saying that the San Cassiano *pala*—"la qual opera . . . sera de le piu eczellenti opere de penelo che habia Ittalia e fuor d'Ittalia"—was so far advanced as to be completed in about twenty days. We further learn from Bon's somewhat confused letter that he, out of courtesy to the Duke, allowed Antonello to break off his work and go at once to Milan, though he asked the Duke to give Antonello permission to return to Venice to finish the San Cassiano altarpiece. (See Beltrami, in *Archivio storico dell'arte*, ser. i. vol. vii. pp. 56 *sq.*; Gronau, in *Repertorium*, xx. 350.) This picture having been executed as late as in 1475–6, it follows that it cannot have revolutionized Venetian painting to the extent supposed by the authors, though its influence no doubt was very great.

[2] Colacio in Anonimo, ed. Morelli, p. 189; Sabellico (M. A. Cocc.), *De situ urbis Ven.* p. 9, in Græve and Burmann's *Thesaurus Antiq. Ital.*, fol., Lugd., Batav., 1722, tom. v. (Sabellico's *De situ* was first published about 1490); Vasari, ii. 570; Ridolfi, *Marav.* i. 86; Sansovino, *Ven. des., ub. sup.*, p. 205.

couragements to perfection, yet accused of gaining his knowledge by a fraud.[1] Gentile Bellini followed, disapproving, yet quickly convinced of the necessity for change ; then came Luigi Vivarini, Carpaccio, Cima, and the swarm of lesser masters. But Antonello's fame as a portrait-painter in the Flemish style soon overshadowed that which he obtained in composing religious subjects ; and he was tacitly admitted by his contemporaries as the originator of the models improved in subsequent years by the higher genius of Bellini, Giorgione, and Titian. We have no written testimony as to the value attached to his portraits on their first appearance, but the specimens which exist lead us to believe that he was soon largely patronized and fashionable.

Of the busts which appeared in 1474, that of a youth in the Hamilton Palace, near Glasgow, is too heavily repainted to give much pleasure.[2] That of 1475, in the Louvre, is of a most surprising realism. Like many easel-pieces of the kind, it shows the head and shoulders of a man at an opening in a dark cap, which covers a wig shorn across the forehead and concealing the ears. A white shirt just fringes the plain straight collar of

[1] See Ridolfi's anecdote of Bellini's introducing himself in disguise to Antonello (*antea*, in Bellini).

[2] Hamilton Palace, near Glasgow. Wood, 1 ft. 3 in. high by 1 ft. 1½ in. Inscribed on a cartello : " 1474, Antonellus Messanus me pinxit." Bust of a Man in a brown cap and with a curtain, or hood, and in a red vest. The hair falls low on the forehead ; but with the exception of a lock to the left of the cheek, the whole picture is repainted. [* It is now in the Kaiser Friedrich Museum at Berlin (No. 18A). Signor L. Venturi (*Le Origini*, pp. 226 *sq.*) associates with it two little portraits of a man and a woman in the Liechtenstein collection at Vienna (No. 734).] Lanzi mentions a portrait in possession of the Martinengo family bearing the inscription : " Antonellus Messaneus me fecit 1474." What has become of it ? (Lanzi, ii. 96).

[* In August 1474 Antonello received at Messina, from a priest of Palazzolo Acreide, a village near Syracuse, an order for a painting of the Annunciation (La Corte Cailler, *loc. cit.*, pp. 374-9, 425). This picture was until lately in the church of Palazzolo Acreide, but is now in the Museum at Syracuse ; it has suffered much injury. Signor L. Venturi gives a reproduction of it in *L'Arte*, ix. 453, and discusses (*ibid.*, xi. 445 *sqq.*) its relation to an Annunciation ascribed to the school of Burgundy in the church of La Madeleine at Aix. There is no trace of a Venetian influence in Antonello's picture. Signor L. Venturi and Mr. Berenson ascribe to Antonello a fragment of a painting, representing some Angels, in the Museum at Reggio. Judging from a poor reproduction of this picture (in *L'Arte*, xi. 445) it seems indeed very likely that it is a work by Antonello ; in which case it surely belongs to the period preceding his journey to Venice.]

PORTRAIT OF A MAN.

a close pelisse. The face is that of a man of mature age, inured
to exercise, hale, muscular, and in perfect training, a man of
prodigious bone, with the self-possession of command in his
mien, in the glare and unflinching openness of his eye and in
the compression of his mouth. A scar just below the nose, a
protruding under-lip and chin, give additional character to the
person. The flesh is ruddy, vivid, and massively shaded. It is
difficult to find so much power, warmth, and relief combined
with such blending and transparence. With the exception of
some projections in the deepest shadow, the whole surface is
smooth and lucid. It shows all the minutiæ of nature, the finest
reflections, infinitesimal modulations of colour in the texture of
the parts, the reverberation of objects in the eye, the blood-
vessels inside the lids. Form is rendered in masterly perfection
and with excellent modelling. Bellini only equalled this towards
1487-8 in the Virgin of the Venice Academy (No. 596), the
Madonnas of the Frari and San Pietro Matire, or the Loredano
of the National Gallery.[1]

Amongst similar creations of which almost contemporary
notices are preserved we have to register, as belonging to
Antonio Pasqualino in the sixteenth century, Alvise Pasqualino,
in a red vest, with the hood of his cap falling on his shoulders,
and Michael Vianello, in a black cap and red dress, both dated
1745. We cannot trace the first; the second is almost surely
that preserved in a mutilated state under the name of Giovanni
Bellini at the Borghese Gallery in Rome. It is a head of less
perfect execution than that of the Louvre, but almost equal
to it, and perhaps more Venetian in air.[2] Still more Italian,
but less carefully executed, is the bust of a man of forty-five,
with shorn hair, in a red cap and brown vest, belonging to Signor
Molfino, an advocate at Genoa. The track of the brush, so

[1] Louvre, No. 1134. Wood bust, a little under life-size; inscribed on a cartello:
"1475 Antonellus Messaneus me pinxit"; bought at the sale of the Pourtalès
collection for 113,500 francs.

[2] Rome, Borghese Gallery, No. 396. Wood, 11⅜ in. high by 9 in.; well pre-
served, but cut down, and without the parapet, consequently without the car-
tellino which may be supposed to have been there originally. This may be
Michael Vianello, in black cap and fall and red dress. The lips here are raised
at the corners to produce an incipient smile. (See Anonimo, p. 59.) [* This picture
is now officially ascribed to Antonello.]

much more apparent in this than in other examples, is perhaps
only visible because the proportions are larger than Antonello's
usual ones ; but the drawing is less precise and the relief less
powerful than before ; there is not so much impasto, nor is
the colour as subtly fused or as transparent in shadow as else-
where. The same handling in a panel at Milan might lead us
to assign to this piece the date of 1746, but we cannot do so
with any certainty ; and we regret this the more as it purports
to represent Antonello himself, and is said to have once borne
an inscription to that effect.[1] The portrait at Milan is in the
Casa Trivulzio, and once formed part of the Rinuccini collection.
It is a highly finished and most precisely outlined bust of a
man of sixty in a black cap and hood and red vest, of enamelled
brilliance and smoothness, yet less melodious in transparence
and more uniformly red in general tone than the scarred
personage at the Louvre.[2] The same peculiarity of treatment,
with broader and freer touch, distinguishes another repre-
sentation of this time—a young patrician in a full wig, with
a very marked face, now preserved in the Casa Giovanelli at
Venice.[3] In this phase of Antonello's art we have less of the
elements which the Bellini assimilated, but more of the metallic
precision preferred by the solid and substantial taste of Cima.

Brighter, and of more silvery smoothness, is the portrait of

[1] Genoa, Signor Molfino ; bust, cut down, and without the usual parapet.
Wood, all but life-size. The face is seen three-quarters to the left, on dark
ground, the eyes very open, and the eyebrows bushy. The flesh of the upper
lip is injured by rubbing and dirt. [* This picture is now in the National Gallery
(No. 1141).]

[2] Milan, Casa Trivulzio. Wood, oil, 1 ft. 2⅜ in. high by 11 in., signed : " 1476
Antonellus Messaneus me pinsyt " (sic.). [* Antonello, as we have seen (antea,
p. 415, n. 2) went to Milan in this very year, 1476. Contemporary with the
Trivulzio portrait is probably the portrait of a young man, crowned with a
garland of leaves, in the Museo Civico of Milan (No. 249). L. Venturi, ub. sup.,
p. 229.]

[3] Venice, Casa Giovanelli. Wood, 1 ft. 1 in. high by 10 in., on dark green-
brown ground, cut down and without the parapet and cartello, also spotted by
restoring under the nose, in the right eyebrow and neck. This portrait, without
a name, is supposed to represent one of the Contarini family. It was once in the
Casa Alvise Mocenigo a San Stae. The wig is combed over the forehead and ears.
There is no cap ; the eyes are grey, the nose large, fleshy, and aquiline, on the
shoulder the patrician's stole. The colouring is somewhat hard and uniform ; it
is ruddy, positive, and enamelled ; otherwise altogether in Antonello's style at
this period. The light, too, is more undefined than in previous cases.

the Berlin Museum.[1] In its minutest details this panel displays extraordinary perfections. It is the likeness of a youth, showing his head and bust at an opening, through which a landscape with fine gradations of twilight is seen. His hair—shorn across the forehead—is covered with a black hood-cap ; the shirt-collar just appears above the border of a black vest, and a fur pelisse hangs on the shoulders. An open, cheerful glance and chiselled features, distinguished mien and fair complexion, indicate luxurious nurture. The mask is wonderfully relieved by contrast of light and shade. The outlines are fine and clean, the touch firmly delicate, the finish perfect; we see the reflections in the iris, the moisture of the orbit, the hairs of the lashes, yet none of the labour of the brush. Polished lustre, rivalling that of metal, is combined with morbidity of flesh ; clear light is blended imperceptibly into grey half-tint, and rich brown shadow with a medium crystalline in its purity. Colour of full substance in the prominences is worked over with a scumble in the transitions and transparents in darks, and general keeping is attained by a flush of glazing. It is the treatment of Van Eyck in the Arnolphini Couple of the National Gallery (1434) or the Jan de Leuw at Vienna (1436), with more modern appliances and more exquisite sparkle. Since the purchase of this picture from Mr. Solly for the Berlin Museum, no one ever ventured to doubt that the date represented by the mutilated ciphers on the cartello was 1445. We now ascertain that the panel, of which the origin had hitherto been concealed, is the same which Zanetti described as belonging to the Vidman and Vetturi collections, and we learn from Zanetti's own printed statement that it bore the painter's signature and the date of 1478. Close observation enables us to detect the tampering to which the signature was subjected, and it is obvious that the last two ciphers of the date were purposely abraded and retouched.[2]

[1] Berlin Museum, No. 18. Wood, 8 in. by 5¾ in.; inscribed on a cartello: " 14 (the two final cyphers illegible). Antonellus Messaneus me pixit." On the upper right-hand corner of the cartello marks of a half-abraded date. On the parapet beneath the cartello in gold letters: " Prosperans modestus esto, infortunatus vero prudens." The colour in the under-lip is slightly abraded, and the tone of the sky is altered by time and dirt.

[2] Zanetti, *Pitt. Ven.*, p. 21. Our information respecting the identity of the Berlin portrait we thankfully acknowledge having received from Dr. Woltmann,

Though busy with so many sitters in these years, Antonello did not entirely abandon sacred painting, and in 1475 he brought out a beautiful miniature Crucifixion, taken years ago to the Netherlands by a Fleming, and purchased at last for the Gallery of Antwerp. We need but look at the illustration in these pages to discern how neatly the landscape is varied with buildings, figures, and animals, how cleverly the writhing agony of the unrepentant, is contrasted with the quiet of the repentant, thief. The characteristic attitudes of these figures are repeated in Carpaccio's panels, and the nude of the Saviour is fairly rendered in bright, warm colour; but Flemish reminiscences are still preserved in the angular folds of the dresses.[1]

Naturalistic as he appears in the treatment of this composition, Antonello is still more in the religious current than in later subjects of a sacred character which we find in Italian collections. We have seen how deeply impressed he was with the grimace of grief peculiar to the Flemings in the Man of Sorrows, of the late Zir collection. As he grew older he changed his mode of handling, without losing realism, and in the Christ at the Pillar, of the Venice Academy, which he doubtless completed after 1476, the vulgar type and the coarse form in which suffering is expressed bespeak a nature incapable of rising to the refined idealism of the Tuscans. The Saviour, a model of muscular and bony strength, is seen almost in profile, bound by the neck and arm, tossing his head into the air in an agony of pain ; a crown of green thorns wounds his temples, the crisp spirals of his chestnut hair float in wild disorder ; tears of blood issue from the punctures and trickle from the eyes; the mouth is open, the brow contracted into

who consulted a. Catalogue Raisonné of the Berlin Museum, bequeathed to him by Dr. Waagen in 1868. [* If Zanetti's reading of this date was correct, this is the latest dated work by Antonello which is extant.]

[1] Antwerp Museum, No. 4. Wood, m. 0·58 high by 0·42, now inscribed : " 1475, Antonellus Messaneus me ƀ pinxit." Whether the 7 was ever a 4 is a matter of evidence and credibility (see De Bast, *Messager des Sc. et des Arts*, 1824, pp. 344–5). The treatment is that of Antonello's later period. The panel was once an heirloom in the family of Maelcamp, one of whose members had purchased it in Italy. It was bought by Prof. van Rotterdam at the Maelcamp sale, by Mr. van Ertborn, of Prof. Rotterdam.

* Somewhat later in date is a very fine Crucifixion by Antonello in the National Gallery (No. 1166), inscribed : " 1477 Antonellus Messaneus me pinxit."

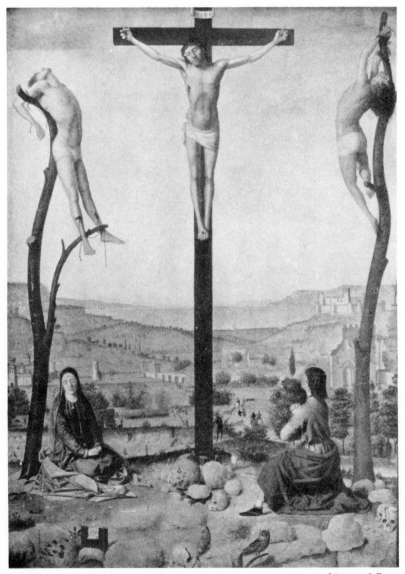

THE CRUCIFIXION.

angles. Minute finish is combined with smoothness and lustre. The flesh looks like chiselled bronze, outlined with unexampled cleanness, burnished to a highly coloured tone of polished enamel. Complex means produce the effects we observe : the glowing preparation of the lights toned down by the super-position of cool and more substantial tints contrasts with cold preparations of shadow warmed by superposed rubbings of thinner texture ; more or less vehicle is used according to the necessity for transparence. To break the monotony of this process, a touch completing the chord of harmony is thrown in, red on the lip or grey on the hair, the whole being brought into keeping at last by a film of glaze. In this way high surface is given to lights and darks, as in the earlier practice it was given to darks alone; but the general result is a ruddy uniformity of fine grain and great solidity.[1]

Bellini, as we saw, remained altogether a stranger to this phase of Antonello's handling. There was too much precision in the technical process to suit his delicate taste as a colourist; but what he rejected became fascinating to Giorgione; and we may believe that Giorgione left his first master's models to follow those of the Sicilian, separating himself for good and all from that branch of Venetian art which was finally repre-sented by Titian.

Antonello himself only held for a time to this complicated system of execution. He did so in a beautiful replica of the Christ at the Pillar, which belongs to Sir Frederick Cook, whilst in a second variety of the same subject, but of more conventional design, he shows that he is about to enter on a final trans-formation.[2] Till now he had excited the rivalry of the Vene-

[1] Venice Academy, No. 589, from the Manfrini Palace. Wood, oil, m. 0·39 high by 0·30 (15½ in. by 11½ in.). There are spots of restoring on the breast to the left ; on the cartello on the parapet are the words : " Antonellus Messaneus me pinxit." The ground is a brown-green.

[2] Richmond, collection of Sir F. Cook; formerly belonging to Sir J. C. Robin-son, who bought it at Granada in 1863. Wood, oil, in 1865 at the British Institution ; 1868 at Leeds. The execution is not so finished, nor the colour so red as at Venice ; but the surface is somewhat altered by cleaning. [* Dr. Frizzoni has ascribed this picture to Andrea Solario, to whose earlier works it indeed shows a great deal of affinity. Cf. Berenson, *The Study and Criticism of Italian Art*, i. 107 *sq.* Another copy of the original by Antonello is in the Budapest Gallery (No. 118); it is the work of Pietro de Saliba.]

tians, and forced the Bellini to struggle for the acquirement of
skill in oils. The time was at hand when he was to lose the
lead which he had hitherto preserved.[1]

Boschini, in describing a half-length of Christ at the Pillar
which stood on the altar of the sacristy at San Giorgio in Alga
of Venice, observes that it bore the false signature of Giovanni
Bellini, but was considered by many as a work of Antonello.
We may suppose that this very picture subsequently passed into
a private collection, and now belongs to the Miari family at
Padua. It bears no signature, but seems a genuine example
preceding by some slight interval of time a number of others
in which the influence of Bellini is apparent. Leaner and
less muscular but not less unselect shape characterizes the
form, which looks as if it had been drawn from memory
rather than from nature, and tinted with the conventional
uniformity of a monochrome scumbled and glazed to a general
dusky olive.[2]

In the same Bellinesque manner Antonello designed the
Christ supported on the slab of his tomb by three angels, com-
missioned for the tribunal of the Council of Ten at Venice, and
now in the Imperial Gallery at Vienna. Painting for such an
important place, he may have desired to excel ; and it is possible
that, before the panel was injured by abrasion and restoring, it
had some attraction ; but in its present condition of wreck dis-
agreeable prominence is given to a species of realism which,
taking its rise in the Vivarini and continued by Crivelli, pro-
duced a strange mixture of transalpine and Italian ugliness.
Drier and leaner than at Padua, but equally Bellinesque in treat-

*[1] The account which the authors give of Antonello's later years is founded
on the supposition that, after having come to Venice in 1473, he made it his
home, and lived there for a considerable length of time ; whereas we now know
that Antonello was at Venice perhaps only in 1475–76, went back to Messina in
1476, and died there in 1479.

[2] Padua, Casa Miari. Wood, m. 0·60 high by 0·50 (23½ in. by 19½ in.). Christ
seen to the hip three-quarters to the left in a stone recess under an arch. There
are two or three retouches on the breast to the right, and on the ground of the
sky. The head is raised, and surrounded by a nimbus. (See Boschini, *Le Ric.
Min.*, Sest. della Croce, p. 62.) [* The editor does not know where this picture
is to be found at present.] In this style we have also the St. Sebastian of Casa
Maldura (*antea*, p. 143), which, though it recalls Buonconsiglio's manner, may also
be by Antonello.

ment, this Christ still called forth imitators, and a semi-replica without a name exists in the Correr Museum.[1] We might number amongst the illustrations of Antonello's later time one or two specimens of comparatively small value, a portrait in the Malaspina collection at Pavia, and a Man of Sorrows in the Casa Francesco Spinola at Genoa, but they are so injured that other and more important panels at Berlin, Frankfort, and Bergamo should be preferred.[2]

Venetian painters, by this time, had become so familiar with the innovations of Antonello that they found no difficulty in making experiments of their own. In more than one instance, those who had looked up to the Sicilian with the hope of one day rising to an equality with him, now looked down upon his efforts from a higher vantage-ground. It became Antonello's turn to inquire whether it might not be for his benefit to adopt some of the improvements apparent in the works of his contemporaries; and in this way, or it may be unconsciously, his art came more and more to lose its early stamp. Form and mask in his figures began to take another shape, drawing a new style, and drapery another cast ; and the Fleming was merged in the Venetian as far as it could in a man of his fibre and education.

[1] (1) Vienna, Imperial Gallery, No. 5. Wood, 4 ft. 3 in. high by 3 ft. 4 in.; inscribed on a cartello on the tomb: "Antonius Mesanēsis." Three angels support the Saviour in the tomb. Their heads are surrounded by stamped nimbs. The wings of the angels are of peacock feather touched with gold. Distance, landscape. Repaints, upper part of head of Christ, flesh of the angel to the right, body of the tomb. A vertical split cuts the leg and arm of Christ, and the face of the angel to the right. All the flesh parts are flayed, and the landscape is touched over throughout. (2) Venice, Correr Museum, Sala xvi., No. 11 ; m. 1·17 high by 0·85, much repainted. Here Christ is seated so that the legs hang outside the tomb. There is a death's-head on the ground to the right. The painter is a follower of Antonello. [* The former picture is surely too feeble for Antonello, and recalls the style of Antonello de Saliba. Recent criticism is inclined to consider the Venice version as an injured original by the master.]

[2] (1) Pavia, Gallery Malaspina. Wood, small bust at a parapet, in which the name : "Antonellus Messaneus pinxi." The yellow hair is covered with a green conical cap, the vest is red ; the ground green. The only part not repainted is a bit at the throat. The likeness is that of a man laughing, and aged between fifty and sixty. (2) Genoa, Casa Francesco Spinola, Piazza Pellicerva. Man of Sorrows. Wood, oil, half life-size—abraded and retouched—a regular type without grimace or contorsion. The head is softly bent ; the hair, divided in the middle, falls to the shoulders. The crown of thorns is on the head, and a puncture on the forehead. Round the neck a knotted cord. The colour must once have been warm and golden. [* Cf. *antea*, 420, n. 1.]

In a Madonna at Berlin the Bellinesque impress and some-
thing which shows where Cima studied captivates our attention.
The Virgin, behind a wall, supports the child leaning back but
erect on a parapet. With her left hand she touches one of his
feet ; he throws his arm round her neck and grasps the hem of
her bodice. Her slender and not inelegant figure is moulded on
those of Bellini and Cima. His is a little stilted and disfigured
by a short neck and protruding belly. The drapery, though still
Flemish in break, is no longer entirely Transalpine. But we shall
observe, in addition, Venetian feeling in the rendering of the
body and features, a modern, and, for Antonello, an unusual
method of handling. The flesh, of solid impasto with brown
olive shadows and cool transitions, is glazed to a sombre tinge ;
the reds of the dress are transparent throughout, the blues
of full texture, enamelled and high in texture in every part ;
but, in this application of a system invented by Giovanni Bellini,
Antonello is no longer the master, but the disciple.[1]

Many pictures which, as we shall have reason to suppose,
followed the Madonna of Berlin are of a similar class. The
same technical handling, but colour of a sadder tinge and a very
coarse expression of pain mark a series of busts of St. Sebastian
martyred, at Berlin, Frankfort, Bergamo, and Padua, some of
them almost too feeble for any but the master's journeymen[2] ; a

[1] Berlin Museum, No. 13. Wood, 2 ft. 2½ in. high by 1 ft. 8½ in., from the Solly
collection ; inscribed on the parapet: "Antonellus Messanesis. p." There is a
spot in the sky to the right. [* This picture is so closely allied to the signed
Madonna by Antonello de Saliba in Catania (cf. postea, p. 449) that there can be
no doubt that it is really a work by the same artist (see Ludwig, in the Berlin
Jahrbuch, xxiii., Supplement, p. 60). The Catalogue of the Kaiser Friedrich
Museum states that the picture under notice comes from Treviso and identifies
it with a picture assigned to Antonello and formerly in the Avogaro collection at
Treviso. The latter painting, however, represented the Virgin Annunciate (cf.
postea, p. 432, n. 2).]

[2] (1) Berlin Museum, No. 8. Wood, oil, 1 ft. 6½ in. high by 1 ft. 1½ in. from
the Solly collection; inscribed on the parapet: "Antonellus Mesaneus P." The
frame seen to the breast, struck with three arrows and a large halo encircling the
head ; distance, landscape. The surface is somewhat opaque, either from retouch-
ing or bad varnish. (2) Frankfort, Stædel, No. 32. Replica of the same size,
from the Baranowski collection, but poorer in execution and without the name.
(3) Bergamo, Lochis, No. 139. Wood, 4 ft. by 3 ft. 3 in. Replica of larger size,
still more feeble and restored, the two last probably school-pieces. (4) Padua,
Casa Maldura. Same subject, three-quarters to the l. Wood, oil, 1 ft. 7 in. high
by 1 ft. 1¼ in., on dark ground with a spot of restoration in the cheek. This is

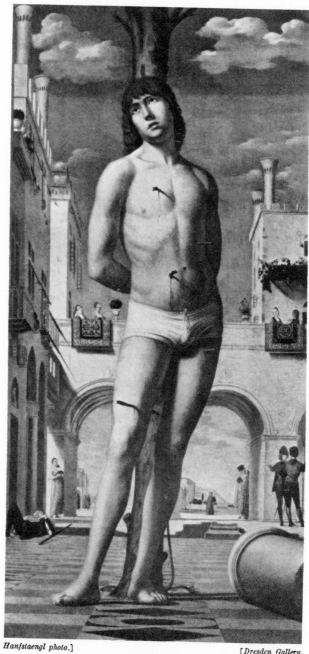

Hanfstaengl photo.]

ST. SEBASTIAN.

[*Dresden Gallery.*

portrait of a nun in the Venice Academy, to be classed amongst
the least prepossessing creations of the atelier, a bust of the
Madonna in the same repository that looks as if it might have
been done by Basaiti; a Christ on his winding-sheet with angels
in the Casa Morbio at Milan, betraying advance in years and
decline in power or a good-natured weakness on the part of the
painter in lending his signature.[1]

perhaps by a disciple (? Pino da Messina). In this same gallery is a bust portrait,
one-third of life-size, under Antonello's name, much repainted. It has been
cleared of its heaviest retouches, but still leaves us in doubt as to its genuineness.
[* The Maldura collection is now dispersed. The former painting may show the
same composition as two Antonellesque busts of St. Sebastian in the Crespi
collection at Milan and in the Hertz collection in Rome.] The frequent repetition
of the Milanese saint, St. Sebastian, might lead us to believe that Antonello was at
Milan at this period.

 * As we have seen, it is now proved that this inference of the authors is
correct. There exist two paintings of St. Sebastian which may be accepted as
being by Antonello himself. One is a little picture in the Lochis Gallery at
Bergamo (No. 222; cf. *antea*, p. 143); the other belongs to the Dresden Gallery
(No. 52). The authors were the first to recognize Antonello's hand in the
latter painting; their views on it are set forth at length in *Geschichte der
italienischen Malerei*, vi. 120 *sqq.* This is a very important work of Antonello's
last years, in which he shows himself strongly influenced by Mantegna and
Jacopo Bellini. Dr. E. Brunelli (in *L'Arte*, vii. 283, n. 1) points out that the busts
of St. Sebastian in Berlin, Frankfort, and Bergamo, in which the saint has a
comparatively calm expression and is turning towards the spectator, are related
to the St. Sebastian at Dresden; while the paintings of the same saint in the
Crespi and Hertz collections, in which he is turning to the left and throws his
head backwards, looking towards heaven with a marked expression of pain, show
an affinity to the Christ at the Column by Antonello.

 [1] (1) Venice, Academy, No. 587. Wood, m. 0·45 high by 0·33. A brown
cloth falls from her head, a puckered kerchief confines her neck; her hands are
wrung together, and tears fall from her eyes. The colour is dull and olive. This
looks like the work of an aged painter. [* In the current Catalogue of the
Venice Gallery it is ascribed to an unknown Paduan painter of the late fifteenth
century.] (2) Same Gallery, No. 590. Virgin Annunciate (with a book at a desk).
Wood, bust, oil, 0·45 high by 0·33, from the hall of the Anti-Collegio de' 20 Savii;
inscribed on the border of the table at which the Virgin is sitting : "Antonellus
Mesanius pinsit." The colour is rich in vehicle, but heavy and raw, and laid on at
one painting in the manner of Basaiti (*circa* 1510). The handling and the name
do not exactly correspond. [* According to Dr. Ludwig, this picture was
formerly in the room called Antisecreta in the Ducal Palace (see Frizzoni in
L'Arte, iii. 79 *sq.*). Another version of the same composition is in the Museo
Nazionale of Palermo (see Brunelli, in *L'Arte*, x. 13 *sqq.*). Differently composed,
and undoubtedly by Antonello, is a bust of the Virgin Annunciate in the
Pinakothek at Munich (No. 1588; from a private collection in Padua).
Boschini, in his *Carta del navegar* (p. 324), mentions a Madonna with a book

Catherine Cornaro, on her return from Cyprus, in 1489, bought of Antonello a small Madonna, which she gave to one of her maids of honour on her marriage with one of the Avogaros of Treviso.[1] Till the beginning of the nineteenth century this Madonna was preserved in the collection of the Avogaro family, but we are unable to trace it now, and thus find it difficult to determine what Antonello had made of his art at this period.[2] Were we to believe Ridolfi, the frescoes of the Onigo monument at Treviso are his; but, if so, Antonello's style had become a counterpart of Bellini's.[3]

In some pieces which collectors attribute to him we discover varieties of handling which practically make the name impossible; in others a conscientious opinion can scarcely be held.[4] One little jewel, the St. Jerome of the Baring collection, still puzzles and excites curiosity. As early as the sixteenth century it was doubtful whether the author was Van Eyck, Memling, or Antonello. The saint, in his study amidst books and numerous articles of furniture, and surrounded by birds and other animals

before her, by Antonello, as being in the Tassis collection in Venice ; perhaps one of the three last-mentioned pictures is identical with it.] (3) Milan, Casa Morbio. Christ outstretched on the cover of the tomb, two angels holding the winding-sheet stretched over him, in the distance Golgotha. On a cartello to the left on the face of the tomb : " Antonellus Messaññ pinsit." Wood, oil, 2 ft. 1 in. high by 1 ft. 8 in. This is a very common and sketchy panel ; it may be a copy from a better original by Antonello. [* The Morbio collection, including this picture, was in 1882 purchased by a syndicate of Munich dealers. See *Kunst-Chronik*, ser i. vol. xvii. col. 661.]

[*][1] Antonello, who died in 1479, cannot, of course, have sold a picture to Catherine Cornaro in 1489.

[2] Ridolfi, *Marav.*, i. 86. Federici (*Memorie*, i. 226) says that the Virgin was an Annunziata, and was inscribed : " Antonellus Messanensis P."

[3] Ridolfi, *Marav.*, i. 86. [* Cf. *postea*, iii. 394, n. 4.]

[4] (1) Venice, Correr Museum (Catalogue of 1859), No. 10 [* now Sala xv., No. 46]. Bust of a young man crowned with laurel. The execution is more like that of Bellini than that of Antonello. [* This is a feeble replica of a picture by Luigi Vivarini, formerly in the Duchâtel collection, and now in the National Gallery (No. 2509 ; cf. *antea*, i. 63, n. 2, and ii. 382, n. 2).] No. 11. Profile of a man with a black cloth on his head, of the Ferrarese school of Tura and Zoppo. No. 12. A portrait, modern, and of the sixteenth century, and much repainted in the hair. (2) Padua, Casa Ferdinando Cavalli. Wood, under life-size, bust of a man in a purple cap and dress and long hair, repainted. This might be by Luigi Vivarini as well as by Antonello, but cannot be recognized as the work of either in its present condition. [* This portrait is now in the Museo Civico at Padua (No. 437). It seems, indeed, very likely that it is by Luigi Vivarini ; cf. Berenson,

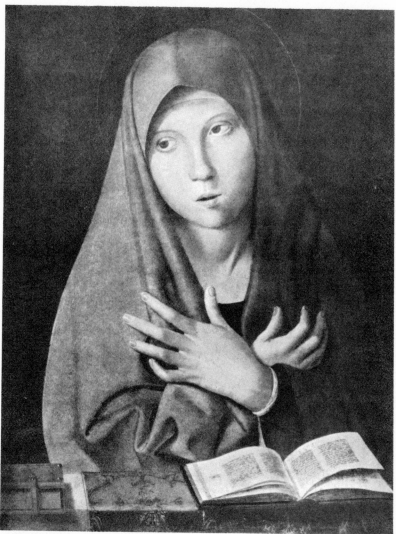

THE VIRGIN ANNUNCIATE.

as he sits reading at a desk, was a favourite personage with Venetian artists, and had been painted by its best masters; but it had never been painted in this way. Firm outline, rich, blended tone, and breadth of light and shade, combined with angular drapery and profuse accessories, make up a cento of which it is hard to say how much is Bellinesque and how much is purely Antonello.[1]

This, however, is not a solitary example in which Antonello's manner, modified by extraneous elements, is noticeable. There are numbers of portraits in divers galleries in which we mark a curious mixture of the Sicilian with the softness of Memling. We cannot venture to be positive as to the authorship, but we may register such works for the sake of inquiry. One of them is a likeness in the Antwerp Gallery supposed to represent Pisano, in which oil medium is imperfectly applied. Another, bareheaded, at the Uffizi, is very like that of Antwerp in treatment. Yet another, with a cap, is in the Venice Academy ; a fourth in the Corsini collection at Florence.[2]

Lorenzo Lotto, p. 84]. (3) Bergamo, Lochis Gallery, No. 62. Bust of a man in a dark cap and brown vest, with yellow hair, full face, looking up; half life-size. This panel has Bellinesque and Antonellesque character, is transparent, but a little empty in tone. It was once assigned to Holbein. (4) Cefalù, in Sicily, Casa Mandralisca (1859). [* The Mandralisca collection is now the property of the town of Cefalù.] Bust portrait of a man of middle age, of good-humoured aspect, laughing ; in a black cap, coat, and waistcoat, on dark ground ; his beard is of a day's growth. Wood, 1 ft. $1\frac{1}{2}$ in. high by $10\frac{1}{2}$ in. This piece is injured by restoring, but seems technically like a work of the period in which the St. Sebastian of Berlin was produced. It is modelled with solid impasto, and finished with transparent glazes. (5) Lonigo, Casa Pieriboni. Wood, under life-size. Bust of the Saviour carrying his Cross ; landscape distance, with towers and houses. This panel, supposed to be of "Titian's school," is of Antonello's school, and very like one which Antonello himself might have painted at the end of his days. [* Present whereabouts unknown.] (6) Paris, Comte Duchâtel. Small bust of a youth of twenty, bareheaded, and with long hair. This beautiful and delicate piece is not by Antonello, but by Andrea Solario. [* Cf. *antea*, p. 382, n. 2.] (7) Palermo, Museo Nazionale. Coronation of the Virgin. This is a curious picture, but by a German painter.

[1] London, Baring collection. Wood, oil, 1 ft. $7\frac{1}{2}$ in. high by 1 $2\frac{3}{8}$ in. Compare the Anonimo (ed. Morelli) p. 74. [* This picture—now in the National Gallery (No. 1418)—is at present universally accepted as a work by Antonello.]

[2] (1) Antwerp Museum, No. 5. Wood, m. 0·28 high by 0·21. Portrait of a man in a black cap and dress in a landscape, in his hand a medal with the words : "Ner. Claud. Cæsar. Aug. C. E. T. R. P. Imper." The distance is not unlike that of Memling in an altarpiece at Chatsworth. Bought at the sale of M. Denon, in

Vasari assures us that towards the close of Antonello's career there was a contest between him and Bonsignori as to who should paint certain episodes in the palace of the Signoria at Venice; and, in spite of the influence of the " Duke of Mantua," Antonello received the commission. It has been usual to assume that this contest occurred in 1493, at which date the Palazzo della Signoria was restored to its former state. But there is nothing certain in the whole of this story, except that Antonello did not live to carry out the commission. He died, according to Vasari, before turning fifty, and was buried with honours at Venice.[1]

We saw that the Flemish element had been introduced into Naples by the importation of pictures from the Netherlands. Strangely enough, most of the panels and frescoes in which the presence of that element is detected were attributed to Antonio Solario, otherwise called lo Zingaro. It may not be unnecessary to attempt to elucidate the mystery which surrounds this " ghost of a painter," and, at the same time, to give some idea of the

Paris. (2) Florence, Uffizi, No. 780. Bust of a man in a landscape in a frizzled wig and a dark pelisse with a fur collar. This portrait is technically like that of Antwerp, and is very reminiscent of the school of Van der Weyden and Memling. It has been somewhat cleaned. (3) In the same spirit is a portrait bust in a dark cap and vest in the Venice Academy, No. 586. Wood, m. 0·26 high by 0·19, from the Manfrini collection; but the colour is warmer. (4) Better and nearer in style to the genuine likenesses of Antonello is a fine bust of a man with a free aspect and glance in a cap, in the Corsini Gallery at Florence. This portrait was ascribed for a time to Pollaiuolo, and is now catalogued as unknown.

[1] Vasari, ii. 571 *sq.* [* Cf. *antea*, p. 415, n. 2.] We may add here a list of missing works. (1) Venice, San Giuliano. St. Christopher at the side of a statue of St. Roch (Sansovino, *Ven. descr.*, p. 126; Ridolfi, *Marav.*, i. 86). (2) Scuola della SS. Trinità. The Dead Christ and the Marys (Boschini, *Le Ric. Min.*, Sest. di Dorso Duro, p. 30. [* The catalogue of the Exhibition of Flemish Primitives at Bruges in 1902 identifies this picture with one included in that exhibition (No. 32), then belonging to the Baron A. d'Albenas of Montpellier and now in the Frick collection in New York. Judging from a reproduction, the editor certainly agrees with Mr. Fry (*loc. cit.*) that the design of the drapery and various details (such as the crucified thieves, which closely resemble those in the Antwerp Crucifixion) point to Antonello as the author of Mr. Frick's painting; and, according to Mr. Fry, "the technique is essentially that of Antonello, the subtle use of semi-opaque *couches* over a brown under-painting." In the general sentiment of the scene— paralleled in Antonello's two Crucifixions and the Correr Pietà—we note the distinct influence of Giovanni Bellini; but what constitutes the extreme interest of this painting is the strong Flemish influence noticeable in it (cf. *antea*,

state of art in Naples during the lifetime or immediately after the death of Antonello.

We might expect to learn of Zingaro that he visited the Netherlands or consorted with Flemings. The very reverse appears to have been the case. The story of his life has a striking analogy with that of Quintin Massys. Some say he was a Venetian, others that he was born, about 1382, at Città di Penna near Chieti. He became a painter in order to win the love of Colantonio's daughter, and took lessons of Lippo Dalmasii at Bologna. He visited Venice, Florence, Ferrara, and Rome, and studied under the Vivarini, Bicci, Galasso, Pisano, and Gentile da Fabriano. At the end of his travels he married at Naples the girl of his choice, and died in 1455.[1] The first compositions to which our attention is called in connection with Zingaro are those to which allusion has been made—the St. Francis of San Lorenzo, the St. Vincent of San Pietro Martire, and the St. Severin of San Severino at Naples. Others betray an influence foreign to the Netherlands.

The Virgin and Child in the Naples Museum under a hanging dais attended by St. Paul, St. Aspremus, St. Peter, St. Sebastian, and four other saints is a large altarpiece of the early part of the sixteenth century, in which the habits of a school different from that of the Netherlands are observable. The figures are drawn with firm and marked outlines, of weighty and even heavy frames ; the colour, of a dull brown tinge, is strongly impregnated with vehicle, highly enamelled, yet sombre and raw ; Umbrian feeling may be detected in the grouping of the Virgin and Child as well as in the style of the ornamentation ; it is of this picture that, we are told, the Virgin is a likeness of Johanna II. of

p. 415, n. 2).] (3) Casa Contarini. A Madonna (Ridolfi, *Marav.*, i. 86). (4) Casa Zanne di Piazza. Figure of St. Christopher (*ibid.*). (5) Antwerp, Van Veerle collection. Virgin, Child, and four Saints (*ibid.*, p. 87). (6) Collection of Baron Tassis, Madonna with a book before her (Boschini, *Carta del Navegar*, p. 324). [* Cf. however, *antea*, p. 431, n. 1.] (7) Florence, Messer Bernardo Vecchietti. St. Francis and St. Dominic on one panel (Vasari, ii. 571). According to annotations in Sir Charles Eastlake's *Materials, ub. sup.*, i. 211, and in Schorn's Vasari, *ub. sup.*, ii. 374, this panel really represented a Franciscan and a canon of the Lateran. It was sold at the beginning of the century by one of the Vecchietti family to Ignatius Hugford, and afterwards belonged to Mr. Woodburn, the picture-dealer in London. It would be desirable to know what became of the picture, which may yet be in England.

[1] De Dominici, *Vite dei pitt., &c., Napoletani*, 8vo, Naples, 1840–48; Lanzi, *ub. sup.*, ii. 5 ; the local Neapolitan chroniclers in Catalani, *Discorso, ub. sup.*, pp. 16, 17, 18, 19 ; and Piacenza in Baldinucci, *Opere, ub. sup.*, v. 148.

Naples (1414–35), the female behind St. Peter is a daughter of Colantonio, and the man on the extreme left is Zingaro himself.[1]

St. Jerome in the Desert, in the Berlin Museum, hitherto assigned to Zingaro, is by Pier Francesco Sacchi, of Pavia ; and St. Ambrose and St. Louis in the Munich Pinakothek are Lombard panels by Cesare Magno or some other follower of Sacchi.[2]

In one of the cloisters of the monastery of San Severino at Naples we find no less than twenty frescoes illustrating the legend of St. Benedict, besides a Virgin and Child between St. Severinus and St. Sosius in a lunette. The earliest is a monochrome representing the saint accompanied by his father, his nurse Cyrilla, two runners and servants, on his way to Rome. St. Benedict rides a horse, his father a mule, and Cyrilla a donkey. All are in the dress of the fifteenth century. This pleasant composition is remarkable for the firmness of the outlines and individual character of its figures, for the broken but appropriate cast of its drapery ; it is rich in detail and landscape, and betrays a painter of Umbro-Florentine education. The rest of the series—in colours—was probably designed by the same artist, but executed by assistants. We are told that the authors are Zingaro, the Donzelli his pupils, and Simone Papa, to whom the poorest of the twenty—Meeting and Reconciliation of the King with St. Benedict—are ascribed. The frescoes are all more or less injured by damp and retouching ; they are, throughout, rich in distances and accessories, and reminiscent of Pinturicchio, della Gatta, or even Cosimo Rosselli, though more minute than anything that we know of those masters. The heavy forms are almost invariably rigid or cold ; the drawing is marked, black, and frequently incorrect, especially in the extremities ; the flesh is dim and cold and shaded up to the outline, the drapery broken and angular. There is much inequality in treatment, and considerable diversity in masks. Of the numerous heads in one fresco, some are better than others ; of the figures, one may be coarsely, the other carefully handled.

[1] Naples, National Gallery, Room VII., No. 10. Wood, figures life-size ; on the hanging dais are two angels. The colours are partly altered by age, partly by retouching. [* This picture was formerly in the church of San Pietro ad Aram at Naples. We know, from contemporary records, that it was ordered in August 1509 from one Antonio Rimpacta, from Bologna, who had completed it by June 1511. See Filangieri, in *Archivio storico per le provincie napoletane*, ix. 96 *sqq.*]

[2] Berlin Museum, No. 116 [* now officially ascribed to Sacchi]. Munich Pinak., Nos. 1027 and 1028, purchased at Naples in 1832 by King Ludwig [* Now catalogued under " Catalonian school about 1500."]

ANTONIO SOLARIO

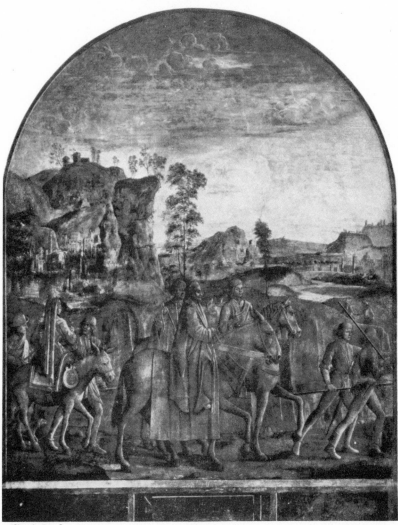

ST. BENEDICT ON HIS WAY TO ROME.

Here and there a Transalpine form is revealed in large noses, heavy jaws, and receding chins. A few numbers of the cycle are crowded and confused and poor in architectural perspective; others are lifeless, defective, and greatly neglected; and this applies particularly to the subjects attributed to Simone Papa.[1]

We close the list with the Virgin and Child and youthful Baptist in the Leuchtenberg collection at St. Petersburg, which proves to be an important production of Andrea Solario of Milan.[2]

It is almost a pity that the historians who take Antonio Solario or the Zingaro round Italy should have forgotten to send him into the Netherlands. We may accept, because we cannot disprove, the existence of the man, but we refuse to acknowledge as productions of one pencil the diverse creations we have named. It was not unnatural that, whilst such a king as René of Anjou governed, there should have been a demand for Flemish pictures in South Italy. It was almost a necessary result of René's own cultivation of Belgian art that Flemings should secure a footing as painters at Naples; but that Flemish legends should find a home in Italy and be received as veracious by Neapolitan writers is a positive misfortune.[3]

[1] Naples, San Severino. These frescoes were greatly damaged by the restoration of Antonio della Gamba in 1759; they will be worse still when restored anew, as is being done at the moment of penning these lines. (See Catalani, *Discorso*, *ub. sup.*, p. 12.) On the basement of a pier supporting the painted ornamental framing of one of the frescoes is a tablet with initials and ciphers now illegible, but interpreted by Aloe (Stanislao): *Le Pitture dello Zingaro*, 4to, Naples, 1846, a. S., "Nicola Antonio lo Zingaro . . . fece." The two frescoes assumed to be by Papa are coarsely executed and much repainted. The figures are short in stature. [* See *postea*, n. 3.]

[2] St. Petersburg, Leuchtenberg collection. See *antea*, Andrea Solario [* See also *postea*, n. 3.]

[3] * There can now no longer be any doubt that there really existed a painter called Antonio Solario, though the life of that artist given by De Dominici is a web of inventions. Antonio Solario was a Venetian by birth and the son of one Giovanni di Pietro. That he belonged to the same family as Andrea Solario is probable, though we do not know in what relationship the two painters may have stood to each other. Antonio's earliest-known work seems to be a Madonna with a Donor, recently acquired for the Naples Gallery, signed "Antonius de Solarius (*sic*) V.P."; this painting is essentially Venetian in style. Probably next in order of time come the frescoes in the cloisters of San Severino at Naples, which, according to the oldest authorities, were executed about 1495, and these show so close an affinity to the authenticated works by Antonio as to leave no room for doubt that they, for the most part, were executed by him or under his supervision. Subsequently the artist went to the Marches. In 1502 he at Fermo agreed to complete for the church of San Francesco, at Osimo, an *ancona* which Vittore Crivelli had left unfinished at his death. Shortly afterwards we find him at Osimo, working on another picture

Piero and Ippolito Donzelli are honestly believed at Naples to have been Neapolitans. We have seen how little ground there is for assigning to them the Annunciation, Nativity, and Coronation of the Virgin in the refectory of Santa Maria la Nuova at Naples. In the same refectory we have a fresco ascribed to Ippolito representing Christ carrying his Cross with numerous figures ; though damaged, it still displays the Raphael-esque manner adopted by Andrea da Salerno or Leonardo da Pistoia.[1]

The Naples Museum contains several panels separately or jointly attributed to Piero and Ippolito : a Crucifixion, which might have been executed by a Venetian follower of Mantegna and Carpaccio, or Michele da Verona ; a Crucifixion, heavily daubed over ; a St. Martin sharing his Cloak, which, if found at Udine, would be classed amongst the works of Giovanni Martini ; a Virgin and Child with Saints—an altarpiece in courses from San Domenico—in the rude style of the school of Benvenuto or Cozzarelli of Siena ; a Virgin and Child with SS. Jerome and Francis, equally poor, by an unknown Neapolitan. In the chapel of Santa Barbara, which is part of the Castello of Naples, an Epiphany is shown in which we are invited to admire the hand of John van Eyck and the corrections of the Donzelli ; that the artist was a stranger to Naples, and that his panel was retouched at a later period is obvious ; but Van Eyck and the Donzelli are both out of question in a feeble and injured picture of the sixteenth century.[2]

for the above mentioned church. This *pala*—noticed by the authors (*antea*, p. 300, n. 4), still exists ; it would seem that Antonio had brought it to an end before January 6, 1506, and had left Osimo by that time. He probably now went to Lombardy, where we may believe that he came into contact with Andrea Solario, whose influence is very noticeable in two works by our artist : a Head of St. John the Baptist in the Ambrosiana at Milan, signed " Antonius de Solario Venetus p. anno Domini MDVIII," and the above-mentioned Madonna and Child with St. John the Baptist, once in the Leuchtenberg collection and now in the National Gallery. See Modigliani, in *Bollettino d'Arte*, vol. i. fasc. xii. pp. 1 *sqq.*

[1] Naples, Santa Maria la Nuova. Refectory, fresco of Christ carrying his Cross much injured by damp and repainting ; not without life in the composition and action of the figures ; the flesh-tones of a raw and dim red tone. There is no connection whatever of style or of treatment between this and the other frescoes in the refectory, though they are ascribed to the same painter.

[2] Naples, Museum, Room III., No. 24. Wood, composition of numerous figures, assigned to Piero. No. 36. Wood, same subject of the same period and style, but ruined by repaints ; assigned to Ippolito. It is stated that both these Crucifixions, which were originally in Santa Maria la Nuova, were ordered of the two brothers at the same time. (Cf. Piacenza in Baldinucci, *Opere*, v. 398.)

De Dominici asserts that Piero Donzelli was born in 1405, that Ippolito was the son of the same father by another mother, and that both were trained in the ateliers of Colantonio and lo Zingaro; he repeats Vasari's account of the manner in which the Donzelli were employed by King Alfonso in decorating the palace of Poggio Reale, adding that they painted in Santa Maria la Nuova at the request of Ferdinand II., and concluding with the statement that Piero died at Naples in 1470, whilst Ippolito ended his days at Florence.[1] This scanty summary of facts contains discrepancies of no common kind, for Poggio Reale was built after 1481, at the request of Alfonso II., Duke of Calabria, and was probably adorned before the close of the century with the Donzelli's designs.[2] We learn from authentic records that these artists lived and laboured much later in the century than the Neapolitans believe, and that they were Florentines by birth and education. Piero, the son of Francesco d'Antonio di Jacopo, bailiff (*donzello*) of the Signoria of Florence, was born in 1451 ; Ippolito, his brother, was born in 1455. It is not known by whom Piero was taught; Ippolito was apprentice to Neri de'Bicci from 1469 to 1471. The brothers were companions in the so-called "Studio" at Florence as late as 1480.[3] The death of

[* These two pictures are now officially ascribed to the school of Mochale da Verona.] No. 3. Wood, under the name of Piero—lunette with small figures, once said to be by Andrea da Salerno. [* Now catalogued under "Venetian school."] No. 12. Wood, tempera, almost life-size. The Virgin and Child, on gold ground, between SS. Sebastian and Giacomo della Marca ; in the lunette, Christ and two Angels between the Virgin and Evangelist (the latter injured); in a predella, Christ and the Twelve Apostles in half-lengths (small). On the frame, "Drusia Brancazia ha facta fare questa fiura ad te se recomanda virgine pura et he dotata, per piu de una messa el di. Dedicata ad honore di Santo Sebastiano." The altarpiece is under the joint name of Piero and Ippolito. Room VI., No. 4. Virgin and Child, SS. Francis and Jerome. Wood. [* This and the preceding altarpiece are ascribed in the current catalogue to the Umbrian school.]

Naples, Castello. Cappella Santa Barbara. The best-preserved part of this picture is that to the right, that to the left was renewed ; but the whole piece is of a very low class. (The authors thus appeal from their own judgment as expressed in *Early Flemish Painters*, 1st ed., pp. 97-8.) Cf. De Dominici, *ub. sup.*

[1] De Dominici, *ub. sup.*, Vasari, ii. 470 *sqq.*, and notes to Vasari, ii. 567.

[2] Vasari, Annot., ii. 484. [* Poggio Reale must have been built before 1481, for we know that paintings were being executed in it in 1478. Rolfs, *ub. sup.*, p, 142.]

[3] * Ippolito Donzelli valued in 1488, together with another painter, the frescoes executed by one Calvano da Padova in the castle called La Duchesca, at Naples. Piero Donzelli was probably at Naples in 1491. See Rolfs, *ub. sup.*, pp. 143 *sq.*

Ippolito is not registered ; Piero's name occurs in the accounts
of the opera of Santa Maria del Fiore at Florence as a painter of
escutcheons and flags in 1503 and 1506. He died on February 24,
1509 (n.s.).[1] It is hard to say which of the pictures at Naples
are genuine and which are not so ; they are all different in style,
and little related to the school of the Bicci. The Donzelli may
have had some share in the frescoes of the cloister at San
Severino, in which we observe a distant reminiscence of Cosimo
Roselli and the Umbrians of the close of the fifteenth century.

We revert to a decided Flemish type of art in pictures
assigned to Simone Papa the elder (1430-88 ?), to whom we have
seen the guides allude as assistant to the painter of the cloisters
at San Severino of Naples. A St. Michael weighing souls
between two kneeling personages attended by their patron saints
once in the convent of Santa Maria la Nuova and now in the
National Museum, seems taken, as far as the St. Michael is
concerned, from Memling's Last Judgment at Danzig, and is
quite of a low-class Flemish treatment. A Crucifixion with
several saints, a triptych in courses in the same museum, is also
Transalpine, but feebler and probably by another hand, whilst a
Virgin and Child with two Angels, under the name of Zingaro,
really betrays the same style as the St. Michael.[2]

Equally unimportant as craftsmen are Silvestro de' Buoni,
Giovanni Ammanato, Roccadirame[3] and others whose alleged

[1] See Neri di Bicci's *Ricordi* in Vasari, Annot., ii. 88 *sq.*, and the *Portata al
Catasto* of " Piero e Polito frate gli e figliuoli di Francesco d'Antonio d' Jachopo,"
dated 1480, in *Giornale Stor. degli Archivi Toscani*, anno vi., 1862, pp. 15–18.

[2] For Simone Papa the elder see De Dominici, i. 172 and Piacenzá, in
Baldinucci, *Opere*, v. 519. He is said to be a pupil of Zingaro. (1) Naples
Museum, Room III., No. 28. Wood, figures life-size. The patrons are Bernardino
Turbola and his wife, Anna de Rosa. The scene is in a landscape of Flemish
minuteness and finish. The figures are short and stout, the drapery broken in
its folds. The flesh colours are reddish and dull. (2) No. 32. Centre and wings.
In the centre, Jesus on the Cross, with Mary and the Evangelist weeping, and
below the Virgin and Child ; on the wings, the two SS. John with SS. Michael
and George in half lunettes. This triptych is opaque and of a bluish grey in
flesh. Wood, small figures. (3) Wood. The Virgin gives a piece of fruit to the
Child, who holds his hand in the act of benediction.

[3] Of Silvestro de Buoni, Roccadirame, and Ammanato, we put together the
following :

Buoni's life is in Dominici, *ub. sup.*, ii. 218 and in Piacenza in Baldinucci,
Opere, v. 521. [* See also Rolfs, *ub. sup.*, pp. 136 *sqq.*] He is a pupil of Zingaro
and the Donzelli (?) and lived till about 1480 (?) (1) Naples, Santa Restituta Virgin
and Child under a baldachin between St. Restituta and St. Michael—predella—
scenes from the life of St. Restituta. On the throne step a signature purporting
to be that of Silvestro de Buoni with the date 1590, but the words have been

works in Naples and its vicinity may be left to the compass of a note.[1] What Naples in its best could produce we see in the numerous altarpieces of Cola dell' Amatrice and Andrea da Salerno.

Cola has been described by Vasari as the best painter and architect in the Neapolitan province, and there is nothing contrary to the truth in his opinion, for the best artists in the march of Ancona or the Neapolitan border might be matched by the third rates in other parts of Italy. Cola's practice was chiefly confined to Ascoli and its vicinity ; and dates from

tampered with. The style of the picture is of the opening of the sixteenth century, recalling that of the pupils of Perugino and Pinturicchio. Wood, figures three-quarters of life-size much damaged by repaints. Monte Oliveto (church of) near Naples. Ascension, between St. Sebastian and a saint in episcopals, three arched panels in one, with figures a little over half life-size. The Saviour in the centre appears in heaven with the orb, and in benediction. He is surrounded by angels. Below, the Virgin and Apostles in a landscape. This picture is by the same painter as the foregoing, but earlier in date ; the personages dry, lean, and angular; the details are touched in gold. (2) Naples Museum, Room III., No. 18, Magdalen. No. 21, St. John the Baptist ; Death of the Virgin. These panels are under Buoni's name, but very poor in the style of his school. [* The Magdalen and the St. John are now simply called Neapolitan school.] (3) Naples, San Pietro Matire, first chapel to the right. Death of the Madonna, much injured by repaints, dated 1501. This seems likely to be by Buoni, though the lower part of the composition has a Transalpine air, whilst the upper is more Umbrian in character. (4) In the same chapel. Virgin and Child between two Saints and a numerous kneeling congregation, heavily repainted, but perhaps originally by Buoni. The Coronation above is more modern by a century. We may also give to Buoni (5) a St. Michael and St. Andrew in Sant' Angelo a Nilo—two panels of soft treatment and colouring that recall Giannicola Manni falsely assigned to Angiolillo Roccadirame, another so-called pupil of Zingaro (De Dominici, i. 152), who is said to have painted a St. Michael for this church.

Giovanni Ammanato the elder. His life in Dominici, ii. 52; b. 1575, d. 1553. What is supposed to exist of this painter is so little and so worthless that we pass it over; and the same course may be followed as regards Simone Papa the younger.

[1] (1) Eboli, Santa Maria della Pietà. Coronation of the Virgin. Wood, tempera, figures one-third of life-size, much repainted. This is an Umbro-Sienese picture of the close of the fifteenth century. (2) Amalfi, Duomo. Christ dead on the knees of the Virgin, between St. Augustine and St. Andrew ; ornament of a chapel, founded in 1505 by Giorgio Castrioti *juniore* (notice of Dr. Matteo Camera). (3) Same church. Virgin and Child between St. Andrew and St. John the Apostle, and in a lunette (daubed over) Christ between the Virgin and Evangelist. These are also Umbro-Sienese and very poor. (4) Savona, near Genoa, Duomo. Virgin and Child and four Saints. Umbro-Sienese altarpiece inscribed : "Tucius de Andrea de Apulia hoc pinxit MCCCCLXXVII." This also is a coarse work, altogether repainted.

1513–43. Till 1520 or 1523 he painted in a dry and ex-
aggerated style which recalls Crivelli, Signorelli, Alunno, and
Pinturicchio. At a later period, though he never, it is said,
visited Rome, he fell into a bolder manner which displays
a fair acquaintance with the modern art of the Raphaelesques.[1]

[1] Cola Filotesìo or dell' Amatrice. His life is in Ricci, *Memorie Storiche
delle arti, &c., della Marca di Ancona*, and he is mentioned by Vasari,
v. 213 *sqq*.

His earliest panel is said to be (1) a Virgin and Child with SS. Francis,
Januarius, and Augustine, dated 1512 or 1513 (Ricci, ii. 87, 104 ; Vasari, annot., v.
213), originally in a church at Folignano, and later in the Fesch collection. (2) At
San Vittorio of Ascoli is a Virgin and Child between SS. Victor in pontificals,
Corradino, Andrew, and Cristenziano kneeling, inscribed : "Pia Civium Divotione
factum MDXIV." Wood, gold ground, figures under life-size, the blue mantle
of the Virgin new and the rest of the picture injured. (3) Rome, Museum of San
Giovanni Laterano. Assumption of the Virgin, arched, with the apostles about
the tomb below; inscribed on the face of the sepulchre : "Cola Amatricivs
faciebat MDXV." (4) In the same Gallery, a pilaster with six saints and two
arched panels, in one of which we see St. Benedict and St. Lawrence; in the other
St. Mary Magdalen and St. Agnes. In the Assumption we note a disagreeable
contrast between the yellow lights and black shadows; the execution is dry and
hard. [* The two last-mentioned pictures are now in the Vatican Gallery.]
(5) Rome, Gallery of the Capitol, from San Domenico of Ascoli, No. 29. Wood,
mixed tempera and oil. Lunette of the Virgin amidst eight Angels; below, the
Death of the Virgin. The figures are of small stature and paltry proportions,
the movements boldly vulgar, and the faces common in mask. The drapery
is angular and carelessly cast—much damaged by varnishes. (6) Ascoli, Ospizio
degli Esposti. Ruined tavola in oil with a Nativity—in the lower part five saints :
Jerome, Anthony, Francis, Giacomo della Marca, and Dominic, and two kneeling
devotees in the foreground. [* This picture is now in the church of San Fran-
cesco at Ascoli.] (7) In the same place, but originally in the Brotherhood of
Corpus Domini, the Communion of the Apostles, inscribed: "Cola Amatricianus
faciebat." All but two figures on the left are repainted. The subject is very
familiarly treated. [* Now in the Pinacoteca Communale of Ascoli, like the
following picture.] (8) Same place, Christ carrying his Cross, with life-size figures.
(9) The same subject, in the refectory of the Minorites, is a fresco signed : "Vivit
Homo Dapibus Anno D. MDXIX." There are no less, certainly, than a
hundred figures in the composition, but much confusion in the arrangement, and
the drawing is greatly mannered; retouching has also impaired the value of the
work. Besides there are (10) several panels in the Esposti at Ascoli, whither
they were transferred from the chapel of Corpus Domini, in San Francesco, *e.g.*
Abraham leading Isaac to Sacrifice, David, two Sybils. These are all on gold
ground, and have been described as bearing originally the date of 1523. The style
is expanded to the breadth of the Raphaelesques. [* Now in the Pinacoteca
Communale at Ascoli.] (11) Ascoli, Santa Maria dell' Ospitale. Here are rem-
nants of frescoes: a Christ crowned with Thorns, with three other figures, a
Christ presented to the People, St. Catherine, St. John, St. Margaret of Cortona,
Sermon on the Mount, and part of a Crucifixion. (12) In the same place, further,
are canvases of Christ carrying his Cross, Christ dead on the Virgin's lap, and

Andrea Sabbatini da Salerno, whose life is confined by
annalists within the years 1480 and 1545,[1] is a man of another
stamp. What we learn of him is on doubtful authority, but
to the effect that—struck by the works of Perugino at Naples—
he started for Perugia, and was only prevented from proceeding
thither by his admiration for Raphael's creations at Rome. He
became a disciple of Raphael and subsequently settled at Naples,
where he produced pictures in large quantities. Amongst the
number of assistants—some of them of humble talents—whom
Raphael employed, it is fit that Andrea Sabbatini should be
numbered. He may be classed on the same level as Jacopo
Siculo or Pacchia of Siena; and with Penni, Leonardo da
Pistoia, and Polidoro, he contributed to the rise of that branch
of the Neapolitan school which fills the sixteenth century.
His best works are in the museum and churches of Naples and
Salerno, and there are three canvases by him in the Ellesmere
collection.[2]

Christ crucified. Both canvases and wall-paintings are ruined. (13) Aquila,
Santa Chiara. A wall in this church is filled with paintings assigned to Cola,
but they are altogether daubed over. Amongst the subjects are a Crucifixion.
By the same hand, but in similar condition, are (14) frescoes in the refectory
of Santa Chiara. Ricci mentions, in addition: (15) Frescoes representing scenes
from the Passion in Santa Margherita of Ascoli; (16) a St. Joseph in Santa
Maria del Suffragio at l'Amatrice inscribed, "Cola Philotesius MDXXVII"; (17)
a Last Supper at Santa Maria delle Laudi at l'Amatrice; (18) the same subject
in the Palazzo Scimitarra, near Teramo; (19) frescoes in the Palazzo della
Canoniera; (20) a Christ going to Calvary in Santa Croce of Città di Castello.
[* For additional information concerning Cola dell' Amatrice see Calzini, in
Thieme and Becker, *Allgemeines Lexikon der bildenden Künstler*, i. 381 *sqq.*]
* [1] He was dead in 1531. See Rolfs, *ub. sup.*, p. 180.
[2] The following are particulars of Sabbatini's practice.
The best picture assigned to Andrea Sabbatini is the Adoration of the Magi
in the Naples Museum (Room III., No. 39), but originally in Salerno. Wood;
the figures are little less than life-size, well arranged, in good and graceful
action. The masks are pleasant and the colours (somewhat injured) warm
and harmonious. No. 5, a miracle of St. Nicholas (much damaged); No. 2,
St. Benedict enthroned between St. Placidus and St. Maurius, with the Four
Doctors below (life-size); Nos. 37 (St. Benedict receiving SS. Maurius and
Placidus) and 41 (St. Benedict clothing SS. Maurius and Placidus)—the two
last predellas of No. 2—are all in the style of the Adoration. Another fine
work of Andrea is an Adoration of the Magi, with figures half life-size in
the sacristy of the Oratorio de' Gerolamini at Naples. We may also notice
the following: (1) Naples, Santa Maria delle Grazie a Capo di Monte, first altar
in the transept. The Virgin enthroned holds the Child, who presses the milk
from her breast and causes it to flow down to the souls in purgatory; right
St. Andrew; above, in a lunette, St. Michael with the balance, kneeling on
the form of Satan. (2) Naples, San Giorgio de' Genovesi. St. George and the

Sicilian art never recovered its splendour after the close of the Norman period. What remains of the thirteenth and fourteenth centuries in the island is scarcely worthy of attention.[1] Under the Viceroys, pictures were imported from Central Italy or the Netherlands; and the painter's craft was in the hands of unimportant guildsmen. We are unacquainted with a single artist of the fifteenth century at Palermo who can be called older than Antonello da Messina ; and of these not one is known beyond the place of his habitual residence. Of Tommaso de Vigilia, Rozzolone, Crescenzio, or Saliba, not one laid the foundation of a school or became entitled to historical recognition ; and it is as clear as possible that Antonello could not have learnt his business from any of them.

Dragon (restored and repainted). (3) Naples, San Domenico Maggiore. Virgin, Child, St. Dominic, St. Martin, and other saints. This picture is no longer to be recognized as a work of Sabbatini, it is so repainted. (4) Salerno, San Giorgio, Virgin and Child, between St. Catherine, a bishop, and two other saints ; to the left a kneeling nun. On a cartello, fragments of an inscription ; in a lunette, Christ appearing to the Magdalen. Originally a fine work, but now in a very bad state. (5) Salerno, Duomo. Christ dead on the Virgin's lap ; St. John, St. Jerome, and another Saint is probably by Andrea. (6) Salerno, San Agostino. Virgin and Child between two monkish saints ; life-size, injured, and repainted. (7) Eboli, San Francesco. Virgin and Child in glory—Angels, with St. Francis and St. John Evangelist in the foreground. This picture is not certainly by Andrea, but has some of his style. (8) London, Ellesmere collection. No. 79, St. Catherine ; No. 80, St. Rosalia ; No. 80A, St. Jerome.

[1] Of old works in Sicily we may quote the following : (1) Palermo, Chiesa del Carmine. The Redeemer between two Angels. Fresco in one of the ceilings much restored, but probably of the close of the fourteenth century. (2) Palermo, Compagnia di Sant' Alberto. Coronation of the Virgin, St. Peter and St. Albert with Christ, the Virgin and Evangelist, and eight other figures in a predella. A poor work, of the style of Turino Vanni or Gera. (3) Palermo, Museo Nazionale, No. 79. Coronation of the Virgin between St. Peter (repainted) and St. Paul, with fragments of an inscription of which this much is legible : " Sott. Disciplina Eccla S. Petri Da Bagnara A. D. MCCCC." This is a rough tempera, with small figures. (4) The same subject, in the same style, is to be found in the same Gallery ; but here the Redeemer is placed in a pinnacle between the Angel and Virgin Annunciate, and Christ with the Virgin and Apostles is in a predella. (5) Palermo, San Niccolò Reale. A third Coronation, with a bishop and St. John the Baptist, of the same defective character, is to be found here. (6) Palermo, Santa Maria del Soccorso. Triptych : the Virgin with a staff, covering with her cloak a frightened child, between St. Nicholas and St. Oliva, on gold ground. This is a picture of the close of the fifteenth century which suggests reminiscences of De Vigilia. There are saints in pilasters, but the predella is repainted in oil. Wood, figures half life-size.

Tommaso de Vigilia of Palermo, whose life is circumscribed within the years 1480 and 1497,[1] is cold, careful, and without power ; his drawing is so elementary that selection in masks or extremities is not to be expected of him. His figures are straight, lifeless, and ill-draped ; he prefers rounded contour to angular break ; and this is a marked peculiarity of his style. His flesh-tints are dull, ashen, and unshaded, in strong contrast with the sharp tones of his dresses. The earliest of his works with which we are acquainted is a triptych originally in the church of Sciacca, a Virgin and Child enthroned with Saints, dated 1486, in the collection of the Duke of Verdura at Palermo, a canvas tempera of 1488 representing St. John in San Giovanni Evangelista, a Madonna between two Saints of the same year in the convent of " Le Vergini," a figure of a saint—of 1489—in San Niccolò, of Palermo. We may assign to him the sixteen canvases with scenes from the life of the Virgin in the church de' Dispersi, and a Virgin with Saints in the house of Count Tasca, at Palermo ; a Pietà and a Virgin and Child afterwards repeated by Saliba, at Castro Reale, and a series of frescoes in the deserted church of Risalaimi near Misilmeri.[2]

* [1] As we shall see, there exists a painting by this artist dated 1460.

[2] (1) Palermo, Duke of Verdura. Wood, tempera. The saints are Joseph, Calogerus, Agatha, and Lucy. On the foreground, a small kneeling Donor; behind, four adoring angels; on the right wing, St. Dominic; on the left St. Christopher; on the closed shutters, St. Sebastian and another saint. This damaged altarpiece is inscribed : " Thomaus de Vigilia Panormita pinsit MCCCLXXXVI." Earlier works by Vigilia are noticed by Di Marzo (*Delle belle arti in Sicilia*, iii. 134), *e.g.* : (2) a Virgin and Child between SS. Peter, Francis, Paul, and Chiara, inscribed "MCCCCLXXX, Thomas de Vigilia pinxit," in the convent of the Chiarine at Palermo [* now missing], and (3) a lost panel of St. Sebastian in Santa Maria di Gesù, inscribed, "Thomas de Vigilia pinxit MCCCCLXXXIIII." Lost, likewise, are (4) his Christ expelling the Changers from the Temple, (5) Christ's Entrance into Jerusalem, (6) Christ's Capture, and (7) Christ before Pilate, once in the tribune of the Palermo Cathedral ; further, (8) a Madonna with SS. Roch and Sebastian, of 1493, in the church of that name at Palermo, (9) a St. Sebastian of the same year in the Brotherhood of the SS. Annunziata at Palermo, (10) a Virgin and Child in San Rosalia of Bivona inscribed and dated 1494, and (11) a picture of 1497 in Sant' Orsola of Polizzi. (12) Palermo. San Giovanni degli Eremiti. The saint is represented writing ; inscribed : "Thomaso de Vigilia pinxit 1488." Canvas tempera, much repainted. [* This picture is now in the Magazzino dell' Ufficio dei Monumenti at Monreale ; according to Dr. Matranga (in *L'Arte*, xi. 453) the signature runs : " (T)omaus de Vigilia pinsit MCCCCLX ind. viii."] (13) Palermo, convent of le Virgini (not seen by the authors), Virgin and Child, St. Jerome and St. Theodore, signed and dated 1488. (See the admirable guide of Mr. Dennis, *Handbook for Travellers in Sicily*, Murray, London.) [* Now missing. See Di Marzo, *La pittura in Palermo*, p. 101.] (14) Palermo, San Niccolò Reale. Saint

With similar defects but more energy and character, Pietro Rozzolone is the fellow-workman or disciple of Vigilia—a realist, unconsciously Transalpine in style, and without feeling for anything that is noble or select in nature. He was a Palermitan, as we learn from Barone, who compares him to Raphael, and is known to have painted at Palermo as late as 1517 ; but we only remember one production attributable with certainty to his hand : a Crucifix commissioned in 1484 for the Duomo of Termini, and of this there is a partial replica in the church of Cefalù. The peculiarity of the Crucifix at Termini is that it represents the crucified Saviour with the wailing Virgin, Magdalen, Evangelist, pelican, and serpent on one side, and the Redeemer triumphant in his resurrection with the symbols of the Evangelists on the other. The latter subject alone is repeated at Cefalù.[1]

Nicholas enthroned in a glory of angels, inscribed : "Thomaso de Vigilia pinxit 1489." (15) Palermo, Santissima Annunziata or de' Dispersi. Sixteen canvases, forming the ornament of the roof, either by De Vigilia or one of his disciples. [* These pictures were in 1536 ordered from one Mario di Laureto. Cf. Di Marzo, *ub. sup.*, pp. 272 *sq.*] Palermo, Count Tasca. Wood, tempera. Virgin, Child, SS. Francis, Bernardino, Louis, and other saints and angels. (16) Castro Reale, Santa Maria del Gesù. Arched panel 2 ft. 8 in. wide 3 ft. 3 in. high. The Virgin is in prayer in front of the cross ; the Saviour is held by St. John and the Magdalen, and two others are in grieving in front and background. (17) Same place, an arched panel of the Virgin and Child enthroned with two angels on the arms of the throne and two others in flight supporting the crown above the Virgin's head ; the Child stands, holding an apple, and receives a flower from his mother. This is better than the Pietà, and, though in style like De Vigilia, might be a juvenile effort of Saliba. [* The frescoes seen by the authors in the church of Risalaimi have been transferred to canvas, and are now in the Museo Nazionale of Palermo (Di Marzo, *ub. sup.*, 109 *sqq.*). For further notices of Tommaso de Vigilia, see *ibid.*, pp. 83 *sqq.*]

[1] Pietro Rozzolone is mentioned in Barone, *De Majestate Panormitana*, lib. 3, cap. ii. pp. 102 *sqq.*, Panormo, 1630, and in Ignazio de Michele's *Sopra un' Antica Croce nel Duomo di Termini Imerese*, Palermo, 1859, p. 12.

De Michele gives the contract for the Crucifix in full, with the date of April 26, 1484. In it the painter is called Petrus de Ruzulono. The latter author also quotes from the MS. of Mongitore in the library of Palermo, describing (1) a St. Peter Martyr in the church of that name, inscribed : "AD. M . CCCCCXVII, Petrus Ruccoloni Pan. pinxit"; and (2) paintings in the ceiling of the Cappella del Santissimo in the parish church of San Niccolò l'Albergaria, inscribed : "Petrus Ruccoloni p. MCCCCC." (*Ibid.*, p. 12.) The figures in the Crucifix of Termini are life-size. The drawing is resolute but incorrect, the outline strong, the colour dull, cold in shadow, and but slightly relieved ; but much of the dullness may be caused by restoring. The Crucifix at Cefalù is a little better than that of Termini. [* For additional information concerning Rozzolone the reader is referred to Di Marzo, *La Pittura in Palermo*, pp. 203 *sqq.*]

We possess a copy of a contract dated Oct. 6, 1504, at Termini by which a

We are without records of Antonio Crescenzio; and what remains of the works assigned to him is without date.[1] He is cleverer than Vigilia or Rozzolone. His fresco of the Triumph of Death in the court of the hospital at Palermo is a fanciful production, which might have been suggested by that of the Campo Santo at Pisa. It represents Death on the pale horse heedless of the poor, who sigh for their end, destroying the high-born and threatening the rich. The figures are thrown together without much regard for appropriate distribution, but drawn with great minuteness of outline. A gentle affectation characterizes the females; lean and cornered forms distinguish the males; and there is much exaggeration and awkwardness in the action generally. We are reminded of Gentile da Fabriano or Pisano, but more still of the Sanseverini, to whom, however, Crescenzio is superior. To this fresco a legend is attached, which again shows that there was constant communication between Sicily and the Netherlands. The legend is that a Flemish painter fell sick in the hospital of Palermo, and, on recovery, showed his gratitude by painting this and other pictures. In

painter named Jacobus Graffeo agrees to restore a Gonfalone for the church of Santa Maria di Misericordia, and a Crucifix for the (now demolished) church of San Gerardo at Termini. (1) A Pietà is shown in the Duomo of Termini [* now in the Museo Civico of that town], which purports to be by Graffeo. It is a repainted canvas, which exaggerates the worst faults of De Vigilia or Rozzolone, but there are other pictures like it in Sicily. (2) A Crucifix with the symbols of the four Evangelists, and (3) an Epiphany in the monastery of the Franciscans at Castro Giovanni. (4) A Christ in the Tomb between the Virgin and Evangelist, and a (5) St. John the Baptist and St. John Evangelist in the anti-sacristy of the Chiesa Maggiore at Castro Giovanni. We might swell this list materially if necessary. [* For Giacomo Graffeo and his brother Niccolò see also Di Marzo, *La pittura in Palermo*, pp. 251 *sqq.*] (6) A fresco of Christ Crucified, with St. John, the Marys, and a kneeling prelate (life-size) in the Brotherhood of Del Santo Crocifisso at Palermo, though much injured, may be considered as the product of a disciple of the school of Rozzolone.

* [1] The authors have been misled by the statements contained in Monsignor Di Marzo's book *Delle belle arti in Sicilia*, according to which there were two painters called Antonio Crescenzio, one working at the beginning of the fifteenth century, the other, the son of the former, working during the first decades of the sixteenth century. As a matter of fact, however, there existed only one painter of that name; he was born about 1467, and died in 1542. He has signed two copies of Raphael's *Spasimo*, which are still extant. Di Marzo thinks that he is identical with the author of two pictures of the Madonna and Saints, one in the Museum of Syracuse, signed: " H. S. Antonellus Panhormita me pinxit año dñi Mº. CCCCºLXXXXVII pº Ind.," the other in La Gancia at Palermo, signed: " Antonell. Pa. pīsit I. D. 28." Janitschek, however, considers this identification as incorrect. Cf. Di Marzo, *La pittura in Palermo*, pp. 123 *sqq.*; Janitschek, in *Repertorium für Kunstwissenschaft*, i. 374

the case of Zingaro the story of Quintin Massys is plagiarized.
Here it is the fable of Memling in the hospital at Bruges.

Fragments of wall-painting in monochrome containing some
powerful and expressive heads are assigned to the same person
in the chapel of the Vanni family adjoining the church of Santa
Maria di Gesù, near Palermo; they seem originally to have been
above his level, and might indeed have been by Antonello da
Messina, but that they are too ill-treated to justify a positive
opinion. A Virgin and Child enthroned amidst numerous saints
in the Museo Nazionale at Palermo is also attributed to Cres-
cenzio, though better than he could do it, and technically like
a creation of Antonio Panormitano. More probably his are the
figures of St. Paul and St. Peter in the same collection.[1]

It was held by many persons that Antonello de Saliba and
Antonello da Messina were identical. The name, country, and

[1] Antonio Crescenzio. Di Marzo (*Della pittura in Sicilia, ub. sup.*, iii. 110)
mentions (1) a Virgin and Child with St. Joseph bearing Crescenzio's signature,
and the date of 1417. [* This picture is now missing; the inscription on it was
either incorrectly read or apocryphal.] (2) Palermo, Ospitale. Rosini (*ub. sup.*,
iii. 31) quotes the legend of the hospital of Palermo, and he gives authority for
believing that before the fresco of the Triumph of Death was restored in the
last century one of the figures to the left amongst those represented as spared—
a man holding a brush and stick—had on his sleeve fragments of a name which
could still be read "Cresc.....". (3) In the same court, and by the same hand, there
was a Last Judgment destroyed in 1723, with the date "MCCCCXL." The figure
in question is much repainted, and no trace of the words is to be found. It is
useless to speak of the original colour—so little of it has been left by the re-
storers. [* This fresco shows no resemblance to the manner of Antonio Cres-
cenzio; we find in it all the characteristics of the style of which Pisanello is
the chief exponent in Italy. Dr. Ozzola (in *Monatshefte für Kunstwissenschaft*,
ii. 198 *sqq.*) ascribes it to a Catalonian master of the second half of the fifteenth
century. The building is now a barrack.] (4) Palermo (near), Cappella
Vanni. In spaces imitating niches there are fragments of figures assigned to
Crescenzio (Dennis's *Guide*, Murray, *ub. sup.*, p. 101) a monk—the Beato Matteo—
life-size; subjects of small figures; St. Matthew writing, with an eagle at his
ear; a dead saint mourned by monks about his bier. Miracles at his shrine.
These are all monochromes of Flemish character. (5) Palermo, Museo Nazionale,
No. 85, from the Minorites. Virgin giving the breast to the Infant Christ, two
angels above her head; at the sides St. Lucy, Agatha, Peter, Paul, Cosmas, and
Damian, and lower still four small figures. Wood, life-size; the colour warm,
reddish, and full of vehicle, the dresses broadly cast, the head not without
character. (6) Same collection, St. Peter and St. Paul, life-size, on separate panels.
These are poor figures, with large and heavy heads and coarse extremities. The
colouring is dull, but the landscape distances are studied. (7) Mongitore MS.,
description of the cathedral of Palermo (Di Marzo, *ub. sup.*, iii. 113) mentions
seven figures of saints by Crescenzio, of which one is said still to exist—a
St. Cecilia in the Cappello Sant' Ignazio of the Duomo. [* There is, indeed, a

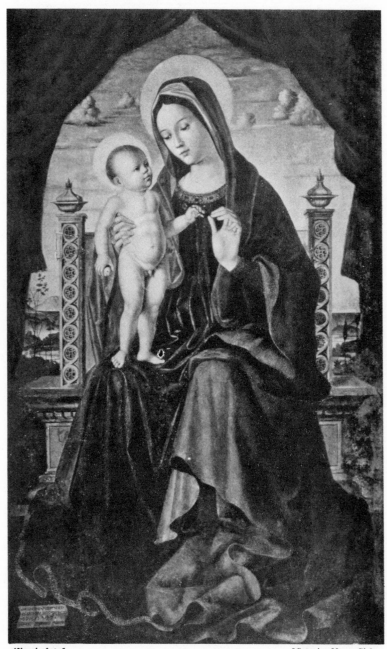

THE VIRGIN AND CHILD.

style, and the judicious suppression of the word Saliba, all
tended to increase the plausibility of this opinion ; but after a
time it was found advisable to review this portion of Sicilian
history which could not be reconciled with chronology ; and
Saliba is now accepted as an independent artist.[1]

Antonello de Saliba was a Sicilian, and probably studied
under the same masters as Vigilia and Rozzolone.[2] We discern
in all three an equal coldness and carefulness of drawing,
timidity of chiaroscuro, and monotony of flesh-tint. But Saliba
improved his style after he became acquainted with the pictures
of Antonello da Messina, and adopted the mixed method of
tempera and oil which he introduced into Italy. The earliest
composition which bears his signature is dated 1497, and is
preserved in bad condition in the church of Santa Maria del
Gesù outside Catania. It represents the Madonna on a marble
throne giving a flower to the naked child standing on her knee—
a counterpart, as regards design, of Vigilia's Virgin at Castro
Reale, but treated technically in the method of Antonello da
Messina, with yellow flesh-lights showing the ground, and semi-
opaque shadows of higher surface. The throne and landscape
remind us of Antonello and the Venetians ; in the slender form
and its dainty action there is something attractive and pleasant ;
the face of the Virgin is regular and plump ; the hands are
delicate and small ; the dress—a tunic without a girdle, and a
mantle falling from the head—cast in copious straight lines,
broken here and there with some abruptness. A gold stamped
nimbus surrounds each of the heads.[3]

figure of St. Cecilia by some early Sicilian master in the Duomo of Palermo ; but
it would seem that it is not one of the pictures mentioned by Mongitore. Di
Marzo, *La pittura in Palermo*, pp. 125-7, 181 *sqq.*]

[1] Antonello de Saliba. For a proof that his picture at Catania was taken for
one by Antonello da Messina see Grosso-Cacopardo, *Memorie de' Pittori Messinesi*
(8vo, Messina, 1821, p. 19), in which the signature of the picture is given as
"Antonellus Messenius 1497," whereas it really runs thus : "Antonellus . Missenius
D'Saliba hoc p . fecit opus 1497 die 2°. Julij."

* [2] Antonello de Saliba was born in 1466 or 1467 ; his father was Giovanni
de Saliba, of Messina, a wood-carver, and brother-in-law of Antonello da Messina.
In 1480 Antonello de Saliba was apprenticed to his cousin Jacobello, the son of
Antonello da Messina. That he visited Venice is probable in view of the Venetian
influences traceable in his works. We possess numerous records showing him at
work in his native town between 1497 and 1535. See Di Marzo, *I Gagini*, ii. 391,
n. 2 ; *id.* in *Documenti per servire alla storia di Sicilia*, ser. iv. vol. ix. pp. 109 *sqq.* ;
id., *Nuovi studi ed appunti*, pp. 74, 152 *sq.* ; Brunelli, in *L'Arte*, vii. 271 *sq.*

[3] Catania (fuor di) Santa Maria del Gesù. Wood, oil, 3 ft. 11 in. high by
3 ft. 2 in. Renewed are the sky, the landscape, the red sleeve, a part of the blue
mantle about the feet. At the upper corners an ugly red curtain has been added

The same handling is to be found in numerous panels without Saliba's signature, the most important of which is St. Thomas Aquinas enthroned amidst saints, with the prostrate Averrhoes at his feet, in San Domenico of Palermo. In this example Saliba struggles with the difficulties common to all painters of that age when they first attempt to use oil medium. His vehicle is viscous and unmanageable; he is still loath to use strong shadow; but he is accurate and careful in drawing and detail, and fond of superabundant gilding. The flesh is of a light rosy tinge, and shaded with red. With similar character we notice further an Adoration of the Magi between St. Biagio and another saint in Santa Maria del Cancelliere at Palermo, Christ and the Marys at the sepulchre in a room adjoining the sacristy of San Domenico at Palermo, and a full-length Madonna in the Museo Civico at Messina. The two last are of a lower class than those previously described, preparing us for the final and disheartening feebleness of Saliba's panels of 1531 in the church of Milazzo representing St. Peter and St. Paul in a dull and sombre key of tone, and with disagreeable peculiarities of form.[1]

We may conclude this section with a notice of pictures which suggest more than any others in Sicily what may have been Antonello's manner before he surrendered tempera for oil—pictures which have hitherto received no sort of notice, but

by a modern. The signature, as above, is on a cartello wafered to the left side of the throne; the panel is split vertically in two places. [* This picture is now in the Museo Civico of Catania.]

[1] (1) Palermo, San Domenico. This picture of St. Thomas Aquinas has been variously assigned to Antonello da Messina (Puccini, *Mem. d'Antonello da Messina*, p. 9 *sq.*, and Gioacchino di Marzo, *Delle belle arti in Sicilia*, iii. 69), to Salvatore d'Antonio (Gallo, *Annali Mess.*), and Jacobello d'Antonio (Grosso-Cacoparolo, *Memorie de' pitt. Mess.*, Messina, 1821, p. 3). It represents the saint enthroned in a chapel, with two boys holding books at the sides of his chair, and two kneeling on the high arms of the throne. At the sides are a pope and a king and other figures, and eight personages—some of them in cardinal's robes—in seats. On the foreground is the prostrate Averrhoes, and in a lunette the Eternal in benediction, a curiously antiquated mask, between four angels. Wood, life-size, mixed tempera and oil, the perspective faulty. [* This picture was originally in Santa Cisa at Palermo, and has now its place in the Museo Nazionale in that town (No. 103). It is a copy of a painting which formerly was in San Domenico at Messina, but which perished in 1848 when the Neapolitan troops set on fire the church and convent of San Domenico. La Corte-Cailler, in *Archivio storico messinese*, iv. 339 *sqq.* It is the original which is mentioned by Gallo and Grosso-Cacoparolo; and Gallo does not ascribe it to Salvatore d'Antonio but to Antonello da Messino (*Apparato agli annali . . . di Mess.*, p. 122.)] (2) Palermo, Santa Maria del Cancelliere. Adoration

different in treatment from those of Vigilia, Rozzolone, or Saliba. One of these is a mutilated altarpiece in the hospital church of Castel Buono. The Madonna in the centre of this monumental piece is modern, but the rest of the work is by one hand, comprising the Ecce Homo in an upper course, St. Anthony, St. Agatha, the Announcing Angel (the Annunciate Virgin is missing) and a predella with the Nativity, the Martyrdom of St. Agatha, and a scene from the life of Anthony the Abbot. Small figures of saints are placed in niches in pilasters. We are reminded here of the Umbro-Sienese school as represented by Domenico Bartoli, Vecchietta, and Matteo. The figures on gold ground and the delicate stamping and gilding of the nimbuses are very characteristic, but we are recalled to Antonello by the thin line of the contours, the fair proportions of the slender shapes, and the broken drapery. The mask and frame of the Ecce Homo are not unpleasant or ill-drawn; there is character in the make and face of St. Anthony and St. Agatha, and the predella scenes are tastefully composed. Careful blending and soft modelling mark the flesh-tints; and this is a peculiarity very distinct from that of the local Sicilians hitherto studied in these pages. A specimen of the same kind in Santa Maria della Misericordia at Termini, dated 1453, is a Virgin and Child between two saints of more modern execution, but enclosed by pilasters and a predella of similar age and

of the Magi, etc.—in a lunette the Nativity—wood, oil. The figures are slender, the drapery in numereus broken folds. Same style as the above. (This also is assigned by Di Marzo (iii. 73) to Antonello.) (3) Palermo, San Domenico, Anti-sacristy. Christ is seated on the tomb between two angels. Two of the Marys kneel in front; a third stands; in the distance rocks and small figures. Wood, half the size of life. (4) Messina, Museo Civico. Virgin and Child enthroned, two angels hold a crown over her head, a bullfinch on the throne-step, from whence the name of a fictitious painter, " Francesco Cardillo." [* Cf. Brunelli, in *L'Arte*, xi. 300 *sq*.] Wood, gold ground, figures under life-size. The Virgin, a long, ill-proportioned figure, is superabundantly draped in dress of broken, angular fold. The outlines are marked, the flesh-tints dull, and shaded with dark red. This is a poorer example than others assignable to Saliba. Equally poor is a Virgin enthroned, with a bust portrait of the Donor on the left (on gold ground), in Santa Lucia of Messina. On the arms of the throne : " Sda Dili Ammalati," and on the steps: " 1516 Masi di Abrugnano." The style is that of Saliba, and the design almost a repetition of that of Castro Reale and Catania. The figures are life-size, much damaged by time and re-paints. (5) Milazzo, Chiesa Madre, Cappella del Crocifisso. St. Peter and St. Paul, the latter signed: "1531. Lu Mastru Antonellus de Saliba pinxit." The figures are of short stature, strongly outlined, and opaque in colour. [* For further notices of Antonello de Saliba see Brunelli, in *L'Arte*, vii. 271 *sqq*.]

execution as the central figure. At Petralia Sottana, in the church of the Matrice, not far from Castel Buono, we discover this class of art in a Virgin and Child enthroned between St. Peter and St. Paul, and in an upper course containing the Redeemer between the Virgin and Angel Annunciate. But here we already mark a feebler handling, in continuation of which, and with more modern features, we may note a Virgin attended by eight saints in San Guglielmo, near Castel Buono, and a large monumental picture of numerous panels in the Chiesa Matrice of Castel Buono.[1]

Amongst the pupils of Antonello we may reckon Pino da Messina, of whom it is on record that he painted for one of the churches of Venice. According to a fashion common to many parts of Italy, a statue of St. Roch in San Giuliano was made additionally attractive by a St. Christopher which Antonello executed on panel at one side and a St. Sebastian furnished in

[1] (1) Castel Buono, Chiesa dell' Ospitale (17 miles from Cefalù). Tempera, on gold ground, injured, spotless, and restored. [* This altarpiece is now in the Madre Chiesa Nuova, in the new quarter of Castel Buono.] (2) Termini, Santa Maria della Misericordia. On the central panel are the words: "1453 prima indizione"; the two more modern panels at the sides contain St. Michael and St. John the Baptist on the right, and other saints by a more recent painter on the left; the framing has a very high profile. In the side-piers, in two divisions, are twelve male and female saints in niches, and in the predella six half-lengths of apostles. (3) Petralia Sottana, Chiesa Matrice (14 miles from Castel Buono). The altarpiece here is also monumental. On the principal courses are the Virgin and Child between SS. Giustina, Peter, Paul, and Agatha, with coloured statues of kings at each extreme. In the upper course at the sides of a niche deprived of its statue the Angel and Virgin Annunciate, and two saints, each under a dais. In the predella is a tabernacle with Christ between two Angels and the twelve Apostles. Wood, gold ground. (4) San Guglielmo (5 miles from Castel Buono). Virgin and Child enthroned, giving the breast to the Infant Christ; at her feet a kneeling patron, at the sides four saints, two of them St. Cosmo and St. Benedict; in an upper course, the Holy Trinity between St. Clara, Agatha (l.), Oliva, and Catherine. [* For further information concerning this work, as well as the altarpieces in the Madre Chiesa Nuova at Castel Buono and in Santa Maria della Misericordia at Termini, see Brunelli, in *L'Arte*, xi. 301 *sqq.*] This altarpiece is executed in a cold style, and shows great defects of drawing. (5) Castel Buono, Chiesa Matrice. The Virgin and Child between SS. Peter, Paul, Agatha, and another female saint; above, the Annunciation and two saints; in a predella, the Pietà and the twelve Apostles. [* This polyptych was completed in 1520, and seems to be the work of Antonello de Saliba. Cf. Di Marzo, in *Documenti per servire alla storia della Sicilia*, ser. iv. vol. ix. pp. 122 *sqq.*; Brunelli, in *L'Arte*, vii. 275.] (6) Same church, a large crucifix above the high portal. Two angels are at the extremes of the horizontal limb, the pelican and the Magdalen at the extremes of the vertical limb—a painting of the close of the fifteenth century.

the same manner by Pino at the other. Both panels are missing, and we are unaware of any other allusion to this Sicilian than that which we find in Sansovino; but he may have been Antonello's journeyman, and we may burden him with the poorer productions of Antonello's shop.[1]

Salvadore d'Antonio, commonly supposed to be Antonello's father,[2] is named as the author of a picture in San Francesco d'Assisi at Messina, which distinctly exhibits a style acquired at the close of the fifteenth century. The subject is St. Francis receiving the Stigmata, and the saint is depicted on one knee looking up in a landscape filled with houses, trees, and animals. At the side of a stream dividing the foreground, St. Ilarius kneels in surprise. This important work is by an artist who studied Antonello and the Venetians. The figures are well proportioned, muscular, and in appropriate action, the draperies careful though angular, and the outline firm. Solid breadth marks the handling, and the landscape recalls Bellini and Palma Vecchio.[3] It is absurd to suppose that the author was father to Antonello; yet it would be hazardous to affirm that he is identical with Salvo d'Antonio, a man of different feeling and

[1] Sansovino, *Ven. descr.*, ed. Mart., p. 126.

[2] Pina da Messina has been identified with Pietro da Messina, a poor artist by whom we have some signed paintings—*e.g.* a copy of Antonello's Christ at the Column, in the Budapest Gallery (No. 118, inscribed : " Petrus Messaneus pinxit ") and a Madonna in Santa Maria Formosa at Venice (inscribed "Petrus Messaneus"). Pino is, however, not a diminutive of Pietro, but either of Giuseppe or of Jacopo ; and Pino da Messina may therefore be identical with Antonello's son, Jacopo or Jacobello, of whom there are records proving that he was active as a painter at Messina in 1479 and 1480, and who may still have been living in 1508 (see Di Margo, in *Documenti per servire alla storia di Sicilia*, ser. iv. vol. ix. p. 79 ; La Corte-Cailler, in *Archivio storico messinese*, iv. 404 *sqq.*). A work by Jacobello is in all probability a very Antonellesque Madonna in the Galleria Carrara at Bergamo (No. 152, signed : "1490 xiiii . . . me(n)sis decebris Jacopus antolli filiu no(n) humani pictoris me fecit"). See Toesca, in *Rassegna d'arte*, xi. 16. Another Madonna by the same hand is in the collection of Mr. R. Benson of London. Pietro da Messina is no doubt the same person as Pietro de Saliba, a brother of Antonello de Saliba, who was working at Messina in 1497 and at Genoa in 1501. For notices of him see Brunelli, in *L'Arte*, ix. 357 *sqq.*

[2] Antonello, as we have seen (*antea*, p. 415, n. 2), was the son of the sculptor, Giovanni d'Antonio.

[3] Vasari, annot. ii. 568. Messina, San Niccolò. St. Francis receiving the Stigmata. Wood, oil, 7 ft. 5½ in. high by 5 ft. 8 in. There are three vertical splits in the panel. Behind St. Francis is an ox; near St. Ilarius a lion. There are also ducks and other birds in the foreground. The colour is brown, and has become blind in parts from varnish and retouching.

education, whose name is found on pictures in Sicily.[1] In the
Funeral of the Virgin in the Sacristy of the Canons at the
Messina cathedral we have undisputed evidence of Salvo's art,
his signature being placed on a cartello in the foreground.
Round the open couch in which the Virgin lies the apostles
perform the service, one of them lying on the ground and seeing
her infant shape rising to heaven amidst angels in the arms of
Christ. An affected air in most figures suggests lessons given
to Salvo by some one like Raffaellino del Garbo in his first
period ; while the glassy, and, we may say, the sombre red
texture of colour laid on at one painting and warmed with
general glazes is treated technically in the fashion of Albertinelli
and Fra Bartolommeo. Yet side by side with these character-
istics we may observe others equally prominent. A realism like
that of Carpaccio is apparent in the personages behind the bier.
One on the extreme left might have been done by Diana, and
some masks remind us of Basaiti.[2] By such distinctions of style
we recognize as Salvo's a full-length St. Peter, both hard and
poorly drawn, in San Dionisio at Messina, and a St. Lucy
full-length, in a landscape, belonging to General Pucci, at
Castellamare, near Naples, where two Angels holding the crown
of martyrdom over the Saint's head are reminiscent of those in
Salvo's Funeral of the Virgin.[3]

Of Salvo's disciple or comrade, Girolamo Alibrandi, it will be
needless to say much. He was born, it is supposed, about 1470,
and spent some years of study in Lombardy. He returned to
Sicily in 1514 with Cesare da Sesto, and left several pictures

* [1] The full name of this painter is Giovanni Salvo d'Antonio. He is recorded
as living at Messina from 1493 until 1522. Di Marzo gives some reasons for
supposing that he was the son of Giordano d'Antonio, a brother of Antonello da
Messina, and also a painter. See Di Marzo, in *Documenti per servire alla storia
di Sicilia*, ser. iv, vol. ix. pp. 87 *sqq.*

[2] Messina Duomo, Sacristy of the Canons. Death and Assumption of the
Virgin. Wood, oil, 6 ft. 3 in. high by 4 ft. 5½ in. Inscribed on a cartello in front :
'. Salvus de Ant. pisit." The shadows of some heads are partly lost. [* This
picture was ordered in 1509 (Di Marzo, *loc. cit.*, p. 96).]

[3] (1) Messina, San Dionisio. St. Peter, erect with the keys, reading ; life-size.
This is a somewhat hard production in Salvo's manner, warm in flesh-tone but
horny in texture. (2) A companion figure of St. Paul, with the sword, seems the
work of Stefano di Sant' Anna, a follower of Girolamo Alibrandi. (3) Castella-
mare, Generale Pucci. St. Lucy erect, with two Angels holding the cross above
her head ; in one hand she holds the dagger, in the other the eyes on a plate ;
distance, landscape. Wood, three-quarters of life-size. The sky above the land-
scape is gold ; the head is injured by restoring. The piece is assigned to
Antonello da Messina. [* Present whereabouts unknown.]

behind him at Messina, the most important of which is a Presentation in the temple dated 1519 in San Niccolò. His manner is a mixture of the Sicilian, Leonardesque, and Ferrarese.[1]

To Girolamo we may give as a companion Alfonso Franco, who painted the feebly composed Pietà bearing the name and the date of 1520 in San Francesco di Paola at Messina. But Franco differs from Alibrandi in this, that his colours have the dusky golden tones of the followers of Pordenone or Paris Bordone.

A more humble illustrator of Sicilian art is Antonello of Palermo, the son (as we are told by Di Marzo) of Antonio Crescenzio.[2] He is one of the few Sicilians for whose life we have written records. He was assistant to the sculptor Gagino in 1527, and valued pictures by brother craftsmen in 1530 and 1532. Twice in his life—in 1537 and 1538—he copied Raphael's *Spasimo*, and the copies are still preserved in the ex-monastery of Fazello, near Sciacca, and in the church of the Carmelites of Palermo.[3] The only composition by which we can judge of his power is a Madonna dated 1528 in La Gancia of Palermo, patiently finished, of an attractive design and faulty execution.

At a lower level, again, than Antonello of Palermo we have Jacopo Vigneri of Catania, Stefano Sant' Anna of Messina, and Fra Gabriel de Vulpe of Palermo.[4]

[1] The style of Alibrandi is a mixture of the Leonardesque with the Ferrarese of Mazzolino, but poor. (1) Messina, San Niccolò. Presentation in the Temple, with life-size figures, inscribed: "Jesus.—Hyeronymus de Alibrando Messanus faciebat 1519." The same subject, by the same hand, is in the sacristy of the Duomo at Messina (figures a little more than half life-size), very much blackened by time and dirt. In the same style is a St. Lucy in the chapel of San Giovanni. Di Marzo (*Belle arti in Sicilia*, iii. 207) mentions a replica of the Presentation as still existing in the church of the Addolorata of Lipari. Alibrandi is said (Grosso Cacopardo, in *Mem. de' Pitt. Mess.*) to have died in 1524; but Di Marzo (*ub. sup.*, p. 220) thinks he is the author of an Epiphany in the church of Venetico in Sicily, bearing the date of 1532.

[2] Cf. *antea*, p. 447, n. 1.

[3] Now in the Museo Nazionale at Palermo, No. 365.

[4] Alfonso Franco, according to Grosso-Cacopardo (*Memorie de' Pittori Messinesi*), was born in 1466, and died in 1524. His picture at San Francesco di Paola of Messina represents the Virgin with the dead body of Christ on her knees, surrounded by persons of all classes, amongst them St. John the Baptist and St. Francis, on the foreground to the left a naked figure, holding the crown of thorns and nails. In a cartello to the right: "Hoc opus fecit Alfonczu Francu Antenteru 1520." Wood, 6 ft. 8 in. high by 6 ft. The figures are heavy, square, bony, vulgarly realistic, and coarse in the extremities and articulations. The drapery is ill-cast and overladen. We know of no other picture assigned to Franco, and none like this, except, perhaps, the Virgin giving the breast to the Infant Christ, attended by six saints and four patrons, an altarpiece assigned to Crescenzio in

The most important artist in Sicily during the sixteenth century is Vincenzo Ainemolo, a born Palermitan,[1] who held the same position in his native island as Andrea da Salerno on the mainland. He seems early in his life to have visited Naples, for we observe, in a picture of the Virgin crowned by Angels ascribed to Perugino, in the Gallery of Palermo, all the distinct peculiarities of his style, combined with an imitation of the Peruginesque ; and this naturally leads us to suppose that he first went to Naples, where he might study the Assumption sent by the great Umbrian to Cardinal Caraffa. At a later period he visited Rome, and became acquainted with Raphael's masterpieces, joining company with the underlings of the workshops—Polidoro and Maturino. Yet he might have been initiated to the Raphaelesque manner in a more indirect way ; and in A Descent from the Cross, preserved at San Domenico of Palermo, he almost repeats some of the figures of Raphael's Spasimo di Sicilia. Whatever may have been the vicissitudes of his life, he became locally famous because he skilfully imitated

the Gallery of Palmero, or the Virgin with the child on her knee giving the keys to St. Peter, a panel in the Gallery of Naples (Room VI., No. 15), classed in the Tuscan school. [* Now officially ascribed to the Lombard school.]

Of Antonello of Palermo there are records in Di Marzo (*ub. sup.*, iii. 157 *sqq.*). His style is only known by a Madonna between St. Catherine and St. Agatha in Santa Maria degli Angeli or La Gancia, at Palmero. At the base of the picture there are busts of a male and female patron with two angels between them holding a cartello, inscribed : " Antonell pa. pĭsit id28." Wood, with a landscape on gold ground of a damask pattern. The picture is injured, heavy and dull in colour, and almost altogether without shadow. The figures are stout, short, and square, and less than half life-size. The drawing is very patient, the drapery poor and ill-shaped.

Jacopo Vigneri. Catania, San Francesco. Christ carrying his Cross, ill-drawn and coloured ; on a cartello the words : " Vigneri 1541." By the same hand, in the Monte di Pietà at Messina, is a half-length of Christ carrying his Cross.

Stefano Sant' Anna. We have seen, his best style is suggested by a figure of St. Paul, companion to a St. Peter in San Dionisio of Messina. St. Dionisius, enthroned on the high altar of the same church, is a mannered and poor picture, with a landscape background, inscribed : " Stephanus 8ᵗᵃ. Anna 1519."

Gabriel de Vulpe. We find this name on a picture of the Virgin and Child with two Angels and St. Peter, John the Evangelist, SS. Roch, and Sebastian, and the Bust of a Patron'in the hall leading to the sacristy at San Domenico of Palermo. It is inscribed : " Fr. Gabriel de Vulpe pinxit 1535." [* This picture is now in the Museo Nazionale at Palermo. See also Di Marzo, *La pittura in Palermo*, pp. 297 *sqq.*]

* [1] This artist was known during his lifetime as Vincenzo di Pavia, *alias* il Romano. It may, therefore, be doubted whether he was a native of Palermo. According to Di Marzo, the name of Ainemolo has been given to him merely through a confusion of Mongitore's. See Di Marzo, in *Archivio storico siciliano*, ser. ii. vol. v. pp. 177 *sqq.*

the arrangement, the feeling, and expression of Raphael's com-
positions. A careful outline, and soft, warm colour, and a
certain ease of hand made his patrons forget the superficial
character of his drawing, and his want of power in producing
effect by shadow. One of his most valuable pictures, The Virgin
of the Rosary, dated 1540, in San Domenico of Palermo, is
interesting for the number and slender grace of its impersona-
tions rather than for clever arrangement. In his Sposalizio at
Santa Maria degli Angeli he reminds us, by an elegant gentle-
ness, of the Bolognese school, and particularly of the elder
Francia or Viti. His very best work, and certainly that which
displays most richness of colouring, is the Virgin and Child
between four Saints in San Pietro Martire of Palermo. It is
not necessary to review his works in detail; it is sufficient to
note that they are chiefly confined to Palermo. Ainemolo died
after 1552.[1]

[1] For Vincenzo Ainemolo consult Di Marzo, *Delle belle arti in Sicilia*, iii.
241 *sqq.*, Gallo's *Annali di Messina*, Baronius, *Majest. Panorm.*, and Murray's
Handbook for Sicily, by George Dennis. [* The exact year of his death is 1557.
See Di Marzo, in *Arch. stor. sic., ub. sup.*, p. 181.] The following are notes of
some of his works :
(1) Palermo, Museo Nazionale. Wood, oil. The Virgin in a mandorla on gold
ground is crowned by angels ; the mandorla in a blue heaven with four angels
about it. This early work, ascribed to Perugino, is on a level with those of the
Umbrians of the 'class of Bertucci da Faenza. The figures are large as life,
affectedly graceful, slender, and dry, the contours crude and wiry. (2) Palermo,
San Domenico. Descent from the Cross, life-size figures. Four men on ladders,
or leaning over the horizontal limb of the cross, assist in lowering the body.
Below, the fainting Virgin is attended by four women. In the predella the
Virgin is seen fainting, as she looks over the dead body of Christ on her lap. The
Magdalen, with outstretched arms, shrieks ; an old woman wipes her tears, and
another supports one of the Virgin's arms ; to the right Calvary, to the left two
figures raising the cover of the tomb. Wood, oil, not free from restoring.
[* This picture has now its place in the Museo Nazionale of Palermo ; it was
originally in Santa Cita in that town.] (3) Same church. Virgin in a mandorla, with
two angels holding a crown suspended overhead. The child on her lap gives the
rosary to St. Dominic, near whom are St. Vincent, St. Cristina, and St. Ninfa.
Lower down numerous figures in adoration. On the pilasters are scenes from the
Passion, in a lunette saints in glory, and in the predella three scenes from the
lives of St. Vincent and St. Dominic. A cartello contains the date 1540. The
principal figures are large as life. (4) Palermo, Santa Maria degli Angeli, or la
Gancia. Marriage of the Virgin, defective in perspective, with about twelve life-
size figures. Wood. (5) Same church. Nativity. The child lies with his head
to the spectator like that in Girolamo dai Libri's picture at the Museum of
Verona. Wood, figures life-size. (6) Palermo [* now Museo Nazionale, No. 1027]
la Martorana. The Ascension. Wood, figures of life-size, (7) Palermo, San
Pietro Martire. Pietà, similar in incident to that in the predella at San

Domenico. Wood, figures life-size, much injured and restored. (8) Same church.
Virgin and Child in front of a screen hanging held up by angels, in a landscape
on the foreground of which are St. Peter Martyr and St. Stephen, St. Agatha and
St. Catherine of Alexandria; in the upper corner to the left, the Eternal. Wood,
figures of life-size. (9) Palermo, Museo Nazionale, No. 91, from San Giacomo.
Christ scourged at the Column with the Eternal and angels in a lunette, inscribed:
" Expensis nationis Lombardorum 15.2 (? 1542)." In several panels, forming part
of the altarpiece, are the Visitation, the Annunciation, the Flight into Egypt, the
Presentation, the Nativity, the Adoration of the Magi, all feeble and washy.
(10) Same Gallery. St. Antonio. (11) Palermo, Santa Maria di Valverde. St.
Anthony and his Pig, and eight small incidents from St. Anthony's life in
framings. (12) Palermo, La Pietà. Pietà.

END OF VOL. II